The Armor of
Light

CALIFORNIA STUDIES IN THE HISTORY OF ART

Walter Horn, Founding Editor

James Marrow, General Editor

Discovery Series

A CENTENNIAL BOOK

One hundred books

published between 1990 and 1995

bear this special imprint of

the University of California Press.

We have chosen each Centennial Book

as an example of the Press's finest

publishing and bookmaking traditions

as we celebrate the beginning of

our second century.

UNIVERSITY OF CALIFORNIA PRESS

Founded in 1893

The Armor of Light

STAINED GLASS IN WESTERN FRANCE,

1250–1325

Meredith Parsons Lillich

UNIVERSITY OF CALIFORNIA PRESS

Berkeley Los Angeles Oxford

Published with the assistance of

the Getty Grant Program

University of California Press
Berkeley and Los Angeles, California

University of California Press, Ltd.
Oxford, England

Library of Congress Cataloging-in-Publication Data

Lillich, Meredith P., 1932–
 The armor of light : stained glass in western France, 1250–1325 /
Meredith Parsons Lillich.
 p. cm. — (California studies in the history of art ; 23)
 "A centennial book."
 Includes bibliographical references and index.
 ISBN 0-520-05186-6 (alk. paper)
 1. Glass painting and staining, Gothic—France—Normandy.
2. Glass painting and staining—France—Normandy. 3. Glass
painting and staining, Gothic—France—Brittany. 4. Glass painting
and staining—France—Brittany. 5. Glass painting and staining,
Gothic—France, Southwest. 6. Glass painting and staining—France,
Southwest. I. Title. II. Series.
NK5349.A3N675 1993
748.594′09′022—dc20 92-30564

Printed and bound in Korea
9 8 7 6 5 4 3 2 1

For Robert Branner (1927–1973)

Mr B, cher maître

CONTENTS

LIST OF ILLUSTRATIONS

Plates follow page 274

FIGURES

<div align="center">PLANS, DIAGRAMS, AND CHARTS</div>

All drawings are by Victoria Lillich-Krüger unless otherwise noted.

ACKNOWLEDGMENTS

My work on western French stained glass found its conception in an interview with Louis Grodecki at Columbia University in 1959, and its nurture in the lifework, generosity, and friendship of Jean Lafond. It is dedicated to Robert Branner, role model whose fundamental impact is best summed up in the phrase: he taught by doing.

My work on Saint-Père de Chartres was supported by predoctoral grants from Columbia University in the 1960s. I am grateful to the National Endowment for the Humanities for a summer stipend in 1970, when primary research and site work were extended to other monuments, and then for a fellowship year in Paris (1976) when the book was structured and most of the work done on Le Mans and the problems of Chapter I. The American Philosophical Society provided grants from the Penrose Fund for work on Vendôme (1972) and on Sainte-Radegonde in Poitiers (1977); Syracuse University's Faculty Research funds supported the work on Dol (1978) and for writing in 1980–81. I am grateful to the American Council of Learned Societies for grants-in-aid for the work on Evron (1970), Sées (1973), and Gassicourt (1978), and for a fellowship year, 1980–81, to write the book. The text was finished at the Center for Advanced Study in the Visual Arts, National Gallery of Art, in the summer of 1981. I am thankful for friends of skill and integrity, Lorna Price and Michael Cothren. Grants from the Getty Grant Program and the University of California Scientific Account have facilitated publication.

I presented a paper on the Vendôme research at the Kalamazoo medieval conference in 1973, under the auspices of the International Center of Medieval Art. My work on Gassicourt was first given at a symposium held in conjunction with the exhibition *Medieval and Renaissance Stained Glass from New England Collections* at the Busch-Reisinger Museum, Harvard University, 1978; both exhibition and symposium were funded by the National Endowment for the Humanities. Research on Evron was presented at the Corpus Vitrearum symposium hosted by the Metropolitan Museum of Art in 1982. Part of the research on Dol formed a section of a paper given at the College Art Association meeting in 1983, and papers discussing various examples of western French stained glass now in the United States were given at the International Glass Conference at Corning in 1982 and at the International Center of Medieval Art session at the Kalamazoo medieval conference in 1987. Publications drawn from the research are cited in the notes as appropriate.

Jean Lafond said that only in Normandy (the part of the west that mattered, to him) could the development of stained glass be charted from 1250 through the fourteenth century. I hope to have extended his vision and I hope to have established—as Robert Branner did so magisterially for the architecture of Burgundy and the arts of St Louis's Paris—the artistic validity and fascination of western French stained glass.

Meredith Parsons Lillich
Syracuse University, 1990

NOTE TO THE READER

In this text, bay numbers for churches presently included in a *recensement* follow recensement volumes I (1978) and II (1981) of the Corpus Vitrearum France (CVFR I, CVFR II, q.v., Selected Bibliography, p. 405). Exceptions are: Chartres cathedral, for which Delaporte numbers are more universally available; and Saint-Père de Chartres, for which I use the numbering system used in my monograph *The Stained Glass of Saint-Père de Chartres* (Middletown, Conn.: 1978). The bay numbering system employed in illustrated plans is identified on each plan.

In the text, saints are referred to with English-style abbreviations: St Marguerite, St Peter, Sts Gervais and Protais. In monuments they are spelled: Sainte-Radegonde de Poitiers, Saint-Denis.

M. P. L.

The night is far spent, the day is at hand . . .

let us put on the armor of light.

—ST PAUL, EPISTLE TO THE ROMANS 13 : 12

Plantagenet Roots

—All things bright and beautiful

(ANGLICAN HYMN)

THIS IS A book about expressionism. "Gothic expressionism" might seem almost a contradiction in terms, yet western French design is marked by the excesses of color and drawing, the psychological involvement and tension, and the exaggeration for effect that have come to be known in art history as expressionism.[1] In western French glass no one is blasé, not even martyrs; even the animals have charisma; executioners love their work; they that mourn do so with abandon. Color is often almost gaudy, drapery painting simplified and abrupt, gesturing hands swollen at the ends of rubber arms. The antithesis of the elegant, harmonious, and fashionably bored art of the courts, western French stained glass is an art ferocious and charming by turns, often in the same window. Its most pervasive quality is energy.

This art dates roughly 1250 to 1325, and its region is the borderlands of the Loire, touching Basse Normandie to the north, Poitou to the south, and the crown lands to the east. These temporal and geographic boundaries spring from history. Won from English control in 1204 (unlike Aquitaine to the south), these regions remained in dispute until the 1240s, when St Louis's brothers Alphonse and Charles received them in appanage. Normandy was handled differently from the west by the French, who allowed its elaborate administrative systems to continue in operation without disruption; once French it was not fought over, and its "recovery" was quick. Its arts have a different Romanesque substratum and evolved independently.[2] Brittany, implicated with Anjou and Poitou in the feudal tussling of the early thirteenth century, was to remain an autonomous duchy but one with strong family ties in the west. Its stained glass will be considered here.

The influence of Normandy was strong in the west, as was the Parisian court fashion, at various times and in various places. These times and venues will be charted in the western stained glass programs to be discussed. Their combined strength plus the evolution of stained glass technique—and once again, the machinations of political history—are responsible for the evaporation of the western expressionistic art by 1325. At that moment, Norman stained glass entered a florescence paralleling that of the Parisian illuminators around Pucelle. The technique of silver stain, first identifiable about 1310, was in general use by glaziers everywhere after 1325.[3] And in 1323 and 1324 there sounded the first drum rolls of the Hundred Years' War, which was fought frequently on western soil.[4]

Western French Gothic glass exhibited characteristics of expressionism almost from the start. The earliest windows that remain, those of the twelfth century in Le Mans and Poitiers cathedrals, radiate a vitality that seems to be a legacy from their Romanesque roots.[5]

1

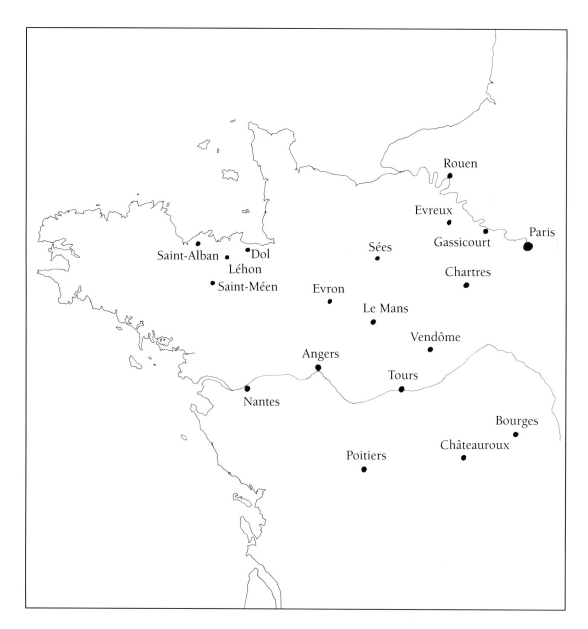

Map of western France.

The unstable dancing postures and warm colors have been linked to the arts of the Plantagenet west—sculpture, frescoes, and manuscripts. As long as the west was English, that is, until the beginning of the thirteenth century, the stained glass made for Angevin buildings developed along these lines until it became a defined style, first labeled the "school of the west" by scholars over a half century ago.[6] Little glass remains from the twelfth century, but what exists in western France is marked by characteristics evolved from the earliest panels there: the color is warm, with much yellow and saturated red; compositions are often on the diagonal, and figures are played off against one another as if bound in magnetic fields; heads

and gesturing hands are enlarged, facial features exaggerated or caricatured; the medallion shapes are graceless but explicit, either straightforward roundels with knobs, or polygons that seem to be all elbows.

In the period after 1204, when Philippe Auguste took over the western territories, many factors combined to suffocate this virile style. The prestige of the vast building projects then in progress in *Francia*[7] was great: Chartres and Bourges, as well as the many architectural projects of the Paris region. In the west the unsettled conditions of a war economy and then a conquered one were unfavorable to art patronage,[8] and the future of the west remained unsure long after 1204 while the volatile adventurer Pierre Mauclerc, cadet of the house of Dreux, maneuvered for power.[9] Mauclerc revolted against the young Louis IX to the extent of doing homage to the English king, was forced to the peace table by Blanche in 1236, led the league of nobles in 1246, and remained a troublous force until his death in 1250. The barons' rebellions of the late 1220s, the mid-1230s, and 1241–1243 involved many western lords. The dates of the western appanages to St Louis's brothers are significant: Alphonse received Poitou in 1241 and Charles became count of Anjou and the Maine only in 1246, a scant two years before the start of the crusade and virtual cessation of monumental building activity at home for the duration, 1248–1254.[10] There is a real and understandable hiatus in the development of Gothic arts in the west, one that is clearly reflected in stained glass styles of the first half of the thirteenth century.

Western stained glass of the Plantagenet period continued to influence the great early thirteenth-century ensembles, particularly Poitiers, which Grodecki has linked to Bourges and Chartres.[11] And some glazing activity persisted, notably the medallion windows of Angers, still in production about 1240.[12] But the strong identity of western art of the Plantagenet era seems extinguished. One must remember that many of the rich western abbeys rebuilt in the first half of the thirteenth century are now destroyed. But Saint-Martin at Tours was rebuilt on a plan replicating that of Bourges.[13] Similarly, there is little likelihood that a building as distinctively French as Marmoutier was glazed in the old Angevin style.[14] The evidence of Saint-Julien of Tours indicates to Papanicolaou that its thirteenth-century glazing program came from Paris, as did its final tracery patterns.[15] When the choir of Le Mans was rebuilt, the glass made for the chapels ca. 1230–1235, some of which remains, took on the French format of compound or star medallions, although its color is marked by much yellow and green, and the psychological involvement of a few figures reminds sensitive observers that they are in the cathedral that houses some of the most expressive fragments of the twelfth century.[16] The glass of the Tours chapels about 1230–1235 follows the lead of the Le Mans Lady Chapel,[17] with star medallions. But the western spirit has stiffened into rigor mortis.

The Mauclerc Lancets of Chartres Cathedral

This book is concerned with tracing the rise of the phoenix. Its first spasm probably occurred at the very end of the vast glazing program of Chartres in the 1230s. Some of the late windows of the Chartres transepts are hasty, simplified designs, but a new style surfaces as well, one that Grodecki has tied to the name of the Master of St Chéron.[18] Grodecki presents a case that this style develops from the St Chéron group in the ambulatory, evolves through late works in the transept of Chartres, and ultimately forms the basis for the developments of the Parisian school of the Sainte-Chapelle.

I have trouble, however, with Grodecki's analysis of the St Chéron Master as the designer of the south rose lancets (those given by Mauclerc) and ultimately influential in the three "blue bays" of the Le Mans clerestory (see Chap. II). Mauclerc's lancets, the famous ensemble depicting gigantic evangelists riding the four major prophets piggyback, are designs matching the considerable violence of their archrebel donor; the St Chéron scenes, on the contrary, are populated by somewhat wooden, vacant, insistently legible forms. It is unquestionably difficult to make comparisons between works of small and large scale, between ambulatory medallions and saints at larger than life size.[19] The drapery painting of the St Chéron atelier is stripped down, abbreviated, as indeed the Parisian style will be; but it has none of the spastic force of the Mauclerc lancets. One of their distinguishing characteristics is a drapery line I call a hooked inkblot. This exaggeration evolved from the standard spoon-fold of the *Muldenfaltenstil* and, in my opinion, is a distant and vastly simplified relative of the wet-drapery conventions of the great prophets of the upper reaches of Bourges.[20] It is possible to paint wooden forms in this way; one of the Troyes clerestory painters, the Theophilus Master, lays on a forceful drapery painting, including an occasional hooked inkblot, to frozen forms with notably static silhouettes. But that is not the St Chéron Master's style, which is perfectly homogeneous in design and in touch: cool, calm, and quite unrattled, the epitome of untemperamental sang-froid.[21]

Mauclerc's remarkable lancets under the south rose of Chartres (*Pl.1*), by contrast, are compositions in which the axes strain in torsion, the dynamic line is in jagged motion, the color violent, the rhythms bristling. Grodecki's description captures well their astonishing force. He sees in the windows

> un degré de véhémence colorée et plastique à peine supportable. Jean s'agitant
> sur les épaules d'Ezéchiel et lui tenant à pleins poings les cheveux, Luc
> encerclant de ses jambes enveloppées de tissus en désordre, la sauvage (et
> noire aujourd'hui) tête de Jérémie, le jeune et beau Matthieu supporté par le
> très vieux Isaie, Marc, ardent et tendu sur le dos de Daniel, à la fois jeune de
> visage et vieux, lourd, de silhouette et de geste, composent une série
> inoubliable par son expression plastique . . . images surnaturelles et
> étranges.[22]

The evangelists are not solidly astride; they squirm and grab their mounts by the hair. They have wild eyes, jutting jaws, prizefighters' noses. Their toes curl and their heels dig in, their clothes crackle as with static electricity. It is almost as if Mauclerc, perennial troublemaker of restless energy, enfant terrible to the end, had painted them himself. Beneath, the stiffened family in full heraldic regalia, not so masterfully drawn, is another side of the same coin. They are there to proclaim Mauclerc's arms, his power, and his new Breton dynasty; the family members are not graceful and elegant but are, rather, emphatically *present*.[23]

Color also sets the Mauclerc lancets apart from the St Chéron group, both the half-dozen windows of the ambulatory and the south transept clerestories, the most trustworthy being the famous bay of St Denis presenting the oriflamme to the *maréchal* Jean Clément.[24] The St Chéron group is strongly and traditionally red and blue. The Mauclerc lancets have an "aspect 'expressioniste' . . . [which] vient aussi de la terrible altération de certains verres, jaunes, pourpres, verts, qui font valoir, par contraste, les couleurs bleue et blanche."[25] This color harmony is significantly new and different: blue is its base while red is secondary; yellow, green, purple-brown, and large areas of white are the accents.

The Mauclerc lancets of the south rose of Chartres are thus distinguishable in my view from the late Chartrain style which culminates in the north rose lancets opposite, a donation of the Capetian monarchy and so marked with dignity and majesty that they are, truly, regal.[26]

The Patriarchs of Saint-Père de Chartres

The expressionistic qualities of the Mauclerc lancets set off sparks before long in Chartres itself, in the glazing program of about 1240 at the Benedictine abbey of Saint-Père. What was glazed is not certain—probably the recently completed nave clerestory—and the original arrangement of the procession of prophets is unclear, though they were no doubt in disputing pairs, an idea taken from the Chartres transepts, and framed in great medallions, as in the Chartres hemicycle clerestory.[27] Twenty-eight patriarchs and the designs of another four, photographed before their destruction in World War II, have survived. All have been reused, in a "shutter" pattern of color and grisaille glazing the clerestory of the *rayonnant* choir constructed ca. 1265.[28]

Several artists were involved in the production of the Saint-Père patriarchs; not all were followers of the expressionism of the cathedral's Mauclerc lancets. Some figures of the series have a blocklike stance, composed mood, and eminent legibility, which evoke the St Chéron Master's designs. The ateliers at Saint-Père shared the tasks completely, however. Sometimes blocklike or slender figures have draperies painted with abrupt black triangles,[29] or colored yellow and green, as in the Mauclerc designs.[30] The reverse also occurs, that is, a cartoon of considerable force painted rather traditionally. The cartoons can be distinguished easily. The St Chéron painter did not like profiles. Of the Saint-Père cartoons, the one I have called B (*Pls.2.A–B*), a profile head on a frontal form, is very close to the structure of Mauclerc's lancets—the same axis in torsion over a solidly planted base, the same jagged active line.[31] The striding cartoons (M, N [*Pl.2.A*], P), not surprisingly, contain a more restless energy.[32] Chiefly, color has evolved. These are blue windows; large drapery areas are yellow, green, purple-brown, and white; even blue reappears in robes. Red is minor. Although there is nothing precisely like it in the cathedral,[33] the color harmony of the Saint-Père campaign of 1240 is a codification of the violent color Grodecki succinctly described in the Mauclerc lancets and may reflect a preference, which Grodecki has also noted at Angers, for a cool tonality in which red is purely secondary.[34] And it recurs in the early clerestories, the three blue bays of Le Mans, where quiet design elements have been left far behind.[35]

My thinking about the sources of the Saint-Père campaign of ca. 1240 has modified without radically changing direction since 1978, when I noted the Chartres north transept glass as the closest to Saint-Père among the cathedral's late windows.[36] The authoritative, monolithic forms of the north rose lancets, painted with a more curvilinear touch than Mauclerc's lancets on the south, no doubt had an influence at Saint-Père; indeed the greater number of the patriarch cartoons have such a straightforward orientation. Since then, two studies already mentioned have influenced my thinking about the more expressionistic prophets of Saint-Père: Grodecki's analysis of the St Chéron Master, his development and following; and Roger Adams's study of the authenticity of the transept windows of Chartres.[37] Grodecki's study stimulated me to factor out the differences between the St Chéron atelier and the Mauclerc lancets, which in my view are unique in the cathedral. Adams's

work has convinced me that the north transept clerestories on the east—the figures in yellow and green, closest in color to Saint-Père—are designs of fairly recent date. Possibly the restorers copied the color in a simplified form (just as they copied the hooked inkblots of the draperies) from the great Mauclerc lancets, a procedure that is, in a sense, just what the Saint-Père glaziers had done about 1240.

The 1240s: A View from the Bridge

Life and art are always in flux, but their directions change infrequently. The arts of France were unsettled in the 1240s, in the process of changing direction from the tenebrous, color-saturated interiors of the High Gothic of Chartres and Bourges to the elegant *rayonnant* cages of light associated with the Court Style of Louis IX. In stained glass this shift introduced lighter, clearer tonalities and, more specifically, a great interest in grisaille and its possibilities for combination with color.[38] The bridge occurs between 1240 and 1260.[39] In the early 1240s the syntax of the totally color-saturated Sainte-Chapelle was old-fashioned but by no means archaic or obsolete, as its success in reinvigorating the medallion style attests. By the early 1260s an ensemble without grisaille is rare.[40]

The reasons for the interest in grisaille have traditionally been three: economy; a wish to light the new calligraphic surfaces of the *rayonnant* interiors; and the eternal desire of artists for a step forward, something new.[41] There is no question that the Gothic aesthetic was undergoing a fundamental permutation—but why? The rapid, even volatile, movements in Parisian intellectual development lead me to believe that a fourth reason provides the impetus for the new aesthetic, the other three simply identifying its modi operandi. This fourth cause is the shift in the theological underpinnings of the Gothic aesthetic of light.[42] Gothic is a style based on the metaphysical concept of God as Light. In the twelfth century, save for St Bernard, the general preference was for the oriental mysticism of the Pseudo-Areopagite, for a divine radiance incomprehensible and unapproachable. It was the "âge d'or de l'érigénisme"—John Scotus Erigena being the translator and interpreter of Dionysius to the West.[43] Nonetheless the more Western Neoplatonism of Augustine gained strength, eventually to take the attack: in 1210, against the Amauriciani; in 1215, against Joachimism and the Porretani; in 1225, against Erigena himself. The struggle was (as Chenu has said) Augustine versus Dionysius, and it culminated in the Ten Propositions, or Condemnations, of 1241 and 1244,[44] which rocked the world of the Sorbonne theologians. Gilson sees a new direction in Parisian light metaphysics after 1230; Dondaine would push back the change in course to 1225; de Bruyne notes the first aesthetic judgments relating the amount of light with the amount of beauty already in William of Auvergne, bishop of Paris (d. 1249).[45] After the Ten Propositions, Light is light, no longer Dionysius's tenebrous, radiant oriental gloom; Augustine is victor. St Louis's court chapel has not yet caught up with the university doctors in this regard; the Sainte-Chapelle glass is truly the swan song of a philosophy, not merely an artistic fashion.

There is evidence that well before the Sainte-Chapelle, other Parisian buildings were glazed with grisaille, starting after 1225 when the new clerestories and chapels of the cathedral of Notre-Dame were constructed.[46] A seventeenth-century painting shows weather-blackened grisailles in the nave clerestories of the cathedral (*I.1*); Le Vieil describes grisailles in choir chapels, as well as in rosaces in the south choir clerestory. His puzzling remark

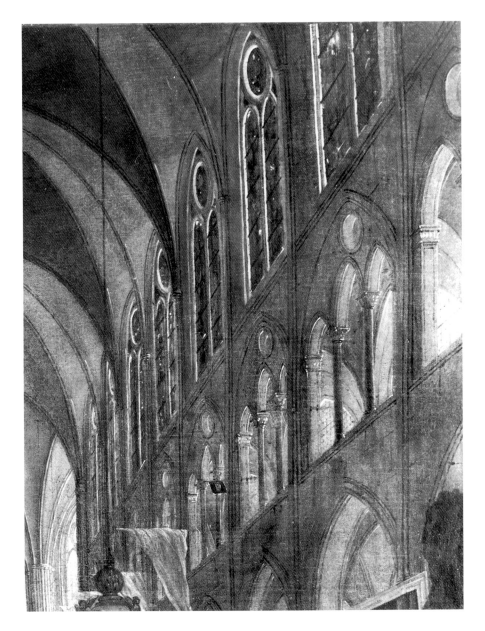

I.1 *Darkened Gothic grisailles in nave clerestory of Notre-Dame cathedral, Paris.*
Their rusty brown color is typical of badly weathered grisaille. Detail of mid-
17th-cent. painting (Musée de Notre-Dame, Paris; ex collection Anthony Blunt).

about colossal clerestory figures, "leurs draperies de verre coloré en blanc," indicates to me that he is describing colored figures swimming in a grisaille field.[47] They would thus be the understandable source for the fragmentary glass of this genre that remains in country churches in the Ile-de-France region: Saint-Merry at Linas, near Montlhéry (Essonne); Brie-Comte-Robert (Seine-et-Marne); and Villers-Saint-Paul (Oise). A more monumental en-semble still containing windows that reflect the Notre-Dame format is, in my opinion,

Auxerre cathedral, the axial chapel and clerestories of the atelier dated by Virginia Raguin 1235–1245.[48] This window genre, combining colored figure panels inside a grisaille surround, the whole within a colored border, will only work for fairly broad lancets of the doublet-and-rose type, which had passed out of fashion by about 1240.

Meanwhile the new long and slender window lights were being glazed in a new system, as ensembles contrasting grisailles along the flanks of the chancel with a colored eastern light or hemicycle group, a system I refer to as summer-and-winter. The nunnery of Saint-Jean-aux-Bois (Oise)[49] is a handsome early example ca. 1230; the choir clerestories of Sens,[50] enlarged after 1230, were glazed in this manner; and summer-and-winter glazing was adopted in Paris in the prestigious Lady Chapel of Saint-Germain-des-Prés, begun in 1245.[51] The upper rows of lights in the nave of Bourges, under way about 1235–1255, were glazed in grisailles.[52] The first colored glass was removed and replaced by grisaille in Chartres cathedral ca. 1235–1240, followed by four lancets about 1260, and four more within the next generation.[53] At mid-century, clearly, a new world was dawning.

Power and Money

The choice of 1250 for the start of our investigation of the new western style thus reflects the moment of metaphysical shift in the Gothic aesthetic. It reflects a political, and therefore economic, shift as well. The Barons' Rebellion of 1241–1243 had scarcely ended when Louis IX took the cross (in December 1244) and began preparations to go to the Holy Land; he left in 1248; his brother Alphonse de Poitiers and the western knights followed in 1249. Alphonse and his brother Charles, both princes appanaged with western lands, returned to France in 1251, the contentious Mauclerc having died on the high seas the year before. Blanche, capable regent for her son, died in 1252; a short period of chaotic adjustment followed until Louis himself returned to Paris in late August 1254 and took the reins.

The crusades were events not only in the political but also in the economic life of the nation.[54] As Robert Branner has established, building programs fell slack as taxes for the wars took precedence; money was an increasing pressure on the crusaders once their adventure was launched. To translate into the art historian's terms: at such times a hiatus in artistic activity is likely, and therefore a lack of clear development within the atelier, master to apprentice. With the return of the crusaders, there would be reason and money to build again and to hire new artists. If they copied from the old, and medieval artists were expected to do so, it was with the eye of the art student, the observer, not with the hand of the insider trained in the studio's traditions.

This is certainly the chronology at Le Mans cathedral, where the chapel glazing predates the crusade and the upper windows closely follow it. At Tours it is the same: the ambulatory predates the crusades, and the triforium of 1255 is in a different style with a summer-and-winter format.[55] Likewise at Saint-Père de Chartres: the patriarchs of about 1240 are reused and augmented by several cartoons of 1260–1270 which, though "copies," are distinguishable from the earlier figures in almost every regard.

This book begins at 1250 for all of these reasons. A new aesthetic, a different concept of metaphysical light; a new set of actors on the stage, both as patrons and artists; and new reasons for patronage, the western counties only now really becoming a settled part of

France. Expressionism, the artistic tendency that surfaces in competition with strong influences chiefly from Normandy and the Parisian court, will be traced in western stained glass to its fruition in the three Benedictine abbeys of the late Capetian era: La Trinité de Vendôme, the nave of Saint-Père de Chartres, and the pilgrimage church of Evron (Mayenne). All three had royally connected patronage. What then is to become of our cherished concept of the Court Style versus the provinces?

The concept of a western school in the late thirteenth century originated with Louis Grodecki,[56] and its definition is possible only after the lifelong work by Jean Lafond on the parallel provincial school of Normandy. This study, like Mauclerc's evangelists, thus rides on the shoulders of giants. The windows of the west are wondrous fair. Their gaiety, the intensity of their dazzling color, their extraordinary vitality and throbbing life, are a legacy to cherish.

✳ Epilogue ✳

The ancestry of the western Gothic style of 1250 is rooted in the Plantagenet domains, which had produced a school of Romanesque stained glass of noteworthy vibrancy and energy. The pedigree is not direct, however, but collateral. When the French took Aquitaine just after 1200—at the beginning of the High Gothic era, the generation of Chartres and Bourges—the west suffered a prolonged and troubled transition not notably improved when, in the 1240s, the king's brothers were appanaged with Poitiers and Anjou/Maine and, marshalling all available resources, followed St Louis on crusade. Both of the vast glazing chantiers of Chartres and Bourges had harbored an occasional expressionist among their designers, and in Chapter II we will see that both cathedrals were consciously exploited models for Le Mans, the first large glazing project following the return of the western knights from the Holy Land in 1251. Grodecki's classic study of 1948 identified the western, "Poitevin" strain at Bourges; this chapter has sought to identify and analyze the expressionistic voice present among the final works at Chartres, notably in the Mauclerc lancets. Soon thereafter, and also in the city of Chartres, some forceful designs appear among an ensemble for the Benedictine abbey of Saint-Père (figures now reused in the later chevet): a prophecy of patriarchs, each framed in an oversize medallion, as in a few of the Chartres and Bourges clerestories. In the same decade of the 1240s, art and theology in Paris were pulling in several directions. One has been very well explored by art historians—the Court Style epitomized in the king's Sainte-Chapelle. The other has received less scrutiny. Thus this chapter has sought to establish that combinations of grisaille were becoming attractive, theologically and otherwise, in Paris before 1250. When, at mid-century, the western knights came home and their society embarked on a less erratic course, there was no clearly codified western style. But there was the regional tradition of forceful Romanesque design, the great High Gothic ensembles of Chartres and Bourges at the region's borders, and the several recent and prestigious experiments of the royal capital further away. In this chapter, we have examined the roots of western Gothic—not the taproot, for it had none, but the diverse radices from which it took shape.

CHAPTER TWO

Maine:
The Cathedral of Le Mans

Un Manceau vaut un Normand et demi

—FRENCH PROVERB

THE STAINED GLASS of the cathedral of Le Mans is as rich, as many splendored, and as wide ranging in date as any ensemble in France. Its riches include precious fragments from the very beginnings of the art[1] as well as grand displays of fifteenth-century portraiture and heraldry.[2] The sheer expanse of glass, as well as its breadth of interest, has militated against a comprehensive monographic study, a task further complicated by much Huguenot destruction (1562), severe storm damage (1810, 1858), and indiscreet restoration in modern times. Still, Le Mans has been lucky. It was the beneficiary of one of the great pioneer studies of French stained glass by Eugène Hucher, whose elephantine volumes of 1855–1862 and 1865 catalog the windows then in the cathedral and illustrate many with drawings.[3] In recent times Louis Grodecki provided a substantial overview of all the cathedral's glass, its history, and its bibliography.[4] His work is the foundation for all further study.

The State of the Question

The Le Mans windows of interest to this study of western glass from 1250 to 1325 constitute in themselves a vast ensemble of broad stylistic range. This is the stained glass provided for the new Gothic chevet (*II.1*), an immense and magnificent construction in the pyramidal "Bourges-type elevation," begun about 1220.[5] The surviving glass made for the ambulatory chapels (mentioned briefly in Chap. I) dates ca. 1230–1235 and adopts a star-medallion format which, even at that moment, was becoming outdated in the Ile-de-France. A second master, a Norman, constructed the Le Mans ambulatory and "inner elevation" from about 1230 to 1245; a third master, of Parisian inclination, built the dazzling cage of clerestory lights from the late 1240s to the consecration of April 1254.

The upper ambulatory windows (clerestories of the "inner elevation" framed by the main arcade) are more or less triangular or tympanum-shaped, formed of five lancets in the straight bays and three in the hemicycle. The lights have straighforward shapes conforming to the lazy arch, and the spandrels beneath are decorated with Norman relief carving. The Parisian clerestory is something else:

10

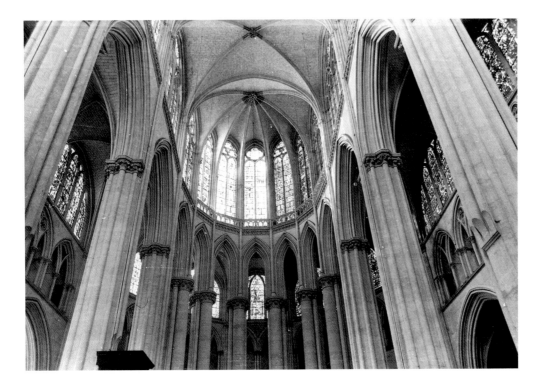

II.1 *Le Mans cathedral. Chevet.*

The language of the forms is like a dialect when compared with the ceremonious and measured speech of Jean de Chelles, but it is a dialect of Paris all the same. The windows are of three sizes—narrow in the eastern bays of the apse, larger in the western ones, and quite broad in the choir. Each pair is matched, north and south, as if to prove beyond any doubt that the differences in pattern were deliberate. On the axis of the church, is a window similar to those in the apse of St Denis; this is flanked by two imitating the apse of the Ste Chapelle, and these in turn by a pair of the same sort but with trefoil arches and an inverted trilobe at the top. The bays of intermediate width have this last pattern above a triplet and triplets form the basis for the designs of the first two pairs of choir windows. The eastern set has two triplets with quadrilobes in the tympana, the upper ones turned on their sides as in the north transept of Notre Dame, while the central set has large trilobes as at Amiens. Finally, the western pair of windows has two doublets below turned quadrilobes. . . . [Le Mans] is clearly the most inventive composition of the entire decade. Variation is the norm rather than the exception, and the performance is indeed dazzling. At small scale or large, in doublet or triplet, and in trilobe and quadrilobe turned right-side up, inverted or placed sideways, the forms seem to be possessed of a life all their own.[6]

Thus the clerestory, while fashionably Parisian in its specific forms, is exuberantly western in the excess and untamed bravado with which those forms are applied.

There are thirteen bays in the upper ambulatory, and thirteen vast bays in the clerestory, all but one (Bay 208, demolished in a nineteenth-century windstorm and reglazed in 1858) still containing medieval glass. The dating of these ensembles has been disputed, Mussat believing that the glazing was practically complete at the dedication ceremony of 1254, others, including Grodecki, placing the end of the campaign two decades later, about 1275.[7] Since Emile Mâle, it has been conventional wisdom that the upper ambulatory glass is largely Parisian in orientation, in the orbit of the Sainte-Chapelle, although Grodecki observed:

> mais il ne saurait être question de voir au Mans les travaux des verriers
> qui ont peint les verrières parisiennes: l'allongement des proportions des
> personnages, les cassures très prononcées des draperies, la rapidité du modelé
> peint réduit à deux teintes, ne se retrouvent pas à Paris, même dans l'art du
> plus "maniéré" des vitriers de la Chapelle, le "maître d'Ezéchiel."[8]

Nine of the thirteen bays of the upper ambulatory are attributed by Grodecki to this principal atelier of more or less Parisian type. In addition he analyzed the remainder as follows:

Bay 100 (axial)—large-scale figures with donor below, in forms and in touch
 unquestionably derivative of Chartres cathedral.[9]
Bay 105 (north choir)—medallions, the work of a folk artist or *naif.*
Bay 101, right lancet (north hemicycle)—medallions, regarded by Grodecki as
 interpolated stopgaps.[10]
Bays 110 and 112 (south choir)—medallions, late mannerist exaggerations of the
 Parisian-style principal atelier.

Grodecki divided the clerestory glass into three stylistic groups: a memorable, expressionistic master of great interest;[11] the Parisian-type principal atelier responsible for most of the upper ambulatory bays;[12] and an exaggerated style, which in some cases is caricaturelike and overly simplified, which he considers late and mediocre.[13]

I will address some of these judgments with evidence drawn from new or corrected identifications of heraldry and genealogy, plus observations of different iconographic and stylistic relationships, with the aim of proposing a chronology for the glazing campaigns and an appreciation of their myriad western qualities as well as their likely regional derivation.

Assessments: Condition, Patronage and Program, Stylistic Orientation

In spite of the publicized troubles afflicting the cathedral of Le Mans throughout its history, the upper ensembles of choir glass are in reasonably good condition. The Huguenots apparently did not gain access to the choir catwalks and had to be satisfied with what mischief they could inflict by harquebus shots and casual projectiles. The *Plaintes et doléances* drawn up after the Huguenot visit list no damages for the choir clerestories; for the upper ambulatory, all damage is consolidated into a single entry: "Et es secondes vittres estant a l'entour du cueur, en nombre treze, painctes, qui ont este cassées et endoumaigées de la somme de trente livres tournois. . . ."[14] Bay 208, destroyed by storm and replaced with an innocuous Gothicizing design of 1858, can be assumed to have continued the south clerestory series of

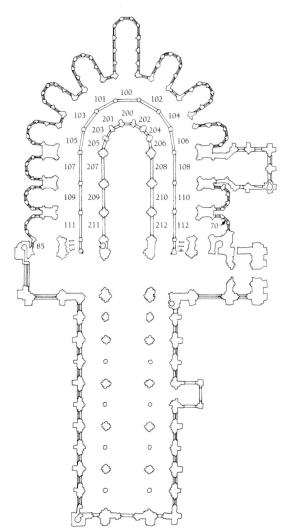

Plan of Le Mans cathedral.

frontal bishops, on the basis of the fragmentary panel of just such a figure now preserved in a north ambulatory chapel. Grodecki's notations of restoration will only be repeated where pertinent to our understanding of the window in question.

The spectacular display of the Le Mans choir would have been even more striking before the Romanesque transept was replaced from the end of the fourteenth through the early fifteenth centuries. The view from the Angevin nave is, however, largely unaffected by the new transepts. The choir glass ensembles contribute to the effect in different ways: the upper ambulatory lights emerge as throbbing color from deep, undefined shadows; by contrast, the clerestory, a cage raised above fifteen-meter columns, presents, in Mussat's eloquent phrase, "un grand mur de verre qu'ornent des personnages monumentaux" (*II.2*). In neither case can the subjects be read clearly or even intelligently guessed at by an observer standing below without binoculars. It is thus not surprising that the iconographic program is likewise unclear. In fact there seems to be none, as at Chartres (excepting the ensembles at the cardinal points). Logic is formal, not iconographic, with medallion windows filling

the entire upper ambulatory save for the striking axial bay; the clerestory is composed of great standing saints across the tops of lancets, with references to donors, also large, relegated appropriately beneath them. The iconographic pattern roughly groups lives of favorite and patron saints in the upper ambulatory medallions and in the clerestory traceries; in the clerestory lancets, standing bishops mostly take to the south and standing apostles and prophets to the north, flanking the Virgin and Christ on the axis. A rigid discipline is not enforced, however.

The riot of topics, the repetition of favorite saints or miracles, and the general disorder are in themselves instructive. These windows are the gifts of guilds, of monastic communities, and of the rich, both bourgeois and noble. A great number of them carry their identifications proudly: the special saints of particular abbeys, guild members at their daily tasks, coats of arms (not all correctly identified previously, yet in many cases significant for the dating). If order exists, it is here. The upper ambulatory's hemicycle was donated by the nobility, whereas the remainder of its bays are gifts of the religious—of abbeys and of cathedral canons. Only the winegrowers break this pattern, and the special circumstances of their gift, as we shall see, suggest that they were the first guild to be so represented in the cathedral.

The other guilds, following their lead, take their places in the clerestory above. Bakers, drapers, woodcutters, and furriers hobnob there with several strata of the rich—the bishop, several wealthy bourgeois, nobility of ancient lineage, canons, and monks. It is a landscape populated by medieval urban society.

The authority to which so disordered a program referred was certainly Chartres, and it seems clear that Chartres waxed large in the mind of the planner as venerable model. By planner, I mean not the artist but the bishop, Geoffroy de Loudun, and possibly his committee of canons, since the influence of Chartres outlasts him. Since Geoffroy saw his cathedral consecrated in April 1254 and died in August 1255, my implication is that the evidence bespeaks a campaign begun by him that continued into the next decade. In the final stages (the south clerestories) one venerable glazing model was replaced by another, the cathedral of Bourges. Since the architecture itself is based on the pyramidal elevation of Bourges, it is a fitting final tribute.

I have not mentioned Paris. Indeed I do not see much that is Parisian here, not in the level of theological thinking, not in the iconography in either program or detail, not in the pattern of patronage, not in the omission of grisaille maintained stubbornly to the end, not even in the medallion format nor in the painting style.[15] These points require some explanation and marshalling of evidence.

At mid-century the omission of grisaille is more significant than its inclusion; it implies a lack of awareness of Parisian currents, as I have suggested in Chapter I. I have come round to the view long espoused by Jean Lafond, that the fashion changed in Paris—and of all fashions particularly this one, since its basis was metaphysical and intellectual. There is little reason to expect anything strongly Parisian at Le Mans. Its bishop was an Angevin without a tinge of Scholasticism about him, its noble donors were border lords who only recently (and chiefly *outre-mer* and in Flanders) had paid feudal obligation to a young and undisciplined Charles d'Anjou, whose behavioral pattern appropriately matched their own. Indeed, the cathedral was consecrated when the French king was absent from his kingdom, and only four years thereafter did England's Henry III relinquish the Maine by treaty. The clerestory

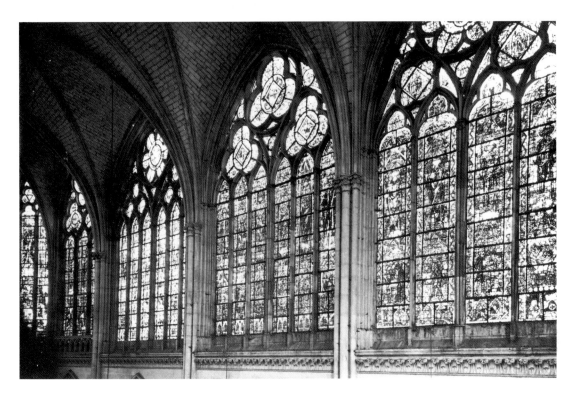

II.2 *Le Mans. Choir clerestory.*

architect had at least been to Paris and no doubt trained there, but the immoderate and unclassic exuberance of his traceries seems to characterize him as a westerner and a braggart at pains to exhibit his schooling.[16]

The so-called Parisianism of the upper ambulatory medallions calls for a more methodical refutation. The concept of a full medallion program, it has been implied, derives from the near-revival of this form in Louis IX's Sainte-Chapelle of the early 1240s. Where it can be demonstrated that Sainte-Chapelle ateliers actually worked, as Virginia Raguin has done for Burgundy, and where the program reflects the sophisticated thought patterns of Scholasticism, as Linda Papanicolaou has shown at Tours, the lineage does indeed seem sure.[17] Neither scenario applies at Le Mans. The program is not sophisticated but in fact nonexistent, the saints' lives a string of local legends and naive folk charms. The medallion format at Le Mans, as Grodecki pointed out, is not really related to that of the king's famous chapel; nor is the painting style. In following up his two observations, the medallion shapes and painting styles must be described, analyzed, and related not only negatively (to Paris) but positively, if possible, to regional sources and roots.

I will attempt to do this in the course of a chronology for the Le Mans glazing, a working hypothesis composed of my interpretations of historical and regional data, of heraldic and genealogical evidence, of iconographic detail, and of stylistic comparisons. My conclusion is that Le Mans is emphatically and without apology a monument of the west, by the west, and for the west.

The Consecration of April 24, 1254

In Chapter I, I proposed that a real hiatus in western artistic traditions occurred in the second quarter of the thirteenth century, roughly from the death of Philippe Auguste's son and the *sacre* of his twelve-year-old grandson Louis IX (1226) to the return of the western barons from the latter's crusade (1251). It was a period of uncertainty and lack of direction. I do not wish to imply that there was no art, since of course there was—human beings, unless actually running for their lives, will embellish their environment as they can. There occurred a break in artistic traditions, however, which implies a real break in the continuity and traditions of artistic training. This is certainly the situation as the upper reaches of the Le Mans chevet were being readied for glazing.

In the years 1251–1254, France found itself financing an absent and defeated king installed with a tiny band of diehards in Acre in the Holy Land, who showed no signs of returning. Things at home were in a state of suspended disarray, much attenuated after the death of the regent Blanche in November 1252, and only set to rights upon the king's return to Paris in the fall of 1254. April 24, 1254, thus seems a most puzzling and unpropitious moment to have consecrated the new cathedral of Le Mans. I believe the reason for this haste was political; the story will unfold below. At the same time, it seems less than likely that the building was finished, fully glazed, and decorated; contemporary evidence shows that in fact the shop was littered with the debris of construction on the very eve of the event, requiring an extraordinary eleventh-hour effort by volunteer citizenry of all ages and social castes.

The same chronicle relates another incident reinforcing the assessment that the glazing could not have been complete.[18] The grand ceremony, which included a procession translating the relics of St Julien to their new cathedral, was attended by the lords of Beaumont and Montfort; the bishops of Tours, Angers, Avranches, Rennes, and Dol; canons and monks of many orders; and the city guilds in force. Guild members carried torches in the procession elevating the patron saint, who was indeed elevated, from his former resting place in the crypt to the main vessel of the Gothic choir. The guild of winegrowers arrived late for muster and were thus unable to carry torches with the rest. They resolved to offer, in place of torches, a window to light the church forever. The window they donated, Bay 107 on the north side of the upper ambulatory, was thus not even commissioned on April 24. A nearby window (Bay 111, at the crossing) was the gift of Guillaume Roland, named in an inscription and depicted as a priest. This detail of costume places his gift during the period of his precentorship at the cathedral, since he was elected bishop in September 1255.[19] The winegrowers' window (post–April 1254) and that of the precentor (pre–September 1255) are both works of the Principal Atelier, comprising nine bays of this level as well as various works in the clerestory. The year 1255 can thus be suggested as the median period this shop was in full activity.

Why was the consecration accelerated, and what glass was probably in place at the time of the ceremony? The answers I propose are interrelated and reinforce the idea of Le Mans as a civic cathedral of the genre of Chartres, with the same kind of funding and mass support as a civic enterprise, and the object of regional pride. The prince of the region, Charles d'Anjou, returned with his Angevin knights from the Holy Land in 1251. While it is likely that some activity in the cathedral's building campaign was stirred by their return, it is more likely that Charles's ambitions thereafter provided the scenario which resulted in the hasty consecration.[20]

Late in 1252 Charles "was freed by the death of his mother to go to war," as Jordan has put it.[21] While his brother St Louis was still in Acre, Charles made haste to pursue the advantage presented at the death of Frederick II and carve himself a northern realm. By October 1253 he had accepted the offer of the county of Hainault and the challenge to give the title substance by military force; by January 1254 he had achieved actual control over Valenciennes. He then returned south to raise a great army of his Angevin knights in preparation to march toward Flanders in May and June and turn his ambitious fantasies to glorious reality. That the aggrandizing expedition quickly aborted in a swift denouement does nothing to alter the situation in the west in the spring of 1254, of war preparations hastily advanced in a mood of high excitement and reckless adventure.[22] The imposing civic and religious ceremony translating the relics of the city's patron saint, Julien, to his splendid new cathedral was held on the very eve of departure of the knights of Charles d'Anjou, a grand patriotic event sending these men off to glory.[23]

The dating of the glazing campaigns must be fitted around these important local events, taking into account as well the following assumptions: that the templates of the upper ambulatory were available to glaziers by about 1240 and well before those of the clerestory; that knights do not make gifts while they are scrambling to collect funds for war or crusade but rather, gratefully, upon their return; and that there was, in any event, not much money or calm in the counties of Charles's appanage in the 1240s, when the bitter feudal revolt of the early part of the decade was quickly followed by the crusade fever of the later part. Thus it seems likely that early efforts by Bishop Geoffroy de Loudun to fit out his new cathedral with glowing windows were sporadic. This, too, is what the stylistic evidence suggests.

The Window of Rotrou de Montfort, Knight

The axial window (Bay 100) of the upper ambulatory, the only window of that level that remains visible from the nave of the cathedral, was constructed by the early 1240s. Its glass is maverick, different from all other bays in the cathedral. The window depicts a monumental Virgin and Child enthroned between Sts Gervais and Protais, ancient patrons of the cathedral;[24] below them a king and another figure, both committing suicide; and below the Virgin the kneeling donor in heraldic surcoat, offering his arms in a lancet. He is Rotrou de Montfort, one of the knights named by the chronicler as having been present at the 1254 consecration.[25] Thus his window has often been dated by that event, though its unique style unquestionably replicates formulas of Chartres and at some remove in skill. Though its color gleams with near-barbaric splendor (Pl.3), its subjects reflect those of the Chartres north rose lancets, copied by rote and without logic,[26] and its painting style repeats the formulas not of the north rose but the older type of wrinkled wet draperies of the Chartres hemicycle clerestory. The Rotrou de Montfort window is a discordant marriage between unrestrained coloristic richness and a stiff, servile copying of disparate and barely understood Chartrain models.

Rotrou de Montfort was the last of his line, a cadet branch of the counts of Mortagne and Perche.[27] His father died on crusade in 1239. The son served St Louis from the early 1240s,[28] was married to Marguerite d'Aluye from 1251,[29] took part with his brother in Charles d'Anjou's Flemish expedition in 1254,[30] and died in 1269 or 1270, predeceased by his wife, leaving only a daughter Jeanne.[31] Rotrou is depicted very young in this window,

and without a wife or even a brother. There is no reason to presume that his gift is as late as 1254; it may even be a commemoration of his inheritance and new title ca. 1240.

While it is possible that so lackluster a painter was in fact trained at Chartres, it is unlikely, even as early as 1240, that he would have combined the new designs of the north rose (most probably only recently installed) with the archaic, wrinkled wet draperies of the earlier Chartrain styles in the hemicycle clerestory. The drapery folds, illogical and over-done, heavily coat the stiff, graceless figures with masklike faces; only the kneeling donor (not copied) achieves a graceful presence. The decorative forms are simplified and childish, even funny: note the periscopic jack-in-the-pulpits, which serve as crockets over the lower right arch. Such decorative motifs are an artist's handwriting and often yield indications of his formation. These "growths," which resemble some kind of microscopically viewed fungus, are unknown at Chartres[32] but do reflect a few such fungus crockets in the upper reaches of Bourges, for example in the Amos and Malachi bays.

The implication is that the Le Mans glazier had not trained at Chartres or at Bourges but in a provincial western milieu. Grodecki's study of the earlier relationship between Bourges and Poitiers indicates the axis.[33] The remarkable color of the Rotrou bay, moreover, emphasizes a hot red set off with strong yellow and a pale, somewhat watery blue, the favorite color gamut of the Plantagenet west. And the large figures of the Virgin, Gervais, and Protais are unframed, totally without enclosing arches, another reminiscence of the earlier western school.

In short, not only are the Chartrain subjects and conventions ill-matched and misunderstood, but the sheer ugliness of the masklike faces and gaucherie of the forms in combination with the opulence and gorgeousness of the color suggest another possibility.[34] My hypothesis is that a western journeyman of about 1240—the ineptitude of whose art will be explained very shortly by the work of several of his fellows—was sent to Chartres cathedral to take notes. I presume that Bishop Geoffroy sent him.

The Master of Bishop Geoffroy de Loudun

Bishop Geoffroy de Loudun (1234–1255) had a reputation for a careful purse.[35] He no doubt intended, following the example of Chartres, that most of the glass of his cathedral would be provided by gift, and the charting of identifiable donors in the windows of Le Mans indicates that his goal was probably achieved. Certainly in the troubled 1240s, while construction was in progress, no money would be spent on glass, and thus it is that after Rotrou de Montfort's gift bay, no more windows were installed until near the consecration date.

Reason suggests that the first pressing task in decorating the choir for the ceremony was the glazing of the axial clerestory (Bay 200) immediately over Rotrou's bay and, like it, in full view from any point within the entire building. All evidence concurs in this judgment: donor, subject program, style. The donor of the axial clerestory is the bishop himself (*Pl.4*), shown as almost mirror-image twins in full scale within borders decorated with eight shields of his arms: *gueules à la bande d'or*.[36] It is not a subtle statement and suggests the stripe of this westerner, a landowner from Saumur in Anjou.[37]

The program of this prestigious bay is the only one in the cathedral to attempt any pretensions of theological subtlety. The left lancet contains Christ wearing the crown of thorns, showing his wounds (at the top; *II.3.A*); and Christ crucified on the tree, his blood

A B

II.3.A–B *Le Mans. Choir clerestory, Bay 200. (A) Christ showing his*
wounds, upper left lancet. (B) Coronation of the Virgin, upper right lancet.

caught in a chalice by a kneeling figure usually described as an angel (below). In the traceries
is the Annunciation, in the right lancet the crowned Virgin (*II.3.B*) being blessed by Christ
leaning from a cloud (above), and the Virgin and Child (below). The pairing of the Virgin
and Child with the Crucifixion in the axial window was a well-established formula by this
time in the region.[38] The bishop's window enthusiastically elaborates on the tradition by
piling on references to the Virgin as Queen of Heaven and to the Judging Christ. The subtle-

ties in the Crucifixion—the *arbor vitae* and the chalice of *sanguis christi*—indicate an aware-
ness of current theological trends, while the crown of thorns (which resided in the Sainte-
Chapelle) was an equally topical and Parisian reference. It should be remarked, however,
that the "angel" with the chalice has no wings and is wearing yellow shoes and red stockings,
revealing a considerable stretch of shin. (Perhaps not an angel but a priest in an alb? wearing
the bishop's colors underneath?)

The bishop's glazier is one of the most distinctive artists of the west, characterized as
"le plus remarquable et le plus original" of the Le Mans glaziers by Grodecki, who describes
his style thus:

> C'est un art violent, presque brutal dans l'expression, aux formes heurtées
> et cassées, dans les silhouettes comme dans le détail du dessin des plis,
> non dépourvu de lourdeur dans la peinture, au modelé abondant, insistant
> sur les reliefs et les creux. Les têtes sont quelquefois vulgaires, ou même
> grotesque. . . .[39]

The cathedral has three bays by this exceptional master, whose idiosyncratic style joins a
highly finished technique with expressionism and a directness bordering on naïveté. His
windows are Bay 200 (given by the bishop); the right lancet of the adjacent Bay 201 (gift of
an anonymous woman and by the woodcutters, shown with their axes); and Bay 211 at the
north crossing (no donor indicated). Since Bay 201 reveals the introduction of the influence
of Chartrain forms into his art, and Bay 211 continues this trend in the hands of lesser
painters of his atelier, we will concentrate our attention on the unfettered style of the Bish-
op's Master in the axial Bay 200.

Unlike the rest of the cathedral windows these three are blue bays, not so much because
their color range is limited but because red is nearly eliminated from a major role, as with
the Saint-Père patriarchs (Chap. I). As at Saint-Père, the blue tonality is offset with large
blocks of white and yellow, and also green and purple. The dark opulence of the color at Le
Mans is electrified by light *scintillants*. The color much resembles that of the Good Samari-
tan Master of the Bourges ambulatory, whose color, according to Grodecki, is distinguished
by the absence of the typical Chartrain contrast of red and blue and by a large proportion of
green, yellow, and light purple tones.[40] From Grodecki's verbal description of the Good
Samaritan Master, the Master of Bishop Geoffroy might even seem to be his reincarnation:
drapery harsh and restless, with angular broken shapes; stocky figures with big heads and
heavy jaws; energy, even violence, in gesture, with limbs overlapping the frames (for ex-
ample, the Le Mans crucified Christ).

There is no question that the Master of Bishop Geoffroy had Bourges in mind. His
border is a design found in the Bourges St Nicholas window (one of the Good Samaritan
Master's ambulatory bays)[41] as well as in the upper nave windows;[42] the lozenge ground of
his window is also found in the upper windows of Bourges.[43] And the image of Christ
showing his wounds is derived from the Bourges figure in the upper ambulatory axial bay
(which also includes a lozenge ground); a more third-class derivation from the same source
was made for the Franciscans of Châteauroux about 1235–1240.[44] That the Le Mans image
is a copy from that venerable model seems undeniable when one notes that the drapery
painting of the Christ showing his wounds is much fussier and more heavily worked than is
characteristic of the Master of Bishop Geoffroy elsewhere.

The ornamental vocabulary in Bay 200 stamps the Bishop's Master as a westerner, comfortable in western traditions. As in the Châteauroux oculus mentioned above, he uses no frames or canopies around his figures. The only exception is the Virgin with the Child, whom he conceives, with great charm, as a votary statue in a niche, being worshiped by the large-size bishop below. This translation of a standard convention (Virgin and Child in axial bay) into a quasi-narrative scene typifies the Bishop's Master and his lively approach.

He paints with a sure hand, relying on firm line without much shading. If the flat-bottomed, strongly triangular eyes seem to have roots among the Bourges ateliers,[45] the drapery painting has evolved along a route we have already traced in Chapter I: the angular, jagged line of the Mauclerc lancets under the Chartres south rose. It emerges not only in the spastic force of the drapery painting and the hooked inkblots but in the contorted axes of the figures and the zigzagging silhouettes. The "angel" catching blood in a chalice is even shown in dorsal view. Thus the very qualities that distinguish the Mauclerc lancets from the work of other late Chartrain masters connect them with Le Mans, an observation that reinforces my sense of the Mauclerc lancets as an alien development at Chartres. The connection between these masters is even more remarkable in the neighboring lancet of Bay 201 at Le Mans, to which we shall turn shortly.

It should be noted that the vocabulary of types in the bishop's axial Bay 200—excepting the Christ exhibiting his wounds, after Bourges—can be accounted for among the Saint-Père patriarchs. The twin images of the bishop at the bottom of the window, axes twisting from full profile to three-quarter and back again, echo many of the Saint-Père cartoons, while the crowned Virgin above is actually caught in movement, legs bent, walking, as are other Saint-Père figures.

The elongated votary image of the Virgin is an extraordinary creation whose torsions and silhouetting recall the Mauclerc lancets strongly. The exaggerated torsions of the Master of Bishop Geoffroy do not last beyond his own work at Le Mans, but the spastic drapery style he introduces has a long life in the Le Mans cathedral clerestories.

The Gervais and Protais Lancet (Bay 201)

There are three blue bays in Le Mans, work of the atelier of the Master of Bishop Geoffroy de Loudun: the axial bay just discussed (200); the right lancet of the adjoining hemicycle bay (201); and the clerestory at the north crossing (211). While the right lancet of 201 is the work of the Bishop's Master, Bay 211 was probably his cartoon carried out by assistants. In both we see this extraordinary expressionist in a new light, reflected, unquestionably, from Chartres cathedral.

Bay 201 occupies a highly visible location in the hemicycle and was no doubt contemporary with the bishop's window next to it. Although the left lancet of Bay 201 (by the Principal Atelier, to be discussed later) does not even attempt to replicate the style or even the format of the right lancet under discussion here, iconographically the two form a group with the adjoining axial Bay 200. The patrons of the cathedral, according to the ninth-century chronicler, were the Savior and St Mary (Bay 200), Sts Gervais and Protais (right lancet of Bay 201) and Saint Stephen, titular saint of the church of the cathedral canons.[46] While the bishop gave Bay 200—where he appears twice in large scale—no donor is indi-

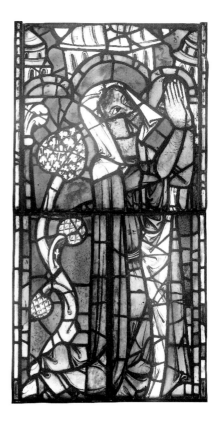

II.4 *Le Mans. Anonymous bourgeoise donor,*
Bay 201, lower right lancet.

cated for the left lancet of Bay 201, where the canons' patron Stephen is martyred above two
such episodes involving St Vincent, titular of the canons' traditional burial place.[47]

The right lancet of Bay 201 is another matter. Its donors, piled one atop the other, are
a kneeling woman dressed as a simple bourgeoise (*II.4*) and the woodcutters shown quench-
ing their thirst. Above them are the cathedral's ancient patrons Gervais and Protais being
martyred, in highly original compositions. Gervais is being flagellated with a six-knot whip
(*Pl.5*); Protais's throat is being cut by a long sword. Their murderers are behind and above
them, piggyback—there can be no doubt of their position, since their feet dangle in the
air—and one grabs his saint by the hair. They are remarkable adaptations by an admirer of
the Mauclerc lancets of Chartres. The donor lady with her stage trees derives from Mau-
clerc's family. The border of fleurs-de-lis is probably adapted from the single Mauclerc bor-
der that includes them, since they are not found otherwise in Chartrain borders. Unlike the
bishop's axial window (200), the Gervais-Protais bay introduces rather awkward canopies,
but the artist is clearly uncomfortable with them, since he uses no separation at all between
the two vertically placed donor groups. These canopies do not derive from the Mauclerc
lancets, however. Their simplified forms come from the vocabulary of motifs in earlier Char-
train canopies—the nave clerestories ultimately, or perhaps the somewhat later and simpli-
fied canopies of the hemicycle clerestories. That the Master of Bishop Geoffroy knew the
hemicycle clerestories of Chartres well can be substantiated by evidence from the third blue
bay of Le Mans, Bay 211 at the north crossing.

Evangelists and Prophets (Bay 211)

The third and last product of the atelier of the Bishop's Master is even more Chartrain in its origins. Bay 211 is a vast four-lancet window with elaborate traceries, the latter depicting major scenes from the life of St Julien, whose relics were translated to the main floor of the new cathedral on April 24, 1254. These three blue bays were probably in place for the occasion. The hemicycle pair (200 and the right lancet of 201) may have been composed in relative calm, although the employment of two different artists for the two lancets of Bay 201 may indicate otherwise. Bay 211, however, seems to have been done in a hurry for the ceremony. Only about three months were available for work between the beginning of Prince Charles's muster and the April ceremony and subsequent departure of his Angevin adventurers. Thus, in Bay 211 cartoons were repeated by the unsteady hands of apprentices. No donor is indicated; the bishop may have paid, since his heraldic colors surround the main tracery scene.

In this tracery St Julien baptizes Defensor, his most notable action, attended by his disciples Pavace and Thuribe and a servant holding the crown removed by the nude ruler for the occasion. The lower traceries show St Julien in his other significant act, striking the miraculous fountain with his crozier (again observed by Pavace and Thuribe). Before we list the subjects of the lower lancets, it is well to inquire why, considering how many empty clerestories awaited glass, Bay 211 at the north crossing would be glazed next after the visible and prestigious axial windows. The answer that suggests itself is that the northwest clerestory was more visible from a specific and important spot. I assume this spot was the new resting place of the body of St Julien, which we know was put in the new choir. To be more precise, it was probably near the great south crossing pier, in full view of Bay 211.

This hypothesis unravels a number of puzzles in the glazing campaigns, such as why the north side was glazed beginning at the crossing rather than at the hemicycle end. The Le Mans chevet is so vast and so high that the clerestories near the hemicycle are almost invisible until one stands nearly opposite them, well within the choir sanctuary.[48] Thus, for the 1254 ceremony, the bays that were most visible were those of the hemicycle and those adjacent to the north crossing pier (Bays 211 and 111). We will return to this argument.

The lancets of Bay 211 have evangelists above and prophets below.[49] Without stressing again that this is the formula of the Mauclerc lancets, though stripped of their ideogrammatic magnificence, all the detail can be traced directly to Chartres. While the figures are under fuller canopies than in Bay 201, the presence of another motif suggests that these canopies were learned from jamb sculptures. This motif is the inclusion under many figures of a socle figure crushed beneath the saint's feet. The socle figures squirm and twist to get a view of their vanquisher, as do the wonderful carvings of the Chartres portals.

That the glass and sculpture of Chartres provided the models for Le Mans is further suggested by the attributes. There are two prophets cartoons, adapted to produce four figures, some with inscriptions repainted since Hucher reported them in 1855. They are, left to right, a prophet with scroll (original inscription: . . . AE), holding a flowered baton out of which emerges a small nude clasping its hands; DAVI[]T holding a scepter (Pl.6.B); YSA[] (now repainted as Isaiah), the same cartoon of the flowering rod budding forth a small figurine, this one with hands in prayer; and finally Moses with horns, tablet, and scepter, plus (in Hucher's report) another figurine, now lost.

The batons flowering with little figurines are the key. On the Chartres north portal, the prophet traditionally called Isaiah carries such an attribute, the tiny bust now mutilated and barely distinguishable.[50] There is a clearer example in the Chartres hemicycle clerestory, Bay 119: "Isaiah" holds a flowering staff from which emerges a bust of Christ; beneath, Moses confronts a burning bush which looks like a long stalk with a Christ emerging from the top.[51] Nearby in Bay 122 a Chartrain King David holds a scepter of the Le Mans type. The Master of Bishop Geoffroy studied Chartres, not from within the shop but most probably as a visitor, and it is hardly surprising that the violent style of Bay 119 would have strongly appealed to him.

The four upper figures of Le Mans Bay 211 are St Matthew, an apostle (now labeled Andreas) with a palm (*Pl.6.A*), an unnamed apostle, and S LVCAS.[52] Here the palm is the unusual attribute for apostles or evangelists; this too can be traced to Chartres. In the Chartres jamb statues the palm of St John is now broken off;[53] in the Chartres windows, two images of St James Major appear with palms (Bay 24 and Bay 106), both labeled and dripping with shells.[54] Imprecise, even careless iconography is the rule at Le Mans, and from the amalgam of his various models Bishop Geoffroy's glazier designed a lush display, in Bay 211, of Old Testament patriarchs beneath New Testament saints. The eclectic detail seems to reflect Chartrain riches captured and brought back in the pages of his sketchbook.

The Master of Bishop Geoffroy disappears from Le Mans after Bay 211, having taught a shop to paint the spastic draperies which continue in more traditional red-blue coloring. He is unique, and so remarkable a painter that one wonders at his origins and training. Although he knows Chartres, its sculptures and its several glass styles, his initial preference in the axial Bay 200 is for western conventions, most significantly the lack of framing. A meticulous plotting of comparisons of his decorative vocabulary (architectural motifs, inscriptions, borders, diapering)[55] to that of the atelier of the Saint-Père patriarchs suggests that he had been apprenticed there. Perhaps he joined them after they had left that job in the mid-1240s. At any rate he was a polished and self-assured master by the time he was hired by Bishop Geoffroy de Loudun at Le Mans.[56]

One also wonders about the career of this master after 1254 when, for us, his forceful personality vanishes. It is possible to trace an offshoot of his spastic draperies, his strange red-free color harmony (blue with strong yellow and white, some green), and his low-set ear and triangular eye formulas at Amiens, in the axial clerestory given in 1269 by Bishop Bernard d'Abbeville.[57] If the Master of Bishop Geoffroy took his extraordinary talents to Amiens, they are now indeed lost to us.[58]

The Panels of the Bishop's Kinsman, Pierre Savary

I have sketched a hypothesis concerning the glazing that was in place for the 1254 ceremony of consecration, based on the following premises: the likelihood that no glazing campaign was undertaken during the troubled 1240s and probably not until at least 1252; the likely haste to hold the ceremony "ready or not"; and the stylistic development and location of the blue bays, suggesting the placement of St Julien's tomb at the south crossing pier of the new choir. What other glass may then have been in place is likely to be that adjoining the highly visible axial bays and the north crossing; we shall see that this turns out to be the case.

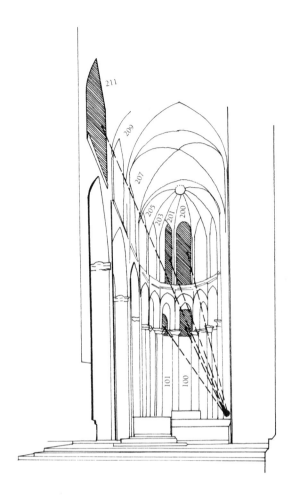

*Le Mans. Cathedral at consecration of the Gothic chevet
in 1254. Suggested location of the tomb of St Julien and
of the glazing in place at the ceremony (shaded bays).*

The upper ambulatory bay immediately to the north of axial (Bay 101) is a hemicycle
bay of three lancets only (*Pl.7*). The right lancet (immediately adjoining the central window
of Rotrou de Montfort, discussed earlier) differs from the others; it contains quatrefoil me-
dallions of a mediocrity and awkwardness unique in the cathedral.[59] They depict scenes from
the life and martyrdom of a monk saint who remains anonymous. Since the upper medallion
has been sliced off to fit the curve of the lancet, Grodecki suggested that these panels are
stopgaps of unknown provenance, inserted in restoration and perhaps even from some other
church.[60]

The lowest panel contains two previously unidentified coats of arms: *gueules au lion d'or*
and *gueules au lambel d'argent* (*II.5*). These are the arms of Pierre Savary II, the grandson of
Bishop Geoffroy de Loudun's sister Marguerite.[61] Pierre became lord of Montbazon in Tou-
raine and assumed these arms from early 1250, and although he died in April 1258, it can
be presumed that after the death of Bishop Geoffroy in 1255, he would have had no cause
to contribute to Le Mans cathedral. A further presumption is that his medallions, completely

II.5 *Arms of Pierre Savary II, lord of*
Montbazon, dated 1257. Drawing, Paris,
Bibl. nat., lat. 5480, p. 375, no. 160.

different from all others at Le Mans, were probably sent there in direct response to an im-
portunate request from the bishop and adapted to fit the hemicycle lancet for the bishop's
ceremony. Possibly they were removed from a chapel at Montbazon or another of Pierre
Savary's rural châteaux, and thus their provincial style is precious evidence of the impover-
ished state of the art south of the Loire about 1250.

These panels differ in every way from the other two lancets of Bay 101: border, mosaic
ground, medallion shape, and color as well as the arrangement of figures and the painting
conventions for faces and draperies. While the border and the painted mosaic differ from
the central and left lancets (where the mosaic is unpainted), they no doubt were produced
at Le Mans when the medallions were cut to fit. The border is a design already present in
Rotrou de Montfort's adjoining window (Bay 100); but in coloration it resembles the iden-
tical border design in Bay 111 (upper ambulatory, at the north crossing pier), which, as we
shall see, is also a work of ca. 1254. The painted mosaic ground is also found there and in
Bay 109 next to it. To pile hypothesis upon hypothesis, Bays 111 and 109 can then join the
group in place about 1254; their donors suggest that this is so. They are designs by the so-
called Principal Atelier whose chronology will be discussed shortly.

The design of Pierre Savary's medallions, not their borders or grounds, therefore, inter-
ests us most (*II.6*). The quatrefoil frames (not otherwise found at Le Mans) are pearled, a
western tradition that occurs intermittently at Le Mans but that maintained full strength in
the Poitou. As at Sainte-Radegonde later, the figures' heads and limbs often spill over the
borders. In fact, the source of all the stylistic conventions can be identified in Poitou. Gro-
decki's analysis of the Good Samaritan atelier of Bourges and at Poitiers cathedral enumer-
ates many characteristics that have been retained in the conventions of the untutored, pe-
destrian designs of the bishop's kinsman Pierre Savary. The color is unfocused; as at Bourges
"one might say that there is no dominant colour."[62] Heads and limbs overlap the borders.
The scenes are cluttered and unbalanced; the figures are stiff and doll-like, chestless, with
no interest in massing or articulation of the volumes of the body; artistic focus is on the
heads, which are enlarged, painted with great wide-set eyes, low brows, and flat tops; the
drapery painting is brusque and angular and based on the convention of the formation of Vs
at the waist (if it is cinched) and at the hem, producing a puzzling sort of reversed fall; the
profiles have hook noses and twisted mouths.

In short, the producer (one hesitates to label so pedestrian a hand as an artist and he
certainly was no master) of the medallions provided by the bishop's kinsman reflects the

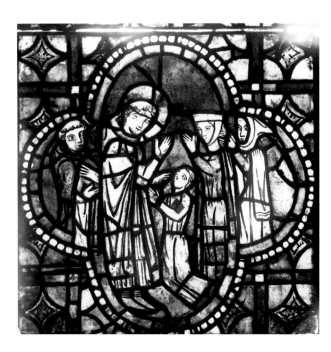

II.6 *Le Mans. Unidentified scene,*
"Pierre Savary medallions,"
Bay 101, right lancet.

stylistic conventions first notable at Poitiers cathedral early in the century, which evolved into high style at Sainte-Radegonde in Poitiers two generations later.[63] The wide-set eyes do not occur at Bourges and Poitiers cathedrals; they are standard at Sainte-Radegonde, as are all the early conventions now evolved, in the hands of masters, into a most remarkable expressive language.[64]

The lancet of the bishop's kinsman is a remnant establishing the impoverished but still viable state of the art south of the Loire during the "interregnum" I have tried to outline,[65] that is, from the unsettled 1240s until the return of the prince Alphonse de Poitiers from crusade in 1251.[66]

Circumstantial Evidence: Saint-Germain-des-Prés

Artists during troubled times leave areas where there is no work and gravitate to places where there is.[67] This economic slant on the continuity, or the lack of it, in western stained glass of the 1240s allows us an insight not otherwise available into one of the great puzzles of the Parisian school of the same period: the childish and maladroit "first atelier" of the Lady Chapel, Saint-Germain-des-Prés, begun 1245.[68] It would appear that at least one displaced western atelier found work in Paris.

Sixteen panels of the Life of the Virgin by this atelier have been identified by Grodecki.[69] Although not so inept as the Le Mans medallions of Pierre Savary, they are astonishingly gauche for Paris. Except for the wide-set eyes, all the Le Mans conventions occur in this peculiar Saint-Germain atelier, plus one not yet mentioned because it is absent from the comparative Poitiers monuments. This is the heavy facial shadowing around the eye socket and running in a wide messy stripe curving down from eye to chin.[70] Also striking in similarity are the long sharp noses, the V convention in the heavy-handed drapery painting, and in general the puppetlike combination of enlarged heads on stiff volumeless bodies. These

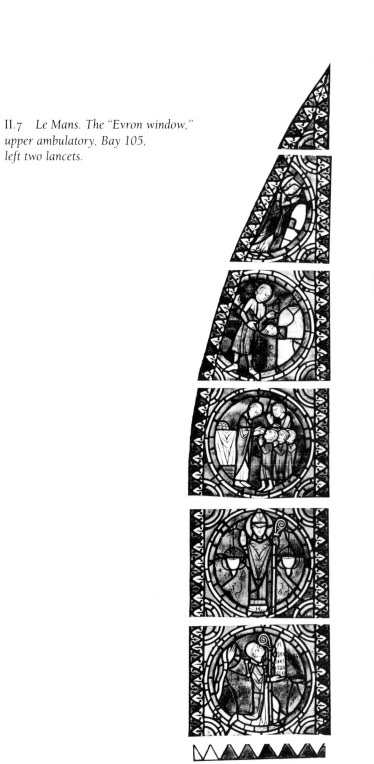

II.7 *Le Mans. The "Evron window,"*
upper ambulatory, Bay 105,
left two lancets.

are strange designs indeed to grace the elegant new *rayonnant* architecture of the great Benedictine abbey of Saint-Germain-des-Prés on the left bank in Paris. They are not at all strange to the west.

The Window of the Abbot of Evron (Bay 105)

Meanwhile, back at Le Mans, another window, gift of the Benedictine abbey of Evron (Mayenne) in the borderlands near Brittany, gives rare testimony about the rural folk arts untainted by the fashions of Chartres or Paris. The Evron window (*II.7*) has all the sophistication of a Swiss cuckoo clock; it appears to be that rarest of all medieval artifacts, a primitive, unrelated to established artistic tradition. While this impression is exaggerated, since the artistic sources of this design are traceable, as we shall see, Grodecki underscored the uniqueness of the Evron window:

> Une fenêtre . . . est d'un style tout à fait exceptionnel: l'ornementation, où apparaissent des palmettes et des feuilles schématisées, est archaïque et sans rapport avec le style courant de l'ornementation du milieu du XIIIe siècle. Les scènes, dans des médaillons de petite dimension, montrent la même naïveté, presque populaire, d'interprétation du style gothique: personnages à grosses têtes rondes, semblables aux têtes de poupées, vêtements schématisés et coupés avec quelque maladresse. On dirait qu'un artisan de village, insoucieux de la mode, ait exécuté ce vitrail offert par l'abbaye d'Evron.[71]

How the Evron window fits into the glazing campaigns of Le Mans is a problem of some interest.

Several other Le Mans bays can reasonably be assumed to be gifts of various monastic communities of the Maine. Also in the upper ambulatory level are the windows of the abbey of Saint-Calais (Bay 104) and probably of Saint-Vincent (Bay 111), and in the north clerestory the abbey of La Couture (left half of Bay 207).[72] Since the style of these windows remains consistent and is that of the Principal Atelier at Le Mans, it seems clear that these abbeys provided funds to glaziers working at the cathedral. The Evron gift was not money, but the glass itself. Since Evron had held a consecration in 1252, attended by Bishop Geoffroy de Loudun, it is reasonable to suggest that this window (which is not the work of a beginner, as we shall see) was made by a glazier working at Evron in the early 1250s, possibly a monk. This hypothesis will be tested from several perspectives and found to be sound.

First, the probable date of donation: the image in the lower left lancet, a kneeling abbot holding a window with the inscription ABAS DE EBRONIO, provides a likely *terminus ante quem* of mid-1255 and a certain one of 1258. Ernaud, abbot of Evron since 1241, had been a friend of Bishop Geoffroy, who died in Italy August 3, 1255. The abbot's relationship with Geoffroy's successor is not documented, but Geoffroy Freslon, elected bishop of Le Mans at the end of 1258, persecuted Ernaud so relentlessly that the pope had to intervene in 1262 and again in 1263.[73] The Evron window is likely to have been presented during Geoffroy de Loudun's lifetime and was perhaps even in place for the consecration, since it is a careful, finished product showing no sign of haste and equally little awareness of the conventions of the glazing ateliers working at Le Mans thereafter.

The subjects concern the Virgin and her miracles: Infancy scenes; the Dormition, As-sumption, and Coronation; the miracles of Theophilus and of the Jewish Child of Bourges. Also included is an image of Bishop Hadouin of Le Mans (624–654), the founder of Evron, as well as a lancet presenting a narrative of the abbey's founding: the legend of the Pilgrim of Evron and his relic of the Virgin's milk (*Pl.8*). Three lancets read from bottom up, but the Infancy and the Pilgrim of Evron lancets unfold their stories from the top down in the western manner that Grodecki noted in the narratives of Poitiers Cathedral.[74] It would be awkward to design the Dormition-Coronation from top down, and the curved and truncated shapes of the outer lancets dictated that the main scenes be placed in the full panels at the bottom.

The iconography of the Infancy in the Evron window is archaic, while that of the Dormition-Coronation sequence is atypical. In the Annunciation, the Virgin sits reading at a desk while the angel approaches from behind, an arrangement predating the Roman-esque.[75] The Visitation shows the two women warmly embracing (not French Gothic prac-tice) and the Virgin is crowned, a rare detail.[76] Two angels frame the women, even more unusual. The Nativity repeats the twelfth-century form with the Child above on a pedestal, ox and ass above that, Joseph seated to the side, head on hand.[77] The Virgin, however, gestures toward Jesus and speaks to Joseph. The Presentation is a hieratic composition of the Virgin and the haloed high priest flanking an altar on which stands Christ, a charming little fellow, shown frontally, with blessing hand.[78] The Flight to Egypt is noteworthy for Joseph's pedlar's sack at the end of a stick, his encouraging backward glance, and Mary's tight embrace of the Child close to her face. The latter two conventions are Gothic innovations.[79]

The Flight has been misplaced in order to allow for the conjunction at the bottom of the lancet, and spilling over into the lower scene of the neighboring lancet, of three scenes of the magi: before Herod; on horseback seeing the star; and the Adoration, spread over two lancets. Such an elaboration of the magi story, while atypical in French Gothic generally,[80] has western precedent both at Angers (ca. 1225–1235)[81] and in the Le Mans Lady Chapel (ca. 1230–1235)[82] and remains strong even in the early fourteenth century, in the glazing at Evron itself.[83] The wise men are crowned and depicted as three different ages; the eldest kneels before the Virgin, crown removed, a detail current only from the end of the twelfth century.[84] The Virgin, enthroned on an altar with candlestick, holds the blessing Child and a scepterlike object with gold baton and red flowerlike top; she is crowned, a detail more common to portal sculpture. In fact she can be identified with the famous life-size cult statue still the pride of Evron, Notre Dame de l'Epine, who holds a scarlet eglantine. This beautiful early thirteenth-century sculpture, carved from a single block of oak, has recently been stripped of nineteenth-century restoration to reveal her dress of sheets of silver with an enameled and jeweled belt and crown. She is "the largest surviving statue reliquary in France."[85]

Without going further it can be seen that the iconographic detail in the Evron lancet is astonishing, and that it indicates sources of the twelfth century, or within archaic traditions, that have not been idly copied but recast and updated with care.[86] The warmth and humanity of the images, however, must be seen to be appreciated.

The lancet that houses the Virgin of the Adoration in its bottom panel continues above with her Triumph—Dormition, Assumption (three medallions), Coronation (two medal-lions). The Assumption scenes comprise the apostles looking up; Christ with the cross of

the Resurrection, looking down at them and pointing up;[87] and the Virgin in a mandorla held by angels. Above is a panel of two angels with candles, and at the top, Christ crowning the Virgin, both enthroned. The glazing of Angers was mentioned in connection with the Infancy; it provides the clue here, as well. The Evron window, though differing in details, is surely a reflection of the traditions of the Angers Dormition-Coronation window of the late twelfth century.[88] The Coronation scene, however, has been modernized: at Angers the Virgin was already crowned, whereas in the Evron window Christ crowns her, a change that begins to appear in monumental sculpture about 1230–1245.[89]

In two other windows of the Le Mans upper ambulatory (Bays 108 and 110 at the south crossing), each by a different painter, Christ crowns the Virgin in the Coronation scene. Although the window of the earlier cycle in the Lady Chapel is now a late nineteenth-century restoration,[90] that there was such a window before the Huguenot destruction can be fairly assumed. And since the odd selection of scenes in the Evron bay is found in Bay 110 as well (Dormition, Assumption in a mandorla flanked by angels, Christ pointing upward flanked by censing angels, and Coronation of the Virgin by Christ), it seems likely that both the Evron window and Bay 110 were based upon the lost prototype in the Le Mans Lady Chapel (ca. 1230–1235). That fragmented ensemble looks less Chartrain than ever.[91]

Moreover, both the Evron bay and Bay 110 depict miracles of the Virgin: not only the ubiquitous Theophilus legend but also the extremely rare story of the Jewish Child of Bourges.[92] Emile Mâle has established that the latter story is unique to Gothic Le Mans, and that its textual source was no doubt the earliest collection of Marian miracles in use, the *De gloria martyrum* of Gregory of Tours, read on the feast of the Assumption. Four of the five miracles related by Gregory of Tours still exist in damaged fragments of about 1230–1235 in the Lady Chapel, making that ensemble the likely model for their depiction in the Evron window and other bays of the upper ambulatory, most extensively in Bay 112.[93]

This relationship is a point of greater importance than has been obvious so far. For if the Evron artist knew and studied the Lady Chapel windows at Le Mans, he certainly rejected their Chartrain style. I will return to this stylistic argument after discussing the iconography of the fifth and most unusual lancet: the miraculous founding of the abbey of Evron. This lancet, which reads from top down in the western fashion, has been described succinctly by Mâle:

> A pilgrim returning from the Holy Land brought back a relic of the Virgin [an ampulla of the Virgin's milk] in his scrip. Between Le Mans and Laval, he stopped at the foot of a tree, tied his scrip to one of the branches, lay down in its shade and fell asleep. When he awoke, the tree had grown so tall he could not reach his scrip. The whole countryside was aroused. . . . The bishop [Hadouin] came: he had hardly made the sign of the cross when the tree bent down before him and presented him with the holy relic. By this, it was understood that the Virgin wished to be honored on that spot, and they built an abbey in her honor.[94]

Since the Pilgrim wears the same costume and hat, and the scenes take similar forms, in the fourteenth-century sculptures and stained glass at Evron itself—whose relic made it a pilgrimage center up to modern times—it is likely that this narrative lancet was copied from scenes in a *libellus*[95] in the possession of the abbey.

The statuelike image of St Hadouin, the bishop of Le Mans who retrieved the Pilgrim's relic and founded the abbey, appears above the donor image of Abbot Ernaud: frontal, ha-

loed, blessing, and flanked by two hanging lamps. The lamps are a clue that this image probably reflects not a text model but a statue at Evron.[96] More secure, since the statue is extant, is the theory that the image of Virgin and Child at the top of the Pilgrim lancet depicts Evron's life-size Gothic cult statue. This is the second copy of her in the Le Mans window. Like the Virgin of the Adoration of the Magi, the Virgin at the apex of the Pilgrim lancet is shown enthroned on an altar between candlesticks, crowned and holding the Child who blesses and holds the orb. Most remarkable is that the glazier has recorded that the sole of the Child's foot can be seen when one views the statue from the floor below it.

The Evron artist's sources thus include models familiar to him from his own monastery as well as those he saw at Le Mans. The latter point will now be pursued, in the analysis of this unusual style. His round medallions framed in plain red and white fillets are not unusual in the upper ambulatory, but the rosette-bosses of the Pilgrim lancet (in the corners between medallions) are not found in the Gothic campaign. Such forms appear at Angers, in the St Peter bay of about 1225–1235.[97] The bull's-eyes in the other lancets have an even earlier and more striking derivation from forms seen ca. 1150 in the Angers Annunciation and in their provincial reductions of the church of Chenu (Sarthe).[98] The twelfth-century debris of Le Mans has now lost most of the original surrounds, but those that remain are comparable.[99]

Since the border patterns of the Evron lancets are totally un-Plantagenet, tracing their sources is even more important in understanding the artist's methods. Significantly, all his border motifs can be localized at Le Mans itself, although from disparate art works. The alternating palmette border of his Coronation lancet occurs only once at Le Mans but is in ubiquitous use in France.[100] His other borders are much queerer, though the zigzag and triangular bases of the patterns are basic to Gothic glazing. The motifs themselves have been closely observed, I believe, from the exquisite decoration in the wide medallion frames of the twelfth-century glass of Le Mans itself.[101]

After all is said and done, and all the elements of the Evron Master's style and iconography have been accounted for, he still remains a bizarre designer. His color is sui generis: largely red, with a great dose of green.[102] The psychological focus and intensity of the figures, as well as their huge heads and unarticulated doll-like bodies, derive from the Plantagenet style. The drawing, however, is precise and careful, predetermined. The drapery painting is economical, even skimpy, but its thin, jagged, clean lines and black triangles are in no way archaic replications of the dead past.

The Evron Master is not a beginner but a fine craftsman. He has studied carefully and rather widely, adapting much from the Plantagenet ensembles of Le Mans and cutting it to his measure. He is, moreover, a supreme storyteller, his groups reduced and readable, his figures carefully silhouetted; and he is a master of strong psychological focus. His little dolls react intensely to one another. His Virgin is *dolce*, a lovely pubescent girl even in death. The Christ Child could easily win a baby contest—he is adorable. The magi consult, the apostles worry, the Pilgrim and townfolk puzzle. If the abbey of Evron were indeed glazed like this when Bishop Geoffroy attended its consecration in 1252, it is a very great loss.

The Evron Master's single window at Le Mans is not an isolated phenomenon but, rather, of extraordinary significance for our comprehension of the development of the western art.[103] All his stylistic conventions have a future development in the west, in the work of two great expressionists who, were it not for the link provided by the Master of Evron,

would be very hard to explain. These two are the St Blaise Master of Sainte-Radegonde in Poitiers and the Jean de Bernières Master who worked at Aunou and at Sées cathedral.

The St Blaise Master, discussed in Chapter IV, is something of a "divine child" whose little dolls with their big heads almost jump out of the window by the force of their intensely focused energy. His drawing has a flair that leaves the Evron Master far behind. Although the Huguenots left us only scraps of his art, it is still possible to see that he favored a gaudy, straightforward color and that he liked to dress his dolls in red and green.

As for the Jean de Bernières Master, discussed in Chapter VI, the careful drapery painting of the Evron Master provides the only plausible explanation for the thin, jagged draperies punctuated with black triangles that mark his western art.[104] One of the important masters of the Sées atelier, he paints draperies just that way, at grand scale, and also prefers red and green.

I have assumed that the Evron Master was one of the Benedictines of Evron. This assumption would explain his lack of concern with Paris, his rooting in western traditions, and the evident time and care taken in his work. I also assume that his abbot (donor of the window to Le Mans) sent him to Le Mans to measure the window or its templates, and that while there he carefully studied the cathedral's existing glass. Probably none of the medallion windows that ultimately were to surround his in the upper ambulatory were then under way or in place. Thus, he studied the twelfth-century glass in the nave and the more recent Lady Chapel lancets. His rejection of the latter as a model, except for iconographic refinements, and his attraction to the early western glass suggest his artistic heritage. His total self-assurance indicates not a unicum but a rural tradition, one that the borderlands will see rejoin the western mainstream in the elegant exaggerations of the Jean de Bernières Master as Sées and the unruly expressive verve of the Master of St Blaise of Poitiers.

The Glazing Program at Le Mans

Planning and Execution (ca. 1255–1265)

The few bays in place for Bishop Geoffroy's 1254 ceremony of translation of the relics of St Julien and consecration of the new building barely sketched out a pattern of glazing, much less a program. These agendas were established shortly, after a few inconsequential hesitations, and once adopted were maintained to the end through a decade of full activity. The pattern dictated heavily colored medallions throughout the upper ambulatory, and in the clerestory two rows of deep-colored large figures (saints under canopies above, donors below). The program soon mandated narratives (saints, Christ, the Virgin) in the medallions, apostles and prophets in the north clerestory, and bishop saints along the south. If the scent of Bourges lingers in details of decoration, style, and iconography in all these groups, it is unmistakable in the great procession of frontal bishops along the south clerestory.

Minimal chronological development appears in this vast display, and the designs of disparate ateliers rub shoulders, often sharing cartoons and even painters, indications of a decade-long period of humming activity. The pattern and program, however, do much to weld into an ensemble these works of many hands and to unify the disparate levels, planes,

bay widths, tracery patterns, lancet groups, and proportions the architects had provided. The following list analyzes conditions at the start of this campaign.

Le Mans: Status of Work prior to 1255

upper ambulatory: Bay 100 (axial)—Rotrou de Montfort's bay, made ca. 1240–1245

 Bay 101, right lancet—Pierre Savary's panels, made south of the Loire ca. 1250

 Bay 105—Abbott of Evron's bay (made by a monk of Evron?), probably before 1255

clerestory: Bay 200 (axial)—Bishop Geoffroy de Loudun's bay

 Bay 201 (right lancet)—a design by the Master of Bishop Geoffroy, showing Chartrain influence

 Bay 211 at the north crossing pier—a work of the atelier of Master of Bishop Geoffroy, showing Chartrain influence and poorer quality execution

The major campaign getting under way at this time added the following, which are the works of the Principal Atelier, hired about 1254–55:[105]

upper ambulatory: Bays 111 and 109 at the north crossing pier—gift of the abbey of Saint-Vincent and of Guillaume Roland, precentor, before September 1255

 Bay 107 (II.8)—gift of the winegrowers, after May 1254, by a different painter in the atelier

 Bay 103—no date indication

 Bay 101, center and left lancets (Pl.7)—gift of Hamelin d'Anthenaise (1250–1260)

 Bay 102—no date indication

 Bay 104—gift of the abbey of Saint-Calais, no date indication

 Bay 108 (II.12)—gift of Archdeacon Robert Le Pele and Magister Philippe Romanus, canons of the cathedral, no later than 1265 (several painters)

Two other distinctive painters work in the upper ambulatory, within the conventions (decorative vocabulary, iconographic sources) of the Principal Atelier:

 Bay 106 and Bay 110 (II.9)—among several painters are works by the Decorator (no date indication)

 Bay 112 (II.10.A–B)—a work by the Tric-trac Master

All of these painters work in the clerestory as well. Again, there is only minor evolution. The development can be charted by five conclusions:

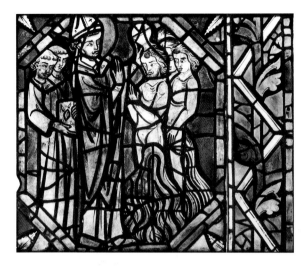

II.8 *Le Mans. Principal Atelier, winegrowers' bay:*
St Julien baptizes Defensor and his knights, Bay 107.

II.9 *Le Mans. The Jewish Child of Bourges thrown into*
the furnace by his father, a glazier, Bay 110.

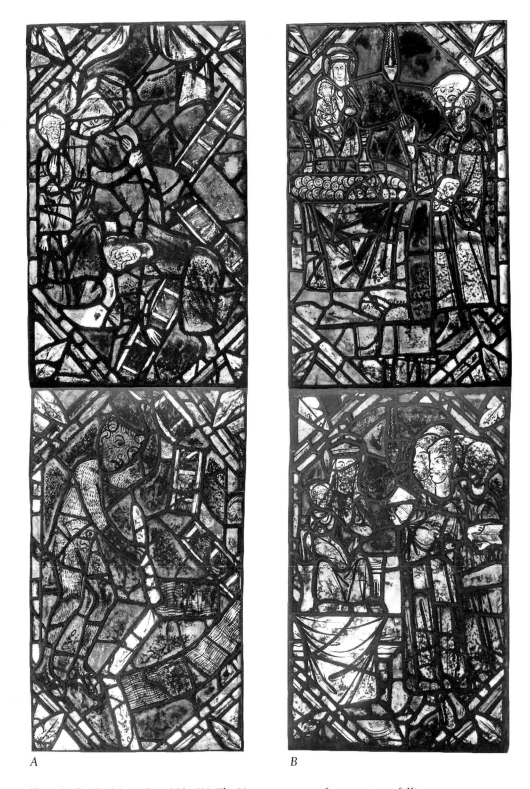

A

B

II.10.A–B *Le Mans. Bay 112. (A) The Virgin rescues a fresco painter falling*
from his scaffold. (B) Miracle of the famine in the abbey of Jerusalem.

First: the distinctive style of the Master of Bishop Geoffroy flickers and dies out, distinguishable only in some cartoons and painting of Bay 209; his distinctive color has vanished. The master himself can be presumed to have moved on. Bay 204 is related and shows no direct influence from him at all.

Second: excepting Bay 209, the first clerestories to be added are the most visible, in the inner hemicycle (Bays 203, 201 left lancet, 202, 204). They are more hesitant and variable in pattern and program than those following.

Third: after this initial phase the chantier establishes a work pattern of assigning the execution of the upper-row figures to assistants. The masters must be studied from the designs of the lower row, which they produced to the specifications of the various donors.

Fourth: the datable bays of the straight choir (207 and 210) suggest that the program was fully evolved and being carried to completion about 1260–1265.

Fifth: allowing for various painters, a homogeneous atelier is at work (excepting Bay 209), and its traditions derive from the program, the decorative vocabulary, and the iconographic formulas of Bourges.

Among the various places a western patron might seek to hire a chantier of trained glazing teams in 1254 (Paris, Normandy?), Bourges is the most likely. The lost glass of the Bourges nave aisles would probably provide the missing link, but in its absence, circumstantial evidence will be marshalled for a relationship between the Principal Atelier, which appears in Le Mans in 1254–55, and the late glaziers of Bourges.

With these guidelines as background, the following summary list of clerestories offers a guide to the discussions and evidence that follow:

Bay 209 —(*II.11.A–B*) Gift of Johannes de Fresnio, bourgeois, no dating indication.[106] Everybody in the chantier worked on this bay. The finest painting, in the donor figure, shows the influence of the Master of Bishop Geoffroy, as do the Chartrain cartoons with socles (comparable to those in Bay 211). Since cartoons of the right two lancets are from a patternbook also used for Bay 204 by painters having no contact with the Bishop Geoffroy Master, Bay 209 is likely to have been the earliest work of the new campaign, already in design when they arrived. The color harmony is that of the Principal Atelier.

Bay 207 —(*Pl.9*) Gift of the abbey de la Couture (left half) and of the de Cormes family (right half), probably before 1263.[107] A pure work of the Principal Atelier, the upper row executed by assistants.

Bay 205 —Gift of the drapers and of a priest (. . . ON DE COLO).[108] A very high-quality work of the Principal Atelier.

Inner Hemicycle (Bays 201–204)

Bay 203 —Gift of the furriers. A composite work, cartoons of the Principal Atelier, probably executed by the Tric-trac Master and the Decorator.[109]

Bay 201 (left lancet)[110]—A pure work of the Principal Atelier. Some restoration.

Bay 202 —(*Pl.10*) A design[111] by the Decorator, hesitant and unfocused in color with archaic wide borders. (This artist worked in Bay 110 of the upper ambulatory and painted some of the designs of Bay 106.) Some restoration.

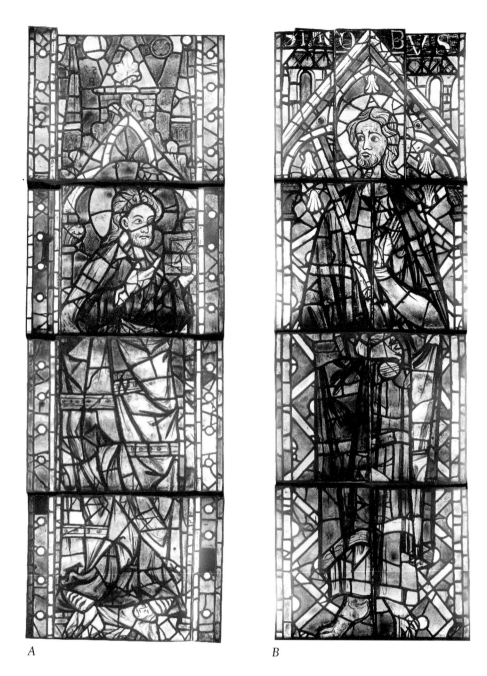

A B

II.11.A–B *Le Mans. Bay 209. (A) Apostle, third lancet from left (feet panel*
corrected). (B) St James Major, right lancet.

Bay 204 —Gift of two bourgeois, not identifiable. Badly damaged. The procession of
bishops from Bay 204 to Bay 212 is a quotation from Bourges. The bishops
of Bay 204 have been "formatted" (canopy, ground, inscription) from the
same patternbook as the two right lancets of Bay 209, and the drapery
painting also relates to some of the painters of that bay.

Bay 206 —(*Pl.11*) Gift of the cathedral chapter. Very severely damaged. A pure
 work of the Principal Atelier, the upper row executed by assistants.

Bay 208 —Lost by windstorm.

Bay 210 —(*Pl.12*) Gift of Jeanne de Mayenne, probably ca. 1265.[112] A work of the
 Tric-trac Master who also produced Bay 112 in the upper ambulatory.

Bay 212 —Gift of the bakers. Very severely damaged. A pure work of the Principal
 Atelier, the upper row by assistants.

This summary forms the base for the ensuing discussions of dating and the documentation
of donors, the iconographic variants that indicate regional usage, and the evidence offered
to justify these stylistic judgments. Finally, a word should be said about the condition of this
glass, since Le Mans carries a bad name for heavy restoration. Hucher's careful mid-nineteenth-
century descriptions detail garbled areas with some precision; some further check is pro-
vided by the hasty remarks of another nineteenth-century visitor, the baron de Guilhermy.[113]
In the century since Hucher and the baron, severe weathering on the south side increasingly
has accentuated the difference between original and restored glass. Old photographs retain
that ugly but useful evidence, which disappeared with the handsome restorations recently
achieved. Le Mans is again magnificent, but its checkered history is in the files.

Donors and Dates

The donors of Le Mans have been the object of study since Hucher, whose theories were
occasionally sound and at times fanciful. While many of the fancies have been deflated since
his time, a considerable mythology still remains. Below is a reliable list of donors.

Guilds

Winegrowers (Bay 107), documented after mid-1254 in the chronicle.[114] They are
shown with their pruning tools, which also form the decorative motif of one of the
borders.

Drapers (Bay 205), shown with the inscription LA VERRINE A DRAPIERS.

Furriers (Bay 203), shown in action.

Woodcutters (Bay 201), shown quenching their thirst, axes at rest.

Bakers (Bay 212), shown in action.

Monastic communities[115]

Abbey of Saint-Vincent (Bay 111): Hucher's suggestion, unproven but reasonable, is
that the two right lancets were given by Saint-Vincent. One has scenes of Vincent; the
other has scenes probably of St Domnole, of a monk with a discipline and another
monk with a window.[116] This bay dates very early, 1254–55.[117] The abbey of Saint-
Vincent was the regular burial place of the canons of the cathedral (see n.47); the
community was on excellent terms with the chapter and could have been expected to
contribute early in the campaign.

Abbey of Evron (Bay 105): Discussed above (*II.7*).

Abbey of Saint-Calais (Bay 104): Scenes of the Virgin, Christ, and the founding of
Saint-Calais.

Abbey de la Couture (Bay 207, left half): Although no date is provided, the community of La Couture had been in open rebellion against the cathedral, the dispute culminating in the excommunication of the abbot and prior and a hearing before the pope in 1247.[118] That stormy past lends support to the stylistic evidence that this bay falls late in the campaign. Shown are a group of monks and the abbot (ABBAS: DE: CULTURA) offering a window to St Bertrand (S BERTRANNI, bishop of Le Mans from 587 to 623), who had founded La Couture and was buried in the crypt there.[119] The crescent-shaped object emerging from the clouds over the figures may be a vine-trimming tool,[120] in reference to St Bertrand's interest in the planting of vineyards and his legendary success in the cultivation of a particularly choice variety of grape.[121]

Priests and canons

Precentor Guillaume Roland (Bay 111): Shown as a priest (GUILLELMUS ROLANDI) and hence before his election as bishop, in September 1255. Roland was the son of a lawyer in the service of Charles d'Anjou;[122] his election as bishop corroborates the spirit of accommodation between prince and cathedral which I have theorized.

Canons Robert Le Pele and Philippe Romanus (Bay 108): Archdeacon Robert Le Pele (DNS.ROB LE.ELE) was of the generation of the 1250s, since his entry in the necrology (April 28) mentions his nephew Julien, also a canon, who first appears in a document of 1280.[123] Magister Philippe Romanus (PHS ROMANUS) served as rector of the church of Izé (Mayenne); his last published charter dates 1262.[124] The necrology credits Romanus with a gift of 10 livres tournois for a window.

Canon Guillaume de Cormes (Bay 207): Shown with his father and uncle, and discussed with them below.

A priest (. . . ON DE COIO) (Bay 205): Untraceable.[125]

Bishop Geoffroy de Loudun (Bay 200): Discussed above (Pl.4).

The cathedral clergy (Bay 206): Shown with the inscription LE VERRIERE ECLES.

Bourgeois

Johannes de Fresneio (Bay 209): JOHES DE FRENEIO. Hucher misidentified him as the procurer of the Cistercian abbey of Bellebranche, who was still alive in 1280. However, he is dressed as a bourgeois in yellow hat and shoes and a green robe with red sleeves, and cannot be a Cistercian.[126] The late date thus established is fictitious.[127] The Agnus Dei (attribute of the Baptist) in the traceries is no doubt a reference to his name Johannes, since the same reference occurs in the bay donated by Jeanne de Mayenne (Bay 210, discussed below).

"Gautier de Pouillé" (Bay 204): Actually two bourgeois are shown. The inscription has been redone and is completely unreliable. Hucher reports that the inscription over the left donor was illegible; and above the right man he could read GA . . . VS DE PO . . . He suggested Geoffroy de Poncé; Ledru suggested Gautier de Pouillé in 1900. If it is Gautier, he was probably dead in 1269–70.[128]

Unidentified woman donor, dressed as a bourgeoise in red and green (Bay 201; II.4). Discussed above.

Nobility

Pierre Savary, lord of Montbazon, the bishop's kinsman (Bay 101, right lancet): (see above, pp. 25–26).

Hamelin d'Anthenaise (Bay 101, center and left lancets): The kneeling knight of Bay 101 has long been misidentified as a member of the family of Chamaillart, lords of Pirmil.[129] The arms on his heraldic surcoat and repeated at the top of the bay (*vairé d'or et de gueules*) belong to Hamelin d'Anthenaise, who inherited the land and arms in 1250 and died without direct heir between July 1260 and the end of 1262.[130] Hamelin was one of the knights who accompanied the prince Charles on the abortive Flemish adventure of 1254 and was a kinsman to the cathedral's canon Robert d'Anthenaise.[131]

Rotrou de Montfort (Bay 100): Discussed above, pp. 17–18.

The de Cormes family (Bay 207; *Pl.9*): Shown are two knights and a young priest amid their arms: *argent à 3 jumelles sable*. The knights are the brothers Guillaume le Maire and Jehan, both participants in Charles d'Anjou's Flemish host of 1254.[132] The young priest between them is Guillaume's son Geoffroy, a canon of the cathedral, who died in the summer of 1263.[133] While a memorial image would not be out of the question, there is nothing in the colorful depiction of this young canon to suggest it, and a date ca. 1260 is thus likely.

Jeanne (*dite* Gervaise) de Mayenne (Bay 210): this is the so-called Tric-trac Window of Le Mans, so dubbed in modern times because the lower row contains life-size players of chess and checkers. To the left of these gamesters is a kneeling noblewoman in heraldic surcoat, and to the right a group of three kneeling women (actually two bodies and three heads are visible) offer a lancet. These and many other details in this huge and many-figured window identify the donor as Jeanne de Mayenne; establish the bay as a complicated and subtle rebus on her name, titles, and estate; and suggest the most probable date as ca. 1265, but no later than 1269 when she died.[134] Jeanne was the mother of a canon of the cathedral—one who, being groomed for bishop, was sent to school in Bologna—and of a knight who fought with Charles d'Anjou. The women behind her are her dead older sisters Isabelle and Marguerite, the trio of the "dames de Juhel," their father being Juhel de Mayenne. Thus is set up the major pun of a great series of puns in this window, the key to which are the "jeux de dames" in the lower row: the so-called tric-trac players.

The Tric-trac window is the work of an artist who first appears as an apprentice painting the Principal Atelier cartoons of Bay 203, and hesitantly executing his own designs in Bay 112 of the upper ambulatory (*II.10.A–B*). Although his style there is still tentative, his verve already shines through: he was never a great painter or technician but obviously a man of imagination and immense good spirits. Many of the visual jokes of the Tric-trac window must be his.[135]

The donations documented in the Le Mans windows thus establish a campaign starting in earnest in 1254–55 and being completed 1260–1265. There is no reliable evidence that glazing dragged on into the 1270s or beyond. The campaign does not weaken or languish in its final stages. Rather, the late clerestories (207 and 210) suggest that the windows of

Le Mans were completed in the mid-1260s and well before the next wave of crusade fever would have begun to dampen generosity.

Indeed they were probably finished none too soon. The glass of the chevet's ambulatory and chapels (the Huguenots smashed it in 1562) included grisailles and some sort of band windows ("moictie painctes et moictie blanches"), according to the post-destruction report.[136] A few meager scraps survive, notably one aging grisaille quatrefoil now in a lancet head off the south ambulatory at the crossing. Its foliage is a desiccated, abstract type datable in the transitional period of grisaille design ca. 1270. The appearance of grisaille as the final cadence of the great color symphony which is Le Mans suggests austerity and even panic, not an aping of Parisian fashion. Indeed, these chapel windows are so inaccessible to view as to be nearly invisible, which no doubt explains why their glazing was left until last.

Regionalism in the Principal Atelier

I have suggested that the Principal Atelier was hired from Bourges. The construction of the Bourges nave was under way in 1230 and finished about 1255, according to Branner.[137] Its glazing followed apace; the glass that still remains for our examination—the grisailles of the upper ambulatory and the clerestory—is undocumented but probably was not finished until the 1260s or perhaps later.[138] The lost windows of the nave aisles were no doubt glazed first, probably at that date in full color. This chantier in Bourges is the one that Bishop Geoffroy raided. Many of its teams lured to Le Mans were probably spurred on by the budget tightening that Branner sees at Bourges near 1260. The proofs for this hypothesis will be sought in iconographic detail and then in stylistic analysis that seeks to establish the regionalism of the Principal Atelier of Le Mans.

The Principal Atelier might well be nicknamed the Alleged Parisian Atelier, following the pioneer assessment of Emile Mâle, a judgment he based on the atelier's adoption of medallions in a deep saturated red-blue tonality in the Le Mans upper ambulatory. Yet scholars following Mâle who have approached the group concur that little specifically and identifiably Parisian can be found.[139] Perhaps the time has come to reassess the presumed Parisian character of medallions in general and those at Le Mans in particular, since medallions, as a modus operandi, lasted beyond the 1240s at Angers, to mention only one western monument. The aim of this discussion will be to describe the Le Mans forms and to seek their context, Parisian or not.

The iconographic program of Le Mans is not theologically sophisticated and displays the expected procession of local saints, among them the cathedral's bishop saints, some of whom had founded regional monasteries: Bertrand (Bay 207), Hadouin (Bay 105), Domnole (Bay 111),[140] Innocent (Bay 101), and Pavace and Thuribe (Bay 204), legendary disciples of St Julien. Also of regional fame was Calais (Bay 104), the hermit founder of the abbey of that name whose relics were divided between there and Blois. Very popular in the west were the early Christian martyrs Gervais and Protais (Bays 109, 100, and 201; Pl.5); Sées cathedral had originally been dedicated to them. Their relics at Le Mans were by legend the gift of the apostle of Gaul, St Martin (whose scenes appear in Bay 109). Martin had given them to the cathedral's bishop St Victor when he sent him to the Maine, and it was Victor, in Merovingian times, who was the great saint of Le Mans.[141] The lack of interest in Victor in the Gothic windows indicates that the shift of allegiance to St Julien, probably instigated by

the unscrupulous ninth-century chronicler, was complete. The chronicler made Julien one of seventy-two disciples of Christ; by the thirteenth century, the *Golden Legend* and Vincent de Beauvais report that Julien was sometimes identified with Simon, the leper healed by Christ at Bethany.[142]

The cathedral of Le Mans was only put under Julien's patronage in 1158, but Papanicolaou has shown that his cult grew steadily after his relics, hidden during the war, 1201–1203, were reinstalled, and that Bishop Geoffroy de Loudun was particularly devoted to St Julien. His legend appears in Bays 107 (*II.8*), 108, and the traceries of Bays 211 and 212 (the two bays probably closest to his tomb).

Other than the predictable local saints, the most distinctive iconographic emphasis at Le Mans, as Mâle has discussed, is on the peculiar Marian miracles (Bays 105, 110, and 112; *II.7* and *II.10.A–B*) such as the legend of the Pilgrim of Evron, the Rescue of the Fallen Painter, and particularly the miracles based on the *De gloria martyrum* of Gregory of Tours: the Raising of the Columns, the Jewish Child of Bourges (*II.9*), the Convent Famine at Jerusalem (see above, n.93). These no doubt were modeled on the scenes of the windows in the Lady Chapel, where fragments of the stories still remain.[143]

More useful regional evidence is provided by a few peculiar variants in standard Gothic stories. One of the most important is the Crucifixion of St Peter in Bay 108 (*II.12*), a pure work of the Principal Atelier. Peter is upside-down on the cross, being nailed by symmetrically placed executioners, in the standard western formula for the scene. The French High Gothic, on the contrary, specifies a tied crucifixion. The earliest western window with a nailed crucifixion of the symmetrical type appears at Poitiers about 1165, and the formula can be seen at Angers ca. 1225–35; after Le Mans it reappears in the Tours choir clerestory and finally in the Saint-Père hemicycle traceries at the end of the thirteenth century.[144]

Another odd western variant is the group of examples of the Virgin holding a palm: she holds a palm, enthroned (Bay 205 traceries); she holds a palm, enthroned next to Christ (Bay 209 traceries); she takes her place in the Jesse Tree, holding a palm (Bay 110); and in the Coronation, Christ crowns her as she holds a palm (Bay 108). The source of the Virgin's palm is the apocryphal story of her death, repeated by Gregory of Tours in the *De gloria martyrum*:[145] the palm is given her by the angel announcing her death; although subsequently she passes it to John, at times the Virgin carries it in the Assumption.[146] Thereafter she gets a scepter. But this is no scepter. It is a western tradition.

In the Jesse Tree of the Le Mans Lady Chapel of about 1235, the Virgin holds a palm,[147] and again in the Tours clerestory Jesse Tree (Bay 202).[148] The Coronation of the Virgin with a palm is even more striking evidence for regional tradition. The cartoon of Le Mans Bay 108 recurs at Bourges as the cartoon for the scene of the rosace of Bay 216 in the south nave clerestory.[149] This discovery leads to another, as Papanicolaou has pointed out: the rather more standard Annunciation of Bay 108 is also based on the same cartoon as that of Bourges Bay 220. Thus, although the windows of the Bourges nave aisles have been lost, when the fifteenth-century chapels were added, some meager evidence of their traditions can be patched together from the colored rosettes over the grisailles in the upper reaches of the nave. We will return to this group when pursuing stylistic questions.

How Parisian, in fact, are the medallions of Le Mans? The decorative vocabulary certainly is not that of the Sainte-Chapelle.[150] Medallions are simple circles or half-rounds, or angular polygons: both types occur from the earliest bays (111, 109, 107) through the composite ensembles of the south side (Bays 106, 108, 110, 112), where many artists collabo-

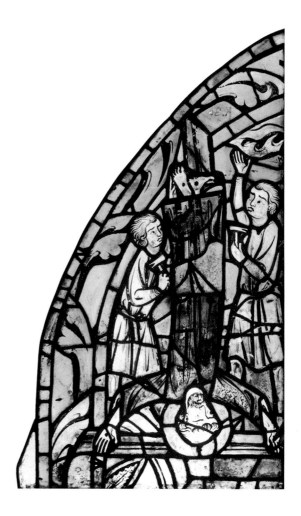

II.12 *Le Mans. Nailed crucifixion of St Peter,*
upper ambulatory, Bay 108.

rated.[151] The medallions of Paris are far more composite, elegant shapes; round medallions
appear only in Bay D of the Sainte-Chapelle, a totally different ensemble in every other
regard.[152] By contrast, the round Plantagenet medallions of the twelfth century set a prefer-
ence for that form in the west that lasted into the 1230s and 1240s at Angers.[153] The awkward
polygons of Le Mans, some of which look as if bites had been chewed from the corners, very
strongly recall the irregular angular polygons of the early campaigns of Angers and the more
complicated polygonal forms that develop at Poitiers.[154] The Le Mans forms have been la-
beled simplifications of Parisian conventions,[155] but if they simplify anything it is the western
patterns of the 1230s and 1240s found at Poitiers and Angers.

 Analysis of filet frames, mosaic grounds, and borders brings us to the same conclusion.
Whereas the first mosaic grounds at Le Mans (Bays 111, 109) are painted, most are not, and
with polygons the mosaic is often omitted entirely. The Sainte-Chapelle mosaic grounds
are painted throughout. Unpainted mosaic, however, is common in the nave rosettes of
Bourges.[156] Le Mans medallion frames are both pearled and unpearled. There is no pearling
at all in the Sainte-Chapelle, though it is typical of the west, again at Angers earlier, at
Poitiers about 1230, and lasting there into the campaigns of Sainte-Radegonde (see Chap. IV).
Almost none of the slender lancet borders of the Sainte-Chapelle can be found at Le Mans.
Rather, the triangle, zigzag, and rosette motifs in use can also be seen framing the grisailles

and their colored rosaces in the Bourges nave. In sum, the decorative conventions at Le Mans fall along the Poitiers-Bourges axis and have no referents in the king's Paris chapel. The Le Mans decoration is not merely simplified, it is different.[157]

The same observation holds true for the color: the delicate, pale tones used for figures in the Sainte-Chapelle simply do not occur in the Le Mans palette. The tonality is rich and saturated, with some yellow (which also occurs in Paris) and a lot of strong green (which does not). Papanicolaou has commented on the "broad gaudy borders and excessive use of a hot red,"[158] and it is the green in conjunction with this fire-engine red that gives the throbbing unrelieved color of Le Mans its characteristic distinction, its difference from the red-blue ambiance and delicately tinted personae of Paris.

The painting style of the homogeneous Principal Atelier of Le Mans (*II.8* and *II.12*) is easy to recognize. Papanicolaou has characterized the typical facial type: "fleshy cheeks, recessed chins, pudgy little mouths and almond shaped eyes with long eyebrows."[159] The bearded face type is less singular but still far removed from Paris. The drapery painting is lean and minimal, understated and cleaner than the Sainte-Chapelle manner, or than the late Angers painting, for that matter. A few enlarged fishhooks delineate legible, weightless forms. Always functional, the painting is occasionally quite beautiful (Bay 104, for example); the pure red glass, particularly, is respected and minimally burdened with paint, to sometimes majestic effect (as in the Bay 108 Coronation lancet).

Where could this simplified linear painting style have come from? The key is provided by an observation by Raguin:

> The grisaille lines used to delineate forms are far harsher than at Tours. . . .
> [T]he Le Mans artist emphasizes a two-dimensional pattern using leading and
> heavy grisaille painting to silhouette one element from another. Indeed, a
> comparison of the width of the painted lines and the leaded areas shows truly
> uniform dimensions.[160]

That is, the painted lines are few and thick, a woodblock print approach. Several briefs must be put in evidence at this point. The first is Papanicolaou's observation that the Le Mans style, and in fact several of the Le Mans cartoons, turn up in the rosaces over the grisaille lancets of the upper levels of the nave of Bourges.[161] What did the painting of Bourges look like in the second quarter of the century? Two precious and somewhat mediocre fragments weakly reflect it. One is the Last Judgment oculus from Châteauroux (Indre) dated about 1230–1240, a design copying the axial window of Bourges (Bay 100) but in a new style that Grodecki characterizes thus: "la peinture est . . . large, à traits accentués, à teintes de grisaille étendues."[162] An even humbler fragment from the same region is the panel from Primelles near Charost (Cher) from the collection of Jean Lafond.[163] A simple parochial composition, it shows a frontal bishop saint and a kneeling lady donor set against a grisaille ground, the earliest known example of this combination—which I will call an appliqué window—later used at Sainte-Radegonde in Poitiers. The bishop is a miniature looking back to the great bishops of the Bourges choir and forward to those of the Le Mans south clerestory. The lady's ugly but psychologically riveted facial expression is noteworthy, and the draperies are painted in thick woodcut-like lines, *peinture étendue*. The Le Mans Principal Atelier derives from these traditions, no doubt well exercised in the lost aisle windows of the Bourges nave.

Among the Le Mans atelier are two artists of more individual stripe: the Decorator and the Tric-trac Master. Neither is a great master and neither is an innovator. The Decorator

prefers wide, old-fashioned borders and reduced figures. His color palette is kaleidoscopic and unraveled, further reducing any impact the personae might have; they are slight and wizened. The painting is, in the large scale of Bay 202 (totally his creation, discounting heavy restoration; *Pl.10*) fussy and overdone, as archaic as the wide borders. In the smaller scale of Bay 106 (where he paints the main atelier cartoons of the Genesis and St Nicolas cycles) and in his own reduced medallions in Bay 110 (Tree of Jesse, Death and Coronation of the Virgin cycle) the painting is quite delicate, with soft washes of shading in the eye sockets. The tint of his paint is a distinctive light brown in both the washes and the line and in both small and large scale.

The Tric-trac Master is a maverick talent. His apprenticeship can be traced in Bay 203, where he seems to have executed the main atelier's cartoons, and he varies neither from the Principal Atelier's red-blue-green color range[164] nor from its polygonal medallions and vocabulary of borders. He is not a great technician; very often the paint was not well fired and now appears thin and peeling. But he has flair. Bay 112 (*II.10.A–B*) is his creation, quite hesitant and adolescent but full of humor: see the facial expression of the painter falling off the ladder, the pursed mouths of the monks singing to the Virgin, and the little Christ Child's expression of fascinated curiosity. The magnum opus of this independent spirit is the vast, late Tric-trac window of the south clerestory (Bay 210; *Pl.12*), a straightforward commission that he has jammed full of puns. It would be interesting to know where his career led him after Le Mans. The style—great eyes, expressive heads and gestures and a lack of much concern with the rest of the body, psychological involvement, a keen narrative gift, and care for the telling detail—reaches its zenith at Sainte-Radegonde in Poitiers. Perhaps he went there.

Le Mans is a vast display of western glazing, based on traditions that have no source in Paris but instead reflect provincial achievement: the Lady Chapel iconography of the 1230s, the Plantagenet formal conventions developed at Angers through the 1240s, the expressive language of Gothic Poitiers and the Bourges Good Samaritan Master, the simplified *peinture étendue* reflected in the Châteauroux and Primelles fragments. The lost nave aisles of Bourges would have provided the logical field of evolution and chronological link to the upper nave rosettes in the same church, as well as to the work of the Principal Atelier working at Le Mans from 1255 to 1265.

Geoffroy Plantagenet, father of England's Henry II, was buried in the Angevin cathedral of Le Mans; Henry II had been baptized in the city, whence sprang his devotion to St Julien. Philippe Auguste conceded to Queen Berengère, widow of Richard the Lion-Hearted, her dowry of the Maine in 1204, and she lived and died there, buried in 1230 at the abbey of L'Epau which she had founded in the outskirts of Le Mans the year before. The worthies attending the consecration of the Gothic chevet in 1254 came from Tours, Angers, Avranches, Rennes, Dol, and the Perche. The king's brother Charles did not receive the Maine in appanage until 1246, left France in 1248 on crusade, and returned to the Maine only to gather forces for another foreign adventure in 1254. Henry III signed away his claims to the region in a treaty ratified, finally, in 1259.

Is it any wonder that Le Mans derived little from the Capetian capital? Bishop Geoffroy de Loudun knew what he was after—a great cathedral glazed like Chartres and Bourges—and for its achievement he took his help where he found it.

✳ Epilogue ✳

Le Mans is not only the first Gothic ensemble in the western style but the most familiar and misinterpreted, from the 1850s to the present. Its vast chantier probably trained glaziers who found work as far afield as Brittany (Chap. V) and the Seine near Mantes (Chap. III). Western expressionism at Le Mans was not yet an established language. Indeed, it began as little more than a regional dialect, a brusque accent full of lustily rolled r's and abrupt glottal stops. As Grodecki pointed out, the matter of the discourse in the earliest design of the upper choir (axial Bay 100 of the upper ambulatory) was derived from Chartres. Aside from a few voices of great originality (the *naif* of Bay 105, who, as we shall see in Chap. VI, can be related to Sées; the atelier of Bays 200, 201 right, and 211, in Grodecki's view, "extremely curious, baroque, of rather mysterious origins"), the medallions completing the upper ambulatory and most of the figures of the vast clerestories above, by the Principal Atelier, have been assessed as increasingly distant reflections of the Parisian mode.

I propose a different analysis. Although Bay 100 clearly mimics Chartres, the nature of the copying is highly significant: the artist did not come from Chartres but rather went there, as it were, to take notes, probably in the early 1240s. A decade later, following the crusade and before the consecration of 1254, the "curious, baroque" master was similarly sent traveling by Bishop Geoffroy to fill his daybook with cadences from the High Gothic: Chartres again, but also Bourges. Is it so surprising that the Le Mans choir architecture, based on Bourges, should be embellished with a glazing program also based on Bourges? The Principal Atelier, which appears at Le Mans ca. 1255 just as the "curious, baroque" Master of Bishop Geoffroy disappears, was hired from Bourges. Most evidence for this hypothesis no doubt vanished when the Bourges nave aisles were remodeled in the Renaissance—most, but not all. From the colored traceries over the Bourges grisailles and from local reflections of Bourges designs, it is possible to reconstruct something of the glazing style of Bourges in the second quarter of the thirteenth century—the style the Principal Atelier took to Le Mans. As the large but homogeneous Principal Atelier took on local western apprentices in the last years of the Le Mans campaign, its fettered, bland, proper, and modulated phrasing is occasionally burdened with fussy detail (Bays 110, 202) or enlivened by the wit of the Tric-trac Master (Bays 112, 210). The latter's stylistic canon and his winsome way with a tale relate his work to some at Sainte-Radegonde in Poitiers (Chap. IV). As for the Principal Atelier, it is unclear where it worked in the 1270s, when the great choir of Le Mans was finished; in about 1280 its clear, modulated voice is heard once again in the hemicycle of Vendôme (Chap. VII). Expressionism at Le Mans is only a small part of the story, albeit its expressionist, the Master of Bishop Geoffroy, ranks with the best of the west. This chapter has sought to diagram his working methods and his references to research at Bourges and Chartres, and also to identify the regional dialects of other Le Mans artists: the vernacular of Evron near Basse Normandie, the Poitevin patois of the Tric-trac Master, but chiefly the measured speech of the Principal Atelier from Bourges.

CHAPTER THREE

Borderlands of Normandy: Crosscurrents

Le mien n'ira pas, j'en suis assurée;
il est à Paris—ou dans la Vendée.

—AUVERGNAT FOLK SONG

L E MANS REIGNS as the chief monument of the nascent western style of 1250–1325 by the simplest of criteria: sheer expanse of glass, square-footage. The display is awesome by this dimension alone. Yet if the Principal Atelier does not paint in a Parisian manner, neither do its traditions derive from the most expressionistic of the glaziers who had worked at Bourges and Poitiers (such as Grodecki's Good Samaritan Master). In comparison to the Master of Bishop Geoffroy de Loudun, who had preceded them at the site, the art of the Principal Atelier of Le Mans is defanged, declawed, tamed. It is the problem pieces of the vast Le Mans ensemble—the mediocre panels of Pierre Savary, the naive folk art of the Evron Master, and the Tric-trac Master's mannerisms and psychological intensity—that herald the future in the west. In the 1260s glaziers from many backgrounds cooperated at various sites, large and small. This chapter investigates several of these campaigns of importance to the evolution of the western style, in the corridor of the Norman Vexin, Hurepoix, and Beauce: Gassicourt near Mantes (Yvelines), Tours cathedral, and Saint-Père de Chartres. Tours, of course, is not on the Seine but on the Loire, a long way to the south. But we shall see that the donor, the glazier, and, some believe, the architect Gautier de Varinfroy were from this corridor of Norman borderlands.

Gassicourt was a tiny Cluniac priory serving a poor rural parish, yet it guards remains of four windows by four different glaziers, two of whom were westerners. Tours was a royal cathedral with a Parisian program and largely Parisian chantier; the deviants from this strong court focus are what command our attention. The Benedictine abbey of Saint-Père de Chartres carried out a rebuilding program after the model of the famous new chevet of the Benedictines of Saint-Denis; although "on faisait bon marché" in reusing windows made earlier for a different location, two windows and a triforium were newly glazed and will be studied here.

The artistic currents are variable and erratic. At Gassicourt were gathered a weak artist whose training had been in the Le Mans chantier, a westerner whose style groups him with the Tric-trac Master and the Poitevin glass of Sainte-Radegonde, and two more mainstream arrtists who, it will be seen, cannot be labeled simply "Parisian." Related to the work of the latter two glaziers are those influences at Tours and Saint-Père that can be factored out from

48

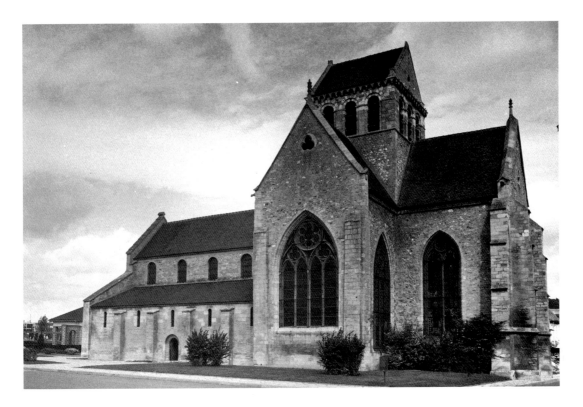

III.1 *Church of Gassicourt near Mantes (Yvelines).*

their more court-derived modes. Normandy looms large in the equation, though what glass has survived for comparison in that great province is, alas, merely bits and fragments in museums and country chapels. The parade of painters in this chapter is rich, the testimony at times meager or faint but nonetheless eloquent, attesting to a bustling creative activity and a climate of healthy optimism in the final decade of St Louis's reign.

Gassicourt

In the thirteenth century, the Cluniac priory of Gassicourt (*III.1*), now a parish church in a suburb of Mantes, was a quiet rural community of about a half dozen monks serving a parish of eleven hearths.[1] Although small and remote, the priory was no doubt self-sufficient. Eudes Rigaud, the famous Franciscan bishop of Rouen, stayed overnight there with the abbot of Cluny the night after they had attended the funeral of Queen Blanche de Castille.[2] Gassicourt's income was sufficient to enlist it among the thirteen Cluniac priories that Pope Boniface VIII rewarded in 1291 with the meaningless title of *decanatus* (*doyenne,* deanery), since he also ordered them to pay an annual tax to support the financially troubled mother house.[3] In the seventeenth century, the dwindling proceeds were still enough for Bossuet to litigate for their control.[4]

Nothing in the charters of the priory's sleepy existence, however, suggests the funding needed for the Gothic remodeling campaign nor, for that matter, the reasons for it. Such

resources must have been provided by a donor, and history suggests the family. A church at Gassicourt had been given to Cluny in about 1070 by Raoul Mauvoisin "the Bearded," seigneur of Rosny and viscount of Mantes.[5] Raoul, one of the Norman knights who had crossed the channel with the Conqueror in 1066, became a monk at Gassicourt before his death in 1074.[6] Nearly a century later, in 1168, the brothers Guillaume and Manasse Mauvoisin issued a long charter establishing the possessions of the priory, many of them donations of the family: "Ista predicta et multa alia, que longum est enumerare, de proprio dono Malvicinorum sunt."[7] In 1200, another Manasse Mauvoisin made an agreement over revenues with the community of Gassicourt.[8] A charter of 1237 indicates that Gui de Mauvoisin, lord of Rosny, used the prior of Gassicourt as one of his agents:

> Guido Malusvicinus, salutem. . . . Significamus vobis quod ad voluntatem et praeceptum domini regis franc' concessimus et volumus quod missio in possessionem quae facta suit, pro nobis, contra burgenses meduntenses, auctoritate vestra per Priorem de Gacicuris, et Priorem Sti Martini de Garena, revocaretur et pro nulla haberetur. . . . Actum apud Roonium, anno domini M° CC° XXXVII°.[9]

As late as 1739 the lord of Rosny—no longer a Mauvoisin—was one of the ratifiers of the community's move to Paris.[10]

The Mauvoisins were a noble clan of great fame and number in Capetian France and intermarried with the Garlandes in the twelfth century.[11] The most famous was Robert Mauvoisin (d. 1215), crusader and companion of the violent Simon IV de Montfort and sometime *chansonnier*. Robert's younger brother Pierre Mauvoisin was a hero at Bouvines.[12] In the next generation, Gui de Mauvoisin was a hero of Mansourrah and the spokesman, chosen by the French barons after the Egyptian misadventure of 1250, who suggested to King Louis IX that they all go home.[13] Although the Mauvoisin family maintained a compound in Paris, there is no question that they retained interest, control, and residence in the Mantes region.[14] Gui de Mauvoisin customarily hanged criminals before the gates of the priory.[15]

There is no way of telling whether it was Gui de Mauvoisin, the king's companion in Egypt (who died between 1262 and 1265), or his son of the same name, who paid for the Gothic remodeling and glazing of Gassicourt.[16] It is a reasonable assumption, however, that one of these two lords of Rosny did so. There was no other rich man around.

The Gassicourt that remains today was built in the late eleventh or early twelfth century, remodeled in the last years of St Louis's reign, redecorated again in the fifteenth to sixteenth centuries, restored by Durand 1855–1876, and again after the heavy bombing of Mantes in World War II.[17] The Gothic remodeling involved vaulting the east end of the church and replacing its windows with enlarged, traceried *rayonnant* lights.[18] There are six new, unmatched windows: some of two lancets, one of three, one of four, and the south transept wall of six. These ad hoc constructions were glazed with a similar variegation of glass designs, which popular tradition has ascribed to the generosity of Queen Blanche de Castille (d. 1252).[19]

Four windows still contain Gothic glass: Bay 0, the axial bay of the choir (Passion medallions); Bay 1, the north bay of the choir (four large standing saints); Bay 3, east window of the north transept (Infancy medallions); and Bay 4, east window of the south transept (medallions of the three deacon saints Stephen, Lawrence, and Vincent).[20] These four ensembles are stylistically unrelated and can be attributed to four masters of disparate backgrounds. Since their art cannot be differentiated chronologically, we can assume that this

Plan of Gassicourt.

quartet of painters worked shoulder to shoulder. More surprising than their dissimilarity is the lack of an evident shop master among them. The chantier appears to have been run quite democratically, equal voice to all—no doubt assembled quickly from available journeymen and probably broken up just as quickly. There was no "school of Gassicourt."

The Master of the Big Saints

While three of these glaziers produced heavily color-saturated medallions, the fourth master filled the broader lancets of the doublet-and-rose windows (Bays 1 and 2 flanking the choir) with great, standing, life-size saints. His choice of scale is peculiar in such an intimate interior. His overpowering figures have the ostentation of a cathedral-scale design, all the more surprising since only the monks could really have seen them easily where they are located, in the side walls of the tiny choir.[21] And in the thirteenth century there were probably no more monks at Gassicourt than glassy saints.

Bay 1 on the north side of the choir has sustained very minimal loss, and although Bay 2 facing it is now almost entirely a work of the late nineteenth century, it originally had a similar design—fragments of a bishop were still in the window when Guilhermy first visited the church in the 1840s.[22] The saints of Bay 1 are: John the Baptist (SIO $\overline{\text{HES}}$ BAP H __), John the Evangelist (S ICHANI EVENGELITE), and two bishops—Sulpice (S SVLPICIVS D FESSORS), and one restored as Nicholas. Most of the inscriptions are original and indicate that the artist was illiterate, since he has copied most S's and the D backwards.

Sulpice reflects the priory's dedication; it was named Saint-Sulpice de Gassicourt probably by 1200.[23] His presence in the Gassicourt window clearly reveals his rising star as a pilgrimage saint in the Ile-de-France. The cult of Sulpice, a seventh-century bishop of Bourges, was located at Saint-Sulpice-de-Favières (Essonne), which had been rebuilt as a magnificent Court-Style church in the late 1240s.[24] The illiterate glazier of Gassicourt has badly garbled Favières, which was variable in any case: Faverias, Fabariae.

Although the Nicholas inscription is now a restoration, it is probably correct. St Nicolas was patron of the chapel of Fontenay-Mauvoisin, revenues of which the monks had received from the sons of Raoul Mauvoisin the Bearded. Fontenay was the Mauvoisins' twelfth-century château.[25]

The attribute held by the Baptist (the Agnus Dei disc) was standard by this time. The palm held by the Evangelist, on the other hand, though generally uncommon, occurs (probably) in Bay 211 at Le Mans, also in the Tours triforium, and in both the hemicycle and the nave cycles at Saint-Père de Chartres, and thus is established as a western favorite.[26] It derives from the same Pseudo-Melito legend that begat all the Virgins holding palms at Le Mans.

The pair of St Johns (*Pl.13*) is an iconographic phenomenon of some complexity and interest, which enjoyed several periods of popularity in the Middle Ages. It occurs as early as the late fifth century in Rome in the decoration of the oratories of the Lateran baptistery. Since the Lateran was the pope's cathedral until 1307, it is the locus of the tradition associating the two Johns with Peter and Paul in papal iconography.[27] This early connection of the two Johns with baptism develops, by the Romanesque period, into an association with the Last Judgment, the pair being the prophets of the First and Second Coming of Christ. All the themes are present in the Portal of St Gall (1180–1190) on the north transept of Basel cathedral,[28] where the two Johns flank a wheel of fortune, the wise and foolish virgins, the deeds of mercy, the dead rising, and Peter and Paul presenting donors to the Judging Christ. Strasbourg cathedral has a pair of St Johns in stained glass of about 1200, now in the north transept but probably from the north choir chapel of the Baptist.[29]

This connection of the two St Johns with the north side of the church and with the baptismal font loses strength in the later Middle Ages: by the fourteenth century the two Johns often serve as twin name-saints for a donor named John;[30] in the fifteenth century they protect from epilepsy.[31] The Parisian Gothic tradition is also unrelated to and distinguishable from the Romanesque program seen at Basel. At Saint-Denis the two Johns shared a twelfth-century chapel at the southwest corner of the chevet; this traditional placement was maintained in the choir glazing of Bourges (where the windows of the two saints are in the southwesternmost chapel) and at Tours (clerestory Bay 212).[32] At the Sainte-Chapelle a Scholastic turn of mind has balanced the prophets of the First and Second Coming, placing the Evangelist to the north and the Baptist to the south of the axial Passion window.[33]

But in Rouen cathedral the cults of the two St Johns are located according to the older tradition: on the north and near the font. Lefrançois-Pillion states:

> En effet, . . . la nef latérale nord était . . . sous la patronage tout spécial des deux saints Jean, car elle contenait et contient encore deux chapelles du Précurseur et dans chacune des chapelles, des chapellenies étaient fondées en l'honneur des deux saints homonymes.[34]

The north door of the main entrance is carved with their legends; behind it the north aisle contains the chapel of Saint-Jean-dans-la-nef; the north transept chapel, dedicated to Saint-Jean-jouxte-les-fonts, is glazed with thirteenth-century scenes of both Johns.[35] The cosmic reverberations of the Romanesque programs have evaporated, however. We are, in Normandy, in the mid-thirteenth century, in the world of the *Golden Legend,* where the relationship of the two St Johns is uncomplicated and amicable:

> And God has deigned to manifest openly that it is unseemly to try to determine which of these two saints is the greater. There were once two learned theologians, one of whom preferred Saint John the Baptist, the other Saint John the Evangelist; so that they came together one day for a formal disputation. And as both busied themselves seeking out authorities and arguments in support of their views, to each of them appeared the Saint John whom he favoured, and said to him: "We are in excellent accord in Heaven; think not therefore to dispute over us on earth!"[36]

Although the full Gothic glazing program of Rouen cathedral is now lost and probably impossible to reconstruct, part of the window of the three deacons still remains; its original location was off the south transept.[37] Thus the program at Gassicourt probably reflected the traditions of the thirteenth-century cathedral of Rouen. As at Rouen the two Johns are on the north, and the deacon saints occupy the east side of the south transept.

The illiterate Master of the Big Saints was not responsible for the program, however, since he was not trained at Rouen. Rather, his eclectic style recalls many lessons learned in the shop at Le Mans. He is not a master but a second-string copier and almost every aspect of his style can be traced to Le Mans: the blue hair and beard (the Baptist, Sulpice, "Hugo") recall the Master of Bishop Geoffroy (Le Mans Bay 211); the beaded halo and rosette-studded ground, the handsome Bay 205; the disputing pairs, Bay 202 and the right lancets of Bay 209; the frontal bishops, the south clerestory series; the shoulders, the expansive saints of Bay 204, and the thickened torsos of Rotrou de Montfort's axial window (Bay 100). The color is the unfocused rainbow harmony of the Decorator of Bay 202. Most undeniable, though, are the roots of his face and drapery painting: the faces (most notably John the Evangelist; *Pl.14*) are absolutely typical of the Principal Atelier; the spastic draperies are a weak derivative of the manner of the Master of Bishop Geoffroy, on a par with, or below, the level of his followers in Bays 209 or 204. This is even more evident in an old photograph that predates the 1936 restoration (*III.2*). Moreover, the bishop's blessing hand has a ring on it, shown in profile—a detail from Le Mans Bay 204.[38]

I would like to suggest not only that the pretentious designs of the big saints at Gassicourt are derived from Le Mans in decorative vocabulary, color, and painting style(s) but also in the very idea of lining up huge canopied figures in rows. The detail suggests that the worka-

III.2 *Gassicourt. St Sulpice, drapery painting of the Master of the Big Saints prior to 1936 restoration, Bay 1.*

day apprentice of Le Mans left about 1260, since his eclecticism is by no means dominated by the procedures of the Principal Atelier. His button-crocketed gables and borders of combined fleurs-de-lis and castles were probably picked up along the Seine; they resemble those of Evreux.[39] A date of ca. 1270 is, moreover, appropriate for his inscriptions, executed in slightly more developed uncial forms than those at Le Mans.[40] At Le Mans both capital and uncial A and T still occur, and letters are still reasonably well spaced in Bays 209 and 204; there are more uncial curves and more compressed crowding of letters at Gassicourt. The minor differences, and the new borders and crockets, suggest that the illiterate journeyman had left Le Mans before the end of that campaign, and that he had gone from there to the Seine.

The Deacons Master

A more imaginative and gifted westerner is the Deacons Master, who designed Bay 4 in the south transept with medallions of the lives of the three great deacon saints, Stephen, Vin-

cent, and Lawrence (*Pl.15*). It has already been mentioned that the original glazing of Rouen cathedral included a similar program in a similar location.[41] Gassicourt's gaily colored bay, exhibited in Paris in 1962 after its restoration by Gruber, was described at the time by Grodecki:

> La composition de la verrière est traditionnelle, les scènes ayant la forme de quatrefeuilles, combinés avec des losanges . . . ; la mosaïque de fond est vivement colorée, le dessin de la bordure est celui du milieu de XIIIe siècle. Malgré ces caractères traditionnels, le style des scènes, le dessin des personnages à membres grêles, à petites têtes et aux mouvements flexibles, révèlent une date assez avancée dans la seconde moitié du siècle . . . ; nous sommes loin de l'art de la Sainte-Chapelle de Paris et des oeuvres qu'elle a inspirées, les vitraux des Cathédrales du Mans et de Tours.[42]

Without having to agree precisely with the assessment of Le Mans in the camp of the Sainte-Chapelle we can readily concur that the Deacons Master is no Parisian, nor did he work at Le Mans.[43] His colorful, vivacious art is pure western, the closest comparison being with the St Blaise Master of Sainte-Radegonde de Poitiers. The *carré quadrilobé* medallions (which Grodecki describes as "quatrefeuilles, combinés avec des losanges" and relates to Sens and the Sainte-Chapelle) also occur in the St Lawrence window at Angers, at Dol in Brittany, and at Fécamp in Normandy.[44]

The window is nearly complete and has suffered relatively little. In addition two panels now in Christ Church (South Hamilton, Mass.) have also been exhibited and published: the ordination of St Stephen by two apostles (Acts 6:5–6) and the Charity of St Lawrence.[45] In the tracery lights are two deacons (from the same cartoon) with the inscriptions: S VINCENT (left) and S LORENS (right).[46] The inscription style is less developed toward the "Lombardic" than the inscriptions of the Master of the Big Saints: capital N and T appear, the letter forms are more blocklike in proportion, and the spacing less compressed. A date later than ca. 1270 would be hard to justify, based on a comparison with the much more developed style of the 1269 inscription in the axial clerestory of Amiens.[47]

The subjects now in the church, some out of order, are as follows, reading from the bottom up:

Left lancet:
—(modern panel)
—Vincent led before Dacien by two henchmen (*Pl.16.B*)[48]
—Vincent on the rack, his bones being broken by two executioners
—Lawrence baptizing St Hippolytus in a green tub, while a witness holds garments[49] (panel in the wrong lancet)
—Vincent on the grill, one executioner with forked stick, other with bellows
—Vincent's soul raised to heaven by two angels (mostly nineteenth century)
—Lancet head: Christ enthroned, blessing

Middle lancet:
—(modern panel)
—Stephen led before crowned figure by a henchman in winged helmet, Stephen's face shining like an angel's (Acts 6:12–15) (*Pl.16.A*)
—Stephen(?) beaten by henchman, pushed through a door
—Stephen led out of town by two men[50] (Acts 7:58)

—Stoning (Acts 7 : 59) by two men, Saul to the left

—Vincent dying in bed, two angels ready to receive his soul in a sheet[51] (panel in the wrong lancet)

—(lancet head: modern)

Right lancet:

—(modern panel)

—Lawrence, nude, led before Valerian by two henchmen (same cartoon as Vincent lancet)

—Lawrence lying down, stripped and beaten with cudgels by two henchmen (*Pl.15*)[52]

—(modern)

—Lawrence on the grill (same cartoon as Vincent lancet)

—Lawrence's soul raised to heaven by two angels (same cartoon as Vincent lancet)

—(lancet head: modern)

The Deacons Master's world is a magical never-never land, his goals dramatic immediacy, action, and fresh, direct emotional appeal. His executioners beat and prod with real enthusiasm for their task, his doll-like saints regard them and their other antagonists with fear, contempt, or with sublime disregard. Color is just as full of life, not subtle or subdued but crude and gay, marked by red and hot yellow, prominent greens (both clear and emerald) and rosy brown (*Pl.16.B*). His palette is much gaudier than the classic red-blue of the Infancy window and has none of the subtle variation, range, and modulation of the Passion window. The painting is strong and fresh with a kind of unfinished immediacy. Each face is individualized; body structure is ignored; gestures and postures emphasized. The actors in these fairytale dramas resemble caricatures or animated puppets and sometimes have the same enlarged heads and hands. In a word, the artist is an expressionist.

The winged helmet on Stephen's persecutor is a telling detail (*Pl.16.A*), typical of English thugs but atypical of those in art of the Ile-de-France; significantly, it occurs later in the hemicycle traceries at Saint-Père de Chartres.[53] The area where vitality, immediacy, and expressionism reigned was western France, and the gaudy color of the Saint-Père hemicycle, its culminating masterpiece, recalls the palette of the Deacons Master at a generation's remove. Closer in time is the very similar magical world of Sainte-Radegonde in Poitiers, where figures with the same "flat-top" heads and bulged foreheads point, push, and leer at each other in a warm technicolor land of saturated red, yellow, green, and deep blue. The Sainte-Radegonde painters are more advanced, convinced, and thorough expressionists— their touch is not so delicate!—but their color, their approach, and their facial types appear earlier at Gassicourt. So does their slashing style of drapery painting, marked by long Vs starting at the hemline; a well-preserved example is to be seen on the saint in the Charity of St Lawrence in Massachusetts. The similarities are close enough to suggest that the Deacons Master found work at Sainte-Radegonde but one suspects that he already spoke with a Poitevin accent.

The Infancy Master

No other westerners worked in the ad hoc chantier at Gassicourt. The medallion windows of the Infancy (north transept, Bay 3) and the Passion (east, Bay 0) are the works of two

very different painters, closer to the Parisian mainstream. Their characteristics and roots are sketched here, both for their intrinsic interest to Gassicourt and for their relationships with other glass of the late Capetian era.

The Infancy window, not so well preserved as the Deacons bay, has like the latter been exhibited and published both in Paris (the six medallions now replaced in the church) and in Massachusetts[54] (Visitation and Nativity fragments). A ninth panel from the series, a Virgin and Child with kneeling magus (from the Adoration), was published in the Octave Homberg sale catalog in 1908 and its whereabouts are presently unknown.[55] The Massachusetts panels provide beautiful evidence of the painter's backpainting. At Gassicourt the exterior wash is also quite visible, a technical complexity not found in the Deacons window.

The following six scenes are preserved in the church (*III.3*):

Left lancet: —Two standing magi with gifts, under arcades (from the Adoration)
 —Herod ordering the massacre: Herod and a soldier under arcades
 —Two soldiers[56] under arcades

Right lancet: —Magus on horseback
 —Sleeping magi awakened by the angel (*Pl.17.A*)
 —Massacre of the Innocents: a soldier raises a sword to attack a
 child in his mother's arms (*Pl.17.B*)

The straightforward iconography can be compared with the Infancy window in the south aisle of Saint-Sulpice-de-Favières (Essonne), an ensemble that includes many apocryphal legends of Sts Anne and Joachim, the Virgin's parents.[57] Indeed the closeness of the layouts of the common scenes suggests that the Saint-Sulpice cycle may reflect the original complement of stories at Gassicourt. If this is the case, the parish chapel of Gassicourt was perhaps located in the north transept (where the window is located), since the parish was dedicated to St Anne.[58]

Since even the medallion forms and ground bear some resemblance, the stylistic differences between the Gassicourt Infancy and the same cycle at Saint-Sulpice (a Court-Style monument in the diocese of Paris) are all the more significant. The glass at Saint-Sulpice is painted by a firm, precise hand, displaying a considerable elegance, which is veiled by an absorption in quaint detail. Gassicourt's Infancy has a lean and hungry look which Grodecki has called:

> un bon exemple de l'art "menu" par l'échelle d'exécution et par la maigreur
> des formes, propre aux ateliers normands et parisiens après 1270. On doit
> comparer ces panneaux aux scènes de la vie de saint Jean-Baptiste du Musée
> de Cluny (enlevés de la Sainte-Chapelle, où ils ont été mis en bouche-trous au
> XVIIIe siècle), aux verrières de Saint-Sulpice-de-Favières et, en Normandie,
> aux plus anciennes fenêtres de la Trinité de Fécamp ou aux fragments
> provenant de Saint[e]-Vaubourg (à Saint-Denis).[59]

As with his critique of the Deacons window, it is not necessary to agree with the inclusion here of Saint-Sulpice to concur wholeheartedly in the judgment of these panels as Norman.

The color palette of the Infancy Master is a classic red-blue, with chief accents in clear hunter green and brown, yellow quite rare, and white used in secondary areas only and not "scintillated" into small spots. Draperies are indicated by a few fine lines, very sparsely and economically applied on the inside of the glass and reinforced by backpainting (a lovely

III.3 *Gassicourt. The six Infancy medallions, prior to restoration, Bay 3.*

III.4 *Rouen Cathedral. Examples of looped curtains, north
transept chapel of Saint-Jean-jouxte-les-fonts (figure
heavily restored).*

example is the lozenge diaper backpainted on the bedclothes of the sleeping magi). There is
no particular care or interest in detail, for example the schematized chain mail and crowns.
The female figures are clumsy and ungainly; there is nothing courtly or mincing about them.
All are singled out and silhouetted against the ground in timeless tableaux, their faces ex-
pressionless, and their careful gestures frozen for eternity. There are two head types: a wiz-
ened bearded male face, somewhat triangular in structure; and a swollen-jawed, coarse-
featured beardless or female type. Facial expressions range from stoic to lethargic, and
mouths appear locked in position.

The Infancy Master's preference is for composing on the diagonal—not crossed diago-
nals, which would produce an excitement undesired by him, but lozengelike framing paren-
theses. The word "framing" is the keynote of his style. He uses little canopies with button
crockets wherever he can, and he lovingly repeats the framing lines of the canopies in the
placement of his figures. Heads tilt to parallel the diagonals of the gables; legs and weapons
angle in below. Gestures are underlined by parallel stage props, among which one device
appears in both Massachusetts panels: the curtain looped over an architectural frame.

These little canopies with button crockets are common coin in the tableaulike compo-
sitions of Normandy in this era. They can be seen developing at Sainte-Vaubourg[60] south of
Rouen, as well as in a long series preserved at Evreux cathedral (*III.14.A–B*, p. 73). The
looped curtains are also in the Norman bag of tricks, for example in glass of the north
transept chapel of Rouen cathedral (Saint-Jean-jouxte-les-fonts; *III.4*).[61] Such draped cur-
tains, of course, simply signify an interior and are certainly not limited to Normandy; but in
late thirteenth-century Norman designs they proliferate haphazardly, like so many used tow-
els in a locker room.[62] The Infancy Master's painting style, spare and thin inside with a rich
wash on the exterior, is also typical of Normandy—though of course weathering and the
occasional polishing by restorers make the latter difficult to study. Some fragments at Evreux
and Fécamp appear to have backpainting. The clean, fine interior line is very common, in
some hands at Rouen cathedral and in the seated Christ in the north transept at Lisieux

cathedral, as well as in countless tiny country churches brought to the world's view by Jean Lafond:[63] Bailleul (Seine-Maritime); and Saint-Germain-Village, Saint-Symphorien, Saint-Antonin-le-Sommaire (all in the Eure).

Thus the Infancy Master was probably recruited closer to home than were the westerners, from just down the Seine. Was he the shop foreman? That would seem a fruitless speculation, but it is nonetheless likely that he was the practiced professional—the westerners are both less secure in their particular handwriting—and that the great artist of the four, the Passion Master, was probably new to the game, no glazier at all.

The Passion Master

The fourth artist of Gassicourt produced the axial window of the Passion, called by Grodecki "un des chefs-d'oeuvre du vitrail à la fin du XIIIe siècle."[64] Though there is nothing western about him, his masterpiece will receive our brief attention not only to complete the overview of crosscurrents on the borders of the Ile-de-France but simply because attention must be paid to an art work of this caliber.

The four-lancet bay contains two dozen medallions, a vast narrative of the Passion from the Entry to Jerusalem through Pentecost, reading left to right across the lancets and from bottom up (III.5). Although only three scenes are completely new, almost all have areas of restoration, often sizable.[65] When Guilhermy first visited in the 1840s, the window lacked a few panels, which he noticed were installed here and there in the nave; he specifically named only the Last Supper. In 1854 he observed that Didron had removed them all for repair, after which they were to be replaced in the apse. The iconography is standard, and the space allows for a very full cycle, for example both the Holy Women at the Tomb and the Resurrection.[66] Most unusual is the placement of the Washing of the Feet in a position following the Last Supper, contrary to normal order in Gothic France; the extreme damage and restoration evident in the bottom rows, however, makes the Gassicourt order suspect.[67]

The Passion Master is remarkable for a beautifully modulated, carefully finished draftsmanship and for an unusually broad range of color. He uses several greens including pea green and turquoise, pink and several depths of rose brown, ice blue, robin's-egg blue, and yellows ranging from very pale to deep gold (Pl.18). He seeks out the streaky ruby for its irregular textured look. In fact, he seems to have been a manuscript painter, since colors of this subtlety, diversity, and modulation are not a simple matter to produce in the medium of stained glass. His figures are small and elegant with well-articulated limbs, and their expressive faces add tension to the familiar narratives. Arms and legs spill over the frames. He is concerned with mass and careful volumetric definition, and includes a dorsal view (one of the mockers of Christ) and a remarkable sleeping soldier seen frontally with bowed head, top of the helmet foremost. He paints beautiful people; his Christ is a handsome man.

The care with which this artist combines line (from fine and thin to slashing and dramatically thickened) with a great many washes fits the supposition that he was a manuscript illuminator, as does his practice of bunching figures in crowds or clumps, not easily readable in the glass medium. His finesse with color and with the brush would make him a noteworthy master in any age but especially in stained glass around 1270. Particularly unusual is the drapery painting, of infinite variety, which combines two contrasting approaches: areas of very lean linework and thin wash are complemented with heavily worked cascades and hem folds worked from-the-black, their effect almost like a photographic negative.

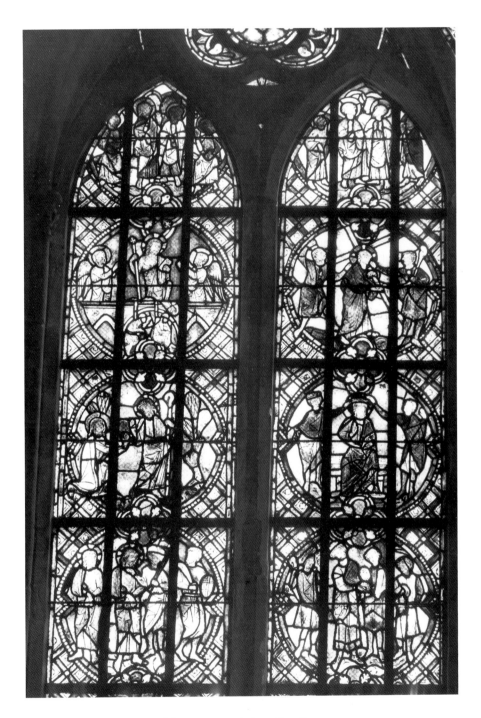

III.5 *Gassicourt. Passion Master, east window, Bay 0.*

Comparisons to other works are not numerous. The Maciejowski Bible[68] shows many of the characteristics at an earlier date and executed in a tighter, harder, more formulaic approach. One stained glass fragment in the south aisle of Evreux cathedral (the martyrdom of St Andrew; *III.6*) combines similar drapery techniques, though not in the same figure. Striking, however, is the resemblance to a few handsome scraps now in the axial window of Saint-Sulpice-de-Favières (*III.7*). The Adoration of the Magi[69] there is also marked by a broad, subtle palette, a painting touch of psychological range and sensitivity, volumetric definition, and a combination of clean spare line with drapery areas worked from-the-black. The clumping of which the Gassicourt Master can be accused, however, is not present either at Evreux or at Saint-Sulpice, where the figures are majestically presented. The path led *from* Gassicourt *to* Saint-Sulpice.

The Passion Master is learning on the job. His medallion and ground formulas and their deep coloring come from the Infancy Master, from whom he also learned to spread scenes over several neighboring lancets. His rainbow palette is a refined version of the unfocused color of the Master of the Big Saints. From the Deacons Master he picked up detail: red-and-green robe combinations, delicately decorated hems, the pillbox hat worn by executioners, and most obviously the henchman's winged helmet (Pilate washing his hands). Both artists share a facility for theatrical immediacy—the face of the Passion Master's Virgin at the Crucifixion is a masterpiece in pathos—but their difference in sophistication would certainly have made of them an odd couple.

One must leave the puzzle of how these four glasspainters got to Gassicourt and collaborated on this remarkable rural project. The Infancy Master, as the most secure and as the Norman, seems likely to have been in charge. Norman and western artists did continue to collaborate in the years to come: in the north rose of Rouen, at Vendôme, in the Saint-Père hemicycle. What makes Gassicourt so special is its sleepy isolation, a most strange environment in which to find the stained glass styles of Gothic France in microcosm.

III.6 *Evreux Cathedral. Crucifixion of St Andrew, fragment mounted in south nave.*

III.7 *Church of Saint-Sulpice-de-Favières (Essonne). Adoration of the Magi, fragment mounted in axial Bay 0.*

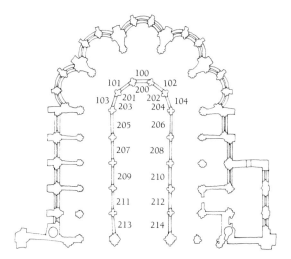

Plan of Tours cathedral.

The Triforium of Tours, 1255

Like the upper ambulatory medallions of Le Mans, the cathedral of Tours has long been considered a Parisian monument beyond the pale. While the assessment is false for Le Mans, as I tried to demonstrate in Chapter II, it is undeniably true for much of Tours. The question has been examined by Linda Papanicolaou, who has identified three campaigns:[70] the triforium, the three axial clerestories, and the Genesis window (Bay 207); the bulk of the clerestory glazing; and a final trio of north clerestory bays (209, 211, 213) dating perhaps as late as the 1270s, that is, after the consecration of 1267. The Parisian art becomes increasingly tainted by local tradition, the medallion style of the third campaign transformed by its "expressive forcefulness and intense color tonality . . . [which] relate it to the glass of the western School of this period at Sées, Vendôme, or Saint-Père, Chartres."[71] Grodecki no doubt had this third group in mind when he suggested that the western school sprang from Poitiers and Tours.[72] Of the figures in these three final clerestories (bays of Nicholas, of Denis and Vincent, and of Thomas and Stephen) Raguin has stated:

> In contrast to the physiognomies of the Sainte-Chapelle narratives, the Tours faces possess a definite dramatic quality. They move from the characteristic dispassion of the Parisian monument to an appearance of deep involvement. Certainly the furrowed brows and the expressive hand gestures . . . depict a world of anxiety and momentous happening.[73]

Though permuted in both color and figure proportion, these final medallion bays still swim in the Parisian wake. It is to the start of the campaign, not the finish, that attention will be paid here.

The triforium is glazed with grisailles[74] in the straight bays and a procession of apostles flanking the Virgin and angels in the hemicycle (*III.8*). I have come round to the opinion of Jean Lafond that a color/grisaille formula of this sort, which one might call a summer-and-winter program, must have been disseminated from Paris; its occurrence in the Lady Chapel of Saint-Germain-des-Prés can be dated to the 1240's, and Saint-Denis also had grisailles in the triforium and at least one documented figure ("Pepin the Short"; see p. 328 n51). The Tours triforium thus follows the latest Paris fashion.

III.8 *Tours cathedral. Choir triforium, examples of grisaille and color. After Bourassé and Manceau, 1849.*

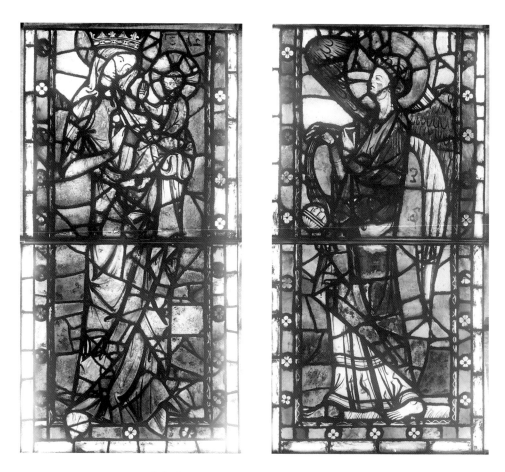

III.9 *Tours. Virgin and flanking angel, triforium, axial Bay 100.*

Papanicolaou identified several hands in the first Tours campaign, the master (responsible for the Virgin and the profile figures) commanding a handsome, monumentally plastic art that seems to be influenced by sculpture (*III.9*). His approach is rare in glass: the Judith Master of the Sainte-Chapelle employs a similar broken-fold style but is otherwise distinguishable;[75] there is only a family similarity with the Gassicourt Passion artist, who also favors dorsal and profile views, well-articulated volumes, and an occasional *bec débordant* fold. The assistants who carry out the rest of the triforium painting at Tours do not command this sculptural quality. It can be found, in more advanced form, only in a problematic group: the four seated apostles now in the Cluny Museum, probably from the chapel of the Château de Rouen and datable in the 1260s.[76]

Color is similarly deployed in an even but saturated balance of red, yellow, green, and blue; the broken-fold draperies are increasingly marked by great black triangles; even the wedge shape between the eyebrows, also found in the Gassicourt Passion Master, still appears. The Château de Rouen fragments include both grisailles and colored apostle panels, as at Tours. As at Tours, the Château de Rouen figures twist in their space; their proportions are elegant, with small heads and real necks (even when bearded); silhouetting and negative space are important; and the postures combine a sense of immediacy with solid implantation. These artistic creations combine mass, elegance, and an indomitable force, charged by an electric energy that leaves the languid high style of Paris far behind.

The original placement of figures and grisailles at the Château de Rouen is impossible to reconstruct, the chapel having been destroyed before 1689 and the fragments later cropped and rearranged into band windows. It is not unreasonable to assume that grisailles glazed the flanks of the chapel and colored glass the hemicycle in a summer-and-winter program, as at the Saint-Germain-des-Prés chapel in the 1240s, the chapel of Saint-Germer-de-Fly (Oise) of 1259–1266,[77] and in the triforium of Tours. The Château de Rouen grisailles are more advanced than those of Tours, just as the drapery painting is more developed: the grounds are clear and the foliage grows upward, while at Tours the grounds are still crosshatched and the pattern still centripetal in orientation.[78] Thus, if the Château de Rouen glazing dates in the 1260s, the Tours triforium must date earlier, and that turns out to be the case.

Coats of arms tucked behind the stone screen of the Tours triforium (in the traceries of the first window south of axial) were unrecorded and, so far as I can tell, unnoticed until my first visit in 1960. These arms—*argent à la fasce d'or* and *sable à la bande d'or*—identify the knight Guillaume Ruffin de Binanville and relate to a document (burned in the bombing of the Tours archives in 1940) that was dated 1255.[79] Several charters establish the Binanville family in Tours,[80] and the family burial chapel was at Châteaudun. The home territory of Binanville, however, which still exists as a small *bois* marked by a road sign, is near Mantes. Guillaume Ruffin (red-headed?) was not only a neighbor of the Mauvoisins of Gassicourt but a fellow soldier in the king's ranks, and a documented friend.[81]

In light of this extraordinary coincidence, it is almost comforting to find that St John carries a palm in the Tours triforium as he does at Gassicourt, in the first campaign of the Le Mans clerestory, and in two cycles at Saint-Père de Chartres, and that one of John's fellow apostles at Tours has dark green hair and beard.

From the above evidence I would conclude with as much reserve as I can muster, as the late Robert Branner once put it, that the stained glass of the Tours triforium, so different in color from the inky blues of the hemicycle above and so un-Parisian in approach, relates to one of the crosscurrents of the 1250s and 1260s, to a style that from its configuration at

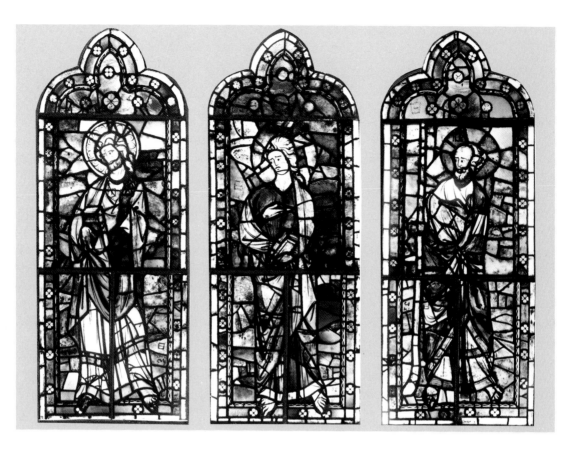

III.10 *Tours. Apostles, triforium, Bay 102.*

Gassicourt, Rouen, and Saint-Germer-de-Fly might appropriately be labeled "Vexinois."[82] Not a perfect term, but one must call it something, this forceful, elegant, sculptural yet strongly colored art, since it is an important current, an eddy that joins and contributes to the western stream.

The coloring at Tours is vivid. The Virgin is in red and green; the apostles in red, yellow, blue, and green, against grounds of alternating red and blue set with yellow rosettes. This is the gorgeous tricolored landscape of the Saint-Père hemicycle at 1300, the gay, balanced trio of primaries that marks the late great masterpieces of the western school at Vendôme and Evron. The progression in poses is just as clear. The Tours apostles (*III.10*) exhibit the sculptural quality and planted stance already present in the early Saint-Père prophets of 1240: they move from strength, one might say.[83] These early strides are now executed with the increased adrenalin which becomes so noticeably present at the end of the century in the Saint-Père hemicycle. It is the same with physiognomy and the expressionistic distortion of hand gesture—the similarity of gesture between the saints of Tours and of the late Saint-Père group is marked.[84] Most of the typical pointing and grasping gestures had appeared first in the early Saint-Père group, where the hands were more mittenlike. The exaggerated drawing of the later Saint-Père cycle seems to have been introduced at Tours. Indeed the peculiar impression of the chorus of apostles in the Saint-Père hemicycle—of so many deaf-mutes energetically attempting to communicate with the spectator—begins to appear at Tours.

In sum: the Tours triforium had a donor who was a knight in the king's service and who lived near Mantes; an elegant sculptural art related to windows of the king's château at Rouen; a color found there and emphatically present later at Saint-Père; and—as we shall soon see in the discussion of Saint-Père—an architect who had worked at Evreux and who later built, among other jobs on the fringes of the Ile-de-France, the new *rayonnant* choir of Saint-Père de Chartres. Clearly all of the pieces of this fascinating puzzle are not now on the board. But the shape of those missing is obvious.

Saint-Père de Chartres, 1260–1270

Following the fashion set by the *rayonnant* rebuilding of the Benedictine abbey of Saint-Denis,[85] the Benedictines of Saint-Père de Chartres razed their twelfth-century choir to the level of the ambulatory vaults and rebuilt it as the dazzling *rayonnant* cage that now exists. Although no documentation remains for this period of the abbey's history, both architecture and glass can be dated from stylistic evidence securely in the 1260s. The architect has recently been identified by the same method of analysis as Gautier de Varinfroy, member of a dynasty of masons and a specialist in architectural adaptation and reuse.[86] Gautier is documented to have reworked the upper nave of Evreux and the choir of Meaux; by stylistic comparison with those two, the alterations of the Saint-Père choir and the reconstruction of Sens, as well as a probable stint at Tours, can also be listed on his curriculum vitae.

Texts establish that he was at Evreux from 1240 until at least 1253 and at Meaux concurrently, from 1253 until at least 1266. The extensive work at Sens, following the collapse of the tower in 1268, seems to have been his final assignment, since his family establishes itself in that area. His design at Saint-Père combines features of both Evreux and Meaux, with detail that relates his entire oeuvre to the architecture of Tours. The date of Gautier's stay in Chartres is therefore most reasonably about 1260–1270.

That the glaziers were working along with the builders and in fact keeping pace can be established not only from stylistic analysis but on internal evidence in the glass itself.[87] All the choir windows of Saint-Père have an added strip, evidently reflecting a revision made by the architect in the height of the upper wall after the templates were made but before the clerestories were completed. In the glass on the south, the added height is accommodated gracefully in enlarged bases along the bottom; on the north, however, the addition is inserted rather awkwardly somewhere in the middle of the bay. The north glass must have been finished and ready for installation when Gautier de Varinfroy changed his mind.

The glazing program necessitated by the reconstruction of the choir upper structure similarly adapted old materials, in this case the series of prophets and grisailles of ca. 1240 (see Chap. I). Their originally intended location was no doubt the nave clerestories (later glazed with the early fourteenth-century program that is there now) but whether the glass of about 1240 was ever installed there is moot. This recycled glass went into the bays along the flanks of the new *rayonnant* choir, the visible and prestigious hemicycle location being saved, no doubt, until funds could be mustered for the existing beautiful ensemble of the end of the century, chef d'oeuvre of the western school and the topic of Chapter IX.

The new upper structure of the choir necessarily maintained the proportions of the twelfth-century bays that form its support. Since these vary markedly in width, the *rayonnant* patterns of the triforium balustrade and the window mullions were broadened or squeezed as necessary to homogenize the effect. In one bay (second from the west, Bays 14–

15) the resulting clerestory lancets were too narrow to accommodate the old glass (see *IX.4.A*, right bay). Thus they were provided with new designs made to fit in smoothly with the old: eight new figures in all, made from four cartoons repeated somewhat unimaginatively. The repetition of cartoons carried no great stigma in the west, as we have seen in the Gassicourt Deacons bay. New grisailles also were needed for this narrow bay, as well as for the clerestory traceries and the glazed triforium below.

The glazing pattern chosen was up to the minute, with grisailles in the flanks of the triforium (as at Tours) and an alternating combination of color and grisaille above (as in the two band windows of the Tours clerestory). Saint-Père is a creation simultaneous with the Tours clerestory and these two color/grisaille combinations, independent and contemporary, both reflect some insecurity. At Tours the band windows have two rows of figures, which happens in England but is not otherwise known in France. At Saint-Père the alternation is not horizontal but vertical, a shutter effect, which, by its uniqueness, declares itself an experiment (*IX.4.A–B*, p. 305).

I have given a great deal of thought to the sources of color and grisaille combinations as a mode of glazing. While in the pioneer period (second quarter of the thirteenth century) banding seems more common in Norman churches and vertical patterns more common in Champagne, I am now convinced, following Lafond, that the change in fashion, which is after all what is reflected in the grisaille triforia and the striped windows of both Tours and Saint-Père, was dictated in Paris. The change translates into art a shift in the theological underpinnings of the Gothic aesthetic, as I have sketched in Chapter I and in greater detail elsewhere. The tastemaker reflected at both Tours and Saint-Père is in my opinion Saint-Denis, where (it can be proven) grisailles glazed the triforium and where (I have argued) band windows filled the nonturning bays of the clerestory.

Four images show us Saint-Denis before its Napoleonic refurbishing with a glazing of clear window glass accomplished by 1816.[88] Two I have discussed elsewhere. *The Mass of St Giles,* a painting of about 1500 by the Master of St Giles (London, National Gallery), shows grisailles in several hemicycle bays (triforium and the base of the clerestory). A sketch by Percier at the close of 1794 or early 1795 depicts the glazing of only one bay in detail, the crossing bay of the south transept's eastern wall. Percier filled the clerestory lancets with oversize standing figures, and in the ground behind them he hatched a lozenge pattern, probably a shorthand indication of grisailles.

Two paintings of the same era can now be put into the evidence.[89] In Hubert Robert's (d. 1808) *La Violation des caveaux royaux dans la basilique de Saint-Denis, 1793* (*III.11*), one can see the lower half of the choir clerestory at the north crossing as well as entire bays in the nave and the west wall of the north transept. All the clerestories have clear glazing (possibly eighteenth century) with cheerful red and yellow borders and tracery lights, while the triforium contains grisailles weathered and darkened to a rusty brown opacity. Even more significant is a painting by P. J. Lafontaine and J. L. Demarne, *Vue de l'intérieur de l'église de Saint-Denis* (Paris, private collection), showing a view into the chevet and part of the north transept's crossing bay. In the transept triforium, grisaille sandwiches a figured panel in the middle of the lancet; a row of standing figures occupies the bottom of the clerestories above; the hemicycle clerestories contain two rows of standing figures (*III.12*).

Several texts mention the colored glass of Saint-Denis. Among them, Germain Millet in 1636 noted the colored transept roses and mentioned that the thirty-seven clerestories included "plusieurs personnages & belles histoires."[90] Jane Hayward has established that a

III.11 *North nave, transept, and choir of Saint-Denis in 1793. Detail from Hubert Robert,* La Violation des caveaux royaux dans la basilique de Saint-Denis, 1793 *(Paris, Musée Carnavalet).*

grisaille lobe in the Glencairn Museum (Bryn Athyn, Pa.) comes from one of the triforium lancets beneath these colored rose windows of the transepts.

To sum up the evidence above, it seems clear that the triforium and clerestories of Saint-Denis were glazed with grisailles combined with colored glass. The Percier and Lafontaine/Demarne images establish that the transept clerestories contained a band of standing figures, which Percier typically emphasized by exaggerating their size. It is possible that some darkening grisailles in the church had been replaced in the campaign of modernization and *badigeonnage* in the eighteenth century. It is also likely that not all the medieval colored panels remained by the 1790s, which would explain Percier's single detailed bay as well as the dominance of clear glazing in the four images.

If I am right, and the enormous prestige of thirteenth-century Saint-Denis put the imprimatur on the band window design, one can understand the sudden appearance of band windows all over France, at Tours, at Saint-Père, at Clermont-Ferrand, at Sées, at Saint-Urbain de Troyes, at Beauvais. One can even imagine these new fashions being described, verbally, by the urbane patrons of Tours and of Saint-Père to their respective glaziers: "windows banded with grisaille and colored standing figures."[91] And that is what each glazier produced, according to his understanding of his instructions.

The Tours triforium of 1255–56 analyzed earlier in this chapter slightly predates the glazing program of Saint-Père and resembles it in a number of ways. The color *gamme* is identical, though Saint-Père is brighter and clearer. One of the Saint-Père figures also has green hair. There are rosettes in the grounds in both ensembles, and the borders of Tours recur in the Saint-Père triforium.[92] The figures are similarly conceived: graceful and light on their feet yet solidly grounded, with the torso twisting above a rooted base.

III.12 *North transept and choir of Saint-Denis in the late 18th century. Detail from P. J. Lafontaine and J. L. Demarne, Vue de l'intérieur de l'église de Saint-Denis* (Paris, private collection). Photo: Réunion des musées nationaux— Paris.

The painting style is not similar. This difference is at least partly the result of the Saint-Père recycling situation, since the 1260 glaziers have tried their best to copy the older style. Their effort is clear in the odd, archaic eyes, and in the slashing drapery painting that has its roots in the Mauclerc lancets analyzed in Chapter I. In spite of their attempts, however, their figures appear more delicate, their color clearer, brighter, and no longer dominated by the early rich blue. Their painting touch is more spare and spiky, not unlike Sées cathedral (ca. 1275) in its brevity and angularity.

What the Saint-Père glaziers' style would normally have looked like, were it not for their enormous effort at adaptation, can probably be guessed. In Bay 22 (north nave) the early fourteenth-century campaign was inaugurated by a St Peter window that reused, and greatly extended, scenes made earlier for an unknown location. There are nine early panels in Bay 22 (again reshuffled in 1991) depicting standard scenes of Peter and Paul:[93] the Calling of Peter and the Giving of the Keys (*Pl.19*); Simon Magus falling; the martyrdoms; an angel receiving a saint's soul; and the two standing saints holding their attributes. The color of these panels is identical with the narrow bay (Bays 14–15) of the clerestory, and they also have rosettes in the grounds and canopies of similar type. The bewildering variety of canopies in the Peter scenes—they are designed in pairs, and each pair is different—finds a parallel in Bays 14–15 where the canopies of the top and bottom rows are totally unrelated.

The painting style of the Peter scenes is thus important, and it is Norman. This statement demands immediate qualification since, in the small group of Peter panels, one can follow the tracks of two artists sharing the tasks. The color is uniformly the western trio of primaries. There are two figure proportions, one neat and elegant (Calling of Peter, Giving of the Keys, Simon Magus), and the other swaying, with enlarged heads and elongated, rubbery arms (donor, saints holding attributes, angel with the soul). The expressionism ranges from totally absent to extraordinarily pronounced, as in the angel who not so much receives the soul as snatches it in a great pincer movement. But we are concerned with the painting, which, with many other factors, is identifiably Norman: facial expressions comatose; figures silhouetted in frozen tableaulike poses; interior line spare and thin, complemented by a wash; spindly canopies, frequently two to a scene and of great variety.

The assessment stands that the shop at Saint-Père ca. 1260–1270 included a careful Norman painter (as well as an expressionist) and that a strong effort was made to archaize the painting to conform to those features of the glass from about 1240 that looked strange to them, namely, the facial features and the triangular, slashing drapery patterns. If this assessment is true, it should follow that at least some elements of the painting should resemble contemporary, large-scale Norman work, of which almost nothing remains. What does remain proves the point, however. At La Trinité de Fécamp are three badly wrecked large apostles (*VI.21*, p. 204): Bartholomew with inscription, a youthful John, and one anonymous.[94] The scratched foliation of the inscription band is identical with that at Saint-Père, even to the barbed finials. The ropey hair is similarly formed of carefully separated curls, as in the right lancet of Saint-Père Bay 14. The hands of both are noteworthy for their arthritically enlarged joints and carefully indicated nails. They have a similar color: red and blue grounds, green and yellow draperies. And they have a trio of different canopies, in one case a Norman twin canopy. The assessment stands affirmed.

To return, then, to the Saint-Père glass in small scale (the Peter scenes now in Bay 22), which I have connected with the same shop as Bays 14–15: the evidence for two collaborating artists is faint, since color and painting are constant throughout. Two approaches are undeniable only in figure layout and proportion: a group of quiet, posed tableaux of small-headed figures; and more vigorous, exaggerated forms using larger frontal and profile heads of remarkable directness (cf. *Pl.19*). The spread-eagled elastic angel described earlier is the hallmark of the expressionist, who seems to have been the subaltern in the shop and who probably cut the glass and chose the primary colors.

His art is not the unicum it appears to be, however. One fragile link survives to chain it, too, to Rouen: two large panels (62 × 92 cm.) of Seine River longshoremen unloading grain sacks (*III.13*), guild signatures from the cathedral which are now in the Musée des Antiquités, Rouen. Lafond has described one of them:

> Ce simple fragment est presque un chef-d'oeuvre de style. C'est merveille de
> voir comment ces deux figures s'équilibrent et comment, chez le premier
> porteur, les plis de la robe, en accentuant le mouvement, s'accordent avec
> l'impression de force que donne le visage. Avec la robe blanche du second, . . .
> le "bec débordant" fait son apparition dans la draperie . . . marqué par un
> triangle noir.[95]

The postures have the same drive, splayed silhouetting, and elastic elongation of gesture as the Saint-Père angel of Bay 22, and the two original faces are in profile.

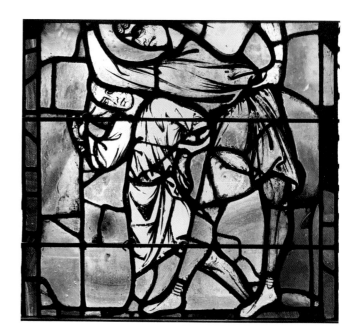

III.13 *Rouen, Musée des Antiquités (from Rouen cathedral). Seine River longshoremen carrying grain sacks.*

The Norman connection of the shop foreman of Saint-Père is more standard and we have seen it before. The Gassicourt Infancy Master produced art in this vein, even to the preference for twin canopies and the variety of canopy designs within the same cycle, but his color was the classic red-blue.[96] Even more informative than Gassicourt is the debris now reinstalled in the south aisle of Evreux, which includes a variety of cycles, painters, styles, color harmonies, and perhaps dates.[97] The canopy types and all the traits of the Gassicourt Infancy painter recur.[98] In the Evreux nave, there are small-headed, neat, posing figures in a Gassicourt color, with draperies in brown and soft green (*III.14.A*): various Infancy subjects, Christ's meal in the house of Simon, St Bartholomew. And there are swaying figures with swollen heads, in a gaudy red-blue-yellow, the coloration of Saint-Père (*III.14.B*): for example the standing Simon and Jude with phylacteries. The latter proportions appear in the donor figure of MEITRE IOHEN DE MEVLANT (Master Jean de Meulan) which, by his foundation of a transept chapel in 1261, provides a dating exactly concurrent with Saint-Père.[99]

Reflections on Modi Operandi

It is almost too good to be true to find the closest comparisons for the Saint-Père glazing of the 1260s in the Tours triforium and in the debris of the original glazing of the Evreux nave, that is, in two buildings that Kurmann and Winterfeld related directly to the architect Gautier de Varinfroy. Their comparison of the architecture of Saint-Père with Tours concludes:

> Es spricht einiges dafür, dass St-Père nicht nur als Verbindungsglied zwischen Evreux und Meaux gedeutet werden kann, sondern auch als solches zwischen den Bauunternehmungen in Tours und der hier behandelten "Gautier"-Gruppe [of Evreux, Saint-Père, Meaux, and later Sens].[100]

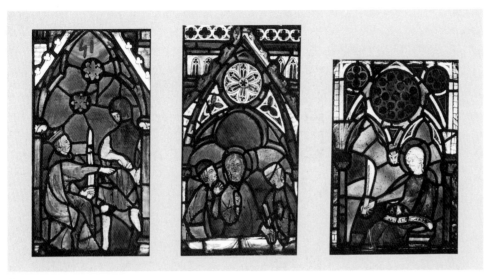

A

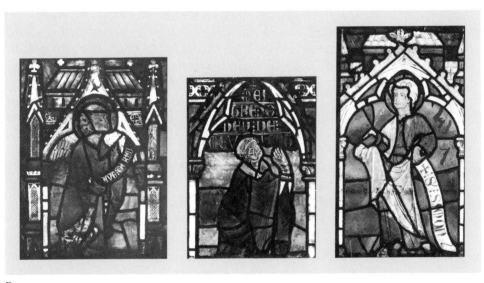

B

III.14.A–B *Evreux cathedral. (A) Fragments mounted in the south nave chapels.*
(B) Master Jean de Meulan (center) and other fragments, mounted in the south nave chapels.

Kurmann and Winterfeld did not know my work and in fact systematically put aside evidence from stained glass;[101] I reached the various stylistic verdicts outlined above before their work was published. The similarities that seemed so inexplicable and fortuitous up and down the Seine and in the Norman Vexin, briefly at Chartres, and far south on the Loire, turn out to be reasonable after all. It is evident that Gautier kept his friends in employment.

I have, however, suggested that the Saint-Père choir built by Gautier was remodeled aping the example of the reconstruction of Suger's Saint-Denis, and that the glazing formulas of the Saint-Père triforium and clerestory took dictation from that archetype. The Saint-Père glass itself has a surprising look, then, nothing Parisian about it. The moral of this tale is similar to that told by the triforium glass of Tours: that the adoption of a glazing fashion or format (such as band windows, or colored medallions, or a summer-and-winter pattern of grisailles flanking a colored apse) did not impose a parallel stylistic handwriting.[102]

The history of medieval arts should be at a sophisticated enough point by now to accept that glaziers did not, necessarily, make the decisions on fashion or format; patrons did. Glaziers moved where there was work and followed orders as their experience and gifts allowed. In the crosscurrents of the 1260s they evidently moved erratically and often.

✳ Epilogue ✳

In the 1250s and 1260s the wellspring of ideas at Le Mans flowed chiefly from Bourges. Other currents took other paths. Poitiers, farther from Paris than Le Mans, but like it appanaged to a prince of the blood, occupies us in Chapter IV; here, we have investigated the shoals and eddies nearer Paris, in the corridor of the Norman Vexin. The often fragmentary remains present a confusion difficult to interpret. Nota bene the tiny Cluniac priory of Gassicourt at Mantes, probably patronized by a comrade-in-arms of St Louis, where four different painters worked elbow-to-elbow in four different styles: two in western modes relating to Le Mans and to Poitiers and two in styles current in the Norman corridor. Different mixes of the same traditions occur, in the remodeling of Saint-Père and in fragments at Evreux, often in the same ensemble or even the same panel.

Although the new Parisian grisaille did not reach Le Mans until the choir program was nearly complete, it is measurable at Tours and at the remodeled Saint-Père in glazing formats adopted at both: summer-and-winter triforium, band windows for the clerestory. This chapter has argued that both formats at Tours and Saint-Père reflect Saint-Denis. Another (also lost) source may have been Saint-Victor in Paris, the importance of which will be suggested in the discussion of Victorine Sées (Chap. VI). What is not Parisian at Tours and Saint-Père—their painting styles and their peculiar and idiosyncratic interpretations of the band window formula (to appear in classical canon at Sées and often thereafter)—is perhaps more significant than what is. In painting styles the Tours triforium and the Saint-Père additions are distributory streams from the same Norman source as Gassicourt. The idiosyncratic band windows at both Tours and Saint-Père are similarly distributory from Paris.

This chapter has attempted not only to chart these currents but to comprehend how they came to evolve. While only an impressionistic view is possible given the meager evidence left to us, the following can be suggested: the architect who worked on the Tours triforium and on the remodeling of Saint-Père was probably the same Gautier de Varinfroy documented previously at, among other jobs, Evreux; and the donor of the Tours triforium glass was a fellow-knight, documented neighbor, and friend of the probable donor of Gassi-

court near Mantes. Thus, donor, architect, and glaziers at Tours came from the same area of the Seine. And the Parisian formats reflected at Tours and Saint-Père are not visual but verbal transmissions—probably by a patron (or architect?) who had been to Paris to a glazier who had not. Style (artistic handwriting) and format (artistic layout) do not necessarily go together. In the 1250s and 1260s the ebb and flow of artistic ideas in the west runs sporadically from Bourges, Chartres, or Paris, but also southward from the Norman Vexin.

Poitou: Sainte-Radegonde de Poitiers

Qu'il m'a aidié mult volentiers:
Ce est li bons quens de Poitiers.

—RUTEBEUF

SAINTE-RADEGONDE DE POITIERS was a church of the convent of Sainte-Croix, oldest nunnery in western Christendom, founded about A.D. 552 by Radegonde, queen to Clotaire I.[1] Destroyed and rebuilt several times, the church (*IV.1*) now includes a tower-porch and choir constructed 1083–1099 and between them an Angevin Gothic nave, the two eastern bays of which date from the early thirteenth century, the western bays from at least a generation later.[2] Founded by a queen, the church never lost its royal connection—from Pepin, king of Aquitaine, buried there in 838, to Anne of Austria whose donations were in gratitude for the cure of her son, the future Louis XIV.[3]

In the mid-thirteenth century the count of Poitou was St Louis's brother Alphonse, appanaged with the county in 1241. According to Kraus Alphonse visited his county only eight times in his life, and after returning from crusade in 1251 only once, in March 1270 in course of departure on the next. In 1264 his officers were accused by the abbey in a legal dispute before the king.[4] One of Alphonse's most trusted agents, Maître Guichart, was installed in a canonry of Sainte-Radegonde by early 1268, however, and it is probably from that time that the church's fortunes waxed.[5] In 1269 Alphonse donated one hundred sous and another one hundred "pro vitreis faciendis," and in his testament of 1270 established an anniversary and chaplaincy at St Radegonde's tomb in the crypt.[6] "Beloved" Guichart was a testator of that will; and Maître Guillaume de Châtelairaut, prior of Sainte-Radegonde, was chaplain and then testator for Alphonse's nephew, the prince Pierre d'Alençon (d. 1282).[7] After Alphonse's death in 1271, Poitou reverted to King Philippe le Hardi, and as we shall see, the final Gothic glazing probably dates to a foundation he made in Alphonse's behalf in 1276 (see below, p. 112). Thus in spite of previous scholarly indecision on the dating, the glazing campaign of Sainte-Radegonde can be established from about 1268 to 1276—the period strongly suggested by all stylistic criteria.[8]

Queen Radegonde had established her disciple St Agnes as her convent's abbess and herself became a simple nun, eventually sealing herself up in a hermit cell and performing miracles only via interviews through its window. Her sixth-century admirers Gregory of Tours, the poet Venantius Fortunatus, and the nun Baudonivia, mention her healing talents and her inclination to wash things: the poor, the sick, her nuns, the convent dishes.[9] Her

IV.1 *Church of Sainte-Radegonde de Poitiers.*

legendary washing is recorded in the Gothic glass campaign, by which time her healing skill had developed into a posthumous specialty of gout and problems of the limbs. The first textual evidence of a developing pilgrimage for the *mal Ste Radegonde* dates from exactly the era of the glazing campaign: miracles are recorded for 1249, 1265, 1268, 1269, and 1270.[10] In the eighteenth century, depositions were still being made concerning miraculous cures of leg problems. The saint's body—or what was salvaged after the sack of the church by the Huguenots—is still in the crypt, in a tomb usually covered with candles.

The Merovingian nunnery had been named for St Mary, then changed to Holy Cross to honor a Byzantine relic sent to Radegonde from the emperor in Constantinople, but by the Gothic era its seal significantly bore the words "Sigillum S. Crucis et B. Radegundis."[11] It

Plan of Sainte-Radegonde, Poitiers.

remained a convent of extremely cloistered, highborn nuns, but increasingly, as we have noted, its community of canons was drawn from royal agents, and the church was becoming a rich pilgrimage center. This is precisely the image presented in the stained glass: one Marian Infancy window; one window treating legends of the True Cross; the remainder of the glass aglow with Capetian heraldry and with votive references to the miraculous cures of popular Christianity. In the figure of the queen-saint the two are combined, and thus we have the striking image of a German princess married to a Merovingian tyrant, washing and healing in full Capetian regalia. In the Radegonde windows we have a glimpse of the ostentatious blue robes embroidered with gold lilies (*Pl.25,* r.) that so bothered the conscience of the dying Capetian princess Jeanne de Châtillon.[12]

The windows have been damaged and repaired so often that the real miracle is that there are any left at all. Froissart records that in 1346 the Gascons and English under the earl of Derby pillaged Poitevin churches for twelve days.[13] Several beautiful fifteenth-century

scraps in different styles (now set into Bay 115) suggest undocumented glazing, perhaps by the duc de Berry (who had Radegonde's tomb opened so he could take her wedding ring),[14] and/or by Charles VII, whose personal veneration of the saint was based on his success in pushing the English out of Normandy (1449–50), which he attributed to her goodwill. He founded a procession in Poitiers for the eve of St Radegonde's feast (Aug. 13),[15] and at precisely this time (1455–1457) a flamboyant portal was added to the old Romanesque tower-porch (*IV.1*), and the church accounts report: "Item a Guillaume Debuc, victrier, pour avoir rappiller les victres de ladite eglise."[16]

In 1562 the Huguenots ravaged the church of Sainte-Radegonde. They smashed windows in the ground-floor chapels and even hammered out the irons, then got into the catwalks "où ilz ont cassez les vitres de la haulteur d'une demye lance avec les deux vitres estant aux deux coings de la voûte du grant autel. . . ."[17] In 1569 Poitiers was under siege by Coligny, Italians were sleeping in the church, and the windows were still unrepaired.[18] Only in 1603–04 is there a small payment "à Chrétien Marquet, pour avoir arentelé les vitres," and there is not a word more for the entire seventeenth century.[19] The documents thus are silent about the anonymous Renaissance connoisseur who, in the Huguenots' wake, must have climbed the ledges with care, collecting here and there glassy heads, hands, coats of arms, beautiful scraps of drapery, an occasional bit of grisaille. These have since been reconstituted into nonsensical panels (now located in Bay 116 and across the bottom of Bay 115), making Sainte-Radegonde a unique monument indeed. For unlike most medieval stained glass, in which the heads are usually the first things to be replaced or repainted, in this exquisite debris it is the heads that are choice and the rest largely meaningless (*IV.2.A–D*).

In the eighteenth century two costly restorations indicate work on the windows. In November 1708 a storm damaged "la rose et le vitrail" on the north so badly that Leduc demanded for their repair "à moins de 400 livres et 10 livres de pot de vin, conditions qui sont acceptées." In 1768 Monsieur Pascault, glazier, received the enormous sum of 924 livres 13 sous.[20] Two of the artisans who worked for Monsieur Pascault engraved their names on a column ("Miel et Dovin—vitriers—Juillet 1768"), and Miel leaded his own name and the date in colored glass into a set of eight Gothicizing medallions he composed out of old heads

IV.2.A–D *Sainte-Radegonde. Heads: (A) Infancy Master. (B) Royal Master. (C–D) Blaise Master.*

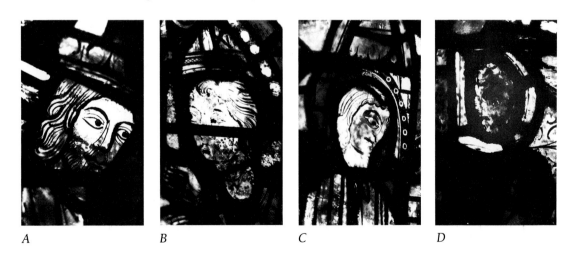

A B C D

IV.3 *Sainte-Radegonde. Eight Gothicizing medallions recomposed of fragments, signed and dated "Miel 1768" (center two panels, upper row). Installed 1768–1950 in Bay 114; medallions now in Bays 115 and 116 in modern colored glass surrounds.*

and fragments (*IV.3*). He installed his concoctions in Bay 114,[21] where they remained until 1950, when they were provided with modern colored surrounds and split between the lower rows of Bays 115 and 116.

The Revolution and the nineteenth century treated the windows with a benign neglect, and not until 1898 was a restoration begun. Henri Carot touched only two bays before the project was abandoned, before World War I. He touched them for the worse: Bay 113 (Last Judgment rose, lancets filled in the post-Huguenot era with medallions from two other bays of the nave) and the famous "appliqué window" of St Radegonde (now Bay 109) are now repainted in an ugly modern hand which hides the fresh Gothic drawing almost completely; their exteriors have been polished, removing the patina and whatever backpainting may have been there. It is thus unfortunate that the two bays Carot worked on have been the best known and most studied windows of the church. As a final stroke of confusion, the bays not blighted by Carot were rejumbled once again after World War II in newly created ensembles by the Chigot atelier of Limoges. As things stand, five bays contain old glass: two touched by the withering hand of Carot; three manhandled in 1950. What the Huguenots could not extinguish has nearly been erased by restorers in the modern era.

Yet even now the debris of Sainte-Radegonde is remarkable and worthy of our attention. At least five distinct artists can be recognized, several with assistants. Carot did not repaint every head and each piece of drapery, and photographs from before his debilitating restoration still remind us of the freshness of many of the sections he did ruin. The modern reconstructions of other debris after World War II have not actually damaged the old glass hidden in the patchwork; it *could* be extracted and cleaned (since it was painted cold) and more sensitively handled. Enough beautiful, precious evidence survives to rewrite quite a full story.

The Sad Remains

There are now five windows with any kind of old glass at all, plus one bay totally designed and made by Carot. The latter is mentioned only because it has been published occasionally as medieval.[22] Three approaches to "restoration" can be identified from the pre-Revolutionary period. The first is the "patchwork of scraps," upside-down and every-which-way (see *Pl.25*), of which only four panels remain (installed since 1950 as a band across Bay 114).[23] The

second approach is the "consolidation of assets," the wholesale removal of remaining glass from some windows into the blank areas of others. Bay 113 received two such series, from an Infancy window and a Passion window on the south (*IV.14*, p. 98); the present Bay 109 is a composite of remains of two matching windows (probably Bays 111 and 109 originally). Since the gainers were the northern bays storm-damaged in 1708, I attribute this approach to that restoration.

The third approach could be called "antiquarian," involving the composition of Gothicizing medallions from beautiful old heads and fragments. This approach was followed by Pascault and his workmen in 1768. The heads they saved are choice, representing work of all the Gothic painters as well as several from the Renaissance. Old scraps were set around them, as available, to form bodies, crowns, gesturing hands, and so on; and more old glass was cut into shapes required to make up "Gothic" borders, mosaic grounds, filet borders, and the like. Produced by this method were Miel's eight signed medallions (*IV.3*) in clear-glass surrounds, installed (until 1950) in Bay 114 to balance the medieval Infancy cycle installed earlier in the bottom of Bay 113 opposite (*IV.14*); and colored medallions to fill the top half of Bay 116 (still there) to balance the colored medieval glass remaining in the top of Bay 115 facing (*IV.21*, p. 106). Thus the 1708 restoration collected colored glass on the north, while the 1768 restoration sought to balance the effect of facing bays in the church.[24] In modern times the work in 1900 and 1950 has sought to copy and extend the old.

In an attempt to clarify this confusion I offer two lists, one of the glass as it is now, the second of the original program. The evidence for these many assumptions will be presented in the remainder of the chapter.

Sainte-Radegonde Glass: Present Condition

North Bay 115—Traceries and upper three rows of lancets largely original though badly damaged, and in their original location though possibly switched in positions. The lower lancets were glazed in the 1950s with a modern medallion design that tries its best to match the gaudy opulence of the Blaise Master's marvelous debris. Included at that time, across a bottom row, were four of Miel's Gothicizing medallions (moved here from Bay 114).

North Bay 113—The rose of the Last Judgment is in its original location. The lancets now contain an Infancy cycle (probably from Bay 110) and a Passion cycle (probably from Bay 116). Carot drastically cleaned and overpainted the lot ca. 1900.

North Bay 111—Modern design by Carot in the style (more or less) of Bay 109.

North Bay 109 (*IV.4*)—This is the famous "appliqué window" of Sainte-Radegonde, of colored figures set stark against a grisaille field. It combines scenes from two matching bays, probably consolidated into one window in 1708–09. Carot repainted it and moved it here from Bay 111 in about 1900; a full set of earlier photographs exists.

South Bay 116—Nothing old remains in its original position. Passion medallions beyond the Huguenots' reach in the upper lancets were probably evacuated to Bay 113 in 1709. In 1768 Pascault's shop made up Gothicizing replacements for the traceries and two upper rows (still there), to copy the effect of what then remained in Bay 115 opposite. They probably dismantled

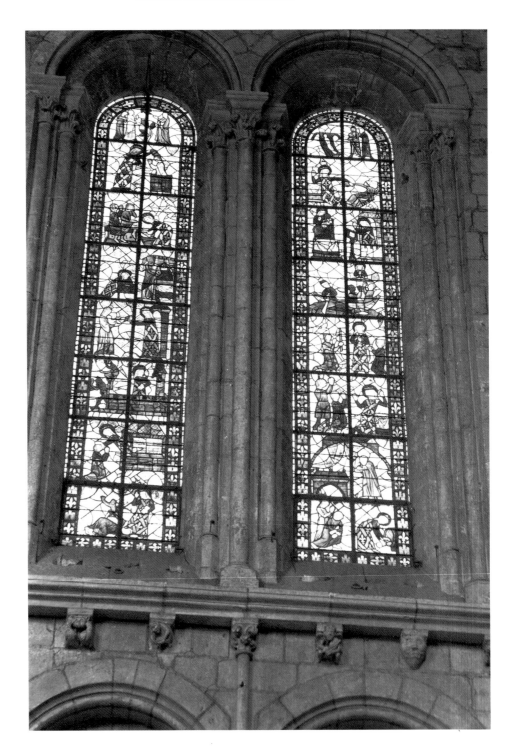

IV.4 *Sainte-Radegonde. Life of St Radegonde: appliqué window, composed, since 1708,*
of panels from two such windows (probably Bays 111 and 109) and installed in Bay
111; Carot severely restored it and moved it to Bay 109 ca. 1900. North nave, Bay 109.

and recycled some post-Huguenot patchwork, since the fragments represent many painters. In 1950 the lower window, like that of Bay 115, was filled with matching color and with four of Miel's medallions (from Bay 114).

South Bay 114—The grisaille in the upper lancets is original. The traceries received scraps, probably in the consolidation of 1709: the Agnus Dei and censing angel discs probably came from the traceries of Bay 116; the royal arms from an unknown location, part of the redecoration of the church about 1455.[25] Four panels of patchwork, in the bottom of the window by at least 1768, were moved up in 1950 to serve as a band in the middle. Debris from this band comes from two different cycles of St Radegonde's legend: one by the Infancy Master (possibly from Bay 112); the other by an elegant royal painter (possibly from the two lights flanking the apse). Miel's eight Gothicizing medallions, in the lower lancets from 1768 to 1950, have been removed to Bays 115 and 116 and replaced by modern copies of the old grisaille above.

The original Gothic program probably had not been altered significantly until the Huguenots came. The extant debris of fifteenth- and sixteenth-century glass probably originated in the choir chapels or perhaps the apse clerestory. It is thinner and much more easily smashed than thirteenth-century glass, in any case.[26] I would establish the thirteenth-century program as follows:

Sainte-Radegonde Glass: Original Program

North Bay 115, Blaise Master—Traceries: Dives and Lazarus cycle; Agnus Dei (emblem of abbess?) (all still there). Lancets: colored medallions, two lancets of St Lawrence, two of St Blaise (six medallions of each remain).

North Bay 113, Alphonse Master—Rose: Last Judgment; arms and image of Alphonse de Poitiers (all still there). Lancets: probably grisaille (lost).

North Bay 111,[27] Appliqué Master—Legend of St Radegonde in "appliqué window," colored figures on grisaille. (See Bay 109 below.)

North Bay 109, Appliqué Master—Continuation of Bay 111, including posthumous miracles. (Remains of both bays are now combined in Bay 109.)

South Bay 116, Passion Master—Traceries: probably included censing angel and Agnus Dei (emblem of abbess?) (both now in Bay 114). Lancets: colored medallions of the Passion and the Legend of the True Cross (now in Bay 113).

South Bay 114, Latticework grisaille—Partially extant (traceries lost). Possibly gift of Alphonse de Poitiers.

South Bay 112(?), Infancy Master— Cycle of St Radegonde in "button window," colored medallions in a grisaille surround (debris now in Bays 116 and 114).

South Bay 110, Infancy Master—Cycle of Infancy medallions in "button window" (now in Bay 113).

Small lights flanking apse, Bays 107 and 108(?), Royal Master—Scenes of Miracle of the Oats (St Radegonde); donated by Philippe le Hardi? (debris now in Bay 114, one head in Bay 116).

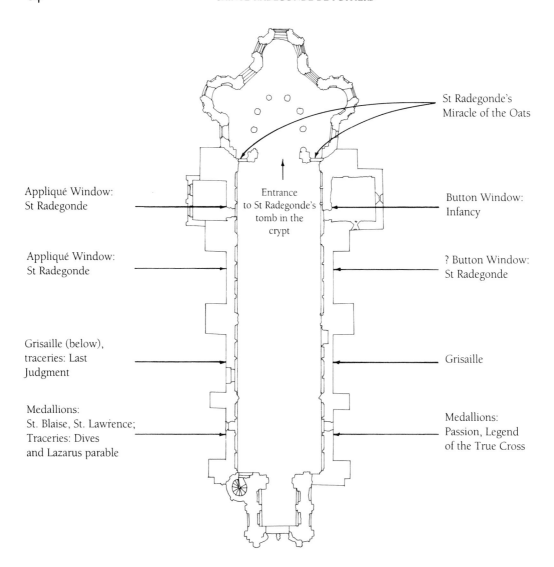

Sainte-Radegonde. Reconstruction of the original program.

By matching up facing bays it can be appreciated that the original program had visual co-
herence, and we shall see that this was also true of the iconography. So far as is possible,
this magnificent wreckage will be discussed in terms of the painters, and since the campaign
was evidently similar to that at Gassicourt—a diversified chantier working more or less
simultaneously—the bays will therefore be treated as entities. Mirabile dictu, it is possible
to recompose the puzzle almost completely, to date the campaign about 1268–1276, and to
glimpse the popular Christian folk piety that gave it life.

The Master of the St Radegonde Appliqué (IV.4)

There is ample testimony that the appliqué window of St Radegonde (which Carot moved
from Bay 111 to Bay 109) and the bay of the Last Judgment rose (Bay 113) were, by the nine-

teenth century, the only "complete" bays in the church (*IV.5 and IV.15*).[28] Since the Huguenot breakage was inflicted from the catwalks and to the height that a demilance could reach, it seems clear that the modern appearance of these two bays dates from a post-Huguenot repair by a process logical to the seventeenth-century mind, that of filling the voids with glass taken from the tops of other damaged windows. Although traces of this procedure are obvious in the lancets beneath the Last Judgment rose, it has not previously been recognized that the St Radegonde appliqué lancets must have been filled out in a similar fashion. This simple realization explains both the erratic sequence of scenes and the striking omissions of important episodes, and the fact that all the old scenes are absolutely identical in style suggests that the original appliqué designs filled two bays of the church, not one. Only one other set of lancets in the church measures exactly the same in width, the bay immediately adjacent.[29] The Carot window commissioned by the parish *fabrique* in 1900 is thus a fortuitously faithful design, since it copies the appliqué style and the general subject of the old bay, though Carot had no knowledge that he was reconstructing the past so accurately.[30] He moved his new window into Bay 111 and displaced the old glass of Bay 111, which he had restored, into its modern location in Bay 109. Thus Bays 111 and 109 probably now present something of their original appearance, though the old panels have undergone quite an exodus and their original sequence remains imprecise.

Carot added three panels to the old appliqué window, filling two blank panels at the bottom and one in the left lancet head. He replaced stopgaps and tried vainly to arrange the scenes into some kind of order; he polished the backs of the glass; and he repainted many heads and draperies with a touch that can only be described as blighting.[31] We must turn to the occasional survivor and to the splendid photographs taken in 1881 to appreciate the forceful and naive rural charm of the Appliqué Master of Sainte-Radegonde.

The donor of the window is unknown, though it has generally been assumed to be Alphonse, since its borders alternate his fleurs-de-lis and castles, and the figures of Radegonde are clothed in fleurs-de-lis.[32] But Radegonde was a French queen; her fleurs-de-lis may need no further explanation. And the border has been used, as we have already seen, at Evreux and by the Gassicourt Master of the Big Saints among many other places. Thus the connection to Alphonse and his documented gifts of 1269 is hypothetical and the dating must rely on stylistic analysis, not an easy task with such a stylistic unicum.

Two points of reference exist, the appliqué format and the grisaille style. Colored figures set stark against a grisaille ground, *en appliqué,* occur occasionally in the fourteenth century, in the clerestory of Saint-Ouen in Rouen, at Chartres, Evreux, and elsewhere.[33] An earlier appliqué window already discussed, the panel from Primelles west of Bourges (see Chap. II, n.163) and the existence of other thirteenth-century examples in the Norman parishes of Saint-Antoine-de-Sommaire (Eure) and Saint-Germain-Village (Eure) indicates to me that appliqué glazing was probably a standard type for rural churches, at least in the western provinces.[34] Its use by a folk artist like the Appliqué Master of Sainte-Radegonde makes this supposition even more likely.

The grisaille ground of his window can be dated stylistically to the 1260s: crosshatched ground, somewhat desiccated palmettes in a centripetal design with no vertical emphasis, in *panneautage* of bulged quarries.[35] It compares closely with the band windows of Tours, which have palmettes in a slightly more advanced stage of atrophy.[36] Thus the appliqué window fits in stylistically with a campaign of the general date implied by Alphonse's gift, ca. 1270. It contains some iconographic evidence for the same conclusion, as we shall see presently.

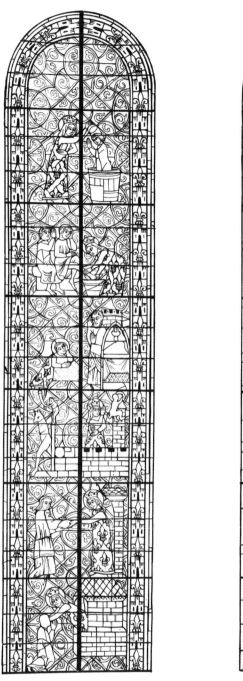
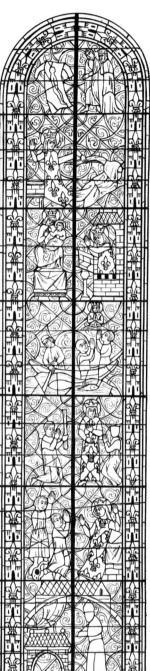

IV.5 *Appliqué window of Sainte-Radegonde before Carot restored and moved it. After de Lasteyrie, 1853.*

A

B

C

D

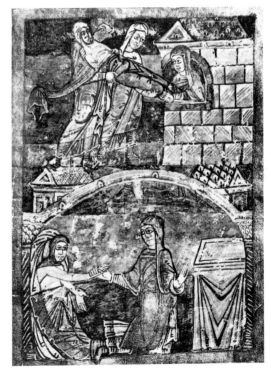

E (top), F (bottom)

IV.6.A–F Libellus *of St Radegonde, 11th cent. (Poitiers, Bibl. mun. MS 250): (A) Radegonde washing the feet of the poor (fol. 29v). (B) Curing of blind Bella (fol. 34r). (C) Boat of Floreius saved from shipwreck (fol. 36r). (D) Healing of the dropsical Animia, in bathtub (fol. 39r). (E) Woman brings dead child to Radegonde's cell (fol. 41r). (F) Saint revives child, pulling arm of the cadaver (fol. 41r).*

In the eighteenth century the tradition still lingered[37] that the St Radegonde cycle of stained glass scenes copied images from the saint's eleventh-century *libellus* (*IV.6.A–F*), then still at the abbey and presently MS 250 in the Bibliothèque municipale of Poitiers.[38] This theory has been tested several times in the twentieth century, first by Ginot in 1920, and found to be substantially correct.[39] Of the thirteen remaining stained glass scenes, eight are related closely to paintings in the *libellus*, illustrating the sixth-century biography of the saint by her friend the poet Fortunatus.[40]

Since the order of scenes in the window is violently confused, they are listed here as they appear in MS 250:

> fol. 25v: Fortunatus, Chap. XI (Ginot, pl. IV). Freed prisoners thanking Radegonde at the castle of Péronne (*IV.11*)
>
> fol. 29v: Fortunatus, Chap. XVII (Ginot, pl. VI). Radegonde washing the feet of the poor.[41] Scene reversed (*IV.6.A*)[42]
>
> fol. 34r: Fortunatus, Chap. XXVII (Ginot, pl. VIII). Curing the blind Bella (*IV.6.B, IV.9*)
>
> fol. 36r: Fortunatus, Chap. XXXI (Ginot, pl. XII). Boat of Floreius saved from shipwreck (*IV.6.C, IV.12*)
>
> fol. 38v: Fortunatus, Chap. XIV (Ginot, pl. XVII). Resurrection of the newborn of Anderedus placed on the hair shirt of Radegonde.[43] Scene reversed
>
> fol. 39r: Fortunatus, Chap. XXXV (Ginot, pl. XVIII). Healing of the dropsical Animia, in bathtub.[44] Scene reversed (*IV.6.D*)
>
> fol. 41r: Fortunatus, Chap. XXXVII (Ginot, pl. XX). Woman brings dead child to Radegonde's cell (*IV.6.E, IV.7*)
>
> fol. 41r: Fortunatus, Chap. XXXVII (Ginot, pl. XX). Saint revives the child, pulling the arm of the cadaver. Scene reversed (*IV.6.F, IV.13*)

Some of the five remaining scenes in the window have been wrongly identified and in any case derive from a different source. Three of them depict episodes told in another sixth-century biography, written by the nun Baudonivia:[45] the vision later known as the Pas-Dieu; the routing of the demons, later evolved into the legend of the Grand' Goule; and, probably, the toothache of Abbot Abbon.

Pas-Dieu—Baudonivia, Chap. XX (IV.7)

Fortunatus does not mention this vision, which Radegonde told only to two nuns.[46] The year before her death Christ appeared in her cell as a handsome young man, pointing to his forehead and saying: "Tu, gemma preciosa, noveris te in diademate capitis mei primam esse gemmam." Legend eventually embellished this story with a palpable coda: the footprint left by Christ on the cell's stone floor, still preserved in the church today.[47] Though the Pas-Dieu legend cannot be traced before the late fourteenth century,[48] the apparition of Christ recounted by Baudonivia was celebrated as a feast by the middle of that century,[49] and a fourteenth-century seal matrix of the prior (*IV.8*) provides the oldest image heretofore recognized of the episode.[50] The scene in the window has consistently been misidentified as

IV.7 *Sainte-Radegonde. Pas-Dieu (top);
woman brings dead child to Radegonde's
cell (bottom). St Radegonde window
(now Bay 109), 1881 photo.*

IV.8 *Pas-Dieu, impression of seal matrix of the prior,
14th cent. (present whereabouts unknown).*

Bishop Medard of Noyon consecrating Radegonde as a nun (Fortunatus, Chap. XII), an episode illustrated in the *libellus* on fol. 27 (Ginot, pl. V).[51] It is close, but the differences are more telling: the "bishop" in the window wears apostolic robes, is barefoot, and his gesture is aimed not at Radegonde but at his own head. To the extent the Appliqué Master could muster in his folk-style painting, this figure is depicted as Baudonivia's beautiful young man, Radegonde's apparition of Christ.

IV.9 *Sainte-Radegonde. La Grand' Goule (top); curing the blind Bella (bottom). St Radegonde window (now Bay 109), 1881 photo.*

IV.10 *La Grand' Goule of 1677.*

La Grand' Goule—Baudonivia, Chap. XXXI (IV.9)

Baudonivia recounts that a servant saw many goats jump the walls when Radegonde visited the convent; Radegonde, understanding that they were devils come to tempt the nuns, made the sign of the cross. By the fifteenth century this episode had evolved into the legend of La Grand' Gueule (or Grand' Goule), a winged monster that emerged each night from its cave on the banks of the Clain to attack the nunnery and to be repulsed by Radegonde with the sign of the cross (*IV.10*). A sort of Poitevin Tarasque, a painted and sculpted image of the Grand' Goule was paraded at Rogations as the third of the abbey's banners, the other two commemorating Queen Radegonde and the famous relic from which the convent took its name, the True Cross.[52]

The window shows at least three creatures jumping the walls; they are not goats but devils, and one of the monsters is larger than the others. The legend's transformation has already begun.

Abbot Abbon's Toothache(?)—Baudonivia, Chap. XL

This scene had lost the entire figure of the sick man by the nineteenth century, and it was occasionally identified as Gregory of Tours at the funeral of Radegonde, or some other bishop visiting her tomb. The 1881 photograph (*IV.11*) indicates that whereas the figure was lost, the curtain over the tomb—which he clasped to his face—was in place. There are thus two possible identifications of the scene, the most traditional being the cure of the toothache

IV.11 *Sainte-Radegonde. Freed prisoners thanking Radegonde at the castle of Peronne (top); Abbot Abbon's toothache (or Raoul de Liez's migraine) (bottom). St Radegonde window (now Bay 109), 1881 photo.*

of Abbot Abbon of Burgundy, which Baudonivia relates was effected by his clenching his teeth on the curtain of honor over the saint's tomb.

The old photograph also proves that the figure never had a miter and thus was not necessarily an abbot; I propose another possible identification. Raoul de Liez, canon of Tours, was cured in 1265 at the saint's tomb after a seven-year-long migraine had turned him into a tormented madman.[53] In other words, it is possible that contemporary thirteenth-century miracles appear in the appliqué window.

Gothic Miracles

Indeed it is my belief that the final two scenes of the window are in fact related to Gothic events. Though cures were, one presumes, ongoing at the queen-saint's tomb, a collection of thirteen of them, dated 1249 to Pentecost 1270, was included in a manuscript *vita* of the late thirteenth century.[54] To these thirteen only two more were added when the text was copied in the fifteenth century, some indication that the years 1249 to 1270 were specially favored.[55] In the absence of a cartulary, one can only presume that this bustle of cured pilgrims and the usual economic benefits thus accrued were channeled by the community into the handsome glazing program we are reconstructing here.

The penultimate scene under discussion (*IV.12*) has consistently borne the identification of the curing of Goda (Fortunatus, Chap. XXXII) on the basis of the long candle in her hand. The scene in the *libellus* (Ginot, pl. XIII) is totally different in layout and personae, however: in the window Radegonde is present; a kneeling woman offers her a stocking as an ex-voto; "Goda" kneels rather than stands, and the "candle" is much shorter. And "Goda" is a man. It would seem that the "candle" is also an ex-voto, and whereas it may be a candle, its strong yellow-brown color indicates that it is more likely a baton, or a walking cane.

Among the thirteen recorded cures of 1249–1270, three were women with leg complaints, and five were men who had been able to abandon their crutches. In the case of Guillaume the carpenter, cured the Wednesday after Pentecost 1270, the manuscript specifies that he left his *baculus* at the tomb as an ex-voto.[56] While it is not possible to state definitively that the window scene shows one of these grateful women and the happy carpenter, it is clear that the *mal Ste Radegonde* by this time was already gout, and that pilgrim traffic at the tomb was heavy.[57]

An identification for the final scene of the cycle has never been attempted (*IV.13*). It shows Radegonde praying before the Virgin and Child, and since no Marian cult existed in France during Radegonde's lifetime, the source cannot be Fortunatus, Baudonivia, or Gregory of Tours. The Virgin and Child do not represent an apparition, however, but a statue on an altar. Since the most potent Virgin statue in Poitiers in the Middle Ages was certainly the enthroned *sedes sapientiae* of Notre-Dame-la-Grande, paraded against armies and for rain-making, the image in the window is likely to be that statue.[58] Radegonde and the Virgin of Notre-Dame-la-Grande are only connected in one medieval miracle, but it is the most celebrated of Poitiers: the Miracle of the Keys. I would like to suggest that that famous legend appears here in its earliest image.

Although the earliest datable text of the Miracle of the Keys is of 1463, like the other folk traditions discussed above, it had been long in developing.[59] King John, so the story goes, on Easter night of 1200 bribed a clerk of the mayor of Poitiers to provide him with the keys to the city gates.[60] The traitor waited until the mayor was asleep and sneaked in but could not find them; at 4 A.M. he finally woke the mayor, telling him that he needed the keys to open the gates for a gentleman. The mayor, not finding the keys either, ran in despair to Notre-Dame-la-Grande, where he saw them held between the hands of the statue. Townspeople later testified that at 4 A.M. they had seen a queen, a nun, and a bishop at the gates, at the head of an army.

The legend thus establishes the primacy of Notre-Dame-la-Grande and Sts Radegonde and Hilaire as the protectors of the city, while exploiting ancient anti-English sentiment

IV.12 *Sainte-Radegonde. Boat of Floreius
saved from shipwreck (top); man and
woman offering ex-votos to St Radegonde
(walking stick and stocking?) (bottom).
St Radegonde window (now Bay 109),
1881 photo. Note the lovely Renaissance
stopgap in upper left.*

which must postdate the Plantagenet era, though perhaps not by much. Images of the three
protectors decorated the city gates, and old engravings of the Romanesque facade of Notre-
Dame-la-Grande, which predate 1809, show the niches for their statues, added possibly in
the late fourteenth century.[61] By the fifteenth century an annual civic procession of the three
communities of canons paraded the ramparts in commemoration of the miracle. The present
Virgin statue of Notre-Dame-la-Grande holds as attribute a metal ring with several enor-
mous keys.[62]

 Returning to the appliqué window of Sainte-Radegonde, we can see that the saint prays
from a crenellated structure (ramparts?)[63] and that Carot's restoration eliminated a curious
irregular object between her and the Virgin statue, which may originally have been a ring of
keys (*IV.13*). The iconography is unclear since the legend was no doubt in the formative
stages in the mid-thirteenth century. With the scenes of the Pas-Dieu, the Grand' Goule, and

the ex-voto offerings of pilgrims cured of the *mal Ste Radegonde,* the Appliqué Master of Poitiers has created for us an astonishing display of popular medieval piety in action.

Just as the popular Christianity of the Appliqué Master characterizes him as a folk artist, so does his style. The relationships between his border type and those of Gassicourt and Evreux have been noted (above, p. 85; Chap III, nn. 39, 98), as well as the comparison of his grisaille to the Tours band windows,[64] but these connections are generic, not derivative of his folk culture. A study of his color, facial types, and drapery painting, on the other hand, suggests that they are so derived.

Like the other *naïf* we have studied, the Evron Master in the Le Mans upper ambulatory, the Appliqué Master is neither a beginner, nor is he hesitant or unsure of his artistic direction. His art is without apology, and since its style is as undeniably direct and popular as its

IV.13 *Sainte-Radegonde. Radegonde revives dead child, pulling arm of the cadaver (top); Miracle of the Keys (bottom). St Radegonde window (now Bay 109), 1881 photo.*

iconography, with the most minimal genuflexion in the direction of conventional border and grisaille fashions, we can only accept its statement as indicative of a healthy regional folk tradition. Comparisons are therefore chiefly useful in tracking this tradition in the work of others.

Aside from a common iconographic climate, the single element shared by the Appliqué Master and the Evron Master of Le Mans is the angular, sticklike drapery painting marked by strong triangular patterns.[65] There are no curves. Each man translates this syntax into his own artistic handwriting, but they work in a common painting language. The facial type of the Appliqué Master (marked by a low forehead, exaggerated bags under the eyes, carefully delineated curves of the upper lip, and a long slender nose ending in a bulbous point) not only shares traits with the Evron Master but also surfaces in the earlier, poorer quality panel from Primelles (Lafond collection).[66] It can hardly be a coincidence that the latter is also an appliqué window, which I have suggested is a rural technique. The Primelles window differs not only in its mediocrity but in its alignment within the magnetic field of Bourges. The Appliqué Master of Sainte-Radegonde is totally oblivious to the formal pretensions of Bourges.

The comparison of the Appliqué Master to Primelles leads to one of greater usefulness for western glass studies, to wit, the relationship between him and the Bishop Geoffroy Master of Le Mans, two emphatically strong artistic personalities. The differences between them begin with scale and with the broader opportunities of the Bishop's Master for stylistic absorption—he, like the rural artisan of Primelles, began in the orbit of Bourges and was also able to study Chartres carefully.[67] Yet the similarities in style are all the more telling since they explain an aspect of the extraordinary art of the Bishop's Master that has been difficult to pin down: their palettes are close. The Bishop's Master uses no red to speak of, dominant blue, a wide range of strong yellows, white and brown. The tones of the primaries used by the Appliqué Master (wine-dregs red, clear sky blue, yellow in tones ranging from gold to mustard tan) are closer to the early stained glass of the Plantagenet west, but the subordination of red in the balance is something new under the Gothic sun.

Once the family relationship is admitted between these two strong-minded individuals, it is easy to see that both are superior storytellers, that neither is afraid of an expressively ugly face, and that the triangular drapery patterns and the peculiar flat-bottomed eye, "English" nose, and lipsticked upper lips also occur in the designs of the Master of Bishop Geoffroy. More than ever, his spectacular talent declares itself as western born and bred.

The Alphonse Master

The Appliqué Master is only one of the established local artists in the chantier at Sainte-Radegonde, though perhaps the most singular. Several hands worked in an equally direct style, though marked by a gaudier color, looser and thicker brush, and greater awareness of the decorative traditions of the Poitiers cathedral windows. The greatest of these artists is not the Alphonse Master but the Blaise Master, but since the work of the latter is now a chaos of precious fragments, we will study first the composition of the Alphonse Master, the Last Judgment rose of Bay 113 (*IV.14*).

Besides the Radegonde appliqué window, the Last Judgment bay was the only other "complete" window in the church in the nineteenth century, and it then fell victim to Carot's

withering attentions in 1905. An old drawing by de Lasteyrie exists with which to authenticate the iconographic detail (*IV.15*), but so far as I can tell, there are no old photographs.[68] Hence the occasional head or figure that evaded Carot is all we have of the painter's hand. His design is of the Poitevin type we have seen briefly in the Gassicourt Deacons Master, rooted no doubt in the traditions of the Good Samaritan Master that Grodecki plotted at Poitiers cathedral.[69] Doll-like figures with enlarged heads, bouncing with joie de vivre, inhabit a strongly colored world where the primaries and emerald green are in about even balance.

The eight lancets beneath the rose have been filled, probably in 1709, with panels from two disparate series: a Passion and an Infancy. Also cleaned by Carot, these will be discussed later, along with theories about their original locations. There is no real evidence for the pre-Huguenot appearance of the lancets of Bay 113, but on the basis of a small clue one can hazard a guess. In the ogive is badly mangled grisaille not unlike the Appliqué Master's grisaille ground.[70] The glazing program of Sées cathedral provides the possible key to the original appearance, one more or less reliable since the grisailles of the facing bay (Bay 114) at Sainte-Radegonde repeat the Sées type (cassette lozenges in heavily colored latticework filets and large corner "nails"). In the north choir ambulatory at Sées is a window with a large colored rose—similar to Sainte-Radegonde Bay 113—above grisaille lancets (see p. 177). At Sainte-Radegonde such a design for Bay 113 would have had the virtue of balancing the grisailles opposite, in Bay 114.[71] Just why, in the first place, the Sainte-Radegonde architect provided an impressive rose to accent this bay is another question. It is possible that the small door here was the canons' entrance to the church.

This rose is Alphonse de Poitiers's gift of 1269.[72] His kneeling image in heraldic surcoat appears twice and his arms many times: "party d'azur et de goules, per le goules poudré a turelles d'or; l'azur poudré a flurettes d'or."[73] The arms are correct on the kneeling figure in the right rosace and are elsewhere reversed through the glazier's mistake.[74] The most likely explanation for such an error would be that he worked from a seal, such as Alphonse's equestrian seal of 1254 (Douët-d'Arcq 1078*). On that seal, because the horse faces to the right, the shield's field of castles appears as though on dexter—since the place of honor on a horse's caparison is at the horse's head. There is some evidence that glaziers used seals to copy heraldic designs, a reasonable hypothesis, as they are both portable and authoritative.[75]

Kneeling behind the prince in the lower rosace are two male figures who are probably his agents in the province, one of them no doubt Maître Guichart, who for services rendered as Alphonse's tax collector received a canonry at Sainte-Radegonde.[76] They kneel facing the left rosace, where St Radegonde appears flanked by her two nuns Sts Agnes and Disciole.[77]

A detailed eschatology is depicted in the rose with all the freshness and simple charm of a fairy tale: angels plucking viols and swinging censers, angels blowing oliphants, the dead rising, Christ showing his wounds, angels showing the instruments of the Passion, the apostles, the blessed (including a queen and a Franciscan) patiently awaiting entry to the heavenly mansions, and a very lively, amusement-park hell in which devils take the damned for a boat ride to the hellmouth, into which lost souls seem to enjoy being upended and tossed (*Pl.20 and* Pl. opp. p. 274). This populated vista spreads across the tracery lights with no frames or borders, only a white fillet outlining each light, and with no established policy on gravity or the location of due north. De Lasteyrie complained about "le manque absolu de symétrie dans la distribution des figures . . . ; le sujet se poursuit sans avoir aucun égard à la forme du cadre" (p. 128). Truly the *cadre* isn't much help, since the large rosace has ten petals (thus indivisible into quarters) and the smaller rosettes seven lobes each.

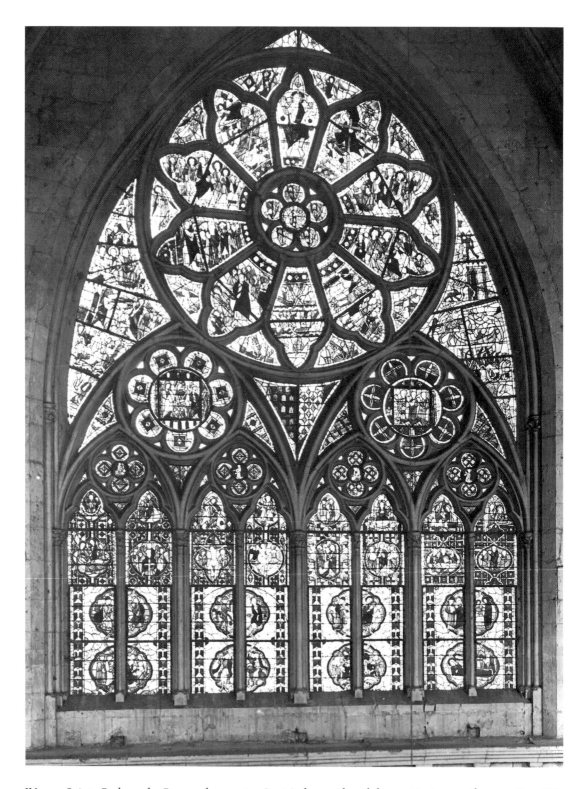

IV.14 *Sainte-Radegonde. Rose and traceries: Last Judgment by Alphonse Master, north nave, Bay 113.
Restored by Carot ca. 1900.*

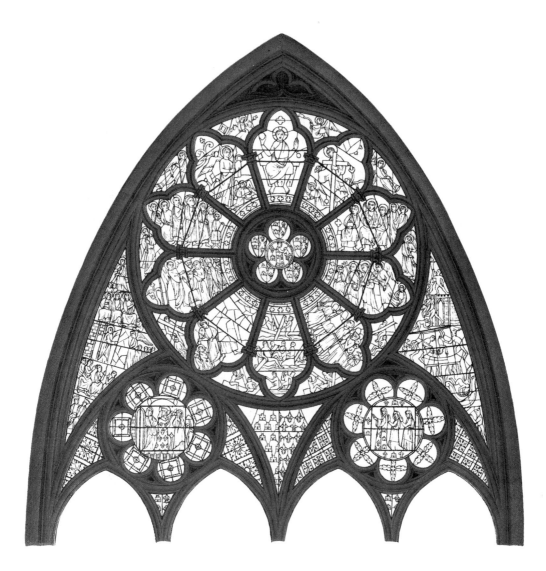

IV.15 *Sainte-Radegonde. Last Judgment, Bay 113. After de Lasteyrie, 1853.*

As a work of art the Alphonse Master's Last Judgment suggests comparison with two others in the west, the smaller and earlier oculus of Châteauroux (ca. 1235) and the larger rose-lancet window-wall filling the great east chevet-end at Dol cathedral in Brittany. The earlier and stiffer Last Judgment at Châteauroux, though iconographically related to Bourges in such particulars as the bleeding hands, compares closely to the Alphonse Master's later design in details like the throne of Christ and the little nudes pushing up their tomb lids. More basic is the undivided spread of the subject in the oculus, within a dry rosette border that is not unlike the only border in the Alphonse Master's rose. Moreover, the Alphonse Master's border illogically encircles the inner curves of the ten rose petals and thus outlines a center oculus, or bull's-eye. The Sainte-Radegonde artist, to put it another way, adapts his multifarious subject across the tracery lights *without framing,* in the old Angevin tradition, just as he relies on the thick red, mustard yellow, and clear blue of the old western palette.

The cathedral at Dol, on the other hand, displays remains of a Last Judgment tracery rose related to the splendidly theatrical performance at Sainte-Radegonde, set over lancets whose colored medallions bear comparison in their iconographic intent to the medallion cycles of local saints and relics in Sainte-Radegonde Bays 115 and 116. The two Last Judgments are not original and copy; they more likely reflect the same model. There is some reason to suspect that the model was at Angers—the Last Judgment rose in the north transept, which was damaged by fire and replaced by André Robin in 1451.[78] Angers will come up again in our discussion of the Infancy Master of Sainte-Radegonde, but since there is more of Angers in the Dol Last Judgment ensemble than in that of Sainte-Radegonde, the evidence for Angers will be presented in that venue (Chap. V).

Sainte-Radegonde's Last Judgment bay is a hybrid: perhaps reflective of Angers in theme, it was painted by a local Poitevin, and probably in a format of color (in the rose) and grisaille (in the lancets, now lost) that was fairly widespread. The Bourges nave could be mentioned as an example of the type; and the format is also found at Sées in the north chevet (Chap. VI). And while the painter of the Sainte-Radegonde bay was a Poitevin, his patron was a prince of France.

The Passion Cycle

The painting style of the Alphonse Master, to the extent it can be appreciated in the post-Carot era, also appears in the Passion scenes inserted, most probably in 1709, into the upper lancets of Bay 113 (*IV.14*). Figures are shoulderless, weightless, and slightly swaying. Drapery painting is sparse and the line almost tangibly thick and stubby, recalling to some extent the look of early woodcuts. The doll-like heads have huge arched foreheads and wide black eyes.

Though the Passion scenes are by the same shop, their color is darker and more completely heterogeneous and unfocused, scattering orange, purple, clear green, and other odd tones haphazardly (*Pl.21*). The subject overlaps that of the rose by repeating the Christ showing his wounds with the angels displaying the instruments of the Passion. The elements (medallions, borders, mosaic grounds) have obviously been crammed into their narrow lancets via an awkward and drastic overhaul. There is only one bay in the church where they would fit exactly: Bay 116 on the south, a window now totally filled out in uprooted fragments. The Passion medallions are 55–57 cm. wide, in borders (which they now ruthlessly overlap) of 11–13 cm. The lancets of Bay 116 are 84–85 cm. wide, making a perfect fit (allowing for leads). The four reliable medallion shapes in the Passion debris can thus be related to the four lancets of Bay 116.

At least two of these medallion shapes (one octofoil, one round; *Pl.21*) follow the peculiarly Poitevin tradition that Grodecki first remarked in the cathedral glazing:

> Trait plus particulier à l'*atelier* de Poitiers, les médaillons sont souvent liés par
> des encadrements continus, les filets d'encadrement passant d'un médaillon à
> l'autre en une sorte de tresse, ou bien . . . en ruban continu, tantôt élargi pour
> épouser la forme du médaillon, tantôt rétréci.[79]

That linkage and the broad, unfocused color and the pearled medallion frames[80] relate the Passion cycle to the cathedral and its formulas, though in the wake of the Huguenots, the post-Huguenot restorers, and Carot, one can say no more. The sixteen extant scenes present a fairly routine Passion: Transfiguration(?), Judas Paid, Last Supper, Betrayal, Christ before

IV.16 *Sainte-Radegonde. Invention of the True Cross,
Bay 116, fragment.*

Pilate, Flagellation, Christ Carrying the Cross, Crucifixion, Angel at the Tomb, Emmaus(?), Christ in Majesty, Christ Enthroned, showing his wounds between angels with instruments of the Passion.[81] Also included is a donor panel: three kneeling, secular male figures of total anonymity.

One fragment now reset in Bay 116[82] hints that the complete iconographic ensemble did not stop with the Passion and Triumph of Christ but included episodes of the loss and rediscovery of the True Cross (*IV.16*), the most famous and ancient of the abbey's relics.[83] The fragment includes the cross on Golgotha, three nails at its base, and a seated figure (in the smaller scale of the Passion cycle) crowned and holding a scepter, no doubt an episode from the Invention of the True Cross.[84] Since in Poitevin shop tradition, remarked by Grodecki in the cathedral glazing, cycles read from the top down,[85] it is likely that the other Invention scenes were at the bottom of Bay 116 and hence smashed in the sixteenth century.

The Infancy Master

The eight panels of Infancy scenes, probably installed in the lower lancets of Bay 113 in 1709 with the Passion cycle, are much more sophisticated than any of the Sainte-Radegonde

glazing we have discussed so far. They differ in almost every way. The color is a classic blue-red, with figures in brown, a soft deep green, tan, and purple (*Pl.22*). The format is not otherwise present in the church and is rare in any case: that combination of color and grisaille that can be called a "button window," in which colored medallions are set on a grisaille surround.[86] The grisaille itself is generally contemporary with that of the Appliqué Master (crosshatched ground, foliage growing both up and down, abstract leaf types), but it is much richer and more elegant in detail. The figures are dignified and well proportioned, the compositions well balanced. Sanfaçon summed it up: "Partout, il y a une 'juste mesure' qu'on ne retrouve peut-être pas facilement ailleurs dans le vitrail."[87] Although unrelated to the western styles we have seen heretofore, the painting has nothing of the sketchy freedom of Paris either. Bodies are not flat; drapery enfolds and describes their volumes with a certain *ampleur*.[88] Faces are painted with considerable finish and marked by protruding, somewhat hyperthyroid, eyes.

The original location of the Infancy cycle was most probably Bay 110 of the south side of the nave.[89] It is evident from the bizarrely elongated manger and reclining Virgin of the Nativity that the panels were not originally separated, as they are now, by a vertical stone mullion in the center (*IV.17*). The rejoined medallions would fit exactly the narrow right lancet of Bay 110 (112 cm.) and, with some filets added, the left lancet (118 cm.).[90] The extant scenes are the Nativity, Annunciation to the Shepherds, Ride of the Magi, Adoration of the Magi, Presentation in the Temple, Flight to Egypt, Christ among the Doctors, and Temptation of Christ.[91] The absence of the Annunciation and the battered state of the Visitation (the left panel is now in the Glencairn Museum, Academy of the New Church, Bryn Athyn, Pa.) indicate that they were among the broken scenes at the bottom.[92] Thus the scenes read in the normal sequence from bottom to top rather than in the Poitevin reverse

IV.17 *Sainte-Radegonde. Nativity, photo of around 1901, illustrating unnatural distortion caused by stone mullions in Bay 113. The left and right sides were probably not divided in the original location, Bay 110 in the south nave.*

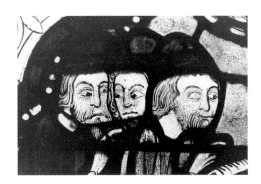
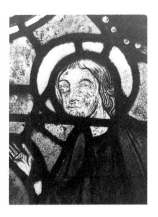

IV.18 *Sainte-Radegonde. Infancy Master, details, Bay 113.*

direction. This conclusion is further attested by the leading in the Temptation, a likely final episode, which betrays the original curve of the lancet head.

It is comparatively easy to say what this style is not: not Parisian, not like anything that we have seen from Bourges or the west. The "button-window" format—medallions swimming in a grisaille sea—occurred sporadically in no particular evolutionary pattern. Numerous elements of the Infancy Master's style can, however, be related to the glazing of Angers in the second quarter of the thirteenth century (*IV.18*). The border resembles the latest Angers design (Bay 101); the relaxed octofoil resembles the medallions of St Maurille (Bay 102); the grave, quiet rhythms of this painter and his attentive care to the delineation of mass—as well as the exaggerated eyes—resemble the St Maurille and St Martin fragments (Bay 102; *IV.19*).[93] Also comparable to the latter fragments are the porpoiselike sheep of Sainte-Radegonde, and the hobbyhorses ridden by two of the magi. The Infancy Master's urbanity and sophistication can be gauged by the frontal horse of the third magus, posed like the knock-kneed lion of Villard d'Honnecourt.[94] Equally memorable, in the Annunciation to the Shepherds, is the shepherd's dog howling at the angel.

This comparison with a painting style of Angers of slightly earlier date brings to mind the unusual Virgin window of Angers cathedral, a colored image set in a grisaille surround.[95] Perhaps the Sainte-Radegonde Infancy panels reflect that early tradition of combining colored glass with grisaille. The grisaille itself, however, is not only later than but considerably different from the older grisaille of the Angers Virgin window and of the Saint-Serge atelier in general. Its stylistic relationships are with the grisailles of the nave of Poitiers cathedral (*IV.20*), and they are very close. Both employ simple geometric leading (circles, quatrefoils, canted squares) at the corners and accent points, and foliage growing up and down in mirror image against a crosshatched ground. A more specifically Poitevin feature of the grisailles of both places is the distinctive foliage type: tendrils spread and unfold languorously, with none of the elastic snap seen in the north; and a rich exuberance of leaf types is illogically combined, like grafts on the same stalk.

Thus the Sainte-Radegonde Infancy Master designs and paints in an Angevin manner, but the grisaille surrounds in his window were executed for him by a workman who had trained at Poitiers cathedral. This conclusion establishes a work hierarchy which is perhaps not so surprising. The Angevin artist was an expert and perhaps an expert has always been "someone from the next county," as the saying goes. In any event the largest atelier at Sainte-Radegonde maintained the traditions of the cathedral. We have examined the Alphonse Master's Last Judgment and the Passion Master's cycle, both from that shop but unfortunately manhandled by Carot's restoration. The great artist of the shop—the Blaise Mas-

IV.19 Angers cathedral. Bay of Sts Maurille and Martin, Bay 102.

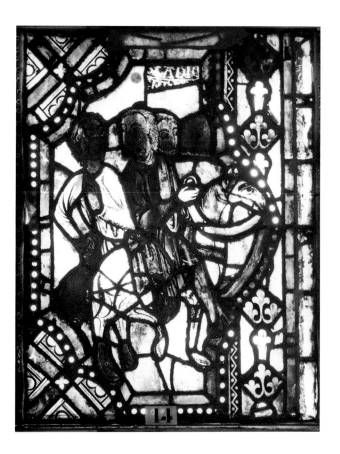

IV.20 *Poitiers cathedral. Grisaille.*

ter—remains to be investigated, and although his window did not escape the Huguenots it did, *Deo gratias,* escape Carot.

The Blaise Master

The Blaise Master is one of the great expressionists produced by the west. I have referred to him earlier as the quintessential expressionist, master of the Poitevin style at its fruition, divine child. He works in the storytelling genre and in the naive folk accents of the Appliqué Master, though his traditions declare him a member of the large Poitevin atelier of the Alphonse Master and the Passion Master. He uses their brilliant, gaudy color—richer than the Alphonse Master, more focused than the Passion Master—and his little doll-like actors are similar conceptions, puppets with flexible formless trunks and great expressive heads. Beyond the circumscribed talents of his fellows, however, his brush is mercurial and deadly sure. The Blaise Master has panache.

I have called him the Blaise Master because the iconography of the Blaise scenes of Bay 115 has been recognized since the nineteenth century.[96] The window's lancets actually treat several subjects, here identified for the first time. The legend of St Blaise occupies the two right lancets, that of St Lawrence the left two, and in the traceries are six lights devoted to Dives and Lazarus. Though the large upper rosace is lost,[97] the small central triangle light of the traceries contains the Agnus Dei emblem. This subject roster is not the haphazard, unrelated aggregate it first appears, as we shall see.

The Huguenots smashed all but the upper three rows of the lancets, leaving six scenes of Blaise and six of Lawrence (*IV.21*).[98] Until the early 1950s the window remained in that condition, the lower area filled with clear glass; since then, modern colored glass designs have been substituted, in a tonality reasonably approximating the old glass above and incorporating four of the eight medallions that Miel composed of old scraps in 1768.[99]

The choice of subjects can be explained by the abbey's cults. In the otherwise extremely sketchy calendar of the abbey's late thirteenth-century customary, Blaise and Lawrence each

IV.21 *Sainte-Radegonde. Scenes of Sts Blaise (right lancets) and Lawrence (left lancets), parable of Dives and Lazarus (traceries), Bay 115, prior to 1950 restoration.*

enjoy two feasts.[100] A miracle of St Radegonde of 1303 states: "Qui incontinenti ad Deum et ad sanctam Radegundem et ad sanctum Blasium, de quo est pretiosissimum sanctuarium in ecclesia predicta, se et corpus et animam vovit et recommendavit."[101] The earliest extant inventory of the abbey's relics (1476) mentions both Blaise and Lawrence: "Item la croix saint Blais, qui est d'argent" and "Item le reliquaire saint Laurens."[102] The importance of these two saints at Sainte-Radegonde suggests that the scenes of the Lazarus cycle in the traceries may reflect a similar relationship, and indeed a statue of St Lazarus is listed among the Huguenot damages.[103] The six scenes all depict the Dives and Lazarus parable, however.

A

B

IV.22.A *Sainte-Radegonde. Blaise Master, Agnus Dei, Bay 115.*

IV.22.B *Sainte-Radegonde. Passion atelier(?), Agnus Dei, now in Bay 114.*

Although medieval conflation of the parable's Lazarus (Luke 16:19–31) with the brother of Mary and Martha resurrected at Bethany (John 11) was complete,[104] other meanings must be allowed for the parable in the traceries.

The pilgrimage nature of the church and the location of the Dives-Lazarus scenes in the traceries of a bay devoted to important church relics strongly suggest that the parable's central message here concerns the importance of confession. The popularity of the subject with the uneducated masses has been linked by Charles Altman to the medieval homily on the Luke 16 text (second Sunday after Pentecost), which transforms the dogs licking sores into "unexpected heroes":

> The rich man represents the proud Jews, Lazarus the humble Gentiles hungry for knowledge. . . . Now the sores of the flesh clearly figure, on the moral plane, the sins of the Gentiles, which can be opened only by confession, thus paving the way for the confessor's saving counsel (represented by the dogs' curative licking). . . . [N]early all commentators after Gregory the Great stress the role of the preacher-confessor. . . . The Victorine *Allegoriae in Novum Testamentum* (generally attributed to Hugh of Saint-Victor) sums up this approach quite succinctly: "The dogs lick the wounds of the pauper, because preachers by preaching take away sins—as if they were touching wounds they lead the sinner to salvation—thus the wounds of the flesh are cured when they are licked."[105]

The halt and lame who flocked to Sainte-Radegonde in the thirteenth century were being encouraged to seek their spiritual health as well.

The small central Agnus Dei (*IV.22.A*) lends itself to a different interpretation, since it repeats another small Lamb of God—a tracery roundel now in Bay 114 but probably moved there from Bay 116 in the post-Huguenot restoration (*IV.22.B*).[106] Recall that Bay 116 originally held the Passion–True Cross medallions, which glorified another relic of the church as do the Blaise and Lawrence cycles of Bay 115. Both windows (facing each other at the

A B

IV.23.A–B *Sainte-Radegonde. Bay 115, prior to restoration. (A) Inscription of*
St Blaise. (B) Inscription of St Lawrence; Lawrence pushed before Decius by a
henchman with cudgel.

entrance to the church) thus bore the Agnus Dei badge in their traceries. Recall further that
Bays 209 and 210 of the Le Mans clerestory have small Agnus Dei[107] discs in their traceries,
which I have suggested refer to the name-saint of the donors Johannes de Fresnio (Bay 209)
and Jeanne de Mayenne (Bay 210; see Chap. II, p. 40). There is evidence of a belief in name-
saints in the west at exactly this time. In the text of a miracle of 1269, a woman named
Radegonde from La Rochelle (Charente-Maritime), wife of Guido "called the Breton," and a
sufferer from gout, decided to make the pilgrimage, saying to her husband: "Domine, Rade-
gundis nominor, et in festo beate Radegundis nata fui, que beata domina consuevit a guta se
fideliter invocantes liberare."[108]

This pile of circumstantial evidence suggests to me that the donor of Bay 115 (Blaise-
Lawrence) and Bay 116 (Passion–True Cross) was the abbess of the convent, named Jeanne
between 1263 and 1284, and that her windows dedicated to the church's most important
relics were commissioned from a local Poitevin chantier.[109] Such was not the case with the
Infancy cycle we have already studied, nor was it true with at least one other elegant wreck
we shall examine, whose sad fragments are installed in Bay 114. The campaign at Sainte-
Radegonde begins to take on the profile of the glazing of Gassicourt, that is, of diverse artists
working together briefly. And out of the eight bays of the nave the Blaise Master was un-
leashed on only one.

The Lazarus scenes (*Pl.23*) of his traceries are of particular interest because the smaller
trefoils, at least, may never have been moved.[110] They are, right to left, Lazarus with the
leper's rattle begging at Dives's house, a servant at the door; Lazarus with rattle, sores being

licked by dogs; Dives dying, his soul being grabbed by devils (blue dogs); Lazarus dying, blessed, and soul taken by angel. The two upper quatrefoils (probably exchanged in position) depict Dives at his dining table, a beautiful woman among his companions and a dog enjoying the scraps; and Abraham's bosom, cradling the soul of Lazarus. Both scenes, though damaged, include handsome heads and bear a generic resemblance to the Moissac porch reliefs, even to the shape of Dives's hat. The range of the Blaise Master's volatile talent is already evident, in the madcap dogs (hounds that walk on their elbows), the exquisite long lashes of the beautiful people at Dives's table, and not forgetting the fleecy Agnus Dei who looks up as though someone had pinched him (*IV.22.A*). Among the peculiar devices of this painter is a diamond-shaped pupil, which makes the glances sparkle.

The twelve medallions below are even more damaged. Each lancet has a different border and different medallion shape, and their narratives ran in the Poitevin manner, top to bottom. Thus the most distinctive scenes, the saints' martyrdoms, are missing. Inscriptions, not used in any other window of the church, make the identifications here certain (*IV.23.A–B*). The blocklike letter proportions and the limitation of uncials to T and E make a date past 1270 unlikely.

Among the six medallions of St Lawrence are three inscriptions: ST LSAVREN. The scenes are scrambled and include the saint preaching; the saint before the emperor Decius (with scepter); the saint before the prefect Valerian (and probably a second scene with Valerian, now mangled); the saint curing the blind man Lucillus by baptizing him; and the saint pushed before the sceptered Decius by a henchman with cudgel (*IV.23.B*).[111]

IV.24 Sainte-Radegonde. Passion atelier. A cure at St Radegonde's tomb, showing ex-votos of packets of oats hung overhead, fragments in Bay 116.

The six scenes of Blaise retain remnants of three inscriptions, the clearest of which is: st' BLASIVS. Blaise appears in miter and crozier as bishop of Cappadocia, in several generic scenes of entering a city with disciples, blessing kneeling figures, and curing a nude child. One scene shows Blaise in exile in his forest cave blessing his animal companions (*Pl.24.A*); another more damaged scene shows Blaise addressed by the kneeling poor woman, while behind her the wolf chases her pig; a third depicts a beautiful figure presenting to the kneeling bishop a smaller agonized figure who is probably the child choking on the fishbone (*Pl.24.B*).[112] Thus Blaise's most popular miracles, which earned him the reputation of protector of children and animals, are all represented.

The colors of the Blaise window are glowing and brilliant, a rich balance of saturated primaries that is warm without being gaudy or raw. Each lancet has a different medallion type: one is the Poitevin circles-on-a-string of the Bourges Passion window; two are found in the late glazing of Angers, ovals connected by small circles (Angers Passion window) and facing half-circles (St Julien bay). The fourth medallion type is a "canted quatrefoil," that is, a quatrefoil set on its buttocks (*Pl.24.B*), which appears to be a simplification of the *carré quadrilobé* used at Angers, Gassicourt, Fécamp, Rouen, Dol, and elsewhere.[113] Simplification is the important word, since the Blaise Master is a master simplifier. His compositions are boiled down to the essence, his settings are understated or even void, his line is quick and spare, his touch sets fire to a telling detail, a facial reaction.[114] His art is like the folk song with its lilting repeated chorus and the sting of truth embedded in the last line of the verse.

The Latticework Grisaille

Bay 114, opposite the Last Judgment rose, is a grisaille of heavily colored latticework framing lozenges of an abstract palmette against crosshatched ground, within borders alternating fleurs-de-lis and castles (*Pl.25*). The border repeats that of the appliqué window (Bay 109) in a narrower dimension.[115] The dry palmette is also generically similar. The colored latticework, however, is unique; it is used at Sées cathedral later, but nowhere that I know of earlier.[116] In fact, it seems to celebrate the heraldic colors of Alphonse de Poitiers: the latticework is made of two blue filets sandwiching one of gold, studded with great red nails. It is not unreasonable to suppose that the lancets beneath Alphonse's Last Judgment opposite also were filled originally with this kind of grisaille. Indeed just such a combination of large colored rose over heavily colored latticework grisaille recurs in the Sées cathedral north choir aisle.[117]

Bay 114 lost its lower panels to the Huguenots and has undergone at least two severe restorations: that of Miel, when debris was made up into filler for the lower half (*IV.3*);[118] and that of the Chigots in 1950, when Miel's Gothicizing medallions were removed to Bays 115 and 116 and the rest of the debris was pushed up to form a band beneath the original grisailles of the upper lancets, which were copied in modern designs below. The window's present appearance as a band window thus is false and dates to 1950.[119]

The debris in the band is a precious jumble that can and should be sorted out. Identifiable are two exquisite panels depicting the Miracle of the Oats (St Radegonde's flight to freedom), scraps of a most significant border, and fragments of another St Radegonde cycle, painted by the Infancy Master and untouched by Carot.

Let us consider the last first: two figures (one a nun with a book at someone's bedside; *Pl.25*, r.) and a group of freed prisoners in the Infancy Master's pop-eyed, carefully finished style. About a half dozen heads from Bay 116 can be added to the group, including a strongly painted fragment of a woman passing a shrouded child to Radegonde in her cell, used by Miel for one of his Gothicizing medallions. The scraps thus present fragmentary evidence of a medallion window paralleling the stories of St Radegonde already depicted in the appliqué window. The medallions seem to have been rectangular with round bites taken out of the corners, in a grisaille surround; a reasonable location for such a second Radegonde window would be opposite the first, in Bay 112 on the south. In that position it would have adjoined the Infancy Master's infancy panels, which I have suggested were originally installed as such a button window in Bay 110.[120] So much for speculation.

The Royal Fragments

The other two fragments in the band also treat the Radegonde legend, but they are by a new painter and are not stories repeated from the appliqué window. The two scenes relate to the Miracle of the Oats (*avoine*):[121] Queen Radegonde, having left the court and taken the veil, had retired initially to Saix, a royal estate near Loudun, when her husband decided to retrieve her, and she fled with her disciples to Poitiers. In a miracle probably aping the apocryphal Infancy legend,[122] Radegonde passed a field where a peasant was sowing oats; the oats grew miraculously; and when King Clotaire rode up in pursuit and questioned the peasant, then harvesting the crop, the latter replied that the queen had passed when he was sowing. The two glass fragments show Queen Radegonde in a fleurs-de-lis-covered robe in the oat field with her disciples (*Pl.25*, r.);[123] and King Clotaire on horseback, also garbed in a Capetian fleurs-de-lis surcoat, a servant in a doorway behind him.

The depiction of the Miracle of the Oats in the thirteenth century is a matter of interest, since it is not included in the twelfth-century life of Radegonde composed by Hildebert de Lavardin.[124] Two separate feasts for Radegonde are included in the late thirteenth-century calendar, however, the added feast of February 28 called *Radegundis reginae reversio*.[125] By 1358 this February feast was called *Beatae Radegundis de Avenis* (wild oats),[126] and the popular custom of presenting packets of oats as votive offerings to Radegonde can be documented as early as the miracle of 1303.[127] On the basis of these two glass fragments, then, the legend of the oats can be established a generation earlier at least, and its currency at the time of the church's glazing campaign around 1270 allows a further identification from among the glass scraps remade for Bay 116. Several include gold-colored strips above the figures, decorated with little comblike forms, probably packets of oats left by pilgrims at the tomb (*IV.24*). The comparison of these "combs" with real growth in outdoor scenes, in the same glass series, makes the identification quite secure.

The two beautiful remnants of the Miracle of the Oats are like no other glass in the church. The figures are larger; they are exquisitely, elegantly proportioned, with handsome stiff-fold draperies and aristocratic faces. The style can be compared to the heavy draperies among the painters of the Le Mans Principal Atelier, while the elongated, graceful bodies more closely resemble those at Tours.[128] But their stately ceremonial quality is unknown in the west and may reflect the Paris style of the 1270s. A comparison, at any rate, is possible

Sainte-Radegonde. Original location of the Miracle of the Oats scenes in Bays 107 and 108 (shown as darkened windows), flanking the entrance to St Radegonde's tomb in the crypt (east end of the nave).

between these handsome "ceremonial" fragments of Sainte-Radegonde and the donor panel among the grisailles of the choir of Saint-Martin-aux-Bois (Oise). The donor depicted there is Jean de Rouvillers, without much doubt a relative of Hugues de Rouvillers, abbot of the Augustinian community of Saint-Martin from 1272 to 1276.[129]

It is possible to make educated guesses about the donor of the Sainte-Radegonde fragments and their original location on the basis of two elements: a great shield of the king's arms set into the Clotaire panel; and remnants of a very broad border (20 cm. wide) repeating the arms *azur à trois fleurs-de-lis d'or*. First, the donor. The large shield of *France ancien* speaks for itself. The border of shields reducing the field *semé* to three fleurs-de-lis, a heraldic design known as *France moderne* since it was adopted as the king's arms from the mid-fourteenth century on, repeats the message.

Various Capetian princes and princesses of the late thirteenth century reduced the field to three fleurs-de-lis, but the first king to do so was Philippe le Hardi, on his counterseal of 1285.[130] Is it reasonable to presume that Philippe le Hardi gave these panels? No other explanation for the arms—in particular for the great shield of *France ancien*—is possible. But it is also likely, since the county of Poitou reverted to the crown at Alphonse's death in 1270, and in 1276 King Philippe donated money to the abbey to maintain the chaplaincy which his uncle Alphonse had established in his will.[131] Alphonse's chaplaincy was in the crypt at the tomb of St Radegonde.[132] The king's foundation of 1276 probably paid for the decoration of the chapel including these panels of glass.

The crypt of course has no windows, so where were they? Here one can only hypothe-size on the basis of the great size of the figures, and the curve of the border fragments that must reflect the shape of the lancet head. The figures themselves are 75 centimeters or more in height, and the panels would have been at least the same width with even a filet type of frame. The 20 cm. heraldic borders would have added considerable width, making them larger than most lancets in the church. Circumstances thus point to their installation as Bays 107 and 108, the two lights framing the apse—wide, short, roundheaded lights in full view of the nave, high above and flanking the stairs to Radegonde's crypt in the center of the bay below. These lights are 125–30 centimeters wide and somewhat more in height.[133]

If this theory is correct, the king's windows would never have been more than the pair we now have in fragmentary condition, and they would have occupied a place of honor and high visibility in the church. Their importance and their exquisite beauty deserve no less.

The Puzzle Reassembled

As I have hypothesized the original glazing program of the church, it has considerable coher-ence: Bays 115 and 116 given by the abbess, colored medallions celebrating important relics and painted by the Blaise Master and the Passion Master, artists of varying talents from the local cathedral training ground; Bays 113 and 114 given by Alphonse, colored traceries over grisaille lancets, painted by the Last Judgment Master from the same shop; Bays 109–112, all odd combinations of color and grisaille, honoring St Radegonde (three bays) and the Virgin (Infancy bay), to whom the convent was originally dedicated by Radegonde herself. Since the measurements of Bays 111 and 109 are identical and those of Bay 110 nearly so, it is quite possible that these windows were switched from the order I have suggested. In such a revised scenario the Infancy window would be to the right of the Last Judgment, counter-poised to Dives-Lazarus, as at the Moissac porch. The program of bays honoring Radegonde above the entrance to her tomb would be even stronger in that arrangement, probably capped by the king's windows of the Miracle of the Oats flanking the apse.

It is not necessary, however, that the skeptical reader accept the entire house of cards I have constructed in order to enjoy the village storytelling of the Appliqué Master, the bril-liant display of the Blaise Master's mercurial wit, the adolescent all-elbows charm of the Last Judgment, the elegant touch of the king's painter. The derivations from the traditions of Angers and Poitiers cathedrals remain important, as do the traditions traceable later to the cathedrals of Dol and Sées. At Dol the east window, without this clue, is a total puzzle: a rose including Last Judgment scenes placed over lancets celebrating the treasured relics, among whose painters is one in the Angevin tradition. The lost Gothic roses of Angers could be the link; who knows? Similarly at Sées, the emergence of a painter of expressionistic violence would hardly be explicable without the clue provided by the Sainte-Radegonde handwriting, the latticework grisailles. Sées and Dol are a long way from Poitou in their separate directions, and the way stations have vanished, but without Sainte-Radegonde the very route would be forgotten.

I remarked at the beginning of the chapter that the figure of St Radegonde combines the two thematic threads of the glazing program, the royal connection and the miraculous cures of pilgrims to the shrine. It can be suggested that the two are just as closely intertwined in the figure of the donor, the Capetian prince Alphonse de Poitiers. Alphonse suffered a

partial paralysis in 1252 and in the following year his sight failed[134] (ailments that have been diagnosed as the aftermath of diphtheria contracted in adulthood) and though neither problem became acute, both remained with him in somewhat abated form for the remainder of his life.[135] In the year of his paralysis the prince took the cross, very probably in hopes of a cure, and in 1263, when his condition seems to have been stabilized, he began serious preparations for crusade, ultimately carried out in the company of his brother St Louis in 1270. Closer to home and in his own appanage of Poitou was the shrine of St Radegonde, who had cured Blind Bella and whose specialty was ailments of the limbs.

Of the churches in this book Sainte-Radegonde was not the only pilgrimage center, but its rural brand of Christian devotion has been introduced only marginally thus far, as in the Evron window at Le Mans. The embryonic legends of the Pas-Dieu, the *mal Ste Radegonde,* and the ex-votos of oats, walking sticks, and stockings express a side of medieval life which—like the back side of the moon—is not often and never entirely seen, but always there.

✳ Epilogue ✳

Mid-thirteenth-century Poitiers, former capital of Eleanor of Aquitaine, was rustic and distant from Paris, while at the same time the *terre* of one of the French king's brothers residing permanently in Paris. Unlike Le Mans, whose appanaged prince seems to have paid little attention to its cathedral decoration, Sainte-Radegonde de Poitiers benefited from its prince's money gifts. For Alphonse was ill in 1253 following his return from crusade, and Sainte-Radegonde was a pilgrimage shrine in the tradition of its founder, a Frankish queen who was also saint and healer. Not all medieval pilgrims could make the trip to Compostela or Rome; Sainte-Radegonde was a more typical rural locus of petition, curing children and beasts, the blind and the halt, headaches and hemorrhoids.

While its windows have been more severely dealt with by restorers than those of any other monument in this book, the ensemble can be reconstructed and dated from the period of Alphonse's improved health (after 1265) until the final testamentary settlement by his executor and nephew, Philippe le Hardi, in 1276. The glazing program emphatically points up the convent's relics and their cures, a great and gaudy advertisement for the pilgrimage and its tangible rewards. The glaziers were westerners, the most coherent group completely conversant with the idiom of Poitiers cathedral just up the hill (Alphonse Master, Passion Master, Master of the Infancy grisailles, and greatest of them all, the Blaise Master). Two other masters are also regional: the Appliqué Master, too distinctive a personality for exact categorization; and the Infancy Master from Angers. The western pedigree of Sainte-Radegonde is thus much simpler to trace than that of Le Mans. Like Le Mans, both Poitiers and Angers cathedrals housed major Plantagenet twelfth-century glazing; unlike Le Mans, both shops continued until almost the mid-thirteenth century, without the abortive zigzags in stylistic direction that mark the Gothic glass of the *cathédrale mancelle.* Sainte-Radegonde is beyond the orbits of Chartres and Bourges; it is representative of a continuing Plantagenet

tradition; and it is later. It not only puts in perspective the pretensions of the Le Mans ensemble (Chap. II), but it informs our judgments about the origins of the Deacons Master at Gassicourt (Chap. III) as well as the provincial ensembles that are the subjects of Chapter V (Dol, on the border of Brittany) and Chapter VI (Sées in the sylvan expanse of lower Normandy).

Patronage and pilgrimage: the donations of the prince Alphonse in Paris provided a western ensemble which would probably have astonished him—a rainbow fantasia vibrating with energy, laced with caricature, oozing charm and naïveté. The final two panels added by the king as his executor are the polar opposite: a royal commission of royal elegance (or if no evidence remains of Parisian glazing ca. 1275, of an elegance found at that date in the up-to-date Court Style abbey of Saint-Martin-aux-Bois fifty miles north of Paris). Sainte-Radegonde's patronage was primarily royal and distant; its pilgrimage was unsophisticated and homegrown; its windows, the extrinsic royal fragments aside, are a proud display, literal and figurative, of local color.

CHAPTER FIVE

Brittany: The Cathedral of Dol

Les esprits de cette province ne se gouvernent pas comme les autres.

—DUC DE CHAULNES

THE CATHEDRAL OF Dol is located near the north coast of Brittany just west of Mont-Saint-Michel, in the region known as Breton Holland because centuries ago it, too, was recaptured from the sea. Brittany is often lumped with Normandy in art-historical studies, but it is different in every way.[1] Though both regions had ties across the channel, they were of a completely disparate character, and the antagonism of the Bretons for the Normans is signified for us vividly by the image in the Bayeux Tapestry of the burning castle of Dinan, located just west of Dol. Race, culture, and history are different; so too is the very bedrock, Brittany providing only a recalcitrant granite not adaptable to the flights of fancy created under the Gothic mason's chisel elsewhere in France in the thirteenth century.[2]

The bishop of Dol, head of the Breton church, had been established by political maneu-ver in the late ninth century as archbishop over six suffragans (Alet, Saint-Brieuc, Tréguier, Léon, Quimper, and Vannes). This status, debated by the church from the eleventh century on and tarnished by scandals, had been eroded in the twelfth century by political pressures and by the subsequent desertion of suffragans one by one to Tours. Though Innocent III in 1199 finally stripped away any substance of the archbishopric and made all Brittany subject to Tours,[3] the ancient and traditional honor, by then grafted onto the mythology of King Arthur, was not so quickly erased. In the Middle Ages no one doubted that the founder of Dol had been an archbishop,[4] and the thirteenth-century incumbents were consumed with the recovery of their lost glory.[5]

Their propaganda ultimately achieved a recognition of their honorific primacy in Brit-tany, in the bull of Boniface VIII in 1299 instructing the archbishop of Tours to accord the bishop of Dol special treatment—form without substance, though Breton pride continued to honor their "archbishop" as late as the royal court of Anne de Bretagne.[6] Some of the Gothic propaganda fills the stained glass of Dol, as we shall see.

The bishops of Dol were temporal as well as spiritual lords, owing feudal service to the dukes of Brittany during the thirteenth century and in a more or less constant state of tension with them. The precarious alliances between church, barons, duke, and king shifted frequently. Mauclerc's armies ravaged Dol in 1233, including the bishop's properties—but in eliminating the temporal baron as a force of any significance, the duke enabled the bishop

116

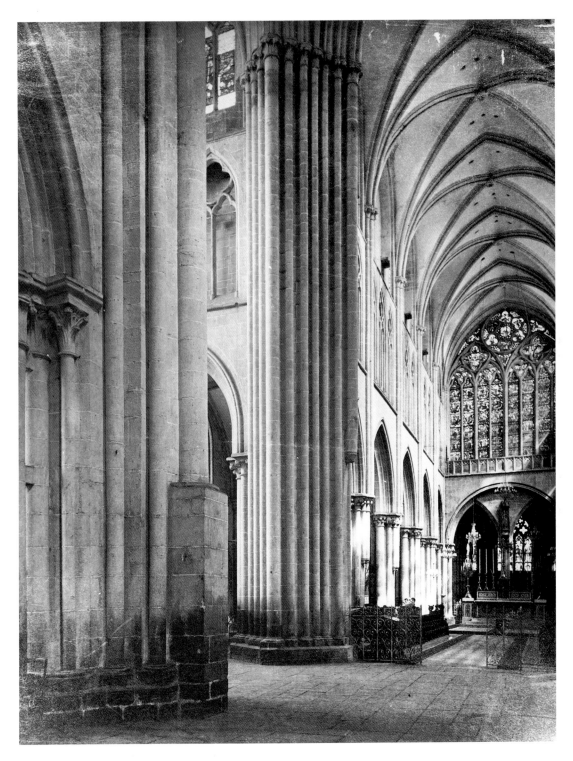

V.1 *Dol cathedral. North transept and chevet, Bay 211, prior to 1890. Photo before 1890, showing grisaille later removed from transept clerestory.*

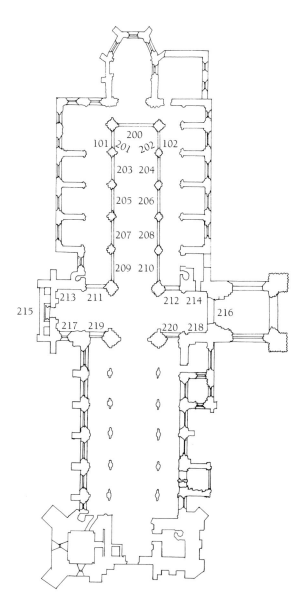

Plan of Dol cathedral.

of Dol to take power. The bishop thus owed service of ten knights to the duke, a consider-
able number, and his military standard was borne by the lord of Combourg. Mauclerc's son
Jean le Roux (1237–1286) as a policy did not confront his barons head-on, preferring to
buy allegiance and land when it was available. His purchases in the region of Dinan west of
Dol, from the profligate Alain d'Avaugour, have been mentioned (Chap. II, p. 336n135.).
Duke Jean II (1286–1305) was more openly antagonistic, but in Bishop Thibaud de Pouancé
(1280–1301) he had an opponent well protected by his services to the crown. At least one
canon of Dol, Raoul Rousselot, served Philippe le Bel as *clerc*. Others served at the English
court.[7] A local tradition maintains that the bishop of Dol, as head of the Breton bishops and
in opposition to the barons and the duke, tried to get the latter excommunicated in 1291,
failed, and fortified Dol in expectation of retaliation.[8]

These mercurial realignments seem to have effectively eliminated outside patronage from the cathedral's Gothic programs of aggrandizement.[9] Dol is an island, a monument to the chapter's diocesan pride and ambitions. The glass refers, as stated earlier, to the bishop's honorific pretensions, to the famous and popular relics housed in the church, and ultimately and in a broadside way to the new Parisian fashion of grisailles. For all we can tell, Brittany had no duke and no nobility.

The Gothic cathedral was completely built in this turbulent century, in two campaigns,[10] following the burning of the previous building in 1203 by John Lackland. Construction began at the west facade, and we can assume the nave[11] was completed by 1223 when the relics of Sts Samson, Magloire, and others were returned from safekeeping.[12] The campaign of the transept and chevet (*V.1*) reflects elegant modes of a generation later and its date of completion is suggested by the new statutes issued by Bishop Etienne for the chapter in 1256, or more reasonably by his additions to those statutes in 1265.[13] While the Anglo-Norman aura of the nave is hardly surprising in the first quarter of the thirteenth century, the later chevet gives pause. It is a distinctly English type of retro-choir, a deep and flat-ended chevet decorated with a huge east window-wall eight lancets across.[14] A canon of Dol was at the English court, however, from the time of Henry III until as late as Edward II. In a period when relations between the Breton nobility and the prestigious French monarch Louis IX were increasingly amicable,[15] this architectural vote of no confidence is worthy of note.

The stained glass that remains is of three types and fits into the historical and architectural contexts in the following ways. First, remains of three large, standing frontal bishops, now found (with a modern fourth) in Bays 211 and 212 of the transept clerestories (*V.2*), suggest a glazing derived from Le Mans about 1255–1260. The original location of the bishops can only be hypothesized. Most probable is the nave clerestory. Second, the great east window-wall (Bay 200; *Pl.26*) presents an iconographic program related tangentially to Sainte-Radegonde (and hypothetically more directly to the lost roses of Angers cathedral), produced by a chantier of at least three painters. Their styles have a close family resemblance and can be related to the last work at Angers ca. 1260 as well as to the conventions of the Appliqué Master of Sainte-Radegonde, a rural painter not related to the main Poitevin shop there. A working date of about 1265 to 1275 could be suggested for the vast project of the east window and, as suggested, an Angevin orientation.

Finally, the grisailles of the choir and transept clerestories and the two pierced triforium bays (101 and 102) represent a new wind stirring. They are northern types complete with *France/Castille* borders and indicate a personality familiar with Parisian fashion, although the painters were probably not recruited from so far afield, since their designs are comparable to those of Sées cathedral (Orne) in Lower Normandy. That new wind, the patron familiar with Parisian fashion who hired them, was without very much doubt the bishop Thibaud de Pouancé.

Elected in 1280, Bishop Thibaud was regularly occupied in service with and for Philippe le Hardi, far from Dol, until the king's death in 1285. Thibaud was nonetheless of local origin, of a noble family holding borderlands halfway between Dol and Angers. At his royal patron's death Thibaud seems to have directed his formidable energies and ambitions toward enhancing his position in Brittany, and thus his grisailles can be dated both stylistically and by historical deduction to about 1285. He left his coat of arms in stained glass, a precious fragment formerly in the traceries of the south transept window-wall (Bay 216; *Pl.27*). The

V.2 *Dol. North transept clerestory, Bay 211.*

very fact that the arms were in the transept and not in the cathedral's great east window is indication enough that this forceful, even infamous, Breton prelate-count found that prestigious project complete upon his arrival in Dol.

Thus the glass at Dol, which inspired several local programs of which fragments remain at the abbeys of Saint-Méen and Léhon, can be dated over a period from 1255 to 1285 and related in turn to the Maine, the Anjou, and finally to Lower Normandy. The complicated evidence for these assertions occupies most of this chapter; a coda is devoted to the glassy evidence in the two Benedictine abbeys nearby. Brittany has been dismissed as having had no glaziers until nearly the fifteenth century. As both fragments and documents establish, that simply is not so.[16]

Vicissitudes of Time

A quick outline of the damages and restorations over the centuries, as they can be reconstructed, will be presented here for reference in these discussions. How completely the Gothic cathedral was glazed by the end of Bishop Thibaud's reign cannot be established, but fourteenth-, fifteenth-, and sixteenth-century remains in the traceries of chapels[17] indicate that such locations, both easily accessible and of great liturgical and social importance, were redecorated at intervals.

The only documented restoration before the eighteenth century was the major project of the humanist bishop Mathurin de Pledran (1504–1521), whose goals of refurbishment for his see encompassed revitalization of the statutes of the chapter as well as major repair of the towers and of the great east window. Indeed his publication of the statutes (1509) ends with a Latin poem with the following terminal couplet: "Vade igitur, felix letare ecclesia Doli, / nam patet ad celos bella fenestra tibi."[18] The early sixteenth-century glass in the "bella fenestra" is extensive, handsome, of superior artistic quality, and tastefully integrated into the original Gothic sections. It will be discussed with the ensemble below. The fact that only one "bella fenestra" is mentioned suggests further that the great window-walls of the south and north transepts, equally immense, were filled not with colored glass but with grisaille and hence not considered worthy of attention. These assumptions will also be considered below.

From the late seventeenth century on, small and frequent accounts establish upkeep of the glass.[19] This maintenance was halted at the Revolution, after which various areas of the building served as stable, warehouse, and tennis court. In 1807–08 Mazot *vitrier* was paid for glass repairs;[20] by 1820 the cathedral was smelling moldy and in urgent need of a roof, and the city financed repairs until 1826.[21] Someone was paying for the upkeep of the east window thereafter, since a piece of blue ground in the Last Supper is scratched with the words "[]re[]tion en 1831 par []roulon."[22] In 1836 when the monument was classified and entered the government's charge, Prosper Merimée admired the east window, and following him in 1837, the baron Guilhermy reported that its panels were "très bien conservés."[23] By 1855 local worry over the care of the glass was marshalled by Alfred Ramé, whose report to the minister on the need for releading and repairs is a critical document indeed, one that was totally lost between various governmental archives but that I discovered published verbatim in a release to the local newspaper *Journal de Rennes*.[24] Two drawings, made from tracings Ramé executed from the ledge, accompanied this report (*V.3.A–B*).

V.3.A *Dol. St Samson sailing to Brittany,*
panel of 1509, east window, Bay 200, lancet F.
Drawing by Alfred Ramé from a rubbing made
from interior ledge in 1855.

V.3.B. *Dol. Archbishop of Dol with his six*
suffragans, east window, Bay 200, lancet G,
panel 2. Drawing by Alfred Ramé from a
rubbing made from interior ledge in 1855.

In 1870 the great east window was finally restored by Oudinot, who made at least nine new panels for it. It remained in Paris far longer than suited the parishioners. When it was deposed again in 1942, the citizenry fought to keep it from being removed from Brittany. After the war the municipality, not the national government, paid for its restoration by Gruber, strongly criticizing first his delays and then (when it was reinstalled in 1951) the sixteen new panels he supplied for it. The dossiers of 1942–1952 in the Monuments historiques contain repeated evidence of the concern for this window on the parts of the Breton press, the mayor, and the "whole population." Oudinot's panels of 1870, which had been removed by Gruber, were eventually recovered by the priest, and since 1978 all nine of them are installed in the sacristy in the south nave. Clearly the great window speaks eloquently, and has spoken for centuries, to the faithful of Dol.

The other glass in the cathedral has not been so cherished. By the mid-nineteenth century the great south transept window (Bay 216) retained only a few original fragments, including, in the traceries, three prophets with their names on phylacteries, and in the small central light between the lancets, the arms of Bishop Thibaud de Pouancé (Pl.27).[25] The arms, probably denoting the huge south lancet as his gift, have been relocated in a western light of the north transept, but the rest of the glass vanished in 1884. In that year Dol's *archiprêtre* took matters into his own hands. Without consulting the minister, he had Küchelbecker and Jacquier, glaziers of Le Mans, install a window that, even in its time, was condemned for surpassing ugliness.[26] In 1887, and with permission, he did the same for the north transept. Next considered were the old grisailles, "sans interêt, criblés de trous & incapables de protéger d'édifice contre les intempéries," which he wished to replace with new band window designs. This villainy was prevented by an unsung hero named Ballu, sent by the minister to the glaziers' studio in 1888, though his order to them to retain all of the old grisaille patterns in their restorations was ignored. Of the eighteen designs which the glaziers told him they had found, we now have evidence for only seven. The curé of Dol struck his final blow in 1890, when he turned his attention to the large bishops of the transept clerestories (Bays 211 and 212; V.2). To the three whose mutilated remains then existed,[27] he added feet panels and other repairs, a fourth bishop copied after their cartoon, and new coats of arms for each, thus baptizing them as the cathedral's four thirteenth-century bishops.[28] It is with a certain sense of relief that one finds nothing in the dossiers of the Monuments historiques between 1891 and World War II.

The Master of the Blessing Bishops

The transept bishops in Bays 211 and 212 are more important than their mangled remains would suggest. Made from a single cartoon, they still present largely original glass in two head panels, three torsos, and two lower sections. The bishops have very simple canopies and a reduced, saturated color scheme of red and blue. Gold appears sparingly for crozier heads, maniples, and orphreys; white for gloves and miters; there is the merest touch of green and brown. The faces have slight whiskers and no haloes.

Nothing suggests that the bishops were made for their present locations, as they have no borders at all and the colonnettes of their canopies are sliced to varying degrees. They can be strongly related to the bishops in the Le Mans clerestories. These two observations should be taken together, since if the stylistic connection to Le Mans is accepted, the Dol

transepts are somewhat too late in construction to have housed the bishops. It is my hypothesis that they came from the nave, where each clerestory bay has a single broad lancet that would comfortably accommodate one bishop inside borders.[29]

At Le Mans the frontal bishops occupy the south clerestories (Bays 204, 206, 208 [now lost], 210, and 212) and share the red-blue tonality. The strongly triangular face and the substantial body proportions at Dol are closest to the earliest window of the Le Mans group, Bay 204. Several aspects of the painting style at Dol, however, relate more strongly to the eccentric ways of the first and greatest master of the Le Mans clerestory, the Master of Bishop Geoffroy de Loudun. By comparison to that expressionistic genius, the Dol figures are flaccid, weak derivatives (V.4). But the elongated eyes at Dol are similar to the style of the Bishop's Master and even closer is the drapery painting marked by hooked inkblots. The distinctive color scheme used by the Le Mans Master of Bishop Geoffroy is not followed at Dol, however. It is therefore to the works of his followers at Le Mans, where his color was abandoned, that we should turn for comparison—that is, to Le Mans Bay 209 and then to Bay 204, where his plastic drapery handling with its notable inkblots finally disintegrated into spastic inarticulation.[30] Thus Bay 204 of Le Mans provides the closest comparison to Dol on many counts. Since the dating of Bay 204 is approximately 1255 or shortly thereafter, the work of the Dol follower, who is not the same artist but another whose style had reached a similar spastic disintegration, may be dated from the late 1250s to ca. 1260. His canopies are primitive even for this date.

It will be recalled that another glass painter of median talent practiced this spastic drapery style: the Master of the Big Saints at Gassicourt (III.2, p. 54). If we accept that the Gassicourt glazier was apprenticed at Le Mans, then a similar training can be posited for the Dol Master of the Blessing Bishops. The latter artist, however, seems to have left the Le Mans shop a little earlier, before the Principal Atelier had really got into action there. The Gassicourt Big Saints Master and the Dol Blessing Bishops Master do not have much in common except their schooling at Le Mans.

One of the most puzzling similarities they share is also perhaps the most significant to the argument just presented: the blessing hand. At both Dol and Gassicourt the bishops' blessing hands wear a ring with a stone in a setting; it sticks out clearly in profile. While I cannot pretend to have examined every blessing hand in Gothic glass, this is a rare detail that must indicate familiarity with a common patternbook. The pattern can be seen in Bay 204 of Le Mans. The right bishop in Bay 204 (and in no other bays of the Le Mans series) has a ring on the finger of his blessing hand.[31] The stylistic analysis connecting the spastic draperies of Gassicourt and of Dol to Le Mans Bay 204 can thus be vindicated by a patternbook transition.

One feature of the Dol Master's painting style is his alone and therefore useful in tracking his traditions later. Vertical drapery folds in lower garments are fringed, so that the line resembles a feather or a fish spine (V.4). These fish-spine draperies are unique in my experience, a signature of this painter. They occur occasionally in the great east window, as do the bishops' rings: see for example, lancet G, presenting the archbishops of Dol with their suffragans (V.11.C, p. 145), where one design served for several cartoons and many painters. The scale of these panels is very much smaller than the blessing bishops of the transepts, making comparisons difficult. But none of them has the red-blue color. Given the probable lapse of years between the two glazing campaigns, a minimal assumption can safely be made, that is, that the Master of the Blessing Bishops trained one of the artists of the east window

V.4 *Dol. Composite photo of transept bishops cartoon, composed of the best remaining panels of both figures of Bay 212: head (left figure), body panels (right figure).*

and that his patternbook was available to them all.[32] That conclusion in itself has some significance in establishing the existence of a "school of Dol."

The only question as yet unaddressed concerning the large transept bishops is just who they are, and answering that question is not easy. The clue is their lack of haloes, since Gothic blessing bishops at Le Mans, at Gassicourt, and generally elsewhere, are saints with

haloes. Dol was a place obsessed with recouping the glory and primacy of its episcopate, tarnished by the papal bull of 1199 and not even partially refurbished until the bull of 1299. A nave full of glassy bishops in full regalia may have been part of the campaign of indoctrination. These figures hold croziers, not the cross staves of the archbishops of the east window, and therefore must have been suffragans. But just how such a program was composed is not possible to say.

The Great East Window

I once suggested, in a discussion of the choir of Saint-Père de Chartres identifying Gothic remains reused within a generation, that fools rush in where angels fear to tread. The great east window-wall of Dol (Bay 200), treasured and monumental symbol of the Breton soul, which seems to have been lovingly repaired every generation since it was installed, is the supreme challenge to the modern analyst. It is a challenge worthy of the effort not merely for the splendor of its total effect but also for the uniqueness of some of its iconographic cycles and the quality and range of its Gothic paint shop.

Its major documented repairs, working back from the present, have been those by Gruber (after World War II), Oudinot (1870), and that ordered by Bishop Mathurin (1509). In addition many workaday restorations are apparent, where a broken original was apparently traced to produce a dull but accurate replacement. And several repairs of considerable artistic merit can be mentioned, for example those of a fifteenth-century hand, master of a fine, wiry line almost like an engraver's, or an eighteenth-century hand producing one remaining head with the flair and innuendo of a fine drawing in pastel chalks (see V.6.E, p. 131 and V.8.C, p. 136). It is hard to know where to start, or how. Without the panels down and on the light-table, a complete census is out of the question and perhaps not possible even then.

One positive side of the problem is that, except in those places where the three documented restorations have produced totally new panels, the substitution of a new bit here and then there has tended to conserve the integrity of the old design. Another positive element is that the character and vitality of the old painting styles are not easily mimicked. The color has been overhauled by the new additions and corrections[33] but can be studied from the original sections. The decorative vocabulary, a nice display of borders and mosaic grounds, is intact. Once the key to the iconographic program is identified, it is revealed as layered but direct and full of interest in both scope and detail. And the painters! One of them, the Catherine Master, is an expressionist of dazzling talent. The Samson Master is a charming storyteller of somewhat lower profile; Lafond singled out one of his designs, the Annunciation to the Shepherds, for an appreciative nod in his pioneer survey of stained glass from 1250 to 1300. The Abraham Master, who produced much of the Passion cycle and the central rosace of the Last Judgment traceries, commands a measured, ceremonial mood. The shop worked together, as is evident in the unsorted stylistic confusion of the remainder of the Last Judgment, the lancet of the archbishops of Dol, and isolated panels elsewhere. And, the Catherine Master aside, they worked in the same regional idiom. The younger Catherine Master was trained by them but his talent, as it develops, bursts the idiomatic bounds.

Dol. The great east window, Bay 200.

Patronage and program will be outlined first and then the component sections will be investigated, for the sake of good order, taking the lancets left to right. This sequence is dictated only by the narrative thrust of the Infancy and Passion cycles (lancets C, D, and E) and accidentally arranges the best for last: the Samson Painter's lancet (F) and the chefs d'oeuvre of the Catherine Master (H). The three documented restorations will be noted as well as, in passing, other isolated repairs of particular curiosity. On the march from left to right, pause will be made en route for peculiar or significant iconography and for acknowledgment of major painters and their roots.

Patrimony and Propaganda

The Dol east window has a Last Judgment in its rose traceries, supported by eight lancets depicting, left to right, cycles of St Margaret, the patriarchs Abraham and Lot, the Infancy, the Passion (central two lancets), St Samson, the archbishop-saints of Dol, and St Catherine. The Last Judgment traceries recall those of Sainte-Radegonde, although they are totally different in style, and in my opinion both probably reflect the lost transept roses of Angers. The north rose made for Angers by André Robin in the 1450s in fact contains the same

program in the rich iconographic expansion of the waning Middle Ages.[34] Beneath the program of Last Things, the cycles of Infancy and Passion (lancets C, D, and E) need little explanation. It is quite otherwise with the remaining amalgam of themes, for which scholars have never previously suggested a satisfactory common thread.

The program is not in fact so mysterious. The east window could be considered a great signboard advertising the patrimony of Dol: its famous relics and its illustrious founding and heritage. That this heritage, primacy of the Breton church, had been annulled by one pope in 1199 and was later, in 1299, recognized by another in a purely insubstantial honorific outlines the message and purpose of this propaganda. The relics are those of St Margaret, for which Dol was famous, and two others for which the cathedral's ownership can be established on the basis of a Latin verse in the fifteenth-century reliquary, which specified:

> Une dente sancte Katherine . . .
>
> Et de quercu fidelis Abraham,
> Tres pueros qui vidit per viam
> Descendentes unum adoravit,
> Trinitatem qui sic figuravit.[35]

A document (now destroyed) establishes that people traveled to Dol in the thirteenth century to take oaths on the head of St Margaret.[36] Only through the poem and the east window can it be inferred that the cathedral also then possessed St Catherine's tooth[37] and a piece of the oak tree (*quercus*) of Mambre that shaded Abraham and his angelic visitors.[38]

The two remaining lancets (F and G) of the east window illuminate other aspects of Dol's glory: its legendary founder the archbishop-saint, Samson, and its early sequence of archbishop-saints with their Breton suffragans. Of course St Samson's lancet also commemorates his relics, which were among Dol's treasures and noted for the curing of madness.[39] Samson is never without his cross staff, symbol of the archepiscopate. It is a reminder to all observers of the legendary honor related by Geoffroy of Monmouth, that King Arthur had made Samson the archbishop of York long before the latter arrived in Brittany and founded Dol.[40]

If the theory requires further proof, that Samson appears as propagandist, and not simply like Catherine, Margaret, and Abraham, in advertisement of his relic, that proof is provided by the lancet of the archbishop-saints. Six different archbishops sit surrounded by their Breton suffragans, who in the thirteenth century were in actuality paying their allegiance, as instructed by the pope, to Tours. No inscriptions name the archbishop-saints. But no matter which early prelates of Dol they represent, Dol did not, in the Gothic era, possess that many saintly corpses.[41] The lancet presents archbishops, not relics.

Who was the propagandist responsible for the east window? No sure response is possible, but it is likely that it was not the bishop alone but the entire chapter. A small clue in the traceries suggests this conclusion. Small white fleurs-de-lis (*Pl.28*) appearing among the foliage, as architectural finials, and held aloft by some of the blessed in the Last Judgment, replicate emblems found in the thirteenth-century seals (*V.5*) of the officials of the chapter.[42] Everything about Dol's Gothic history suggests that its canons and bishops spoke with one voice and with incessant arrogance.

Before starting the descriptive march across the traceries and lancets of the great east window, it is appropriate to characterize the three major restorations briefly. The modern work of Gruber is intentionally distinctive in style but of a strong, even crude, coloration

V.5 *Seal of the seneschal of the Bishop of Dol, 1290. After Dom Morice, 1742.*

that tends to overpower the Gothic glass; the nineteenth-century pastiches of Oudinot are insipid in both design and color but generally inoffensive (*V.6.H*, r.). The panels of the 1509 restoration are remarkably fine (*V.6.A–H*). They employ *jaune d'argent*, and carnation (*jean-cousin*) for the flesh tints,[43] in a warm rainbowlike harmony including clear soft green, salmon pink, and even orange. The designs attempt to copy the simplified Gothic drawing, but in charming and inventive compositions, which capture the essence of a later folk piety. Scenes are "archaized" not only by means of the simple drawing and omission of landscape or setting but also through use of old-fashioned costumes related to French fashions of more than a century earlier.[44] These scenes will be given some attention here in the hope that scholars of the Renaissance will be able to relate them to the thriving Breton glazing activity of the sixteenth century.

The Last Judgment Traceries

The subjects in the parts of the traceries are as follows: in the rosace are Christ showing his wounds, the praying Virgin (fleurs-de-lis foliage), and angels with instruments of the Passion (*V.7.B*). In the spandrels are angels with oliphants (*V.7.C*). In the left quatrefoil are the blessed (male and female), shown enthroned, crowned, and playing viols or holding up white fleurs-de-lis and red roses. In the right quatrefoil are depicted Christ leading souls from hell (*V.7.D*), the hellmouth, and the damned in marmite. Finally, in the trefoils are souls rising from tombs.

Painters: The best-preserved figures of the rosace (Judging Christ, praying Virgin) are by the Abraham Master (*V.7.A*). All three major painters worked together on the remainder. The nudes of the Abraham Master and assistants have a peculiar ribbed binding at the collarbone, making them look as though they are wearing skeleton-imprinted leotards.

Restorations: The restorations in the traceries are scattered throughout; only sizable new designs will be mentioned. Gruber did three lobes of the rosace and, in the quatrefoil of the damned, the upper lobe and the hellmouth. Oudinot did the upper lobe of the quatrefoil of the blessed.

V.6.A–H *Dol. East window, Bay 200, 1509 panels. (A) St Margaret led before Olibrius, lancet A. (B) Lot and his family leaving burning city of Sodom, lancet B. (C) Entry to Jerusalem (left head 18th cent.?), lancet D. (D) Flagellation, lancet D. (E) Carrying of the Cross, lancet E. (F) St Samson sailing to Brittany, lancet F. (G) Archbishop of Dol with his six suffragans, lancet G. (H) St Catherine presented before Maxentius, lancet H, left figure 1509 (right group by Oudinot, late 19th cent.).*

Iconography: The blessed hold aloft white fleurs-de-lis and red roses (*Pl.28*). I have theorized that the former double as emblems of the chapter of Dol. The conception of heaven as a garden of roses and lilies, based on II Esdras 2:19, was long-lived, from the early Christian period through the end of the Middle Ages. Dol's thirteenth-century stained glass paradise is probably based directly on the Golden Legend, where the red roses signify the troops of the martyrs and the white lilies symbolize the hosts of angels, confessors, and virgins.[45] The barefoot Christ leading souls from hell is atypical of Last Judgment ensembles. A variant occurs at Saint-Méen (Ille-et-Vilaine), discussed at the end of this chapter.

E

G

F

H

The painters' close collaboration and the great variety of restored pieces make the Last Judgment traceries much more difficult to study than the rest of the window. Based strictly on the evidence of thirteenth-century pieces, the iconography is that of Châteauroux:[46] the judging Christ with blood visibly gushing from hands and feet; the praying Virgin in white headdress; angels blowing crossed oliphants; the nude souls (where possible in the tight quarters at Dol) rising from patterned sarcophagi. The relationship to the Sainte-Radegonde Last Judgment is of a general, familial nature, aside from a few details: very close are the damned in the marmite, the line-up on the bench of crowned blessed, and particularly the figures playing medieval violins "on the shoulder" with carefully depicted bows. Since the style of the Sainte-Radegonde Last Judgment is emphatically Poitevin and totally dissimilar, and since the two mature painters of Dol (Abraham Master, Samson Master) paint in the manner of the late work at Angers,[47] I have suggested that the lost prototype reflected at both Dol and Sainte-Radegonde was the Last Judgment rose(s) of Angers.

V.7.A–D *Dol. Last Judgment, traceries of east window, Bay 200. (A) Abraham Master, Judging Christ.*
(B) Samson Master, angel with cross. (C) Catherine Master, angels blowing oliphants. (D) Christ leading
souls from the hellmouth.

Lancet A: St Margaret

Although there was so little left of this lancet in the nineteenth century that its subject was considered unrecognizable,[48] the identification of Margaret is based solidly on comparisons of the thirteenth-century sections with other Gothic window cycles, and on the strength of the iconographic detail in the sections added in 1509. The fame of the relic of Margaret's head[49] in thirteenth-century Dol would in itself suggest her election to the roster of the east window.

Painter: The Catherine Master; his developing style will be discussed with those of the other glaziers at the end of the description of the lancets.

Restorations: The two panels and ogive that remain from the original lancet have miscellaneous repairs of some interest, which will be discussed in passing. In addition are those by Gruber (three panels, Margaret's dragon) and one panel done in 1509. In the mid-nineteenth century, there was another 1509 panel, now lost, depicting the beheading of a blonde saint, no doubt Margaret, in the top of lancet C.[50] The martyrdom of the saint kneeling with flowing uncovered hair can be seen at Chartres Bay 26.[51]

1509 PANEL: MARGARET BROUGHT BEFORE THE GOVERNOR OLIBRIUS
BY TWO HENCHMEN

Silver stain, carnation, and brown as well as black paint are used. The color includes a deep red for Margaret's long dress, pink stockings on the left executioner, and clear green and brown. The henchmen's archaizing costumes include pointed shoes, long fitted tunics with low belts and many buttons, and the exaggerated headgear of the late fourteenth century. Margaret's blonde hair is uncovered. The posturing of Olibrius recalls Réau's remark:[52] "Il joue dans le théâtre des Mystères le role ridicule d'un fanfaron, d'un bravache, comme le capitaine Fracasse."

PANEL: MARGARET WITH THE DRAGON IN PRISON

The dragon is Gruber's, replacing one by Oudinot. None was recognizable before 1870 but such a scene is standard in Margaret windows (Auxerre, Clermont-Ferrand).[53]

PANEL: MARGARET BEATEN BY TWO HENCHMEN BEFORE OLIBRIUS

This is another standard scene in Margaret's legend. Though heavily repaired at various times, the design is integral. Olibrius's head, crown,[54] and the little green dragon above his head are original. The Margaret in an off-the-shoulder blouse is a pretty, modern replacement. The two henchmen have sustained various repairs (the one on the right now wears an orange tunic) but are based on fine designs by the Catherine Master, whose extraordinary style is better preserved in the Catherine lancet (H).

OGIVE: SOUL BETWEEN TWO ANGELS

Gruber inserted a stunning head of Christ (fifteenth century?) for the soul; the angels are by the Catherine Master.[55]

Lancet B: The Patriarch Abraham

Although only one 1509 panel and one thirteenth-century panel now remain, it is probable that the lancet treated stories of Abraham in commemoration of Dol's relic of the oak of Mambre (Gen. 18:1–16).[56] There must have been a panel showing Abraham's three angelic visitors. In the nineteenth century the scene of the sacrifice of Isaac (Gen. 22:1–18) and a sixteenth-century panel of Isaac carrying the bundle of wood remained.[57] Abraham windows are not common, but there is one at Poitiers cathedral and another at Auxerre.[58]

Painter: The single thirteenth-century panel is a fine, representative work by the Abraham Master, who also produced the Passion cycle in lancets D and E and was probably the head of the atelier. He will be discussed below.

Restorations: Gruber made four panels; Oudinot did the ogive; and one panel was replaced in 1509.

1509 PANEL: LOT AND HIS FAMILY LED FROM THE BURNING CITY OF SODOM BY THE ANGEL (V.6.B)

The story is from Genesis 19:12–17. The family group includes two men in front and a young woman with uncovered blonde hair holding two young children by the hand. The children have close-cut hair and wear loose ankle-length dresses. The burning Sodom is shown in the left background in a Giottesque perspective. Silver stain is used, as well as carnation for flesh tones.

PANEL: ABRAHAM BEGGING GOD TO SPARE SODOM AND GOMORRAH (Pl.29)

As told in Genesis 18:23–33. Abraham and God (with cruciferous halo) on the left, the avenging angel above, the burning city on the right. The angel's cloud is restored.

Lancet C: Infancy

One fine panel remains, the Annunciation to the Shepherds. Before the Oudinot restoration, four other thirteenth-century scenes were still recognizable and, according to Ramé, in mostly good condition: the Annunciation, the Visitation, the Adoration of the Magi, and the Nativity ("horribly mutilated").[59] There is no evidence of unusual iconographic focus.

Painter: The single remaining panel is a charming work of the Samson Master, a talented storyteller whose style is discussed below (pp. 147–49). This panel has been singled out for praise by Lafond in 1953 and illustrated in color in *Le Vitrail en Bretagne*, pl.I.

Restorations: Gruber contributed three panels plus sections in two others made by Oudinot. Gruber inserted a head by the Abraham Master into the modern panel of the Adoration of the Magi, and the head of the angel in the ogive is old.

PANEL: ANNUNCIATION TO THE SHEPHERDS

An angel with phylactery above; three shepherds below, a youth seated with bagpipes, and two falling back dazed, one with his hand to his eyes and the other "blinded." Among their charges are goats and pigs, which the Samson Master has introduced from the scene in the

Samson legend (F) where the saint changes pigs into billy goats. There is also a dog listening to the pipes.

Lancets D and E: The Passion

The cycle is nearly intact, with innumerable tasteful repairs. Lancet D has the Entry to Jerusalem (1509), the Last Supper, the Washing of the Feet, Judas receiving thirty pieces of silver, the Betrayal, and a modern panel.[60] The ogive shows the Dove of the Holy Spirit. Lancet E has the Flagellation (1509), the Carrying of the Cross (1509), the Crucifixion (by Gruber, replacing one seen in the mid-nineteenth century), the Descent from the Cross, the Marys at the Tomb, and a Noli me tangere.

Painter: Both lancets are by the Abraham Master, probable head of the shop.

Restorations: These two lancets have been lovingly, and apparently constantly, repaired. The most noteworthy of the new heads will be mentioned below. The new panels are three of 1509, and two by Gruber plus much of a third (Betrayal). The ogive of lancet E is by Oudinot. Between 1316 and 1328 the Dol east window was copied at the parish church of Saint-Alban (Côtes-du-Nord), discussed at the end of this chapter (*V.18*, and pp. 116f.). All four lancets of the east bay decorating the flat chevet of Saint-Alban contain a Passion series—like Dol, restored in the sixteenth century with Renaissance additions. The presence among the original 1316–1328 scenes at Saint-Alban of the three subjects of the Renaissance panels of Dol (Entry to Jerusalem, Flagellation, Carrying of the Cross) provides good evidence that the 1509 Dol restorations were not fanciful but faithful replacements of Gothic panels then in damaged condition.

1509 PANEL: ENTRY TO JERUSALEM (V.6.C)

The Christ on his small mount looks much like a *palmesel*. The left heads are repairs, the one at the far left a loose copy of the sixteenth-century design unlike any other in the window. It resembles eighteenth-century chalk sketching.

1509 PANEL: FLAGELLATION (V.6.D)

The right executioner wears a long padded tunic with many buttons, bloomers, tights, and a decorative, low-slung belt with dagger. His head is an old repair of some strength.

1509 PANEL: CARRYING OF THE CROSS (V.6.E)

The smaller scale in this panel may indicate that the scene is more closely related to the lost Gothic original. This scene and the Flagellation are close to the Gassicourt designs in general layout.

PANEL: LAST SUPPER (V.8.C)

Frontal blessing Christ, offering Judas (across the table) the sop according to the text of John 13:26. Peter to Christ's right holds the key; a youthful John sleeps on Christ's breast; Judas reaches for a fish in a dish; an apostle at the far right holds a table knife. These details

A

V.8.A–C *Dol. Abraham Master, east window, Bay 200,*
lancet D. (A) Judas receiving 30 pieces of silver.
(B) Washing of the Feet. (C) Last Supper (left two heads
are later replacements of different dates).

B

C

also occur at Saint-Père and in the badly worn panel at Gassicourt. Judas hides a round object.[61] There are many careful restorations, including the handsome chalice, which has a late Gothic shape. The two heads to the left are repairs of different times, the far left one from the fifteenth century(?), the other perhaps of the sixteenth. The heads on the far right are characteristic of the Catherine Master.

PANEL: WASHING OF THE FEET (V.8.B)

In generally good condition.[62] The iconography will be discussed below.

PANEL: JUDAS RECEIVING THIRTY PIECES OF SILVER (V.8.A)

A fine panel of a rare subject, discussed below (see n. 64). Even rarer is Judas's halo, which appears to be original (it is red), and the pile of coins instead of a moneybag.

PANEL: BETRAYAL

The figures of Christ and Judas are generally original, as is the lantern. The rest is by Gruber. Judas, without halo, kisses Christ who faces him.

PANEL: DESCENT FROM THE CROSS (V.9.C)

A fine, stately scene. The Virgin holds Christ's freed arm; Nicodemus removes the nail from the other arm with tongs; the feet are still fastened to the cross; Joseph puts his arms around the body to support it. St John's gesture of hand to sorrowing face derives from the Crucifixion, as indeed does the whole arrangement. This quiet, originally Byzantine type of Descent shows no sign of the extra figures or heated passions that are introduced before the end of the thirteenth century.[63]

PANEL: THE THREE MARYS AT THE TOMB (V.9.B)

The scene is very close to Gassicourt, though this angel wears brown and has no cross staff. The handsome painting of the sleeping soldiers, with its strong definition of mass, can be compared to that of the Catherine Master, who was a younger member of the shop. The right soldier's pink shield is a repair.

PANEL: NOLI ME TANGERE (V.9.A)

A beautifully preserved panel. The Magdalene crouches awkwardly and Christ (nude under his drape, and holding a cross staff as at Saint-Père) tilts away from her.

Iconography: The original scenes are fairly standard for the Gothic era except for the Marys at the Tomb—normally replaced by the Resurrection by this period—and the rare scene of Judas receiving the thirty pieces of silver.[64] Although the order of scenes, of course, may not be original in view of the numerous restorations, there is strong reason to believe that it is. Judas receiving the silver occurs in the synoptic gospels *before* the Last Supper, and only in

A

B

C

V.9.A–C *Dol. Abraham Master, east window, Bay 200,
lancet E. (A) Noli me tangere. (B) The Three
Marys at the Tomb. (C) Descent from the Cross.*

St John's account *afterwards,* as it does at Dol. Joannine detail also occurs in the Dol Last Supper, where Christ gives Judas the sop (John 13:26). The order of events in the Gospel of John also dictates that the Washing of the Feet follows, rather than precedes, the Last Supper, although the latter was invariably the order in French Gothic art works.[65]

The fact that the Passion window in the east wall of Gassicourt, roughly contemporary with Dol, also includes Judas being paid and the Marys at the Tomb (with the Resurrection as well), and lines up the scenes in the same order (Last Supper, Washing of the Feet, Judas Paid) suggests a common source or at least a common tradition.[66] Since the styles of the Gassicourt and Dol Passions are completely unrelated, the iconographic similarities bear investigation, which produces many questions, few answers, and some tantalizing speculations about the paths iconography traveled in the west.

Peter's gesture in the Washing of the Feet at Dol is also atypical of French Gothic tradition; he casually grasps his knee. If the restored Peter at Gassicourt can be trusted, his action too is atypical; he makes the "stand-off" gesture, which will be discussed below. Both have in common a negative factor: neither shows the "Byzantine" gesture of Peter holding his hand to his head, which refers to his request, "Lord, not my feet only but also my hands and my head." This "Byzantine" gesture, introduced to European art in the late tenth century, was standard by the Gothic period.[67] Thus Dol and Gassicourt are unusual for thirteenth-century France on several iconographic counts.

In an attempt to define their tradition I would like to introduce here the terms used, for lack of better ones, by Kantorowicz: Roman and Non-Roman (see n. 65 above). Concerning the iconographic sequence placing the Last Supper before the Washing of the Feet, he states: "It would be hazardous to call this sequence of events without qualification 'Roman,' although it is remarkable that in the Roman orbit there is a certain predilection for this chronology" (p. 221). About Peter's stand-off gesture, a parallel tradition in the early church to the "Byzantine" hand-to-head gesture, Kantorowicz makes the following remarks: "Monsignore Wilpert was inclined to call this gesture of humble remonstrance and deprecation the 'Roman gesture.' . . . In the later Middle Ages, the 'Byzantine' gesture dominated the West, whereas the 'Roman' gesture became comparatively rare" (pp. 235, 241). Turning from iconography to liturgy, Kantorowicz notes two traditions (pp. 243–49): "the Roman vulgate valid throughout the Western Church"; and a Non-Roman type found in the thirteenth-century offices of Rouen, Paris and the Sarum rite and marked by the concluding versicle *Domine, non tantum pedes meos sed et manus et caput* (Lord, not my feet only but also my hands and my head). To put liturgy in iconographic terms, the Non-Roman offices (Rouen, Paris, and Sarum) show Peter hand-to-head. Clearly if Gassicourt and Dol do not comply it is not because of regional preference.

Two data lead me to believe that Kantorowicz's Roman tradition might better be called "monastic." One is the general distinction of his Roman liturgies that, unlike the Non-Roman group, stress *caritas*—always a monastic concern. The other datum is more concrete, an art work: the psalter of Saint Swithin's Priory, Winchester (ca. 1150–1160).[68] This is a monastic psalter in parallel columns of Latin and Norman French, but neither the order of scenes nor Peter's gesture is the Non-Roman type of Sarum and Gothic France. The Last Supper precedes the Washing of the Feet in which Peter makes a stand-off gesture. If such a manuscript source is posited, one could say that at Gassicourt the gesture is similar but weaker, while at Dol the meaning has totally evaporated (which happens in both iconography[69] and liturgy, as Kantorowicz observes), and Peter just does not know what to do with his hands.

Thus Dol is farther from the source than Gassicourt, and the two have no direct relationship. Gassicourt was a small Cluniac priory, Dol was not an abbey at all. To attempt a reconstruction of the stemma one must now draw upon the iconographic study of the Passion window of the Benedictine abbey of Saint-Père de Chartres, in which I suggested that the source was a pen-drawn Romanesque psalter,[70] on the basis of a detail in the Saint Swithin's manuscript that is under discussion here. The Saint Swithin's psalter is without question a monastic work.[71] It seems clear that a similar monastic manuscript existed in an abbey in western France and, piling hypothesis on hypothesis, that abbey was probably Saint-Père. Gassicourt was in the diocese of Chartres. Dol, though much further away, had even closer ties to Saint-Père. St Gilduin, bishop-elect of Dol, was buried there and as patron was depicted in the axial clerestory.[72] More to the point, Clement de Vitré, elected bishop of Dol in 1231, retired from his post about 1242 to finish his days as a monk of Saint-Père de Chartres.[73]

What I am suggesting is that communities with art projects in mind contacted their friends, and that in various ways and at various times artists and models got together. This theory would seem to do some violence to our preconceptions about artisans' shop pattern-books, which were certainly also used, but the complex evidence presented above cannot be mere coincidence or a series of accidents, and in any case more than one model was probably used.[74] One assumes that the pen-drawn Romanesque monastic psalter housed at Saint-Père de Chartres was in some way important, sacred, or famous, and of that circumstance we may never know more.

Lancet F: St Samson of Dol

St Samson, legendary archbishop of York and actual founder of Dol, was the cornerstone of Dol's claim to primacy over the other episcopates in Brittany.[75] His relics were among Dol's greatest treasures, invoked against madness; as late as the nineteenth century the insane were chained in the apsidal chapel at the *chaire de Saint Samson* while mass was said for them.[76]

There was a real Samson, a sixth-century English missionary.[77] There was also an archbishop Samson of York, with whom the missionary was early and erroneously confused. Since the missionary Samson signed his name at the Council of Paris in 557 "Samson, peccator, episcopus," someone had evidently made him a bishop, but of what it is not clear, since Dol was not a regular see until after Brittany regained its independence from Charlemagne in the ninth century. The earliest vita (dated by scholars either seventh or ninth century) states that he was consecrated bishop before he left England, by St Dubric who in legend crowned King Arthur, thus germinating the myth that Arthur had advanced Samson to the archbishopric of York.

The lancet includes miracles from the vita and from later embroidered texts, the last being a propagandistic tract composed by Baudri de Bourgueil, archbishop of Dol (1046–1130).[78] Baudri's text, which went into the breviary, identifies Samson as archbishop without qualification and introduces into the miracles folk legends of great charm. This ingenuous charm is transmitted in the glass, where the basic message of the lancet, Samson's status as archbishop, is advertised throughout by his prominent and omnipresent cross staff.

Painter: The Samson Master, who also designed the Annunciation to the Shepherds (sole survivor of the Infancy cycle in lancet C), is a lively raconteur, master of the anecdotal detail.

Restorations: One panel is by Gruber and one is the charming channel crossing of 1509, discussed below.

1509 PANEL: SAMSON CROSSING TO BRITTANY (*V.6.F*)

Samson and two monks are at sea in an open boat with mainsail. Above, the devil breaks the mast. Ramé considered this detail the artist's fancy while Duine believed it was a folk story.[79]

PANEL: SAMSON AND THE DEMONIAC GIRL (*Pl. 30*)

This beautifully preserved panel depicts Samson's most familiar miracle, related by Vincent of Beauvais.[80] Samson (left) has just touched shore; water is at his feet and the boat prow is behind him. He is met by the local chieftain Privatus and his wife (right), who present their mad daughter in hopes of a cure. The painter has shown them as crowned king and queen and has ignored the fact that the wife, in the vita as well as the *Speculum historiale,* is leprous and also in need of a cure. But wild-eyed, hands tied, in a wrinkled yellow dress, their child is indisputably mad. Although this miracle was familiar enough to be illustrated in the so-called Breviary of Philippe le Bel,[81] the glazier has probably invented his scene by adapting a different source, probably a cycle of St Martin. The evidence for this hypothesis, which is based upon the fruited tree that bends over for no reason apparent in the story, will be examined below.

PANEL: SAMSON CURES THE DEMONIAC GIRL

This panel has been out of sequence since at least the nineteenth century, above the scene of Samson in Paris, and has therefore been regularly misidentified as one of the Parisian miracles.[82] The layout closely resembles the previous panel: Samson on the left with water still under his feet; king and queen on the right; mad girl in the same yellow dress. Samson's head and crozier have been poorly restored, and the dragon emerging from the possessed girl's mouth is mostly Oudinot's design. As one of the brown wings is original, there was evidently a Gothic dragon in the same location.

PANEL: SAMSON IN PARIS, BRINGING A DRAGON ON A LEASH TO KING CHILDEBERT

This beautiful panel relates a story from the vita. Samson, in Paris on political business, to bring back the young Breton heir from the court of Childebert, heard of a dragon on the banks of the Seine, which was terrorizing the citizenry. He led it to court on a leash, thus proving his powers, and then ordered it to be gone, which it did via the rue de Dragon on the Left Bank.[83] The king is enthroned in an arcaded interior. Note the fish-spine pattern in Samson's drapery. The Samson Painter's little dragon has a goat's head, a serpent's tail, large brown wings, and except for his green skin, the appearance and demeanor of a lapdog.

PANEL: SAMSON TURNING PIGS INTO BILLY GOATS (*V.10*)

Back in Dol, and according to a legend from Baudri's vita, the evil wife of Frogerius ordered her servants to turn the pigs into the cathedral's hayfield. Samson realized what was happen-

V.10 *Dol. Samson Master, St Samson turning*
pigs into billy goats, east window,
Bay 200, lancet F.

ing and turned them into billy goats, astonishing the herdsmen (shown in the panel) and
eventually the woman herself, who thereupon begged pardon and got the metamorphosis
reversed. Samson, as usual, stands to the left, while the two surprised servants at the right
point to the billy goats among their swine. The useless tree undulating up the middle is
another clue to the iconographic source.

Iconography: Although the Samson Master is not a very skillful designer, the awkwardness
of the lined-up figures is some indication that he was adapting the peculiar Samson stories
to a more firmly established visual cycle. As bishop-saints frequently appear before kings,
cure demoniacs, and so on, it might be assumed that he used standard shop patterns. This
practice would explain the mistakes, such as showing Privatus as a crowned king and his
wife as a queen with no symptoms of leprosy. Using shop patterns would also explain the
images' lack of focus, as in the scene on the shore with its graceless marginalia of the prow
and water. Similarly the pigs–billy goat scene is a standard lineup that does not even include
the villainess or her conversion (*V.10*).

 One clue to the existence of a more precise model is the bending tree in the first
demoniac scene (*Pl.30*). Since the story offers no excuse for it to lean over so prominently
or indeed for a tree with red seed to be present at all, the model must have included such
a tree.

 That model was probably the miracle of the pine, one of the established miracles from
the life of the most famous bishop of western France, St Martin. In the St Martin window of
Tours (Bay 204), the scene presents the tree in the center, the bishop to one side, and two
figures to the other[84]—the whole composition closely resembling the arrangement of Samson
metamorphosing pigs at Dol. In the same Tours window Martin heals a small demoniac
person in a layout almost identical to the one at Dol, the lunatic shown with hands tied and
a dragon rising from his mouth. The top of the same Tours bay contains a scene of Martin's

relics riding in a boat with mainsail very similar to the 1509 version at Dol, which may, therefore, be a closer replacement of the original than it appears.

It is not necessary to assume that the Dol glazier knew the Tours window, and indeed such knowledge seems unlikely. Rather, his model was a St Martin cycle of the same Touraine tradition. The regional iconography of St Martin, studied by Papanicolaou,[85] was well established in the twelfth and thirteenth centuries up and down the Loire. It was most likely authenticated by the authority of a venerable model residing in the pilgrimage church of St Martin at Tours. The nature of that model and of its iconographic stemmata, as Papanicolaou indicates, is a large subject badly in need of attention.

Lancet G: The Archbishops of Dol

Each of the six panels contains the same design: an enthroned archbishop-saint with cross staff and halo, blessing, surrounded by the six suffragan bishops of Brittany. The scene's formality as well as the cumulative rhythmic impact of its incessant repetition emphasize rank, hierarchy, and the heavy weight of tradition. It is therefore surprising to find that none of the five original panels are exactly alike. There are three different cartoons and even these replicas were executed by different masters with the obvious intent of creating as vast a population of individualized prelates as possible. Some are beautiful, majestic, or frozen, others are ugly, some smile or speak, some have big ears.

They are thus completely contrary to the large standing bishops of the transepts, which are carbon copies of each other, ideograms of "Bishop." This distinction is significant in characterizing the two glazing campaigns, since the east window atelier took the same care to diversify the rising souls in the Last Judgment above. In these two areas of the great window, lancet G and the Last Judgment traceries, the painters evidently worked together, not from haste but for the express purpose of idiosyncratically varying the results. It is a most unusual Gothic procedure.

The lancet's theme is past glory, since the Breton suffragans (Léon, Tréguier, Saint-Brieuc, Alet, Vannes, and Quimper) had long since switched their obedience to Tours, in most cases well before the papal bull of 1199 (above, p. 116). There are no inscriptions to identify the archbishop-saints.[86] Since continuity of tradition is implied, it is not unreasonable to assume that they are the first archbishops listed by the chapter of Dol in its twelfth-century adjudications with Tours over the primacy: Samson, Magloire, Budoc, Genevée, Restoald, and Armel. The authority for this list was the same text of Baudri de Bourgueil,[87] which was drawn upon for the Samson cycle of lancet F. The fame of Sts Leucher and Turiaw might suggest that they were included.[88] It is a moot point.

Painters: As stated above, the entire shop worked on the lancet. Each painter was usually responsible for an entire panel, though the Catherine Master (the subaltern in the shop) has done some heads in the panels of the Samson Master.

Restorations: One panel was replaced in 1509 (V.6.G). Its prelates are standing rather than sitting, and their crozier heads have the elaborate knops, stems, and volutes of the later period. Fifteenth-century repairs have provided some new heads elsewhere, for example the archbishop in the second panel from the bottom,[89] and some cheerful pink and lime green draperies.

Iconography: The three cartoons (panels 2 and 3, panels 4 and 5, panel 6; V.11.A–C) are variants from the same patternbook, one that had evidently been at Dol for some time.

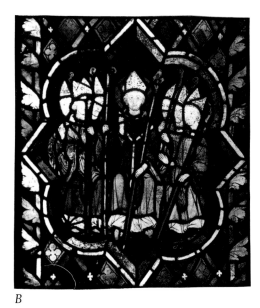

A B

V.11.A–C *Dol. Archbishop of Dol with his six suffragans, east window, Bay 200, lancet G. (A) Samson Master, panel 6. (B) Abraham Master, panel 4. (C) Catherine Master, panel 3.*

This continuity is suggested by two small details that repeat idiosyncrasies of the Master of the Blessing Bishops in the transept: the ring on the blessing hand and the fish-spine draperies (p. 124). All the original blessing hands have rings, and despite heavy repairs, original fish-spine draperies still exist in panel 3 (Catherine Master), panel 4 (Abraham Master), and panels 5 and 6 (Samson Master). They cannot therefore be attributed to the single master who produced the hieratic transept bishops, and indeed different elements of his style reappear in the two older masters of the east window, the Samson and Abraham painters. Since their styles and patterns relate to, but their approach differs from, the Master of the Blessing Bishops of the transept, it is my assumption that he trained them and that they had worked elsewhere. These and other stylistic assessments will be addressed below.

Lancet H: St Catherine (V.6.H, p. 131)

Although Catherine was universally popular in glass as well as in other media in the thirteenth century,[90] the choice of the wise virgin saint for inclusion in the great east window is strong evidence that the relic of her tooth, documented at Dol by the fifteenth century (see nn. 35, 37 above), already numbered among their treasures in the Gothic period.

Painter: The Catherine painter can be seen developing into mastership in this lancet. Panels 3 and 4 are formal, stilted designs typical of and probably provided him by the Abraham Master, though executed by the Catherine Master with his usual expressionistic vigor. (The effect is roughly similar to a Bach exercise played on electric guitar.) The Catherine Master's own swirling, centrifugally exploding compositions appear in panels 2, 5, and 6.

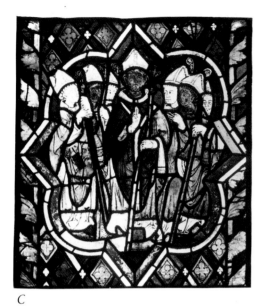

C

Restorations: The introductory panel was replaced in 1509, and its right side again replaced by Oudinot. Otherwise the lancet is in generally fine condition.

1509 PANEL: CATHERINE PRESENTED BEFORE MAXENTIUS

Only the enthroned Maxentius to the left remains from the sixteenth-century design. He holds a bare sword, point up.

PANEL: CATHERINE DISPUTING WITH THE PHILOSOPHERS

This is one of the Catherine Master's designs. Catherine stands to the right—actually she crouches in order to compress herself into the frame. The dove at her head appears ready to peck her. The philosophers fan out to the left like a hand of playing cards, the foremost seated in a spool-rack chair.[91] On the lectern before them is an unrolled phylactery, while Catherine holds aloft a clasped Gothic book; the artist thus refers to the received tradition that scrolls had preceded codices, and that their contained wisdom was superceded by that of Christianity.[92]

PANEL: MAXENTIUS ORDERS THE CONVERTED PHILOSOPHERS BURNED ALIVE

The philosophers in a flaming cauldron (repaired) rivet their attention on the hand of God (upper-right corner), their backs to Maxentius. The latter stands to the left, with crown and scepter. Above him to the right, paralleling the relationship of the hand of God to the philosophers, is a brown demon's head with pointed ears. The equilibrated design is typical of the Abraham Master's compositions, though executed by the Catherine Master.

PANEL: CATHERINE IN PRISON, CONVERTING THE VISITING EMPRESS
FAUSTINA AND PORPHYRIUS, CAPTAIN OF THE GUARD

The head of the empress is a dull repair probably traced from a broken original. This petri-
fied composition was probably provided to the Catherine Master by the Abraham Master; its
arrangement of architecture on one side, figures on the other, is very close to his scene of
Abraham and God arguing the fate of Sodom (*Pl.29*). The painting of the architecture has
the same dullness and cardboard appearance of the Catherine Master's scene of Margaret in
prison. Architecture was not his strong suit. The Abraham Master's cartoon probably was
not so bad, judging from his burning city of Sodom.

PANEL: THE WHEEL TORTURE (*Pl.31*)

This most familiar Catherine scene is depicted in a beautifully preserved panel full of the
Catherine Master's expressionistic energy. The spinning of the wheel sets up a spinning of
the compositional elements: the praying Catherine on the right, the hand of God above, an
astonished observer contracting behind her, angelic hands above and upper left giving the
wheel a murderous push, the cadavers of two mangled executioners sprawled beneath. Great
drops of blood fly from the wheel. The action spins counterclockwise before one's eyes in a
spaceless and timeless display of great power.

PANEL: CATHERINE BEHEADED AND HER SOUL TAKEN TO HEAVEN BY ANGELS (*Pl.32*)

This composition also whirls, but its pyramidal movement focuses strongly on the buoyant,
rising soul at the top center, the only Gothic soul known to me displaying a cheerleader's
chest. Two flanking angels hold the sheet, not so much in support of the soul as to screen
the remainder of its nudity from prurient view. The body of the headless saint (kneeling and
praying) forms the base of this vertical axis. An immense red rose floats beside it, graphic
symbol of martyrdom.[93] The composition's diagonal thrust climbs the left side via an angel
censing the ascending soul. On the right the diagonal is propelled through the executioner,
the Catherine painter's most remarkable figure, whose distorted form sends the line shooting
from the bottom-right corner up his sword sheath and silhouetted backbone to the soul on
high. One clawlike hand grasps the severed head by the hair while the other elastic arm
holds the sword in its sheath. His gesture seems to be one of withdrawing the sword rather
than replacing it, thus telescoping this martyrdom into a capsule whose sequential actions
take place in the observer's brain.

OGIVE: CATHERINE'S BEHEADED BODY ON MOUNT SINAI

The hand of God and a censing angel receive the headless praying corpse (draperies repaired).

Iconography: Though the cycle is quite standard, the compositions—certainly those de-
signed by the Catherine Master himself—are not transfers from a model but newly created.
The ogive contains the only even slightly unusual detail, a reference to the legend that
Catherine's head and body were transported separately to Mount Sinai.[94] This legend was
also followed in the Angers window of about 1180–1190, a wonderfully expressive creation

of the Angevin Romanesque.[95] Although its scenes and designs differ, the agitation and expressive power of the early Angers window define the stylistic orientation of the Catherine Master almost three generations later.

The Chantier of the East Window

I have mentioned frequently the three strong artistic personalities of the east window—the Abraham Master, the Samson Master, and the Catherine Master—and touched briefly on the nature of their relationship with the Master of the Blessing Bishops in the transept, in my opinion an earlier painter who trained their shop. I have also suggested that the Catherine painter learned from the others, and that his mastery develops to brief fruition only in the final two panels of the Catherine lancet. Before examining these judgments, the chronology must be addressed: if the master of the transept bishops was trained at Le Mans in the period 1255–1260, while the expressionistic legacy there of the Master of Bishop Geoffroy de Loudon was ebbing and dying, and if his work at Dol (of which only three figures remain) occupied the early 1260s, and if he trained the Abraham Master and Samson Master but did not himself work on the east window—does the style of the east window allow its dating in the 1270s, or beyond?

The great east window is deeply colored (though each painter had his own color preferences), and the *carré quadrilobé* medallions and mosaic grounds were traditional and long-lived Gothic elements. In the discussion of the *carré quadrilobé* frames of the Deacons window of Gassicourt (for which I have suggested a date in the 1260s; see p. 55), comparative examples were listed from as early as ca. 1215 at Sens. They also occur at Fécamp and then about 1275 at Saint-Urbain de Troyes.[96] At Saint-Urbain a deformation has set in: the lobes are much enlarged. Similarly at Dol, a deformation occurs with the Catherine Master, youngest of the chantier: the classic *carré quadrilobé* is altered, not for greater curvilinear emphasis as at Troyes, but through his typical explosive exaggeration. All points are sharp, even the lobes, making the shape into a centrifugal star.

The borders offer still more help with dating. Excepting only the fleurs-de-lis of the Infancy (lancet C) the borders are all standard motifs of rising foliage, comparable, for example, to the clerestory of Tours. But unlike Tours, real leaves appear at Dol, in a variety of natural shapes and with veins and fringed edges. Their naturalism significantly modernizes without yet altering or abandoning the old formulas (V.8.A–C, V.9.A–C, V.11.A–C).[97] As the new formulas of cassette motifs do appear in the grisailles of the Dol chevet, which as we will see probably date in the mid-1280s (pp. 150 f. below), a terminal date for the east window of around 1275 is reasonable.

The two established painters of the east window share in the traditions of the master of the transept bishops and seem to have used his patternbook (V.4). An occasional fish-spine drapery line appears and also is used in wings (angels, dragons). The early, deep red-blue color is adopted by the Abraham Master; the hooked inkblots and blackened triangles in the draperies are more typical of the Samson Master, whose color is softer and more modulated. The facial conventions are adopted sporadically. If there are similarities, there are also differences that suggest the Abraham and Samson painters had had experience elsewhere before they began the east window of Dol. If they can be accepted as the elders of that chantier, it is appropriate to analyze their styles first, and then turn to the hesitant mimicking by the Catherine Master and his first steps alone.

The Abraham Master, by virtue of his traditionalism and his production of the central areas of the window (Last Judgment rosace, Passion lancets D and E), would seem to be shop foreman. This status is also suggested by his providing cartoons for the Catherine Master's first essays (panels 3 and 4 of the Catherine lancet). His color is based on a red-blue axis and is very somber—angels often wear brown. This quiet, even gloomy coloration complements the still, ceremonial, measured tone of his compositions. He avoids overlapping to the extent possible, preferring a tableaulike presentation of frozen gestures, clear against the ground (V.9.C, p. 138). Where the scene requires a group he splays the heads out in a fanlike manner, providing no sense of the bodies beneath (V.8.B, p. 136). This fanning group has been copied from him in the Catherine Master's tentative design for the scene depicting Catherine and the philosophers, and indeed, the Abraham Master consistently appears as the Catherine Master's mentor. They make a peculiar pair, with an evident generation gap.

The compositional principles of the Abraham Master are clarity and equilibrium, and he simplifies designs as much as possible into two balanced forces. The effect can be dull. Where he can concentrate on a very few forms he achieves a sonorous resolved cadence; see, for example, the finest of his compositions, the Noli me tangere (V.9.A), where the two figures float without benefit of setting or baseline in perfect equilibrium, both tilting, each off balance without the other. Compositions are squared off, as in the scene at the Easter tomb, where the angel's wings form the framing corner (V.9.B). The Abraham Master regularly cuts off the bulges of the carré quadrilobé (with decorative arches at the top or bottom) or otherwise just ignores them.

The heads are neatly groomed. There is one basic male and one basic female type, both blandly good-looking and repetitive, making scenes appear as though they were being acted by families of identical quintuplets. They take things philosophically, with expressionless faces and eyes that do not always focus on the action. The hair is ropy but well constrained and only a drooping earlobe, like an earring, emerges beyond it; the drooping earlobe is particularly close to those done by the Master of the Blessing Bishops. As mentioned earlier, the nudes have a ribbed band at the neck, similar to that on an undershirt. The figure type is slender and insubstantial. The draperies hang straight and usually stop at the ankles; on the women they fall in a simple angular break at the ankles, the feet sticking out beyond. The Abraham Master's paint line is schizophrenic: thin and fine in the faces, much thicker in the draperies, where it is angular and jagged and achieves some sense of plasticity. The regional affiliations of this stylistic language will be discussed below.

The Samson Master prefers a lightened and more varied range of color, of greater subtlety (Pl.30). He likes color: his pine tree has red cherries; his pigs are pale yellow and pinkish brown; his dragon, pale green. He has no real compositional sense, and his designs are rather incoherent and messy, with forces reduced to two opposing sides that neither balance nor interact and are not well framed (V.10, p. 142). They fill up but do not utilize well the odd carré quadrilobé shapes. These failures can, of course, be excused in a new cycle like the Samson legend, but they also register in the otherwise charming Annunciation to the Shepherds, only survivor of his Infancy lancet. The charming detail is the hallmark of this prolix and anecdotal entertainer.

The Samson Master's figures are blocklike, thick, and gracelessly but solidly rooted, even when on tiptoe. Draperies bunch over their feet. The miters consistently appear to be a size too small, and slightly rakish. The faces have variety and focus and at times a sparkling

immediacy. They are rather ugly, with big cauliflower ears and tight button curls across the forehead. The miters, forehead curls, and triangular shading in the cheek are particularly close to the Master of the Blessing Bishops.

Like the Abraham Master, the Samson painter uses different paint lines for faces and for draperies. For face painting his line is very delicate and thin, with irregular thickened accents, as though a fountain pen were dropping ink droplets at intervals. In the foreheads and cheeks is often a broad triangular wash, not always easy to see. The Abraham Master never uses these washes, and the Catherine Master tries his hand briefly before abandoning them completely. The Samson Master's drapery line is thicker than the face line, angular like the Abraham Master's but with a more emphatic stroke, and occasionally punctuated by the black troughs and triangles of the transept campaign.

The Catherine Master's hand can be recognized in a few tentative heads in the traceries and in a single panel and isolated heads in the archbishops of Dol lancet (*V.11.C*, p. 145), practicing the idiosyncrasies of the other two painters. His art never blends in, even when he is copying by rote, and unless his mature style is comprehended, his early attempts often can be taken for later repairs. The Margaret and Catherine cycles, to the far left and right, are his, though so little remains of the Margaret panels that their place in his development cannot be judged. The final two Catherine scenes, his youthful designs, are, in both the medieval and modern senses of the term, chefs d'oeuvre.[98] One wonders where his career led him.

The Catherine Master's color is bright and direct, employing pure primaries unabashed (*Pls.31, 32*). His own compositions are circular in conception, expanding into the whole irregular space and at times even spilling over the frame. The story elements in his two final panels are organized on expressionist principles without concern for scale or spatial relationships. They are remarkable compositions for the thirteenth century, and their forceful exaggerations place him among the great western painters.

His figures are much larger in scale, more expansive, than those of the older masters. The faces are ugly, as are those of the Samson Master usually, but always full of strength. They are never beautiful even when it would be appropriate. His women are amazons. He never uses the fine facial line, which both other painters employ, even when he is carefully copying their cartoon. His drapery painting at first is chaotic and disorganized, and always thicker than the others', but in his developed work his touch becomes handsomely economical, a few powerful lines articulating volume effortlessly. His command is such that plasticity is evoked at will, when needed to further the expressive force. Though his student exercises derive from the formulas of both other masters, in his final work his art is his own and gimmick-free: the very essence of western expressionism in color and in drive, in methods and in goals.

The Catherine Master looks back to the expressionism and color of the Plantagenet west, the twelfth-century art of Poitiers, Le Mans, and most particularly Angers. And he looks forward to the forceful expressionism and strong, bright color of the final western ensembles of the Gothic era: Sées, Vendôme, and Saint-Père. It is not necessary to treat his development as some sort of mysterious evolutionary process, however. A young artist who worked as hard as he did at copying his elders certainly did not train in a vacuum in Brittany. It seems most likely that he wandered at least to Angers, where one can imagine his astonished reaction when he first looked at the expressive power of the late twelfth-century Catherine window there.

I am led to hypothesize this picture of an adolescent on vacation because of the stylistic affiliations of his elders, the Abraham Master and the Samson Master, to that region. The last Gothic windows of Angers, those of 1240–1260, are the closest equivalents to their style. In Angers Bay 101, left lancet (St Julien),[99] many elements of the anecdotal style of the Samson Master are evident, such as the draped feet, the facial types, and the thin line used in painting those faces. The drapery painting in this lancet is quite varied but includes the angular twiglike line seen at Dol. The other late lancet (Angers Bay 101, right) has a more tableaulike balance and clarity, close to the Abraham Master's ceremonial approach. The decorative vocabulary of Angers includes mosaic ground and borders like those of Dol and even a *carré quadrilobé* cycle (St Lawrence, right lancet of Bay 103).[100] The Dol painters develop and polarize a broad range of stylistic elements of the Angers ensemble.

Except for the unusual Bay 101 (left lancet) at Angers, however, the drapery painting is not one of these elements. For a comparably abstract approach to draperies, based on angularity, on broken and unbending line accented by dark triangles, one must recall the rural conventions of the Evron Master (Le Mans upper ambulatory Bay 105; *II.7*, p. 28) and the Appliqué Master of Sainte-Radegonde (see pp. 32–33 and 95–96). Both these glaziers are as gifted raconteurs as the Samson Master. The Appliqué Master's slashing draperies and caricatured faces (*IV.13*, p. 95) are closest of all, his robes accented with dark triangles and his ugly faces (*IV.7*, p. 89) much resembling those of the Samson Master. When he tries very hard to produce a beautiful face (as for the Christ in the Pas-Dieu) the result looks closer to the Abraham Master's people. Their women's faces are composed of the same formulaic elements (for example, the Dol scene of the Marys at the Easter tomb). Thus in Angers, or more accurately the Angevin countryside on both sides of the Loire, is the rootstock that produced the great east window of Dol.

I have indicated that I see a dynastic connection between the painters of Dol, both the master of the transept bishops and the three artists of the east window. Without indulging the imagination unduly, we can envision a framework of training and work experience for them that suggests a greater local continuity than has seemed to be the case in the monuments studied in previous chapters. Very little is known about the changing social patterns of glaziers in the Gothic period, but the meager evidence suggests that the profession was peripatetic at the beginning of the thirteenth century and beginning to stabilize by its final decades.[101] Annual stipends first appear at Saint-Denis in the mid-1280s; several individuals can be tracked through the surviving tax rolls of Paris of the period 1292–1313. A century later, the later medieval dynasties of glaziers already begin to appear, as at Rennes, and glaziers join the stable household of the duc de Berry. Perhaps such a family settled itself at Dol at this time. The *Livre rouge* of Dol cathedral (written between 1312 and 1323; Arch. dépt. Ille-et-Vilaine G281) records obituaries for a landowning glazier named Guillaume Bordin, his widow (or daughter) Onessia la Vitrere (possibly a practicing glazier as well), and heirs among whom is an energetic and successful Julian Bordin.[102] As Jean Lafond once put it,[103] "Il me faut toute ma prudence . . . normande pour ne pas avancer" that the subject of the present essay has been the three Bordins of the cathedral's cartulary.

The Grisailles of Bishop Thibaud

When Thibaud de Pouancé took office as bishop of Dol in 1280, the cathedral probably had stained glass at least in the nave and in the great east window. Thibaud was born not far

from Dol, about halfway on the direct path from Dol to Angers, to the seigneur of Pouancé and La Guerche, a minor border lord who voted with Brittany.[104] Though his precise family genealogy is unclear, it is more than obvious that Thibaud was what Walter Cahn has called "upward mobile."[105] He is variously identified as canon of Dol and of Angers, and dean of Bayeux, but it is certain that he was already precentor of the prestigious cathedral of Reims by 1275, as proven by his surviving seal of that date.[106] He was by this time active in the service of Philippe le Hardi: in 1276 he and the Templar Ernoul de Visemale were sent to Germany to question a "wise woman" about the guilt of the queen in the suspected poisoning death of Philippe's eldest son, Louis; in 1283 he served in the judgment for the king against his uncle Charles d'Anjou over the county of Poitou; and he was in Gerona on the king's business in 1285, when his expenses included five horses, which collapsed under him en route.[107] He was an executor of the king's testament.

Until Philippe died in 1285, it is unlikely that Thibaud spent much time in Dol exercising the bishopric to which he had been elected in 1280. In 1285, however, he seems to have brought his impressive energies home. In the years remaining until his death in 1301, Thibaud marshalled the Breton bishops against the barons and sometimes against the duke, who after 1286 was the forceful Jean II; he nagged the pope until in 1299 the privileged primacy of Dol over the bishops in Brittany was, to a degree, reaffirmed; and in general earned himself such a reputation that on his death a friar denounced him from the pulpit:

> nomine Theobaldus de Poence: et erat de magnis magistris regis unus; homo potens, episcopus Dolensis fuit, superbus raptor, et luxuriosus, et omnibus aliis viccis plenus, quibus mundus solet implicari. In fine fuit infirmus, et contractus cogitavit quod nullum bonum fecerat in tota vita, sed semper malum; vidit quod erat obligatus ad penam inferni. (Tunc dixit:) Ha! Deus meus! dixit ipse, video quod teneor propter pravitatem meam ad dampnacionem eternam; et eternitas non habet finem! Precor te, ut, ex tua misericordia, et merito passionis, velis mihi concedere quod anima mea sit in igne inferni omnibus diebus, usque ad diem iudicii, ita quod tunc miserearis mei et non puniar eterna pena![108]

> Thibaud de Pouancé: he was one of the high magistrates of the king; a powerful man, a bishop of Dol, a haughty plunderer, dissolute, and full of all the other vices known to the world. In the end he was sick, and he knew that he was in such a state because, in his entire life, he had never done any good, only bad. He saw that he had to suffer the punishment of hell. (Then he said:) Oh! My Lord!, said he, I see that I must suffer eternal damnation because of my depravity—and eternity has no end! I beseech thee, by thy mercy and thy suffering, to see to it that my soul stays in hell's fire forever, right up to the day of judgment, so that at that time thou may have pity on me and I may not suffer eternal punishment!

Thibaud went to hell, but before he did, he had given his cathedral an embroidered cope, established a prebend and later his anniversary,[109] and he had no doubt seen the glazing to completion.

Bishop Thibaud de Pouancé's stained glass coat of arms, *de gueules à 2 léopards d'argent à la cotice d'azur* (Pl.27), was moved to its present home in the north transept in the 1880s, from the central light beneath the rosace of Bay 216, the great south window.[110] Although the rest of his glass in the south window has been lost, including the fleurs-de-lis noted by de Lasteyrie in 1853, it is possible to conjecture about its original appearance (see p. 154). I

A

V.12.A–B *Dol. Grisailles, clerestory.*
(A) Bay 201. (B) Bay 209. *B*

have suggested already that Thibaud would certainly have placed his arms and gift in the pres-
tigious east window had it not already been glazed upon his arrival. The existing clerestories
of the choir (*Pl.33*), however, and the two pierced triforium bays beneath them (Bays 101
and 102), can probably be attributed to Thibaud, for several reasons.

Stylistic analysis suggests the optimum date for these grisailles, and for their borders,
in the mid- to late 1280s. They were drastically overhauled in 1890, but enough old glass
remains, notably in the traceries and on the north,[111] to compare well with Brune's descrip-
tion of 1850:

> on trouve épars quelques fragments assez considérables de grisailles ornées de
> bordures fleurdelysées et de petits fleurons de couleurs rouge, jaune et bleue.
> Les dessins qui composent ces grisailles sont très-variés, et tracés en noir avec
> une extrême délicatesse.[112] (*V.12.A–B*)

First, the borders: they are made up of *France* (fleurs-de-lis), *Castille* (castles), castles alter-
nating with cassette motifs (a simple geometric knot interlace), and cassettes alone. While
France and *Castille* borders were common after the Sainte-Chapelle, particularly in the
1250s–1260s, they last until well past the end of the century. Before 1300, however, they

begin to be combined with cassette motifs and are increasingly replaced by such motifs in the fourteenth century, particularly in Normandy. Examples of combined borders can be found in Saint-Père de Chartres hemicycle Bay 6 (ca. 1295) and nave Bay 26 (ca. 1305–1315); at Evreux the transition can be followed step by step; and at Saint-Ouen de Rouen, the cassettes have triumphed.[113] At Dol most borders are straightforward heraldic motifs; only two are combined with cassettes and only two are of cassettes alone (*V.12.B* and *Pl.33*). It is thus reasonable to date them toward the beginning of the disintegration of such heraldic borders, that is, in the 1280s.

The grisailles themselves are the type of design known as bulged quarries, in which the leading and strapwork have begun to straighten toward lozenge shapes, modified into geometric patterns accenting the corners and the small colored boss in the center of each panel. Grounds are still hatched; foliage sometimes still grows centrifugally both up and down, though at times it already arises from a central stem (*V.12.A*); and the leaves are no longer palmettes but a wide range of quasi-naturalistic forms resembling maple, geranium, and strawberry leaves. While these are all transitional features occurring in this generation here and there in different combinations of the old and the new, the Dol foliage is easier to pinpoint within the development. All the leaves are fringed and their stems curl naturalistically (*V.13*) around and under the main stalks in a manner most reminiscent of the final (ca. 1285) patterns at Saint-Urbain de Troyes.[114] I have never seen this kind of twisting stem foliage datable any earlier. However, it does not yet incorporate recognizable clover and ivy, which make their appearance in the 1290s, in the Saint-Père hemicycle triforium,[115] in the St Vincent chapel of Beauvais (ca. 1290–1295) with borders of intermingled *France* and cassettes, and at Evreux (the second chapel south of axial) in the late 1290s.[116]

If the Dol grisailles date about 1285 they should resemble those of the cathedral of Sées, and so they do. There are several different grisaille types at Sées—one of the most distinctive being the colored latticework we have already remarked upon at Sainte-Radegonde—but the bulged quarry designs share with Dol the characteristic thick, swollen, inflated aspect of their leaves and strapwork. This swollen style is totally different from the languorous hybrid growths of Poitiers cathedral (and the Infancy cycle of Sainte-Radegonde), from the just-

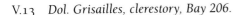

V.13 *Dol. Grisailles, clerestory, Bay 206.*

mentioned colored latticework, or from the more elastic snap of the stems in northern gri-
sailles. It is, in fact, close enough to Dol to suggest that Bishop Thibaud found his chantier
in Lower Normandy.

In addition to the characteristics so far noted (fringed leaves, swollen foliage and strap-
work), the Dol grisailles include several noteworthy motifs. One is a sort of flower pot from
which leaves occasionally emerge (V.13); some Sées grisailles also have them.[117] Another looks
like a ball bearing floating in the ground. Sometimes they are clear and unpainted, but more
often they are black with a reserved cross or rosette motif, resembling a sort of sacred
cueball. While they appear intermittently in northern French grisailles in the second and
third quarters of the thirteenth century,[118] Dol is a very late example. The Breton taste for
such reserved motifs is evident, at even larger scale, at Saint-Méen and at Léhon, both dis-
cussed later; there they reach the size of baseballs or even softballs.

The case rests that Bishop Thibaud arrived at Dol in the 1280s to find colored glass
probably in the nave and almost certainly in the big east window, and that in addition to a
lost south (and north?) transept facade, he glazed the remaining bays of the choir and
transept—with grisailles. Since he was not a man to do things cheaply, why? Since he *was*
a man intimately familiar with the court, the answer seems obvious: he was importing Pari-
sian fashion. The combination of grisailles flanking a colored axial ensemble had been intro-
duced in the 1240s in Paris (Saint-Germain-des-Prés Lady Chapel) and adopted later in the
Tours triforium and at Saint-Germer-de-Fly. As a Parisian mode it was even older and more
venerable than band windows, which were exported to the west at precisely the same time,
to the Victorine cathedral of Sées.[119]

It is probable that the great transept facades of Dol (Bays 215–216) did receive band
windows, or possibly all-grisaille lancets,[120] since they were not considered worthy of resto-
ration in 1509 with the "bella fenestra," Bay 200, in the east end of the chevet. It has ever
been the fate of grisaille to be thus overlooked.

Band windows would have been peculiar-looking and difficult to design in the very
short and stubby clerestories of Dol (Bays 211–212). It is possible, however, that Bishop
Thibaud did his best to have banded windows, that is, combinations of grisaille and large
colored figures, where they would show most. To put it another way, it is possible that the
blessing bishops, which I believe came from the nave, were moved into the east transept
clerestories and surrounded by grisailles[121] at his orders—moved, that is, from the nave
clerestories, where they were largely invisible, to a location from where they were (and
are) in full view of the congregation at the crossing, and in fashionable grisaille surrounds.
Though the facts remain that their style relates to about 1255–1260 and that their borders
have been sliced, who did it, when, and why, can only be guessed. Bishop's Thibaud's back-
ground and motivation at least make him a contender.

The Question of a Breton Dynasty

I have suggested that the glazing remaining at Dol ranges in date from about 1260 (the
blessing bishops), from the 1270s (the east window), and from ca. 1285 (the grisailles). I
have also theorized that the first master came from Le Mans, at a fairly early point in the
glazing program there; that there was some relationship between him and the masters who
began the east window; that the latter also had been influenced from the Anjou; and that the

grisailles relate to those of Sées cathedral (Orne). Sées is actually closer to Dol than is Angers, but the three form an isosceles triangle, a wedge defining the ancient borderlands of western France. If the stylistic analysis outlined above is integrated with the sparse documentation of a glazier and his clan at Dol (and I certainly do not insist that it can be so integrated), one would expect at the very least to find some other evidence of the clan's glazing activity in the *dolois*. This thin ice is worth the trouble of traversing for its interest to social history. It seems increasingly clear that the last quarter of the thirteenth century marked the transition in work habits of glaziers and possibly of other artisans as well, from itinerant to more stable and rooted.[122]

There are pathetic scraps of late thirteenth-century stained glass still to be found near Dol, at the former Benedictine abbey churches of Saint-Méen-le-Grand and Saint-Magloire in Léhon-près-Dinan. As we shall see, they are related to Dol. The Léhon atelier worked later, between 1316 and 1328, at the parish of Saint-Alban (Côtes-du-Nord), and there, too, the long shadow of Dol still falls. The style reflects the absorption of many other western elements, and the technique hesitantly tries out the new silver stain then appearing in the European craft, but Saint-Alban pays its greatest debt to Dol: it is essentially a late copy of Dol's great east window.

Saint-Méen

The abbey of Saint-Méen-le-Grand (Ille-et-Vilaine), to the southwest of Dol, was founded about 550, was reestablished by the Benedictines about 1008, after the Viking raids, played an active and varied role in the post-Renaissance period, and now serves as a parish church.[123] The ruined nave was demolished in 1771 and the cult disoriented in the remaining building, so that the great south window-wall is now in the "transept" to the left of the altar.[124]

In the traceries of this south bay are seven fragments of a Last Judgment including the arms of the dukes of Brittany. Though the fragments have been moved about among the lobed lights of the traceries, the existence of old glass filling many of the lobes would seem to indicate that the original location of this Last Judgment was here. It can be considered a *précis* version of the Last Judgment of the Dol east window traceries, and Dol's Abraham Master probably produced it. At least two of the remaining heads are his work.

Two nineteenth-century descriptions by Ramé (1847)[125] and Brune (1846, repeated by Pol de Courcy in 1864 and André in 1878),[126] as well as a drawing of one panel by Ramé (*V.14*),[127] indicate that the debris has suffered additional losses since then; and a photograph of October 1919 (MH 42102), though too fuzzy to be very useful, does show that the fragments have been moved again in the present century. The existing fragments are a coat of arms of the dukes of Brittany; Christ showing his wounds; an angel with spear (and modern oliphant); an angel with oliphant; souls rising from tombs (*Pl.34*); St Peter (with keys) leading a soul from the hellmouth (cf. Ramé drawing); and two souls (taken and rearranged from the St Peter group since the Ramé drawing was made).[128] Old decoration remains in the lobes of the central rosace, two of the sexfoils in the level beneath it, and two of the cinquefoils in the row below.

The coat of arms, now moved into the center of the main rosace, was in its uppermost light in the nineteenth century, according to Ramé. These are the arms used by Mauclerc, his son Jean le Roux, and his grandson Jean II (*Pl.35*): *Dreux echiqueté (or et azur) au canton*

V.14 *Church of Saint-Méen-le-Grand (Ille-et-Vilaine). St Peter leading souls from hell, now in traceries of south window. Drawing by Alfred Ramé, ca. 1845.*

d'hermine.[129] The shield is now surrounded by modern glass and evidently lost the Dreux border *gueules* in the move but is otherwise a fine example of Gothic heraldry. Although either Jean I (d. 1286) or his son would be possible donors, the former is more likely. Not only do the style and iconography of the Last Judgment relate closely to the Dol east window, which I have dated in the 1270s, but the amicable relations between Saint-Méen and Jean le Roux would suggest his patronage. In 1259 the abbey cooperated with the duke's policy of quiet acquisition, trading him the priory of Sarzeau for certain tax revenues.[130] The glazing was possibly part of their reward.

In the nineteenth century the main rosace was filled, as at Dol, with Christ showing his wounds. This panel, beautifully preserved but for one piece of the ground, retains the same iconographic detail: blood spurts out from the wounds, as at Dol, Le Mans, Châteauroux, and ultimately Bourges; and the rigidly frontal Christ sits on a backless, arcaded gold bench. The Abraham Master's touch is apparent at Saint-Méen in the face and hair and in the formulas of the nude torso. Another fragment that can be attributed to the Abraham Master is the angel with oliphant (as at Dol, a huge belled instrument gripped with both hands).

The angel with spear (and modern oliphant), though a battered fragment, also repeats a subject of the central rosace of Dol.

The panel of the souls rising from their tombs (*Pl.34*), which is in fairly good condition, resembles Châteauroux or Sainte-Radegonde more than Dol, where the souls are cramped and truncated in the limited space. The scene of St Peter leading the souls from the hell-mouth recalls the peculiar iconography of Dol, where it is Christ himself who appears at hell to release a few (*V.7.D*, p. 132).[131] Among the fragments lost since the nineteenth century are two blessed, shown as at Dol—crowned, seated next to one another, one of them playing a viol.

In addition to the standard floriate palmettes (shown in Ramé's drawing), the lobes of the tracery lights contain sixteen decorative motifs of a most singular type. They are circles of white or yellow glass, covered with opaque black paint from which a six-rayed star or six-petaled rosette has been reserved. As decorative elements they thus resemble the sacred cueballs of the Dol grisailles, although those at Saint-Méen are large enough to decorate a lobe (*Pl.34*), approximating the size of *boules* used in French parks on Sunday afternoons. While there is nothing precisely similar at Dol, *boules* can be found among the meager debris at Léhon.

Saint-Magloire de Léhon

The tale of the priory of Saint-Magloire in Léhon-près-Dinan (Côtes-du-Nord)[132] is as complex and sad as that of Saint-Méen. Founded by a Breton king in the ninth century to house the relics of St Magloire, it was pillaged by the Vikings, established as a dependency of the Benedictines of Marmoutier in the twelfth century, suppressed in 1767, sold in 1792 and abandoned, its stained glass removed to its adjoining parish church. The monks' church

V.15 *Church of Saint-Magloire de Léhon (Côtes-du-Nord), Beaumanoir chapel. Stained glass fragments, photographed by René Couffon before 1935.*

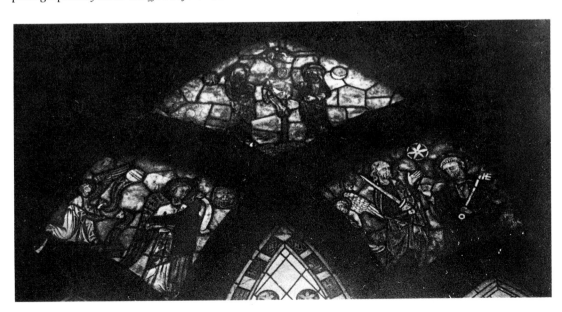

V.16 *Saint-Magloire de Léhon. 19th-cent. drawing of fragments by J. Even. The abbey was then a ruin and the glass installed in the axial window of the parish church next door. After Fouéré-Macé, 1892.*

quickly became a roofless, overgrown ruin.[133] At the end of the nineteenth century the ruin was given to the parish, which roofed and restored the old priory church from 1885 to 1897 and then moved in.[134] The salvaged stained glass panels, which had spent the nineteenth century in the parish church's axial bay, were moved back to the monks' church, not to the rebuilt axial bay but to the chapel of the Beaumanoir family south of the choir (now a sacristy). A few fragments still remain there, though a photograph of 1935 (*V.15*) indicates that these poor survivors have since sustained even another restoration and further loss.[135] In the words of Jean Lafond, "lorsqu'un vitrail n'est plus scellé dans sa fenêtre, il a tot fait de gagner la porte . . ."

Remnants still existed (in 1978) in the old Beaumanoir chapel: a Crucifixion with Mary and John; Sts Peter and Paul (two larger fragments; *Pl.36*); part of an angel and a bearded head (smaller fragments) (*V.17.D, C*); four *boules,* including a six-rayed star (two examples), six-lobed rosette with reserved cloverleaves in the lobes, an Agnus Dei disc (*V.17.A–B*); and four pieces of border (two castles and two interlace cassettes). The figures, all wearing green and yellow, are characteristic of the Samson Master of Dol: blocklike and awkward but stable bodies, the draperies painted with blackened troughs and triangles; ugly faces with a marked hairline and hard, repeated curls at the forehead, bulbous ears with great black channels, a line delineating the cheek. The touch has thickened and evolved toward greater abstraction,

however, and can now be compared with the art of the expressionists of Sées, for example the heads in the St Augustine chapel.[136] This evolution is also apparent in the *boules,* which much resemble those of Saint-Méen (*Pl.34;* the stars are nearly identical) but surpass them in complexity. The designs of border motifs are comparable to the Dol grisaille borders. Thus everything indicates a dating contemporary with them, in the 1280s, related to the Samson Master's work of the 1270s and to the windows of Sées ca. 1280.

This hypothesis is a skeleton that we can flesh out, to a limited degree, from old photographs, drawings, and verbal accounts. Couffon's photograph of 1935 (*V.15*) shows several more angels in the same style (one with censer, one with garment and phylactery), several more *boules,* and a border of mixed fleurs-de-lis, castles, and interlace cassettes. In addition Couffon mentions a Virgin and Child under canopy adored by a kneeling monk-donor under another canopy, the whole in red, yellow, and green. Without a photograph judgments are impossible, but the color, the arcades, and indeed the grouping are found in the clerestory

V.17.A–D *Saint-Magloire de Léhon, Beaumanoir chapel. Fragments.*
(A–B) Boules. (C) Head, John the Baptist(?). (D) Angel.

A

B

C

D

of Sées. This suggests a relationship of the existing Peter and Paul fragments to the grand army of standing apostles with attributes, many in the same colors, also at Sées.

Moving back in time we find the next witness in the Abbé Fouéré-Macé, proud curé of the parish during its reclamation of the ruined abbey church. In 1892, before the consecration and before the glass was moved from its nineteenth-century haven in the axial bay of the parish church, he listed its subjects.[137] His account confirms the Peter and Paul, the Crucifixion, and the angels; and it mentions the mixed border of the 1935 photo as well as a border of *Castille* and another of fleurs-de-lis, which he saw surrounding the Virgin and Child and the donor-monk. In addition he adds a blessing bishop, St Magloire (now lost, as well as a pair of donors added ca. 1400).[138] Alfred Ramé in 1855 described the same window in much the same way, noting the borders of *France* and *Castille* and adding:

> une simple grisaille du commencement du XIVe siècle, semée ça et là de
> médaillons de couleur, où on reconnait un crucifiement. Saint Jean-Baptiste,
> saint Pierre et saint Paul, enfin saint Magloire entre deux donateurs, et une
> Notre-Dame aux pieds de laquelle est agenouillé un prieur de Léhon.[139]

Ramé's account thus adds the fact that grisailles were included.

A nineteenth-century drawing by J. Even (*V.16*) of the central lancet shows the mixed border, the crucifixion, and the blessing St Magloire. At the time of the drawing the base of the Crucifixion was already lost, but the Christ still had arms, which had disappeared when the photograph of 1935 was made. Behind the blessing St Magloire is an inscription, in the manner of Sées:

PM AGL [Maglori Parisios?]
AP AR

He stands and blesses absolutely frontally, however, in the exact posture of the rigid blessing bishops in the transept of Dol (*V.4*, p. 125).

The Even drawing indicates a trellis ground behind the Crucifixion, now replaced. This is another significant detail, to which one can add Ramé's comment of 1847: "On y distingue entre autres un saint Pierre et un saint Paul, s'élevant sur un fond de mosaïque comme dans les vitraux de la première époque."[140] Thus trellis grounds were general at Léhon. There are none at Dol, but they do appear in the bays of the Le Mans clerestory (Bays 200, 209, 203, and 204),[141] which form the stylistic heritage of the frontal blessing bishops of Dol. Since *boules* are also found in some of these early Le Mans bays,[142] it seems very likely that they as well as the latticework ground traveled to Dol and then to Léhon in the shop patternbook of the first master of Dol, along with the frontal blessing bishop, the ring on his finger, and so on. Even's drawing of Léhon is too sketchy to record a ring on the blessing hand.

The final (earliest) witness of the Léhon glass is a description of 1636, when the glass had not as yet left the great east window-wall of the priory.[143] The description states only that the great bay contained the arms of Beaumanoir: *d'azur billeté d'argent*. While nothing allows a precise dating of the tombs from the Beaumanoir chapel,[144] the arms seen in the axial bay in 1636 can be verified for Jean de Beaumanoir from the Chifflet-Prinet Roll of 1285–1298, and they also occur in the march of Brittany in the Wijnberghen Roll (datable before 1285 to 1304).[145]

To restate the hypothesis: the stained glass of Léhon was probably provided by the community (the monk-donor) and the Beaumanoir family (the arms). It included the

priory's name-saint Magloire as well as Peter and Paul and standard Christological sub-jects.[146] Its style is, in my opinion, a development from the formulas of the Samson Master of Dol, which (possibly influenced by the younger Catherine Master there) has thickened the fine line of the face painting of the Dol east window and enlarged the stylistic compo-nents in the direction of the exaggerations of Sées cathedral. The similarities to Dol in face and drapery painting and in figure design are in addition to those that can be attributed to a Dol patternbook: the frontal blessing bishop Magloire, and perhaps the postures of the Crucifixion.[147] Since it is my belief that the Dol patternbook had been made up at Le Mans during the campaign of the 1250s, motifs such as the trellis ground and the *boules* would also have come from there.

The original glazing of Léhon also included elements comparable to the later grisailles of Dol, beginning with grisaille itself, and including the border motifs. These have already been related to Sées, and at Sées other similarities to Léhon suggest such a synchronism: the bright color marked by green, yellow, and red; the standing saints with attributes, rooted in three-quarter view; the arcaded Virgin adored by the arcaded donor; but most notably the facial painting of the Sées expressionists, whose swollen ears, button curls, V-slashed cheeks, extended eyebrows, and flat-bottomed eyes are vocabulary in the same language. The pre-cious fragments at Léhon are now a battered few, but enough to forge the link between Dol and Sées.

Saint-Alban

Far thicker fog shrouds the medieval history of the parish church of Saint-Alban (Côtes-du-Nord) than of the monastic communities of Saint-Méen and Léhon. Couffon struggled with the meager documentation, in the only published study of the glazing.[148] In 1469 the parish was the repository for the wheat measure used by the lords of Montafilant, and their arms were then in the window traceries.[149] The present church is largely a seventeenth-century construction; only two bays remain of the Gothic chevet (*V.18*). This, like Dol, has a flat east wall decorated with a great window. At Saint-Alban, however, the glass reveals a hesitant use of the new technique of *jaune d'argent* (see Chap. I, n. 3).

As at Dol, the Saint-Alban east window was restored in the sixteenth century, when six panels as well as new lancet heads were added. In the nineteenth century the traceries, which by the fifteenth century had included coats of arms of local nobility, were restored with what was, without much doubt, their original subject, the Last Judgment. Still remaining are a few scraps of the Gothic tracery glass, indicating a tracery program very much like Dol's: an angel blowing an oliphant (left kite), a number of heads of the resurrected souls, and so on. In 1926–27 the window was restored by the Parisian atelier of Tournel.

The original program, then, was a reduction of Dol: Last Judgment in the traceries, with the Passion cycle in the four lancets below. Of the Gothic glass fourteen panels remain, their order now running left to right, reading from the bottom row up, and although the six Renaissance panels are presently located in a block at the top, their subjects would only minimally interrupt the Gothic sequence. The Gothic·scenes are as follows; those subjects found in the Gothic series of Dol are indicated by DG, those in the 1509 replacements at Dol by DR:

V.18. *Church of Saint-Alban (Côtes-du-Nord). East window, photographed by René Couffon before 1935.*

Row 1	—Debris composed in 1926 restoration, including some Gothic heads	
Row 2 [150]	—Entry to Jerusalem (two panels)	DR
	Washing of the Feet	DG
	Last Supper	DG
Row 3	—Garden of Olives (two panels)	–
	Betrayal	DG
	Christ before the grand priest	–
Row 4	—Flagellation (*Pl.37*)	DR
	Christ before Pilate	–
	Carrying of the Cross	DR
	Deposition	DG
Row 5	—Entombment	–
	(and three Renaissance panels)	
Row 6	—Holy Women at tomb	DG
	(and three Renaissance panels)	

The Renaissance subjects, not now in any apparent order, are Crucifixion, Pietà, Descent to Limbo, Resurrection, Noli me tangere, and Ascension.[151] A useful control on the Gothic order is provided by the borders, which alternate in the four lancets: blue filets and ermine (lancets A and C, first and third from the left), red filets with castles (lancets B and D). Thus the present sequence of the Washing of the Feet and the Last Supper, reversed here from the order at Dol, is probably original. The unusual placement at Dol has been related to a monastic source,[152] which was no doubt unknown to the painter of Saint-Alban and therefore corrected by him in accordance with normal French Gothic practice. He has repeated several of the Dol subjects, notably the Holy Women at the Tomb and the quiet, dignified Deposition,[153] which are all the more *retardataire* at the late date of the Saint-Alban glazing.

This dating can be established by the heraldic motifs in the borders: the ermine of Jean III, duke of Brittany, and the castles of his duchess Isabelle de Castille (d. 1328). Although as Couffon points out they were married in 1310 and Jean III inherited his duchy in 1312, the dating can be narrowed still further. The Breton dukes only abandoned the *échiqueté* arms of Dreux for the *hermine plain* in 1316.[154] The east window of Saint-Alban thus dates between 1316 and the death of the duchess. While it is not likely that Jean III himself had anything to do with the tiny rural parish of Saint-Alban, we can hypothesize a more likely donor of the window containing his arms. Saint-Alban was in the county of Lamballe, ruled by the lords of La Hunaudaie, the family Tournemine, who had acted as agents of the duke since the time of Mauclerc.[155] This was their parish; in 1290 one of them even signed his name as "Alanus dictus Tornemine, de parrochia Sancti Albani." The Tournemines were wealthy and cultivated a romantic lineage back to English kings; in later days a Breton expression ran, "Monsieur de La Hunaudaie est un peu moins grand seigneur que le roi."[156] In 1304 a document lists the duke's lieutenant-general as Olivier Tournemine. He or another Olivier was a Breton hero in service to St Charles de Blois as late as ca. 1340.

The east window of Saint-Alban, dated between 1316 and 1328 and probably given by Olivier Tournemine, joins the handful of datable monuments where the new glazing technique of silver stain makes its first bows in Europe. I have tried to establish elsewhere the

probable chronology for its dissemination as a new technique from the court in Paris after the death of Philippe le Bel in 1314.[157] Saint-Alban was thus up-to-the-minute.

The messy, tentative appearance of the stain at Saint-Alban would suggest that 1316 is more likely than 1328, by which time the exquisite Canon Thierry strip of the Chartres south transept bears witness to the French glaziers' mastery of the new technique. The earlier date is similarly suggested by the evident stylistic connection between Saint-Alban and the debris at Léhon, by the same atelier or even the very same painter. The Léhon fragments (*Pl.36* and *V.16*) probably date in the 1280s, and are the hesitant, eclectic product of a young artist. The window of Saint-Alban has the assurance and definition of a work of his old age.

What has happened to the Léhon master's style in thirty years, and what elements from the even older Dol window seemed striking enough to him to copy at such a remove in time? To put it another way, what is there of Dol in the Saint-Alban design of post-1316, and what formal and stylistic elements were rooted elsewhere? From Dol, besides the general program and some details of the selection and appearance of scenes, comes the use of medallions and, more notably, even their peculiar shape, a version of the *carré quadrilobé*. Like certain elements of the iconography, *carré quadrilobé* medallions in 1316 emanate a distinctive aura of déjà vu.

The color, on the contrary, owes nothing to the deep saturated Dol ensemble of over a generation before. All the grounds are red, both inside and beyond the medallion frames. The silver stain, applied none too skillfully, contributes a rather raucous yellow note. Blue is the first choice for robes, border filets, and so on. In short, the Saint-Alban window is a composition in the red-yellow-blue primaries so typical of the late western school, a coloration seen at Poitiers and at Sées, and standard through the campaigns of Vendôme, Evron, and Saint-Père, all of which were more or less complete when the window of Saint-Alban was made.

The painter's youthful designs for Léhon, almost as deeply colored as Dol, precede his exposure to this influence. His handwriting is nonetheless recognizable, notably in the painting of facial features, marked by narrow-set eyes in heavily shaded sockets, angular hooked eyebrows, broad straight noses with spreading tips, ears set too low, stubby Us defining the cheek, all distributed on ill-shaped craniums (*V.17.C–D*). Similarities are apparent in the draperies as well, painted with thick stubby lines, forming forks or troughs infilled with shading almost like niello work. His was not a graceful touch in the 1280s, and over a long career his painting became, as one might expect, not more refined but more sketchy and impatient with unneeded detail. The Léhon artist was not a great master and his forms remained stiff and badly articulated, but his development is instructive nonetheless. At Léhon the figures are awkwardly but carefully posed in total isolation, each an island, a problem unto itself, the additive work of youth (*Pl.36*). By the end of his career at Saint-Alban he had stopped fussing over detail and over drapery folds and had worked out a narrative style of considerable charm, the wooden forms as unbending as ever but combined in dramatically functioning clumps, and the faces of far greater variety and of more immediacy and intensity of expression and interaction. Those of villains are often excellent caricatures of brutality, and some of the heads of Christ are genuinely beautiful (for examples of both see the scene of Christ before the grand priest). He found his metier as a storyteller.

The elements of his late style not derivative from the model at Dol or from his own early work at Léhon are also noteworthy. The most obvious of these is the *jaune d'argent*, clearly a new trick for the old dog, very sloppy and unsure, sometimes too heavy, sometimes

too light, not always confined accurately within the outlines of forms. Besides hair, beards, utensils, and so on, he tried it out instead of potmetal yellow glass for the cassettes and castles of the borders, and he even attempted several rather unsuccessful gold-brocade robes. The result is so hesitant and unjelled that it seems likely to be one of the first essays in the new technique remaining to us. A comparison can be made with two other early examples of silver stain, one a lancet of 1313 in the Norman parish of Le Mesnil-Villeman, and the other the first works by the Pilgrim Master of Evron using *jaune d'argent.*

The first comparison is more accurately a contrast. The small stained donor panel of the parish church of Le Mesnil-Villeman (Manche)[158] is a pure Norman work, permeated by the Norman flavor: the borders include small heads, of great popularity in Normandy later; the figures are strongly outlined, their careful silhouettes strongly contrasted with the spare drapery line within, augmented by a delicate wash; and the figures are posed in a frozen tableau under a double canopy (*Pl.38*). The silver stain of Le Mesnil-Villeman, although a little irregular, has been applied with a lighter and more sensitive touch, and the artist has even experimented with it on blue glass in a try at making green.

The second comparison is to a western artist whose career, like that of the Léhon master, spanned thirty years. First identifiable about 1290 in the final work at Vendôme, the Pilgrim Master worked on and off at Evron through several decades, his late works (notably a series of bishops now in Pennsylvania; see p. 291 f. below) incorporating simple essays in the new silver-stain technique. Neither the Saint-Alban nor the Evron glass adapts well to the delicate new stain, which provides a most unsatisfactory vehicle for the dramatic vigor and energetic distortion of western expression. The quiet tableau at Le Mesnil-Villeman is clearly the winner in this contest, and the quick popularity of the new stain in Normandy is easily understandable.

If the comparison of the gaudy primary-triad coloration of Saint-Alban with that of the much earlier glazing at Poitiers or Sées is valid only in the most general terms, the relationship with the late western ensembles employing the same color gamut is much closer. The first campaign of Evron (Bays 107 and 105; see Chap. VIII, p. 284 f. and also Chap. VII, p. 240), in the 1290s, is the probable training ground of the Léhon master not only in color but also in the specifics of facial and drapery painting. Though the large, forceful apostles of Bay 105 are works of far greater strength and articulation than his art was ever to produce, they indicate the nature of the tutelage, while in the traceries of Bay 107 the very same lessons are repeated by the less-skilled brush of a country apprentice. The Bay 107 designs reproduce the color and painting language of the master of Bay 105 in a charming nursery-land singsong: puppetlike Christ waving his wounded hand, a nutcracker of a Matthew evangelist symbol, a web-footed eagle of St John, and gingerbread lion and ox. Particularly notable is the formal, iconic, frontal mask of Christ, which most probably was in the shop patternbook. The master of Bay 105 adapted it for the frontal apostle (Paul?) of his central lancet; the village apprentice of Bay 107 copied it for the Christ showing his wounds; it reappears in the Evron axial bay, in the Gnadenstuhl; and the Léhon Master made use of it in his designs for the Last Supper and even for the Flagellation at Saint-Alban (*Pl.37*). Color, facial and drapery types, and even an interest in narrative—among the Pilgrim Master's many talents—could have been absorbed by the Léhon master from a few seasons' employ at Evron.

Brittany, which of all France was to suffer a particularly turbulent and agonized fourteenth century, developed in the fifteenth and sixteenth centuries a flourishing stained glass art the equal in quantity and originality to any center in France.[159] How fitting it is, that the

first Breton window to employ the new technique of silver stain, so basic to the later art, should be a reductive facsimile of the great Gothic *maîtrise-vitre* of the east wall of Dol. Earliest glass ensemble remaining in Brittany, and a work of art that has been cherished from the moment of its fabrication to the present, the great east window-wall of Dol, as well as the fragmentary transept bishops that suggest its roots, the surrounding grisailles that complete its ensemble, and its several Gothic progeny in the neighboring *dolois*, are a Breton treasure equally unique and no less worthy of renown.

✳ Epilogue ✳

Dol is a mirror. Looking into this reflecting glass, architectural historians have seen now England, now Normandy, now Anjou. The glass historian also perceives a range of reflections, all of western France. The school of Dol can be traced nearly as long as can the western school itself, from at least 1260 until nearly 1320. Its relationship to the west is in some ways the classic one of provincial reflection, such as, for example, late medieval Spanish panel painting, reflecting now Tuscan, now Flemish schools as fashions and artists came and went. At Dol the earliest style, of the blessing bishops now in the transepts, derives from Le Mans, but from mid-campaign at Le Mans, about 1255–1260, before the Principal Atelier had come to dominate the work. The great east window of Dol reflects the end of the campaign at Angers, probably including the lost transept roses, of perhaps the 1260s. Thus the vast window-wall at Dol can be dated ca. 1265–1275. The grisailles of the chevet are in the Parisian mode, in execution after the manner of Sées, and datable to the advent of the king's trouble-shooter Bishop Thibaud de Pouancé, following the death of Philippe le Hardi in 1285. Thibaud probably also glazed the lost south window-wall with grisailles or band windows; he may even have moved the blessing bishops from the nave clerestory into their present positions facing down the congregation from the heights of the transepts. Their format of grisaille and color striping bears comparison with the vertical band windows of the Saint-Père chevet, ca. 1260–1270. Contact with Saint-Père should not come as a surprise when we realize that a bishop of Dol had retired in the 1240s to become a monk of that abbey. The iconography of Dol, however, bespeaks the folk world of contemporary Sainte-Radegonde—a Last Judgment with many medallions advertising the relics (Abraham's oak, St Margaret for women in childbirth, St Samson who cured madness)—while shrilly emphasizing Dol's legendary claim to archepiscopal rank.

Of the three painters of the Dol east window, the Catherine Master, youngest and in training during most of its production, displays briefly an awesome talent that ranks him among the supreme artists of the Gothic west. While his art, too, reflects that of Angers, it recalls not the careful Angevin Gothic of those who trained him but the expressionistic verve of the Plantagenet glazing also housed in Angers cathedral. The Abraham Master—his chief teacher, perhaps his father?—later worked at Saint-Méen-le-Grand producing, probably before the death of Duke Jean II in 1286, a Last Judgment in the image of Dol. The Samson Master's style is trackable, less directly, in the fragments at Léhon, where a blessing bishop

and other *manceau* details turn up in concert with grisaille and a new forceful drawing reflecting the latest western work at Sées about 1280.

The precious scraps at Léhon evidence both a careful attention to past, even archaic, models and a tentative, unfocused essay into new directions of color and exaggerated line. In sum, they seem to be very youthful designs by a craftsman whose later, developed style appears after 1316 at Saint-Alban. The mature design at Saint-Alban is that curiosity, a copy of a venerable masterpiece (the great east bay of Dol), but like such copies of old masters executed by Manet or even Picasso, the artist has selected and rejected, translated and modernized. The new technique of *jaune d'argent* makes a simultaneous appearance at Saint-Alban, in the western school at Evron less than one hundred miles distant, and even closer at Le Mesnil-Villeman in Lower Normandy. The Breton school thus provides a parallel track to the main theme of this book, a secondary plot line, testimony of the changing fashions of the west reflected as in the eye of a beholder.

CHAPTER SIX

Lower Normandy:
The Cathedral of Sées

Causae pulchritudinis sunt quattuor . . . scilicet magnitudo et numerus,
color et lux.

—JACOBUS DA VORAGINE, *MARIALE*

By THE STANDARDS of its own century as well as by those of our own, the cathedral of Sées (Orne) is *pulchra,* endowed with size and harmony, color and light (*VI.I*). But as Jean Lafond once commented, the stained glass of Sées has not been lucky.[1] He noted that it had been consistently dated incorrectly and illustrated by drawings of the nineteenth-century restorations. His pilot study of 1953 brilliantly rectified these mistakes by establishing the identifications of donors documented from 1270 to 1285 and by illustrating with several of his own superb photographs the finest remaining fragments of four of the glaziers.[2] If Sées has been unlucky—and its history is pockmarked with major disasters—it has had the good fortune to be studied by Jean Lafond. A generation after Lafond's work, it is now possible to refine some of his hypotheses by reference to the documentation of the nineteenth-century restorations (which were unavailable to him). And one can clarify some of his judgments concerning those restorations, since, sad to say, the medieval glass has now deteriorated further and thus set off the later work more distinctly.[3] The donors identified by Lafond and others can be further illuminated by heraldic, archival, and iconographic data. On the strong outlines of his study emerges a richly nuanced and detailed picture of this provincial borderlands cathedral at the end of St Louis's reign.

Lafond concentrated his appreciation on the elegance and fine drawing of the two Norman masters: in my nomenclature, the Protais Master and the Nicholas Master. The art of the great expressionist to whom I shall refer as the Magdalene Master he dismissed as "curieuse." One of the few remaining masterpieces of this artist, a panel unknown to Lafond, can now be identified among the fine glass of the Glencairn Museum (Academy of the New Church, Bryn Athyn, Pa). The brusque exaggerations of the Sées clerestory have been even less sympathetically received by art historians: "des corps, trapus à l'excès et parfois difformes . . . des visages souvent d'une laideur cocasse."[4] Westlake (1882) put it more noncommittally, remarking that "Sées Cathedral contains a number of figures which appear to be of an entirely different type to those I have seen elsewhere in France."[5]

Yet no observer has failed to applaud these ugly windows for the "sonorité magnifique" of their color.[6] It is a color harmony whose gaudy vigor is a major component of the mature western style: rooted in the Plantagenet Romanesque; kept alive in the strong regional styles

168

VI.1. *Sées cathedral. Choir.*

of the borderlands (the Poitevin Blaise Master, the Evron window at Le Mans, the Catherine Master of Dol); and in triumphant flame in the late western hemicycle ensemble of Saint-Père de Chartres. The balanced red-blue-yellow coloration of Sées is a simple declarative sentence in this regional dialect.

The recognized glory of color at Sées is the more noteworthy considering that the glass ensemble is composed entirely of band windows, with no exception made even for the normally colored axial lights. The secure dating to 1270–1285 makes Sées cathedral the first

precocious example in existence of such an ensemble.[7] Nearly synchronous are the two band windows inserted into the medallion clerestories of Tours, the shutter windows adapted to the new choir clerestory of Saint-Père, and perhaps the similarly adapted transept clerestories of Dol.[8] But Sées is a full statement, in its peculiar, primitive, provincial tongue, of the formulas typical of fourteenth-century Saint-Ouen de Rouen and the cathedral of Evreux. How to explain this? Where do band windows come from? Lafond believed that such strong shifts in fashion were dictated from Paris, and I have already examined the logistics of such transfers, not primarily by means of artists but via the wishes of donors.[9] Certainly the provincial art of Sées, antonym of the Court Style, caps this argument.

If so, the Parisian connection of the patrons of Sées must be established. This is not difficult. The cathedral of Sées was served by a Victorine community of canons regular, reformed by the Parisian abbey of Saint-Victor in 1131,[10] and following the Augustinian rule until its secularization in 1547.[11] The Victorines and the reformed community of Lisieux maintained close ties with Sées in the Gothic period.[12] Officials of Sées continued to be drawn from these contacts. Among the glass donors, Bishop Jean de Bernières had been a canon of Lisieux when called to Sées; Gui du Merle, bishop of Lisieux and donor of a clerestory window at Sées, was a relative of the canon of Sées Raoul du Merle, who had been elected bishop in 1202 but was opposed by John Lackland.[13]

Although Saint-Victor's overall medieval appearance was lost to us when the church of 1518 was built,[14] the original twelfth-century choir and crypt were conserved behind it (as a chapel dedicated to St Denis)[15] until the razing of the whole complex in 1811–1818. The description written by Piganiol de la Force in 1742 indicates that its windows had been remade in the thirteenth century.[16] The thirteenth-century construction at Saint-Victor included the large cloister (from which one entered the crypt of the chapel of St Denis) as well as the infirmary chapel. The windows of the latter, shown in a fifteenth-century manuscript (VI.2), have *rayonnant* traceries not unlike those of the generation of Sées.[17] In 1832 Langlois recalled the abbey razed ca. 1815:

> L'établissement religieux qui présentait dans Paris, avant la révolution, le plus
> haut degré d'intérêt sous le rapport de sa vitrerie peinte, était sans contredit
> l'abbaye de Saint-Victor; c'était un véritable musée chronologique en ce genre,
> car ce célèbre monastère renfermait une nombreuse série de vitraux dont les
> époques de fabrication s'étendaient du XIIe. ou du XIIIe. siècle au XVIIe.[18]

From the sequence of witnesses above, it can be hypothesized that Saint-Victor had thirteenth-century glass in *rayonnant* traceries in the old choir.

What it looked like is unknown. It is believed that the study of the Pseudo-Dionysius at Saint-Victor in the twelfth century had provided the intellectual energy behind Abbot Suger's aesthetic choices, such as the appearance of his stained glass.[19] But in Paris, by the *rayonnant* Gothic period, the light metaphysics of the Areopagite had, one might say, removed the deep blue filter.[20] The complex sociopolitical struggle fought with philosophers' verbiage, which Chenu labeled "Augustine versus Pseudo-Dionysius," had culminated in the Sorbonne's Ten Propositions of 1241, after which Light was light. It is most likely that the Victorine brain trust would have seen this intellectual imprimatur quickly reflected in their church glazing. In short, the *rayonnant* glass of Saint-Victor would have been among the most likely places to find band windows in post-1241 Paris.[21]

VI.2 *Scene in the infirmary chapel of Saint-Victor in Paris, showing* rayonnant *window traceries. Jacques Le Grand, early 15th cent., Paris, Bibl. nat. MS lat. 14245, fol. 191v, detail.*

I am by no means suggesting that quiet, rural Sées was an intellectual center comparable to the Victorines of Paris. In 1250, following his first visitation to Sées, Eudes Rigaud felt compelled to address the following letter to the bishop. The intimate eyewitness view it provides of the cathedral canons and their country life may excuse the length of the quotation:

> Item, we found not only that the rule of silence is infringed, but, indeed, that it is hardly observed at all, whether in the church, the cloister, the refectory, or the dormitory. The canons, even in the presence of lay folk, quarrel with one another, and the Divine Office is disturbed. Item, we found that quarrels of this kind are not curbed by anyone. Item, the cloister is very badly kept, and in it the canons gossip and sit with lay folk, nor is there anyone to keep out those who wish to enter. Item, the canons invite seculars, both cleric and lay, and even dubious characters, to eat with them, bringing them into the refectory without bothering to ask permission. . . . Item, in the dormitory we found unseemly serges and coverlets, that is to say, striped ones. Item, . . . almost all of the archdeacons are publicly known for having property. . . . Item, Brother Oliver has been defamed for disobedience or impudence; Gervaise [*sic*], the cellarer, and the cantor, of incontinence, of too much running about the town and drinking there, very often without any companion and without permission. Item, the same cellarer and cantor frequently absent themselves from Compline and from Matins; item, we found the cellarer to be publicly known for having property and to be negligent in celebrating his Mass, which he omits altogether. Item, we found Hugh Cortillers ill famed of engaging in trade, of possessing property, of incontinence, and of inebriety. Item, we found William of Herbei publicly known for having property and for incontinence; he wears unseemly clothes, to wit, those of many colors, and even wears them when he walks abroad, and without a surplice or frock. . . . Item, we found that the canons, on going into the town, very frequently stopped for a drink in the houses of the townspeople.[22]

Eudes's report suggests that the popularization of Parisian aesthetics in the cathedral of Sées was probably related to the intellectual sophistication of the abbey of Saint-Victor as the

Voragine quotation that begins this chapter is to the great *summa* of St Thomas Aquinas. It was a very distant mirror.

Pockmarked History

The Gothic art of Sées has been ignored in modern times. Unlike the majority of French windows, the Sées glass was not removed during World War II or photographed for the Monuments historiques. It has thus remained nearly inaccessible to study. Heavily restored in the nineteenth century but ignored in the twentieth, it suffers increasingly from "glass sickness," and some windows are now nearly impossible to photograph.

Worse, Sées has suffered from a widespread misunderstanding (*VI.3*). In the final quarter of the nineteenth century, facing collapse and oblivion, the magnificent cagelike chevet was dismantled stone by stone and ultimately replaced, upon new foundations sunk to a depth of some five to eight meters, by the architect Ruprich-Robert (*VI.4*).[23] This widely publicized and drastic act of mercy was generally accepted at the time not only as imperative but as a reliable reconstruction.[24] It later became fashionable among architectural historians, however, to smile or, worse, to ignore it.[25]

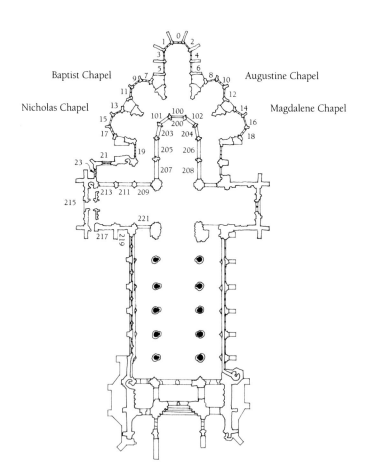

Plan of Sées cathedral.

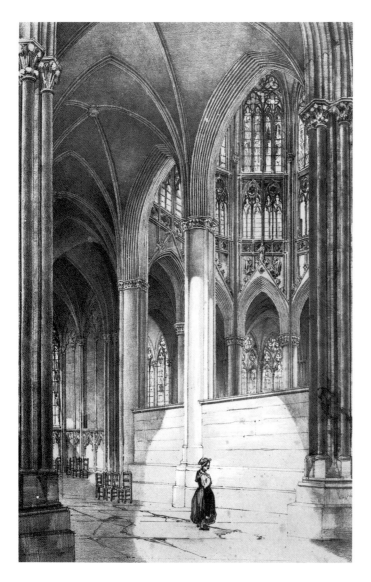

VI.3 *Sées. Choir ca. 1845 (before Ruprich-Robert's reconstruction). After de la Sicotière and Poulet-Malassis.*

But Sées is not another Pierrefonds, the imaginative product of nineteenth-century "Gothicke." The trend to ignore it has at last been reversed in the architectural analysis of 1969 by Pierre Héliot, who takes the *rayonnant* chevet of Sées seriously and without apology.[26] It is my intention to do the same for its stunning ensemble of windows. But first, let us review the remaining slings and arrows of its outrageous fortune.

Founded by the sixth century and dedicated to Sts Gervais and Protais, the cathedral of Sées enters medieval history on the words of Orderic Vitalis.[27] In 1048 the early Romanesque church was burned by its own bishop, to dislodge two brothers "scelerati" who had seized it. The church that replaced it, dedicated in 1126 in the presence of the king of

VI.4 *Sées. Choir ca. 1892 (during Ruprich-Robert's reconstruction).*

England, was destroyed either when Louis VII burned Sées in 1150 or when Henry Plantage-
net attacked the town in 1174. These fires damaged the foundations, not built down to
bedrock to begin with, causing Ruprich-Robert to exclaim when he excavated them: "Il y a
quelque chose de véritablement pénible à voir la magnifique architecture qui s'élève au-
dessus d'un pareil chaos."[28] The existing Gothic church was constructed over this subterra-
nean chaos. The nave, built in the Norman style in the early thirteenth century, retains none
of its old glass.[29] The transepts and chevet, built in the *opus francigenum* of St Louis, are
resplendent with band windows.

On the Gothic campaigns the cartulary maintains a conspiracy of silence, as Barret has
remarked: "Chose étrange! . . . Le cartulaire du chapitre offre pour le XIIIe siècle une série
d'actes, pour ainsi dire jour par jour; mais des travaux, des maîtres de l'oeuvre, des ouvriers,
il n'en est pas mention."[30] Evidence of the dating of the Sées chevet thus derives not from
documents, of which there are none, but from the donors whose images and names appear
in the stained glass. They are men who flourished 1270–1285.

From that moment until almost modern times, a litany of wars and raids interweaves
with that of restorations and repairs. In the fourteenth century, Sées was on the front lines
of the English war, its cathedral fortified as Fort Saint-Gervais and burned in 1336, 1353,
and 1375. A charter of Charles V details the events and damages of 1375 and orders the
repairs, among which can be identified two fine new windows made for the north chapels

and an isolated head here and there.[31] In 1450 the cathedral was pillaged by the English.[32] Among the windows of the restoration of Bishop Jean de Perouse were fifteenth-century figures of the cathedral's patrons Gervais and Protais, added to the choir triforium (noted by Guilhermy in 1860, and since lost). In the next century Bishop Jacques de Silly (1511–1539) restored the cathedral and its glass, adding his arms in so many traceries throughout the church that later observers credited all the glazing to him.[33] An 1845 description of his restoration of the north rose allows us to qualify it as one of those consolidations that restored by regrouping old glass fragments wholesale: "pour la composer, il employa les anciens vitraux de l'église, . . . de fragments de toute espèce qu'on ne s'est nullement donna la peine de chercher à raccorder. Ses armes . . . se voient sur cette rosace."[34] In 1563 and again in 1568 Protestant mobs vandalized the church.[35] The arms of Bishop Louis du Moulinet (1564–1601) were added to the glass thereafter and have been lost in recent times.[36] Unspecified glass is listed in the increasingly piecemeal and desperate restorations of about 1610 (Mgr. Bertaut) and after a hailstorm of 1611 (Mgr. Suarès), of 1740–1775 (Mgr. Néel de Christot), and of 1780 (Mgr. d'Argentré), work that was undertaken as the structural deficiencies of the foundations grew ever more obvious.[37] The choir vaults were replaced with wood; a baroque dome was removed; the towers were reinforced; the structure was condemned in 1740; by 1800 the cathedral was unsafe for the cult, the end in sight.

In 1811 Napoleon came, saw, and, shocked at the decay and abandon, acted, exiling the old bishop and signing the order that turned the tide.[38] The nineteenth-century restorations were extensive and can be charted in the archives. Unspecified repairs were made on the windows in 1817–18 and 1837, and in the 1850s the south transept glass was "restored" by Steinheil and Coffetier in a manner that obliterated for posterity any trace of medieval remains.[39] The restoration of the north transept by Steinheil and Leprévost followed in the 1870s. While severe by modern standards, this project retained much medieval glass (which was polished) and copied the replaced designs with some accuracy.[40] Guilhermy's visit in 1860 provides a valuable control on this work. For the restoration of the glass of the choir chapels and clerestories that occupied Leprévost from 1879 to 1895,[41] there are as controls not only Guilhermy but also the account published in 1876 by Marais and Beaudoin.[42] The choir clerestories retain their medieval appearance, and their old glass was not reworked, although many heads and an occasional panel were replaced. In the chapels, which had sustained more loss over the centuries, Leprévost recopied all of the grisailles and greater amounts of the old designs. As Lafond states, "il est rare qu'un personnage 'ancien' n'ait pas été complété pour une bonne moitié."[43] Among these precious old designs, which are free from overpainting though now increasingly weathered and disintegrating, are many interesting works and several masterpieces.

Summary Catalog

The summary catalog of medieval glass of Sées cathedral that follows is compiled from observations in the mid 1970s and incorporates the notes of Guilhermy, Lafond, and others. Though comments on donors, iconography, and style cannot be avoided in passing, the emphasis here is on questions of authenticity and original presentation in order to prepare the stage for those discussions to follow. Sées is a distinctive monument, none would deny.

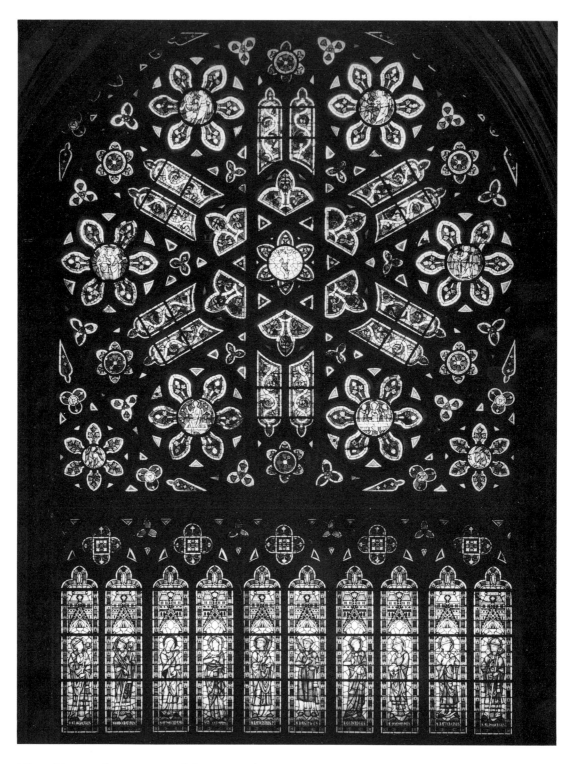

VI.5 *Sées. North rose. Lancets below are modern.*

An accurate assessment of its glass makes clear its signal importance in tracking and defining the western expressionistic art.

North Rose (Bay 215; VI.5)

Although the gallery below it has been lost, the rose itself retains about a third of its original mosaic and foliage decoration.[44] The highest concentrations of old glass are in the spoke at the 12 o'clock position and the area from 6 o'clock to 9 o'clock. The six medallions of Resurrection subjects, modern copies by Leprévost, are nonetheless reliable evidence of the medieval program, since they retain western variants that will be discussed below. The original of the Holy Women at the Tomb (at 9 o'clock) was inventoried in Paris in 1884.[45] The color harmony of this rose can therefore be studied, as can its unusual iconographic detail and its type of decorative foliage. It will be seen that all these factors suggest connections with western monuments and a probable dating in the early 1270s. The north rose of Sées is therefore probably the earliest glass remaining in the church.

North Transept Clerestories (Pl.39)

Among the six band windows, on the west (Bays 217, 219, 221) only a few old grisailles and canopies remain; on the east, two of the three bays (Bays 209 and 211) retain some old glass, polished and retouched: five figures and grisailles.[46] The fine apostle figure (Pl.40), now in the Victoria and Albert Museum, London, I believe came from the middle bay on the east (Bay 211).[47] Though the back has been polished and the painting slightly reinforced, it is a fine example of the Master of Jean de Bernières, which probably left the cathedral before Guilhermy's first visit in 1837.

North Transept Chapel and North Ambulatory

The first bay of the north ambulatory (Bay 19) is lit by a large window of six lancets, under an elaborate rosace glazed with mosaic similar to that of the north rose: combined palmette, formalized shamrock and more naturalistic fringed leaves. The Agnus Dei at the center is Leprévost's copy after the original illustrated in a drawing of the 1850s (VI.6).[48] The heavily remade but authentic grisaille pattern is a colored latticework similar to that found at Sainte-Radegonde.

The north transept chapel has two band windows with even more gaudily colored grisaille. The unusual border pattern looks heraldic—it might be blazoned *gueules au pal d'argent surmonté d'un trèfle d'or*—and its bright coloration may have dictated that of the filets coloring the grisailles. The east triplet bay (Bay 21) is a fine, integral design (VI.7) presenting Bishop Jean de Bernières (1278–1294), identified by inscription and flanked by the cathedral patrons Gervais and Protais, a work in every way typical of the Jean de Bernières Master's style. The north window (Bay 23) is a more composite operation that shares the same border and grisaille with Bay 21 but was perhaps compiled for the new bishop's chapel from figures already prepared. The puzzle presents Elizabeth (modern face) and the Virgin of the Annunciation (VI.8), who appear to be unmatched elements from a larger matched series.[49] Their awkward canopies, unique at Sées and only comparable to the primitive first attempts of the Jean de Bernières Master at Aunou (VI.24, p. 209), do not seem to fit them.[50] The figures match in style, having been designed and cut by the Nicholas Master but painted

VI.6 *Sées. North ambulatory window, Bay 19. After Ferdinand de Lasteyrie, 1857.*

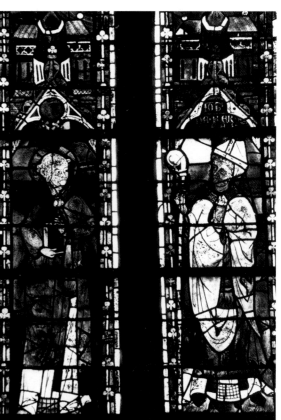

VI.7 *Sées. Bishop Jean de Bernières (right) and St Gervais, north transept chapel, east wall, Bay 21.*

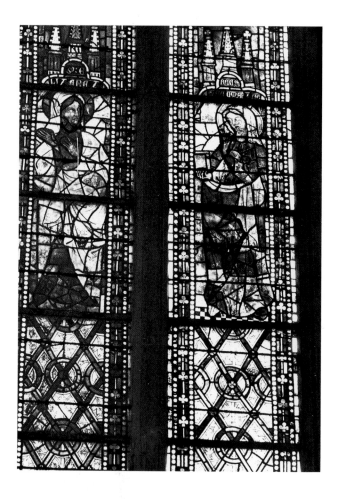

VI.8 *Sées. St Elizabeth (left); Virgin of the Annunciation (right). North transept chapel, north wall, Bay 23, before 1953.*

by the Jean de Bernières Master, while the huge pearled filets around the borders are found only in the Nicholas Master's axial clerestory.[51] The window presents a conundrum to be tackled later (pp. 195–96).

Choir Clerestories

The medieval splendor of the grand ensemble of band windows in the choir clerestory is still striking in spite of the replacement of many heads and occasional panels (*VI.9*). The grisailles of the two south hemicycle bays (Bays 202 and 204) are modern. The adjoining Bay 206 in the south choir now contains no old glass whatsoever.[52] Leprévost's new designs, signed and dated 1894, replace the damaged group that Guilhermy said included a Virgin and Child and a donor in blue dalmatic, kneeling and presenting a window, with name inscription.

Of no little interest are the several remaining inscriptions, which will be discussed with the donors later. Only the one in Bay 204 (FOLIN) is the fabrication of Leprévost.[53] Even in this case it can be suggested that what he was copying was IOhAN, since the kneeling figure in brown chasuble offers his window to John the Baptist. Amidst this bevy of donors, established by Lafond as the officers of the Augustinian community, the prior Johannes III Galliot[54] (not otherwise represented) would be the most likely candidate.

VI.9 *Sées. North choir, Bays 207 (left) and 205.*

VI.10 *Sées. Chevet before Ruprich-Robert's reconstruction, ca. 1878.*

Radiating Chapels: Legendary Scenes and Donors

Lafond's remarks about the decomposition, drastic alteration, and misplacement of the glass in the four radiating chapels are only too accurate. Leprévost restored them between 1879 and 1894.[55] The original grisailles, none of which remain in the church, survive only in a handful of precious examples in American museums,[56] and nineteenth-century photos of Sées (*VI.10* and *VI.4*, p. 174) make it clear that not a great deal more of the grisaille existed at that time.

Nevertheless the varying amounts of original glazing found in the radiating chapels are enough to provide clues to their subject program and donors as well as tantalizing evidence of the styles of two distinctive masters, all questions to be deliberated below. A more precious stylistic document is the powerful, vivacious design of a group of monks also in the Glencairn Museum at Bryn Athyn. This marvel can be identified as originating in the St Augustine chapel, to the south of the axial chapel.[57] The panel is a masterpiece of the Magdalene Master, one of the great expressionists of western French art; *Deo gratias,* it survives, and in much finer condition than any of the deteriorating fragments by the artist that remain in the church.

Axial Chapel

The cathedral's medieval patrons, Sts Gervais and Protais, reappear in the axial chapel as they do in the window of Jean de Bernières in Bay 21 of the north transept chapel, still in the company of bishops of Sées. All have inscriptions. In 1860 Guilhermy was able to read LVESTI, whom Lafond no doubt correctly identified as Silvester (Bishop of Sées 1203–1220, and thus builder of the Gothic nave). That the second bishop's inscription ends in EPIS . . . SAG (*episcopus sagiensis*) is unmistakable, though the name (GACOBI?) eludes grasp. Not saints, not donors, Lafond believed them to be something rarer in medieval programing, namely memorials.[58]

Guilhermy, who saw the chapel before it was lengthened one bay by Ruprich-Robert, found these four figures flanking the axial window. In it was a tympanum ensemble of the Virgin and Child with angels, above lancets containing two apostles (one with a cross) inside a border of *Castille*.

The Virgin group of the tympanum is now divided between Bay 3 on the north and the Los Angeles County Museum of Art. Guilhermy's two apostles are presumably to be identified, without their *Castille* borders, among the four of medieval origin now preserved in the westernmost bays of the chapel. Such meager remains of the original grisailles as survived to the nineteenth century are represented only in the Glencairn and Los Angeles museums. Modern glass donated by Mgr. Trégaro (bishop, 1882–1897) now fills the lights of the apse and two modern saints fill out the remaining chapel lancets.[59] The axial chapel confronts the visitor with a dismaying conglomeration of rebuilt debris. Since it includes not only some fine canopies with interesting inscriptions but also several full figures and two of the finest heads left in the church, the puzzle will repay our attention.

Medieval Glass from the Axial Chapel

tympanum group: Virgin and Child, angels with candlesticks (quatrefoil now in Bay 3, heavily decomposed and restored; *Pl.41.A*); censing angels (two trefoils in the Los Angeles County Museum of Art; *Pl.41.B*).[60] They can be recognized in situ in a nineteenth-century photograph (*VI.10*).

memorial group: Sts Gervais and Protais (*Pl.42*) and two bishops without haloes (now in Bays 3 and 4). Original canopies, borders, inscriptions. One original head remains (*VI.20, p. 203*); panels heavily weathered and restored and a slice removed from the midsection of each figure.

grisailles: Four trefoils in the Los Angeles County Museum of Art, presumably from traceries of Bays 1 or 2; two panels in the Glencairn Museum, with borders matching the memorial group (*VI.11*).[61] (Nineteenth-century copies of the latter now in the chapel.)

apostles group (*VI.12.A–E*):

Now in Bay 5 (north)—St Paul with sword (*VI.12.A*; figure badly decomposed, head an ancient restoration); apostle (only bottom panel has old glass, badly decomposed).

Now in Bay 6 (south)—St Peter with key (*VI.12.E*; well preserved); apostle with cross (*VI.12.D*; well preserved but new head).

VI.11 *Glencairn Museum, Bryn Athyn, Pa. Grisaille from axial chapel of Sées.*

The program, insofar as it can be reconstructed, is of some interest. The patron saints Gervais and Protais with the two bishops of Sées form a memorial group visually appropriate to the axial chapel, since they are of larger scale and a more elaborate decorative scheme. The apostles group is a different case.

To the four apostles now in the axial chapel—none in original borders or canopywork, and of varying conditions and interest as works of art—can be added two others, following Lafond. These two apostles (*VI.12.B–C*), still in *Castille* borders and under original canopies with lamps, have been misplaced in Bay 18 in the Magdalene chapel (southwest radiating chapel) since before Guilhermy's visit. Their heads are now the work of Leprévost, as are the colonnettes flanking each figure (the canopies have been similarly widened). The St Peter (*VI.12.E*) now among the apostles of the axial chapel is presumably to be identified with a Peter figure that in 1860 formed part of the debris filling Bay 12, the right bay of the *other* radiating chapel on the south (the Augustine chapel), and at that time he, too, had a *Castille* border.[62] The two apostles Guilhermy noted in Bay 0 also then had *Castille* borders.

More likely than Lafond's theory (that these six originally decorated the axial chapel) is a more complicated one. We have here probable evidence of a very old restoration of the cathedral glass, when windows from places of less visibility and importance were cannibalized to fill gaps in the choir chapels. We can even postulate a date for this mass exodus, based on the evidence of St Paul's head (*VI.12.A*). Old but not thirteenth century, it bears a certain resemblance to the Baptist window (Bay 11) that was added to the northeast radiating chapel in the repairs ordered by Charles V in 1375 (see above, n. 31).

Nor is it impossible to reconstruct the probable medieval location of the apostles group before the exodus, on the basis of the canopies and lamps retained by the two figures now in the Magdalene chapel, and the *Castille* borders that they still have and that were once related to three of the others. These details match up with the heavily restored and polished debris of five apostles still found in Bays 209 and 211 in the north transept clerestories (see above, n. 46, and *Pl.39*) and so do the cartoons. They make a series.

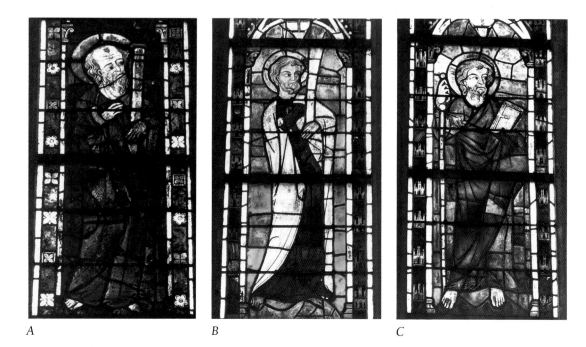

A B C

VI.12.A–E *Sées. (A) St Paul, now in Bay 5. Head is an old restoration (ca. 1375?). (B) Apostle with club(?), now in Magdalene chapel, Bay 18 (head modern). (C) Apostle with staff, now in Magdalene chapel, Bay 18 (head modern). (D) Apostle with Latin cross, now in Bay 6 (head modern). (E) St Peter with key, now in Bay 6 (Magdalene Master).*

With the apostle in the Victoria and Albert Museum (see above, n. 47, and *Pl.40*), another repetition of these cartoons, two-thirds of the north transept clerestories can thus be reconstructed, a series of apostles repeated on a limited number of models by several different masters. To put it another way: there are eighteen lancets in the north transept clerestory, and twelve of the original figures line up to be counted (four now in the axial chapel, two in the Magdalene chapel, one in London, and five still in situ). Despite its checkered past, the group has great interest as a rare example of the adaptation of atelier cartoons in the hands of painters of widely varied artistic temperaments (see below, pp. 207, 213–15). Is it possible to create a masterpiece using a patternsheet? On the basis of the old glass in the cathedral of Sées, that and other questions can now be approached.

Patrons and Program

The simple, straightforward program at Sées, no less than the dating that can be established for the donors and the pervasive band window scheme, all suggest a single brief campaign in both conception and execution. As at Le Mans and not infrequently in Gothic glazing, a vast, homogeneous decorative scheme was made a reality by many donors, who were al-lowed to populate it with their own images and their own saints. Heraldry, recently perfected as a medieval language of visual identification, plays an occasional and most appropriate

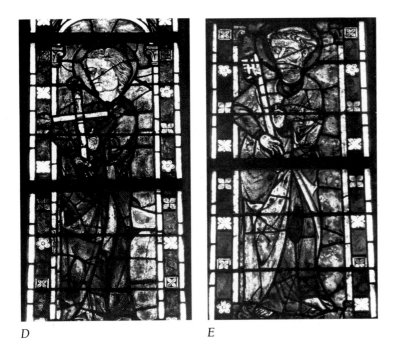

D E

role. At Sées, however, many donors were men of religious vocation who undoubtedly had no family escutcheons. Inscriptions often assume the burden of identification.

The program is simplicity itself. The north rose presents Christ's Resurrection. The Annunciation once found in the south rose,[63] as well as the Virgin cycle on the south portal below it,[64] suggest that the south rose was dedicated, as logic would dictate, to the Virgin and the Incarnation. This simple iconography was probably decided by the canons. Equally straightforward, and probably also their decision, are the references in the axial chapel and the axial clerestory (Bay 200) to the cathedral's name saints Gervais and Protais and the memorial images of the cathedral's bishops. In the rest of the clerestories the rank of apostles and saints is interrupted only by donors of exactly the same scale, often kneeling repetitiously before the Virgin. In the band windows of the chapels large-scale patrons honor saints in large scenes under identical canopies. This unsophisticated ensemble will be examined below for what evidence its iconography and patronage can provide. As we shall see, it has a few secrets to tell.

North Rose, Western Program

The handsome north rose (VI.5) has windmill tracery resembling the more famous north rose of the cathedral of Rouen, a rose-in-square design of the rare and audacious type that has all four corners pierced, as at Tours and Clermont. Filled largely with decorative foliage, its windmill arms are studded with six medallions by Leprévost, some of which are trustworthy copies of the original series of the Resurrection. They are the Noli me tangere, Three Marys at the Tomb, Ascension, Road to Emmaus, Supper at Emmaus, and Doubting Thomas. Their trustworthiness can in fact be upheld chiefly on iconographic evidence. In western

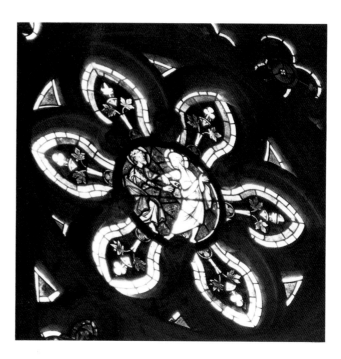

VI.13 *Sées. Doubting Thomas, copy by Leprévost (late 19th cent.) of medallion in north rose.*

France, Resurrection cycles retained a Romanesque flavor for a long time. The episode of the Three Marys at the Tomb,[65] for example, is preferred in place of Christ Leaving the Tomb as late as the fourteenth-century Passion window of Saint-Père de Chartres.[66] Another example is the elaboration of Emmaus scenes, often reduced to the Supper alone in late thirteenth-century art elsewhere.[67]

Much more significant is the Doubting Thomas (*VI.13*). The "coercive" form of the scene is shown, in which Christ himself seizes the apostle's hand and thrusts it into the wound. This coercive form does not occur in Gothic art of the Ile-de-France. It has an interesting and varied history, appearing in the Near East at a very early date, in German Romanesque examples, and in English Gothic art, for example in the mid-thirteenth-century frescoes at Westminster Abbey and later in *opus anglicanum*. Its tradition was established in Aquitaine and lingered on in western France long after the French conquest of 1204, a late example occurring in the Passion window of Saint-Père. It is a detail that Leprévost would hardly have included were it not in his western model.

Of Radiating Chapels, Dedications, and Donors

The saints commemorated in the four radiating chapels, Nicholas and John the Baptist on the north, and the Magdalene and Augustine on the south, probably indicate medieval dedications, since all can be confirmed in the cathedral's register of benefices (*pouillé*) of about 1335.[68] Both donor and scene panels have suffered loss and drastic repair, and have evidently been augmented and moved around at intervals in the cathedral's past.[69] No thirteenth-century scene of the Baptist remains, for example; the saint's window added in the repairs of about 1375 can be presumed to retain the original dedication on the evidence of donors, as we shall see. By matchmaking donors and patron saints, in fact, it is possible to hypothesize on the chapels' original thirteenth-century arrangement.

VI.14 *Sées. St Nicholas chapel, panels of the murder of the
three boys, ca. 1838 (two panels reversed, one upside-
down). After Lecointre-Dupont.*

The St Nicholas chapel retains the thirteenth-century glass of two of its three bays,
handsome scenes (*Pls.43.A–B*) of the murder of the three boys by the innkeeper (Bay 15)
and of St Nicholas dowering the three poor sisters (Bay 13). Although these scenes were so
badly disordered in the nineteenth century (*VI.14*) that they were generally identified as St
Julian killing his parents,[70] both are standard episodes shown in standard format. They
resemble closely, in reverse, those of the small lancet of St Nicholas at Champ-Dominel
(Eure), of the first half of the thirteenth century.[71] The iconographic suggestion of a common
Norman tradition is borne out by stylistic evidence since, as we shall see, the St Nicholas
Master of Sées was very likely a Norman.

The missing donor of the Nicholas chapel is no doubt to be found among the two
heavily restored donor panels now located redundantly in the adjacent Baptist chapel
(Bay 7).[72] Of the two, the most likely is the panel of Amicus Dei, dean of Argentan (*VI.15*, r.),
whose inscription reads:

<div align="center">

DECAN [D] E ARG

TH′ : AMI: DEI

</div>

VI.15 *Sées. Donor panels grouped in Baptist chapel, Bay 7: Guild of drapers (left);
Amicus Dei, Dean of Argentan (right). (The two major heads are by Leprévost.)*

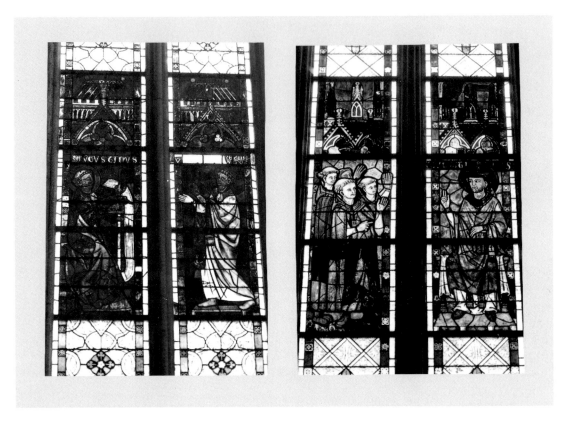

VI.16 *Sées. Montage of the Augustine chapel, Bays 8, 10, 12. (Heavily restored; center and right bays are over half modern.)*

Identified since the nineteenth century as inquisitor of the province and so called in charters of 1251 and 1257, Amicus Dei probably lived until 1285.[73] Lafond's suggestion that the inquisitor chose St Nicholas because of the anthem "Amicus Dei Nicolaus," while not impossible, is much less likely than the straightforward reference to his position as dean of Argentan, where the chapel of the château was dedicated to St Nicholas.[74]

The second of the donor panels now in the Baptist chapel shows the Guild of Drapers (*VI.15*, l.): LA: VERRIERE:DES:DRAPIERS:. Although the scene of the Baptist (Bay 11) dates only from the 1375 restoration, the antiquity of its subject can be assumed from the drapers' donation. The Baptist often served as patron of guilds of drapers, tailors, furriers, or wool carders,[75] as for example in Florence where he was honored from the thirteenth century by the Calimala, the drapers who dealt in imported French cloth.[76] The window of the Baptist in the south aisle of Saint-Quentin (Aisne) is the gift of the tailors and porters of woolsacks.

The St Augustine chapel on the south (*VI.16*) honors the Augustinian rule followed by the Victorine chapter of canons at Sées, and was no doubt glazed by the gift of one of them. In the left bay (Bay 8) the donor, in chasuble and maniple, receives the rule from the saint, seated before a desk. Although the donor's name inscription is now illegible, that of the saint is still clear: S: AVGVSTINVS. St Augustine, a rare subject in medieval art, appears a second time with inscription in the traceries; and a third time, named and mitered, instructing a

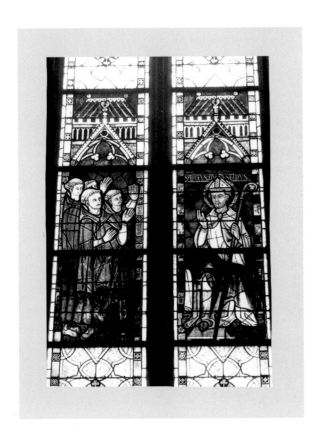

group of his monks in the central bay (Bay 10).[77] The chapel glass has weathered to near opacity in places. The fine Glencairn Museum panel of Augustine's monks, which originated here, is a work of remarkable painting by one of the best expressionists in western French art (*VI.17*).

In Bay 14 in the fourth radiating chapel, dedicated to the Magdalene, are a second donor figure of Amicus Dei (DECAN' DE ARGET_/_MI:DE) and a pathetic wreck of the scene of Mary Magdalene wiping Christ's feet with her hair (Luke 7:36–50). Although grotesquely patched with old fragments of heads and hands in a very early restoration,[78] the scene retains two sections to interest us: a tabletop full of round, braided bread loaves and grinning fish; and an abstract, exaggerated figure of the crouching Magdalene (*VI.18*), her beautiful and powerfully drawn face now, sad to say, too opaque to photograph. It remains to explain why Inquisitor Amicus Dei would have chosen the Magdalene for his second chapel. She may, like Nicholas, refer to his position as dean of Argentan, where there was an Hôtel des Trois-Maries.[79] In any case, would not the Magdalene, the ultimate forgiven sinner, or the most unswerving example of the true faith, be an appropriate theme for an official of the Inquisition for Sées?[80]

The axial chapel has been left for last because it has been tampered with so violently and so often. Ruprich-Robert lengthened it by an extra bay when he rebuilt it, and the axial

VI.17 *Glencairn Museum, Bryn Athyn, Pa. Magdalene Master.*
Augustinian canons, panel from Sées, Augustine chapel.

lights (Bays 0, 1, and 2) were then provided with nineteenth-century designs while the medieval remains were shifted yet again. Lafond's hypothesis that six of the apostles now scattered about the chapels (*VI.12.A–E*) were originally grouped here is attractively straight-forward[81] but unconvincing, if for no other reason than that their style differs considerably from the four handsome wrecks of the original ensemble. I have already listed and discussed this old glass (above, p. 182): traceries of the Virgin and Child with angels (*Pl.41.A*); Gervais and Protais, cathedral patrons (*Pl.42*); and two uncanonized bishops memorialized with them, Silvester who built the nave and another whose garbled inscription leaves him incognito. Can anything be reconstructed of the original iconographic scheme?

The original dedication of the chapel was certainly Marian, though probably not to Mary of the Annunciation as has been suggested, no doubt on the basis of the 1335 *pouillé* (Cappella Anunciacionis).[82] More likely the chapel is the *pouillé*'s Cappella Sancte Marie de Bella Vavra, and this identification may allow us to suggest a glazing program, as we shall see.

Guilhermy saw the Virgin and Child traceries in the axial lights, no doubt their original location. Of the ten lancets (five windows) of the original chapel, the two memorial bishops of Sées and the patrons Gervais and Protais would have occupied four places, two to each side. In the flanking windows at the door, Guilhermy saw grisailles (with later coats of arms inserted) and "some small mitered heads." One can only guess from that precious note that

the original commemoration of bishops dead or alive may have been much more extensive. By the time of Guilhermy's visit, the axial bay contained apostles that, I believe, were moved there from the transept clerestories. What might have been in the axial window originally?

We return to the question of the dedication, recalling that the stained glass program includes the cathedral patrons Gervais and Protais and a series of past bishops of Sées—an episcopal chapel. Although the cathedral was unquestionably dedicated to Gervais and Protais by the time of Orderic Vitalis, in the late eighteenth century the bishop switched its dedication to the Virgin in the confused belief that she was its original patron.[83] His misconception was rooted in the circumstances of the introduction of the faith at Sées, reflected in the Ordo as well:

> Ouvrons l'*Ordo diocesain* de Séez. Pour la cathédrale, il indique comme
> patrons: d'une part la Vierge, au titre de son Assomption, d'autre part les
> saints Gervais et Protais. Le diocèse est sous le patronage de la Vierge. Il est
> logique que son église-mère le soit aussi. Mais les saints Gervais et Protais
> ont été très certainement les titulaires d'une des églises de l'ancien groupe
> episcopal.[84]

Such an "ancient episcopal group of churches" in the Merovingian era normally included a baptistery dedicated to St John, an episcopal church often consecrated to Mary, and a church serving the parish and usually dedicated to a famous martyr saint. At Sées, according to du Mesnil du Buisson, the early church of the martyrs Gervais and Protais was on the location of the present choir and eastern part of the nave, while the bishop's church further south and nearer the Orne, probably the original Christian chapel of the area, was dedicated to Notre-Dame-du-Vivier (Latin: *vivarium*).[85] Hence it is not precisely correct that the Virgin's dedication preceded that of Gervais and Protais at the cathedral. And thus, since the large Romanesque cathedral encompassed the jurisdictions of both earlier churches, parish and bishopric, their patrons are both retained in the Ordo: Sts Gervais and Protais, and the Virgin of the Assumption.[86] In the 1335 *pouillé* of the even more immense Gothic cathedral,

VI.18 *Sées. Magdalene Master. Magdalene wiping Christ's feet with her hair, Magdalene chapel, Bay 14B.*

Sées. Location of bishop's churches in Merovingian Sées: (1) Cathedral of Sts Gervais and Protais, on the site of the present cathedral choir. (2) Notre-Dame-du-Vivier, the first episcopal church, near the banks of the Orne. After du Mesnil du Buisson.

the ancient name may already have shown signs of time passing and memories fading; the only known copy, from the sixteenth century, gives the corrupt form, *bella varra,* which later scholars then attempted to correct at intervals, *bella* crossed out and *varra* altered to *vavra,*[87] also gibberish. It is not unreasonable to imagine, however, that the episcopal program of the Gothic axial window still preserved an image referring to the episcopal patron, the Virgin of the Assumption.

The Assumption, however, is an awkward scene to design for a divided, doublet window. An example of the trouble it could get a glazier into can be found in the late twelfth-century Bay 123 at Angers, a medallion window of the Virgin's Triumph (Dormition, Assumption, Coronation), where a central iron almost obliterates the Virgin of the Assumption.[88] Such a sequence of Triumph medallions lived on, in western France, well into the Gothic era; the upper ambulatory of Le Mans even has three examples (Bays 104, 105, and

110). But Sées has no medallion windows, and the surviving figures of the axial chapel are the large-scale Gervais, Protais, and the two memorial bishops. It is thus more likely that the axial doublet bay of Sées contained the popular Gothic scene of the Virgin's Coronation, shown as at the cathedral of Evreux: Christ in one lancet crowning his mother in the other.[89] The destruction of these figures most probably dates before the 1375 restoration ordered by Charles V.

Friends of the Cathedral

The chapels were glazed by the drapers' guild, as well as by a canon of the monastic community and by the inquisitor of Sées. No more lay donors are to be found in the clerestory, where the great sequence of band windows presents officers of the chapter and more ecclesiastic well-wishers. With the exception of the axial bay (200), the clerestories offer a confusion of repeated apostles (with attributes, with books or phylacteries) punctuated with donors, all churchmen, kneeling with their name inscriptions before a saint or the Virgin. The Virgin was repeated three times.

The inscriptions permitted Lafond to identify these men from the Register of Eudes Rigaud. They are found as follows:

north: Bay 207—MESTRE OSMONT kneeling before the Virgin and Child.
　　　　　—(Modern apostle with cross), St Peter with key (*VI.27.A*, l.), St Paul holding bare sword by the point (*VI.28.A*, l.), St Bartholomew with knife (*VI.28.A*, r.).
　　　　　　　Osmont was a clerk of the bishop of Sées in 1256, not yet called a master.[90]

Bay 205—Donor (*Pl.44;* inscription illegible) holding a seal matrix on a chain, which signifies his position as the officer of the chapter who was keeper of the seal (*chancelier, sigillifier*).[91] His seal case has a small, upside-down fleurs-de-lis.
　　　　　—Apostles repeated and reversed from the same cartoon, phylacteries (*VI.29.A*).

Bay 203—Bishop saint with inscription h'EP_s S ; three apostles. The *episcopus sagiensis* most likely would be St Hubert (Annobertus, fifteenth bishop), though this is a guess.[92]

Bay 201—Bishop saint (anonymous); three apostles.

axial: Bay 200—Two deacon saints, certainly the cathedral patrons Gervais and Protais (*Pl.45.A*); two bishop saints. Lafond suggested Latuin (first bishop of Sées) and Godegrand.[93] I would propose Vaast (bishop of Arras) for the saint on the right, whose orphrey is decorated with a small beast that could be Vaast's companion bear,[94] while the orphrey of the deacon paired with him bears the letter V. Although no chapel in the *pouillé* of 1335 was dedicated to a bishop saint of Sées, there was a chapel of St Vaast.[95]

　　　　　　　This identification seems likely since the traceries of Bay 200 also commemorate a medieval chapel. They present St Anne holding her daughter, the young Virgin,[96] with two censing angels

(*Pl.45.B*), a probable reference to the cloister chapel built in the late thirteenth century and dedicated to the Virgin and St Anne.[97]

south: Bay 202—Donor in blue hooded cope; three apostles with phylacteries. The garbled inscription:

> :R:DEP
>
> [missing line]
>
> PCVR̄

Lafond interpreted the last line as P[RO]CVR[ATOR], that is, the community's purveyor or fiscal agent. The initial of his first name is clearly R.

Bay 204—Donor kneeling before John the Baptist, bare shinned and wearing a fur-lined robe, holding the Agnus Dei (modern). The copied inscription, which now reads FOLIN, I have suggested was IOHAN (for Johannes, possibly the prior Jean III Galliot).[98] Two apostles with phylacteries (left one modern).

Bay 206—Bay dated 1894, by Leprévost. Previously Guilhermy saw a donor in blue dalmatic with name inscription, presenting a window to the Virgin and Child; four other figures, badly damaged.

Bay 208—Gui du Merle, bishop of Lisieux, kneeling before the Virgin and Child (*Pl.46.A*). Sts Peter and Paul to the right, Nicholas and Ursin to the left. The bishop's identity was established by Lafond from the damaged inscription and the coats of arms in the traceries: *gueules à 3 quintefeuilles d'argent*.[99] Gui was elected bishop in 1267 and dead by 1295.

Several interesting details can be added to Lafond's discussion of Bay 208. The bay's standing saints include Nicholas, in reference to a collegiate church dedicated to him at the family château of Le Merlerault, and Ursin, whose relics were venerated in Lisieux.[100] The other pair of saints in the window, Peter and Paul, were adopted from Gui's counterseal as bishop.[101] Lafond noted that the du Merle arms—most famous in the thirteenth century as the arms of the famous soldier Fouques du Merle, *maréchal* of France[102]—are *armes parlantes*, the *quintefeuilles* representing leaves of the *néflier* (*mespilus*) tree. This is not the only instance of *armes parlantes* in the window, however. The du Merle escutcheon is actually repeated three times in the traceries (*Pl.46.B*), twice as blazoned above and once with added cadency mark—*lambel d'azur*—to indicate Bishop Gui, as cadet in the family. The borders of the window's lancets alternate the tinctures and *quintefeuilles* of du Merle with a motif of yellow with three black birds without beaks or claws. Such a bird in heraldry is termed a merlette. Gui, as younger brother,[103] was of course the little Merle, the "merlette."[104] Thus the bay of Bishop Gui du Merle, which takes its place so quietly among the clerestory series of band windows, is—like the Tric-trac window of Le Mans—a personal emblem of its donor, tailored to fit.

It remains to ask why, and when, the bishop of Lisieux would donate an elaborate window to the cathedral of Sées. Gui's family lands of Le Merlerault lie about twelve kilometers northeast of Sées, and one of his ancestors, Raoul du Merle, canon of Sées in 1184, had been chosen for bishop in 1202 (though unconfirmed by the English king). The bish-

oprics of Lisieux and Sées had maintained close ties since the Victorine reforms of the early twelfth century, and one of Bishop Gui's own canons at Lisieux, Jean de Bernières, was elected bishop of Sées in 1278 (see above, p. 170). I think it unlikely that Gui's gift was so late as 1278, however. In 1271 his kinsman, the soldier Fouques du Merle, disputed with the preceding bishop of Sées, Thomas d'Aunou, over properties that Fouques had attached to the income of the collegiale of Saint-Nicolas at the château of Le Merlerault, a disagreement that ultimately went to arbitration.[105] Gui's gift of a great clerestory bay, with its images of Nicholas, of the du Merle family arms as well as those cadenced for Gui himself, of Gui's merlettes, and of Ursin the cult saint of his bishopric, looks very much like a peace offering. If so, its execution might date ca. 1275.

In 1278 a canon of Lisieux, Jean de Bernières, was elected to the office of bishop of Sées. At his death in 1294 his tomb inscription declared him "Prudens modestus gratiosus edificator ecclesiae sagiensis," indicating that the great building project was completed in his reign.[106] His window (VI.7, p. 178) in the eastern aisle of the north transept (Bay 21) shows the bishop with inscription standing flanked by yet another depiction, the third in the cathedral, of Sts Gervais and Protais. The other figures of Gervais and Protais, in the axial chapel and in the axial clerestory, were no doubt already in place, and most of the choir glazing was finished or in progress when Bishop Jean arrived. It is possible that the Agnus Dei disc (VI.6, p. 178) in the rosace of the bay immediately to the right around the corner in the north choir aisle (Bay 19) was inserted by Bishop Jean, and the unusual border motif and heavily colored grisailles found in his window reappear in the north transept window immediately to the left (Bay 23). The border, like that of Gui du Merle, has the appearance of a heraldic reference and is most easily described in blazon: *gueules au pal d'argent surmonté d'un trèfle d'or.*[107] All things considered, the north transept glazing (excepting the earlier rose) would seem to have been in process at Bishop Jean's arrival in 1278. This assumption is based not only on the late, decorated forms of his window itself (Bay 21) but also on a certain iconographic confusion in the left bay, probably indicating some tampering with the original scheme.

I have introduced this puzzling north window (Bay 23) earlier (see VI.8) and will here simply repeat its contents: grisailles and border matching the Jean de Bernières window to the right, with the addition of large pearled filets (needed to adapt panels to a new scheme?); a pair of female saints, touched by a late mannerist sway; panels with inscriptions and canopies. The inscriptions do not match, one denoting s: ELIZABEZ and the other the Annunciation (Ave Maria gracia, but misassembled):

<div align="center">

RACIA
+ AUE MARIA G

</div>

The canopies with the inscription bands are extremely primitive, awkward designs. It is these canopy-inscription panels that have been reused. Close observation reveals unquestionably that strips have been added to each on both sides.

We are no closer to solving the puzzle of where this glass came from, but a solution suggests itself. The panels probably glazed the Cappella Anunciacionis of the 1335 *pouillé,* and (since the *pouillé* omits the present name of this very chapel, St Latuin) that Cappella may have been right here.[108] The early style and saturated color of the canopy panels suggest that they glazed an early window, such as this lancet beneath the north rose—a doublet-and-rose of simpler design than the elaborately traceried Jean de Bernières window on the

adjoining east wall. If so, then its original borders were early, wide borders and the original design stacked Annunciation, Visitation, and so on, in layers. In other words, the lancet was revamped into a band window to match the new band window of Jean de Bernières (Bay 21) next to it.

With Bishop Jean's chapel the glazing was probably accomplished. Its procession of donors—Amicus Dei (1251–1285), Osmond (from 1256), Gui du Merle (1267–1285), and finally Jean de Bernières (1278–1294)—indicate a campaign well within the years 1265 to 1285. In addition to this positive witness there are some curious absentees: the bishop who preceded Jean de Bernières in office and reigned during almost the entire campaign; and the temporal lord, Pierre d'Alençon, fifth son of the monarch St Louis.

The bishop was Thomas d'Aunou, confirmed in office by Eudes Rigaud in 1258 and dead, after a long fever, on June 17, 1278.[109] Lafond noted his absence from among the chapter officials of the clerestory and made the half-humorous suggestion that the glazing might be dated 1278 *sede vacante*.[110] Thomas was a bishop of the stripe of Thibaud de Pouancé of Dol—ambitious,[111] always ready for a scrap. We have already noted his legal dispute with Fouques du Merle in 1271. Among those he fought with were his own canons. Their disagreements were eventually brought to arbitration and the dispute settled in the spring of 1266 by Eudes Rigaud, in favor of the rights of the chapter, prior, and archdeacons against the pretensions of Bishop Thomas.[112] Since the glazing campaign of ca. 1260–1270 was so obviously the chapter's project, the bishop's lack of interest probably requires no further explanation.

The prince is a related case. Appanaged with Alençon in the late 1260s, he began a running dispute, after the death of his father in 1270, against Bishop Thomas over jurisdiction of the town of Sées.[113] The bishop took his case before Parlement in 1272 and finally received their ruling against the prince in November 1277.[114] Perhaps it is not merely an accident that the stained glass of Sées includes numerous borders of *Castille* (*VI.12.B–C* and *Pl.43.B*), but only a single lancet—seen by Guilhermy in the Nicholas chapel and since lost—with the fleurs-de-lis of France and of the prince, Pierre d'Alençon.[115] Pierre d'Alençon seems to have had nothing more to do with Sées until a parting gesture establishing income for his anniversary at the cathedral, dated March 12, 1282 (n.s.)—hence on the eve of his departure for the Italian wars and his death in 1283.[116] The charter mends fences with the prior and chapter. The bishop is not mentioned. But by mid-1282 the chapter's glazing project was probably no longer in need of donors.

Glaziers Norman and Western

One looks in vain at Sées for internal evidence in the decoration or figural program of a development or progression in the campaign. Excepting the north rose and the puzzling canopies patched into Bay 23 below it, the campaign is homogeneous. While the Jean de Bernières chapel (*VI.7*) probably finished the campaign, one cannot even make a definitive judgment on such a basic question as whether the clerestory ensemble preceded or followed the chapel windows. Several variants in canopywork, in grisaille, and in borders are found almost at random, not in consistent decorative systems with other such features. One can only note an undeniable attempt to simplify the clerestory designs to enhance legibility at a distance. Inscriptions up there are simple and grossly enlarged; color is spread over unbro-

ken areas and with little nuance; hands and feet are swollen; the shading of facial contours approaches the exaggerations of ballet makeup. Michael Cothren has remarked on a similar simplification in the first band windows of Beauvais and at about the same time, 1268–1272, work of a shop that differs from Sées in almost every other regard.[117] Whereas painting at large scale always dictated alterations in an artist's style, as for example at Le Mans, this emphatic simplification is not merely a characteristic of all clerestories per se.

The Sées chantier included five masters (Lafond suggested three or four) of differing backgrounds, who worked, as it were, over each other's shoulders. Their compositional talents are not always distinct; they often worked from the same patternsheets. Yet it is not difficult to establish several preferences in decorative vocabulary and in color, and to track the figure painting of five artists. Their shop practice of mutual aid makes it less easy to pair up the decorative and figural work of each, though this will be attempted insofar as is feasible.

These stylistic elements will be analyzed in turn, not only with the usual goal of distinguishing the artistic profiles and heritage of the masters but, because Sées is so solidly dated, to provide comparison with the inscriptions, grisailles, and canopywork of less precisely chronicled art works. Another part of the rich harvest of this study is rare evidence of cartoon sharing or, more precisely, the use by several artists of a common patternbook. Patternbooks are one of the fascinating enigmas of medieval art, the final argument into the void in answer to questions of the transmissions of motifs. The Sées windows provide a rare working demonstration of the results different men obtained with the same modelsheet before them.

A word should be added about the band window. Because Sées is at the beginning of this tradition in monumental glazing, one hopes its study will suggest the roots of the new format. In discussing Tours and Saint-Père in Chapter III, I have already voted with Lafond in seeing Paris as the source, perhaps Saint-Denis or (more likely in the case of Sées) Saint-Victor. But there is absolutely nothing Parisian about the style of Sées: the painters were Normans or local, from the rural western borderlands of the Loire. How to explain their ease with the new format? Unlike the hesitations and experimentation of the Saint-Père shutters, or the double layer of figures in the two band windows inserted at Tours, at Sées the band window appears without apology and with the absolute conviction of a classic statement. Why are the provincial Norman painters of Sées so comfortable with the new visual syntax?

I once hypothesized that the idea of a band may have germinated from the practice of glazing a strip of small scenes across a grisaille in modest rural chapels, citing Norrey-en-Auge (Calvados) ca. 1240.[118] Another instance of the same date is Saint-Pierre-sur-Dives (Calvados), though now nearly completely copied in modern glass. The forms are close enough to Norrey-en-Auge to hypothesize that the same shop produced both, though of course the painting can no longer be studied. This type of parish glazing lasted a long time; see Le Mesnil-Villeman (Manche), which has touches of silver stain (*Pl.38*). In this scenario the band window would be an adaptation and upgrading of a standard type of parish church decoration, standard at least for Normandy. The remnants of just such a rural chapel exist less than four kilometers outside Sées at Aunou-sur-Orne, the glass there painted by the Jean de Bernières Master before he went to the cathedral (see below, *VI.24* and pp. 208f.). The remaining fragments suggest a scheme of "country-style" band windows and the sequence of his work can be established on the basis of the unsophisticated framing at Aunou, as well

as the probable date for its heraldry, about 1265. To cap the argument, Norrey-en-Auge and (originally) Saint-Pierre-sur-Dives ca. 1240, and Aunou ca. 1265 have elementary quarry grisailles, a type unknown in the Ile-de-France at this generation (if one can judge by fragments at Brie-Comte-Robert, Montlhéry, Villers-Saint-Paul, and elsewhere). This provincial latticework reaches glorious full bloom at Sainte-Radegonde around 1269 (*Pl.25*) and in the chevet of Sées in the 1270s.

The vigor of the Sées glazing, the direct appeal and the rustic quality of some of its painters, lend plausibility to such a hypothesis. Paris dictated the fashion of band windows, but the locals of the western borderlands were comfortable with it because they knew a band window when they saw one.

Inscription Style

A transitional, uncial alphabet is employed (*VI.26*, p. 212). Although both block and curved A, N and T appear, and block V consistently, the curvilinear quality is dominant and the letters are becoming compressed in width. C and E are always closed, S often is; ligature combinations of AR and AN occur, the latter a strange concoction using an uncial N. Since no strong organizational system is present—neither the older blocklike proportions and reserved territory of classic capitals nor the telegraphic verticality of Black Letter to come—the inscriptions are marked by irregularity and nervous vigor; it is a script in transition (*Pl.42*).

Grisailles

A comparable transition is apparent in the grisailles, where both stylized palmettes and more naturalistic foliage are found, both curved leading and straight latticework, with filets both colored and clear. All grounds are crosshatched.

The overall development of northern Gothic grisaille was from medallion or centripetal patterns of curvilinear type through a rising vertical emphasis to a final angling-out of the leading and filets at the end of the thirteenth century into rigid lattices of repeated quarries or lozenges, simple cassette (unit) designs with no continuous pattern. All but the earliest of these types are represented at Sées. There is little doubt that straight leading and repeated cassettes were less expensive to produce, and that their popularity in the fourteenth century, like the popularity of the band window scheme itself, owed much to that fact.[119] It is equally clear that where economy required, rural designers in the early thirteenth century had produced quarry grisailles just as they had anticipated various combinations of color and grisaille such as the band window, appliqué window, and others. To the rural parishes of Aunou and Norrey-en-Auge can be added the very elementary cassette quarries painted on the grisaille of the panel from Primelles near Charost (Cher).[120] Sées looks increasingly like a rural chapel that has "grown up."

The most standard grisaille patterns at Sées seem to be the earliest, the bulged quarries of the choir chapels. Since all are now modern, the patterns have been suspect. However, in 1978 Michael Cothren identified two of the patterns (four panels) in the Glencairn Museum (Bryn Athyn, Pa.), from the Nicholas chapel (acc. nos. 03.SG.53 and 03.SG.54) and the axial chapel (acc. nos. 03.SG.48 and 03.SG.78). Leprévost copied them exactly. The Nicholas chapel panels are familiar central-stem designs of ivy and geranium, the foliage of the swol-

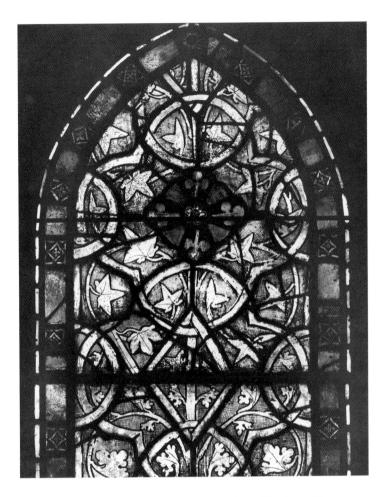

VI.19 *Corning Museum, Corning, N.Y. Grisailles from Sées,*
Augustine chapel.

len, bloated appearance peculiar to Sées. The grisailles of the Virgin chapel (*VI.11*) have a stiffer, more mechanical leading and stems growing up the sides of the panels (rather than the more common *tige centrale*), a peculiarity that also occurs in the more well-known axial clerestory to be discussed shortly.

Helen Zakin has identified several other bulged quarry grisailles from Sées, including one at the Cloisters (Metropolitan Museum of Art, acc. no. 69.263.10) (of which copies exist in the Magdalene chapel) and a lancet in the Corning Museum of Glass, from the Augustine chapel (*VI.19*).[121] The most fascinating observation to make, on the basis of these identifications, is that the grisaille painting of each chapel follows that of the figures. That is, the axial chapel grisailles are refined, like the beautiful memorial group of the Protais Master; the Nicholas chapel grisailles are somewhat correct and routine, in the restrained style of the Nicholas Master; the Corning grisailles from the Augustine chapel are robust, the paint in marked impasto, the filets interlocking in a complex three-dimensional network, the foliage almost electrified. The Augustine chapel, of course, is the location of the Magdalene Master's vivid group portrait of the monks of Sées (Glencairn Museum), simi-

larly forceful. In other words, at Sées, each master-glazier produced his own grisailles. While elsewhere such a shop procedure cannot be presumed, necessarily, on this strong evidence neither must it be automatically assumed that grisaille production was only work for apprentices.

While bulged quarries filled the radiating chapels, latticework grisailles were adopted for the clerestory. The adoption was wholehearted: only Bay 200, the axial bay, does not conform.[122] Economy does not seem to have been the consideration. Frequently the lattice is of colored filets studded with contrasting *fermaillets,* thus augmenting the cost of production not merely by the presumed expense of colored glass but chiefly by the extensive and costly additional leading required. The most elaborate bay in the clerestory, the window given by Bishop Gui du Merle (Bay 208), has grisaille cassettes of a stylized fleuron enclosed by a gaudy latticework of red filets and green and yellow studs. The only comparable grisaille we have seen was the contemporary colored latticework on the south wall of Sainte-Radegonde (see above, p. 110, and *Pl.25*), made of the heraldic colors of the prince Alphonse.

Another lavish design at Sées, the transept chapel of Bishop Jean de Bernières, has grisailles of gaudy brilliance, in which red and blue latticework, enhanced by gold "nails" and large gold rings, provides a noisy counterpoint to a naturalistic foliage design rising from a central stem (Bays 21 and 23). One might consider it an overlay of colored latticework on the more typical formula of the decade, which we have seen at Dol only slightly later in date: the Jean de Bernières chapel is after 1278, Thibaud de Pouancé's grisailles at Dol probably around 1285. As at Dol,[123] the leaves are serrated and fringed like geraniums (*V.12.B*), and both foliage and stems appear bloated and swollen. The hybrid style of the Jean de Bernières grisailles, like everything else about this chapel glazing (Bays 21 and 23), suggests that its design was the last finishing touch at Sées.

Similarly swollen, fringed leaves rising from a central stem recur in two clerestories (Bays 203 and 201) in a simpler grisaille than Bishop Jean's. Straight leading surrounds quarries painted with clear latticework filets, color restricted to bosses set into the center of each panel. This rather dry design becomes common late in the century, for example at Vendôme (grisailles now set in the north choir clerestory at the crossing), and later in the nave of Saint-Père de Chartres.[124] As with the band windows, the Sées example stands precociously at the commencement of the series.

The Sées axial clerestory (Bay 200) has a more peculiar grisaille: rising naturalistic foliage (here clover) with colored bosses accenting the *panneautage* and a leading pattern of slightly bulged quarries, all standard, but here appearing in bizarrely enlarged proportions. It is the best-known of the Sées grisailles, exhibited in Paris from 1910 to 1934 and in 1953, and published as early as 1896 by Ottin in an inaccurate drawing, the error of which was further compounded by its juxtaposition with one of the elegant late patterns of the Saint-Père triforium.[125] The resemblance is superficial—both have clover—and would not have gained such general acceptance had photographs been used.[126] The actual design of Sées has a more normally proportioned, less elongated *panneautage* than the drawing, which falsely renders it like a border, the result of Ottin's ignoring the irons and narrowing the pattern so that the bosses appear to touch the frame. In narrowing the design he removed one of its most curious features, the stems that rise not by the normal route up the center but along both sides.[127] The foliage is sturdy, stubby, and enlarged; the leading is awkward and graceless; the filet pattern appears in a larger scale than the typical patterns of Normandy. One might imagine that the design had been adapted from a patternbook the artist was seeing for

the first time. The grisaille of the axial clerestory is as odd in its way as the latticework grisailles of Sées and the band window scheme, and all carry the aura of men taken up with new ideas.[128]

Borders

In the second half of the thirteenth century stained glass borders, like grisaille, developed first a vertical emphasis and finally a simpler, more rigid pattern using unpainted color and studlike cassette motifs (rosettes, knot interlace, and the like). In addition the mid-century fashion for royal fleurs-de-lis and castles of *Castille* only gradually spent its force; we have seen it lingering at Dol in the mid-1280s (*V.12.A*, p. 152). All these formulas appear at Sées, though simple cassettes are most numerous (*VI.29.A–B*, p. 216). Fleurs-de-lis do not appear at all,[129] and *Castille* borders were used almost exclusively for the series of apostles (*VI.12.B–C*, p. 184) that I believe were made for the transept clerestories (many are now dispersed here and there throughout the chapels). Besides the apostles, the only other medieval *Castille* border frames a scene of St Nicholas in the north chapel (Bay 13), painted by the Nicholas Master (*Pl.43.B*). The series of apostles, on the other hand, was probably supervised by the Jean de Bernières Master, though executed by various painters, and he had previously used fleurs-de-lis and castles in his glazing at Aunou (*VI.24*, p. 209).

Rising palmettes embellish axial lights at both levels (*Pl.42*), and it is reasonable to assume that they were considered "fancier."[130] They frame the work of different painters, however, and even these few borders were not executed by the same artist. The attractive heraldic borders of bishops Gui du Merle (Bay 208) and Jean de Bernières (Bays 21 and 23) have already been noted.

Canopies

The canopies only add to this picture of shop confusion. All figural glass at Sées (except in traceries and the north rose) is framed by canopywork, whether single figures or scenes. There are no bases. Framing colonnettes are added only in the broadest clerestories, Bays 207 and 208 at the crossing. "Capitals" are bunches of leaves, totally nonarchitectural (*VI.29.A–B*, p. 216). Single and doubled gables occur about equally. Their crockets are either "wilted" or, more commonly, reduced to small buttons. There are a few variants.[131] The crockets of Bay 207 are slightly larger buttons; those of Bay 201 are fleshy leaves; in Bays 200 and 202 they are altogether absent. In the axial chapel the crockets are minute ivy leaves.

The double gables, as well as the tiny buttons and ivy leaves (*Pl.43.A*), can be associated with Norman practice and have been discussed in passing in Chapter III (Gassicourt). In contrast, the architectural constructs rising above the gables in a wide variety of combinations often have a blocklike density that is not typical of Normandy, but is later typical of the western ensembles of Vendôme, Saint-Père, and the early designs of Evron in the north choir. The little gargoyles that often mark those designs, however, make only one appearance at Sées, in the very wizened examples of Gui du Merle's window (Bay 208).

Only the Protais Master's canopies can be identified with any assurance, surmounting his four figures in the axial chapel (Bays 3 and 4; *Pl.42*), his entire remaining output at Sées. More elaborate and refined than the others, they have tiny ivy crockets that associate him

with Normandy, and as we shall see, his painting style does too. To characterize his fellow artists, we will now examine the figure painting.

The Painters

There are two main styles of drawing at Sées, and each master may have had his apprentice or coworker. No direct development is apparent; if anything, the styles cross-fertilized each other. Moreover, cartoons were repeated and adapted, and in some cases a master's drawing seems to have been traced (through the glass while on the cutting table?), reproducing even his detail but in drier fashion. An analysis of style must therefore be based primarily on the chapels where the historiated program would require fresh compositions. Two of the Sées glaziers can be identified in this way: the St Nicholas Master and the Magdalene Master. Although only fragments remain in the other radiating chapels, the chapel of the Baptist can probably be grouped with the St Nicholas chapel on the north ambulatory,[132] as can the Magdalene and St Augustine chapels on the south. Thus one master did, or at least oversaw, the two south chapels while the other took charge of those on the north. Since one chapel of each group was donated by the inquisitor Amicus Dei, presumably at the same time, a picture begins to emerge of the size, activity, and working methods of the artists in the glazing campaign.

In addition to the St Nicholas Master, who produced decorative tableaux, and the Magdalene artist, a marvelous expressionist, a third painter of first rank can be identified for the original program of the axial chapel. I will call him the Protais Master after his only design that still has its medieval head, that of St Protais. A fourth painter will be identified as the Jean de Bernières Master after his work in that chapel, though he had previously worked at Aunou-sur-Orne and then was probably in charge of the transept clerestories at Sées. A fifth produced much of the choir clerestory, no doubt under the direction of the Magdalene Master (who did donors and prestige work there) but in a unique folk style stressing pattern. He is an artist of the stripe of Grandma Moses and Henri Rousseau *le douanier,* most rare in medieval art, and I will dub him the Primitive of Sées. They are five strong individuals. I will discuss them briefly below, with comparisons that serve to characterize the Protais and Nicholas Masters as Normans from closer to the Seine, and the rest of the chantier as of local western origin.

The Protais Master

The Protais Master, whose work appears only in the axial chapel, commands a refined and sophisticated art. I have already mentioned his fancy canopies, embellished with delicate traceries and with tiny ivy and clover crockets (*Pl.42*). His borders are also unique in the cathedral: rising, alternating leaves that resemble semaphores with serrated edges (*VI.11*). The four figures remaining of the memorial group (Gervais and Protais, plus two bishops of Sées, all with inscriptions) are now little more than monumental ruins, disfigured by severe weathering, by modern replacement of glass, and by truncation in height, a slice having been removed from the midsection of each figure. As a result they now are, in Lafond's phrase, "magots difformes."[133]

VI.20 *Sées. Protais Master. Head of St Protais, Bay 3.*

Only one head, St Protais's, is original (*VI.20*). Its striking beauty makes the loss of the others the more sad. Lafond's appreciation of this most elegant draftsman merits repeating:

> [L]a construction traditionnelle s'assouplit pour serrer de plus près la realité vivante, surtout dans le nez et dans la bouche. Les paupières sont indiquées, de même que l'iris de l'oeil; la chevelure s'ordonne en boucles, non sans grâce; seule l'oreille demeure en dehors de la nature ou plutôt elle ressemble à un coquillage.[134]

It can be added that the St Protais Master creates monumental, spreading figures and employs a varied, nuanced palette. The delicacy of the features and the approach to realism may be compared closely to the debris of three apostles from the Lady Chapel of the abbey of Fécamp in Haute Normandie (*VI.21*).[135]

Although one is comparing wrecks to wrecks, the similarity of the hair curls and the arthritic hands is also striking, as is the artist's treatment of the halo, which he paints with a delicate line that hovers like a phantom aureole loosely outlining the head. Indeed they are most probably the work of the same painter. If so, then what sequence had these two commissions in the Protais Master's career? The Fécamp apostles stride with nervous vigor,[136] the Sées worthies are more massive and sedate. The simpler canopies at Fécamp—as in Normandy, each one different and one double-gabled—certainly predate those of Sées's axial chapel by some years. Lafond dated the Fécamp trio to the mid-thirteenth century, perhaps about 1260, which would allow a decade or longer for the evident evolution in decorative vocabulary.

The Protais Master, then, came to Sées from Fécamp but certainly not directly, and at Sées his greater elegance and the prestige of his axial chapel commission suggest that he was hired to be foreman. It was probably his patternbook that was put at the disposal of the local

VI.21 *La Trinité, Fécamp. Heads.*

VI.22 *La Trinité, Fécamp. Grisaille.*

chantier, providing canopies—and borders and grisailles—which at Sées are touched with a slight archaism. What borders and what grisailles? The trio of Fécamp apostles have *Castille* borders. Associated with them at Fécamp are two precious grisaille panels also in *Castille* borders (*VI.22*), whose desiccated palmette foliage definitely predates the swollen and quasi-naturalistic leafage of Sées by the same considerable block of time as is evident in the Protais Master's canopy designs. Nonetheless the Fécamp grisailles are colored, nail-studded latticework. Here is an explanation for the *Castille* borders and colored latticework grisailles of Sées that makes sense.

The Nicholas Master

Lafond considered the Protais Master a Norman "se rapprochant assez de ce qu'on voit à Rouen et à Evreux à la même époque," and grouped with him the painter of the Nicholas legend in the north chapel.[137] The Nicholas Master does have a similar approach to facial features, though totally without delicacy or nuance. His art can best be studied in the scenes of the murder of the three boys and the dowering of the three sisters (*Pls.43.A–B*), though he also contributed the axial clerestory (Bay 200, Gervais and Protais, bishop-saints Latuin? and Vaast?).

Most of the heads in the Nicholas scenes are original, although quite darkened. Forms are rounded and full within emphasized and carefully delineated silhouettes, set off emphatically against the ground. The artist creates a shallow, tipped-up Gothic space when the scene requires it but prefers to play outlined shapes against a neutral ground. The drawing within the silhouette is spare and clean, and the facial features are rendered with tight precision. They are not graceful; even females often have huge ugly ears. Peculiar to this artist alone is his preference for depicting hair on a separate piece of glass, a compartmentalization of form symptomatic of his approach in general.[138] Color is rich and saturated, with strong gold, much deep green, and red. The murder mimed against its throbbing red ground is very effective (*Pl.43.A*). Although figures have thick necks and their gestures are silhouetted, heads and hands are not notably out of scale. The containment of this style is marked, but the narrative has been injected with life by the sway and instability of the postures and an occasional detail. For example, in contrast to the normally bland facial features, note the exceptionally expressive profile head with hook nose (now nearly opaque) of the middle boy being murdered. All these traits, which I would characterize as "posed" or tableaulike, are frequent in Norman glass of the latter thirteenth century (see p. 71f.). At Sées they are robust, untouched with elegance, but equally untouched with mannerism. It is decoration of a high order.

As mentioned before, the Nicholas Master also contributed the axial clerestory (Bay 200), the only choir clerestory where the traits of the Norman glaziers reappear. Gobillot was the only author to notice this difference, which is a matter not simply of more lavish designs for the axial window, as Lafond interpreted it, but of a different artist.[139] The censing angels in the traceries are silhouetted with the Nicholas Master's care, and his drawing can also be appreciated in the delicious little fragment of the Child Virgin held by her mother, St Anne (*Pl.45.B*). The faces of the deacons Gervais and Protais in the lancets below have his precise features and bland expressions.[140] Hair is represented on a separate piece of glass. In contrast to the rest of the clerestory windows, the palette is varied and multicolored; the

heads are smaller and the proportion of head to body more elegant; there is less movement, the figures posed quietly, even stiffly, and stuffed into their lancets. And unlike the other clerestories, there is no backpainting at all.[141]

The Jean de Bernières Master

The style of the Jean de Bernières Master will be characterized on the basis of the window of Bishop Jean de Bernières between deacons Gervais and Protais, in the east wall of the north transept (Bay 21). From this it can be hypothesized that he painted Bay 23, the matching bay to the left, on cartoons of the Nicholas Master, and that before embarking on the project of the bishop's chapel (after 1278), the Jean de Bernières Master was probably in charge of the glazing of the transept clerestories (Bays 209, 211, 213, 217, 219, and 221), a workaday series of repetitious apostles. Before coming to Sées and encountering the Norman patternbook, he had glazed the little chapel of Aunou just out of town, probably 1265. Thus in tracing his style we will work backward from his latest, most distinctive work. At that point it will be easier to see its roots in the regional, artisan work of the Evron Master's bay in the Le Mans upper ambulatory (Bay 105), a project of about 1255. The abbey of Evron is closer geographically to Sées than any other monument in this study, roughly sixty kilometers to the southwest. On the basis of this comparison it seems reasonable to assume that the Evron window of Le Mans is not the maverick it appears, and that its folk style had regional viability for several decades.[142]

The Jean de Bernières window (Bay 21) is a work of bright, childlike color—red, blue, and yellow. The figures of Bishop Jean and the cathedral's patron saints are tightly contained and outlined against the ground, with small, rather triangular heads painted with mean, wizened features—noses pointed, the mouth line distinctly drooping (VI.7, p. 178). The cartoon of the deacon saints has been adapted from the same pattern as that of the handsome St Protais in the axial chapel (see p. 203, Pl.42), and to totally different effect. Thus the Jean de Bernières Master's habits emerge: unnaturally truncated, squirrel-like arms; a twisted body axis, with angled heads and torsos over frontal legs;[143] the drawing minimal, reserved and lean. His drapery painting is notable for long, thin, spiky lines resembling twigs in winter, combined sparingly with solid black triangles at the ends of folds and an occasional patterned curl at the hemline.

The same drawing can be seen in the patched lancet to the left (VI.8, p. 179), of Elizabeth and the Virgin of the Annunciation (Bay 23). Compare, for example, such well-preserved sections as the Virgin's sour features, her twisted hand, and the lean spiky line of her draperies, with similar details of Bishop Jean and the deacon to the left of him. The color, however, is more muted and nuanced, and the forms of the women are full and spreading, with hair made from a separate piece of glass and the postures mannered and swaying. The cartoons and the glass cutting were done for him, probably by the Nicholas Master.[144]

Moving backward in time from Bishop Jean's commission of 1278, we find the style of the Jean de Bernières Master only in a group of repeated apostles that has been referred to intermittently in this chapter, probably made for the transept clerestories, though remnants have undergone quite a diaspora. These fragmentary exiles will now be reassembled and the project as a whole discussed. Still in the north transept clerestory are five apostles (Bays 209, 211; Pl.39), but since the glass has been polished and overpainted where not simply

replaced, little but the cartoons can be studied. One or another of these cartoons is repeated in all of the émigré apostles now found in the axial chapel (four of the figures in Bays 5 and 6; see *VI.12.A–D*) and the Magdalene chapel (the two apostles in Bay 18) as well as the fine saint in the Victoria and Albert Museum (*Pl.40*).[145] The drawing on the latter has been reinforced, particularly on the head, but the new paint is a different color and can be distinguished from the old. The pair in the Magdalene chapel have modern heads, good copies that nearly fooled even Lafond;[146] those in the axial chapel have all been shortened in midtorso,[147] and the pair on the chapel's north wall (the outer figures of Bay 5) are wrecks preserving less than half their medieval glass.[148]

The similarity of the cartoons with those of the Jean de Bernières window is clear. As in Bay 21, the apostles have truncated, squirrel-like arms and hands; small knoblike heads on real necks; a torsion between the angled upper body and straight legs; and a careful silhouetting of the contained form against the ground. His drapery style (thin, spare, twig-like lines with an occasional curlicue hem) can be recognized most easily in the two apostles now in the Magdalene chapel, the only émigrés to retain their canopies, the hanging lamps above their heads, and *Castille* borders.[149] The draperies of the London apostle (*Pl.40*) include several of the master's black triangle folds.

Though the shop practice of working together might be suspected from the variety of palettes, it is beyond question in one extraordinary case: the St Peter in Bay 6 on the south wall of the axial chapel, whose virile, striking head (*VI.25*) Lafond described in this way:

> La tête de saint Pierre est curieuse. Non seulement le peintre a tracé des rides
> sur le front, mais il a creusé la joue d'une grande ombre triangulaire pareille à
> celles qu'il prodiguait dans ses draperies, pour en accentuer les "becs
> débordants."[150]

This powerful figure (*VI.12.E*) is one of the few works that still exist to be appreciated of one of the west's remarkable expressionists, the Magdalene Master, who will be discussed shortly. The painting differs significantly from the rest of the series, though the model is identical. All of the Magdalene painter's exaggerations are there, among them the elongated eyebrow, patterning of hairs, heavy slashing V in the cheek, and absolutely electric gaze. The drapery strokes are thick, brusque, and angular. Even allowing for the missing slice now removed from the figure's middle, the outline of the cartoon itself has been "angularized." The artist uses backpainting lavishly. A very instructive comparison is offered by this St Peter and the apostle in the Victoria and Albert (*Pl.40*), made from the same cartoon in general use in the north transept but as different as night from day. No more succinct exposition of the freedoms and constraints of medieval design practice could be imagined than the comparison of these two saints. If ever proof is needed that medieval art allowed for the development of a personal style—even in a medium as technically complex and recalcitrant as stained glass—that proof is here.

The Jean de Bernières painter, no doubt in charge of the apostles project, is not, however, as stylistically remote from the Magdalene Master as it might appear. His line is not thick or violent—the V in the cheek becomes a fine line in his figures—but his attachment to distortion is basically similar. This is more apparent in his earlier work in the parish church of Aunou-sur-Orne, where his style is unshackled by the restraints of the Norman patternbook. Aunou has surfaced in the arguments of this chapter from time to time and will now be introduced more directly.

Aunou-sur-Orne, Country Chapel

The parish church of Aunou-sur-Orne is a simple unaisled chapel four kilometers east of Sées.[151] In the Middle Ages it was a dependency of the Benedictine abbey of Saint-Martin in Sées, and it seems to have served as a funerary chapel for a family of the lower nobility. Its choir still contains one thirteenth-century window plus coats of arms in the tracery of that one and two others, the same family arms charged with various cadency marks (*VI.23* and *Pl.47*): *d'or à 6 fers à cheval d'azur (à la bande de gueules, à la fasce de gueules* and *à la fasce de gueules à 3 annelets d'argent*). Clearly the four choir windows were originally glazed at the same time and at the family's expense. The family can be identified as de la Ferrière, and one can suggest the optimum dating of the gift as about 1265, upon the death of the eldest brother.[152]

The glass that remains shows the figure of St Eulalie kneeling, her long hair flowing behind, a bird (her soul) emerging from her mouth; her executioner raising a sword, instrument of her beheading; remnants of borders (fleurs-de-lis and castles), two grisaille patterns, very elementary canopy frames, and part of an inscription (SANCTA EVLALIE) (*VI.24*). Every element, including the color palette of balanced primaries, connects the window of Aunou with the glazing of the Jean de Bernières Master at Sées cathedral: the facial features; the drapery indicated by spare, thin lines; the contained forms silhouetted against the ground, with the same combination of quiet precision and understated distortion. The forms are in torsion, the heads angled over more frontal bases. Most notable are the grotesque misproportions of the executioner's figure, his raised arm centered and enlarged. The clean precision of the line and the distortive expression of the forms make a tense marriage.

The canopywork, if one can even use that term, gives an indication of relative chronology. The only comparable example in the cathedral is the pair of awkward, atypical canopies reused over the figures of Elizabeth and the Virgin Annunciata in Bay 23 in the north transept facade. They certainly predate the Norman patternbook. The dating of the Aunou window to just before the main campaign of the cathedral choir seems beyond argument—and thereby is established the existence of a parish church glazed in "country-style" band windows in the vicinity of the cathedral before its program was in execution.

VI.23 *Church of Aunou-sur-Orne (Orne). Arms of de la Ferrière, cadenced à la bande de gueules, ca. 1265. Original grisaille in left and lower lobes.*

VI.24 *Aunou-sur-Orne. Martyrdom of St Eulalie.*

The cult of the child martyr Eulalie, though well established in western France by the early Middle Ages,[153] possibly centered at the Benedictine abbey of Evron, which possessed her relic.[154] The mention of Evron recalls the odd bay of ca. 1255, given by the abbot of Evron to the upper ambulatory of Le Mans and presumably the product of a folk artisan or monk who may have gained his sure touch in glazing the abbey church dedicated in 1252 (see p. 254 and *II.7,* p. 28). The scale is much smaller than Aunou and the decorative vocabulary very different; I have suggested that it was arrived at by the artist's study of pre-Gothic designs at Le Mans cathedral. While the facial conventions, the color, and the psychological focus share a general kinship, only the drapery painting is notably close to that developed by the Jean de Bernières Master. Thin, jagged lines applied precisely and sparingly

are punctuated with an occasional blackened triangle and with irregular blobs along the path of the line, as though a fountain pen were dropping ink. Over a decade separates the two regional works, suggesting an established folk tradition in what was, even then, a remote province, out of touch not only with the court but also with the sophisticated centers of Upper Normandy. The delicate scratched pattern framing the Eulalie figures and the elementary architectural and grisaille patterns (largely but not totally modern) are a Gothic patois unrelated to the modulated accents of the Norman patternbook the artist was introduced to in his job at Sées cathedral.

The Magdalene Master

The Magdalene Master is an expressionist of flair and power, whose art, while related in its distortion to the Jean de Bernières Master, has thrown care to the winds. Less remains of his work and what exists is in more fragmentary and ruined condition. Already mentioned is the forceful St Peter of the apostles series (VI.25; now in Bay 6 in the south wall of the axial chapel), one of his most striking figures, although painted from the common model (see above, p. 207, VI.12.E and VI.25). In Bay 14 in the Magdalene chapel are a badly weathered donor panel of Amicus Dei, and the grotesquely patched wreckage of the supper scene of the Magdalene wiping Christ's feet with her hair (VI.18, p. 191). I have named the master for this extraordinary Magdalene figure; it will be discussed below. In the Augustine chapel the panels of the donor receiving the Rule from the seated St Augustine (Bay 8) retain original heads in a dry, unbending caricature of the master's touch. They are most likely the weak products of an apprentice following the master's cartoon very carefully, for example in such details as the distinctive elongated eyebrow. The other two windows in the chapel (Bays 10 and 12) both have a cluster of monks listening to the teaching of a seated St Augustine (VI.16, pp. 188–89), though so much is restored in each that little can be said about them. The original panel of one of the groups of monks is now in the Glencairn Museum, however, a handsome work sparkling with the Magdalene Master's particular electricity (VI.17, p. 190).

The artist's hand can most easily be studied from the Glencairn panel:[155] the penchant for angular form, the rapid slashes in the draperies, the boxy hands with long slender lines extending the fingers and with fingernails added here or there—an ideogram of a hand. Space is flattened and ambiguous; forms crowd, shove, stumble over each other. In the heads the means are simple—triangular head shape, thick downward gash for the mouth, a play of pattern as an ear, flat-bottomed, staring eyes. Yet with his simple means the master has drawn a cluster of five monks who are five individuals. More than praying, they seem to be caught in the act of applauding their patron Augustine.

The supper with the Magdalene wiping Christ's feet (Bay 14) is a frightful wreck of the scene, the figures above the tabletop deformed by old repairs in smaller scale destroying the integrity of the design.[156] The panel has been widened and its borders eliminated, though more than three-quarters of the canopy above is original. The objects on the table, depicted with freshness and wit, compose with repeated bread rolls, knives, and grinning fish an ideogram of a meal (VI.18, p. 191). Beneath the table is the Magdalene's crouching figure, a twisted, abstract form culminating in the striking head, now so darkened that one can barely discern the bold, lovely features and the violent sweep of hair.

VI.25 *Sées. Magdalene Master. Head of St Peter, detail of figure now in Bay 6. Photo before 1939.*

The Magdalene Master's art is now nearly extinguished by ill luck and glass sickness—alas. He is among the great expressionists of the western French school. The sources of his style, with its vital intensity and its selective exaggeration, lie ultimately in the twelfth-century Plantagenet stained glass art, but the links are enigmatic. I have suggested that western artists such as the Evron Master of Le Mans (a folk artist but not an expressionist) and the Catherine Master of Dol (a developing expressionist) actually studied Plantagenet windows, the former at Le Mans and the latter at Angers. The simpler accents of the Blaise Master at Sainte-Radegonde may have been hyperbole within a more continuously developed Poitevin language. The unfettered brush of the Magdalene Master of Sées, the strength and directness of his design, and the eloquent distortion of form occur in one other example in Normandy: two large panels of about 1260 showing longshoremen at their toil (*III.13*), from the cathedral of Rouen (now in the Musée des Antiquités).[157] The drapery painting is in a similar idiom, marked by thick, angular gashes placed irregularly and punctuated with blackened triangles. The orphaned state of the Rouen panels cancels further inquiry, but their existence at Rouen is significant. Parallel to the Norman style of quiet tableaux painted with a few well-positioned fine lines, from which the rural art of the Jean de Bernières Master derives, was an unmuzzled Norman style of great power and sophistication to which the art of the Magdalene Master is related.

The choir clerestory, excepting the axial bay of the Nicholas Master, was probably glazed under the supervision of the Magdalene Master. His direct participation was probably limited to the donor portraits, the lavish window of Bishop Gui du Merle (Bay 208), and an occasional head such as the fine apostle with book in Bay 201 (which has no donor figure). In addition to Bishop Gui, the donors of Bays 207 and 204 (Mestre Osmont [*VI.26*, r.] and the canon "Folin") are still largely original.[158] The Magdalene Master's coworker in the clerestory was not the weak apprentice of the Augustine chapel, however, but a unique talent, an artist who pushes the master's exaggerations past caricature to a new idiom, the insistent patterning of folk crafts.

VI.26 *Sées. The Primitive of Sées. Master Osmont praying to the Virgin,
Bay 207 (Osmont's head by Magdalene Master).*

The Primitive of Sées

While I have called the Magdalene artist an expressionist, this follower is a primitive. Hands are bloated and mittenlike,[159] feet are like flappers, black-ringed eyes make figures look like raccoons (*VI.26*, l.). Heavy backpainting, which the Magdalene Master also used but more discreetly, increases a fussy, belabored quality of draperies. It is an unsubtle art marked by folklike reduction, by energy and lack of polish, and by a primitive's fascination with pattern.

Left to his own devices, the Primitive of Sées preferred to play with arrangements of patterns and has left some strikingly composed band windows achieved by reversing a cartoon that includes an undulating phylactery (*Pl.44;* Bays 205, 202, 204). While other glaziers, including the Magdalene Master, varied their repeated cartoons by a changed attribute or the reversing of a head, the Primitive of Sées reversed his cartoons in order to create symmetrical ink-blot arrangements (*VI.29.A*). His patterns are most effective, at the height of the clerestory, and as Westlake has commented, they are unlike anything else in France. To strike a virtuous Beaux-Arts stance and label his art ugly or inept is to reject the unimpeded message and strong appeal of the color and pattern of folk art. A different aesthetic can be defined, which Grodecki once formulated in a succinct comparison: "une sorte de

beauté rustique que l'on pourrait comparer à celle de la faience, pendant que . . . [more fashionable windows] sont comme de la porcelaine fine."[160] The Primitive of Sées is probably as close to folk art as the luxury medium of stained glass can get.

Shop Practice: Cartoons, Modelbooks, Distribution of Labor

Much of the Sées glass consists of single figures (apostles, bishops, deacons), which even the most casual observer perceives as based upon repeated cartoons. To leave the observation at that point is to miss some most unusual evidence of how a medieval glass atelier worked. Some practices common to many Gothic ensembles have already been noted: the painting of series cartoons by different masters (see above, p. 207), the altering of cartoons by a change in facial type or position,[161] or attributes, or the total reversal of a figure. Our understanding of shop practice has been based on such visual evidence in many Gothic monuments, combined with the twelfth-century account of Theophilus, who describes the laying-out of a cartoon on a whitewashed table. From such a full-scale cartoon the glass of several lancets could be cut and painted, glass that could easily be painted on the reverse side in order to vary the effect.

At Sées, in addition to the reuse of cartoons in such a standard manner, there is evidence of a rarer sort, indications of the transmission of designs in an atelier modelbook. The use of modelbooks and patternsheets by medieval artists has been assumed for a long time, and the fragile evidence of such small, portable models is increasingly the object of study.[162] Stained glass studies have produced little solid evidence;[163] what exists is chiefly from a later period.[164]

Because the glaziers of Sées are so distinctive, their adaptations of the same model make instructive comparisons, showing which details were meticulously copied, how selected details were combined, and how much the artist's personal touch succeeded in flavoring the finished product. The comparisons are truly surprising. The copied details are hand and feet positions and fundamental drapery arrangements, chiefly the introduction of a different color (the inside of a fold, a cuff, part of a cloak, maniple) and the placement of hemlines and indication of major folds. Heads and attributes are reversed or altered with far greater freedom. In the hands of different artists and adapted to the differing proportions of lancets, the results sometimes vary so enormously that only by careful comparison of the placement of drapery colors is a common model even suspected. Only then do minor details, such as the location of curls in the hem and the positioning of feet, seem to be related at all.

I have already suggested that the deacon saints of the Jean de Bernières window (Bay 21) derive from the same pattern as those of the Protais Master in Bays 3 and 4 of the axial chapel.[165] The image of Bishop Jean himself is similar to one of the Protais Master's bishops, as well as to one of the greatly elongated bishops of Bay 200 of the clerestory, though damage and the vastly different proportions of the lancets make certainty impossible. The following checklist suggests groups of cartoons made by different artists (and often used by them several times), which though varying in dimensions, proportions, and general appearance are probably based upon the same patternsheet.

Sées Patternsheets

Each artist's cartoon is placed on a separate line. Bay numbers refer to the plan (p. 172). Lancets are lettered A, B, C, and so on, from left to right. Major alterations, such as heads or whole panels, are noted. Figures in the axial chapel have been truncated by the removal of a slice in the middle; figures in the north transept have been severely polished and retouched.

Pattern 1 Bay 208 (E, F) (*Pl.46.A*)
 Bay 205 (B, C, D) (*Pl.44*)
 [Modern: 205C and D, heads; 208E, lower panel]

Pattern 2 Bay 208 (A, B)[166]
 Bay 203 (A); Bay 201 (A)
 [Modern: 208A; lower panel is largely new]

Pattern 3 Bay 207 (A, B) (*VI.27.A*)
 North transept Bay 209 (A) (*VI.27.B*); émigré now in Bay 18, Magdalene
 chapel (B) (*VI.12.C*)
 [Modern: 207A, head panel; émigré, head]

VI.27.A–B *Sées. Pattern 3. (A) The Primitive of Sées, north choir, Bay 207, lancets A and B. (B) Jean de Bernières Master, north transept, Bay 209, lancet A (polished and repainted).*

A

B

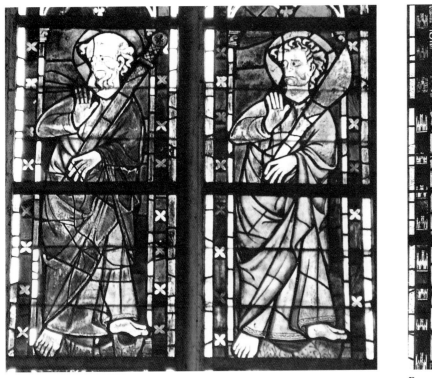
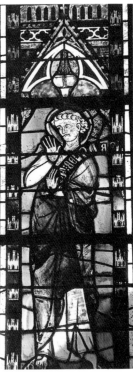

A B

VI.28.A–B *Sées. Pattern 4. (A) The Primitive of Sées (left head by Magdalene Master). North choir, Bay 207, lancets E and F. (B) Jean de Bernières Master. North transept, Bay 209, lancet C (polished and repainted).*

Pattern 4	Bay 203 (B, D)
	Bay 207 (E, F) (*VI.28.A*)
	North transept Bay 209 (C) (*VI.28.B*)
	[Modern: 207F, lower panel; 203B, head]
Pattern 5	Bay 205 (E, F) (*VI.29.A*); Bay 202 (C)
	North transept Bay 211 (A) (*VI.29.B*)
	[Modern: 205E, head]
Pattern 6	Bay 203 (C) (*VI.30.A*); Bay 201 (C)
	North transept Bay 209 (B) (*VI.30.B*); émigré in Bay 18, Magdalene chapel (A) (*VI.12.B*); émigrés in axial chapel Bay 5 (A, C)
	[Modern: Magdalene chapel émigré, head; Bay 5A, head panel; Bay 5C, head is an ancient restoration (fourteenth century?)]
Pattern 7	Bay 201 (B, D)[167]
	North transept Bay 211 (C); émigré in axial chapel Bay 6 (B) (*VI.12.D.*); London apostle (*Pl.40*)
	Emigré in axial chapel Bay 6 (A) (*VI.12.E*)
	[Modern: 201D, head; Bay 6B, head]

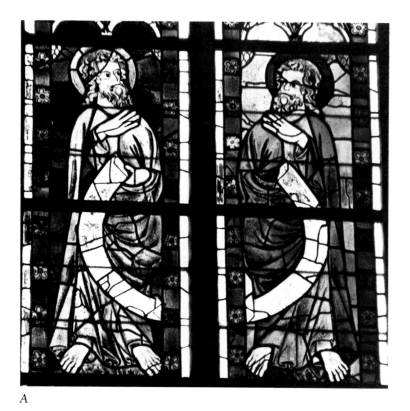

A *B*

VI.29.A–B *Sées. Pattern 5. (A) The Primitive of Sées. North choir, Bay 205, lancets E and F (left head modern). (B) Jean de Bernières Master. North transept, Bay 211, lancet A (polished and repainted).*

Careful comparisons of these groups surprise us both by the detailed precision with which the model was reproduced and by the difference in the final outcome. The reliance on a model—at once sacrosanct and a point of departure—had a fundamental impact on medieval art and produced that combination of uniformity with diversity that we ultimately recognize as "medieval." It is an unfortunate but popular stance among modern scholars to denigrate the use of patternsheets, the repetition of cartoons, and the general reliance by medieval artists on models, but we fundamentally misinterpret the art of the Middle Ages in so doing. Basic work remains to be done on the essence of such transfers of form.[168] The medieval artist was trained to start with a pattern. What he did next is what we should judge.

The shop practices at Sées bespeak a simple, communal, and less hierarchical craft structure than often confronts us, at least with such clarity. Repeated cartoons and reliance by several artists on the same modelbook are not the result of haste or impecuniousness, as so often interpreted, but of custom. The cooperation of several artists on one product is another such custom, which is not recognized often enough by modern observers. Eva Frodl-Kraft has commented on the composite nature of stained glass production:

> [E]ntre la création de l'esquisse et la terminaison du vitrail se situent quatre
> opérations relativement indépendantes, et en partie mécaniques, qui peuvent
> très bien être exécutées par des personnes différentes. Le fait que le carton
> existe indépendamment de son exécution définitive dans le vitrail a conduit le

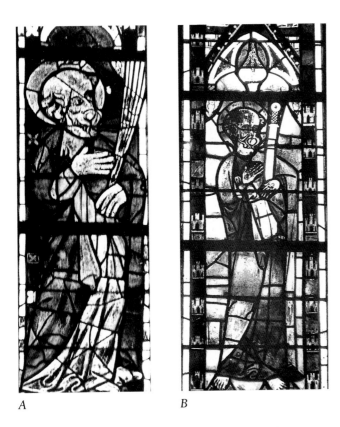

A B

VI.30.A–B *Sées. Pattern 6. (A) The Primitive of Sées
(head by Magdalene Master). North hemicycle, Bay 203,
lancet C. (B) Jean de Bernières Master. North transept,
Bay 209, lancet B (polished and repainted).*

XIXe s., par suite de son estimation exagérée ou au moins de son évaluation anhistorique de toute réalisation artistique individuelle, à classer la peinture sur verre parmi les arts mineurs et à la considérer comme une peinture de second ordre. Les opérations du travail sont au nombre de six: préparation du verre; dessin du "patron" [cartoon] en grandeur d'exécution; découpage des morceaux de verre colorés selon le carton; peinture; cuison de la peinture; mise en plomb.[169]

Although several of these steps are, as she suggests, mechanical, three operations fundamentally affect the result: the designing of the cartoon, the choice of color and cutting of the glass, and the painting.

At Sées several interesting collaborations have been noted. I have suggested that the figures of Elizabeth and the Virgin (*VI.8,* p. 179) in Bay 23 of the north transept were designed and the glass colors chosen and cut by the Nicholas Master, while the painting was done by the Jean de Bernières Master, who was no doubt responsible for the whole chapel. In the Augustine chapel the features of Augustine and the donor (Bay 8) are marked by the idiom of the Magdalene Master, though executed by a much weaker hand probably following his cartoon very carefully. The Magdalene Master's St Peter (*VI.12.E*), among the émigré apostles now in the axial chapel (Bay 6), is a powerful image following the cartoon of the

Jean de Bernières Master but probably cut (since the outline is more strongly angled) and certainly painted by the Magdalene Master and marked by his special fire.

Vin de Pays

So much is unusual about the Sées windows that it has generally been easier to ignore them or dismiss them as mavericks, peculiar ancestors of the band windows of Saint-Ouen and Evreux, atypical country cousins of Rouen (a judgment based in part on the similarity of rose window traceries with Rouen cathedral). Erroneously dated by the early literature as late as the fourteenth century, the Sées glass seemed gauche, provincial, and isolated, without relevance to contemporary developments of the medium. Since Lafond's identifications of the donors, establishing their gifts in the decade of the 1270s, the judgment of maverick is misleading and simply wrong. I have tried to establish Sées not as bizarre and inexplicable but as rooted firmly in its border region and in its important, pivotal decade—following the death of St Louis, when the Parisian fashion in band windows spread like a contagion. The atypical character of Sées is at once more easily explained and more significant to the history of the Gothic stained glass art of western France.

As might be expected from its geographical location on the borders of Lower Normandy, Brittany, and the Aquitaine, Sées has Norman affiliations as well as connections with the western region of the Maine and the Loire valley. The department of the Orne is a borderland:

> Le caractère du département de l'Orne est divers comme celui de la
> Normandie elle-même. Il constitue moins une unité géographique qu'une
> entité politique façonnée par l'histoire. Situé au sud de la province
> [Normandy], au bord d'une région souvent disputée, il en fut la marche
> frontière. . . . Ainsi le Perche lui a successivement appartenu et échappé . . .
> [and] l'une de ses anciennes capitales, Nogent-le-Rotrou . . . [is presently]
> rattachée au départment d'Eure-et-Loir.[170]

Norman and western artists shared the tasks at Sées. The Protais Master, an elegant artist originally from Fécamp, and the Nicholas Master exercise a sophisticated Norman idiom of carefully and cleanly executed tableaux. The Jean de Bernières Master's touch is similar but closer to the folk artistry of Evron in the western Maine, while his distortion is related to even more ancient regional traditions. The Magdalene Master is a first-rank expressionist whose power draws even more directly on those traditions, as does the Primitive of Sées, whose untutored folk tongue transforms distortion to pure pattern and who simply exults in pure color. His color formula of gaudy balanced primaries remains a hallmark of the stained glass of western French monuments for the next generation.

Sées is a mixed marriage of Norman and western species. A similar stylistic profile, though with Norman style less and less dominant over the western idiom, is typical of the Benedictine abbeys southwest of Paris at the end of the Capetian era: La Trinité de Vendôme, Saint-Père de Chartres, Evron. But this stylistic mix was not the case in monuments preceding Sées, such as the cathedrals of Le Mans and Tours. One would not expect Norman influence at those sites, and the western idiom there is muted, unfocused, and erratic. At Le Mans the major stylistic input, I believe, came from Bourges; at Tours it was Paris. Sées is a pivotal monument in many ways, not least of which is the flexing of regional muscle.

The Norman presence at Sées, which permeates the decorative vocabulary (canopy-work, borders, grisailles), waned in the later western monuments, just as the exterritorial styles at Le Mans and Tours proved mutant as those glazing campaigns ran their course.[171] Just as Sées is pivotal in the reestablishment of the validity of the regional idiom, it is pivotal in its wholehearted endorsement of the band window. I have discussed this phenomenon from several perspectives and recognize that important links in the chain are missing, not only those Parisian monuments that initiated the fashion but probably some of the way stations along the paths of transmission. It is not impossible that the chief link between Victorine Sées and Paris was Victorine Lisieux, all of whose glazing is lost.[172] If that were so, the strong Norman flavor of the Sées band windows would be even more understandable.

Since Sées is the earliest full set of band windows still extant, one more observation may be permitted. The "cathedral formula" of the High Gothic glass ensembles of Chartres and Bourges, marked by a rigid dichotomy of scale between high windows (large single figures) and chapels (small framed narratives), is nowhere observed. It seems less likely a rejection of the dictated cathedral formula[173] than a reflection of the strength of another tradition, that of rural parish glazing, where of course the dichotomy never had an application. As I have tried to suggest, Sées, most rural of cathedrals, is atypical of cathedrals but not of its rural, regional landscape.

It is therefore unfortunate that the Sées windows, insofar as they have been mentioned at all, have been grouped previously with the more sophisticated art of Normandy. By geographical proximity, architectural style, and reference to the later band window ensembles of Saint-Ouen and Evreux, the grouping suggests itself, and Sées does indeed include some refined Norman figure painting as well as much decoration in that idiom. The expressionist painters warrant equal time in our study of the development of the art. The designs that Lafond called "excessively stubby and sometimes deformed," "curious," with "faces often of a comical ugliness," "impossible postures," all in a "magnificent sonority of color," announce the abstraction, virility, and brilliance of an important group of Gothic stained glass. *Ecce* the western style. The gaiety and energy of such a memorable ensemble as Saint-Père may have been distilled from humble *vin de pays*.

✳ Epilogue ✳

If—God forbid!—Sées no longer existed, modern scholars would have to invent it. But if it did not exist, who could imagine such a place? One of the most audacious of *rayonnant* stone cages, glazed with a full set of band windows—classic statement of the *opus francigenum* of St Louis's France—yet glazed by a team of artists who painted as if Paris were on the moon. There is a certain "cathedral tone" about their product. The iconographic program is simple and direct, even repetitive, and dictated often, as at Chartres and then at Le Mans, by donors' wishes for yet another Virgin Mary. The shadow of episcopal grandeur, as at Dol, falls on the axial designs; Sts Gervais and Protais, patrons of the cathedral, appear three times and always in the good company of the Sées bishops, sainted or not. The five glaziers

dive into this task without a trace of boredom, indeed with a remarkable enthusiasm. The two Normans among them can be related to lost programs at Fécamp (ca. 1260) and possibly Lisieux, a Victorine cathedral like Sées, with which it kept close contact. The remaining three glaziers of Sées, though each is distinctive, seem to be on home ground. One paints in the manner of the unique "Evron window" of Le Mans, produced ca. 1255 most probably at the abbey of Evron by one of its monks. Another is an even purer folk primitive; one can imagine that he, like the grandfather of the modern Chartrain glazier Lorin, came home one final evening past the manure piles in his farm's inner court, slammed his grimy hat on the kitchen table, and announced, "I'm going to make stained glass windows!"

Most memorable of the Sées quintet, by virtue of sheer creative fire, is the explosive expressionist Magdalene Master. Distortion of form, excesses of color intensity, exaggeration to create psychological tension for expressive purpose—these qualities have marked a series of great expressionists in this book: the designer of the Mauclerc prophets; the Master of Bishop Geoffroy in the axial clerestory of Le Mans; the Poitevin charmer called the Blaise Master at Sainte-Radegonde; the Breton enfant terrible of the Catherine lancet at Dol. At Sées, solidly dated by its parade of donors to 1270–1285, this violent western patois has finally assumed the resonance and authority of a statement ex cathedra.

CHAPTER SEVEN

The Western Realm:
La Trinité de Vendôme

Ce dauphin si gentil, aujourd'hui que garde-t-il
De tout son beau royaume?
Orléans, Beaugency, Notre-Dame de Cléry,
Vendôme, Vendôme!

—CARILLON (SIXTEENTH CENTURY)

URING THE REIGN of St Louis (d. 1270), the great western counties were appanaged, or controlled by the more precarious means of treaties, marriages, or show of force. By the first years of the reign of his grandson Philippe le Bel (1285–1314), the western realm was consolidating. Maine reverted to the crown in 1285 with the death of Charles d'Anjou, as had Poitou previously by the death of Alphonse, and Chartres was purchased by the king in the following year. The late trio of closely related western monuments that mark the fruition of the western glazing style—Vendôme, Evron, and Saint-Père de Chartres—are situated on the fringes of the Maine, and their donors include courtiers and princes of this regal society. That their art is emphatically un-Parisian suggests the strength and vitality of western traditions. All were established Benedictine monasteries, where one might expect traditions to be nurtured.

The relationships of these three campaigns of the mature western school are not so much developmental as interwoven. Each will therefore be presented on its own evidence and documentation, in the hope that the movements of ateliers and masters will come to seem less the arbitrary fancy of art history than the reasonable reflection of societal events and the work patterns of the craft.

La Trinité de Vendôme (*VII.1*), unquestionably the earliest of the three ensembles, is the first monument where the mature western style appears. There are, however, two styles at Vendôme and they are probably not coeval but sequential. Like Sées, the ensemble was in all probability an early experiment in band windows, but the gaudy reduced coloration of Sées recurs only with the latest work of the second, western atelier of Vendôme. (The present band window scheme is a modern restoration; on the original arrangement, see below, p. 225.) The relationship of Sées and Vendôme is thus generic only, the Sées campaign ending by about 1280, and the Vendôme glazing commencing about the same time by a non-western master and only later, possibly 1285, continued by a western atelier. The regional formation of the latter shop can only be guessed on the basis of color, of total disinterest in finesse, and of a few decorative details that occur in much more tentative form in the Gui du Merle

221

VII.1 *Abbey of La Trinité, Vendôme. After Ch. Metais,* Cartulaire; *Peigné-Delacourt, 1869.*

window, a late design at Sées (pearled halo, introduction of gargoyles into the canopywork). The link to Sées is not direct and, what is more regrettable, the immediate roots are lost. Vendôme, moreover, was conceived as a modest program and has suffered radical alteration in the sixteenth century as well as an explosion in 1870. Thus it now forms a most fragile bridge between the formative stages of the western style—in the generation 1250–1280— and the late, great ensembles of the succeeding era.

Evidence of the Gothic Schema

The former abbey church of La Trinité de Vendôme (Loir-et-Cher), located north of the Loire between Tours and Orléans, still contains glass dating both before and after the seven band windows of the chevet that occupy us here. Earliest and most famous is the twelfth-century lancet of the Virgin, now installed in the Gothic Lady chapel.[1] Another fragment of a Virgin lancet, of early thirteenth-century style,[2] was removed from the flamboyant facade and exhibited in Paris in 1884 and has since been relocated in the north transept. Both images have probably been *spolia* since the *rayonnant* Gothic building campaign that constructed the present chevet, and thus their original placements are unknown.

The seven band windows were made for the *rayonnant* clerestories in which they are still found, but the extent and exact arrangement of that glazing program have been lost with the alterations of Abbot Louis de Crevent begun after 1492. Renaissance glass was made for chapels and clerestories; the figures of the Gothic band windows occupying the latter were retained in the bottoms of their lancets, leaving the broad field above free for the late designs.[3] The bizarre effect can be appreciated from the single Renaissance bay that remains (north clerestory Bay 203) and from old photographs (*VII.2.A*). It is a miracle the Gothic panels were not simply destroyed. Gothic fragments of grisaille (*VII.3*) still found in traceries and lancet heads at all levels of the elevation, however, suggest an original program much like that at Sées: grisaille in the triforium, and band windows in the clerestories and perhaps the chapels. The *rayonnant* campaign thus filled the entire choir and continued, at the start of the fourteenth century (*VII.4*), in Bay 27 in the northeast aisle of the nave.[4]

An explosion in 1870 shattered the Renaissance clerestories excepting Bay 203, damaging the thirteenth-century band of Bay 201 to a lesser extent. Modern repairs have retained the Gothic bands at the bottoms of Bays 205 and 203 (since the top of 203 still contains its

VII.2.A–B *La Trinité, Vendôme. (A) Choir, before the 1870 explosion, showing Renaissance glass installed above the Gothic "band" in Bays 201, 200 (axial), and 202. (B) Present arrangement. Left to right: Bay 205 (Gothic band beneath grisailles); Bay 203 (Gothic band beneath Renaissance glass); Bays 201 and 200 (Gothic band between modern grisailles).*

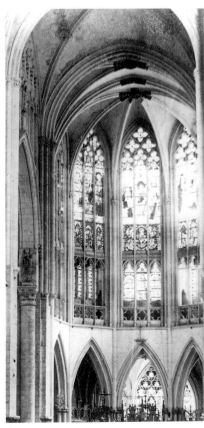

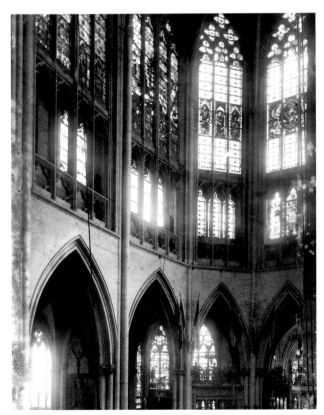

A

B

VII.3 *La Trinité, Vendôme. North radiating chapel, 13th-cent. grisailles in traceries of Renaissance window.*

Renaissance panorama) while restoring the hemicycle and south bays as more typical band windows (*VII.2.B*). The original Gothic schema was probably a little different.

Bays 205 and 206, facing each other at the crossing, never received Renaissance complements, and both now contain old grisailles in their traceries and lancets. The mid-nineteenth-century drawings in the album of Gervais Launay[5] indicate that the figure bands were then located at the bottoms of both bays, with grisailles above, and the observation of the Baron de Guilhermy concurs:

> Les fenêtres de l'abside présentent une série de petits personnages; au-dessus,
> à la première fenêtre de chaque côté [i.e., Bays 205 and 206], grisaille; aux
> autres fenêtres, au-dessus de la première rangée, figures du XVIe siècle.[6]

Bay 205 still has its figure band at the bottom, and its grisaille, though damaged, is largely medieval, though composed of two different patterns in unequal amounts. Bay 206 now has a modern band window format; six of its sixteen grisaille panels are completely new; the grisaille pattern is too narrow and is padded out to fit by completely modern borders; and its style is tighter, drier, and unquestionably less evolved than the delicate grisailles that remain in the traceries above (as well as throughout the triforium and clerestory generally). From the above evidence I conclude that the post-1870 restorations simply consolidated the remaining grisailles of Bay 206 into holes in Bay 205[7] (where they would fit exactly) and concocted the new band window of Bay 206, using its old figure band and a group of grisailles from elsewhere.[8] In any case, the design of Bay 205 is the more authentic.

The figure band of Bay 205 could, of course, have been lowered about 1492, but—unlike the five bays that received Renaissance additions at that time—there would have been no particular reason to do so, and the Renaissance project is more understandable and less miraculous in this context. New glass was simply made to replace old grisailles, which were removed. Some may survive among the grisailles recently installed in the flamboyant facade.

The band windows of Vendôme were most probably a variant type,[9] with their colored figure band running across the bottom of the lancets—a type found only once, later, at Cologne. Moreover, since all of the Vendôme canopies have been truncated at the top, the original figure band would have been more expansive, occupying a larger area of the bays. The experimentation implied by this unique design did not stop with Vendôme. The second Vendôme atelier later worked at Evron, where they introduced the curiously precocious schema of a row of figures across the bottom of the lancet topped not by grisailles but by greatly extended canopywork, producing a completely colored ensemble to grace the hemicycle there (see Chap. VIII, p. 279).

Plan of La Trinité, Vendôme.

VII.4 *La Trinité, Vendôme. Bay 27, northeast chapel of the nave.
Traceries and left lancet have early 14th-cent. grisailles; middle
lancets Renaissance; right lancet modern.*

The First Vendôme Campaign: Charters and Heraldry

Until fairly recently the Vendôme glazing was believed to date after 1308, when Pope Clement V, in Poitiers, issued a bull granting indulgences for the reconstruction of the church. Thus projected into the second decade of the fourteenth century, the Vendôme glass seemed burdened by déjà vu provincialism that was archaizing in comparison with the glass at Sées and Tours a generation before, and no more than a marginal curiosity in the development of

the art. The terminus provided by the bull is not *post quem,* however, but *ante quem.*[10] It indicates that a lavish building program, well under way, had come to a temporary lull for lack of funds. The commencement of this lavish campaign can be situated after 1272, when a charter established the abbey's arrangements to quarry building stone.[11] Thus documents completely vindicate Jean Lafond's prophetic observation of 1954:

> Si un document ne fixait pas à 1306 [*sic*] le debut de la reconstruction de la Trinité de Vendôme—et si Saint Louis ne figurait pas dans l'iconographie— on attribuerait sans hésiter au dernier quart du XIIIième siècle . . . les fenêtres hautes du choeur.[12]

The problem of St Louis (canonized 1297) concerns the second atelier and will be addressed later. The first atelier, which glazed the hemicycle, concerns us now.

The *rayonnant* construction began east of the Romanesque choir and joins the transept of that earlier church, no doubt reprieved from destruction by the abbey's financial difficulties at the end of the century.[13] The monks saved panels from the windows of the old building: the two Virgins still exist today, and Renaissance alterations may have destroyed more old panels. These *spolia* may have been reset in the radiating chapels, earliest part of the *rayonnant* construction. The "non-conforming" grisaille panels, now placed in Bay 206, may have been made for this purpose. They generally resemble the grisailles of Tours, dated by Papanicolaou before 1267: bulged quarry leading, foliage that grows both up and down. At Tours the ground is still crosshatched and the foliage composed of desiccated palmettes; at Vendôme, the clear ground and inclusion of some naturalistic leafage suggest a slight evolution and thus a date of about 1275.[14]

The prestigious hemicycle bays of the clerestory (Bays 201, 200, and 202) most probably received the first big donation. At any rate their templates would have been available first for clerestory glazing, and the optimum date of their commission, as we shall see, is ca. 1280. They probably predate by only a short interval the next project in the clerestory, a related commission of the mid- to late 1280s but executed by a different shop.

The three hemicycle bays (201, 200, and 202) form a stylistic group of great beauty marked by deep, rich coloration and great elegance, unquestionably a major commission (*Pl.48.A–C; VII.5*). Bay 201 contains yet another Virgin and Child, enthroned and flanked by angels with candles. This bay may have commemorated the abbey's chapel, founded in 1070, located northwest of the church near the main gate[15] and dedicated to Notre-Dame de Pitié and St Michael.[16]

The axial clerestory (Bay 200) depicts the Trinity, to whom the abbey was dedicated, surrounded by the four evangelist symbols (*VII.5*). The archaic appearance of this composition caused Ferdinand de Lasteyrie and Emile Mâle to date it in the twelfth century,[17] but Louis Grodecki[18] has theorized convincingly that it is a close copy of a lost twelfth-century original that probably occupied a similar location in the Romanesque building. As Grodecki has pointed out, the patterned mandorla resembles that of the famous twelfth-century Virgin lancet still preserved at Vendôme. The iconography also suggests this copying, since the Trinity appears as the Gnadenstuhl[19] framed in mandorla and evangelist symbols, in the formula introduced from Byzantine art into Europe in the early twelfth century.[20] The mandorla and evangelist symbols disappear after the mid-thirteenth century, when the throne becomes increasingly elaborate.[21] The Vendôme design is, in fact, closest to the earliest Gnadenstuhl found in western art, from a Cambrai missal of about 1120 (*VII.6*).[22] Not only the

VII.5 *La Trinité, Vendôme. The Trinity (Gnadenstuhl). Bay 200.*

general form but also the details of decoration are similar, notably in the outer ground pattern and the design of the throne.

The differences between the two are also telling. The Romanesque example presents the visionary Filioque theology in an image of stark schematization. At Vendôme a beautiful, youthful God the Father presents the crucified Christ, the dove of the Holy Spirit connecting the two heads not impersonally with his wingtips (as remained standard in the northern French and Mosan regions)[23] but in a caressing diagonal, which is paralleled in the designs of both figures below, by the arm of the crucified Christ and by the drapery hem of the Father. The composition's asymmetries—the jagged zigzag of forms down the axial cross and the graceful, repeated curves of the upper half—focus strongly on the union of the three heads. It is no casual copy. The Gothic beauty of the Father and the sinuous, rhythmic line connecting the forms of the Three-in-One go a long way beyond Romanesque abstraction.

The third of the hemicycle bays (Bay 202; *Pl.48.A–C*) commemorates the Sainte Larme, the legendary relic of the tear wept by Jesus upon hearing of the death of Lazarus (John

11:35). This famous relic established Vendôme as a center of pilgrimage from the Middle Ages until almost modern times.[24] Christ's teardrop, captured and placed by an angel into a container of angelic fabrication and given to the Magdalene after the resurrection of Lazarus, had reached Vendôme in the eleventh century and was in fact encased, according to Mabillon, in an outer coffret of eleventh-century Bavarian manufacture. In the Gothic church, the relic in its coffret was housed in a chapel-sized stone monument built between two of the north piers of the hemicycle, the design of which is preserved for us in a drawing of Gaignières.[25] Its decoration was notable for a full sculpted portal with jamb figures, historiated capitals, carved frieze, and tympanum and voussoirs, in which the Magdalene figured very prominently.

According to tradition the Sainte Larme had been a gift to the abbey by its founder, Geoffroy Martel, count of Vendôme. Geoffroy II Martel, son of the tyrannical count of Anjou Foulques Nerra and ancestor of the Plantagenet kings, was born at Angers in 1006, inherited Anjou from his father in 1040, and died in 1060. A baron of the stripe of his father, he had achieved control of Poitou by marrying its widowed and defenseless countess, Agnes de Bourgogne, and in 1132 had seized the county of Vendôme by force from his own nephew. He founded La Trinité, according to the twelfth-century chronicler Jean de Marmoutier, on a site miraculously indicated to him as he looked out the window of his newly occupied château. The abbey was dedicated May 31, 1040.[26]

Bay 202 depicts the donation of the Holy Tear, source of the abbey's identity and prosperity. In the left lancet (*Pl.48.A*) the donor kneels and offers the reliquary coffret with

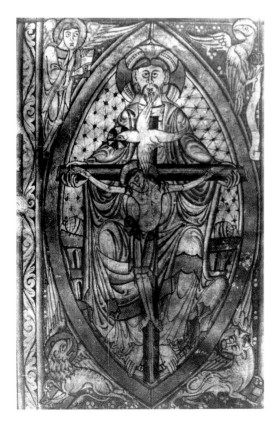

VII.6 *The Trinity (Gnadenstuhl). Missal, Cambrai, Bibl. mun. MS 234, fol. 2r (ca. 1120).*

veiled hands to the abbot and monks, depicted in the center lancet (*Pl.48.B*), while to the right (*Pl.48.C*) a monk at an altar suspends the precious relic for the devotion of a crowd of kneeling faithful. Thus the sequence of cause and effect runs left to right, while the composition, flanked by the kneeling figures of the donor and the faithful, is dominated by the standing abbot and community. They, and not merely the relic, are the real subject. All the actors in this sequential tableau are marked by the youthful grace of courtly chivalric romance. Geoffroy Martel appears as a radiant young knight in Gothic chain mail and full heraldic surcoat. He does not wear his own arms, since of course the Plantagenet robber barons of the eleventh century had none. His legendary founding donation is telescoped and conflated with the lavish donation of the Gothic windows in which he appears,[27] and the arms that he wears enable us to identify the Gothic donor.

The arms are those of the Capetian royal house, *France ancien,* marked with a cadence: *azur semé de fleurs de lis d'or, à la bordure de gueules.* They identify the prince Pierre d'Alençon,[28] fifth son of St Louis, born in Acre about 1251, appanaged with Alençon and Perche in 1268, married to the countess of Blois and Chartres by 1271, and dead (without living heirs) in the Apulian wars in April 1284 (n.s.).[29] Although Pierre's arms were assumed upon his death by his nephew Charles de France, count of Valois, there was no count of Alençon as long as the widowed countess lived (d. January 1292 n.s.) and the count of Valois had no attachment to the western lands until he received them in appanage in 1293. Pierre's gift does not appear in his testament of July 1282, dictated on the eve of departure to his final campaign and death at age thirty-three, nor does the romantic chivalry of the window suggest a memorial image of such tragic dimension. We can suggest a date for his beautiful windows, however. Pierre's father-in-law, Jean de Châtillon, the count of Blois, died in May 1280,[30] not only leaving his county of Blois to Pierre's wife but releasing for Pierre's use the vast revenues of the county of Chartres—"richest diocese in Christendom"—with which she had been dowered but which her father had retained until his death. In mid-1280 Pierre was not only count of Blois and thus overlord of Vendôme,[31] but he was rich.

VII.7 *Seal of Pierre d'Alençon (November 1271).*
Douët-d'Arcq 886.

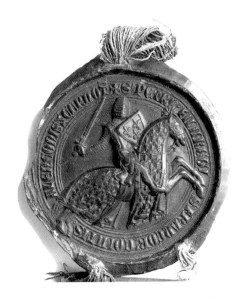

VII.8 *Disgrace of Louis I of Hesse,
1438. After Léon Jéquier, ed., Galbraith,
Manuel du blason, 1977.*

Since the heraldic identification of the legendary donor Geoffroy Martel was lost in
modern times, and the knight in his surcoat of fleurs-de-lis was sometimes identified as the
youthful St Louis,[32] I offer further and more circumstantial proof that he is indeed Alençon.
The figure of St Benedict in Bay 205 (see *Pl.49.B* below) now presents a coat of arms, care-
fully leaded into his panel upside down (and inside out). The arms are those now called
France moderne (*azur à trois fleurs-de-lis d'or*). The glass is thirteenth century, and the pres-
ent position is not original, the lower panel of Benedict's robe having been carefully patched
to accommodate the shield in this curious position. Its replacement upside-down was a
deliberate act.[33]

This is the appearance of the arms of Pierre d'Alençon as they occur on his equestrian
seal (*VII.7*) and on several seals of his wife. Indeed, if such a seal had been used by the
glazier as a model, the omission of the *bordure*, which is indistinct at such a small scale,
would be explained. But why upside-down? Inversion of arms, which for Matthew Paris[34]
had implied simply that the baron was dead, quickly took on the connotation of morally
dead, or disgraced.[35] A particularly vivid image on a letter of reprimand of 1438 depicts
Count Louis I of Hesse, with his inverted shield, hung by the feet from a gallows, crows
picking at his soles (*VII.8*). The scandal most likely to have provoked such action at La
Trinité was the three-month tribunal held by Charles VII in 1458 at the Château de Ven-
dôme, which condemned to death the companion of Jeanne d'Arc, Jean V, duc d'Alençon. If
the stained glass panel was upended then, it follows that a local tradition still recognized it
as Alençon's, despite its close resemblance to the fifteenth-century arms used by both king
and Bourbon overlords of Vendôme.

It is possible, as the next step in the hypothesis, to suggest its thirteenth-century location somewhere in the hemicycle. While one cannot rule out a location in the clerestory (then still in band windows), the most probable site is the axial triforium directly beneath the Gnadenstuhl Trinity image. That triforium bay (Bay 100) now contains an abbot kneeling before a standing saint,[36] lancets that Lafond has dated "antérieures de 1450 et fort dignes d'attention."[37] Worthy of attention they are indeed, though they probably date 1458 and replace the coat of arms of the ancestor of the declared traitor Alençon, those arms being moved to the refuge of St Benedict himself.

The Master of Pierre d'Alençon

The three hemicycle bays of Pierre d'Alençon, given about 1280 (*VII.5* and *Pl.48.A–C*), form a homogeneous trio distinguishable in every regard from the remainder of the clerestory: color choice and combination, canopywork and decorative vocabulary, figure proportion and painting, the conception of the lancets as units of a larger compositional field rather than as single units, and so forth. The question of whether the difference is one of school or one of date can be answered most correctly that it is both.

The borders are straightforward *France* and *Castille,* a standard formula increasingly modified or weakened as the 1280s progressed, as is evident in the grisailles of Dol (see Chap. V, pp. 152f.). Each lancet of Bays 201 and 202 has flanking colonnettes with functional, architectonic capitals and bases, as in the band windows of Tours (before 1267) and the Amiens axial clerestory (ca. 1268). This architectonic quality was gradually abandoned in French art of the late thirteenth century, and organic foliage serves for capitals in the rest of the Vendôme program, as it had already done at Sées. Although all canopywork at Vendôme was truncated in the Renaissance alterations, the gable forms (and the conventions of brickwork and roof tiling) of the two ateliers remain to be compared, and they are also totally different.

The general development of gables in French glass (and other media) from 1250 to 1300 runs through the following stages: beginning with no crockets at all, through the introduction of palmette crockets curled down, to the substitution for them of more natural leaf forms (ivy, clover, maple) in frontal silhouette and at a more spiky, stiffened angle, to the final crockets, which would remain popular well into the fourteenth century, the familiar "frayed cabbage" leaves that have a somewhat fleshy or wilted appearance and curl not down but up toward the *epi.* In other words, the development is from crockets curled down to curled up, and (as in grisailles) from dry palmettes through outlined ivy and clover to more softened natural forms. The only regional variant of importance to this book is the minuscule button crockets of Normandy, which go through both of the developmental tracks just outlined.

The unique crockets of the Vendôme hemicycle—large ivy and clover turned frontally—are thus an earlier development than the wilted cabbage found consistently in the remainder of the clerestory. A general comparison can be made to Sées (1270–1280), where the early gables have no crockets, and several late ones (Jean de Bernières and Gui du Merle windows) already have wilted cabbage, with minuscule ivy and clover used by the Norman Protais Master, and large frontal leaf crockets found in only one window of the clerestory (Bay 201, swollen maple leaves). A second general comparison can be made to Saint-Urbain

de Troyes, where frontal leaf crockets were introduced in a few of the clerestory gables, presumably among the restorations after the fire and troubles of 1266 and probably completed when the cult was celebrated in 1277. An example of frontal leaf crockets appears over Micheas in the south clerestory.[38] Still a third general comparison can be made with Beauvais, where frontal leaf crockets occur only in Bay 305, dated by Cothren in the original glazing of about 1268–1272.[39] The latest example of frontal leaf crockets known to me, an example far more elaborate than at Vendôme, is the group of related chapel glass at Evreux cathedral: the south chapel given by Nicholas de l'Aide, cardinal of Nonancourt 1294–1299, and the north aisle chapel founded 1299–1310 by Matthieu des Essarts.[40] By that era frontal leaf shapes had largely dropped out of use for crockets in France, as the frayed-cabbage type gained widespread acceptance.[41] No exact comparison to the Vendôme ivy and clover crockets has survived in the glass medium.[42] One example in manuscript illumination, apparently equally isolated, is however coeval with the Vendôme hemicycle. One small group of scenes among the riches of the Psalter of Yolande de Soissons, made at Amiens ca. 1280–1285, has frontal ivy and clover closely resembling the crockets at Vendôme.[43]

Neither glass nor manuscript paintings, however, resemble the Vendôme figural style, the stylistic roots of which are regional. The color of the hemicycle bays is a deeply saturated harmony of red-blue touched with strong gold accents, with figures in rich tones, the whole fractured by whites scattered in small *scintillants* throughout (*Pl.48.A–C*). The axial bay (Bay 200) contains more red than Bays 201 and 202, as well as a mustard yellow in place of gold, variations probably reflecting the twelfth-century original that formed its model. The painting is of high quality, the slender, contained forms drawn with economy and precision and infused with a youthful beauty. The almond-shaped eyes, neatly groomed beards, and domed heads are close to facial types associated, through Tours, with court art.[44] The figure proportions are not, however, greatly elongated or overly emaciated, the postures do not sway, and the painting is not the free, sketchy touch associated with the Court Style. Stylistic comparison must be made on the basis of the bay of the Sainte Larme, since the Virgin and angels bay (201) was badly damaged in 1870, and the axial Trinity (Bay 200) was no doubt influenced by its Romanesque model. The elaborate tableau of the donation of the relic (Bay 202), by its coloristic splendor as well as by its graceful, polished forms, directly reflects the finest late work of the Principal Atelier in the Le Mans clerestory (see Chap. III, pp. 37f., 45): Bay 205 and the donor rows of Bay 207 and of the heavily darkened Bays 206 and 212. Where the Principal Atelier worked in the 1270s (and developed the unusual ivy and clover crockets) cannot be guessed, but ca. 1280 it worked for the prince, Pierre d'Alençon.

The Second Vendôme Campaign:
Circumstantial Evidence

Pierre d'Alençon died in the middle of 1284. His young widow Jeanne de Châtillon, who had buried two infant sons at Royaumont in the 1270s, her father in 1280, and now her royal husband, was also to lose her mother on crusade in Acre in 1288 and to face her own sudden and unexpected death at age thirty-eight in January 1292.[45] Her involvement with the continuation of her husband's glazing program is suggested by varied pieces of evidence to be discussed below. A hiatus in work is indicated by the date of the hemicycle about 1280,[46] by Pierre's departure to Italy before the middle of 1282, and even by the possibility that Jeanne may have gone south with him, since she was in Carcassonne in May of 1285.[47]

After Pierre's death Jeanne appears to have turned her thoughts to charity. To finance her benefactions she sold her rich county of Chartres to the king in July 1286, and her county of Avesnes to her cousin Hugues de Châtillon in 1289.[48] Both sales were *en viagère*, that is, affording her a life annuity. Her most famous charity was the construction and endowment of fourteen cells at the Charterhouse of Paris, a gift completed by 1290 and commemorated there in a fresco depicted in a Gaignières drawing and later by Millin (*VII.9*).[49]

The fresco is important to the argument of the Vendôme glass in two ways. First, it depicted the fourteen lucky Carthusians kneeling behind Jeanne de Châtillon, who was shown being presented to the Virgin by her name-saint John the Baptist in hair garment and carrying the Agnus Dei disc. His appearance in identical fashion among the Vendôme apostles, a program that finds no other easy explanation, thus is logically the countess's mark. At Vendôme, moreover, the Baptist occupies the first lancet of Bay 204, directly following the scene of the Sainte Larme in which Pierre d'Alençon's image appears (Bay 202), while the apostle immediately following the Baptist is St Peter, Jeanne's husband's name-saint (*VII.10*). Second, in addition to providing a coeval Gothic image of Jeanne's name-saint, the Charterhouse fresco provides circumstantial evidence for dating. The Charterhouse project was finished by 1290, when it was endowed. Since Jeanne's long will of January 1291 singles out neither Vendôme nor the Charterhouse for special consideration, it can be presumed that the former, like the latter, was a project complete and in the past, her interest in 1291 consistently directed "a mon nouuel Hopital de Guise, que i'ai ordené à fonder . . ."[50]

Jeanne's interest in La Trinité de Vendôme can be construed from various sources. The most poignant is a long deathbed account of her agonized last moments.[51] Increasingly frantic as the end drew near, she repeatedly broke in on the litany being recited for her, piling final, additional bequests in honor of the Trinity, of John the Baptist, and of the Magdalene. All three were particularly venerated at Vendôme, the Magdalene as the penultimate source

VII.9 *Jeanne de Châtillon donating fourteen cells (fresco at the Charterhouse of Paris). Gaignières drawing (Oxford, Bodleian MS Gough. Draw. Gaignières 2. f.27a).*

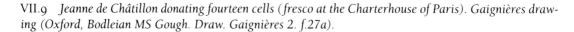

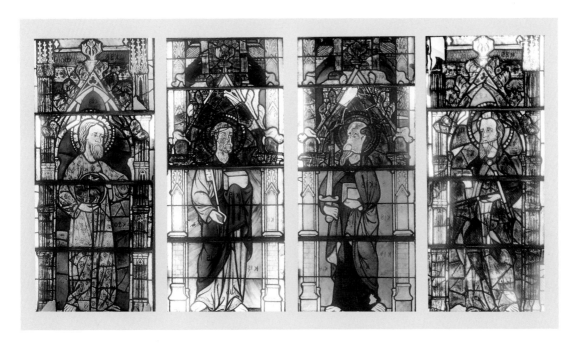

VII.10 *La Trinité, Vendôme. Sts John the Baptist, Peter, Paul, and Andrew. Bay 204. (Modern: bodies of Peter and Paul.)*

of the Sainte Larme relic itself (see above, p. 229). A continuing relationship of the Châtillon family with La Trinité is indicated as late as 1377. In that year Jean II de Châtillon, who, although he was count of Blois, resided and died in the Netherlands, made a trip south to the court of Charles V and seized the occasion to make the abbey of La Trinité a gift to establish his anniversary.[52] But the end was in sight; his brother Guy de Châtillon inherited the county of Blois from him and sold it, in 1391, a century after Jeanne's death, to the house of Orléans.

The Emergence of the Western Atelier

Beyond the hemicycle's axial trio of clerestories glazed by Pierre d'Alençon (Bays 201, 200, and 202) are four more high windows in the Gothic chevet of Vendôme, glazed in a new and different style: Bays 205 and 203 on the north and Bays 204 and 206 opposite them on the south. The group comprises sixteen lancets (four to a bay), a parade of canopied apostles and saints located as follows:

NORTH	SOUTH
Bay 203 (*VII.11.A–B*)	Bay 204 (*VII.10*)
Apostle with club (James the Less?)	John the Baptist
Bartholomew (knife)	Peter
John the Evangelist (palm)	Paul (bald)
James (sword; shells in ground)	Andrew (Latin cross)

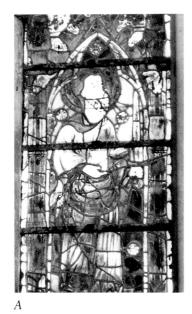

A B

VII.11.A *La Trinité, Vendôme. St James with shells, Bay 203. Photograph greatly overexposed.*

VII.11.B *La Trinité, Vendôme. Sts John the Evangelist, Bartholomew, James the Less(?), Bay 203 (from the album of Gervais Launay, 1840–1860?, Vendôme, Bibl. mun.)*

Bay 205 (*Pl.49.A–D*) Bay 206 (*Pl.50.A–D*)
 Apostle with sword (Matthew?) Barnabas (flame)
 Apostle with sword (Thomas?) Apostle with pike (Philip?)
 Benedict with Rule Louis with scepter and *main*
 Christopher holding Christ Child Eutrope being martyred

The apostles have no inscriptions but have been identified here on the basis of the attributes they carry, which are from the repertoire depicted in the related group in the nave of Saint-Père, where they have name plaques.[53] There was no certainty, however, about the apostles and their attributes in the late thirteenth century, and all the late western groups exhibit an uneasy fluidity. In the Saint-Père nave the twelve apostles do not include Peter, but do admit three Jameses, as well as Barnabas and Mathias. At Vendôme the lack of inscriptions makes a full head count impossible, but even so, the group includes a bald-headed Paul and Barnabas, who was very popular in the west, as well as the intruding John the Baptist, discussed earlier. In other words, the group of twelve includes only nine actual apostles. In the unnamed group in the Saint-Père hemicycle are included Peter as pope, Paul, Bartholomew, Barnabas, and twelve additional apostles with various attributes. It is by no means impossible that the original program at Vendôme was projected to populate all four bays (sixteen lancets) with a similarly amorphous display.

Such an original program would imply a change in plan, which the figures' stylistic continuity indicates to have occurred not at some point in time long afterwards but in medias res. The four non-apostles now found in the lancets nearest the crossing all have

special significance. They are: in Bay 205 on the north, St Benedict, patron of the community;[54] St Christopher, titular patron of the Romanesque chapel of the abbot, still in existence south of the chevet;[55] and in Bay 206 on the south, St Eutrope,[56] whose relics had been donated by the abbey's founder Geoffroy Martel and were kept within the stone vault with the Sainte Larme itself (*VII.12*); and St Louis. Louis IX had died in 1270 and was canonized during the reign of his grandson Philippe le Bel in 1297. It is unlikely that this image dates as late as that, a point to which we will return after discussing the stylistic groupings of these sixteen lancets.

The second Vendôme campaign (Bays 205, 203, 204, and 206) offers more variation than the first, but always within the definition of a western expressionistic art. In comparison to the hemicycle, the style is less rich and more direct in color and in the use of pattern, subjects are less complicated, and effects are more exaggerated. Canopywork has now completely usurped the function of borders and is constructed from a vocabulary of motifs common to Evron and Saint-Père de Chartres, the late western ensembles: gargoyles, friezes of quatrefoils and maple leaves, tiling, double-line brickwork. The crockets, turned sideways, are lush and overgrown in appearance. The canopy upper structure was truncated in the Renaissance and may have been taller in the bays of the second campaign than in the first.

Of the four windows, the glass of Bays 205 and 206 at the crossing is in a magnificent state of preservation, while Bays 203 and 204 are now in very poor condition. Bay 203 is nearly opaque.[57] The figures of Peter and Paul in Bay 204 have been drastically patched; only

VII.12 *La Trinité, Vendôme. Stone vault for relics of the Sainte Larme, St Eutrope, and others. Located between two pillars of the north choir; destroyed 1803. Gaignières drawing (Paris, Bibl. nat. Est. Va 407).*

the upper panels of the fine heads and some canopywork are still original.[58] The gay coloration of the other windows (205 and 206), however, can still be made out in both these decrepit ensembles. It is the joyous blend of primaries, with fresh green, clear brown, and liberal amounts of white and yellow, that marks the mature western style. It is found earlier in the Sées clerestories in a reduced formula of primaries; in the north choir bay at Evron, by the Vendôme shop; and in the gorgeous hemicycle ensemble of Saint-Père. At Vendôme this coloration is varied by giving each bay a distinctive emphasis: clear rose brown in Bay 203, fresh green in Bay 206, the unabashed primaries in Bay 205.

The different weathering of the glass alone would suggest that Bays 203 and 204, now almost destroyed, and Bays 205 and 206, both in brilliant health, originally formed separate groups. There are in fact three groups. The first is the pair of Peter and Paul (*VII.10*) in Bay 204, slightly smaller and cut in a different *panneautage* than the rest, their canopies formed of motifs combined additively and with a certain hesitation. Although the lower panels (bodies, attributes) are now modern, the distinctive head types are clearly those traditional for Peter and Paul. It is probable that this pair, perhaps intended as patron saints for Pierre d'Alençon, was produced before the hiatus in the two campaigns. Whether or not they were concurrent productions with the hemicycle trio, the artist who produced them had a totally different training than the Pierre d'Alençon Master, whose art springs from that of the Principal Atelier at Le Mans. The distinctive artist of Peter and Paul can be oriented only generally from the wreckage of the evidence at hand: two strong heads, scalloped and pearled haloes, and some canopywork but no bodies, attributes, or drapery painting. Some of the canopy motifs, notably the gargoyles and flying buttresses, had been introduced and combined in a related manner in the late Gui du Merle clerestory of Sées, but the connection is not direct. The Peter and Paul are careful, somewhat tentative designs by an artist taking the Sées formulas in new directions. After a short hiatus, his shop was called back to continue and finish the Vendôme program and, in the process, the atelier's western art loosened and relaxed as it gained focus, increasing in both strength and freedom as it gained assurance. This Western Atelier also worked at Evron and at Saint-Père and no doubt eventually numbered a sizable group, working not only in the color and design traditions that we first noted at Sées but also in that chantier's democratic and cooperative methods.

The second group at Vendôme is composed of the other two saints of Bay 204 (John the Baptist and Andrew; *VII.10*) and the four apostles in Bay 203 opposite (*VII.11.A–B*). These designs are alike in format, painting, and color as well as in the condition of the glass itself, which is deteriorating at a rapid rate, in sharp contrast to the beautiful, hard, glassy appearance of Bays 205 and 206. John the Baptist is in the best condition, though the head is now a modern copy. These figures are inactive, although their postures are expressionistically flattened and distorted. Like Peter and Paul, they are slope-shouldered, their haloes are pearled, and their robes are decorated with a delicately painted edging (visible at the necks of the former pair). The color is distinctive, with blue relatively insignificant among the primaries, and a large area of rose brown added in nearly every figure. It is an odd color to set against a singing red ground. In addition to the red or blue grounds there are two yellows (one brassy, one pale and tannish), some dark green, and various shades of the unusual rose brown. Backpainting is still noticeable on the robes of Bartholomew (Bay 203) and the Baptist (Bay 204). The canopies are composed of the vocabulary of motifs introduced over Peter and Paul, now coordinated into a distinctive architectural framework that marks all

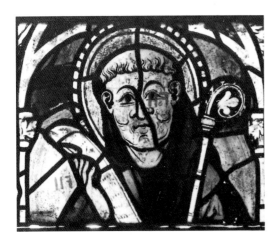

VII.13 *La Trinité, Vendôme. St Benedict with the Rule, north choir, Bay 205, detail.*

the products of the Western Atelier. Among its notable details are gargoyle rainspouts of the gables, a quatrefoiled balustrade, double-line brickwork, and a characteristic maple-leaf frieze pattern. Traceried niches and colonnettes are now introduced into the flanking architectural supports, which had been more solid and unadorned, based on the evidence of the few old sections of the Peter and Paul panels.

The condition of the third group (Bays 205 and 206; *Pls.49.A–D; 50.A–D*) is as excellent as the second group is poor. The palette is similar but less modulated and more emphatically based on red-blue-yellow, a gay, gaudy ensemble with a painting style of like simplicity and directness. Even allowing for difficulties created by the differing weathering, the coloration of Bays 205 and 206 is brighter, simpler, and includes more whites. The painting follows the shop's formulas but with greater reductive and expressionistic force. While the similarities with the second group are strong, a developmental maturation is evident in the differences between that group and these two bays "d'un coloris plus clair et d'un art plus avancé."[59] The fine condition of the glass suggests a different glass batch and melt, while the introduction of non-apostles into these bays, I have already suggested, may have been a shift in plan. The distinctive subjects allowed a freedom from the patternbook that may account for much of the "advance."

Bay 205 has a simpler color scheme of pure primaries, less fussy canopywork with no gargoyles, and a rather workaday roster, excepting the riveting charisma of the genial, ugly St Benedict, where the designer was no doubt free of the patternbook and on his own (*VII.13*). Bay 206 includes minimal variants: gargoyles have been reinstated in the canopywork, which has begun to coagulate into more coordinated systems; strong green takes a basic role in the coloration; and for the first time the figures slightly overlap the frame (Philip's halo, Eutrope's axe, Louis's crown and scepter). As in Bay 205, the non-apostles steal the show. St Louis is a masterpiece of strength and finish, the totally frontal pose coordinated with that of Benedict directly across the choir. The Eutrope lancet (*Pl.50.D*) does not exhibit such suave polish but is nonetheless unique in the group and grounded in the expressionistic tendencies of this Western Atelier. It is not a standing icon like all the others but a scene, a reduced narrative of the saint's martyrdom constructed of the kneeling, praying saint, a racing executioner poised for the blow, and the blessing hand of God. It is

an ideogram of the martyrdom, its succinctness and instability recalling the art of the Geof-
froy de Loudun Master in the axial bay (200) of Le Mans, where the executioners of Gervais
and Protais are also airborne.

The fresh and imperfect design of St Eutrope being axed to death does not disdain the
traditions of Vendôme, as it might appear. Rather, the artist has sought and found his inspira-
tion in the hemicycle campaign (*Pl.48.A–C*), where the commemoration of the Sainte Larme
takes the form of such a constructed ideogram. The relics of Eutrope, like those of the Holy
Tear, had been gifts of the abbey's founder, and they were kept together in the great stone
vault in the choir (*VII.12*, p. 237). The ideogram of the Pierre d'Alençon Master in Bay 202
provided the Eutrope artist with models for a kneeling figure, a profile face, miter, and ma-
niple, and for the overlapping of elements beyond the frame. His expressionist bent, how-
ever, has transformed his materials. This distinctive young artist moves with the Western
Atelier to the abbey of Evron, where his ideograms gain compositional suavity and assur-
ance. In the Eutrope lancet of Vendôme we have the earliest work of the Pilgrim Master of
the Evron hemicycle, and in his inspiration in the Vendôme hemicycle we have the thematic
basis of his sophisticated designs for the Châtillon family in the Evron windows, as we shall
see in Chapter VIII.

To sum up: the three groups of the Western Atelier at Vendôme comprise Peter and
Paul of Bay 204 (possibly commissioned by Pierre d'Alençon with the hemicycle ca. 1280);
the rest of Bay 204 and Bay 203 opposite (probably commissioned by Jeanne de Châtillon
after Pierre's death in 1284); and Bays 205 and 206, works of greater assurance and maturity
by the same shop. The question is: just how much time elapsed between the quiescent state
of their art in the second group and the less delicate, more forceful, touch of Bays 205 and
206? An extended hiatus is not likely. The problem is St Louis, canonized in August 1297.
Do Bays 205 and 206 date near 1300, an untenable hypothesis for the solid architectural
structures, the stocky body proportions, and the foursquare postures? Or was the St Louis
inserted into an earlier program with such surgical prowess that no scar remains, the design
aping to perfection the color, the truncated and shrunken arms, thick-necked and stubby
bodies, and facial conventions of the group? Or is there a third solution?

To return to the non-apostles and their significance: those in Bay 205 on the north,
Benedict and Christopher, are straightforward references to the patrons of the abbey and of
the extant Romanesque chapel, just as the north hemicycle bay (Bay 201) honors the Virgin,
to whom the lay cemetery chapel was dedicated. In like manner the non-apostles Eutrope
and Louis in the south Bay 206 embroider upon the themes of the south hemicycle window
of the Sainte Larme (Bay 202): the relics given by the founder and kept together; the prince
in his Capetian heraldry, fifth son of the sainted king. By keeping this pattern in mind, it is
possible to recognize the program, the north windows (on the right hand of the axial
Trinity) honoring church and abbey and the south bays commemorating relics and donors,
the secular Christian realm. Church and state are in their assigned order.

Among the south lancets (Bay 204) are Peter and the Baptist, commemorating Pierre
and his widow Jeanne. It is probably no coincidence that the last glazing on the south (Bay
206) lined up the apostle with pike (Philip) and St Louis, reflecting the names of the couple's
dead sons, the baby princes Louis and Philippe. Eutrope in the same bay was not just "an-
other Vendôme saint" but one rapidly rising in court popularity at just this time. His feast
was being added to Parisian calendars. In 1296 the cartulary of Notre-Dame records that, in
response to a gift by Philippe le Bel and his queen Jeanne de Navarre,

Capitulum vero parisiense, non immemor tanti beneficii, considerans
devocionem quam dicti rex et regina habent erga sanctum Eutropium,
episcopum Xantonensem et martirem, constituit festum predicti beati Eutropii
in Parisiensi ecclesia ad semiduplum, II kalendas maii, sollempniter
celebrari.[60]

The new popularity of St Eutrope in French royal circles bears some examination. His
cult at Saintes on the Pilgrimage Road, which had been fostered by Cluny and by Eleanor of
Aquitaine, seems to have been a favorite of the brother of St Louis, the prince Alphonse de
Poitiers. Alphonse made donations to the saint's tomb in 1269 and in his will, executed by
his nephew King Philippe le Hardi in 1276 and in 1280.[61] Philippe le Bel was in Saintes in
1286; in 1288 Edward I of England forwarded a request to Saintes[62] for prayers for the
success of his negotiations with, and for the prisoners in, Aragon, among them princes of
the French crown who were freed to return to Paris. By whatever means the cult reached
Paris, it was solidly established there by the continuous support of Philippe le Bel who, in
addition to the 1296 cartulary reference cited above, founded a chapel of St Eutrope in the
north ambulatory of Notre-Dame as late as 1312.[63]

But I would argue that the Vendôme image of St Eutrope predates his Parisian cult
supported by the king from 1296 on, just as the adjacent image of St Louis in the Vendôme
choir predates his canonization in 1297. That argument will be taken up next. The signifi-
cance of St Eutrope in the Vendôme glazing program requires a further word here, since the
hypothesis can apply, as we shall see, to St Louis as well. The hypothesis is this: according
to the pilgrims' guide to Compostela and to Vincent de Beauvais, St Eutrope, first bishop of
Saintes, was a disciple of St Denis.[64] His passion, they report, was written in Greek by St
Denis himself, and sent by him to Greeks in Constantinople. One recognizes at once the
landscape of Dionysius the Pseudo-Areopagite and of his tireless propagandists at the abbey
of Saint-Denis near Paris.[65] Mathieu de Vendôme, abbot of Saint-Denis from 1258 to 1286,
seems the most likely source for the Vendôme glazing program funded in the mid-1280s by
the widowed princess Jeanne de Châtillon. It is a question to which we shall return since,
as we shall see, the argument for Mathieu de Vendôme, in the case of the image of St Louis,
is even stronger than in the case of St Eutrope.

The Image of St Louis

The dating of the image of St Louis (canonized August 1297; *VII.17*, p. 249) and its relation-
ship both to the Vendôme program and to the incipient iconography of the king-saint are
issues of significance, given my hypothesis of an involvement with the Vendôme program
by the countess of Blois, Jeanne de Châtillon, between 1284 and 1290, before her death in
January 1292. It seems clear that the Western Atelier continued to work for her Châtillon
relatives at the abbey of Evron, and it must be admitted that their preeminent position at the
French court would suggest their inclusion among the noble donors who rushed to com-
memorate the king's canonization with new chapels, altars, and images.[66] Among those com-
missions was probably the image of St Louis, inserted into the preexisting hemicycle glazing
of Saint-Père de Chartres.[67] But, while the St Louis at Vendôme is certainly among the latest
designs of the shop, nothing about Bay 206 suggests the early fourteenth century; the stocky
figure proportions (well under the ratio 1:6) and the almost total absence of mannerist sway

in the postures date more reasonably before 1290 than over a decade later. If the image of Louis alone was added later, then it was unquestionably by the same atelier making every effort to replicate their work and succeeding to a degree that must astonish and terrify art historians.[68]

Another hypothesis must be entertained, that the image, though haloed,[69] predates the canonization and is a product of the 1280s, when the advent of a French pope (Martin IV, 1281–1285), the depositions of miraculous cures at Louis IX's tomb (1282–83), and then the more relentless and obstinate will of the young Philippe le Bel (king in 1285 under the age of eighteen) made the long-anticipated canonization seem imminent. Georgia Sommers, writing about the tomb of Louis IX at Saint-Denis, has stated:

> As the French expected Louis [d. 1270] to be canonized immediately and of course translated shortly thereafter, it is unlikely that an expensive and elaborate tomb was ordered in 1271. The first inquest took place in 1273 but nothing came of it as Gregory did not act in time and Innocent V, Hadrian V, and John XXI died before reading the documents. In 1278 ambassadors approached Nicholas III asking for a new inquest, but plans for this were interrupted in 1280 by the death of the Pope. Martin IV (1281–85), a French Pope, pushed the proceedings ahead in 1282.[70]

In that year, 1282, began the public inquest into the life and miracles of Louis IX, which lasted until March 1283. And also by late May 1282, according to Elizabeth A. R. Brown, Louis IX's grave at Saint-Denis was marked with a magnificent silver-gilt tomb matching those of his father and grandfather.[71] A final payment of eighty-eight *livres* was made for it in 1287–88 by Philippe le Bel.[72]

One wades into the controversy over the tomb and nascent iconography of St Louis with trepidation and chain mail.[73] The meticulous work of Elizabeth A. R. Brown, however, has prepared the way for reentry into the lists. She has established that not one but two famous images, both worthy to serve as archetypes of the developing iconography, were created in the late Capetian era. The first, in place by mid-1282, was the silver-gilt tomb just mentioned. The second, also at Saint-Denis, was a rich gilt statue made for the new chapel of St Louis, built between 1299 and 1304 between the chevet and the abbatial complex to the south:

> The chapel served as a third center of veneration for St. Louis, offering pilgrims a site in addition to Louis' tomb and chasse where they could implore his help and offer thanks for miracles performed. A rich gilded statue of the saint was commissioned by the monks in 1299–1300, and it seems likely that they intended to use it on the altar of the chapel. In this statue may lie the key to understanding the many miniatures of the early fourteenth century manuscript of Guillaume of St-Pathus' work on St. Louis which show a standing image of the king, for the white covering draping the structure on which the king is poised clearly show that it was intended to represent an altar. Thus, *the artist may have been inspired by the statue of St. Louis of 1299–1300, as well as by the saint's tomb,* which is shown in a number of other miniatures (Bibliothèque Nationale, fr. 5716).[74]

The bitter squabbles over the appearance of the tomb and the variants in the earliest images of the saint can finally, I submit, be settled by reference to these *two* archetypes available to the artisans carrying out the flood of commissions of the early fourteenth cen-

tury. Among the disputes has been the question whether the hypothesized archetype was bearded or not, and hence whether it was intended as a "portrait" of the king, who kept the short beard he grew on crusade for the remainder of his life. Another controversy has raged over what objects the lost archetype carried: relics of the Passion (nails, reliquary of the True Cross, Crown of Thorns) or symbols of royal power (scepter and so-called *main de justice*). Evidence exists for all of the above among the various early images of St Louis that remain. *Two* archetypes, one a tomb of a king commissioned within ten years of his death, the other a cult statue made thirty years after that event and following his elevation to sainthood, quickly sort out this confusion. Thus the beard,[75] the scepter, and the *main* are likely on a royal tomb of ca. 1280, while a more generic smooth jaw and instruments of the Passion are appropriate references, twenty years later, to the beloved national saint who had brought the Crown of Thorns to Paris and built the Sainte-Chapelle to house it. This agglomeration of details also permits some fine-tuning of the dating of the early iconography, since the tomb archetype would have been available in the 1280s and 1290s, whereas the gilt altar statue would only have been visible when installed in the new chapel after about 1300.

The Tomb of St Louis

The image of St Louis in Bay 206 at Vendôme is bearded and carries a scepter and *main* (*VII.17*, p. 249).[76] He wears a crown and a chlamys or mantle attached at the right shoulder and decorated with fleurs-de-lis. In other words, he appears in coronation regalia, notably the chlamys secured at the right shoulder,[77] as well as the *main de justice* first described in the so-called Ordo of Reims,[78] now dated by Richard A. Jackson after 1215 and probably to the first years of St Louis's reign. For Hervé Pinoteau the appearance of the chlamys and *main* can be dated even earlier.[79] At any rate, there can be little doubt that Philippe le Hardi wore this regalia at his coronation in 1270.

Erlande-Brandenburg has established that the coronation regalia were customarily displayed on the cadaver at royal funerals, providing the king died close enough to Paris that his body need not be boiled or otherwise eviscerated to make the trip home.[80] Louis VIII (d. 1226), Louis IX (d. 1270), and Philippe le Hardi (d. 1285) all met their ends some distance from the capital, but Philippe le Bel (d. 1314), who died at Fontainebleau, was garbed in the chlamys, scepter, and *main* for his funeral procession, as we know from an eyewitness;[81] so too his sons Louis X (d. 1316) and Philippe V (d. 1322).[82] And the tomb of the heart of Philippe le Bel, made about 1327 for Poissy, shows him with the chlamys and *main*, establishing a type of royal tomb adopted thereafter for the first Valois kings.[83] The studies of Bautier and Elizabeth Brown, establishing Philippe le Bel's increasingly obsessive self-identification with his sainted grandfather, "le modele auquel le roi brule de se conformer,"[84] suggest to me that this "new" type of funeral and this "new" type of tomb reflected not only the coronation and power of a king but also, one might say, of *the* king. What I am proposing is that the lost silver-gilt tomb of St Louis depicted him in chlamys, scepter, and *main*, and that the Vendôme window depicts the tomb.

My reconstruction of the tomb's appearance has the happy advantage of being applicable to either of the two forms theorized for that monument, which was destroyed about 1415: *gisant*[85] or standing image.[86] Although the silver-gilt tomb followed the pattern of metal tombs established by those of Philippe Auguste and Louis VIII (both presumably *gisants*), it was not just another royal tomb but altogether singular, as the mind-boggling accounts of thirteenth-century French chroniclers make abundantly clear.[87] They describe

VII.14 *Six* montjoies *(anonymous drawing, Collection Lallemand de Betz, Paris, Bibl. nat. Est. Vx 16, p. 115).*

the monument as lavishly expensive, splendid, unique in the world. Without doubt the tomb was an "investment" coordinated with the inquests, specifically the reopening of the original 1273 inquest by order of Nicholas III in 1278, and the second inquest ordered by Martin IV and held 1282–83.[88] Elizabeth A. R. Brown has commented:

> Whether Philip III or the monks of Saint-Denis were responsible for the tomb is unknown, but the memorial had the virtue of attracting attention to Louis' grave, which was a rich source of benefits, both spiritual and material, for the abbey. These benefits could only have been expected to increase and multiply as a result of Louis' canonization.[89]

As such, the spectacular monument was unquestionably an object of religious and political propaganda. I find convincing Sommers's argument that "Philippe [le Hardi] and Matthieu de Vendôme [abbot of Saint-Denis] must have been aware, too, of the monument in Westminster Abbey recently erected for Edward the Confessor, the sainted King of England, as they were engaged in securing the same rank for Louis."[90]

The tomb of Louis IX, thus considered as an object of propaganda, can be most logically related to the series of *montjoies*,[91] stone monuments erected along the route from Paris to the abbey of Saint-Denis during the reign of Philippe le Hardi (*VII.14*). Each of these markers, probably nine in number, was formed of a cross surmounting a polygonal base, deco-

rated with three large standing kings under elaborate canopywork. Some of the images clutched the tie-strings of open mantles in the standard "royal gesture" (see n. 83), while others wore the chlamys with its characteristically oblique hemline crossing the front skirt, according to drawings made between 1684 and 1696.[92] Exposed like cathedral facades to constant weathering, damaged by Protestants in 1562 and 1567 and restored thereafter, before they were methodically obliterated in 1793, the kings carried objects that are by no means clear in the baroque drawings. Lombard-Jourdan has analyzed the *montjoies* of Philippe le Hardi thus:

> En plaçant sous le règne de Philippe III l'érection des montjoies de la Plaine du Lendit, sorte de "galerie de rois" scindée en groupes de trois, on les situe donc dans l'évolution artistique entre les gisants de Saint-Denis, commandés par Louis IX, et les rois du Palais, exécutés sur l'ordre de Philippe IV. . . . Les trois séries de rois sont voisines dans le temps: les statues des montjoies, non caractérisées, sont de peu postérieures aux gisants sans personnalité de Saint-Denis et de peu antérieures aux rois individualisés et désignés du Palais.[93]

Let us take her remarks further. The *montjoie* kings include the chlamys (whether or not any ever held the *main*). The series of kings attached to the pillars of Philippe le Bel's Grand' Salle in the palace, about which more will be said later, included examples of both chlamys and *main* (*VII.15*). The earliest series, the *gisants* of the 1260s, however, not only were horizontal rather than vertical, but none wore the chlamys.

VII.15 *Interior view of the Grand' Salle, palace of Philippe le Bel (16th-cent. drawing, Jacques Androuet du Cerceau, Collection Lallemand de Betz, Paris, Bibl. nat. Est. Vx 15, p. 269).*

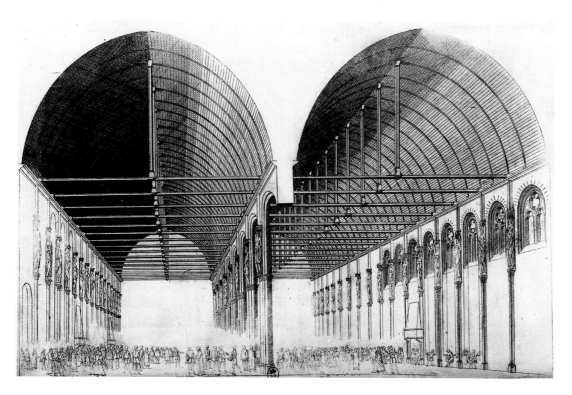

I have suggested that the silver-gilt tomb figure of Louis IX made ca. 1280 did wear the chlamys, and that it was a commission similar not only in time but also in religious-political purpose to the *montjoies*. But where did the chlamys come from? There was at least one tomb at Saint-Denis during the lifetime of St Louis on which a dead king was garbed in coronation robes, including an outer one pinned at the shoulder and resembling the chlamys: the bronze tomb of Charles the Bald, datable before 1223.[94] Grandson of Charlemagne and first king of France 843–877, royal patron of signal importance to the abbey of Saint-Denis, Charles the Bald was the essential model of the Capetian dynasty.[95] It is not surprising that a seal of Louis IX depicts the identical robe pinned at the shoulder,[96] and it is a likely hypothesis that Charles the Bald's bronze tomb and his distinctive robes were reflected in the propagandist tomb monument erected about 1280 for Louis IX. The seal of Henry III ratifying the treaty of Paris of 1259 also shows the English king, Louis IX's brother-in-law, in chlamys.[97] When all is said and done, it is hard to imagine that the silver-gilt image of the dead king of about 1280 could have worn anything else.

The *main de justice* is another story. Since the accepted scholarly view of the *main* contends that it first appears at the funeral of Philippe le Bel (1314), and thereafter on royal seals with Louis X (1314–1316), it is a symbol of some interest here. The Vendôme window can hardly be as late as 1314. And the *main* is unlikely to have made its debut in art at Vendôme.

The Main de Justice

What is the *main*[98] and where does it appear in art? As a part of the coronation regalia, the hand of justice is obviously a symbol of royal power. The several hands that have formed part of the regalia of various French monarchs, kept in the Saint-Denis treasury over the centuries, have been objects composed of a right hand carved of ivory and making the gesture of benediction, attached to the top of an often-jeweled baton. Thus, to paraphrase Marie-Madeleine Gauthier, the iron hand of history slips on the velvet glove of art.[99]

In the so-called Ordo of Reims, now dated to the early years of Louis IX's reign, the *main* is described thus: "virga ad mensuram unius cubiti vel amplius habente desuper manum eburneam."[100] After the king is anointed, to the antiphon *Inunxerunt regem Salomonnem,* he is revested with the scepter in his right hand and the "virga in sinistra." Thus, although no verbalized reference is made to justice, the antiphon suggests the wisdom, peace, and judgment of Solomon.

Although coronation acclamations had long compared Carolingian and Capetian monarchs to David, Solomon, and other Old Testament heroes,[101] the Judgment of Solomon was clearly a theme whose time had come at exactly the period to which the Ordo of Reims is now dated. The contemporary appearance of this subject on the right tympanum of the Chartres north porch has been discussed by Katzenellenbogen:

> The Judgment of Solomon corroborates the idea of the afflicted Church.
> According to a sermon ascribed to St. Augustine, the true mother typifies the
> Church, the false mother the Synagogue. King Solomon symbolizes
> Christ. . . . The allegorical meaning of Solomon's Judgment was explicitly
> represented about 1230 on the south transept of Strasbourg Cathedral. Here
> King Solomon is shown on the *trumeau,* flanked by statues of the Church and
> the Synagogue on the walls. . . . [T]he Judgment of Solomon demonstrate[s]

the successful endurance of the Church against temptations of the Devil, of the flesh, of heresies, and against her antagonist, the Synagogue.[102]

An even more explicit iconographic connection between Solomon and Louis IX is found in the north rose of Chartres in the early 1230s.[103] One of the five immense lancets beneath the rose depicts Solomon not as a wise old man but as an adolescent blond; this figure is generally accepted to represent the young Louis IX, crowned in 1226, whose heraldry liberally decorates the great rose ensemble.

A king with as strong a preference for the Old Testament as St Louis[104] would be likely to introduce a symbol like the *main* into a new version of the Ordo, and the afflictions of the Church, which his crusades sought to succor, suggest just as strongly that the emblem would be meaningful to his contemporaries. One may add to these historical truisms the purely art-historical development of individualizing attributes, which is a noteworthy feature of thirteenth-century iconography, and its parallel in the heraldic development of individualizing emblems.[105] Both saints' attributes and heraldic symbols have tentative beginnings in the earlier period but begin serious maturation only in the course of the thirteenth century, and both are well-established visual codes by the end of that century. In addition, Kantorowicz has stressed the central role played by Louis IX in building that structure of regal mythology "on which all his successors would thrive."[106] The conclusion that the introduction of the *main* into the revised Ordo is a product of the reign of Louis IX is hard to avoid.

The *main* was not included on the dynastic series of *gisants* made in the 1260s for Saint-Denis, and it is impossible to know whether any of the *montjoies* of about 1280 (*VII.14*) had the *main* or not, through Philippe le Hardi must have held one at his coronation in 1270. The statues of kings decorating the Grand' Salle of the new palace of Philippe le Bel (*VII.15*), made by Evrard d'Orléans between ca. 1311 and 1313,[107] held scepters and *mains* according to Gilles Corrozet (1586), who saw them before the destruction of the hall by fire in 1618.[108] Corrozet also records a statue of St Louis on the trumeau of the chapel's portal at the Collège de Navarre, founded in 1304 by Queen Jeanne de Navarre and under construction from 1309. Beneath the statue were engraved a crown, scepter, and *main* with inscriptions. The inscription of the *main* read: "Iusticiae quae manus vult sese cuncta regantur."[109]

There is therefore no question that the *main* iconography was established by the reign of Philippe le Bel, and near certainty that it was part of his coronation regalia (1285), as well as that of his father Philippe le Hardi (1271). The inclusion of a *main de justice* on the splendid and "unique" silver-gilt tomb erected in 1282 for Louis IX, primus inter pares amid the dead kings of Saint-Denis, seems most likely.

None of the early statues of Saint Louis in chlamys[110] which have escaped destruction still retain their hands or the objects they held. The earliest manuscript painting to show the image in chlamys is the nearly postage-stamp-sized miniature (*terminus ante quem* 1320) decorating folio 20r of the 108 folio Register of Ordinances of the *Hôtel du roi*, the royal household (*VII.16*).[111] While other depictions follow in manuscripts of the saint's life and miracles,[112] the usefulness of the ordinance register resides in the fact that it is not in any sense a religious or cult object but (if such things could ever be totally separated in the Middle Ages) a secular rule book. The image resembles the Vendôme window to a startling degree (*VII.17*). Louis IX is bearded, is garbed in a chlamys covered with fleurs-de-lis, and holds a scepter and a *main de justice*. This tiny image and the Vendôme lancet are, I submit, as close as we shall ever get to the appearance of the 1282 tomb.

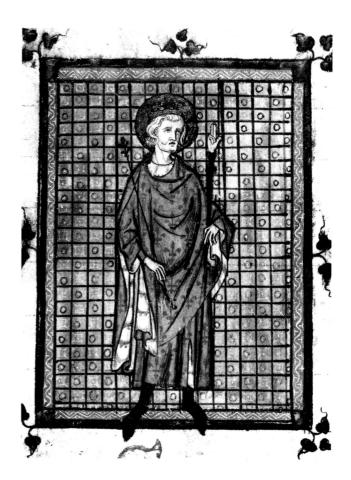

VII.16 *St Louis with chlamys, scepter, and* main. *Register of ordinances of the royal household, before 1320 (Paris, Arch. nat. JJ57 fol. 20r, detail).*

The iconography of St Louis has been studied previously in two distinct parts, the man (up to his death in 1270), and the saint (after his canonization in 1297). Certainly images of him continued to be made in the interim of nearly a generation's time. During the reign of his son, the 1282 tomb commission was of central importance, but unquestionably others came into being, with the tomb as the only and the "official" prototype. Among the numerous lost and unclearly dated images that later observers have recorded[113] must have been some made in those three decades, such as the *montjoies* and the stained glass window of Vendôme.

Mathieu de Vendôme?

When all is said and done, the strong involvement of the prince Pierre d'Alençon and his widow Jeanne de Châtillon in the glazing of the Benedictine abbey of La Trinité at Vendôme remains puzzling, even allowing for their positions as count and countess of Blois. Although it is impossible to prove, one suspects the éminence grise was Mathieu de Vendôme, abbot of Saint-Denis (1258–1286), twice regent of the realm, counselor of kings and princes, servant and strong defender of his abbey and his king, a latter-day Suger. Mathieu maneuvered with success to get Louis IX buried at the abbey, and thereafter for his canonization.

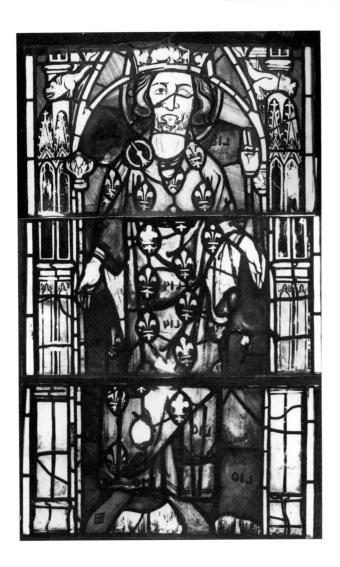

VII.17 *La Trinité, Vendôme. St Louis with chlamys, scepter, and main, Bay 206.*

He also succeeded in getting the count of Blois, Jeanne de Châtillon's father, to leave Saint-Denis a rich bequest, which his daughter executed in 1284.[114] Mathieu certainly knew Louis IX's fifth son Pierre and the count's daughter Jeanne—he is said to have married them—and the abbot no doubt had as much to do with the commissioning of the silver-gilt monument of ca. 1280 as Philippe le Hardi, perhaps more.

Who was Mathieu de Vendôme? Seventeenth-century authors disavowed by Félibien[115] tried to establish his connection to the counts of Vendôme, but in fact nothing was known then, or is known now, of his family, his education, or his entry into the Benedictine order. Did he take his vows at La Trinité de Vendôme?

✳ Epilogue ✳

The Vendôme windows are kin to the stained glass ensembles of Evron (Mayenne) and Saint-Père de Chartres. The nature of this consanguinity will be pursued on stylistic evidence in the next two chapters. There is no documentary evidence; Gothic glaziers, as Delaporte once remarked, did not bother much with work contracts or bills of lading. The resemblances are tantalizingly offhand: all three were Benedictine abbeys; all were in the same "association of prayer" (which also enrolled Cluny, the cathedral of Chartres, Sainte-Radegonde de Poitiers, and many, many others); members of the Châtillon family were donors at Vendôme and Evron; images of St Louis appear at Vendôme and Saint-Père (where he is inserted into a preexisting ensemble); and so on. In the tightly interlaced society of the late Capetian world, it would be hard to make much of any of it, were it not for the style.

A few iconographic peculiarities are held in common, such as Barnabas with his flame, always included among the apostles. Aside from apostles' attributes, however, the splendid grand plan of Saint-Père's sophisticated program owes nothing to Vendôme. The Evron program, on the other hand, if indeed one can dignify it with that term, is a catchall of ideas that only makes sense when one grasps that they are a reflection, as in a glass darkly, of Vendôme. Saint-Père seems to have had no direct connection to Evron, beyond the fact that the latter community had been founded in the tenth century by monks from the former. The artistic stemma is therefore complex. It springs from Vendôme, from which both Evron and Saint-Père derive but on different schedules, in different directions, and with a different pulse.

Evron is chronologically a straightforward, small step from the latest work of Vendôme, its first designs products of the last Vendôme masters (Bays 205 and 206). Evron was a rural community in an isolated border region, sleepy, provincial, in many ways as folksy as the cathedral community of Sées not so far away. Saint-Père, in contrast, was by heritage, income, and location a sophisticated and influential community accustomed to the corridors of power. One of the early Vendôme designers (the glazier of Peter and Paul in Bay 204), and possibly the Master of Pierre d'Alençon as well, seem to have joined the large and polyglot chantier of the Saint-Père hemicycle—perhaps when the prince died in 1284. When his widow revived the Vendôme campaign neither artist returned, and it may have been an apprentice of the former who signed on, bringing the patternbook with him. The Pilgrim Master, probably in charge at Evron for several decades, was trained at Vendôme and, between campaigns at Evron, spent some time working on the Saint-Père nave, taking another nave glazier back with him to Evron.

There is something monkish about it all. Indeed, the oddities of the Vendôme program may have been suggested by the Benedictine abbot of Saint-Denis, Mathieu de Vendôme, whose very name and lack of a family history suggest an early vocation at La Trinité. The nature of the complex stylistic kinship, evident in the glazing of Vendôme, Evron, and Saint-Père, may result from a particular familial affinity among their several glaziers: that of brotherhood in Christ under the Regula Sancti Benedicti.

CHAPTER EIGHT

The Western Realm: Evron

Les chênes et les moines sont éternels.

—LACORDAIRE

THE BENEDICTINE ABBEY of Evron (Mayenne), planted in the no-man's-land between Normandy, Brittany, Anjou, and Maine, is a creation of granite and of oak, its origins lost in legend, its history a melding of fact, medieval forgeries, and guess-work, its ancient traditions continued (since 1803) by a community of nuns, and its well-being guarded over by the municipality and the Amis de la Basilique (*VIII.1*). Evron lies, as it has lived, beyond the spotlight.[1] Its past and present are so entangled as to be impacted, its history and mythology almost beyond factoring. Its emblem is, appropriately, the life-size enthroned Virgin and Child with sweetbriar.[2] Sedes sapientiae, coated with silver foil and jewels, and handsomely restored, she starred in the Paris exhibition of 1965 (*VIII.2*). She was carved about 1200 from a great oak, which was at that time over three hundred years old.

The tower-narthex and four nave bays of the present church date from the revitalization of the monastery begun before the year 1000 and continuing into the eleventh century.[3] The so-called Chapel of "St Crépin" to the north of the present choir is a twelfth-century struc-ture built, according to Camille Enlart, by a crusader;[4] its frescoes, studied by Mérimée before their catastrophic "restoration," were probably thirteenth century.[5]

Several thirteenth- and fourteenth-century tombs survive from the sizable number re-corded in drawings for the antiquarian Gaignières, as well as a fresco,[6] not to dwell for the moment on the choir architecture, sculpture, or the stained glass ensemble of that period, which will occupy us for the remainder of this chapter. In addition to subsequent Renais-sance tinkering with portals and a few window traceries, later centuries did not neglect the abbey buildings, which were totally replaced in the classic style between 1726 and 1744 and have been attributed by Lavedan, on stylistic grounds, to the "plus grand architecte bénédic-tin de l'époque, le frère Guillaume de la Tremplaye."[7]

Nor were the treasury or church furnishings neglected. Among the paintings, sculp-tures, and metalwork of all centuries should be remarked a silver-gilt Virgin of the late fifteenth century, a gilt and enamel reliquary of 1515–1520 bearing a *poinçon* of Angers, and two silvered copper busts made in 1644,[8] all shown in numerous exhibitions. Less portable are a baroque oak organ facade, and furnishings of ca. 1780 including oak *boiseries* on stalls, throne, and paschal candlestick, wrought-iron choir grilles, a great copper lectern, and an altar of sculpted marble.[9] Among nineteenth-century embellishments is a painting given by Napoléon III. After World War II stained glass by a citizen of Evron was installed in the great south transept bay.

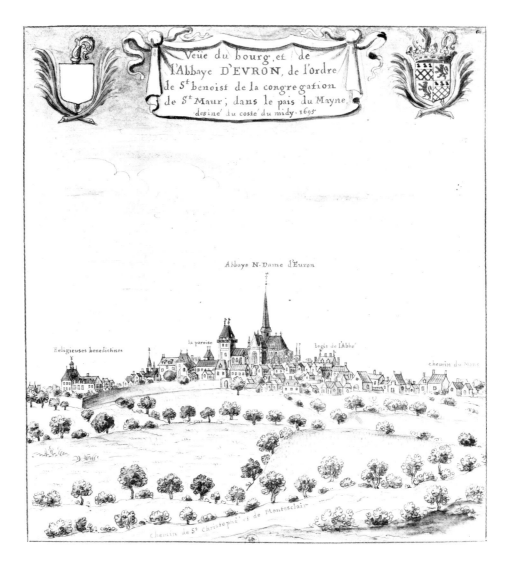

VIII.1 *The Abbey of Evron in 1695. Gaignières watercolor, Paris, Bibl. nat. Est. Va 111.*

Past and present—and future. The waters of the fountain where the legendary Pilgrim of Evron took his nap, having hung up his relic of the Virgin's Milk, and awoke to find the thorn tree grown out of reach, continue to flow in a well several meters from the high altar, covered now by a floor slab.[10] In recent years not only have the Virgin of Evron and other treasures been restored, exhibited, and studied, but "émigré" stained glass panels have surfaced in various collections and at auction. Victims of more than one exodus and indicative of several drastic overhauls of the church glazing, these panels help to reestablish the extent of the program throughout the church and over time. More remarkable, they make of Evron a pivotal ensemble of major significance in the study of the medium. They contain silver stain, the new technique of *jaune d'argent* introduced about 1310–1320, which is not otherwise present in the glass in the church. Evron is thus the unique example of a medieval glazing shop before and after it picked up the new technique.

On July 3, 1974, the vaults fell.[11] Mirabile dictu, the glass in the clerestories survived nearly intact. Having hibernated in storage during the long architectural repairs, it is reinstalled at last. The time is propitious for a study of the Gothic glazing ensemble, its program, its genesis, and its original arrangement.

Enigma Variations

In the Middle Ages Evron (since 1855 in the diocese of Laval) was within the county of Maine and the diocese of Le Mans. St Hadouin, bishop of Le Mans, founded it, according to the pretty legend of the Pilgrim of Evron already encountered in Chapter II (p. 31), depicted in the window of Le Mans (Bay 105) donated by the abbot of Evron. The first appearance of this legend is in the highly fictitious ninth-century *Actus pontificum cenomannis in urbe de-*

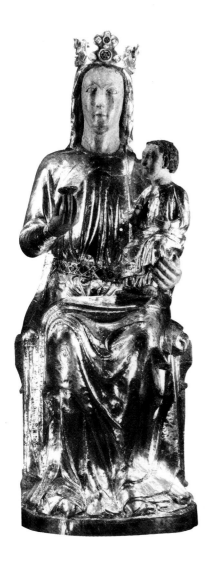

VIII.2 *The Virgin of Evron (early 13th cent.). Oak sheathed in gilt silver with translucent enamels, rock crystal, and precious stones.*

gentium, at which time Evron was unquestionably an established monastery.[12] Mérole, another bishop of Le Mans, had been a monk there and retired to die there in 774. Indeed, Evron existed in Hadouin's time, since he mentions it in his testament of February 6, 643 (n.s.). The church he mentions may be the chapel of the Virgin built alongside a fountain in the fifth century by an earlier bishop, St Thuribe.[13] While generations of Benedictine historians have grappled with possible combinations of these ancient traditions, it can be assumed that the abbey was of at least seventh-century foundation and, since at least the ninth century, a center of pilgrimage to the relic of the Virgin's Milk.[14]

While no precise evidence of Norman attack exists,[15] the Benedictines of Saint-Père de Chartres were called upon to repopulate the reestablished Evron ca. 985. The rich man behind this project was, scholars now believe, the viscount of Maine, Raoul (fl. 967–1003), followed by his son, also Raoul (d. before 1040).[16] Although his name was excised from two forged charters of foundation, the first forgery before 1073 and the second, which we shall discuss shortly, of the Gothic era, his role in the restoration can be reconstituted from an authentic document of 994 and the confirmations of two contemporary popes.[17] The existing tower-narthex and four nave bays are now presumed to date from the construction supported by Raoul and his descendants.

By the twelfth century the monastery was in need of reform, accomplished by Abbot Daniel (d. 1143) sent from Marmoutier, reform that was presumably accompanied by new construction. Of the Romanesque campaign the only remains are the Chapel of "St Crépin" and a single arcaded bay along the Gothic nave.[18] The function of the former is unknown. The location of the latter (*VIII.3.A*), now like a beached whale in the open air flanking the Renaissance portal of the nave, suggests that the primitive church of Raoul and his son may later have been provided with a Romanesque east end. By the early thirteenth century, documents establish the existence of auxiliary structures such as the infirmary chapel of Saint-Michel, the abbey's parish church of Saint-Martin, and the leper house of Saint-Nicolas, recipients of donations by various noble families of the borderlands.[19] Snows of yesteryear. . . . Nineteenth-century excavations located the infirmary chapel, destroyed in 1611. Only the spires of the others (razed in 1793) can be seen in a view of 1693 in *Monasticon gallicanum*. Gaignières's 1695 watercolor (*VIII.1*) labels Saint-Martin "la paroisse."

In the 1250s, two inexplicable data: in 1252 a charter establishes that Geoffroy de Loudun, bishop of Le Mans, consecrated the abbey church of Evron, Abbot Ernaud presiding.[20] And in 1254 or early 1255 Ernaud donated a window to Bishop Geoffroy's new cathedral, a window totally unlike its neighbors, an example of "folk art." While the window of the abbot of Evron (Le Mans upper ambulatory Bay 105; *II.7*, p. 28) is naive, it is not the work of a beginner, and I have suggested that it was made by one of the monks, whose evident technical capacity may have been nurtured by glazing projects at his own abbey. Nothing survives of any comparable glazing at Evron. And it has been the judgment of architectural historians that no architectural framework survives that might have been built to hold it, or for that matter, could even have been ready for consecration in 1252. The abbey church consecrated by Geoffroy de Loudun (d. 1255) has been truly a "sunken cathedral," its bells echoing from beneath the waves of history. Nor is there any record of a disastrous fire or other catastrophe that would have erased it so quickly. For the building of the spacious Gothic structure now attached to the nave of *l'an mil*—two nave bays, nonprojecting transept, and elaborate chevet—must have occupied a campaign of some years, and can be established by charters as in use before the 1330s. I shall argue, in fact, for a considerably earlier date of construction.

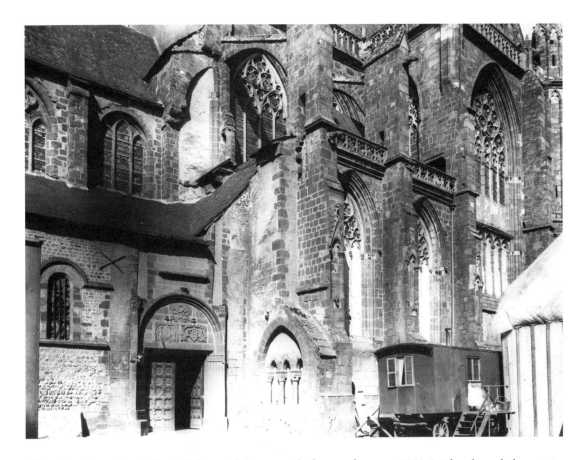

VIII.3.A *Evron. South flank (left to right): east end of nave of ca.* A.D. *1000 (with enlarged clerestories and Renaissance portal); two Gothic nave bays, incorporating a section of arcading from an earlier transept (center bottom of photo); Gothic transept facade with off-axis window and (at eastern corner) buttress and* tourelle d'escalier.

But to return for a moment to the "sunken cathedral" of the early and mid-thirteenth century: it is possible to establish its source of revenues, the viscounts of Blois, of the family de l'Isle (Lille-sous-Brulon).[21] In a charter of 1211 Renaud, viscount of Blois, established the anniversaries of his father Robert and his mother, buried in the abbey church.[22] This Robert, whose tomb can probably be identified among the mutilated stone *gisants* still in the church,[23] was unquestionably important to the monks of Evron. A thirteenth-century necrology establishes the anniversary of the "Translatio corporis domni Roberti, vicecomitis Blesensis, restauratoris nostri monasterii; Renaudus miles, nostrae congregationis, et Johannes."[24] While Renaudus and Johannes will be discussed shortly, Viscount Robert's stature can also be established by another important bit of evidence. There is (also significantly for the solving of enigmas to be discussed shortly) a document forged by the abbey in the thirteenth century to pander to the vanity of the de l'Isle family and to encourage, or perhaps reward, their interest. The forgery rewrites the foundation of the reestablishment of the abbey of A.D. 989, substituting for Raoul, viscount of the Maine, the name of Robert, viscount of Blois.[25]

While Robert (d. 1211) is called *restaurator nostri monasterii,* and not specifically of the monastery's church, the interest of the de l'Isles in Evron continued into that part of the thirteenth century when the "sunken cathedral" was built. The family arms were seen in the stained glass by Dom Briant in the eighteenth century: "au vitrail du costé du cloistre. d'or a une croix de gueules qui est de vic. de Blois fondat[r]."[26]

By reference to a seventeenth-century plan of the abbey[27] this phrase can only mean the north side of the nave or the north transept, hence the first part of the Gothic structure to be added to the ancient nave: finally, a clue to the "sunken cathedral" of 1252! Lefèvre-Pontalis has established that the two Gothic nave bays were constructed on the location of a twelfth-century transept; an isolated section of its arcading remains on the south (*VIII.3.A*). His plan and commentary indicate other irregularities:[28] the vaulting, buttresses, and windows of the north aisle of the Gothic nave bays are out of alignment and peculiar; the lower level of the north transept wall (*VIII.3.B*) is decorated with niches for tombs, the masonry of which makes a messy joint with the ambulatory to the east; on the south transept wall there is similar mismatch of the lower tomb niches with the other masonry, the large window is notably off axis, and its eastern buttress is placed well before the end of the transept. The *tourelle d'escalier* (*VIII.3.A*) at the corner is part of the chevet campaign—and the "sunken cathedral," it seems fairly clear, had a shorter transept. Although its walls have

Plan of Evron.

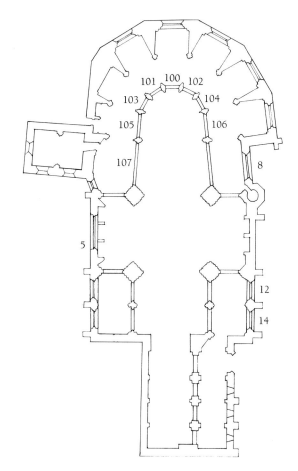

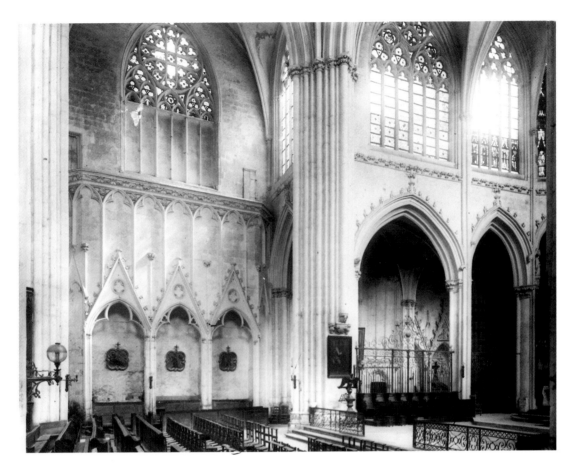

VIII.3.B *Evron. North interior (left to right): north transept facade with tomb niches; northeast crossing pier with arms of Bishop Geoffroy de Loudun; north choir, Bays 107 and 105.*

certainly been drastically reworked—extended, heightened, refenestrated—I would suggest that the present transept incorporates masonry walls from the "sunken cathedral," the choir of which was razed and replaced by the present chevet of such great elaboration and elegance. On the pier at the entry to the choir is another clue. The set of corbels depicts a bishop over a coat of arms (*VIII.3.C*). The carving, and no doubt the whole pier, belongs to the chevet campaign, but the coat of arms, if it can be trusted after obvious recarving, commemorates the destroyed choir. It displays the arms of Bishop Geoffroy de Loudun, who consecrated the "sunken cathedral" in 1252.

Moreover, the last viscount of the line, Renaud II de l'Isle (d. 1277), was buried in that church, since the necrology indicates that his tomb was moved along with the others. Drawn for Gaignières and described in detail by Dom Chevalier before it was sold in 1777, the tomb of Renaud II was a resplendent gilt and enameled affair, translated to a position of honor near the high altar.[29] It was one of the distinctive western French group of tombs of which we have already noted examples in the tombs of Juhel de Mayenne and the Bishop Guillaume Roland, and it can therefore be dated stylistically to the period of the death of Renaud in 1277.[30] The head was adorned by a circlet of pearls, and the heraldic surcoat and shield

VIII.3.C *Evron. Arms of Bishop Geoffroy de Loudun, cul-de-lampe, northeast crossing pier.*

displayed the arms of Renaud II de l'Isle, verifiable from his seals and from the Bigot Roll: *or à une croix de gueules.*[31] This Renaud[32] became viscount of Blois between 1231 and 1249, married but had no heirs, and ended his days—from sometime after 1269 until his death in 1277—among the monks of Evron, hence his description in the Gothic necrology quoted above as *Renaudus miles, nostrae congregationis.* . . . He is without much doubt the patron of the "sunken cathedral" consecrated in 1252.

The entry in the necrology can be milked further, since it specifies the moving of the tombs of Robert "restorer," of Renaud (d. 1277) "of our congregation," and of Johannes. First, the designation "of our congregation" implies that the scribe of the thirteenth-century necrology still remembered Renaud. Second, the tomb of Johannes can only be that of the Abbot Jean (1263–1288), the only other Evron tomb of such early date.[33] It is reasonable to assume that this *translatio* of tombs was from the old church into the new Gothic chevet (where they were located in later times),[34] and that it encompassed all the important tombs of the old church. It is thus significant that it did not include the next tomb in chronological order, that of Gilles du Chastelet, *chambrier,* who died at the end of the thirteenth century. Gilles was buried in a chapel of the new hemicycle under an elaborate sculpted arcade including a figure of his name-saint, Gilles.[35] Lefèvre-Pontalis has dated it on stylistic grounds to the first years of the fourteenth century, that is, directly following the death of the *chambrier.* The present Gothic chevet can thus be dated with some precision on the basis of the *translatio* of tombs: it was finished after 1288 but before ca. 1300. Since this precisely corresponds with the stylistic dating of the earliest of its clerestory stained glass, the dating, considerably earlier than that given by previous architectural historians, seems firm.

The present Gothic chevet, then, dates perhaps ca. 1290–1300 for its construction and the beginning of its decoration, and its patron cannot have been a de l'Isle. We shall see that a strong case of circumstantial evidence can be assembled for the identification of its patron, as well. Before undertaking this task, the stylistic dating of the chevet's architecture must be addressed, since it is customarily assigned to about 1320.[36]

It should be remembered that Evron is made of granite, the building material of Brittany, with only traceries and sculptures of limestone. Granite cannot be forced with ease into the graceful patterns of the *rayonnant.* Moreover, the architectural feature singled out

as of greatest significance, the elimination of the triforium and therefore reduction to a two-part elevation, displays nothing of the fourteenth century in its detailing (*VIII.3.B*). It is surely to be understood as a close follower of the cathedral church of the diocese, Le Mans, whose major elevation is remarkably similar, as are its heavy molded arcades, tracery patterns, prominent abaci, horizontal sculpted string course between the levels, and so on. As for the detail, the string course looks back ultimately to Amiens, the heavily sculpted detail (corbels, architectural friezes, capitals) can be found nearby at Sées. The polygonal exterior wall of the radiating chapels, infilled for stability, is appropriate to granite and is of even older roots, ultimately reflecting, as Lefèvre-Pontalis pointed out, the Gothic chevet of Pontigny. All things considered—granite, borderlands location, strong reliance on Le Mans (finished ca. 1260)—the Evron chevet is a most reasonable design for the 1290s.

The patron of this beautiful chevet can thus be sought with some guidance as to when, and where, to look. The main clue is, like the purloined letter, visible to all who stand in the chevet: the young lord in the clerestories overhead (Bay 102; *VIII.4*), dressed in the heraldic surcoat of Châtillon (*de gueules à 3 pals de vair, au chef d'or*). The discussion of his precise identification will be postponed, since the glass of the hemicycle in which he is found is not among the earliest of the glazing ensemble, but his family certainly was involved in the chevet's decoration and very likely in its construction. The Châtillon arms *de gueules à 3 pals vair* appear without the *chef d'or* in another window of the hemicycle clerestories (since 1900 moved to Bay 103). And after the Middle Ages the abbey adapted the ancient arms of the counts of Blois of the house of Châtillon for its own.[37] After 1515, when François I recognized the abbots of Evron as titular barons, Abbot François de Châteaubriand installed a carved stone tympanum over the church's public entrance (*VIII.3.A*),[38] displaying his family arms and those of his new barony—copied (without much doubt, since they also omit the *chef*) from the Châtillon arms in the chevet's window. And by the eighteenth century the abbey had followed suit, adopting as its arms the same model with added *chef d'azur* incorporating *issuant* a depiction of their famous statue of the Virgin.[39]

If the powerful and high-born Châtillons were interested in Evron, which does not lie in their vast domains, the reasons must be sought. The branch of the family that inherited the county of Blois in 1292 upon the premature death of Jeanne de Châtillon, whom we have discussed in relation to Vendôme in Chapter VII, is the only reasonable possibility. In other words, the monks of Evron, having run out of de l'Isles, the viscounts, turned to the counts of Blois. From 1283 until early 1292, however, there was no count of Blois, only a countess—Jeanne de Châtillon, widow of a son of St Louis, aunt of King Philippe le Bel, and probable donor about 1285–1290 of the stained glass of La Trinité de Vendôme. It seems likely that such a farfetched plea by the monks of Evron would be given reception by her successor, her cousin Hugues de Saint-Pol, only under the fanfare at the moment that he came unexpectedly into his new largesse, in 1292.

How did the Evron community talk Hugues into it? Here again, the emerging Gothic heraldic language as well as the abbey's propensity for pious revision of history offer a hypothesis. The Châtillon arms are composed of vair with a *chef*, and heraldic vair, it is often remarked, looks like bells. The twelfth-century chapel at Evron owes its modern nickname "St Crépin" (who was the shoemaker saint) to a series of carved archivolts on its portal, which look somewhat like shoe soles. They also look somewhat like bells—or heraldic vair.[40] It seems probable that the monks sold the new count of Blois, who came from northern France and did not know the *pays de la Loire,* a story about his ancestors having

VIII.4 *Evron. Guy de Châtillon as a youth,*
Bay 102.

constructed the "St Crépin" chapel. Neither he nor they, most probably, knew the real donor or date of construction, or indeed that heraldry then had not been a viable language. Some strength for this hypothesis lies in the appearance of the Châtillon arms in the Gothic glazing: only vair, omitting the golden *chef*. Since early *chefs* occasionally functioned as *brisures* indicating cadency, the new count may have believed that his ancestors had used only the vair.

Hugues was married to Béatrix de Flandres and in 1289 had purchased Avesnes (at the Flemish border) from his cousin Jeanne.[41] Unlike his more famous brothers and cousin, whose careers kept them in the king's service as administrators or military commanders in the Flemish campaigns,[42] Hugues was something of an amateur poet who wrote "avantures

guerrieres et amoureuses de divers Princes en forme d'Histoires, qui est ce que nous appel-lons Romans."[43] Only upon Jeanne's death and his inheritance of Blois did he have any interest in the region, and he adopted its traditions wholeheartedly. Both he and his wife eventually were buried at La Guiche in the funerary chapel founded by Jeanne's father, where she had been buried, as were several counts of Blois to follow.[44] Hugues made his will in 1299 and he died about 1303, leaving his eldest son Guy de Châtillon (who was also to be buried at La Guiche) still a minor.[45]

This is the blond youth in heraldic surcoat kneeling in Bay 102 of the Evron clerestory (*VIII.4*). His surcoat makes his identification sure, since the arms are his alone: Châtillon without cadence.[46] Still a minor in 1306, Guy de Châtillon was married in 1311 to a prin-cess, but she is nowhere included.[47] Rather, his chevalric image in the window more prob-ably commemorates an even more glorious moment in his young life, his knighting in 1313 in the grand ceremony orchestrated by King Philippe le Bel for the knightings of his own sons and other gilded youths, attended by the king and queen of England. Much has been written about the rationale and financing of the knighting of 1313.[48] That it was an occasion worthy of recording in stained glass is beyond argument.

Thus, the Gothic chevet was probably begun ca. 1290 and its decoration still in progress around 1315. This dating can be both explained and expanded. The explanation for the delay lies no doubt in financial pressures in France, commencing roughly 1295 and building to a crisis by 1304.[49] Bays 107 and 105 (at the north crossing) probably date before the crisis, and the hemicycle bays thereafter; the only really remarkable thing is that all are by the same atelier. How did they survive in the bad days of inflation? Once glazing was re-sumed the shop worked probably until the 1320s, since the hemicycle windows, the latest still in the church, do not include the new technique of silver stain, whereas émigré panels from the glazing ensemble, by the same shop, do. Silver stain appears in the west in 1313 in the parish church of Le Mesnil-Villeman (Manche),[50] and sometime after 1316 in the equally rural church of Saint-Alban (Côtes-du-Nord) (see Chap. V, pp. 161–65), and the Evron figures are similarly tentative in their utilization of the new technique. With the fragment in Rouen (1327) and the famous Canon Thierry strip in the Chartres south transept (1328),[51] the silver-stain technique already dictates a new style, the delicacy of which makes a poor marriage with the expressionism of the west. The silver-stained saints of Evron sing its swan song, rendering it with appropriate vigor. They are the last, but not the least, of the ancien régime.

The Glass: Then and Now, At Home and Abroad

The glass of Evron has not been studied.[52] Information on it from the Gothic period to the Revolution is meager, and modern descriptions postdate the drastic relocation of panels of 1840 or Carot's overhauling of ca. 1900, or both. For the panels that entered the art market at those critical moments, there is circumstantial and stylistic evidence only. Nonetheless the glass collected in the choir around 1840 was not seriously tampered with and Carot's rearrangements are sensible if not always correct in detail. His additions are easily distin-guishable from the exterior, and, unlike at Sainte-Radegonde, he did not paint or polish the old glass, some of which is in astonishingly beautiful condition. Thus the glass in the church can be considered an authentic core upon which to build stylistic attributions of émigré

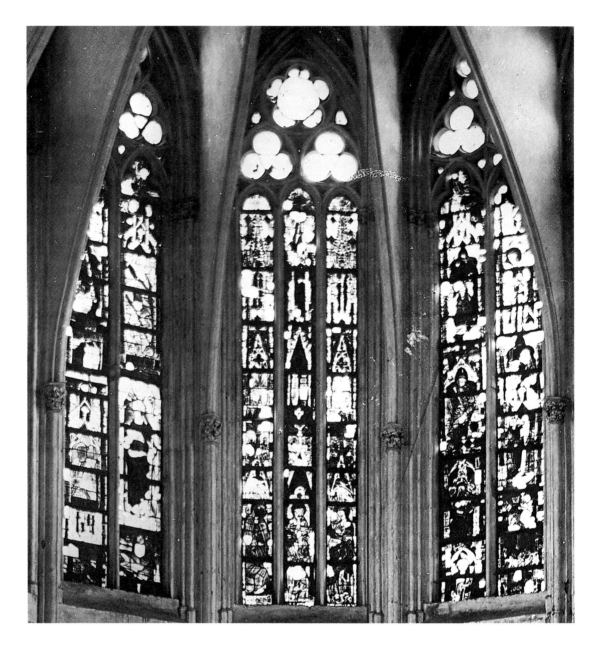

VIII.5 *Evron. Chevet, detail of ca. 1875 photo, with diagram showing glass moved by Carot. Outlined panels were stopgaps probably installed ca. 1840. Present location of the glass, moved ca. 1900 by Carot, is indicated where it is known. Angel: archangel Michael. Panel H: Renaissance figure of St Hadouin, probably replacing a lost figure of Hadouin in the same location.*

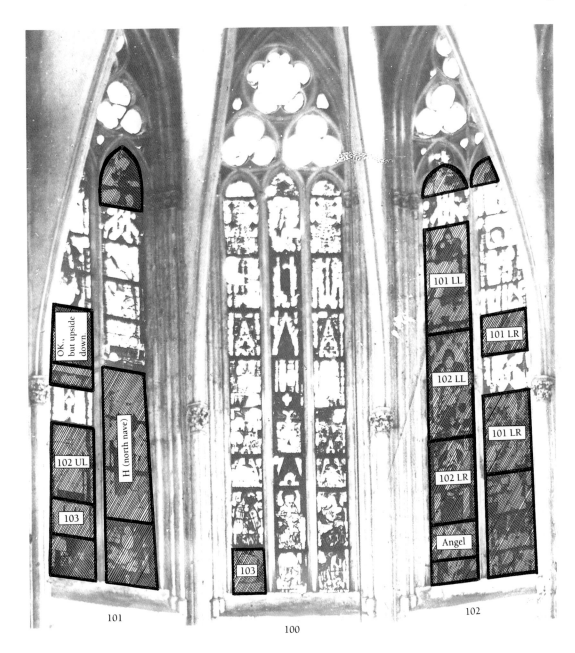

panels, hypotheses of lost chapel ensembles, and the like. The evidence will first be outlined chronologically, and then the present ensemble described as it was when the vaults fell in 1974, with notations of those minor damages and with suggestions for minor corrections of location. In addition, the émigré panels, which include some silver stain, will be introduced and accorded some well-deserved attention, as the first works of the Vendôme-Evron atelier assaying the revolutionary new technique.

Before 1800 the historian has little to work with. A sixteenth-century figure of St Hadouin under a *niche à coquille,* now installed in Bay 5 in the north nave aisle,[53] indicates a Renaissance glazing campaign of some sort.[54] Dom Chevalier (1669) mentions that the Pil-

grim of Evron legend appears in the "great windows of the church," and Dom Briant lists three coats of arms.[55] Two were in the choir: an abbot with the arms *azur au chevron d'or accompagné en chef de 2 étoiles d'argent* (probably Ricoeur, seventeenth century; now lost);[56] and a shield bearing *gueules à 3 pals de vair* (Châtillon; now in Bay 103).[57] The third was in the north (transept or nave): *or à une croix de gueules* (de l'Isle; now lost).[58]

The extensive redecoration campaigns, which Lefèvre-Pontalis lists for the fifteenth, sixteenth, seventeenth, and eighteenth centuries, no doubt took their toll of the Gothic windows, as did war and the threat of it. In 1369 the abbey had to be fortified; in 1577 the Huguenots under Bussy d'Amboise gained entry and vandalized it; the town was overrun in 1592 by the Ligueurs and again in 1593 by the English.[59] Upon the monks' return from hasty flight in 1577, they had quickly fortified their monastery and dug a moat. While the moat was filled in 1616, the windows on the south side of the church, which the monks had sealed up, remain blinded to this day—what medieval glass they may have contained either destroyed or perhaps still bricked therein.[60]

From 1800 until the present, Evron has undergone two major restorations, one of ca. 1840 and another about 1900, as well as repairs following an explosion in 1943[61] and those dictated by the fall of the vaults in 1974.[62]

The 1840 restoration collected colored glass from all over the church to fill the lacunae in the hemicycle clerestory (*VIII.5 and diagram*). There is little question that the church was then in a ruinous state, the spire leaning, rain coming in the vaults, and many traceries fallen and replaced by iron bars, the glass "mal assortis."[63] La Sicotière's remarks at the time, however, suggest that the five colored windows of the present chevet were still recognizable:

> Il faut placer en première ligne les vitraux qui garnissent cinq fenêtres du choeur et qui paraissent assez anciens. Sur l'un d'eux se voit l'histoire du pèlerin; sur d'autres, de petites arcades ogivales encadrées dans un triangle. Ils sont malheureusement fort dégradés.[64]

The restoration was overseen by the priest Gérault himself, who wrote in 1840, while work was in full swing:

> Il est visible qu'autrefois les vitraux étaient entièrement remplis de verres peints; mais par suite de restaurations maladroites, une très-grande quantité de panneaux de couleur avaient été remplacés par du verre blanc: d'autres, par leur ridicule rapprochement, attestaient l'ignorance du vitrier. Le temps avait insensiblement fait justice de cet assemblage bizarre; la majeure partie des plombs étaient consommés et plusieurs panneaux se trouvaient détachés. Il a fallu recueillir et ajuster avec le plus grand soin possible les vitres de couleur répandues ça et là dans l'édifice, pour composer les travées complètes de cinq fenêtres au fond de la grande apside.[65]

These testimonies are quoted here at length in order to establish both the authenticity of the core of hemicycle designs at Evron, as well as the approaches of the 1840 and 1900 restorations: Gérault filled blank areas with stopgap debris gathered from elsewhere in the church, while Carot in ca. 1900 attempted to remove this nonconforming glass, to reestablish the original order, and where needed to fill out the gaps by his own designs in the original style. Gérault's patchwork of around 1840 can be assessed on the basis of several nineteenth-century photographs (*VIII.5*) and by the description of Lefèvre-Pontalis and the prerestoration report of Carot.[66] Based on these nineteenth-century sources, the following list can be established (corresponding exactly to the present ensemble discussed on pp. 276f.):

VIII.6 *Evron. St Michael, now in Bay 14. Head panel original,
remainder reconstituted by Carot. After Acézat sale catalog.*

hemicycle: Bay 104—saints
 Bays 102 and 101 (flanking axial)—legend of the Pilgrim of Evron
 Bay 100 (axial)—Trinity (as Gnadenstuhl) flanked by Virgin and Saint
 John; kneeling donor holding a window
 Bay 103—Adoration of the Magi
north: Bay 105—five apostles with attributes
 Bay 107—grisailles (across the bottom)

In addition Carot's report noted the coat of arms, the portrait of the youth in heraldic sur-
coat (*VIII.4*), the sixteenth-century St Hadouin, and several added saints (which he used in
Bay 102). The traceries of the hemicycle, he said, had been replaced by eighteenth-century
clear glass. And he concluded that although the panels were lamentably mixed up and
even upside-down, with Renaissance stopgaps, it was nonetheless "easy to see where they
should be."

 Carot began restoring the windows in 1900 but only collected his money slowly and
with difficulty, since the spire, then about to collapse, presented a more pressing concern to
local officials. He had apparently decided in the meantime on a project of self-help. The
inventory of his cartoons and tracings, completed in 1989 for the Bibliothèque du Patri-
moine, includes among the Evron group scale drawings dated 1901–02 of panels that have
since come to rest in Montreal, Glasgow, and three American collections. While scholars
had previously related some of these *membra disjecta* to Evron, the Carot cartoons now allow

a secure provenance (see n. 110 below). They also include two presently unaccounted for, which match in format several of the émigré panels. Perhaps these two will also materialize eventually, somewhere in the world's museums.

The Carot drawings, nos. 66518–67 in the Patrimoine's "Inventaire d'un fonds de cartons, dessins, projets et relevés de vitraux, realisés entre 1855 et 1910," are all to scale but executed variously in pencil, charcoal, black or brown gouache, and occasionally in color. Cartoons of panels now in the church, where the new glass is easy to detect, make clear that no distinction exists in these working drawings between ancient and new designs. They do not always exactly match the surviving panels, and in a few cases they clearly document Carot's invented additions.

Represented among Carot's cartoons are panels that, in January 1911, he offered to the government's architect Léon Vincent, saying that he had reconstituted them from nonconforming debris in Evron: a St Michael (three panels) and a Gnadenstuhl (two panels).[67] Since the glass already belonged to Evron, the decision of the Ministry was to pay Carot somewhat less than he asked and to order him to install the panels in aisle windows of the church, but somehow, in the period of World War I, this did not come to pass. The Michael (*VIII.6*) and Gnadenstuhl resurfaced in the Acézat sale of 1969 and are now back in Evron, installed in Bays 12 and 14 of the nave.

Of the pair—and indeed of all the glass panels represented among Carot's tracings but not replaced by him in the church—the most significant is the St Michael. It contains silver stain on the head and wings, a technique used on many of the *membra disjecta* but not now present in windows still at Evron. Its importance to the historian is twofold. First, the head panel bears a close resemblance (in size, panel format, design of canopywork, and halo) to a coherent group of four émigré panels representing bishops. Second, and crucial, the St Michael is the only one of the *membra disjecta* for which we have independent proof of its origin at Evron. We have only Carot's word that his working cartoons represent Evron glass, and they present very ambiguous evidence, since there is no way to tell from them what or how much may have formed an original core around which he constructed the total panel. Indeed, it is only with the recent inventorying of his cartoons that some émigré glass can be assigned an Evron provenance. But in the case of the St Michael, nineteenth-century photographs provide the proof (*VIII.5*). The panel of the head of St Michael is clearly visible as a stopgap at the bottom of the left-hand lancet of Bay 102.

The original location of Michael, and for that matter of the two smaller canopied figures of a Virgin and a balding St Paul, which Carot also found as nonconforming debris in Bay 102 and left there,[68] can only be guessed on the basis of scale. The smaller two do not match each other in proportion, color, or style, have different (old) canopies, and probably came from different chapels of the choir, where their small size would be appropriate. The body panels of St Michael are heavily reworked, and would be suspect anyway since their ground is blue while that of the head panel is red (*VIII.6*).[69] It is the head panel, in any case, which is of greatest interest, since the face, halo, and canopy all match exactly the design of a group of standing bishop saints under canopies: three fine figures in the Glencairn Museum (*VIII.7*), and a fourth matching fragment in the Philadelphia Museum of Art (*Pl.54*).

The four bishops indisputably make a group, to which Michael can be added, the program (as at Vendôme) probably commemorating saints honored at the abbey: Michael (infirmary chapel Saint-Michel), Nicholas (leper-house chapel), Martin (the abbey's parish church), and relics of importance such as Julien and Thuribe, who according to legend

VIII.7 *Three bishop saints from Evron, photographed in an installation after 1906, Grosvenor Thomas collection (?) (now in the Glencairn Museum).*

struck the spring now under the floor slabs near the high altar. All four bishops are among Carot's cartoons, nos. 66518–21.

The three Glencairn bishops (*VIII.7*), handsome panels in magnificent condition except for one modern head, appear in a large glass transparency, a photograph given to me by the restorer Dennis King and identified by him as Costessey Chapel in Norwich.[70] Since the bulk of the Costessey collection was formed early in the nineteenth century, I previously had hypothesized that the bishops left Evron for Norfolk with similar cargo acquired in Europe in 1802–03 by the Norwich merchant John Christopher von Hampp. Carot's cartoons now establish him as the instigator of their travels. On April 9, 1906, Carot dated the cartoon of the bishop whose head he was replacing; in 1913 the three bishops were in the Grosvenor Thomas collection; in 1922 the latter's son Roy Grosvenor Thomas published a photo of one of the trio; and in 1923 he sold them to Raymond Pitcairn, founder of the collection that now forms the Glencairn Museum. In 1919 the Philadelphia Museum of Art had already acquired, probably from Thomas, the fourth bishop panel (St Nicholas and the orphan boys), the most deteriorated fragment of the series.[71] The width of the bishops panels, around 48 centimeters, would fit only one window of the Evron choir, Bay 106. As the finest panels surviving from the late glazing campaign of Evron ca. 1320, they will receive a full discussion of style and program below (see pp. 291–94).

The Evron cartoons comprise, in addition to the glass returned to the church and the series just mentioned, three distinct groups of panels, and all of the related glass that survives has suffered Carot's heavy and drastic reworking. The first of these groups is the most unusual, a single panel (cartoon no. 66554) of St Lawrence, now in the Claude Violette collection in Montreal.[72] The width of about 38 centimeters, even allowing for added borders, does not seem to fit any of the church's apertures, and the design finds no match either in Evron or among the other émigré panels. It is earlier in style than any other Evron glass, the architectural frame simpler and the painting more hesitant, more closely approximating the developmental stage of Le Mans in the 1250s. The panel seems to be a survivor from the "sunken cathedral" consecrated in 1252.

A second group is composed of two scenes of St Anne with the young Virgin, now in Forest Lawn, Glendale, Calif. (cartoons nos. 66542, 66543), and a matching design for which we have only the cartoon (no. 66524), depicting a balding, bearded and haloed head (Joachim? Joseph?).[73] The "Joachim" cartoon has the identical canopywork found on the California panels, though not included in their cartoons. It replicates the canopy design of the bishops series discussed earlier, with minor alterations necessitated by the greater width of these panels, around 50 to 54 centimeters. Only one bay in Evron matches that dimension, the five-lancet clerestory in the south transept's east wall (Bay 110), where the widths range from 53.2 to 55 centimeters. The subjects (St Anne leading the child Virgin and the Virgin's education by St Anne) would be a natural extension of the choir program and appropriate to a Marian pilgrimage church like Evron. The male saint could form part of a more typical scene from the subject of the Virgin's childhood, either her Nativity or Marriage.

The California canopies, omitted from Carot's drawings, could well be recycled medieval work; two north transept clerestories in the church still contain canopywork in their lancet heads. Unfortunately Carot's cartoons provide grave reasons, however, for questioning the authenticity of any figural part of the California panels. There are minor differences between cartoons and glass—variances in halo color and pattern, and widely divergent facial types. The cartoon of the Education of the Virgin includes in the margin two trial sketches for Anne's curling hand. There are serious stylistic problems: the panel of Anne leading the Virgin features a prominent inscription that would be the only one at Evron, and it reads ANNE rather than ANNA; the eccentric patterned ground of that scene also does not appear at Evron or, for that matter, in France;[74] in the Education panel, the outlines of Anne's head and the canopy each overlap the other, and her face bears the idiosyncratic and unforgettable features used by the Appliqué Master of Sainte-Radegonde in Poitiers, whose window Carot was restoring in the same years (see pp. 81, 84f.); in both California scenes, the figures are crowded into the space and sliced off in a graceless, abrupt manner totally unidiomatic for Evron and hard to imagine before the impact of Japanese prints on late nineteenth-century Parisian painting. There are iconographic anomalies as well. St Anne is barefoot. The child Virgin is crowned (in French art she never wears more than a filet in her hair), and her crown is the tall, late-German type.[75] Moreover, neither of the California subjects appeared this way in Gothic art. St Anne leading the child Virgin presumably relates to the scene of the Presentation of the Virgin in the temple, at the age of about three. The most crucial component of that scene—stairs—is not even suggested at Evron. The Education panel relates to the theme of St Anne teaching the young Virgin (aged about twelve) to read, a theme that appeared in continental Europe no earlier than the fifteenth century.[76] In the stained glass of Chartres cathedral, Mary goes to school and learns to read with other children from a male *magister* with switch in hand.

Cartoons by Henri Carot. Evron restorations ca. 1900. (A) St Lawrence; (B) "Joachim"; (C) St Anne leading the child Virgin; (D) St Anne teaching the young Virgin; (E) "Pope St Gregory"; (F) St Jerome (in St Céneré's hat)

The third group from the Evron cartoons is a pair of panels depicting saints writing (cartoons nos. 66522, 66545 [1–2]). The first design, unrelated to any known glass, is the head panel of a saint wearing a miter; the mate, in the Burrell Collection in Glasgow, is a full panel showing a saint seated at a writing desk, under identical canopywork, and wearing

a chasuble and a red pith helmet. At first blush it would seem that we have here two of the four Doctors of the Church, Pope St Gregory and St Jerome in his red cardinal hat.[77] Again, there are problems. The headgear of "Gregory" is an impossible hybrid, with the tall rounded contours of the required papal tiara but decorations in the manner of a bishop's miter (which at Evron takes a smaller and more angled shape).

For the Glasgow saint there are two cartoons, varying slightly. The glass itself is heavily and sloppily overpainted, and significant parts are severely weathered on the inside, rather than the outside—including the canopy, the face, both hands, and the top of the lectern beneath them. The glass making up the chair is miscellaneous repainted scraps. Furthermore, Jerome does not wear a cardinal's hat until after the compilation of his works by Giovanni d'Andrea in 1348.[78] On the Chartres south transept he is bareheaded, and in the choir clerestories of Saint-Ouen de Rouen, glazed before 1339, he sits at a writing desk garbed in a monk's hood. So who is this holy man in the red hat?

The most likely hypothesis is that Carot recast (into the church father Jerome) various fragments, including the hat, from an image of the popular *petit saint* of the region, St Céneré. Ceuneau describes the local farmhouse of yesteryear with its crucifix and its pottery statuettes of the Virgin and St Céneré.[79] Céneré and his elder brother Céneri were born in Umbria in the seventh century, became cardinal-deacons of the Church, and wandered to western France as hermits; their vita was authenticated by Mabillon. Céneri pushed on to the diocese of Sées in Lower Normandy, while Céneré remained near Saulges just south of Evron. The church and parish of Saint-Céneré that lay 15 kilometers west of Evron (just past Montsur) was given to the abbey by its legendary founder in A.D. 989, and the monastery was still enjoying the revenues in 1469.

The frontal red hat in Glasgow is a fine detail. Red became the color for cardinals under Boniface VIII in 1294, and a fourteenth-century cardinal's hat had a very tall crown.[80] Folk sculptures of St Céneré retained his high crowned hat after the introduction of the familiar pancake-shaped cardinal's biretta, and in the seventeenth century the saint's feast was called the *feste des potz,* no doubt from *pot,* a Renaissance helmet with a high rounded dome and small brim. The Glasgow hat surely belonged to Céneré, whose image would have fit in very nicely with the program of the bishops series commemorating chapels under Evron's control.

The Carot working drawings allow us to relate a number of émigré panels to Evron and to discount a number of others that have been suggested, but the above cases make it clear that the evidence provided by the cartoons must be sifted with painstaking care and extreme caution. At the very least, however, they allow us to conclude that the Evron glazing was extensive, its program unusual, and its quality and detail worthy of our attention.

Old Wine in New Bottles

The stained glass in Evron swims in the wake of La Trinité de Vendôme and comprises three distinct groups: Bays 107 and 105 at the north crossing, after 1292; the five hemicycle bays (Bays 100–104), after 1313; and the silver-stained émigrés of around 1320. The earliest Evron chantier is the one that worked latest at Vendôme (Bays 205 and 206), and as both were probably Châtillon commissions, it seems likely that the Evron painters got the job on the basis of their work at Vendôme. Not only does the Vendôme late style appear at Evron, but the program of Vendôme resurfaces in somewhat unbuttoned fashion, as though the glaziers themselves were adapting ideas from the Vendôme program but with little guidance.

The relationship of Evron with Saint-Père de Chartres is rather more complex. The hemicycle program there probably began with the tracery medallions of ca. 1280, a program that aborted before coming to term. Among the painters in the Saint-Père hemicycle crew are some from the early Vendôme campaign (Bays 201, 200, 202, and the Peter and Paul from Bay 204), since that is the point at which the hiatus at Vendôme occurred, probably at the death of Pierre d'Alençon in 1284, if not with his still earlier departure on campaign. The county of Chartres was purchased from his widow Jeanne de Châtillon by the king in 1286, and the Saint-Père hemicycle program seems to have been in progress at approximately the same time. It was completed before 1297, since the images of Sts Louis and Gilduin (abbey patron) were inserted into the axial bay thereafter, probably as late as around 1304 when the king came to Chartres and donated his golden armor in thanksgiving for the victory at Mons. The style of Sts Louis and Gilduin, at any rate, relates to that of the Saint-Père nave ensemble (datable by donors ca. 1305–1315) rather than to the earlier and more accomplished hemicycle.

The glaziers of the first Evron campaign of the 1290s probably found work at Saint-Père before their atelier was called back to Evron some decades later. While it is hard to trace individual hands among the great confusion of artists of the Saint-Père hemicycle, it is easier to see the influence of the Saint-Père hemicycle format at Evron: the double layers of gabled figures (Evron bays 102 and 104); and the flight of canopies, at Evron exaggerated to untoward heights (Bays 104, 100, and 103). Without the Saint-Père hemicycle, the Evron hemicycle would be bizarre and inexplicable indeed. With it, the formal ideas at Evron can be seen to be adapted piecemeal and hit-or-miss, in exactly the same manner as the iconography was adapted from Vendôme. The mental processes and inventive talents of the artists are the same: derivative, mannerist, and cluttered, the ideas coming apart at the seams. The final silver-stain campaign at Evron adapts, too, but from itself, coming full circle: the silver-stained saints are based on the Vendôme-derived saints of the first campaign (Evron Bay 105).

The artist is in fact the same. I prefer to call him the Pilgrim Master, after his finest hour in the Evron hemicycle, the beautiful series of the Pilgrim of Evron in Bays 102 and 101. His youthful work we have seen in the last bay at Vendôme—the narrative of St Eutrope being axed—and his narrative talents came to fruition in the Evron hemicycle. He adds a pinch of this narrative to the recipe of the Evron first campaign (Bay 105, five straightforward apostles) to concoct his silver-stained ensemble, the last we have of Evron and of the western school (VIII.7). The Pilgrim Master has had a long career in the west, and has learned a new stain technique for his craft, but his style has remained distinctively his own. How fitting that the west's final chapter should be written in his expressionist idiom.

The proofs for these many and varied assumptions will be examined now in detail, proceeding with the Evron campaigns in chronological sequence and fielding questions of style, iconography, donors, and program, as they come. The complex interrelationships with the Saint-Père campaigns will be given more attention in Chapter IX.

Two points must be made about Evron before the campaigns are addressed in detail. The first concerns Carot's restorations of ca. 1900. They are absolutely clear-cut and readable on the exterior of the glass. The Evron glass was not so much deteriorating as it was pock-marked by holes and gaps, and what he found, and what we can still appreciate, is by and large in fine condition. The areas of Carot's fabrication will be indicated in passing, as will suggestions for minor corrections in his arrangements based on data he could not have known. Second, there is no way to know which apertures may have been glazed (or when

VIII.8 *Evron. Christ and the four evangelist symbols, traceries, Bay 107.*

such glazing would have occurred), in the nave, the vast clerestories of the transepts and
their facade walls, the south bays of the choir clerestory (Bays 106 and 108), and all the
windows at ground level. In the north transept bays, lancet heads still guard scruffy frag-
ments testifying to canopied programs. Thus, any of the three Evron campaigns could have
been more extended than it is now possible to determine. Let us turn with gratitude to what
we have.

The Campaign of the 1290s: Bays 107 and 105

All that remains of the first glazing campaign of Evron are sections of two bays, the choir
clerestories at the north crossing. Both lost great areas, probably to blankglazing when the
eighteenth century lavishly redecorated the choir, or perhaps to Hampp and his kind, follow-
ing the Revolution. It seems likely that both bays were originally band windows, resembling
those at Vendôme, but the question at Vendôme as to whether the band was originally at the
bottom of the lancet or in the middle cannot be settled on the basis of the remains at Evron.
The row of canopied figures, which is all that is left of Bay 105, is at the bottom; the row of
grisailles, all that is left in the Bay 107 lancets, is also at the bottom. That enigma remains.
The progression of images is as follows:

Bay 105: Five canopied apostles with attributes (*Pl.51*).
 Left to right: flame and book (Barnabas); pike and book; bare sword
 (frontal figure); halberd; sheathed sword and book.

Bay 107: Grisailles within borders (fleurs-de-lis, castles, cassettes) in a row of three
 panels across the bottom and in the lancet heads.

 Tracery lights (*VIII.8*): Christ showing wounds; the four evangelist
 symbols, with phylacteries.[81]

The five apostles of Bay 105 are in remarkably fine condition. Lefèvre-Pontalis described them and attempted to name them.[82] But while the first apostle (whose attribute he could not identify) is unquestionably Barnabas with his flame, a favorite in the late western cycles, the identifications of the others cannot be firmly fixed.[83] At Vendôme and in the Saint-Père hemicycle, as at Evron, the apostles with attributes bear no name inscriptions. The series in the Saint-Père nave does have inscriptions, but in such confusion—among the twelve are three Jameses, for instance—that they hardly inspire confidence. More fruitful speculation might concern the question whether the Evron program, like the others, originally had more than five figures, and if so, did they compose a second row (of five) in the same window? Were they a second group of five in the facing bay? We still get only ten (or, if a double row, twenty). Perhaps they were the lost row of Bay 107 adjoining, which has six lancets.[84] In that case the tally would be eleven.

In color, in drawing, in decorative motifs (canopywork, haloes), and in facial types, the five Evron apostles bear a strong family resemblance to the final bays of Vendôme (205 and 206 at the crossing). Like those bays (and unlike Vendôme Bays 203 and 204 that precede them) they have no backpainting. The color harmony is a balance of primaries (clear red, bright blue, strong yellow) with white and a touch of emerald green, of gaity and peasantlike vigor. The two apostles to the right are almost entirely in primaries and white (*Pl.51*); a pale green is introduced in the left pair, while the central figure (Paul?) is set off not only by his hieratic frontality and his scalloped halo but also by a more subtle coloration using purple-brown and a paler yellow. Comparisons can be drawn to Sées, where the balance of primaries first appears; with Vendôme; and with the Saint-Père apse, where this gamut is the basis for a remarkable display of fireworks. While white is included in all these ensembles, there is as yet little attempt to modify color saturation to harmonize with grisaille. Such harmonization appears within the series of the Saint-Père nave. In fact Evron Bay 105 occupies a midpoint between the Saint-Père hemicycle and nave in the handling of color.

The Evron canopywork is derived from that of Vendôme (*VII.10*, p. 235). Differences are slight and indicate a development: the Evron figures are somewhat more slender and shoulderless, their canopies slightly more vertically extended. The choice and arrangement of architectural motifs is especially close to the later and much more elaborate canopies of the Saint-Père nave (Bay 28, for example), although gargoyles—found in some of the Vendôme canopies, in Evron Bay 105, and in the Saint-Père hemicycle—are dropped from the nave series at Saint-Père.

The painting is, at its best, as forceful as the color: loose, selective, and exaggerated. At less than best it degenerates into flabby definition, as in the hands. The heads of the Evron apostles are very close to those at Vendôme: emphatic large-pupiled eyes outlined by double lines, triangular in shape with flat bottoms; two types of eyebrows, rounded and hooked (the latter occurs at Sées [*VI.28.A*] and also in the Saint-Père apse); a ∪ line in the cheek (cf. St Benedict, Vendôme Bay 205); mouth formed of a heavily emphasized top line, ac-

cented at the ends, over a smaller, thinner lower line; large coarse noses, those in frontal faces resembling a side-view nose with an added nostril (St Louis, Vendôme Bay 206, *VII.17*, p. 249; Evron Bay 105, central figure; Evron Bay 107 traceries [*VIII.8*], Christ showing wounds). The static electricity of the Saint-Père hemicycle saints is nowhere to be found and it is only with the added figures at Saint-Père (Sts Louis and Gilduin in the axial bay) that a close comparison can be made to Evron. In sum: the chantier of Vendôme is present at Evron and then in the larger shop of the Saint-Père nave; and the painters of the Saint-Père hemicycle had branched off the western stemma at an earlier moment, most probably at the hiatus in the Vendôme campaign near 1285. While it is not possible to guess at the number of individuals involved in the Saint-Père hemicycle, surely there cannot have been many at the other sites. The chantier that moved from Vendôme to Evron was perhaps no larger than a master and his apprentice.

The row of grisailles in Bay 107 is also in remarkable condition, scarcely weathered at all. They are bulged quarry patterns with naturalistic foliage rising from a central stem, against a clear unhatched ground, each panel accented in the center by a small colored *bosse*. A date in the 1290s is most reasonable, both for the grisailles and for their borders, which combine the old *France* and *Castille* with a scattering of cassettes. The drawing of the grisaille foliage is very handsome indeed, elastic and definitive, even elegant.

The Christ and evangelist symbols in the traceries above (*VIII.8*) are rather a different matter. Elegance is not their hallmark. Certainly more elegant models were available: the axial bay of Vendôme (*VII.5, p. 228*) has a set of evangelist symbols of great suavity, as did the frescoes of the "St Crépin" chapel at Evron itself.[85] But in Bay 107 the lion and the ox do not strike a *contrapposto* stance. Rather, they freeze in profile, their heads turned to stare frontally and stupidly at the viewer somewhat like stuffed toys. The eagle, also stiffly profiled, has big feet. The Christ appears not to be showing his wounds so much as waving bye-bye. Indeed, the animals are more fun than the inept human forms. The conventions of the Bay 105 apostles are here (color, halo decoration, facial features) but the spirit is pure distilled folk charm. If these are the designs of the apprentice, their childlike appeal, recalling the naïveté of the Evron bay at Le Mans, suggests that the master did not bring him along from Vendôme.

The Campaign of about 1310–1315: The Hemicycle Bays 100–104

The hemicycle of Evron consists of five bays (*VIII.9 and diagram*) glazed in two alternating patterns, which reflect the alternating dimensions and lancet divisions of the windows. Bays 103, 100 (axial), and 104 are made up of three lancets each, about 40 to 41 cm. wide. Their glass is a row of figures across the bottom surmounted by soaring canopies. Bays 101 and 102 have two lancets each, about 64 to 66 cm. wide. Their glass is two rows of canopied scenes.

I have suggested that both formats, the double row of framed figures and the soaring canopywork, derive from Saint-Père, where canopies have begun to rise and where the double row is standard. The alteration of these two mutually exclusive visual systems at Evron is also derived from the same kind of oil-and-water mixture filling the Saint-Père nave. Indeed the Evron hemicycle ensemble would seem an even more bizarre aesthetic

Plates

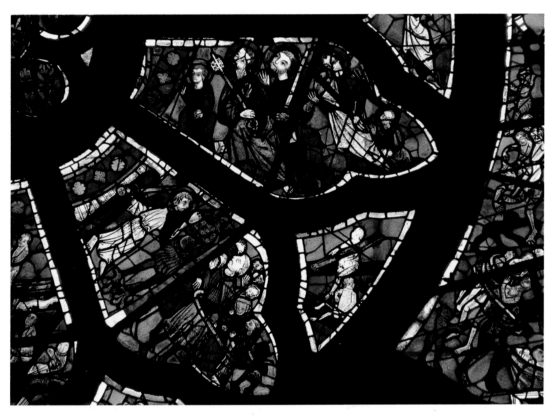

Sainte-Radegonde. Sts Peter and Paul, angel bowing a violin, dead rising, roped souls going to hell. Bay 113, detail.

1 *Chartres cathedral. Mauclerc lancets, detail, south transept below the rose window.*

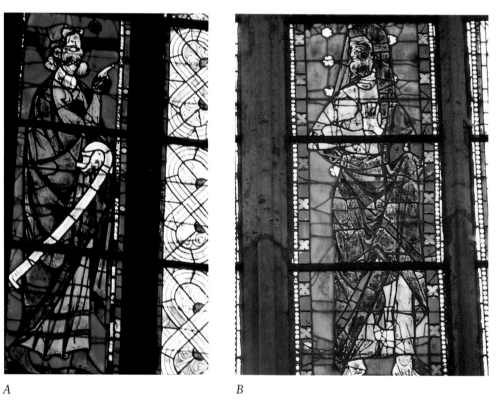

A B

2.A–B *Church of Saint-Père de Chartres. Choir. (A) Prophet (Cartoon N), Bay 16. (B) Prophet (Cartoon B), Bay 8.*

3 *Le Mans cathedral. Upper ambulatory,*
Bay 100, left.

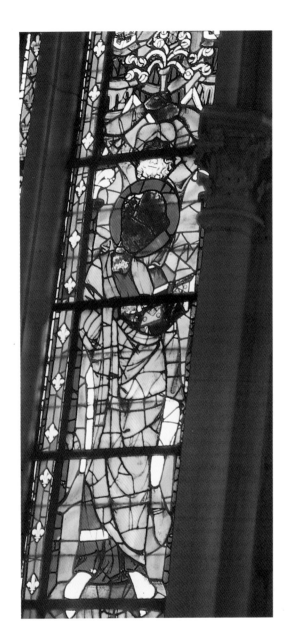

5 *Le Mans. Flagellation of St Gervais,*
Bay 201, right lancet.

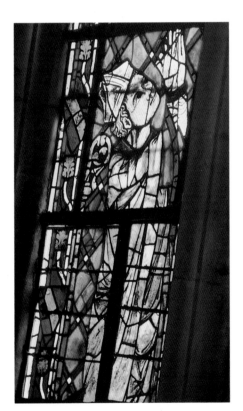

4 *Le Mans. Bishop Geoffroy de Loudun,*
choir clerestory, Bay 200.

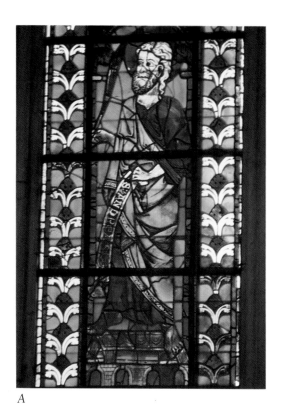
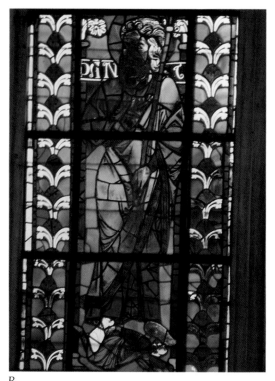

A

B

6.A–B *Le Mans. Bay 211, second lancet from left. (A) Apostle with palm, top. (B) David, bottom. Inscriptions repainted.*

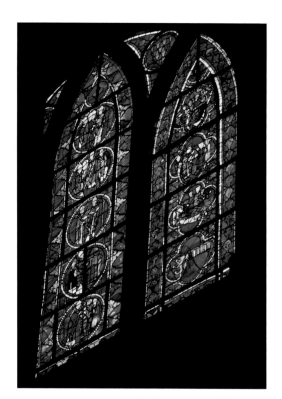

7 *Le Mans. Upper ambulatory, Bay 101.*

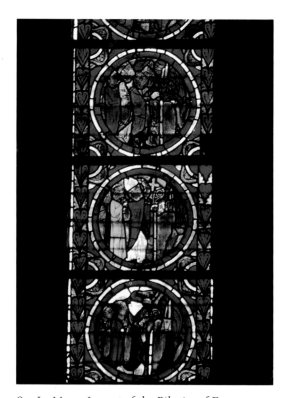

8 *Le Mans. Lancet of the Pilgrim of Evron, Bay 105, second lancet from left.*

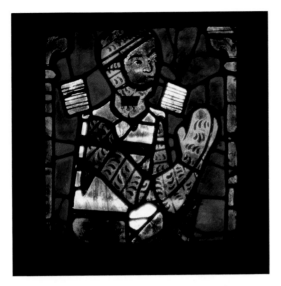

9 *Le Mans. Donor, one of the brothers de
Cormes, choir clerestory, Bay 207 (third lancet
from right, lower row).*

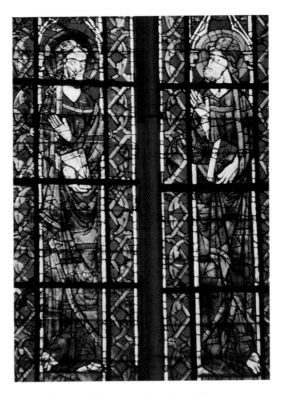

10 *Le Mans. Two apostles, choir clerestory,
Bay 202.*

11 *Le Mans. Bishop saint, choir clerestory,
Bay 206.*

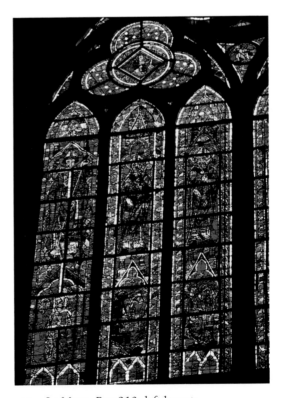

12 *Le Mans. Bay 210, left lancets.*

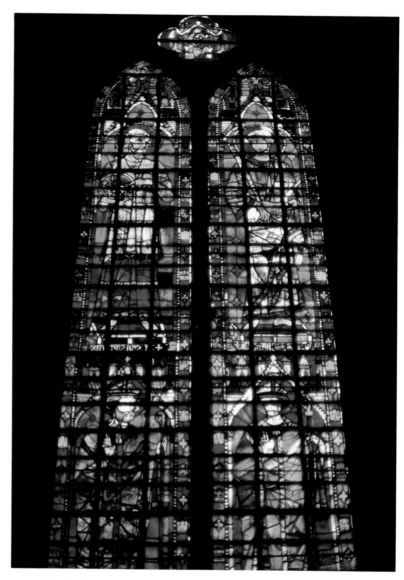

13 *Church of Gassicourt near Mantes (Yvelines). Master of the Big Saints, Bay 1.*

14 *Gassicourt. John the Evangelist, detail, Bay 1.*

15 *Gassicourt. St Lawrence being beaten, Bay 4.*

A

B

16.A–B *Gassicourt. Bay 4. (A) Stephen led before the Council, detail. (B) St Vincent led before Dacien, detail.*

A

B

17.A–B *Gassicourt. Bay 3. (A) Sleeping magi, detail. (B) Massacre of the Innocents, detail of mother.*

18 *Gassicourt. Paying of Judas, detail, Bay 0.*

19 *Church of Saint-Père de Chartres. Abbot donor, Calling of Peter, Giving of the Keys, Bay 22. Photo before 1991 restoration.*

20 *Sainte-Radegonde. Souls in hell. Bay 113, detail.*

21 *Sainte-Radegonde. Passion scenes, reset in 1708 into Bay 113 (lancets 3 and 4 from left).*

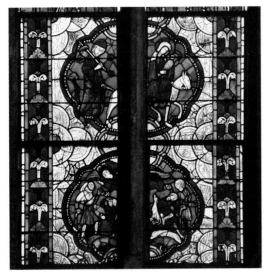

22 *Sainte-Radegonde. Annunciation to the Shepherds (bottom); Flight to Egypt (top). Infancy panels moved in 1708 to Bay 113.*

23 *Sainte-Radegonde. Blaise Master, scenes from the parable of Dives and Lazarus, Bay 115. (Central head is modern.)*

A

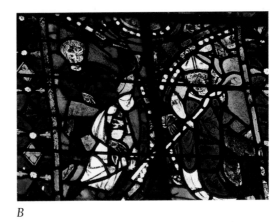

B

24.A–B *Sainte-Radegonde. Bay 115. (A) St Blaise preaching to the animals. (B) St Blaise curing the child choking on a fishbone.*

25 *Sainte-Radegonde. Band of fragments from the life of St Radegonde (Infancy Master, Royal Master). Grisaille Bay 114, left two lancets.*

26 *Dol cathedral. Chevet, east window, Bay 200.*

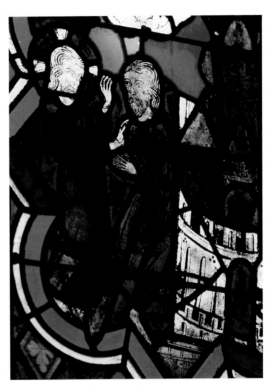

27 Dol. Coat of arms of Bishop Thibaud de Pouancé. Originally in traceries of Bay 216, south transept window (now in west wall of north transept).

29 Dol. Abraham Master. Abraham begging God to spare Sodom and Gomorrah. East window, Bay 200, lancet B.

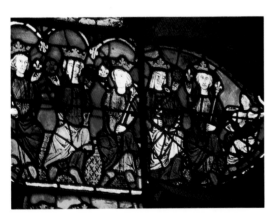

28 Dol. Blessed holding aloft white fleurs-de-lis (emblem of the chapter of Dol?), Last Judgment, traceries of east window, Bay 200. (Several replacements, including second head from the left, of 1509?)

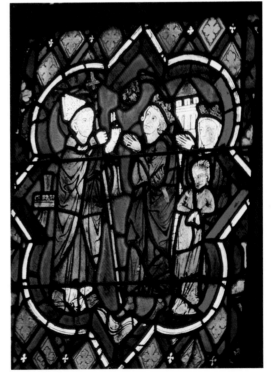

30 Dol. Samson Master. St Samson and the demoniac girl, east window, Bay 200, lancet F.

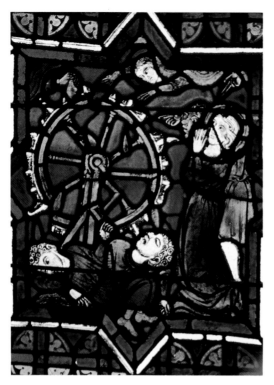

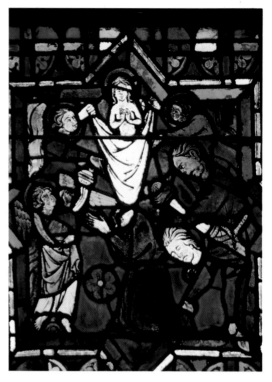

31 *Dol. Catherine Master. Wheel torture, east window, Bay 200, lancet H, panel 5.*

32 *Dol. Catherine Master. Beheading of St Catherine. East window, Bay 200, lancet H, panel 6.*

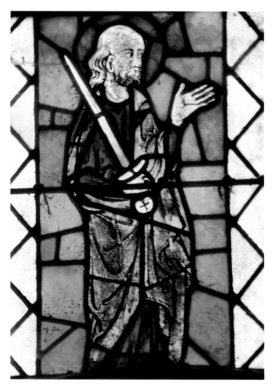

34 *Church of Saint-Méen-le-Grand (Ille-et-Vilaine). Souls rising, south window.*

36 *Church of Saint-Magloire de Léhon, Beaumanoir chapel. St Paul, fragment.*

33 Dol. Grisaille, north chevet clerestory, Bay 207.

35 Saint-Méen-le-Grand. Coat of arms of duke of Brittany, south window.

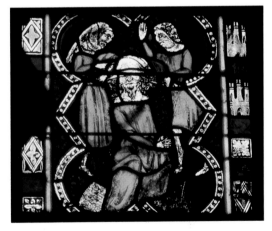

37 Church of Saint-Alban (Côtes-du-Nord). Flagellation, east window, lancet A.

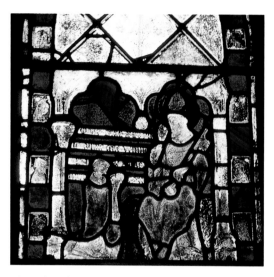

38 *Church of Le Mesnil-Villeman (Manche).
Master Guillaume before St Peter, 1313.*

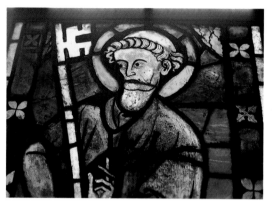

40 *Victoria and Albert Museum, London.
Apostle from Sées, north transept clerestory,
Bay 211, lancet B.*

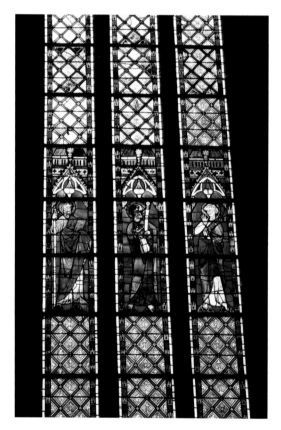

39 *Sées cathedral. North transept clerestory,
Bay 209.*

41.A *Sées. Virgin and Child with angels,
quatrefoil from traceries of Bay 0. Now in Bay 3.*

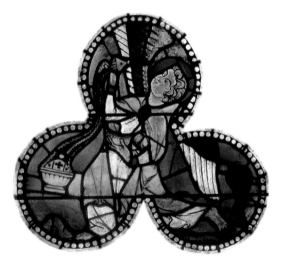

41.B *Los Angeles County Museum of Art.
Protais Master. Censing angel from Sées, trefoil
from traceries of Bay 0.*

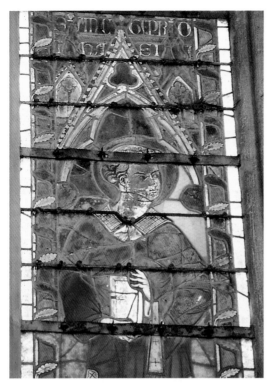

42 *Sées. St Protais, now in Bay 3 (in Bay 1 in 19th cent.).*

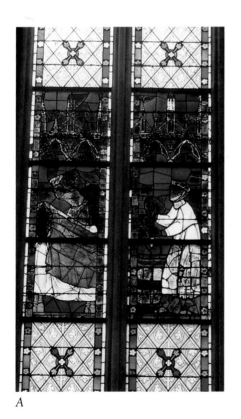

A

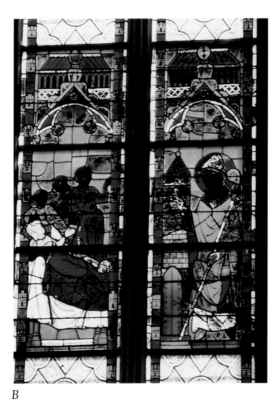

B

43.A–B *Sées. St Nicholas chapel. (A) Murder of the three boys by the innkeeper, Bay 15. (B) St Nicholas dowering the three poor sisters, Bay 13.*

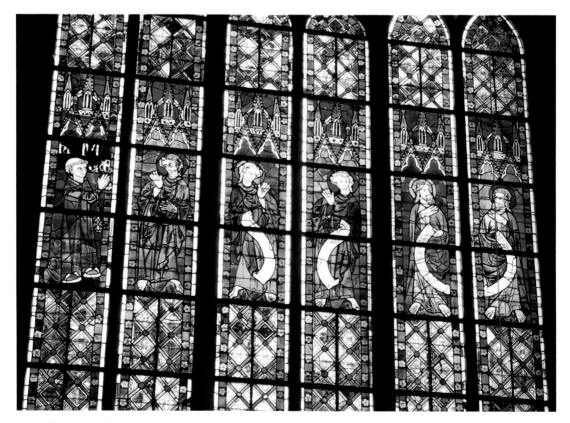

44 *Sées. North choir, Bay 205.*

45.A *Sées. Nicholas Master. Sts Gervais and Protais, bishop saint (St Vaast?), detail of Bay 200.*

45.B *Sées. Nicholas Master. St Anne and the young Virgin with angels, traceries of Bay 200, detail.*

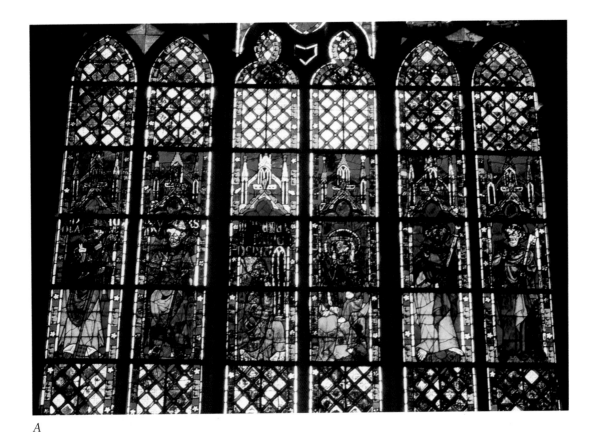

A

B

46.A–B *Sées. Bay 208. (A) Bishop Gui du Merle with the Virgin and Sts Peter, Paul, Nicholas, and Ursin. (B) Traceries with arms of du Merle (upper two), cadenced for Gui du Merle (lower one).*

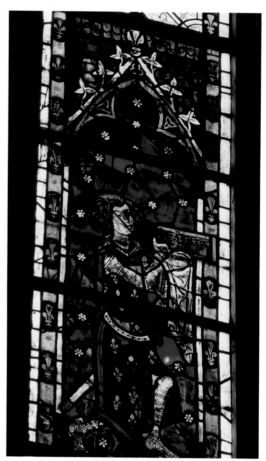

A

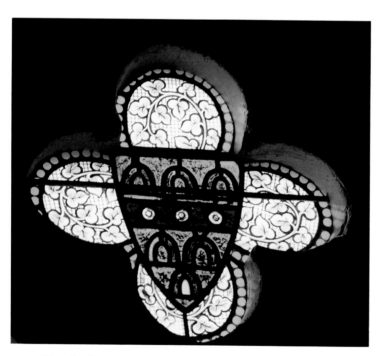

47 *Church of Aunou-sur-Orne. Arms of de la Ferrière, cadenced*
à la fasce de gueules à 3 annelets d'argent, *ca. 1265.*

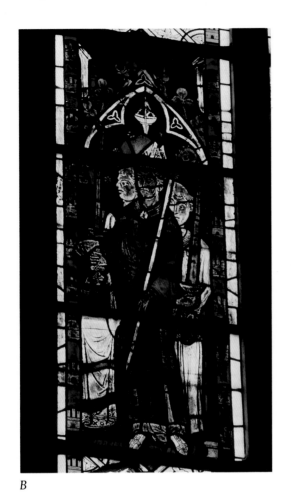

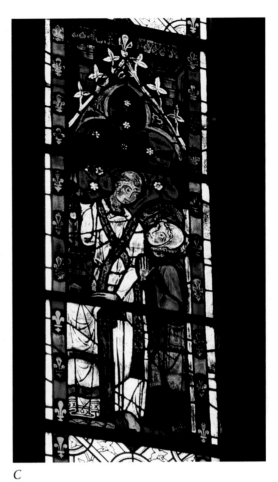

B C

48.A–C *Former abbey of La Trinité, Vendôme. Pierre d'Alençon as Geoffroy Martel, presenting the Sainte Larme to La Trinité, Bay 202.*

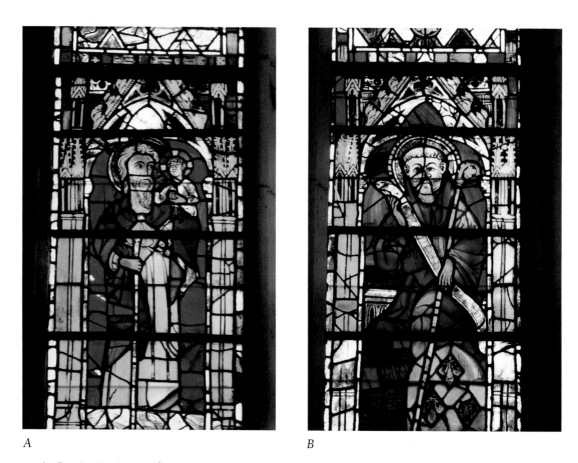

A B

49.A–D *La Trinité, Vendôme. North choir, Bay 205. (A) St Christopher with Christ Child; (B) St Benedict with the Rule; (C) Apostle with sword (St Thomas?); (D) Apostle with sword (St Matthew?).*

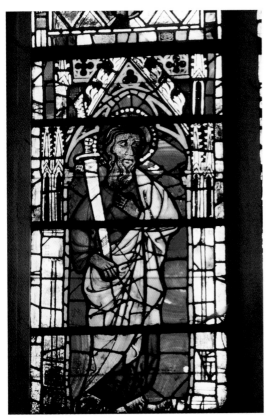

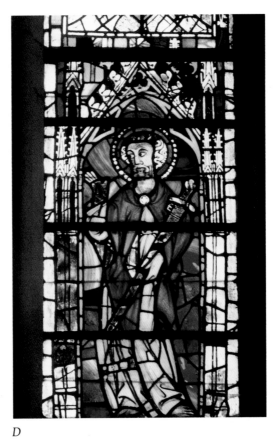

C D

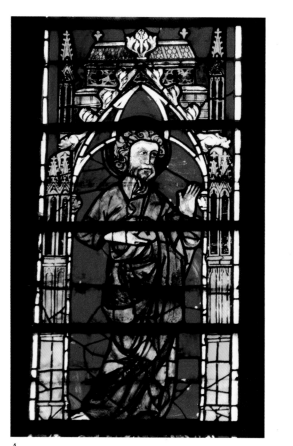
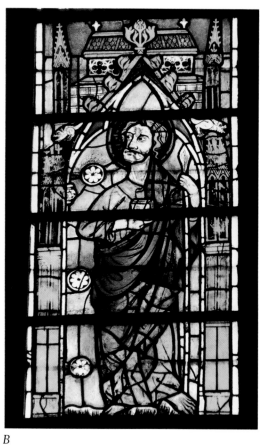

A B

50.A–D *La Trinité, Vendôme. South choir, Bay 206. (A) St Barnabas with flame; (B) Apostle with pike (St Philip?); (C) St Louis with chlamys, scepter, and* main; *(D) St Eutrope being martyred.*

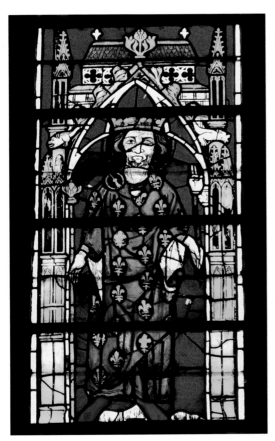

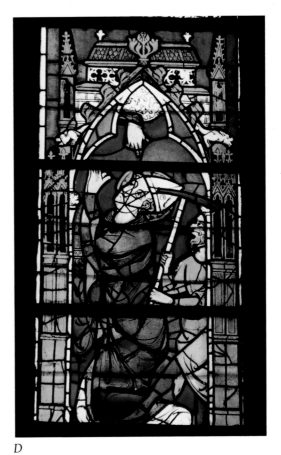

C

D

51 *Former Abbey of Evron. Five apostles, Bay 105.*

52 *Evron. Axial Bay 100.*

53 · *Evron. Legend of the Pilgrim of Evron, Bay 101.*

54 *Philadelphia Museum of Art. St Nicholas (installed in museum).*

55 *Saint-Père de Chartres. Axial and south hemicycle, Bays 1, 3, 5.*

56 *Saint-Père. Archbishop saint, hemicycle, Bay 2 (lower right).*

G H I

A B C

57.A–L *Saint-Père. (A–F) South nave, Bays 19, 21, 23, 25, 27, 29. (G–L) North nave, Bays 18, 20, 22, 24, 26, 28.*

J

K

L

D

E

F

58 *Saint-Père. Baptist bay: Beheading of the Baptist, Salome awaiting the head. North nave, Bay 26.*

59 *Saint-Père. St Catherine lancet: Catherine prays while defeated philosophers are burned. South nave, Bay 27 (left).*

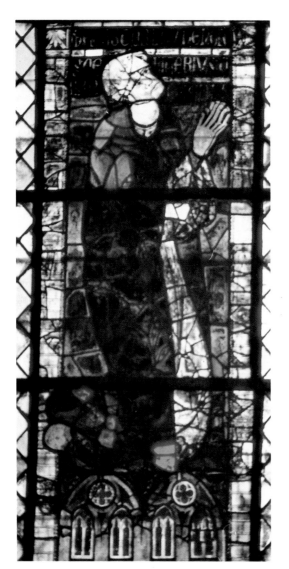

60 *Saint-Père. Laurent Voisin, chancellor of the prince Charles de Valois and donor of Bay 21. South nave. Photo before 1980s restoration.*

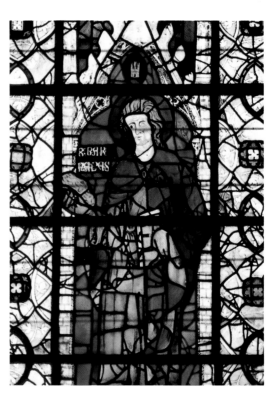

61 *Saint-Père. St Barnabas with a flame. North nave, Bay 28.*

polyglot than it certainly is, without the realization that it factors elements of the vast Saint-Père program. Thus, a date after the Saint-Père nave was well under way is indicated, although not as late as the completion of that ensemble (about 1315), since the color at Evron shows no signs of the lightening evident in the final designs at Saint-Père such as the Passion of Bay 18. The two donors who can be identified at Evron, to be discussed shortly, suggest that the hemicycle campaign began by at least 1313, and since these donor-windows represent both formats, that it was homogeneous.

The two Evron groups are similar in style, but differences in color, in narrative talent, and in compositional preference suggest that two masters produced them. Their painting conventions are very closely related. The Pilgrim Master (Bays 101 and 102; *Pl.53*) likes a bright western palette and has a talent for narrative. He is the better designer, an expressionist who exaggerates, twists, or ignores forms to make a point forcefully. The Master of the Soaring Canopies (Bays 104, 100, and 103) is a mannerist who tries for elegance and monumentality and does not succeed (*Pl.52*). His forms vacillate in focus, and the color tonality is muddy and slightly off pitch. His art is cluttered, illogical, and unbalanced, both in compositional design and in the very drawing, setting out in too many directions and getting nowhere.

Just as both masters borrow their formal apparatus from Saint-Père, they both adapt iconographic themes from Vendôme. Again, the Pilgrim Master shows greater skill in the process: his series of scenes showing the Pilgrim of Evron (pp. 284f. below) and the abbey's (re)foundation is based solidly on the Vendôme window (Bay 202; see Chap. VII, pp. 228f.), which telescopes its new patron into the world of the original foundation and donation of the Sainte Larme (*Pl.48.A–C*). It works at Vendôme and it is just as attractive a fancy at Evron. The Master of the Soaring Canopies borrows from Vendôme less successfully, in the Gnadenstuhl of the axial window (Bay 100). Evron was not dedicated to the Trinity and thus the majestic theme of the axial clerestory of La Trinité de Vendôme (*VII.5*, p. 228) is not particularly appropriate here. Its very composition is unfocused, the tiny Crucifixus of the Gnadenstuhl dwarfed by the giant towering forms of the sorrowing Virgin and St John that the glazier felt compelled, in a Marian church, to add in the flanking lancets.

The Evron hemicycle bays are listed below, with comments on their themes, donors, and present condition. Although the glass on the south has suffered greatly (that side faces the sometimes hostile world), enough remains even in the worst wreckage of Bay 104 to suggest the original design. Panels totally fabricated by Carot ca. 1900 are indicated by diagonal hatching in the diagram with VIII.9. The replacement of elements within the designs, such as heads, are noted in subsequent discussions of the two masters and their art. Evidence will be offered there for the judgments in this descriptive list. Finally, only the scenes of the Pilgrim of Evron (Bays 102 and 101) were seriously garbled when Carot found them in 1900, and his arrangements were based on good sense but inadequate information. A hypothesis, based on the data and theories of this chapter, will be offered for the original sequence and appearance of these bays, the Châtillon gift of 1313. An assessment of the hemicycle campaign concludes the inquest.

Traceries
 Glass removed from all hemicycle bays in the eighteenth century and now replaced by Carot's designs.

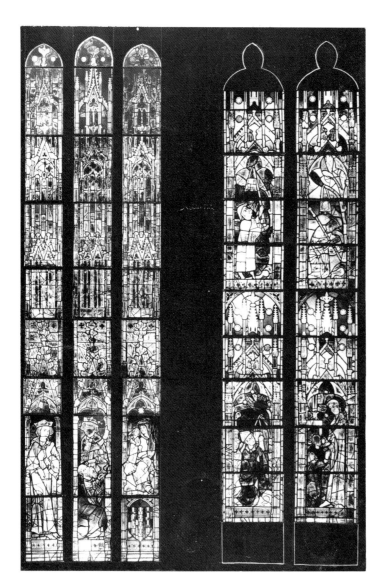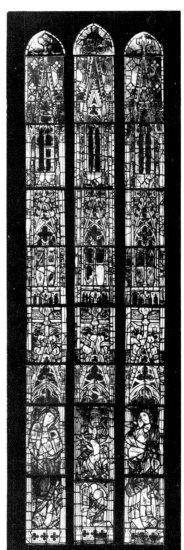

Bay 103 (north)

Format. Soaring canopies.

Subject. Adoration of the Magi (*VIII.10*, p. 280); Châtillon coat of arms (since 1900)

Donor. Lost; probably occupied the panel beneath the Virgin (where Châtillon arms are now located), as in this artist's Bay 100.

Condition. Authentic except for the coat of arms, which is itself old but now set in an entirely modern panel made by Carot, who moved it here from Bay 102.

Bay 101 (north; *Pl.53*)

Format. Double rows of scenes.

Subject. Pilgrim of Evron and foundation of the abbey: (a) Pilgrim rests at the spring, with relic in his pouch hanging on a thorn tree; (b) Upon awakening, Pilgrim cannot reach the pouch, as the tree has miraculously grown (*VIII.13*, p. 286); (c) Bishop Hadouin and monks pray, tree bends; (d) a monk offers relic to the faithful at the altar.

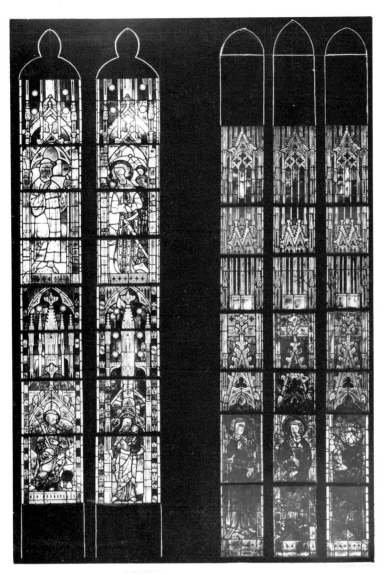

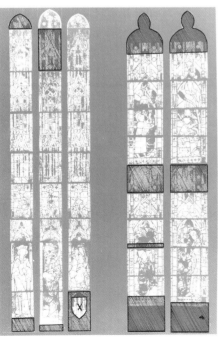

VIII.9 *Evron. The five hemicycle bays:
(left to right) Bays 103, 101, 100, 102,
104. The schematic indicates
restorations in the five hemicycle bays.
Diagonal lines = Carot's additions of
ca. 1900. Panels marked X = old glass
from elsewhere in the church.*

 Donor. Since this window matches Bay 102 it was no doubt part of the same gift, by Guy de Châtillon; the Châtillon coat of arms (now in Bay 103) probably originated in the traceries here.

 Condition. The four scenes are old but probably not in their correct sequence. Since the lancet heads, the bottom panel, and the row of panels between the scenes are all Carot's designs, the window may have been a band window (with two bands, as at Tours).

Bay 100 (axial; *Pl.52*)

 Format. Soaring canopies.

 Subject. Trinity (Gnadenstuhl) with sorrowing Mary and John.[86]

 Donor. Anonymous donor (monk?), kneeling and offering window.[87]

 Condition. Authentic.

Bay 102 (south)

 Format. Double row of scenes.

 Subject. Pilgrim of Evron; Guy de Châtillon kneeling in heraldic surcoat (as "second founder"; *VIII.4*, p. 260). In place of the two missing scenes Carot adapted standing figures of St Paul and the Virgin, which he found among the nonconforming debris filling this bay from 1840 to 1900. Their smaller scales and varying proportions and canopies suggest that they came from two different chapels (see n. 68).

 Donor. Guy de Châtillon, probably in commemoration of his knighting by the king on Pentecost 1313.

 Condition. In addition to the two stopgap panels listed above, no original glass remains in the lancet heads, the bottom panels, or in the row between the scenes (as in Bay 101). Both Bays 101 and 102 were probably band windows with two bands, their grisailles eliminated in the eighteenth-century redecoration or when the hemicycle was stuffed with colored fragments in 1840.

Bay 104 (south; *VIII.12*)

 Format. Soaring canopies (mostly modern).

 Subject. Two tonsured saints who are probably Gervais and Protais; the third figure is a patchwork of Renaissance pieces.

 Donor. Probably the abbot Gervais Langlois (fl. 1313–1318). His figure may have occupied part of the third lancet.

 Condition. Largely modern. The two Gothic saints and the old canopies above one of them are identical with the more perfectly preserved glass of Bays 100 and 103.

The Master of the Soaring Canopies

The Canopies Master, responsible for Bays 104, 100, and 103, will be considered first (*VIII.9 and diagram*). His greatly extended canopies, remarked upon by Lafond, comprise the best-known feature of the Evron glass:

On n'a donc pas attendu le XVe siècle pour "concevoir le dais comme une flèche de cathédrale, avec ses contreforts, ses arcs-boutants, ses fleurons." Et ce n'est pas l'invention du jaune d'argent—absent içi aussi—qui a provoqué l'essor des tabernacles.[88]

Rising above the row of figures to fill seven panels of the lancets, the canopies are composed of architectural motifs, including gargoyles, in areas of blocklike massing typical of the early campaign (Bay 105), as well as the spindly mullions and more aerated superstructure found also in the Pilgrim Master's more restrained designs (*VIII.13*). As usual, the Canopies Master does not quite know how much is enough. Although Lafond's remark does not suggest it, such vast, insubstantial upper structures are not typical of French design, either in the years Evron was glazed or later. They can be most closely compared with the Upper Rhenish group that Becksmann localized at Strasbourg from the mid-thirteenth century to ca. 1340 and traced to the architectural drawings made for the cathedral's facade.[89]

Just how or where the Master of the Soaring Canopies could have seen Upper Rhenish designs is a matter of pure speculation. Although Carot's handiwork has replaced most of the early fourteenth-century heads, the few remaining originals indicate adherence to the drawing conventions of the 1290s campaign (for example, God the Father in Bay 100) as well as strong resemblance to the swollen-jawed facial type employed by the Pilgrim Master (*VIII.4*), as though the figures suffer from toothache or mumps (Bay 104, saint with flail, *VIII.12*).[90]

Color, however, has taken an altogether distinctive direction. In a gay "architectural" environment of strong yellow and white against grounds of paintlike red and somewhat mottled blue, the figures by contrast display themselves in muted off-green and purple-brown in a range of saturations. The effect is mannered. In spite of the vast areas of bright canopywork, these heavily colored windows convey a strangely solemn mood. Although the adverse effect of weathering must not be discounted, the somberness springs chiefly from the peculiar palette and from the backpainting practiced on this ensemble.[91] Backpainting was used neither in the 1290s campaign nor in the late windows of Vendôme (Bays 205 and 206), though it does occur in Vendôme Bays 203 and 204, and it was used very sparingly by the Pilgrim Master. Here again, it is overdone.

Such an excessive detail is the scalloped halo that the Canopies Master prefers, selected from motifs used occasionally at Vendôme and employed only as an accent for the central frontal saint of Evron Bay 105 (cf. Bay 104). Indeed, the figures of the Master of the Soaring Canopies differ in many ways from those of the rest of the church. Crowded and jammed into airless compartments, swathed in fussy draperies making cluttered silhouettes, they often have an adolescent gracelessness. Several common postures and gestures from western expressionism are retained, in particular the cross-legged striding pose (see figures in Bays 103, 104; cf. Bay 105), the nonexistent shoulders and the truncated, boneless arms. The artist is sometimes capable of a noteworthy distortion of gesture, such as the mourning Virgin's clasped hands in the axial Bay 100 (a figure now robbed of all cohesion by the modern face). He seems to be a western artist working at cross-purposes, his native expressionistic exaggerations uncomfortably adapted to a more illusionistic style. Several figures of the Adoration of the Magi (Bay 103) show the struggle, now won, now lost (*VIII.10*). The Virgin is a figure of Mosan robustness, the articulation of her seated figure achieved with a

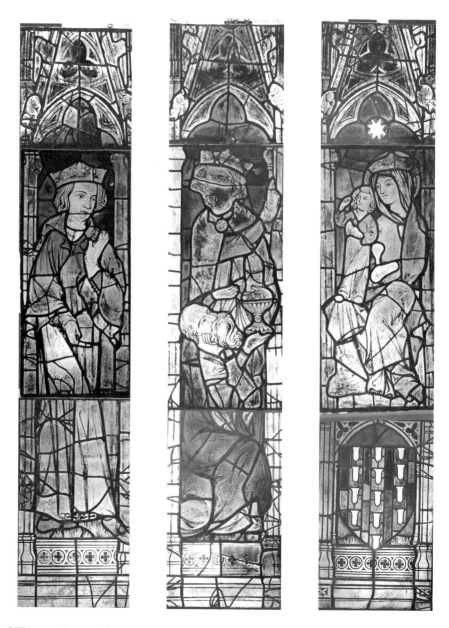

VIII.10 *Evron. Adoration of the Magi, Bay 103. Coat of arms installed here ca. 1900.*

touch of grandeur. The kneeling magus has this kind of "bottom," but his boneless arms are from another tradition (his head, chalice, and two pieces of drapery between them are modern). Expressionism and illusionism together create confusion; the modern heads now disfiguring many of these scenes make matters worse. But such weaknesses are, one must admit, absorbed into the solemn effect produced by the color and the figures' inflated, statuesque scale. Under the bright cagelike canopies the effect cannot be called cohesive but—

transformed, as is so often the case, through the magic of the stained glass medium—it still must be judged impressive.

The themes of the Canopies Master's three bays likewise lack cohesion. The Gnaden-stuhl with its giant mourning figures (Bay 100) has already been mentioned. It is a peculiar choice, uncommon for Gothic France, and was most probably borrowed somewhat mechanically from the majestic composition in the same location at Vendôme. The Adoration of the Magi in Bay 103 is no more obvious a theme. Why the Adoration, of all Marian themes; why at such enormous scale; and why are the magi much larger than the Virgin herself? Several iconographic peculiarities of Evron, however, suggest that the emphasis on the magi is not haphazard or accidental here. The piers of the hemicycle in the chevet are decorated with large sculpted scenes under niches presenting a full Infancy cycle: Annunciation, Visitation, Nativity, Presentation with Anne and Simeon, Flight to Egypt.[92] The Adoration of the Magi is omitted only because it had been accorded a more visible location, on the cul-de-lampe of the northwest crossing pier (*VIII.11.A*). There it faces one of the most charming and well-known reliefs of the church, represented by a cast in the Palais de Chaillot: the cul-de-lampe showing Confession symbolized as a violent toothache (*VIII.11.B*).[93] In the upper group a monk, chin on hand, listens attentively to the confession of a kneeling penitent; below, another monk looks in the mouth of a penitent while two others await their turn, moaning or crying and clutching their heads. The placement of these two reliefs beyond the choir is surely not accidental, since they address directly the many pilgrims who came to the relic of the Virgin's milk. As at the pilgrimage church of Sainte-Radegonde, the sufferer is reminded that confession is the first step toward the cure he seeks (see Chap. IV, p. 107).

But what of the Adoration of the Magi cul-de-lampe? Réau has pointed out that the magi were protectors of voyagers and pilgrims, hence the numerous hostels named at the sign of the Étoile or the Maure (the black magus).[94] The Le Mans window donated by the abbot of Evron about 1254 (Le Mans Bay 105) is further evidence of the magi's importance at Evron, its Infancy cycle including a particularly extended emphasis on magi scenes: the magi on horseback seeing the star, the magi before Herod, and the Adoration spread across two lancets. Such emphasis on the magi is an iconographic archaism.[95] In addition to the crowned Virgin and the old, bareheaded, kneeling magus found at Le Mans, the cul-de-lampe on the Evron crossing pier includes a detail repeated in the glass of Bay 103: the Child stands erect, a toddler in a toddler's gown, on the Virgin's forward knee. This erect toddler may reflect a lost image revered by Evron pilgrims, a more recent work than the venerable Sedes sapientiae (*VIII.2*, p. 253) depicted ca. 1255 in the Le Mans window. A probable copy of the lost statue, from the abbey's village of Néau nearby, is now preserved at Evron.

The large Adoration of the Magi of Bay 103 is thus a pilgrimage image, but whether its donor was a monk or a grateful pilgrim is impossible to know. By comparison with the Canopies Master's Bay 100, where the little donor shares the lancet with the Gnadenstuhl and thus reduces its size, it is likely that the donor of the Adoration occupied the now-lost panel beneath the Virgin and her toddler—and his presence there was thus responsible for their smaller scale.[96]

The subject of the third bay of the Master of the Soaring Canopies (Bay 104) is also, at first glance, difficult to explain. Remaining are two standing tonsured saints, one with sword and the other with flail and small cross (*VIII.12*).[97] The third lancet, patched with Renaissance fragments most notable in the head and hands, probably depicted the kneeling donor (mentioned by Carot in his 1889 report). Since the mottled blue draperies of the patched

VIII.11.A *Evron. Adoration of the Magi, cul-de-lampe, northwest crossing pier.*

VIII.11.B *Evron. Confession as cure for toothache, cul-de-lampe, southwest crossing pier.*

VIII.12 *Evron. Sts Gervais and Protais, with donor(?), Bay 104. Damaged in 1974;*
Renaissance head lost.

figure are coeval with the glass in the pair of tonsured saints, one can guess that the donor
may have worn the blue habit that glaziers often give to Benedictines. Who are the tonsured
saints in Bay 104? In the diocese of Le Mans, of which Evron was a part until 1855, one
thinks automatically of the early patrons of the cathedral—Sts Gervais and Protais (see
Chap. II, p. 21). The identification can be affirmed easily. The large named standing figures
of these saints in the axial window (Bay 100) of the Le Mans upper ambulatory (*Pl.3*), gift
of Rotrou de Montfort, are comparable in many respects: they are tonsured, and one of them
carries a cross staff (see Chap. II, n. 24). Further evidence is provided by the Le Mans
clerestory window (Bay 201) where St Protais is being decapitated by a sword and St Gervais
beaten with a flail (*Pl.5*), precisely the attributes they carry at Evron.

It is St Gervais's flail at Evron that gives pause. It is not the knotted rope depicted in Le
Mans Bay 201 but a most peculiar flail: a gold baton with three small golden balls suspended
from the top, somewhat like the common conception of a fool's scepter.[98] It is possible that
the donor's identity can be confirmed by this detail. The abbot of Evron named in charters
of 1313 to 1318 was Gervais Langlois, whose arms, according to Gérault, were "azur à
3 pommes de pins d'or et une rose en coeur or."[99] Abbot Gervais's mutilated tomb still
remains in the north transept of the church.[100] The inscription included his name, the date
(XIXMC terno = 1319) and a famous humorous, macaronic verse:[101]

QVID DICAM DE L ABE.
PRVDENS FVUT ET SINE LABE

The abbot must have had a sense of humor, and it is tempting to see the flail made from his
family's golden pine cones as one of his little jokes. That the monks of Evron in his genera-
tion were accustomed to using name-saints can be established by contemporary evidence.
The tomb of the late thirteenth-century *chambrier* of the monastery, Gilles de Chastelet,
includes a bas-relief of his funeral presided over by an enthroned St Gilles (see at n. 35
above). Thus St Gervais presides in Bay 104 for Abbot Gervais Langlois.

The Master of the Pilgrim of Evron

I have already given higher marks to the Canopies Master's coworker, the Master of the Pilgrim of Evron (Bays 102 and 101), for greater strength and focus as a designer (see p. 275). He is a western artist at home in his traditions, comfortable with bright strong color, a good storyteller, an unabashed expressionist. His apprentice piece is at Vendôme: the axing of St Eutrope in Bay 206, the only narrative in the late campaign there, and a design which, though hesitant in many respects, reveals his careful study of the commission and of the hemicycle bay (Bay 202) already presenting the story of the related relics of the abbey (see Chap. VII, p. 240, and *Pl.48.A–C*). He is a thoughtful artist, capable of considerably more depth than his coworker in the hemicycle of Evron.

I have suggested that his double-tier format is derived from Saint-Père and his color is similarly related (*Pl.53*). He uses the primaries that his atelier relied on in the Evron campaign of the 1290s (*Pl.51*), in which he was probably involved, and that were also preferred by the related shop of the Saint-Père hemicycle, though with perhaps a modicum more white throughout. The closest color gamut to his can be found in the Saint-Père nave, however, where these primaries are worn with a difference: the blue is clear, the red dense and darkened, the yellow a tawny mustard hue, the white pasty, the green somber. Similarly his vocabulary of canopywork motifs is that of Evron Bay 105, but extended, elaborated, and aerated as in the Saint-Père nave. The blocklike massing of the earlier campaign has been invaded by spindly forms silhouetted against the ground color, and the older motifs (such as gargoyles, the maple-leaf frieze, the strip of quatrefoils, etc.) are now reduced and shrunken, weary. That he knew Saint-Père seems undeniable, and his possible role in that ensemble will be investigated in Chapter IX.

It is more likely that he was there employed in the narrative bays, since he is interested in storytelling and good at it. The Pilgrim bays at Evron present, in large format—somewhat in the manner of the large simplified narratives of the Le Mans hemicycle clerestory so many decades earlier, and those more recently of the Sées chapels—the famous story of the relic of the Virgin's milk and the legendary events of the abbey's miraculous founding.

The Gothic era knew this legend well, and we have already encountered it in the Le Mans upper ambulatory, where it appears in Bay 105, gift of Abbot Ernaud of Evron. That window establishes for us the order of scenes, a point to which we will return shortly. As related in the ninth-century *Actus pontificum cenomannis in urbe degentium*, the story recurs here as told in Chapter II (p. 31).[102] Around A.D. 630, during the episcopate of St Hadouin of Le Mans, a Pilgrim returned from the Holy Land with a precious relic, an ampulla of the Virgin's milk. He stopped at Evron by a spring to rest, hanging his pouch containing the relic on a nearby hawthorn tree. He awoke to find the tree mysteriously grown, carrying his precious pouch high out of reach. As the tree proved impossible to fell by an axe, the bishop St Hadouin was called, and at his prayer the hawthorn tree inclined. The pilgrim retrieved his relic and presented it to the bishop, who built a monastery on the spot dedicated to Notre Dame de l'Epine. The scenes of the Pilgrim thus comprise a kind of founder's window (or windows).

Vendôme, it should be recalled, has the same kind of founder's window in a similar location in the hemicycle clerestory: the window of Geoffroy Martel (played by the prince Pierre d'Alençon in his heraldic surcoat; *Pl.48.A–C*) donating the Sainte Larme to the abbey he had founded at Vendôme to house it (Bay 202). There can be no doubt that the Vendôme

image provided the idea for the Evron cycle. The kneeling donor in heraldic surcoat and the monk presenting the relic to the faithful (*Pl.53*) are particularly close replicas.[103] The Pilgrim Master translates the theme—the conflating of the legendary founder and his pious donation with the Gothic patron who is presently footing the bills—into the late western idiom, employing expressionistic selection and exaggeration to most telling effect. The Vendôme window is a tightly drawn, elegant tableau, and the Pilgrim Master has studied it carefully. His rosettes strewn through the ground derive from it, and the subtly rendered profile, as well as a certain flabbiness about the jaw (the swollen face), not formerly a part of his atelier's repertoire. On a much more fundamental level he has taken lessons in how to set off a narrative, to select and spotlight its star actors and pivotal events. He has in fact improved upon the model, for while the Vendôme scene is a quiet ceremonial tableau, the Evron version is a series of ideograms. Bodies shrink or expand according to the story's need; elastic arms encircle important props; sleep, supplication, the devotional kiss of the faithful are immediately conveyed.

The selection of scenes in Evron Bays 102 and 101, as well as the postures and the costume of the Pilgrim (*VIII.13*), are close to the Le Mans upper ambulatory window (*II.7*, p. 28), which of course was not really readily available itself as a model, as it had been installed since 1254–55 in an obscure location in that vast cathedral upper structure. I suggested in Chapter II that the Le Mans window was based on a *libellus* at the pilgrimage church; at any rate its medallions of the narrative of the miracle of the Pilgrim and his precious relic are more busy with figures and incidents than are its other cycles. The medallions do not include a kneeling knight, nor a monk presenting the relic to the faithful at the altar, the two Evron scenes that are so very close to their counterparts in Vendôme Bay 202. The sources from which the Pilgrim Master worked are thus rather clearly the Vendôme composition and some illustrated narrative (perhaps but not necessarily a manuscript) available at Evron.

Of the eight positions provided by Bays 102 and 101, two designs are now lost. Remaining are two iconic figures—the Pilgrim of Evron, and the "second founder" Guy de Châtillon kneeling in his heraldic surcoat (*VIII.4*, p. 260)—and four scenes from the legend. The scenes are as follows: the Pilgrim asleep at the spring, his relic hung on the hawthorn tree; the Pilgrim upon awaking trying in vain to reach the pouch in the tree above (*VIII.13*); Bishop Hadouin praying and the tree bending; a monk of Evron offering the famous relic to the faithful at the altar. These elements are now in an arrangement of Carot's choosing that, although reasonable, is probably not the original sequence. We will return to that question shortly. A comparison of the three narrative scenes to their close counterparts in the Le Mans medallions pinpoints the Pilgrim Master's talents as an expressionist. He eliminates witnesses and repetitious detail as is appropriate to his larger format, but he certainly does not abandon detail altogether; rather, he selects and spotlights significant details and postures that immediately convey the events. His focus is dramatic and uncluttered.

I have characterized the Pilgrim Master as an expressionist, which implies an approach willing to bend the "truth" to score a point. One small example: the knight Guy de Châtillon, kneeling in Bay 102, has a halo (*VIII.4*, p. 260). I have suggested that the adolescent Guy, count of Blois since his father's death while he was still a minor, and married to a niece of the king, is shown here as he appeared at the knighting of Pentecost 1313, a grand event orchestrated by Philippe le Bel upon the knighting of his own sons (on Guy, see at n. 46 above). The young Châtillon was a member of France's very highest aristocracy, a gilded

VIII.13 *Evron. The Pilgrim of Evron trying to*
reach his relic pouch hung on the hawthorn tree,
Bay 101.

youth of the bluest blood. While the Châtillons had produced a near-saint some centuries earlier, and were to produce another among one of Guy's own sons,[104] nothing in the chronicles of the early fourteenth century remotely suggests that Guy himself was particularly saintly, particularly pious, or even particularly intelligent or able. He was simply rich. He owes his halo to the glazier's enthusiasm.

In attempting a reconstruction of the original appearance of Bays 102 and 101, two types of information will be useful: the nineteenth-century photograph (*VIII.5*, pp. 262–63) and accounts of the goals of the eighteenth-century and 1840 restorations; and the subjects and sequence of scenes in other medieval examples showing the legend of the Pilgrim of Evron, that is, the Le Mans window ca. 1254 and a sculpted relief in the Evron north ambulatory. The photograph establishes that the 1840 restoration, which aimed at rounding up *colored* debris (*VIII.5*) from throughout the church and placing it in the hemicycle, had produced a much worse patchwork in Bays 102 and 101 than in the bays of the soaring canopies. This is also suggested by the present remains of old glass, which in Bays 103 and 100 (soaring canopies) approximates the entire windows (*VIII.9*). Carot noted further that the traceries had been filled with eighteenth-century blankglazing (which had not been disturbed in 1840). No old glass remains for the lancet heads of Bays 102 and 101 or for their lowermost panels, or for the row of panels between the two tiers of scenes (all of which Carot filled in with extensions of the colored canopywork). It is therefore reasonable to suppose that these two bays, unlike the totally colored Bays 104, 100, and 103, were originally band windows with two bands sandwiched between grisailles, above, below, and between them (*VIII.14*). Whether or not the eighteenth century removed these grisailles for increased light—and it seems likely—the restoration of 1840 replaced those areas with *colored* debris from elsewhere in the church, suggesting that the spotty effect produced by color, by old grisailles (or eighteenth-century blankglazing), and by gaps and replacements where the two lost scenes would have been located, was by 1840 quite chaotic and intolerable. This assessment is also suggested by the remarks of several observers of the 1830s (see at n. 63 above). Better a colored crazy quilt than one made of those varied elements.

In attempting a reconstruction the possibility must first be entertained, at least briefly, that the roundup of 1840 drew some of the Pilgrim scenes from elsewhere in the church. This possibility can be quickly discounted, since the six remaining panels are 63.5 to 66 centimeters wide, too large for any other location in the chevet. Moreover the relationship with the Vendôme founder's window, in the hemicycle flanking the axial bay, gives confidence that the present location is indeed the original one for the sequence of founder's scene at Evron.

To return to the nineteenth-century photograph (*VIII.5*), the following scenes can be identified in the two bays (though sometimes upside-down, unaligned, or interrupted in sequence by debris):

Bay 101 (north)

LEFT:

—Pilgrim reaching for pouch in tree (3 panels, bottom one upside down; *VIII.13*)
—Icon figure of Pilgrim of Evron (top and bottom panels only, the middle panel lost now and presumably also then)
—Châtillon arms (stopgap near bottom)

VIII.14 *Evron. Reconstruction of original arrangement of Bays 102 and 101 as band windows.*

Saint Hadouin

Virgin

RIGHT:

> —Sleeping Pilgrim near the spring (3 panels)
> —Sixteenth-century figure of St Hadouin with inscription denoting him as "founder of the monastery." This figure was put by Carot in the nave, but it exactly fits the wide dimensions of Bays 112–114. I believe that it is a Renaissance replacement for a lost Gothic original.

Bay 102 (south)

LEFT:

> —Bishop Hadouin and monks praying and tree bending (3 panels)

RIGHT:

> —Kneeling knight Guy de Châtillon (3 panels; *VIII.4*, p. 260)
> —Monk presenting relic to faithful (only the head panel can be identified in photograph)

On assumption—which of course is only reliable in the most general outlines—that panels are more likely to be in their original lancet than elsewhere, the following program can be reconstructed from the above (*VIII.14*):

Bay 101 (north)			Bay 102 (south)	
		TOP		
Pilgrim reaching for pouch	Pilgrim sleeping		Bishop Hadouin praying	Monk presenting relic to faithful
		BOTTOM		
Pilgrim icon	Hadouin icon (16th c.)		?	kneeling knight

In sum, the top row contained narrative scenes, and the bottom row contained icon figures of the founders (the Pilgrim, St Hadouin, the knight who founded the monastery).

The order of scenes established on the above evidence is, furthermore, what can be called Gothic order. That is, the sequence begins at the right (dexter, north) side of the axial Christ and moves out to the north; it then returns to the left hand of the axial Christ (sinister, or south, side) and moves out to the south. This is, for example, the order of the narrative band that bisects the Chartres west portal ensemble, the so-called capital frieze of Chartres. Such symbolic and hierarchical order is also a consistent part of Gothic sculpted tympana, where the position of greatest honor is always to the left (dexter) of Christ. This sequence places the iconic figures of the Pilgrim and of St Hadouin, the legendary and spiritual founders, on the dexter (north), and the kneeling knight, the secular founder, on the sinister (south). Is it possible to establish the missing figure who was next to him? The only clue is that Guy is not only kneeling, but praying.

What can we learn from the elements of the legend depicted in the Le Mans medallion window of 1254? In addition to the narrative scenes, there is the kneeling abbot offering his window, and not really a part of the sequence (*II.7*, p. 28), as well as an icon figure of St Hadouin above him, and at the top of the narrative scenes, the Virgin and Child. Although the Le Mans window does *not* include a kneeling knight as "second founder," such a figure *is* included in another example of the legend, a pair of reliefs in the north choir ambulatory of Evron (*VIII.15*),[105] occupying cramped quarters in gables. The right relief contains a com-

VIII.15 *Evron. Legend of the Pilgrim of Evron, reliefs in north choir ambulatory.*

pacted tableau of ideograms: the Pilgrim near the spring trying in vain to reach his pouch in the hawthorn tree (right); the praying St Hadouin and monks (left); and between them in the middle, the standing Virgin, since it was, after all, her miracle. All of that occupies only one of the two sculpted gables. The left gable has one figure only: a knight in chain mail on warhorse, his hands clasped in prayer. Unfortunately neither his surcoat nor his horse's trappings bear heraldic emblemata, but it is clear, at least, that the secular foundation is given equal weight with the miracle, and as second founder[106] he is a very significant part of that legend.

Of the actors in the drama, included in the Le Mans window and/or the Evron ambulatory relief, only the Virgin is missing from the Evron windows 102 and 101 as reconstructed above. Considering that Evron is a Marian pilgrimage church, her omission is striking. In the hemicycle she appears in Bay 103 (north) in one of her joys, the Adoration of the Magi; and in Bay 100 (axial) she appears in one of her sorrows, at the Crucifixion. It would be most appropriate were she to appear in Bay 102 (south) in her role as miracle worker and mediatrix between Christ and man. Indeed she may survive in a Canadian collection.[107]

My reconstruction of the Pilgrim of Evron Bays (102 and 101) follows (*VIII.14*). As the gift of Guy de Châtillon, they included his image in Bay 102, and most probably the Châtillon coat of arms was set into the traceries of Bay 101.[108] They were probably band windows,

the upper band being filled with scenes of the Pilgrim legend in "Gothic order"; the lower band was filled with single figures important in the founding of the abbey, including the Virgin. It should not be so surprising that the Pilgrim Master would use band windows. The church already had some magnificent grisailles in Bay 107. The Vendôme founder's window is a band window. The Saint-Père straight choir (Bays 8–17) has double-tier lancets alternating with grisaille strips; in the nave a set of windows in a double-tier format includes grisaille strips flanking the colored ones (Bays 24–25, 28–29), this group itself alternating with a set of totally colored windows (18–19, 22–23, 26–27), just as Bays 102 and 101 in the Evron hemicycle interweave with the totally colored bays of the soaring canopies (104, 100, and 103). A pair of double-tiered band windows as reconstructed for the hemicycle of Evron would be the most likely invention of the Pilgrim Master, an artist who thought so seriously and who adapted so reflectively and imaginatively from all the past aesthetic experiences of his life.

The campaign of the Evron hemicycle is the work of two artists of the same background, training, and work experience, one more superficial and cluttered in approach, the other a talented and sensitive master. There is little doubt that their hemicycle project was conceived and executed as a unit, and the date was most likely about 1313, if the kneeling image of the young blond Guy de Châtillon did indeed commemorate his knighting by the king. The window of Sts Gervais and Protais, gift of Abbot Gervais l'Anglois (Bay 104), supports this dating, since the abbot appears first in documents of 1313 and died most probably in 1319. The masters worked for different types of patrons: the Pilgrim Master's bays were the Châtillon gift, while those of the Master of the Soaring Canopies were probably donations, at least in two cases of the three by members of the monastic community. Of the two artists, the Pilgrim Master had worked in the last bay at Vendôme and most probably on the 1290s campaign at Evron; but what became of the naive apprentice of that campaign (the Bay 107 traceries) is unknown, as is the previous career of the rather pompous and flaccid Master of the Soaring Canopies. The Pilgrim Master, at any rate, had a longer record at Evron. He came there from Vendôme, he produced the handsome Châtillon gift of about 1313, and as we shall see, he contributed a series of glassy saints employing the newly introduced technique of *jaune d'argent*. The old dog had learned a new trick and showed it off for his friends. Was he a monk? Since he worked at Benedictine abbeys for over thirty years it is tempting to think so, but there the hypothesis must stop.

The Campaign of about 1320: *Membra disjecta*

Of the late campaign of glazing at Evron, marked by the introduction of the new technique of silver stain, no glass at all remains in the church. While all but one of the museum panels traceable to Evron by the Carot cartoons of 1901–02 contain silver stain, they are in most cases in very questionable condition following his ministrations.[109] The happy exception is the trio of bishop saints in the Glencairn Museum—happy not only because they are handsome and little damaged but because the entire series has survived in some form, and the program can therefore be reconstructed and even located in the church. Furthermore, the authenticity of the group is unchallenged, since one of its parts, the panel of the head of St Michael, appears in a nineteenth-century photograph among the stopgaps in the choir (*VIII.6*, p. 265).[110] In addition to the archangel, the group comprises St Nicholas (Philadel-

phia; *Pl.54*) and three bishop saints whose identities will be discussed shortly: a bishop resuscitating a dead child; a bishop striking a spring with his crozier; and a bishop without identifying attribute or action (*VIII.7*, p. 267).

The present condition of these figures, as might be expected, varies considerably. The angel has been totally reworked (false patina on exterior, new painting inside); thus only general observations about it have validity. The Philadelphia fragment is in a permanent museum installation where its exterior can only be examined with difficulty. The inside of the glass surface is disintegrating and has been repainted over the weathering as well as spatter-painted in spots to even out the appearance of the patina. As even the finest quality glass now in the church shows some signs of patina on the inner surface, this deterioration is probably very old. The three Glencairn bishops are, by contrast, in very fine shape, the only major restoration being the obvious and rather ugly new head provided for the bishop striking the spring.

Except for the silver stain on this group of five, their style is a perfect amalgam of the earlier campaigns in the church. The color harmony is little altered, employing the same saturated gold and opaque white canopywork and deep red and blue grounds (*Pl.54*). The bishop striking the spring is in primary colors; the bishop resuscitating the child wears a clear purple that was also used in Bay 103; the deep green of the angel's panel is like that of Bay 101. Although the little gargoyles are finally banished from the canopywork, it is otherwise close to the blocklike massing of Bay 105 (*Pl.51*) of the early campaign, suggesting that this later group occupied a similar location and was intended to match that work of the 1290s. The shoulderless bodies and irrational angularity of draperies are like those of the Canopies Master, while the clarity and legibility of forms and silhouettes obviously recall those of the Pilgrim Master. The painting style also relates to all previous groups: the angel's wings, pointing hand, and facial features, as well as the crosshatched haloes, all find their closest comparisons in Bay 105; the double lines and tousled snail-shell curls of the angel's hair occur in the worshipers of Bay 101 (as well as earlier at Vendôme); the swollen jaw is also typical of Bays 101 and 102.

The closest affinity of this group of five is unquestionably to the Pilgrim Master, not only in his preference for unequivocal silhouetting of reduced narrative groups but in the detail of miters, vestments, and croziers, facial features, and the like (*VIII.14*).[111] If the bishops recall figures in Bay 105, it is probably because they were intended to make a match, and if they adopt purple and shoulderless angularity from the Canopies Master, it is because the Pilgrim Master never looked at anything without responding to it. From Vendôme's St Eutrope to the silver-stained bishops, his language has remained his own while developing in intensity and control. His youthful work at Vendôme is hesitant but carefully studied and fresh; in the early campaigns of Evron his style gains smoothness and consistency; and in the mature series of the bishops, it is lean and taut, the silhouettes full of tension and angularity, the gestures riveting, the focus sure. The silver stain tentatively applied to hair, wings, and miters is a new tool in the gnarled hands of an old master.

Who are the bishops, where do they come from, and what is their program? The panels vary somewhat in width, since some have been sliced to fit later locations: St Michael, 44.5 centimeters; the three Glencairn bishops, 48.8, 47.8, and 43.5 centimeters wide. It seems most reasonable to take the dimension of the Philadelphia St Nicholas as closest to the original, since the width has been augmented by added borders rather than diminished; it

VIII.16 *Glencairn Museum, Bryn Athyn, Pa. Detail
of St Julien resuscitating the son of Anastasius. From
the Pitcairn Collection.*

measures 48.8 centimeters. This is exactly the dimension of the lancets of Bay 105 (*Pl.51
and VIII.3.B,* p. 257; the five apostles of the 1290s) and of the facing bay across the choir
(Bay 106). Since the groups look alike, this location seems the most logical.[112]

Thus the program probably dovetailed with the themes already in the choir, as the
format was adapted to that of Bay 105 opposite. An archangel and bishops, however, make
odd bedfellows. While the identification of the angel as Michael is not certain, since the
lower panel with the dragon is suspect (*VIII.6,* p. 265), neither is it unlikely, as we shall see.
The identification of the Philadelphia bishop as St Nicholas, although not absolutely secure,
is likely. The fragment shows him with two orphan boys, not three, a variant found in a late
thirteenth-century sermon once attributed to Bonaventura.[113] The bishop striking the spring
suggests Julien, since that was his most famous miracle, but Julien also resuscitated the son
of Anastasius (*VIII.16*) as well as two other people. Julien was not only the "apostle of the
Maine" but by the thirteenth century the patron of Le Mans cathedral, whose previous pa-
trons Gervais and Protais are already present in Evron Bay 104—and Evron owned a relic
of him.[114] If the resuscitator is Julien, then the bishop striking the spring is almost certainly
the striker of Evron's own spring, the bishop saint Thuribe (see at n. 13). Thuribe, bishop

of Le Mans, had struck his miraculous spring and founded a chapel of the Virgin beside it in the fifth century, long before Hadouin, long before the Pilgrim. It was considered to be his spring (and chapel) that the Pilgrim chose for a resting place, and that still flows beneath the high altar.[115] Thuribe is thus a founder of Evron, in the company of Hadouin, the Pilgrim, and the kneeling knight of Bays 102 and 101, just as Julien is a patron of the diocese in concert with Gervais and Protais.

If the group thus includes Bishop Julien of Le Mans, patron of the medieval diocese, and Thuribe, founder of Evron, what might Michael and Nicholas represent, and who is the bishop without attribute? The emphasis on local saints suggests a program commemorating the abbey's dependencies. The monk's infirmary chapel was dedicated to St Michael. The chapel of their leprosarium was under the patronage of St Nicholas (on these structures, see n. 19 above). The abbey's parish church, a few yards from the chevet, was dedicated to St Martin, one of the most famous bishop-saints of France, thus making him by far the most likely candidate for identification with the anonymous bishop of Glencairn. This idea of local commemoration is another borrowing from Vendôme, where the apostles were invaded in the last campaign by Benedict and Christopher (Bay 205) and Louis and Eutrope (Bay 206; *Pls.49.A–D, 50.A–D*). While Benedict is the community's special saint and Louis that of the royal patron, Christopher and Eutrope earned their places by virtue of their patronage of two of the ancient chapels on the abbey precinct (see Chap. VII, p. 237). Under such ground rules an angel and bishops are no more peculiar companions than Christopher and Benedict and Eutrope and St Louis.

Terra Incognita

The identification of silver stain in the final glazing campaign of Evron, adopted by the artist who had worked there for thirty years, adds another small piece to the puzzle of when and how this new technique was introduced to Europe. Lafond[116] has pointed out that the recipe was probably translated and available to the west in the lapidary of Alfonso el Sabio, ca. 1279. If so, it certainly did not take long for it to make the voyage from the royal court of northern Spain to the most rural outreaches of western France: 1313, Le Mesnil-Villeman (Manche); 1316–1328, Saint-Alban (Côtes-du-Nord) (*Pls.37 and 38*). Although the Evron bishops are not dated by donors or charters, they are stylistically close enough to the hemicycle campaign of 1313, and far enough from the pale elegance and delicacy of the Canon Thierry strip at Chartres, 1328, to suggest that a date before the 1320s is likely. The new stain is touched ever so hesitantly to wings, miters, and curls (*Pl.54*). One would say that the new technique is not understood or put to advantage; it has as yet, at any rate, in no way altered the Pilgrim Master's color harmony or his brushwork.

Evron, then, is an ensemble at the gates of a new world but not yet entered in. The silver stain is of the new. The soaring architectural fancies were also, eventually, to have a fashionable future. The design was practical: it economically filled great areas that otherwise would have contained grisaille, and it brought the figures closer to the eye while avoiding the aesthetic problem of combining colored figural glass with an immense expanse of clear glazing, which became increasingly light and translucent as glassmaking was able to produce ever thinner and thinner glass. Lewis Day has remarked about such soaring canopies:

The notion of a stone-like niche in glass, to frame a picture already framed by
real architecture, does not as such commend itself to the logical mind. . . .
Still, . . . it must be allowed that the Perpendicular canopy proved a singularly
effective means of enshrining . . . colour enough to give a window richness
without great loss of light. . . . [A] better scheme for the distribution of white
and colour in a window remains yet to be devised.[117]

The idea of vertically extended canopies, born in the Upper Rhineland, as Becksmann has
established, may have been adopted into *Francia* at Evron. With the advent of silver stain it
was quickly to find its perfect executant. The merger was not effected at Evron, however.
The device of soaring canopywork owes its ultimate triumph, but not its circumstance, to
jaune d'argent.

 The Evron ensemble includes both soaring canopies and silver stain but not in the same
designs and not even in the same campaigns. Its Janus-like position in glass is unique. The
vigor of its art indicates that the new ways did not arise to replace exhausted traditions.
Evron has been grouped, in the literature, with fourteenth-century Normandy. Yet the fash-
ions associated with Normandy—*jaune d'argent,* canopies—at Evron are unrelated to the
elegant delicacy and finesse of such fourteenth-century ensembles as Saint-Ouen de Rouen
and Evreux. Rather they exude at Evron the robust force of the mature western school,
Vendôme and Saint-Père de Chartres.

 A thorough investigation of early silver stain will never be possible, since so much
glazing has been lost from these decades, as from all others. The east window of Saint-Alban
(*Pl.37*), a late genuflection in the direction of the famous east window of Dol, is a previously
recognized station along the transitional path. Silver stain is everywhere present in this
exuberant composition marked by figures swelling over their frames in gaily colored disor-
der. The final campaign at Evron is an earlier, more tentative example, a first step in com-
bining stain with a vigorous expression. The combination did not work. The technique of
silver stain led glaziers into a pale-hued, sophisticated terra incognita, which they very
quickly made their own.

✳ Epilogue ✳

Evron is a riddle wrapped in a mystery inside an enigma. Nowhere among the western
monuments do we encounter, or are we forced to confront, the disparity in medieval and
modern thinking as at the pilgrimage church of Evron. The mythological fog engulfing the
past is so dense that it has become reality. Musing on medieval pilgrims, relics, and miracles,
Sir Kenneth Clark observed, "They cared passionately about the truth, but their sense of
evidence was different from ours." Evron offers a *millefeuille* of "medieval" evidence (some
of which has been sifted by modern textual critics seeking out forgeries), and the remains
of the works of art themselves. Both have something to tell us about the Gothic past.

 What do they tell about Evron? A more rural and probably poorer abbey than Vendôme
or Saint-Père, it relied more heavily upon its pilgrimage status for identity. The emphasis in

sculpture and glass on the magi (those first pilgrims to Mary) and on the Pilgrim of Evron (who translated her milk to the rural Mayenne) makes this clear. Though both a Marian cult and a pilgrim returning from the Holy Land strike the modern scholar as distinctly Gothic phenomena, both figured in the belief and textual forgeries composed in the Maine by the ninth century. The legendary ties of Vendôme and Saint-Père to Evron are no less obscure. Just before the millennium, following Norman raids, Evron was reestablished; the financial sponsor was a local nobleman, but the monks who repopulated the abbey came from Saint-Père. Less than a century later was perpetrated the earliest of the forgeries inserting into that archival past the family name of de l'Isle, minor lords who lived at Vendôme. The modern mind struggles to explain why a hereditary viscount of Blois, from Vendôme, would support Evron in the Mayenne; perhaps he was a pilgrim. The interest of the de l'Isles, once attracted, was sustained or perhaps revived by successive Gothic forged charters; it continued until the line ran out at the death in 1277 of Renaud de l'Isle, a knight who had in later years joined the monks' community.

This entire burdensome preamble is needed to comprehend the stained glass of the Gothic chevet of Evron: its patronage, its programs, its style. Its identifiable patrons, beyond several anonymous Benedictines, are the Châtillons, among the most glittering families near the crown, whose vast lands did *not* include Evron. When a Châtillon from the north came into the unexpected inheritance of the rich county of Blois in 1292, the monks seem to have succeeded in attracting his purse by forging yet another legend—perhaps based on the recent patronage of the de l'Isles, viscounts of Blois, and on the similarity of the new count's Châtillon heraldry to a curious sculpted motif decorating one of the abbey's Romanesque doorways. The glazing program of the new Gothic chevet, as it can be reconstituted following losses and transformations in modern times, is a rambling pastiche of "campaigns" drawing themes and types from both Vendôme and Saint-Père over possibly thirty years—from about 1292 until the beginning of silver stain near 1320—and always under the guidance of the same artistic hand. Such a record of survival and interdependence argues that the craftsmen were few, and that they were monks. But where did the Pilgrim Master at the end of his long career pick up the new technique of silver stain? That is the final enigma.

The Western Realm: Saint-Père de Chartres, Revisited

The church itself is one of the most remarkable in existence, and would doubtless be better known had Chartres no Cathedral. . . . In any other town its glass alone would bring pilgrims from afar. For not only are the thirty-six great lancet windows of rare beauty, . . . but the impression which they give you on first entering the church is almost unique. The apse is ablaze with colour, the triforium of the choir glazed, chiefly in grisaille, and the delicate triforium of the nave is topped by huge lights of colour and grisaille, which are interrupted by hardly any framework of stone. It seems as if the whole of the upper part of the building were one continuous sheet of glass gloriously coloured. The effect, indeed, is scarce an illusion.

—CECIL HEADLAM, *THE STORY OF CHARTRES*, 1902

ASIDE FROM THE fact that Headlam could not count—there are twenty-nine clerestories in Saint-Père including the one blinded when the *tourelle d'escalier* was built in the fourteenth century (*IX.1*)—he was a keen observer. The glass of Saint-Père is splendid indeed. It is also unquestionably the touchstone of the western style: its early reused glass, made about 1240, was discussed in the first chapter; its campaign of ca. 1270 was mentioned in Chapter III; the earliest hemicycle traceries were noted briefly in Chapter VII; and its late ensembles in the hemicycle and nave have been invoked repeatedly in the studies of Vendôme and especially of Evron. The hemicycle ensemble of Saint-Père is the apogee of western glazing, and the extensive nave campaign the most lavish and sophisticated program of all western monuments.

The documentation, style, and iconography of Saint-Père were treated at length in my monographic study published in 1978, and those arguments will not be belabored here. Rather, the late ensembles of the hemicycle and nave will be approached in this chapter as were the earlier campaigns in Chapters I and III, as they relate to other monuments and to developments of western glazing at large. When this approach occasionally vindicates minor hypotheses espoused in the monograph,[1] attention will be paid, and recent ancillary research by others will be noted.[2]

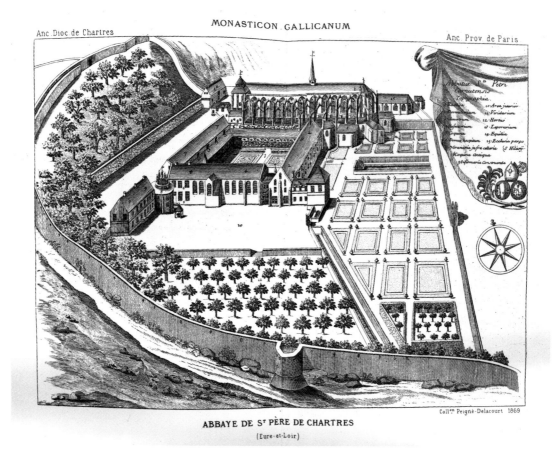

IX.1 *The Abbey of Saint-Père de Chartres. After* Monasticon gallicanum; *Peigné-Delacourt, 1869.*

The Hemicycle: *Cappo lavoro*

In the six bays of the Saint-Père hemicycle,[3] ablaze with color, a college of energetic saints confronts the spectator (*Pl.55*). The figures, in two canopied rows, are massive in both scale and proportion and pulsate with nervous vigor. There is no indication of a donor, and there are no documents. The program is straightforward: Virgin and Child and Crucifixion in the axial bay (as at Le Mans and many other places), apostles and confessor saints (popes, bishops, abbots) around them, martyrdoms in the traceries above (*IX.2; IX.5*, p. 307). Images of St Louis and St Gilduin—Breton saint from Dol who was buried at Saint-Père and whose posthumous miracles provided the financial means for the abbey's building projects— were added to the axial bay in a different style but with no great variance in date. Thus a dating of about 1290 for the hemicycle is likely, the added figures being inserted after the canonization of the Capetian king in August 1297. The similarity of Louis and Gilduin to the saints of the nave suggests that they were added near 1305, when that campaign was getting under way.

The color of the Saint-Père hemicycle is an overwhelming fireworks of primaries with white, emerald green, and some brown. Many cartoons are reused, with mutations. Yet the work is painstaking, and the detail on vestments, borders, haloes, attributes, and physiognomy is infinitely varied. The canopywork is elaborate and highly decorated, inhabited by gargoyles and angels, yet it never dominates, as will the rather pedestrian work of the Evron Master later. Painstaking effort has gone into this display and the dazzlement is carefully calculated. The ground colors of the canopies and the figures, for example, take contrapuntal rhythms. The upper canopies have alternating ground color: left lancets of all bays are blue;

IX.2 *Saint-Père. St Barnabas with a flame, hemicycle, Bay 5 (lower left).*

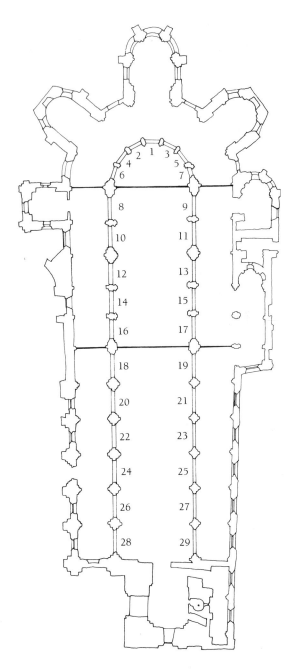

Plan of Saint-Père de Chartres.

right lancets of all bays are red. The lower canopies' ground color is uniform; all lancets are red. The ground colors of the figures can be charted (R = red; B = blue):

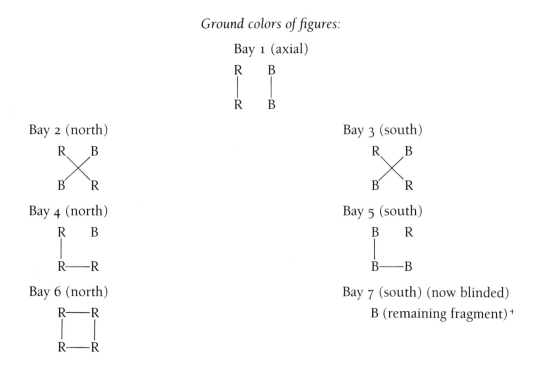

Ground colors of figures:

Bay 1 (axial)

R B

R B

Bay 2 (north)

R B

B R

Bay 3 (south)

R B

B R

Bay 4 (north)

R B

R——R

Bay 5 (south)

B R

B——B

Bay 6 (north)

R——R

R——R

Bay 7 (south) (now blinded)

B (remaining fragment) [4]

The violent hues do not make up a very ceremonial fugue; the effect is more like Carl Orff's *Carmina Burana.*

The program is as complexly structured as the format. In my study of the hemicycle apostles in 1978, I emphasized the hesitancy and indecision still operative in the late thirteenth century concerning their identities, appropriate visual symbols (attributes), and even their number, the group in the hemicycle including at least fifteen, plus Peter shown as pope, with many attributes repeated. It is possible to oversell the resulting chaos, and my purpose here will be to seek to sketch the structure that does in fact exist, and thereby to establish the degree of organization (or lack of it) with which the late thirteenth century felt comfortable.[5] The nave program of a decade later, as I have noted elsewhere, still shows signs of flux but is marked by greater urgency and rigidity in organization: there are twelve apostles (although their number includes Barnabas, Mathias, and three Jameses) and they are provided with inscriptions in addition to attributes.

The elements of the hemicycle program are charted below, making it possible to assess the strictness or relaxation of their organization and, more important, the theme of the

ensemble and its sources, as well as to suggest the subjects now lost. The sources are both Chartrain and western, and the theme encyclopedic. The axial bay was reserved for major Marian and Christological themes. In addition, the traceries present martyrs, arranged as indicated on p. 303:

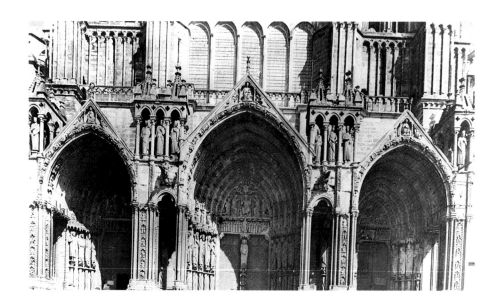

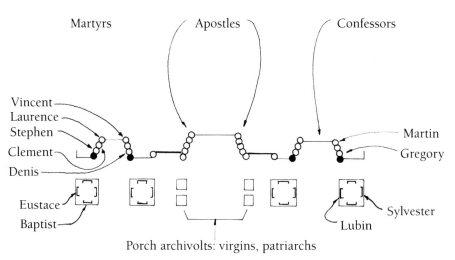

IX.3 *Chartres cathedral. South transept portals, with iconographic diagram.*

Traceries:
Bay 1 (axial)
Nativity Annunciation

NORTH SOUTH

Bay 2: abbey patrons Bay 3: precursor, protomartyr
 Peter crucified Paul beheaded Baptist beheaded Stephen stoned

Bay 4: deacons Bay 5: apostle
 Lawrence grilled Vincent thrown Andrew crucified (lost)
 into the sea

Bay 6: apostle, saint Bay 7:
 Bartholomew Eustace in (lost)
 flayed burning bull

It is clear that the protocol order zigzags back and forth, north to south. The hierarchy is also clear: abbey patrons in the position of honor (to dexter of axial bay), then Christological types (precursor, protomartyr), the latter introducing the trio of great deacon saints of the church, then apostles, then a saint of local popularity (Eustace, often shown in the cathedral programs). It should be evident already how much this program derives from the great south portal of the cathedral[6] (notably the martyrs door to the left), and it is to that ensemble that we shall look further (*IX.3 and diagram*).

The program of the hemicycle lancets is as follows. Again, the axial bay is reserved for Marian-Christological themes, the others filled with apostles and confessors of various ecclesiastical rank:

Lancets:
Bay 1 (axial)
Crucifixion Virgin and Child

NORTH SOUTH

Bay 2: Bay 3:
 apostle Peter (apostle) as pope Paul (apostle) apostle
 apostle archbishop (*Pl.56*) apostle apostle

Bay 4: Bay 5:
 apostle apostle[7] apostle apostle
 apostle bishop apostle apostle

Bay 6: Bay 7:
 apostle abbot[8] (lost)[9]
 apostle abbot

The church's patron Peter, again in position of honor, serves to introduce both apostles and confessors of ecclesiastical rank; while Paul, in second position, leads a group of apostle-martyrs including Barnabas (holding the flame; *IX.2*) and possibly Mathias. Again, the south portal of the cathedral provides the model, in the jambs of the right door (confessors of varying ecclesiastical rank) and of the central door (apostles with attributes). Moreover, Peter's dual role as chief apostle and as head of Ecclesia is emphasized. I have noted previously how much the Saint-Père hemicycle figures resemble jamb statues,[10] and the resemblance is more than skin-deep.

A

B

IX.4.A–B *Saint-Père. Two-tier formats. (A) North choir, Bay 16, ca. 1240 (left); Bay 14, ca. 1270 (right). (B) North choir and hemicycle, Bay 8, ca. 1240 (left); Bay 6, ca. 1290–1295 (right).*

Thus the thematic program of the Saint-Père hemicycle derives from the south portal of the cathedral, which overlooks it from the top of the hill. That great summa can most succinctly be epitomized as Ecclesia, or creation *sub gratia*. It is a program that spoke to the monks of Saint-Père, since they repeated it yet again in their nave windows, allotting each division within the structure (Marian-Christological themes; apostles; popes, bishops, abbots; precursor; saints of local importance) an even more clearly marked piece of turf.[11] The importance at Saint-Père of the patron Peter, and thus his position to dexter of axial, necessitated, in the hemicycle, a "mistake" in positioning of the confessor group that followed him in line (pope, archbishop, bishop, abbot). That mistake was corrected in the nave, where Peter gets a whole bay on the dexter side (north, Bay 22), just after the Passion, while the confessors occupy a location of lesser importance (south = sinister) in relation to the apostle-martyrs, just as they do on the cathedral's south portal.

Can we then suggest what the lost martyrdoms may have been, in the medallions of the traceries of Bays 6 and 7? The lost medallion of Bay 6 was almost certainly an apostle, probably a major one such as Matthew or James.[12] The traceries of Bay 7 just as probably held martyrdoms of popular saints, such as Eustace in Bay 6. The left pier of the cathedral's south porch is decorated with twenty-four martyrdoms,[13] among which are Eustace (west face), the Baptist (south), Vincent and Lawrence (east), as well as Denis and Clement. It is likely that the two lost saints were among that heavenly crew, perhaps Blaise (very popular in Gothic France), Saturnin (whose martyrdom, the body bumping down the stairs, is visually distinctive), or perhaps even Thomas Becket (whose martyrdom is included on the pier's east face).

Last but hardly least among the lost subjects are the two of the axial bay, replaced within a decade by the addition of Sts Louis and Gilduin (*Pl.55,* bottom of left lancet). Again on the basis of the cathedral portal, it is possible to hypothesize that the subjects were Marian-Christological, most likely a Christ showing his wounds and a Virgin crowned, as truncated versions of the themes in the cathedral's transepts. These subjects recommend themselves on another basis, that of the relationship of the Saint-Père hemicycle with earlier western glazing programs, specifically with that of Le Mans from over a generation earlier.

The Le Mans clerestory established the format of double-tiered canopies framing large figures. The genesis of this pattern can be seen in the works of the first glazier, the Master of Bishop Geoffroy de Loudun, who, I believe, took his inspiration from the major ensembles of Chartres and Bourges but who certainly did not find there the answer to his vexing problem of how to fill the immense expanses confronting him at Le Mans. He struggled with the problem, but before he had left the Le Mans shop (after Bay 211 at the north crossing pier), the two-tier format had taken root.[14] At Saint-Père, of course, the two-tier pattern was dictated to the hemicycle master by the glass already in place in the choir (*IX.4.B*). The reuse of the earlier prophets there had already made problems for the designer of ca. 1270, who put the old glass in Bays 8–13 and 16–17 but was obliged to produce a fresh design for the exceedingly narrow Bays 14–15 (*IX.4.A*).[15] He more or less had to retain the same size figures to keep his choir program coherent, but faced the problem of just how to fill up the lancets vertically. His solution for Bays 14–15 was to use extraordinarily enlarged bases for the figures, bases which are unique for their day. The hemicycle master decided on a different course, and thus were born the soaring canopies over his saints (*IX.5*), which the Evron master (p. 278) was to carry to ridiculous extremes. But the double-tier format refers ultimately to the solution of the Bishop Geoffroy Master at Le Mans.

IX.5 *Saint-Père. Hemicycle, Bay 2 (left) and axial Bay 1.*

One of the goals of this book has been to pinpoint the paths of such influence. Ideas, even visual ideas, can of course be abroad, accepted in a period and region as the normal solution. This is not the case with the double tier, so far as we can tell from the evidence provided by the other monuments in this book. They use band windows, or small medallions, but not double tiers of large-scale figures. It is not a usual, but rather, an unusual procedure, which suggests a familiarity with Le Mans, where it had been stamped Approved.

Another goal of this book has been to try to define the depth or superficiality of influence. It is possible to know about something because one has seen it, or because one has been told about it, or because one has been trained at a certain site. All these methods have suggested themselves from time to time as I pondered the paths of influence within the relatively small geographical area and relatively short chronological period under examination here. The features common to Le Mans and the Saint-Père hemicycle are the similarity of the double-tier format, the narratives in the traceries above, and the program, although it is somewhat more unbuttoned at Le Mans, since there it was evidently worked out in medias res. In the end Le Mans contained an axial bay devoted to Marian-Christological themes, surrounded by a hemicycle encompassing a rather unfocused spectrum of ideas, flanked by a choir with, for the most part, apostles on the north and bishops on the south. Significant here is the axial bay. The program at Saint-Père probably reflected it, and thus probably originally included, as at Le Mans, a Christ showing his wounds and a Virgin crowned—lost when Sts Louis and Gilduin were inserted.

I have suggested that the first glazier of Le Mans, the Master of Bishop Geoffroy, was sent to Chartres to take notes. Was the Saint-Père master, in his day, then sent to Le Mans on a similar mission? It seems most unlikely; more probable is that someone present in the planning stages of the Saint-Père hemicycle knew Le Mans. The first work of the hemicycle seems to be the rather quiet, tightly executed martyrdom tableaux in the tracery medallions, a series aborted before completion and finished by a different artist. This is the series that uses decorative vocabulary (in the lobes of the quatrefoils) resembling the Vendôme hemicycle of the early 1280s: the silhouetted ivy and clover crockets of Bays 201 and 202 (*Pl. 48.A–C*). That was the Vendôme atelier—the Master of Pierre d'Alençon—which, I believe, had trained some long time before with the Principal Atelier of Le Mans.[16] The martyrdom tableaux in the hemicycle traceries of Saint-Père (Peter, Lawrence, Vincent, Bartholomew, Eustace, the Baptist, Stephen, Andrew) constitute a very uneven series. The cartoons are very fine, distinguished by their legibility and focus, and by the button heads and slender elongated bodies of the Vendôme hemicycle. A few are superbly painted, such as the crucifixion of Peter; a few are painted by a very weak hand (Vincent); and others seem to have been painted by western artists represented in the lancets below (Baptist).[17] The master probably came to Saint-Père, started on the cartoons, and died. At least he left nothing more in the church.

The Vendôme connection, however, remained strong throughout the hemicycle campaign. Among the works of the large Saint-Père chantier are traces of the master of Peter and Paul (Vendôme Bay 204), who seems to have left there at the death of Pierre d'Alencon, as well as of painters working in the same style as the later Vendôme bays. Certainly copies of the Vendôme patternsheets were in use in the Saint-Père hemicycle, a very much more elaborate production but composed in identical decorative vocabulary and syntax. The canopywork language of Vendôme and the Saint-Père hemicycle also bears the message in the Saint-Père nave and in all campaigns at Evron. Its distinctive motifs are listed below:

CANOPYWORK DESIGN ELEMENTS	SAINT-PÈRE bays	VENDÔME bays	EVRON bays
double line brickwork	hemicycle; nave	205, 204, 206	100, 105
frieze of circles enclosing quatrefoils	hemicycle; nave bays 25, 29	205, 204, 206	all bays
frieze of maple leaves and inverted Vs	nave	204	100, 101, 105
unarchitectural leaf as capital of colonnette	nave bays 20, 25	206	102, 101
gargoyles	hemicycle	204, 206	102, 103, 105
roof of tiling panels separated by clear strips	hemicycle	204, 206	102, 101, 105

The ductus of this distinctive decorative handwriting begins and remains massive and block-like until the very final stages at Evron, where spindly elements make their first tentative appearance.

The stemma of relationships among these three ensembles, as well as the artistic identities of the large chantiers of Saint-Père, are difficult issues. I would suggest that the Vendôme shop of the early 1280s was hired thereafter for the new project of the Saint-Père hemicycle. But the Chartres project seems to have had a slow season as well, and in any event was manned by a much larger crew. The chantier of the late campaign at Vendôme (which worked in a more forceful version of the style of the earlier Peter and Paul of Bay 204) went to Evron, it seems relatively clear, in the early 1290s. Nothing, however, remains at Evron as evidence of an ongoing campaign between then and about 1313. In contrast, after the completion of the Saint-Père hemicycle in the 1290s (a project that had minimal contact with Evron), there was work again at Chartres about 1305–1315, in the nave. And when the Evron project of the hemicycle resumed ca. 1313, the Pilgrim Master, who had worked there in the 1290s, returned, showing obvious traces of exposure to the radiation of Saint-Père. Thus Vendôme functions as a feeder for both the other work sites. And the artists of the early Evron atelier of Bays 105 and 107, possibly the Pilgrim Master with a local apprentice only, probably worked at Saint-Père in the first decade of the fourteenth century before returning to Evron with a lesser artist, the Master of the Soaring Canopies, in tow.

The significance of the Saint-Père chantiers is therefore very great, and it is all the more disappointing to encounter there a work force operating by the motto of the glaziers of Sées, We're all in this together. Nothing can be more frustrating than trying to track these painters, who worked on a face here, who-knows-what there, or whatever was on the bench. Face painting and drapery painting do not necessarily go together, and the decorative vocabulary of haloes combines scallops, pearling, hatching, and painted and reserved motifs in every possible sequence. Cartoons are reused,[18] but at least one example occurs of the Sées type of work cooperation, that is, two different masters designing their figures after the same patternsheet: the two abbots of Bay 6 are taken from the same model but given differing dimensions and are rendered in totally different painting styles. More commonly, very different hands turn out saints whose cartoons are subtle mutations of the same design on the

bench. Among the faces there is a thick-lined dramatic style with enormous eyes (Bay 6 upper right, Bay 4 upper right, Bay 2 upper left); a delicate touch that uses fine line, washes, and reserved circle areas for the cheeks and forehead (Bay 2 lower right, *Pl.56;* Bay 5 lower right; Bay 4 lower left);[19] and several more workaday painters whose styles follow these leaders, to some degree.[20] There are probably nearly a half-dozen artists at work on faces alone, in styles ranging from caricature-like to nuanced to dull. The collection is endlessly varied and impossible to factor.

Who then is the mastermind of the Saint-Père hemicycle ensemble? Surely not the first Vendôme master (Master of Pierre d'Alencon), who contributed a few ideas to the program and a few cartoons for the traceries before vanishing. And probably not the painter who finished the three remaining tracery medallions (Annunciation, Nativity, beheading of Paul) and whose work appears in the axial Crucifixion and Virgin (*IX.5*)—master of the squared-off ugly mug but not particularly forceful. The most dramatic of the artists can be discounted too, a painter who forces his enlarged features into cartoons obviously not of his making, as in Bay 2 upper left. The strong will of the mastermind is constantly at work, in the color rhythms as well as in the program, and he probably drew most of the cartoons, but which ones he painted is harder to determine. The cartoons, however, are proof enough of his talent. In comparison with those of Vendôme, the style he was coming from, they are explosive. The wiry toes and energetically curling hair of Vendôme reappear, but the postures are injected with life, and the hands and their gestures are much finer and more riveting. It seems clear that the mastermind and planner of the hemicycle had studied the earlier works of the Saint-Père choir (*IX.4.A–B and Pl.2.A–B*), particularly the ferocious, hieratic prophets of the earliest series, reused immediately adjacent to his hemicycle bays in choir bays 8–13 and 16–17. The striding movement of those awesome patriarchs, the pointing gestures, the maniacal profiles, the direct frontal confrontations, all are absorbed and retransmitted in his art.

In struggling with the chantier of the hemicycle, I am reminded of Colin Eisler's commentary on the analysis of the three Limbourg brothers by Millard Meiss. Meiss wrote:

> Did Herman execute Nicodemus and the man behind him in Paul's *Entombment?* Did not Paul supply the drawings and perhaps paint the Virgin and Saint John in Herman's first scene of the Crucifixion? . . . As an initial guide . . . Paul was the most perceptive, the most thoughtful, and the most ambitious. Jean was the most lyrical, the most elegant and the greatest opportunist. Herman was the most demonstrative, he can even be melodramatic.

To which Eisler responded:

> This reads . . . like a collective report-card from a progressive school concerning three gifted siblings. . . . Such drive for identification . . . can border on the counter-productive when it is alien to the genesis of the works under consideration [and] . . . prove as fruitless and self-defeating as that of isolating the contribution of the members of a balancing act, essentially all for one and one for all.[21]

The hemicycle of Saint-Père is such a balancing act, and the mastermind behind it had a lot of help but ruled his troupe with an iron discipline.

The Iconography of St Louis, Revisited

The addition of Sts Gilduin and Louis to the axial bay of Saint-Père (*IX.5*) recalls similar figures of Louis and Eutrope in the final work at Vendôme and must elicit a comment in comparison. The saints at Vendôme are not obvious insertions in the program, which has twelve apostles in addition, and they are significantly earlier creations than those at Saint-Père, if my hypothesis is correct about the dating of Vendôme before ca. 1290. The figures at Saint-Père reflect a similar theme, that is, the pairing of a Capetian saint with a saint of great local importance, and they have been executed by a glazier trained in the Vendôme style, although the designs are quite pedestrian. The iconography of St Louis reflected in the Saint-Père figure is by no means so interesting as the Vendôme figure with its chlamys pinned at the shoulder and its *main de justice* (*VII.17*, p. 249). At Saint-Père the Capetian saint wears a regular vair-lined cloak, opening in the front to reveal a fleur-de-lis covered tunic, and holds a book and a scepter.[22]

If the Vendôme image of St Louis reflected the tomb statue of the 1280s, as I believe, then the Saint-Père image reflects a later and more codified and standard image, most probably derived from the statue erected at the abbey of Saint-Denis after the canonization of 1297. This was a gilt statue intended for the altar of the St Louis chapel, constructed 1299–1304 between the chevet and the abbey buildings to the south and decorated with stained glass windows created between 1301 and 1303. Elizabeth A. R. Brown,[23] in presenting her important research on this chapel, made the suggestion that the gilt statue may have provided a second model, with that of the earlier tomb of the saint already in the royal abbey, for the varied types of image of St Louis in such early cycles of his life as the *Vie et miracles de Saint Louis* by Guillaume de Saint-Pathus (Paris, Bibl. nat. MS fr. 5716).

Georgia Sommers has written of the thirty-one miniatures in that manuscript depicting the saint:

> Worn over one or both shoulders, the mantle is pulled across the body about the waist. For the most part the saint carries a sceptre and hand of justice or two sceptres, but twice he holds a book in his veiled hand and six times he gestures with empty hand.[24]

About the same manuscript Erlande-Brandenburg has written:

> [L]e roi est souvent figuré debout sur une sorte d'autel, tenant de la main droite la main de justice, de la gauche une croix ou le sceptre. . . . L'artiste ignorait même s'il devait le dessiner imberbe ou barbu, et sans raison nous voyons apparaître puis disparaître cette barbe forte courte dans le cours du même ouvrage.[25]

A number of the early fourteenth-century statues that are often discussed in these arguments have a regular cloak, for example, the one in the Villiers collection and the statue of Senlis.[26] Just what the early sculptures carried in their hands is often impossible to establish, but the combination of book and scepter lasted a long time. A very late example can be found in a primitive terra-cotta in the chapel of Jarry, of the early seventeenth century.[27]

The date when the images of Sts Louis and Gilduin were added to the Saint-Père axial bay can only be suggested on the basis of their dullness, their basic resemblance to the nave campaign probably begun by Abbot Jean de Mantes (1306–1310), and the general period of

proliferation of images of the Capetian saint, from about 1300 to 1305. In 1304 the king presented his golden helmet to Chartres cathedral in thanksgiving for the victory of Mons, and after the queen's death in 1305 Philippe le Bel increased his religious donation, particularly to abbeys, and his fanatic absorption with the memory of his sainted grandfather.[28] The Saint-Père image is likely to date around 1305, but whether given by the abbey to please the king or by the king to please the abbey would be conjecture.

There is a third and more likely hypothesis. The St Louis (and St Gilduin) may have been offered by Laurent Voisin, whose figure appears as donor in the next Saint-Père campaign (nave Bay 21; *Pl.60*). MAGISTER LAVRENCIVS CAPITERIVS CARNOTENSI[S], as the inscription titles him, was dean of the cathedral of Chartres from the early 1290s until his death in the winter of 1314–15, as I indicated in 1978. What I have found out about him since then is significant: during the same long career he served as judicial chancellor to the prince Charles de Valois, indeed as one of the "principaux personnages de son entourage."[29] Charles had held the county of Chartres in appanage since the early 1290s; Charles's elder brother was the king; and Charles's daughter was the princess married in 1311 to the young blond Châtillon whose image in heraldic surcoat (*VIII.4*) decorates the Evron hemicycle. If Laurent Voisin was instrumental in inserting the image of the newly sainted Louis IX into the already

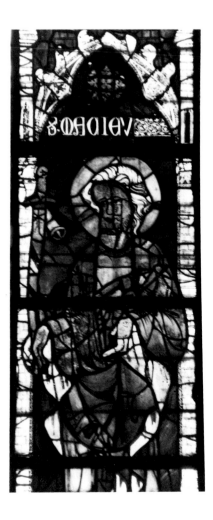

IX.6 *Saint-Père. Apostle with sheathed sword, Bay 20 (right). Photo before 1980s restoration, which corrected inverted positions of* MACIEV *(with ax) and* JACOBVS *(sheathed sword).*

A B

IX.7.A–B *Saint-Père. North nave. (A) Bay 24. (B) Bay 28 (left) and Bay 26.*

glazed hemicycle at Saint-Père, the movement of glaziers between that abbey and Evron, suggested in Chapter VIII and below on the basis of stylistic evidence, gains plausibility.

The Nave: *Grande Fugue Brillante*

The twelve nave bays of Saint-Père de Chartres (*Pl.57.A–L*) are, like the stained glass of the Sées choir and a few other lucky monuments, solidly dated on the basis of donors:[30] the abbot Jean de Mantes (1306–1310) of Bay 22 (*Pl.19*); the canon Nicolas de Maison-Maugis (d. 1308); the dowager countess of Dreux, Béatrix de Montfort-l'Amaury (d. 1312) of Bay 19; and the canon Laurent de Voisin (d. winter of 1314–15) in Bay 21 (*Pl.60*). Moreover, since the window of Abbot Jean is stylistically *une belle salade* prepared from paired scenes from some other location and extended by new additions (*IX.9.A–B*) to fill out the great clerestory expanse, the good abbot probably conceived and organized the campaign, pushed it off, raised the funds to make it a reality, and possibly created the program and format. Although he did fund another project before he died (in 1308 he donated a great bell), the honor of completing the church decoration fell to his successor Philippe des Cierges (d. 1329), whose tomb showed him with the church in his hands.[31] The latest date suggested

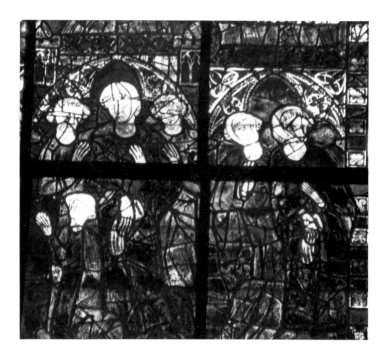

IX.8 *Saint-Père. St Clement lancet: Theodora praying, her blinded husband Sisinius led by servants. South nave, Bay 23.*

by the evidence is for the St Denis lancet of Bay 23, which I believe to be a design created by the glazier from two *libelli* available in the scriptorium of Saint-Denis: the *libellus* of 1250[32] and the luxurious Vie de Saint Denis begun in 1314 and presented to the king about 1318.[33] The nave windows of Saint-Père can thus be situated between 1306 and about 1315.

Although many panels were deported to the ambulatory in the late seventeenth century, these have now been put back, and in general the ensemble resembles its original state, now more than ever: the restorations of the 1980s have provided Bays 20–21 (*Pl.57.B*) with deeply colored latticework flanking their medieval figures, as the scraps in the lancet heads prove that they had originally.[34] Such latticework enjoyed a vigorous long life in the west, from Bourges and Le Mans until Chartres cathedral's St Piat chapel well into the fourteenth century. It is good to have it back at Saint-Père.

The nave ensemble orchestrates the themes and patterns of the chevet into an intricate and full-voiced fugal structure. Visual and programmatic elements are speeded up and re-laxed, inverted and reversed, played in canon and at thirds and fifths. The color-saturated narratives (nave Bays 18–19, 22–23, 26–27; *IX.8–IX.12* and *Pls.58, 59*) embroider the martyrdom theme of the hemicycle traceries, in microcosmic canopywork reflecting that of the hemicycle lancets under those traceries. The sequence of iconic figures (nave Bays 20–21, 24–25, 28–29) repeats the apostles and confessors of the hemicycle lancets, but in closed rank and lockstep (*IX.6, IX.7, IX.13, Pl.61*). Their double-tiered canopies and their flanking vertical strips of grisaille reflect, as though in a convex mirror, the patterning of the earliest glazing of the straight choir as well as the noisy chorus of holy men in the hemicycle. The summa is splintered into chapter headings and exempla, but the ideas are

from Saint-Père, direct and undiluted. The nave program of about 1305–1315, a decade and more after the hemicycle, begins and remains a Gothic summa, increasingly codified but not yet unbalanced by the lay spirituality of the century to come. That new wind is only the softest breeze on the horizon: two anonymous lay donors (*IX.7.B*) kneel as "participants" in the Baptism of Christ in Bay 26.[35]

IX.9.A–B *Saint-Père. Bay of Peter and Paul. (A) 14th-cent. additions: two right panels, top central panel. (B) 14th-cent. additions. North nave, Bay 22. Photos before 1991 restoration.*

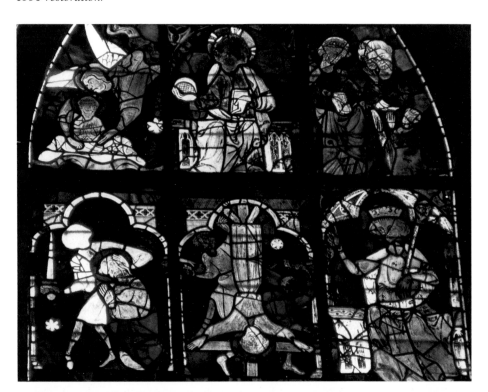

A

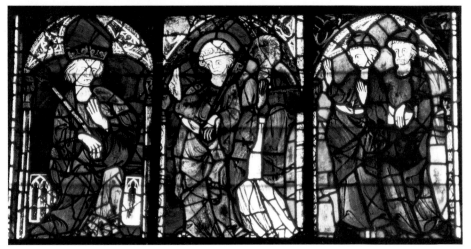

B

Structure of the Program (Pl.57.A–L)

NORTH			SOUTH
Bay 18: Passion	←narrative→	Bay 19:	Anne and Joachim; Infancy
20: apostles	←iconic→	21:	pope-saints; Virgin with donor Laurent de Voisin
22: Peter and Paul	←narrative→	23:	Pope Clement and bishop St Denis, patron of France (martyrs)
24: apostles	←iconic→	25:	bishop-saints
26: Baptist	←narrative→	27:	Catherine and Agnes (female martyrs)
28: apostles	←iconic→	29:	abbot-saints

Although the formats interweave, the thematic program situates apostles and Christological themes (Passion; Peter, the first apostle; the Baptist, precursor) on the north or dexter side, and themes devoted to Mary and Ecclesia on the south. The hemicycle program has been rescored for full orchestra, but its organization has also been "corrected" and made neater.

Within the program, themes take assigned places in a rigid hierarchy, central Marian and Christological topics leading off, major apostles first.[36] Last in line on dexter is the Baptist, final Old Testament prophet and representative of them all. Last on the opposite side, at the lowest point in the encyclopedic structure, are the two popular female saints of the Gothic era, Catherine and Agnes, the only women saints represented in the church. The ranks are as preordained as are those of the feudal society of the late Capetian era. All the saints who appear in the nave, except Catherine, have illuminations in the sanctoral of the early fourteenth-century missal of Saint-Père.[37] For that reason, and because the selection of Catherine's scenes is slanted away from martyrdom and toward her prowess in theological debate, I have assumed that her window was one of those in the large gift of the cathedral canon, Nicolas de Maison-Maugis.

Little else was left to chance. The narratives were not idly based on shop custom or artists' patternsheets. A careful study of iconographic detail suggests that the Passion lancet (Bay 18; *IX.12*) was based on a non-French source of the twelfth century at the latest, probably a monastic psalter. Since the studies of the Passion cycles of Gassicourt and Dol have provided evidence of familiarity with such a model, it thus seems most likely that it was a famous and venerable possession of the abbey of Saint-Père.[38] Similarly, the lancet of St Denis (Bay 23) was, I have suggested, created by an artist sent to study the *libelli* of the royal abbey. The Infancy lancet (Bay 19) contains a detail reflecting a much more ancient tradition, that of the doubting midwife, possibly transmitted by a Carolingian object in the treasury. One of its other peculiarities, however, may find its explanation in the *libelli* of

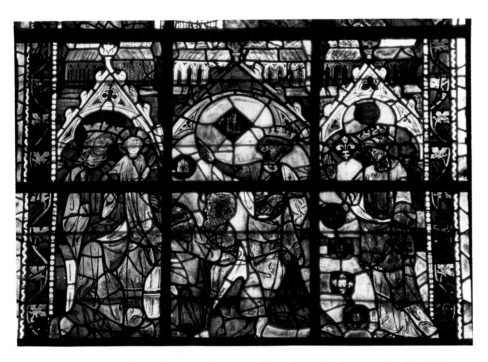

IX.10 *Saint-Père. Infancy lancet: Adoration of the Magi. South nave, Bay 19 (left).*

Saint-Denis as well. While the sequence of Infancy scenes in Bay 19 is classic for the Gothic era (*IX.10*), it is capped with a Dormition of the Virgin where one might expect (when a Marian cast is present) the more common Coronation scene. The Dormition, however, was a vital episode in the legend of St Denis (Dionysius the Pseudo-Areopagite), who stated in *De divinis nominibus* 3.2 that he had been present at the event. Thus the Dormition of the Virgin is included among the illustrated scenes in both *libelli* of the abbey of Saint-Denis.[39]

The adjoining lancet of the Virgin's parents and childhood, by contrast (*IX.11*), was probably modeled after an ivory casket, a luxury object of the nobility (and this is the lancet given by the countess of Dreux). Although cycles of the Virgin's birth and childhood of this elaboration were no longer common in Gothic art by the early fourteenth century, the trend was less apparent in ivories, and Gertrud Schiller has published such a casket (Toulouse, Musée Paul Dupuy; beginning of the fourteenth century), which resembles the Saint-Père window in many particulars.[40]

The nave program is no less rooted in the cathedral portals than is the hemicycle, suggesting that the hemicycle program had been recorded and was studied by the nave iconographer. Where his program is most imaginative, in the choice and playing out of the narratives, with their rich and diverse models, the nave iconographer reveals his great thought and care. Was this Abbot Jean? The strong coherence of the result, in spite of its production over a decade or more as the work of many hands and its funding by donors from all three estates of society, is probably his achievement.

The format and interleaving of the nave windows (*Pl.57.A–L*) are as rooted as is the program in the church's previous glazing. The measure to which they play upon the earlier

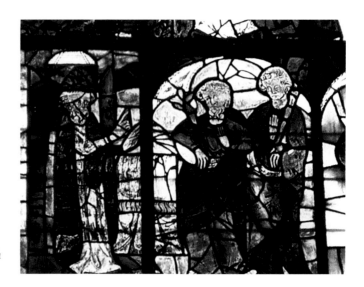

IX.11 *Saint-Père. Lancet of Joachim and Anne: Calling of the suitors. South nave, Bay 19 (right).*

forms of the choir can be taken by the briefest comparison with other monuments of the fourteenth century. The color-saturated narratives in canopied rows are ideas of their own time and can be compared to those of Fécamp,[41] though their small scale recalls the hemicycle tracery medallions (as do their themes), while their canopy designs rework the vocabulary of the large-scale architecture in the hemicycle, as has been mentioned. The shutter-effect alternation of vertical strips of grisaille and color (*IX.7.A*), in the iconic bays, occurs nowhere else but at Saint-Père and simply translates into the syntax of the fourteenth century and the scale of the great nave bays the grisailles and large figures of the church's straight choir (*IX.4.A–B*). The very idea of alternation, however, adopted from there, is expanded to a larger dimension by the interweaving of window formats in the nave. The nave ensemble of Saint-Père is a creation, within the givens of its situation, that is as marvelous as I. M. Pei's East Wing for the National Gallery in Washington, D.C., taking its place in the parade of marble piles down the Mall, on its peculiar trapezoidal site, as organically as if it had grown there and as much a statement of its age as was the Capitol building now reflected in its great glass walls.

The glaziers of the nave campaign were the same chantier that produced the hemicycle, some years down the road. They used the same patternsheets to produce the same sorts of borders, canopies, haloes, and attributes, in a style that gained in tradition and total self-assurance what it had abandoned in fine-tuned precision of detail. The older painters of the hemicycle traceries and axial scenes have disappeared from the shop. Among the minor painters of the hemicycle who shoulder a major load in the nave is the hesitant, slightly dull hand evident in Bay 6 (upper left). The facial type of the delicate painter in Bay 2 (lower right; *Pl.56*) recurs: worry wrinkles, washes, and great reserved circles for the forehead and cheeks (for example in Bays 20 [*IX.6*, p. 312] and 24). Does the lack of refinement now indicate the master at a mature stage in life or someone he trained? The shop sometimes uses the same colors with the same aplomb, a strong yellow, saturated red, and clear blue, with white accents. But does the development of a more mannered harmony, with purple used as a ground, and bluish green, indicate a development and in the hands of the old guard or the new?

The four bays with grisailles have four different designs. Those on the south (Bays 25 and 29) are deadly dull lozenge patterns with straightforward but uninspired foliage, while those on the north (*IX.7.B*, p. 313, and *IX.13*) are exquisite bulged quarry creations of the most delicate painting, embellished with reserved pattern and with color injected so as to bring the effect of the grisaille and the adjoining colored strips (which have much white in the canopies) into greater balance.[42] The grisailles of Bay 24 (*IX.7.A*, p. 313) rank with the most beautiful of Gothic glazing.

The borders are quite varied and include standards like *Castille* (Bays 18, 19 right lancet) found in the grisailles of about 1270 in the straight choir, as well as unusual shells (Bay 24, where St James is among the quartet of apostles). The *Castille* motif is found in a bay that would place early in the development of color and canopywork as well as in a bay which would place late. And what is one to make of the *Castille* border of Bay 27 (*Pl.59*), composed of white castles and yellow filets? The most standard borders occur with the most noteworthy windows and vice versa in no logical hierarchy of quality. In other words, the artists of the Saint-Père nave chantier maintain the work habits of the shop, and no real chronology can be established for their work.[43]

The color harmony of the nave is built on that of the hemicycle plus, of all things, brown. Brown and tans are used in heavy doses by most of the nave shop, sometimes in addition to the strong yellow of the hemicycle (Bays 18, 19 left, 25, 29), other times nearly in substitution (Bay 19 right, the additions to Bay 22, Bays 23 and 26). While red, blue, and brown provide the basic color harmony of the nave, each of the iconic bays has been given a different accent, as at Vendôme. Bay 25 is noteworthy for blood red, whereas Bay 29 is a yellow-blue combination with scarcely any red at all; Bay 28, the most unusual of the lot, reduces both red and yellow for a cool, subdued tonality characterized by a chilly bluish green, white, blue, and brown. The browns range from very pale to very dark, and are sometimes almost purple, sometimes not purplish at all. It is not a hue of much importance in the hemicycle, where gay primaries reign supreme. In contrast, brown and purple are found in the older glazing of the straight choir, a series of windows of basically blue tonality, with only minor areas of red and yellow. The unusual browns in the nave thus seem most reasonably explained as an attempt by the chantier to harmonize the large program there with what preceded and adjoined it, the great patriarchs of about 1240.

The two great artists of the Saint-Père nave are the Baptist Master (Bay 26) and the St Denis Master (Bay 23). They work in a closely coordinated style.[44] The Baptist Master's figures, in comparison to those of his colleague, have a more mannerist sway, they occupy their assigned panels more comfortably, and their draperies are painted with sporadic loops and curves (*Pl.58*). Of the two he is the more classical, his style more ceremonially dramatic. The St Denis Master's figures rake off the assigned panel space with no regard for the canopywork above (*IX.8*, p. 314), their explosive angularity has nothing of the curvilinear about it, their draperies are handsomely shaded with areas of fine parallel lines. Both artists are fine expressionists, among the noteworthy artists of the western style.

Both these masters contributed panels to the first project of the nave, the additions and extensions of the Peter-Paul story which were adapted to the vast expanse of Bay 22 (*IX.9.A–B*, p. 315). Of the other narrative bays, Bay 19 left (Infancy; *IX.10*, p. 317) was probably painted by a classically (Paris?) trained artist from the Baptist Master's cartoons; as apprentice of the Baptist Master he has left a spoon-fold or two among the draperies of the Baptist bay as well. The right lancet of Bay 19 (Joachim-Anne; *IX.11*, p. 318) is, I believe,

the work of the Pilgrim Master of Evron, probably his earliest assignment at Saint-Père, since in the Catherine-Agnes bay (Bay 27; *Pl.59*) and the Passion bay (Bay 18) his style takes on greater and greater assurance, as it takes on his typical angular silhouette and sparse, selective drapery painting (*IX.12*).[45] Although never a first-rank designer, he became, in time, a very fine artist.

The large iconic figures show the same variation. The worst is Bay 25 (bishops), mediocre, stubby designs executed in a grotesque, heavy-handed style with messy, thick drapery lines. The abbots (Bay 29) are probably the work of the Master of the Soaring Canopies of Evron, as are the popes and Virgin in Bay 21. The stupid expressions, elongation of proportion, and busy, confused drapery painting later form part of his style at Evron. The donor figure in Bay 21 (Laurent Voisin; *Pl.60*) is a finer piece of painting than he is capable of, much resembling one of the late masters of the Saint-Père hemicycle (Bay 6 lower left). The Master of the Soaring Canopies may likewise have worked in the hemicycle (cf. Bay 6 upper left, with messy draperies and bland face). He had not worked in the first Evron campaign as the Pilgrim Master had, at any rate, and no doubt was signed on by that artist to work on the Evron hemicycle on the basis of their acquaintance in the Saint-Père nave.

The Baptist Master probably produced the apostles of Bay 20 (*IX.6*, p. 312), well-focused, statuesque figures with loop draperies. Bay 24 is probably the work of the St Denis Master, also strongly focused figures (*IX.7.A*, p. 313), but with heads and attributes at rakish angles, and the lovely shaded folds that are his particular speciality. Both Bays 20 and 24 have the facial type noted in the work of the most delicate master of the hemicycle (the great twin circles reserved in the forehead from an overall light wash), a peculiar formula of the Saint-Père chantiers as early as the ca. 1270 campaign (cf. the bald patriarchs of Bay 14). Finally, there are the atypical apostles of Bay 28. The canopies are more exaggeratedly vertical and elaborate, the color is totally new (much blue, bluish green, white; *Pl.61*), the proportions of the figures are marked by tiny heads and flattened, expansive torsoes, the

IX.12 *Saint-Père. Passion bay: Ascension. North nave, Bay 18.*

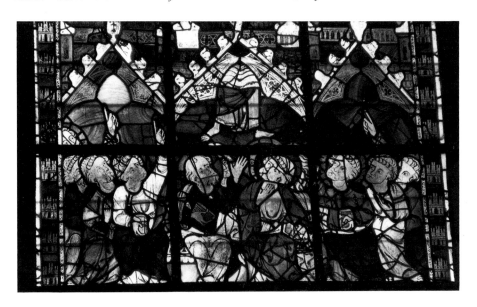

IX.13 *Saint-Père. St James the Less with a staff. North nave, Bay 28.*

expressions are mild and good-natured (*IX.13*), and the delicate flanking grisailles are carefully balanced in effect. This artist has learned the St Denis Master's lovely shading, but his art looks forward to Rouen and to new worlds to come.

"Esse Parisius est esse simpliciter"

The intention of this book has not been to denigrate the enormous importance of Paris in French Gothic art. That would be impossible, in any case: the influence of the capital was, one may be forgiven for saying, capital. The point of Chapter I is that Paris had not always, or even for very long, been the capital of the western realm. The point of Chapter II is that Paris did not invent medallion glazing, and that there is no reason to assume that all medallion glazing of the mid-thirteenth century is Parisian. The point of Chapter III is that the adoption of the Parisian fashion was chiefly the decision of patrons, and their wishes were sometimes transmitted to provincial workmen who carried out orders in their own stylistic handwriting. This is not true of Auxerre, where painters from the Sainte-Chapelle actually signed on the job, as Raguin has established; it is, however, basically true for the majority

of regional commissions. The point of Chapter IV is that even programs supported by princes who lived in the capital did not necessarily employ Parisian workmen. The point of Chapter V is likewise, at further remove: that the ecclesiastical factotums of princes also supported Paris-style art, produced by local artisans, in their own venues. The point of Chapter VI is that monastic communities with strong Parisian ties employed regionally available glaziers. And the point of the final chapters is that the rich Benedictine abbeys of the western realm, supported by the sophisticated tastes of wealthy French aristocrats (the Châtillons, the king's son, the king himself?), employed western glaziers, and without apology. The book has sought to track the strong expressionist impulse present in western glazing from its misty origins, an impulse never abandoned, and one that reigned triumphant in the end. Only a new craft technique, silver stain, managed to overwhelm it. After 1325, not only do the rules of the game change but also the object of the game itself.

Another goal of this study has been to refocus our view of the developmental paths that can be charted in French thirteenth-century stained glass, most remarkable period of a most remarkable art form. The Capetians were strong kings, rich kings, often wise kings, and they molded the modern French nation. Their art has been accorded a careful scrutiny and awarded a greater significance in the general view. The story has its preamble in the seventeenth-century drawings of royal tombs and the arms and inscriptions of the nobility on view in church art, and its development in the strong currents of nationalism and of romanticism in the nineteenth century. Its dénouement is, then, to be written in the twentieth. The accepted view of French thirteenth-century stained glass, dictated by this approach, established Chartres and Bourges as the classic statements and the Sainte-Chapelle as the logical culmination, after which a somewhat mysterious, inexplicable aesthetic sea change took place, becoming apparent roughly at the death of St Louis in 1270. Glass style next took a recognizable form with the introduction of a new technique, silver stain, in the first quarter of the fourteenth century. Not all the windows discussed here date after 1270, but most postdate the Sainte-Chapelle of 1245–1248. They could therefore be considered, in the older view, stained glass of the transition. But "transition" is not accurate; they are not coming from that style nor leading toward the next. The *fluorit* of western style from 1250 to 1325 had little to do with what went before (except in Aquitaine) or after. The arts of Maine, Touraine, Anjou, and Poitou, not to mention far-out Brittany, show little direct interest in the Court Style, neither in 1250 nor in 1320.

Paris and the Court Style are rich subjects deserving the attention they receive, and it does not detract from their centrality to begin to investigate the roads and modes by which the influence moved. What is *not* Parisian has been one of the subjects of this book; another has been the separation of thought process and function of the patron and the workman, of those who would ape the fashion when they got back home and of those whose job it then was to attempt to do so. All roads lead eventually, at least at one end, to Paris. In my monograph on Saint-Père, I suggested that the sources of the western style of 1250–1325 came from Troyes and Champagne.[46] While the picture is more complicated, I am not willing to let Troyes go.

While the Auxerre clerestory, in my opinion, reflects the lost thirteenth-century glazing of the enlarged clerestories of Notre-Dame in Paris (see Chap. I, pp. 7–8), Troyes and Saint-Denis present a more multivalent relationship. In matters architectural the two are unquestionably close, though Robert Branner judged Troyes the instigator and Bongartz, Bruzelius, and Bouttier more recently have reversed the call.[47] In musing over the lost glazing of Saint-Denis ca. 1240–60, Grodecki evoked the coeval ensemble of the Troyes chevet:[48] a color-

saturated interior of standing worthies in the triforium beneath great clerestories presenting three layers of large-scale figures and scenes. Whether Troyes preceded or reflected (and if so, to what degree) the lost ensemble of the abbey of Saint-Denis is a question that I think is ultimately insolvable. But I believe that the glazing of Saint-Père and its rebuilt *rayonnant* architecture do, intentionally, reflect Saint-Denis. And I have tried to collect the evidence (see Chap. III, pp. 68 f.) that the Saint-Denis program included grisailles, introduced for theological reasons significant in the capital. The conundrum is, how do these three monuments interrelate and what do they tell us about the nuances of Parisian influence in Gothic art?

A thorough analysis of the vast ensemble at Troyes will be required before we can hope to achieve a solution to this teaser. Nineteenth-century restorations at Troyes are insensitive and ubiquitous. The original program, however, was not grisaille-free: cut-down panels of mid-thirteenth-century grisaille patterns survive, relocated in an east clerestory of the south transept and elsewhere.[49] At the very least it can be asserted (as I did in 1978) that an unconventional choice of medallion frames for large clerestory figures was made at both Troyes and Saint-Père in the 1240s. Did the band windows of the Saint-Denis clerestories have large-scale medallion frames?

By and large, the direct breath of Paris is not as commonly felt as has been suspected. The medallions of the upper ambulatory of Le Mans are, I believe, the work of a late Bourges atelier. There is also less direct Norman work than I once believed:[50] the Le Mans style just referred to, that of the Principal Atelier, is the shop that surfaces in the hemicycle of La Trinité de Vendôme, not the style of a Norman painter; and it is this Vendôme master who contributes the cartoons and a little of their painting in the traceries of the hemicycle of Saint-Père.

If, then, western stained glass is not transitional in the commonly understood sense of the term, by the same token neither is it provincial. "Regional" is a better word, since it is the art product of a region, drawing its strength from the roots of that region. In the medium of architecture, a parallel case is offered by Burgundian Gothic, which Robert Branner factored into its most distinctive elements and established as a regional, not a provincial, style. The regional style of western stained glass is based on unabashed vigor, broadness, and forcefulness of communication—in a word, expressionism. Most unusual in this art is the place of grisaille. One normally thinks of grisaille as delicate, nuanced, understated. How then can it serve an expressionist? In the west, grisaille is adopted with open arms and used for contrast: strong color and no color to speak of. The grisailles of the western ensembles are as much a part of the noisy message as are any other element.

Bertolt Brecht has written:

Who built the seven towers of Thebes?
The books are filled with names of kings.
Was it kings who hauled the craggy blocks of stone?
And Babylon, so many times destroyed,
Who built the city up each time? In which of Lima's houses,
That city glittering with gold, lived those who built it?
In the evening when the Chinese wall was finished
Where did the masons go? Imperial Rome
Is full of arcs of triumph. Who reared them up? . . .

. .

So many particulars.
So many questions.[51]

I was somehow glad to find out that the name of the architect who raised the *rayonnant* cage atop Saint-Père was Gautier de Varinfroy,[52] but if the other strong personalities of this study have had to be baptized only as Masters X, Y, and Z, they are nonetheless quite a cast of characters. One of the interesting lessons of this study is just how appreciative they were of each other's work, strong individuals though they were. Art historians very often treat stylistic influence as though it were some kind of mysterious contagion, a social disease of often unknown origin but chartable consequences. By concentrating attention on the human beings behind the glass—the patrons and the artisans—I hope to have demonstrated that the transmission of the virus was often carefully engineered, not mysterious at all.

This book deals with medieval windows not only in themselves but as evidence of men and women who made them and who, by implication, considered them a suitable response of commemoration of the events of their society and of their personal lives. Art history is, first of all, history—or should be—and its first concern should be the investigation of the people in the past who used visual forms to embody their goals, aspirations, and responses to life. Art is as capable as any other type of human creation of carrying a heavy load of propaganda, hopes and dreams, joy, sorrow, triumph, despair. Those messages in colored light were transmitted in the western realm of late Capetian France by the impetuous pulse of expressionism.

NOTES

See Selected Bibliography, pp. 405–7, for sources cited in notes in abbreviated form.

CHAPTER 1

1. Expressionism: "A manner of painting, drawing, sculpting, etc., in which forms derived from nature are distorted or exaggerated and colors are intensified for emotive or expressive purposes." *The Random House Dictionary of the English Language,* unabridged ed. (New York: 1966), p. 503.

2. Norman Gothic architecture awaits its champion to define and chart it, as Robert Branner did Burgundy. Norman stained glass, on the contrary, benefited from the lifelong devoted attentions of the great Jean Lafond, and is therefore more accessible to the student than the glass of many regions of France.

3. On silver stain, see: Jean Lafond, *Trois études sur la technique du vitrail: Essai historique sur le jaune d'argent* (Rouen: 1943); Lillich, "European Stained Glass around 1300," pp. 45–60.

4. On the beginning skirmishes of the Hundred Years' War, see May McKisack, *The Fourteenth Century, 1307–1399,* The Oxford History of England (Oxford: 1959), pp. 105ff.

5. Grodecki, *Le Vitrail roman,* pp. 57–78.

6. Lucien Magne, *Décor du verre* (Paris: 1913), pp. 122ff. Now see Grodecki, *Le Vitrail roman,* chap. III, "Les Vitraux de l'ouest de la France."

7. On the term *Francia,* see Jordan, *Louis IX and the Challenge of the Crusade,* p. 38n14.

8. Kraus, *Gold Was the Mortar,* p. 267n38, gives bibliography. Compare his discussion of Poitiers (pp. 157ff.) with Rouen (p. 177).

9. On Mauclerc, see Sidney Painter, *Scourge of the Clergy: Peter of Dreux, Duke of Brittany* (Baltimore: 1937).

10. Branner, *Saint Louis and the Court Style,* p. 86. Only in the Treaty of 1258 (ratified Dec. 4, 1259) did Henry III finally renounce all claims to Touraine, Anjou, Maine, Poitou, and Normandy.

11. Grodecki, "A Stained Glass Atelier of the Thirteenth Century," pp. 87–111; *Le Vitrail français,* p. 116.

12. CVFR II, pp. 285–95. In addition to Angers, small churches in the Touraine are discussed in Grodecki, *Le Vitrail roman,* pp. 80–88: Chenu (Sarthe) (glass now in Rivenhall, Essex); Charentilly; Les Essards; Chemillé-sur-Indrois; Montreuil-sur-le-Loir (The Saint Louis Art Museum, Missouri). See also: CVFR II, pp. 108–109, 111, 273, 308–309; Françoise Perrot and Anne Granboulan, "The French 12th, 13th and 16th Century Glass at Rivenhall, Essex," *The Journal of Stained Glass* 18/1 (1983–84), pp. 1–14; and on Montreuil, CV Checklist III, p. 202.

13. Robert Branner, *La Cathédrale de Bourges et sa place dans l'architecture gothique* (Paris: 1962), pp. 170–72; Carl Hersey, "Current Research on the Church of Saint Martin at Tours," *Journal of the Society of Architectural Historians* 7 (July–Dec. 1948), pp. 11–12. At its destruction in 1797, Saint-Martin contained much stained glass (though weathered, dirty, and patched with white

glass), according to a manuscript of 1807 which is discussed by Papanicolaou, "Windows of the Choir of Tours," pp. 146–47; see also CVFR II, pp. 123–24.

14. Charles Lelong, "Observations et hypothèses sur l'église abbatiale gothique de Marmoutiers," *Bulletin monumental* 138 (1980), pp. 117–71. The Huguenots in 1562 destroyed the windows, which were replaced by uncolored glass thereafter (p. 120 nn32, 149). Papanicolaou, "Windows of the Choir of Tours," pp. 149–50, hypothesizes, on the basis of a regional comparison, that Marmoutier's glass was Chartrain in style.

15. CVFR II, pp. 121–23; also see Papanicolaou, "Windows of the Choir of Tours," pp. 67–69, 72f., 137–42, and "Stained Glass from Saint-Julien," pp. 75–76. On the French traceries on the south side see Marcel Deyres, "Le Projet de construction du choeur à l'église St.-Julien de Tours," *Bulletin de la Société archéologique de Touraine* 35 (1969), pp. 397–406.

16. The Eloi Master has an energetic style and lively color, but the calmer "principal atelier" has been called Chartrain for lack of a more compelling comparison: *Vitraux de France*, exh. cat., Musée des arts décoratifs (Paris: 1953), pp. 58–59, pl. 14; Grodecki, "Les Vitraux du Mans," pp. 77–81. See the excellent discussion by Catherine Brisac in *La Cathédrale du Mans*, pp. 109–12; also CVFR II, pp. 246–47.

17. This is the opinion of Linda Papanicolaou, "St. Martin and the Beggar: A Stained-Glass Workshop from the Lady Chapels of the Cathedrals of Le Mans and Tours," *Studies on Medieval Stained Glass*, Corpus Vitrearum United States, Occasional Papers 1, ed. Madeline Caviness and Timothy Husband (New York: 1985), pp. 60–69.

18. Louis Grodecki, "Les Problèmes de l'origine de la peinture gothique et le 'maître de saint Chéron' de la cathédrale de Chartres," *Revue de l'art* 40–41 (1978), esp. pp. 52f.; Grodecki and Brisac, *Le Vitrail gothique*, pp. 68, 244–45, color pl. 58.

19. On this question, see Caviness, *The Early Stained Glass of Canterbury Cathedral*, p. 53; Grodecki, "Saint Chéron," p. 57; Virginia Raguin, "The Visual Designer in the Middle Ages: The Case for Stained Glass," *Journal of Glass Studies* 28 (1986), pp. 35–37.

20. See for example pl. 21 (Ezekiel), in Louis Grodecki, *Vitraux des églises de France* (Paris, 1947).

21. See for example fig. 39 of *Le Vitrail français*, p. 65.

22. Grodecki, "Saint Chéron," p. 58. *Le Vitrail français*, pl. XIV, shows two lancets in color.

23. Mauclerc was duke of Brittany by virtue of his marriage to the heiress Alix, and therefore, after her death in 1221, held the title only until the majority of his son Jean le Roux, in 1237. The duchess is included here as his claim to power, and there is no real reason that the window should be dated before her death. Their children Jean and Yolande, born in 1217 and 1218, are shown in early adolescence; Mauclerc probably remarried ca. 1230–1234. See Meredith Lillich, "Early Heraldry: How to Crack the Code," *Gesta* 30/1 (1991), pp. 41–47.

24. I have come round to the view that most of these figures are late copies, which was first expounded by Jan van der Meulen in "A *Logos Creator* at Chartres and Its Copy," *Journal of the Warburg and Courtauld Institutes* 29 (1966), esp. p. 96; more recently, van der Meulen, *Chartres, Sources and Literary Interpretations: A Critical Bibliography* (Boston: 1989), pp. 241–42, 595, 597, 598, 603. Roger Adams's work on this theory is most convincing: see his "The Chartres Clerestory Apostle Windows: An Iconographic Aberration?" *Gesta* 26/2 (1987), pp. 141–50. I use as evidence for stylistic arguments here the following bays (Delaporte numbering): Bay 97, Bay 102, and the lower donors of Bays 99 and 100 in the south transept.

25. Grodecki, "Saint Chéron," p. 63n72.

26. Grodecki, "Saint Chéron," p. 60. The north rose is dated ca. 1240 by Hervé Pinoteau, "Autour de la bulle 'Dei filius,'" in *Vingt-cinq ans d'études dynastiques* (Paris: 1982), pp. 295–324. Jean-Bernard de Vaivre prefers 1240–1250 and considers the present lancet figures to be sixteenth-century copies (correspondence with the author, 1981).

27. Disputing pairs occur in Chartres rather naturally in the doublet windows of the clerestory. In the transept the broader lights sometimes accommodate a pair in each lancet, as in Bay 102.

Both disputing pairs and giant medallions are found in the choir clerestory glazing of Troyes cathedral, contemporary with Saint-Père. See *Le Vitrail français*, p. 49, fig. 29.

28. Fragments of the original borders of these patriarchs, probably intended for a nave clerestory location ca. 1240, have been identified: Alain Matthey de l'Étang, "Etats-Unis: Brynn [*sic*] Athyn, deux panneaux de bordure chartrains au Musée Glencairn," *Bulletin monumental* 146 (1988), pp. 130–32. Also see Lillich, *Saint-Père*, p. 9, chaps. II (esp. p. 44n47) and VII.

29. Lillich, *Saint-Père*, pls. 20 (Bay 10 bottom left) and 17 (Bay 8 top left).

30. Lillich, *Saint-Père*, color pl. III (Bay 11); also Bay 10, top figures.

31. Lillich, *Saint-Père*, p. 24; list of cartoons of the choir prophets. Cartoon B appears once in Bay 8 (bottom right) and twice in Bay 9 (right figures, the upper one with a restored panel of the head and shoulders). See *Saint-Père*, pls. 17, 18.

32. For example, Lillich, *Saint-Père*, color pl. II (Bay 8 top right); pl. 35 (Bay 16 lower left).

33. There is a blue bay in the Chartres hemicycle, Bay 122 (north of axial), but it has no yellow and a very mannered olive green. The effect is different, much more chill. The Saint-Père color harmony is not chill but rich and saturated.

34. Grodecki, *Le Vitrail roman*, p. 82.

35. See Chap. II, p. 20, Bays 211, 200, and the right lancet of 201.

36. Lillich, *Saint-Père*, pp. 69–74.

37. For Grodecki, see n. 18; for Adams, see n. 24.

38. Ultimately the glass itself became thinner and hence more light-passing. The pioneer study of the new style is Gruber, "Quelques aspects du vitrail en France," pp. 71–94. See also Philippe Verdier in *Art and the Courts*, pp. 108–12; *Transformations of the Court Style*, pp. 100–109.

39. This transition was established in Louis Grodecki, "Le Vitrail et l'architecture au XIIe et au XIIIe siècles," *Gazette des beaux-arts*, 6th ser., 36 (1949), pp. 18, 20.

40. Into the mid-1260s Le Mans cathedral was still being glazed with deeply colored glass throughout the upper ambulatory and clerestory; the campaign ended with grisailles completing the glazing of the ambulatory chapels. See Chap. II.

41. Gruber, "Quelques aspects du vitrail en France," pp. 72, 79.

42. This paragraph is a summary of my study exploring this idea at length, to which the reader is referred: "Monastic Stained Glass," pp. 225–42 (with bibliography).

43. Marie-Dominique Chenu, O.P., "Le Dernier avatar de la théologie orientale en Occident au XIIIe siècle," *Mélanges Auguste Pelzer* (Louvain: 1947), pp. 159–81.

44. Victorin Doucet, O.F.M., "La Date des condamnations parisiennes dites de 1241. Faut-il corriger le Cartulaire de l'Université?" *Mélanges Auguste Pelzer* (Louvain: 1947), pp. 183–93.

45. Etienne Gilson, *History of Christian Philosophy in the Middle Ages* (New York: 1955), p. 260; H. F. Dondaine, O.P., *Le Corpus dionysian de l'université de Paris au XIIIe siècle* (Rome: 1953), p. 84n43; Edgar de Bruyne, *The Esthetics of the Middle Ages* (New York: 1969), p. 61.

46. Branner, *Saint Louis and the Court Style*, p. 16.

47. I have reprinted the Le Vieil text in an appendix of "Monastic Stained Glass," with remarks on seventeenth- and eighteenth-century evidence for how certain words should be interpreted. See there nn. 118–21 for bibliography on the monuments in this paragraph. The seventeenth-century painting showing the brownish, weathered grisailles of the Notre-Dame nave was published by Pierre-Marie Auzas, "La Décoration intérieure de Notre-Dame de Paris au dix-septième siècle," *Art de France* 3 (1963), pp. 124–34, with a large color reproduction on p. 125. The painting has been acquired by the Musée Notre-Dame, Paris.

48. On the small Ile-de-France churches: CVFR I, pp. 82, 89–90, 212. Villers-Saint-Paul is illustrated in Lillich, "Monastic Stained Glass," p. 235. On Auxerre: Raguin, *Stained Glass in Burgundy*, pp. 60–63; CVFR III, pp. 114, 121–23. A late example is Villeneuve-sur-Yonne: CVFR III, p. 198; Françoise Gatouillat, "La Vitrerie de Notre-Dame de Villeneuve-sur-Yonne au XIIIe siècle," *Etudes Villeneuviennes* 10 (1987), pp. 2–8.

49. On Saint-Jean-aux-Bois see: Arthur Mäkelt, *Mittelalterliche Landkirchen aus dem Entstehungsgebiete der Gotik* (Berlin: 1906), pp. 48–51; Marcel Aubert, review of Andrew Philippe, *L'Abbaye de Saint-Jean-aux-Bois (1132–1634)*, *Bulletin monumental* 91 (1932), pp. 321–22; CVFR I, pp. 207–208.

50. On Sens architecture see Robert Branner, *Burgundian Gothic Architecture* (London: 1960), p. 181. This traditional dating has been called into question by Kurmann and Winterfeld, "Gautier de Varinfroy," p. 133; they date the Sens choir reconstruction to the end of the thirteenth century. On the Sens glass, see CVFR III, pp. 181–82; drawings may be found in Charles Cahier and Arthur Martin, *Monographie de la cathédrale de Bourges* (Paris: 1841–1844), Etudes 15–16 (hemicycle medallions) and Grisailles F (grisailles). I would like to thank Linda Papanicolaou for bringing these windows to my attention.

51. See the description by Sauval in the appendix to my "Monastic Stained Glass," as well as bibliography in n. 115 there. In that study I argued that the triforium of Saint-Denis (probably glazed 1241–1258) received grisailles, probably in a summer-and-winter ensemble, which was quickly copied in the triforium of Tours in 1255 and at Saint-Père; and that the clerestories of Saint-Denis were the first band windows, copied quickly in two bays of Tours and with variations at Saint-Père. For new evidence supporting my hypotheses, see Chap. III at nn. 89 and 90.

52. Lillich, "Three Essays on French Thirteenth-Century Grisaille Glass," pp. 70–73.

53. Lillich, "A Redating of the Thirteenth-Century Grisaille Windows of Chartres Cathedral," *Gesta* 11/1 (1972), pp. 11–18.

54. On the war financing between 1245 and 1248, see Jordan (as in n.7), chap. IV.

55. The date of the triforium glazing can be established by the coats of arms, which I have published in "The Triforium Windows of Tours," pp. 29–35.

56. See Lillich, *Saint-Père*, pp. 4, 76n1, 77n17.

<div align="center">CHAPTER 2</div>

1. Grodecki, *Le Vitrail roman*, pp. 57–70; Brisac in *La Cathédrale du Mans*, pp. 51–52 and 59–69; CVFR II, pp. 243–45.

2. *La Cathédrale du Mans*, pp. 139–46 and 159; CVFR II, p. 257.

3. Eugène Hucher, *Calques des vitraux de la cathédrale du Mans*, 2 vols. (Paris: 1855–1862), (book is 85.5 cm. high); Hucher, *Vitraux peints de la cathédrale du Mans* (Paris: 1865), (62.5 cm. high).

4. Grodecki, "Les Vitraux du Mans," pp. 59–99.

5. Robert Branner, *La Cathédrale de Bourges et sa place dans l'architecture gothique* (Paris: 1962), pp. 176–80; *La Cathédrale du Mans*, pp. 81–102; Mussat, *Le Style gothique de l'ouest*, pp. 121–29.

6. Branner, *Saint Louis and the Court Style*, p. 81. For a nuanced opinion, see Michel Bouttier, "La Reconstruction de l'abbatiale de Saint-Denis au XIIIe siècle," *Bulletin monumental* 145 (1987), pp. 368–70, 374, 380.

7. Mussat, *Le Style gothique de l'ouest*, p. 129 and n.20; Grodecki, "Les Vitraux du Mans," p. 61; Grodecki and Brisac, *Le Vitrail gothique*, p. 130.

8. Grodecki, "Les Vitraux du Mans," p. 87; see also Emile Mâle, "La Peinture sur verre en France," in André Michel, *Histoire de l'art* (Paris: 1906), vol. 2, pp. 382–83; Grodecki and Brisac, *Le Vitrail gothique*, p. 128.

9. Grodecki, "Les Problèmes de l'origine de la peinture gothique et le 'Maître de saint Chéron' de la cathédrale de Chartres," *Revue de l'art*, nos. 40–41 (1978), p. 61.

10. Grodecki, "Les Vitraux du Mans," p. 86.

11. Bays 211, 201 (right lancet only), and 200. See ibid., p. 93; Grodecki, "Saint Chéron," p. 61 and n. 88; *Le Vitrail français*, p. 153 (right).

12. Bays 209, 207, 205, 201 (left lancet), 202, 210. *Le Vitrail français*, p. 153 (left).

13. Bay 203 on the north; Bays 204, 206, and 212 on the south.

14. Ambroise Ledru, ed., *Plaintes et doléances du chapitre du Mans après le pillage de la cathédrale par les huguenots en 1562,* Archives historiques du Maine, 3 (Le Mans: 1903), p. 247. This inconsequential sum can be compared with the cost of 35 *livres tournois* for two "formes de voyre blanc bordé." An excellent summary of the history of damage and restoration at Le Mans is in *La Cathédrale du Mans,* pp. 107–109.

15. See n. 136 below on the remaining grisailles.

16. While architectural historians agree that the Le Mans choir clerestory uses Parisian forms, Bouttier's careful analysis of detail (see n. 6 above) seduces him into attributing the design to Jean de Chelles. The latter's Notre-Dame transept is playful but has little in common with the dramatic explosion of effects at Le Mans. As usual, Jean Bony comes closest to defining the latter's "unique visionary quality": Bony, *French Gothic Architecture of the 12th and 13th Centuries* (Berkeley: 1983), pp. 260–65.

17. Virginia Raguin, "The Isaiah Master of the Sainte-Chapelle in Burgundy," *Art Bulletin* 59 (1977), pp. 491–93; Papanicolaou, "Windows of the Choir of Tours," chap. V and pp. 234–40.

18. G. Busson and A. Ledru, *Actus pontificum cenomannis in urbe degentium* (Le Mans: 1902), p. 491: "Addere libet de clausoriis et cultorum vinearum, qui videntes cereos aliorum, ad quorum exemplum nichil fecerant, inter se mutuo loquentes aiebant: Alii fecerunt momentaneum luminare; faciamus vitreas, que illuminent ecclesiam in futurum. Fecerunt autem formam integram quinque vitreas continentem, in quibus ipsi per officia depinguntur."

19. Léonce Celier, *Catalogue des actes des évêques du Mans jusqu'à la fin du XIIIe siècle* (Paris: 1910), p. 312.

20. My argument and evidence have been presented in "Consecration," pp. 344–52.

21. Jordan, *Louis IX and the Challenge of the Crusade,* pp. 124–25, 141.

22. The first battles of the summer were indecisive. There was an uneasy truce, then a treaty in July, the month St Louis landed in Provence. The king was in Paris by the end of August and put out the fire, paying his brother Charles for the loss of his dreams and his new county.

23. Charles d'Anjou was not on good terms with the bishop of Le Mans; he contributed nothing to the cathedral's construction and was in no way involved in the consecration ceremony. Quite the contrary—the *Actus* specifies that, having been called to arms by the prince, those attending the ceremony chose to do so nearly at risk to life and property (Busson and Ledru, *Actus pontificum,* p. 491). The attitude of the prince, who was not from the region and rarely went there, in no way affects my argument that the consecration was radically accelerated once the Angevin barons had been called to war. I am grateful to Jane Williams for her skepticism.

24. The patron saints are shown standing and tonsured, with their names inscribed below them; Protais on the left wears a dalmatic and holds a book; Gervais, in a cloak, holds a cross staff. See n. 9 above, n. 26 below. A restoration chart is published in Catherine Brisac and Didier Alliou, *Regarder et comprendre . . . Un vitrail* (Le Mans: 1985), p. 67.

25. The arms of this knight (*gueules à 2 léopards d'or passants*) are verifiable by his seal of 1261 and the Bigot Roll of 1254. For the seal: Louis Douët-d'Arcq, *Collection de sceaux des archives de l'Empire* (Paris: 1863), no. 2912. For the Bigot Roll, see n. 30 below; see also Lillich, "Consecration," p. 350 and fig. 2.

26. Grodecki, "Les Vitraux du Mans," pp. 81–83, points out that the legends of Sts Protais and Gervais do not explain the suicidal "socle" figures, which are derived from those of the lancets below the Chartres north rose. The stocky, immovable forms are likewise derivative.

27. The best sources of his life are: A. Robveille, *Seigneurie et paroisse de Montfort-le-Rotrou* (Laval: 1910), pp. 17–21; Louis de Grandmaison, *Cartulaire de l'archévêché de Tours* (Tours: 1894), vol. 2, pp. 298–300.

28. *Recueil des historiens des Gaules et de la France,* ed. M. Bouquet et al. (Paris: 1855; Paris: 1968), vol. 23, pp. 685b, 727d (1242); vol. 22, p. 750g (1269).

29. Paris, Bibl. nat., Touraine VII–Dom Housseau, nos. 3006 and 3009. She was still alive in November 1261 when they established their anniversaries: Arch. de la Sarthe H 1113.

30. They are listed in the Bigot Roll that records the armies: Paul Adam-Even, "Un Armorial français du milieu de XIIIe siècle, le rôle d'armes Bigot—1254," *Archives héraldiques suisses* 63 (1949), nos. 237, 235.

31. Rotrou made his will in 1269. His daughter and heiress sealed as the wife of Guillaume l'Archévêque, lord of Parthenay, in April 1272: Francis Eygun, *Sigillographie du Poitou* (Poitiers: 1938), no. 543.

32. The funguslike crockets at Chartres, Bay 103 of the south transept, are in canopywork of questionable authenticity. See Chap. I, n. 24.

33. Grodecki, "A Stained Glass Atelier of the Thirteenth Century," pp. 87–111. It is my feeling that Bourges is the key monument for understanding what development can be traced in the west—or would be, if the glazing of the nave aisles had not been lost.

34. In contrast, the Chartrain adaptations in the clerestory of Coutances are based on forms and subjects of the Chartres hemicycle clerestory group, without any evidence of an awareness of the late "Saint Chéron" style. Small formulas are exaggerated, such as the bulbous heels, but nothing disturbs the judgment that the main Coutances painter knew Chartres well, and that he had left there before the late Chartrain style developed.

35. The chronicler (*Actus*) reports with satisfaction that the bishop had not put the see into debt, a remarkable feat for a cathedral builder in the 1240s: see Mussat, *Le Style gothique de l'ouest*, p. 122n4.

36. See *La Cathédrale du Mans*, pp. 106, 108, 119. Bishop Geoffroy de Loudun's arms are verifiable by his tomb in the Chartreuse du Parc-au-Maine (Parc-au-Charnie), drawn for Gaignières (Paris, Bibl. nat. lat. 17036, fol. 163), and by his seal of 1239. The seal (Eygun, *Sigillographie*, no. 409 counterseal) is illustrated in L.-J. Denis, "Notes et documents sur la famille et les armes de Geoffroy de Loudun, évêque du Mans," *Province du Maine* 13 (1905), p. 243.

37. Geoffroy was seigneur of Trèves-sur-Loire near Saumur. His eldest brother Foulques had died ca. 1200 and his second brother Hemery before 1231, when Geoffroy (then precentor of the cathedral of Le Mans) inherited the *terre*.

38. See Lillich, *Saint-Père*, pp. 191, 195n5. The Crucifixion in the axial clerestory of Beauvais includes a chalice: see Cothren, "Glazing of the Choir of Beauvais," p. 348, pl. 103.

39. Grodecki, "Les Vitraux du Mans," p. 93.

40. Grodecki, "A Stained Glass Atelier of the Thirteenth Century," p. 89. See also Grodecki, "Le 'Maître du Bon Samaritain' de la cathédrale de Bourges," *The Year 1200: A Symposium* (New York: 1975), pp. 339–59.

41. Grodecki, "A Stained Glass Atelier of the Thirteenth Century," pl. 21b.

42. Charles Cahier and Arthur Martin, *Monographie de la cathédrale de Bourges* (Paris: 1841–1844), pp. xxxii–iii and Grisailles A.

43. Lozenge grounds are common in the upper windows of the Bourges choir. They have a long life in the west, still in use in the Saint-Père nave by the remarkable expressionist who designed the window of John the Baptist (Bay 26) (Lillich, *Saint-Père*, p. 65, pls. 76–78). See also the original filler flanking the saints in Bays 20 and 21 (pls. 55–57).

44. CVFR II, pp. 199–200. The Châteauroux composition, like the Bishop Geoffroy bay at Le Mans, is also unframed in the western manner, but its coloration has a more standard red-blue base.

45. Compare, for example, Malachi in the Bourges north clerestory: Grodecki, *Vitraux des églises de France* (Paris: 1947), pl. 22.

46. The ninth-century chronicler is the infamous Le Mans Forger. See most recently Walter Goffart, *The Le Mans Forgeries* (Cambridge, Mass.: 1966), particularly pp. 36, 173. See n. 142 below.

47. The canons were buried habitually at the abbey of Saint-Vincent. See Julien Chappée, A. Ledru, and L.-J. Denis, *Enquête de 1245 relative aux droits du Chapitre Saint-Julien du Mans*, Société des Archives historiques du Cogner (Paris: 1922), p. cxlii.

48. The plan indicates that the choir widens just beyond the crossing piers, worsening this problem. This widening is part of the thirteenth-century construction of the choir (and not the fifteenth-century construction of the transept) since it contains two small windows, Bays 113 and 114, glazed by the thirteenth-century glaziers.

49. Bay 211 is illustrated in Becksmann, *Die architektonische Rahmung des hochgotischen Bildfensters,* pl. 1.

50. Illustrated in Willibald Sauerländer, *Gothic Sculpture in France, 1140–1270* (New York: 1972), pl. 85. On the identification of the Chartres jamb statue see Roger J. Adams, "Isaiah or Jacob? The Iconographic Question on the Coronation Portals of Senlis, Chartres, and Reims," *Gesta* 23/2 (1984), pp. 119–30.

51. Illustrated in CVFR II, p. 37. Although the inscription was restored by Gaudin in 1920, Westlake's drawing records it: N. H. J. Westlake, *A History of Design in Painted Glass* (London: 1881), vol. 1, p. 56.

52. Hucher reported the second figure's inscription as []DREAS. The third figure repeats the cartoon of the first, but the face is now an ancient, grotesque repair, probably dating from after the Huguenot damage—a Renaissance concept of medieval drawing.

53. See Sauerländer, *Gothic Sculpture,* p. 432. John has a palm at both Saint-Père and Tours. For a discussion of this Joannine attribute see Lillich, *Saint-Père,* pp. 96–97, 101–102n25, 118.

54. Illustrated in Yves Delaporte and Etienne Houvet, *Les Vitraux de la cathédrale de Chartres* (Chartres: 1926), vol. 3, pls. clxxxvii, ccxv.

55. My list of the decorative motifs of the Master of Bishop Geoffroy, with their corresponding motifs at Saint-Père: border with two-sprigged floriate pattern (rosette, SP Bay 10); frontal houses with black, outlined arcades (SP Bay 8); outlined black trefoils (SP Bay 17); doubled half-circles (fan-tile) roofing (SP Bays 8, 16); alternating ovals and diamonds with one side outlined, divided by two dots (used for draperies, books); patterns of doubled-lined scallops; patterns of undulating lines embellished with tiny circles.

56. His obvious difficulty with the large format in Bays 200 and 201 suggests, however, that he had not designed in large scale before.

57. CVFR I, p. 221. The plates in *Le Vitrail français* were no doubt purposefully placed in sequence to emphasize this relationship; see pls. 117, 118 (pp. 153, 154). Bernard d'Abbeville became bishop of Amiens in 1258. The inscription still in the window (BERNARD EPC ME DEDIT. M. CC. LXIX) is reported in several seventeenth-century accounts, the earliest by Adrian de la Morlière, *Antiquitez, histoires et choses plus remarquables de la ville d'Amiens* (Paris: 1627), p. 234. Evidence is provided by old accounts that the choir triforium and clerestory were filled with apostles and prophets, some meager debris of which now fills the central lancet of each triforium bay.

58. On the destruction at Amiens see Georges Durand, "La Peinture sur verre au XIIIe siècle et les vitraux de la cathédrale d'Amiens," *Mémoires de la Société des antiquaires de Picardie* 31 (1891), pp. 389–424. He assigns the large-scale removal of glass to the Parisian glazier Dupetit working for the architect Godde in 1812–13; he reports a tradition that the glass had been sold to England (pp. 399–400).

59. Hucher in 1865 stated this observation flatly: "Ces trois panneaux sont d'une exécution excessivement mauvaise; on ne retrouve nulle part ailleurs ce faire incorrect et maladroit." (Hucher, *Vitraux peints* [as in n. 3], "Triforium, Sixième fenestre. Troisième lancette.")

60. Grodecki, "Les Vitraux du Mans," p. 82.

61. My evidence was published in "Consecration." The lords of Montbazon served Philippe Auguste and St Louis and patronized Fontevrault Abbey. See references in: *Recueil des historiens* (as in n. 28), vols. 20–24; *Layettes du trésor des chartes,* ed. Alexandre Teulet and Joseph de Laborde (Paris: 1863–1875), vols. 2 and 3; the Fontevrault charters in Paris, Bibl. nat. lat. 5480, pp. 153, 374, 377 *et passim.*

62. Grodecki, "A Stained Glass Atelier of the Thirteenth Century," pp. 89–97 (Bourges Good Samaritan Master); pp. 100–106 (Poitiers).

63. On the dating at Poitiers cathedral, see: ibid., p. 107; Grodecki, "Les Vitraux de la cathédrale de Poitiers," *Congrès archéologique* 109th session (1951), pp. 160–62; Mussat, *Le Style gothique de l'ouest,* pp. 257–58. The late glass is dated ca. 1230–1240. A vivid demonstration of the evolution between Poitiers cathedral and Sainte-Radegonde (see Chap. IV) can be found in the panel of ca. 1210–1220 in the Metropolitan Museum, with a replaced head by the Sainte-Radegonde atelier (illustrated in *The Year 1200, I: The Exhibition* [New York: 1970], no. 201). On these thirteenth-century restorations in Poitiers cathedral see Grodecki, "A Stained Glass Atelier of the Thirteenth Century," p. 101n12.

64. There is one new direction at Sainte-Radegonde: the noble ladies, angels, and saints now have high *bombé* foreheads.

65. Pierre Savary II was lord of Montsoreau on the Loire near Saumur (through his grandmother Marguerite, the bishop's sister); in 1250 he inherited his natal home of Montbazon (south of Tours) and Colombiers (just north of Poitiers).

66. On Poitiers in the 1240s, see Kraus, *Gold Was the Mortar,* pp. 163–64. He is overly harsh on Alphonse, whose glass at Sainte-Radegonde was not recognized as his (and therefore dated too late) in the literature that Kraus relied on.

67. Examples include the illuminators who left Flanders to work in France for the duc de Berry and the several talented but untutored Dutchmen who went south to work in Flemish cities in the fifteenth century.

68. On the date of the chapel see Branner, *Saint Louis and the Court Style,* p. 69.

69. Grodecki, "Stained Glass Windows of St. Germain-des-Prés," *Connoisseur* 160 (August 1957), pp. 34–35, illustrated figs. 6, 7; Philippe Verdier, "The Window of Saint Vincent from the Refectory of the Abbey of Saint-Germain-des-Prés (1239–1244)," *Journal of the Walters Art Gallery* 25–26 (1962–63), figs. 46–49; CVFR I, pp. 46–47 (Bay 4); Grodecki and Brisac, *Le Vitrail gothique,* pp. 92–96; Mary Shepard, "The Thirteenth Century Stained Glass from the Parisian Abbey of Saint-Germain-des-Prés" (Ph.D. diss., Columbia University, 1990), pp. 140–48. She characterizes the style as "expressive and dramatic" and "bristling with energy," and she traces the glaziers to the Notre-Dame transept roses after Saint-Germain was finished.

70. Heavy facial shading appears irregularly in the second quarter of the thirteenth century. See, for example, one of the ateliers working ca. 1230 at Rouen cathedral (illustrated in *Le Vitrail français,* figs. 27, 109). The Rouen atelier is otherwise completely distinguishable from the western group we are discussing.

71. Grodecki, "Les Vitraux du Mans," p. 88; see also *La Cathédrale du Mans,* p. 115 bottom.

72. There is weaker evidence in two more cases. Bay 112 contains monastic miracles of the Virgin; the Cistercians of L'Epau have been suggested as the donor. Hucher, on less firm grounds, hypothesized that Bay 103 was given by Abbot Robert de Saint-Paul-le-Gautier of the abbey of Beaulieu, since its subjects are St Paul and the Virgin, patroness of Beaulieu.

73. See Dom Leon Guilloreau, "Les Tribulations d'Ernaud, abbé d'Evron (1262–63)," offprint, *Bulletin historique de la Mayenne* 20 (1904?), pp. 414–22; Lillich, "Consecration," n. 15.

74. Grodecki, "A Stained Glass Atelier of the Thirteenth Century," p. 105. There is local precedent at Le Mans: the Infancy cycle in the Lady Chapel reads from the top down. See Grodecki, "Les Vitraux du Mans," p. 80.

75. Gertrud Schiller, *Iconography of Christian Art* (New York: 1966), vol. 1, p. 42, ascribes the desk and book to the Carolingian and Ottonian periods. The ca. 1260s debris in the Evreux nave includes another and equally inexplicable example: see Chap. III, p. 72.

76. On the crowned Virgin in Infancy scenes in the twelfth century in western art, see Hayward and Grodecki, "Les Vitraux d'Angers," p. 14 and n. 2. Another rare example is the Chartres west facade, lintel of the Infancy portal.

77. This formula lasted through the thirteenth century in the west: see the Tours clerestory Bay 202; also Saint-Père axial bay of the hemicycle, tracery light (Lillich, *Saint-Père*, p. 105).

78. Schiller, *Iconography of Christian Art*, vol. 1, p. 92. The Chartres west portal probably had a blessing Christ, now broken.

79. Ibid., p. 120, gives examples of Joseph's backward glance from the tenth century and before, but it is not typical of the French Romanesque.

80. Ibid., pp. 98f., states that the magi narratives, Carolingian in origin, enjoyed a second period of popularity in the twelfth century and were not depicted together in such detail thereafter.

81. Hayward and Grodecki, "Les Vitraux d'Angers," pp. 45–46 (Bay S 1); CVFR II, p. 288 (Bay 100).

82. A. Marquet, *La Cathédrale du Mans* (Le Mans: 1983), p. 52 (fenêtre 4). On the state of restoration see Grodecki, "Les Vitraux du Mans," p. 80; CVFR II, p. 246 (Bay 3).

83. In the early fourteenth-century clerestories of Evron, the Adoration occupies an entire bay. The life-size magi, in two of the three lancets, are over twice the size of the Virgin and Child they worship. See Chap. VIII, pp. 279f. (Bay 103).

84. Schiller, *Iconography of Christian Art*, vol. 1, pp. 105–108.

85. Jean Taralon, *Treasures of the Churches of France* (London: 1966), pp. 283–84, pls. 160–61; Taralon, *Les Trésors des églises de France*, exh. cat., Musée des Arts Décoratifs (Paris: 1965), color pl. VII, pp. 133–34, with bibliography. See also Chap. VIII at n. 2.

86. A number of the "modern" details can be found in the Infancy cycle of the Sainte-Chapelle (Bay I): Flight to Egypt with Joseph looking back and Mary clutching the Child to her face; Nativity with Mary gesturing to a sleeping Joseph; Adoration with first king kneeling, crown off.

87. Illustrated and mislabeled in CVFR II, p. 251.

88. Hayward and Grodecki, "Les Vitraux d'Angers," pp. 20–21 (Bay N 16); CVFR II, p. 294 and pl. XVI (Bay 123). Another copy of the Angers Dormition window is at Les Essards, between Angers and Tours (Grodecki, *Le Vitrail roman*, p. 88; CVFR II, p. 111).

89. Sauerländer, *Gothic Sculpture* (as in n. 50), pl. 131 (Strasbourg, ca. 1230); pl. 141 (Lemoncourt, ca. 1230), etc. See also Emile Mâle, *Religious Art in France: The Thirteenth Century* (Princeton: 1984), pp. 256–57.

90. Marquet, *La Cathédrale du Mans*, p. 53 (fenêtre 8); CVFR II, p. 248 (Bay 4).

91. The western tradition established by the Angers window may be traced back to the twelfth-century tympanum of Saint-Pierre-le-Puillier, Bourges: now in the Musée du Berry, discussed by Emile Mâle, *Religious Art in France: The Twelfth Century* (Princeton: 1978), pp. 437–38, fig. 307.

92. Michael Cothren, "The Iconography of Theophilus Windows in the First Half of the Thirteenth Century," *Speculum* 59 (1984), pp. 308–41. On the Jewish Child of Bourges: Mâle, *Thirteenth Century*, pp. 263, 265; Lillich, "Gothic Glaziers," pp. 72–73 and fig. 1.

93. The miracles of Gregory of Tours's account that appear in the Lady Chapel windows and again in Bay 112 are the Raising of the Columns by Children and the Convent Famine at Jerusalem. Bay 112 adds to these stories the Marian miracle of the Rescue of the Fallen Painter: for an elaborate illustration of the latter from the Cantigas of Alfonso X (second half of the thirteenth century) see Virginia Egbert, *The Mediaeval Artist at Work* (Princeton: 1967), p. 49.

94. Mâle, *Thirteenth Century*, pp. 265–66. Relics of the Virgin's milk were white clay from the Grotto of Bethlehem, sold in *encolpia* and worn around the neck. See Taralon, "Le Trésor d'Evron" (1961), p. 307n2.

95. On *libelli* of Benedictine pilgrimage abbeys as the sources of artistic traditions, see Caviness, *The Early Stained Glass of Canterbury Cathedral*, p. 142; Lillich, "Monastic Stained Glass," pp. 208–11. The *libellus* of Sainte-Radegonde, Poitiers (now in the Bibliothèque municipale), was the source for the window of her legend in the church. See Chap. IV, p. 88.

96. The Huguenots cleaned out the Evron treasury, but a bust of St Hadouin in silver-coated copper was made in 1644: Pierre-Marie Auzas, *Trésors des églises angevines*, exh. cat., Château d'Angers (Angers: 1960), no. 78. There is also a baroque terra-cotta figurine of Hadouin: Augustin Ceuneau, *Evron, la basilique et l'abbaye bénédictines, la ville* (Evron: 1949), p. 37.

97. Hayward and Grodecki, "Les Vitraux d'Angers," p. 34 (Bay N 8); see also the earlier Dormition bay, p. 20 (Bay N 16), illustrated in CVFR II, pl. XVI (Bay 123).

98. Angers: Hayward and Grodecki, "Les Vitraux d'Angers," p. 16 (Bay N 18). Chenu: CVFR II, p. 273; Grodecki, *Le Vitrail roman*, pl. 67. This glass is now at Rivenhall in England. One could also mention Poitiers cathedral ca. 1170: ibid., pl. 59.

99. Ibid., pls. 52, 55; CVFR II, p. 243.

100. Le Mans Bay 108 (CVFR II, p. 252); Bourges, in the Moses bay and in the nave grisailles. Other examples from the first half of the thirteenth century include Saint-Vaast, Agnières (Somme), the Sainte-Chapelle.

101. Compare the illustrations in: Grodecki, *Le Vitrail roman*, pl. 50; *La Cathédrale du Mans*, p. 64; *Le Vitrail français*, pp. 66, 97.

102. The recent cleaning of the Evron cult statue revealed the original painting of the throne in red and green. Taralon, *Treasures* (as in n. 85), p. 284.

103. Another western window with decorative vocabulary (medallion frames, corner rosettes) similarly based on twelfth-century western practice is at Vivoin (Sarthe) near Le Mans: *Le Vitrail français*, p. 130; *La Cathédrale du Mans*, pp. 117–18; CVFR II, pp. 272–73, where it is illustrated facing an example of the twelfth-century type on which it is based (Chenu). In my opinion, Vivoin does not fall within the venue of this book: the style and color are not closely related to western expressionism, and the date of 1255 suggested in recent literature is, I believe, too late.

104. On the Jean de Bernières Master of Sées, who painted the glass of the chapel of Aunou nearby, see Meredith Lillich, "A Stained Glass Apostle from Sées Cathedral (Normandy) in the Victoria and Albert Museum," *Burlington Magazine* 119 (July 1977), pp. 497–500 and fig. 1. His figure is a composition in the Evron Master's colors—red, green, and yellow. See also Chap. VI, pp. 206 f.

105. The upper ambulatory bays by the Principal Atelier are illustrated in: *La Cathédrale du Mans*, p. 113 (Bay 101, donor in left lancet, incorrectly identified) and p. 115 top (Bay 103); *Le Vitrail français*, p. 148 (Bay 103); Grodecki and Brisac, *Le Vitrail gothique*, pp. 128–29 (Bays 103, 107); Grodecki, "Les Vitraux du Mans," p. 85 (Bay 107); Linda Papanicolaou, "A Window of St Julian of Le Mans in the Cathedral of Tours: Episcopal Propaganda in Thirteenth-Century Art," *Studies in Iconography* 7/8 (1981–82), figs. 5, 10 (Bay 107); CVFR II, pp. 249, 252 (Bays 102, 108, 109). Bay 104 (CVFR II, p. 250) is not by the Principal Atelier but a probable collaboration of the Decorator and the Tric-trac Master, glaziers who also collaborated in the Le Mans clerestory Bay 203.

106. Details of Bay 209 are illustrated in: Grodecki and Brisac, *Le Vitrail gothique*, pp. 32, 131; *La Cathédrale du Mans*, p. 124 (color); CVFR II, p. 255.

107. A complete montage of Bay 207 is illustrated in *La Cathédrale du Mans*, p. 121 top.

108. A complete montage of Bay 205 is illustrated in Grodecki, "Les Vitraux du Mans," p. 89. I have taken the apostle with the Latin cross to be St Andrew, on the basis of a similar pairing of Andrew and Bartholomew in Bay 24 of Saint-Père de Chartres. Andrew's cross and Bartholomew's knife were among the earliest of the apostles' attributes to reach standardization.

109. The painting is typical of the Tric-trac Master but hard and dry, as though it were the tracing of a cartoon. The color gamut (excepting the donors) has the unraveled quality typical of the Decorator; perhaps he did the glass cutting. Illustrations of Bay 203 are found in: Grodecki, "Les Vitraux du Mans," pp. 94–95; *La Cathédrale du Mans*, pp. 121 bottom (donors) and 126; CVFR II, p. 254 (donors). The donors are furriers, not drapers as labeled.

110. Illustrated in *La Cathédrale du Mans*, p. 122; *Le Vitrail français*, fig. 117 left.

111. Bay 202 appears on the right of the color plate in *La Cathédrale du Mans,* p. 106. The "masons' signature panel" reported by Hucher can be discounted. The panel he saw (two men with batons watching two men hammering on an anvil) is now among the debris in the north chapel. It is small in scale and cannot have originated in the clerestory.

112. Illustrated in CVFR II, p. 256; Lillich, "Tric-trac Window," pp. 26–27.

113. Paris, Bibl. nat. nouv. acq. fr. 6103, fols. 92r–94v.

114. The text is quoted above, n. 18.

115. Hucher suggested other monastic gifts with less solid evidence; see above, n. 72.

116. Hucher mentions without evidence that the arms of Saint-Vincent included a discipline. St Domnole, a late sixth-century bishop of Le Mans, founded the abbey of Saint-Vincent and was buried in its crypt. See Louis Duchesne, *Fastes épiscopaux de l'ancienne Gaule* (Paris: 1899), vol. 2, p. 322.

117. It is a homogeneous design and datable by the appearance of Guillaume Roland in the center lancet; see discussion above. This bay is directly beneath Bay 211 at the north crossing and was probably in place in 1254.

118. Chappée, Ledru, and Denis, *Enquête de 1245* (as in n. 47), *passim.*

119. Duchesne, *Fastes épiscopaux,* p. 322.

120. Compare the tools of the winegrowers, shown in scenes and borders of Bay 107.

121. *Butler's Lives of the Saints,* ed. Herbert Thurston and Donald Attwater (New York: 1963), vol. 2, p. 677; Ambroise Ledru, "Saint Bertrand, évêque du Mans, 586–626 environ," *La Province du Maine* 14 (1906), p. 376, and 15 (1907), pp. 51, 124 (citing Busson and Ledru, *Actus pontificum* [as in n. 18], pp. 114, 118–19).

122. According to the early but reliable account of Antoine de Corvaisier, *Histoire des évêques du Mans* (Paris: 1648), p. 516. A similar but unnamed priest is shown in Bay 209, stylistically of a piece with this window. There is no evidence that this figure is Roland.

123. Bertrand de Broussillon, *Cartulaire de l'évêché du Mans, 936–1790* (Le Mans: 1900), nos. 737–38.

124. Ibid., no. 519.

125. René-Jean-François Lottin, *Chartularium insignis ecclesiae cenomannensis quod dicitur Liber albus capituli* (Le Mans: 1869), pp. 138, 439, lists an archdeacon Odon from 1232 to ca. 1280.

126. See color plate in *La Cathédrale du Mans,* p. 124 top. In comparison, the procurer of the Victorine community of Sées is shown in the window there bareheaded and wearing a blue-hooded cape over a white robe.

127. Ledru initially realized this: "Il est téméraire d'identifier cet individu avec celui du vitrail comme l'a fait M. Hucher, sans autre motif que la similitude des noms." (Ambroise Ledru, *La Cathédrale Saint-Julien du Mans: Ses évêques, son architecture, son mobilier* [Mamers: 1900], pp. 422–23.) In his guidebook of 1923, however, he had swallowed his former misgivings and adopted the identification: Ledru, *La Cathédrale du Mans, Saint Julien* (Le Mans: 1923). There was also a knight called Johannes de Fresneio (Fresnes, Fresnai, Fresnoy) well documented in the king's service. The Le Mans donor is neither monk nor knight.

128. Ledru, *La Cathédrale Saint-Julien,* p. 425. While Ledru gives "before December 4, 1276" for Gautier's death, a charter of 1270 reaffirms an accord made by him in 1250, a procedure normally following a death: Arch. de la Sarthe H 23.

129. Grodecki, "Les Vitraux du Mans," p. 85, probably following Ambroise Ledru, "Note sur Vincent de Pirmil, Archévêque de Tours, 1257 à 1270," *La Province du Maine* 13 (1905), pp. 116–17.

130. My evidence was presented in "Consecration," pp. 348–49.

131. Robert died around 1245. De Broussillon, *Cartulaire du Mans,* p. 254; Chappée, Ledru, and Denis, *Enquête de 1245* (as in n. 47), p. cxlv.

132. They are nos. 189 and 190 of the Bigot Roll, which records that army. The brothers are documented from 1247 to 1274. See Lillich, "Consecration," p. 345.

133. G. Busson and A. Ledru, *Nécrologe-Obituaire de la cathédrale du Mans,* Archives historiques du Maine, 7 (Le Mans: 1906), p. 146 and n. 2, p. 229 and n. 2; Lottin, *Liber albus capituli,* nos. 578, 640.

134. The evidence for this identification and interpretation is presented in Lillich, "Tric-trac Window."

135. Herewith a brief list of his puns: "Maienne"—the giant pair of bishops; "La Chartre" (Jeanne's own land)—the vaulted cells along the bottom of the bay; the games are gambling *jeux-partie,* and pun on the state of jeopardy of Mayenne at this time in the hands of Jeanne's nephew Alain d'Avaugour, a debtor whose sale of his inherited lands to the duke of Brittany was being challenged in Louis IX's court by his children; the gameboard appears in the heraldic colors of the duke (the *échiqueté* of Dreux). In the traceries, the inscription IOHES described by Hucher, the Agnus Dei disc, and the figures of Sts Gervais and Protais all refer to Jeanne and to her baptised name, Gervaise. The use of name saints is quite precocious. The puns and the name saints are discussed in my "Tric-trac Window."

136. Ledru, *Plaintes et doléances* (as in n. 14), pp. 245–46. The grisaille quatrefoil now in Bay 70 was exhibited in Paris in 1884: Lucien Magne, "Le Musée du vitrail," *Gazette des beaux-arts* 34 (Oct. 1886), pp. 309–10. A copy of the Arch. phot. photograph, among the Heaton papers (vol. 9, p. 20, 2) in the Princeton University art library, bears a label stating that the grisaille panel was "found in roof—Cathedral of Le Mans XIII century." Other grisaille scraps are in Bay 85: CVFR II, p. 248; *La Cathédrale du Mans,* p. 111.

137. Branner, *Bourges* (as in n. 5), pp. 63–68, 72.

138. Lillich, "Three Essays on French Thirteenth-Century Grisaille Glass," pp. 70–73.

139. Grodecki, "Les Vitraux du Mans," p. 87; Papanicolaou, "Windows of the Choir of Tours," pp. 229–30; Raguin, *Stained Glass in Burgundy,* p. 81. My own views have evolved since I first grappled with the problem in *Saint-Père* (1978), pp. 71, 74.

140. See Léonce Celier, "Les Anciennes vies de Saint Domnole," *Revue historique et archéologique du Maine* 55 (1904), p. 385 (text of the cure of the deaf-mute child Rainarius).

141. Duchesne, *Fastes épiscopaux* (as in n. 116), vol. 2, p. 309.

142. On the author of the *Actus,* "un imposteur et un faussaire," see: Duchesne, *Fastes épiscopaux,* vol. 2, p. 323; Julien Havet, "Les Actes des évêques du Mans," *Bibliothèque de l'Ecole des chartes* 54 (1893), pp. 597–692, esp. 657; Goffart, *The Le Mans Forgeries* (as in n. 46), p. 51. On the development of the apostolic legend of St Julien: Papanicolaou, "A Window of St Julian of Le Mans" (as in n. 105), pp. 35–64.

143. Grodecki, "Les Vitraux du Mans," p. 78; illustrated in Mâle, *Thirteenth Century* (as in n. 89), p. 262, and in *La Cathédrale du Mans,* p. 105 bottom right.

144. See Lillich, *Saint-Père,* pp. 105–107. Le Mans also has two other crucifixions of Peter (Bays 111 and 101) on a horizontal cross. There is no precedent for this in the iconography of Peter; the artist probably used a cartoon of the crucifixion of Andrew. On the horizontal crucifixion of Andrew, not typical of the Ile-de-France, see Lillich, *Saint-Père,* pp. 108–109 and notes. In Bay 101 the artist has adapted the western tradition, however, since Peter is being nailed; this never happens to Andrew. Bay 111 is bizarre: the whole scene is sideways, executioners included, yet it cannot be set incorrectly in the window since it fits into the top of the lancet.

145. The best account of the iconographic theme is Joseph Duhr, "La 'Dormition' de Marie dans l'art chrétien," *Nouvelle revue théologique* 72 (1950), pp. 134–57.

146. Mâle, *Thirteenth Century,* p. 254 (Sens and Troyes windows), to which can be added Bay 153 of Chartres. Among pre-Gothic manuscripts see the Sacramentary from Mont-Saint-Michel, Pierpont Morgan MS 641 (after 1067): William Wixom, *Treasures from Medieval France* (Cleveland: 1967), pp. 30, 348–49 (no. II 5).

147. The Virgin panel is among the few trustworthy parts of this highly restored window: Grodecki, "Les Vitraux du Mans," p. 78; CVFR II, p. 247.

148. Papanicolaou, "Windows of the Choir of Tours," p. 44; Jean-Jacques Bourassé and F.-G. Manceau, *Les Verrières du choeur de l'église métropolitaine de Tours* (Tours: 1849), pl. VII. Two manuscripts by different painters of the "Leber group" contain the peculiar detail of the Virgin in the Jesse Tree, holding a palm: Vat. MS lat. 120, fol. 2; and Paris, Bibl. nat. lat. 8892, fols. 13, 16. See: Robert Branner, "Le Premier évangéliaire de la Sainte-Chapelle," *Revue de l'art* 3 (1969), figs. 7, 8, 12, pp. 37–48; Emile van Moé and Jean Lafond, "Le Psautier Leber 6 de la bibliothèque de Rouen," *Trésors des bibliothèques de France* (Paris: 1927), vol. 1, pp. 91, 93 (noting unexpected presence of palms). The Leber group is hypothesized to have a Normandy origin. I would like to thank Michael Cothren for bringing to my attention the Leber group manuscripts.

149. Bourges is illustrated in Grodecki and Brisac, *Le Vitrail gothique*, p. 125. See Papanicolaou, "Windows of the Choir of Tours," pp. 230–31.

150. Grodecki, "Les Vitraux du Mans," pp. 82–84, has listed the range of forms found at Le Mans.

151. Smaller oval or bulged medallions occur briefly in Bays 106 and 110, associated with the painting of the Decorator, an artist of minor talent and impact. See discussion, pp. 45–46.

152. On Bay D (Judith-Job): Louis Grodecki and Jean Lafond, *Les Vitraux de Notre-Dame et de la Sainte-Chapelle de Paris*, Corpus Vitrearum Medii Aevi, France I (Paris: 1959), pp. 241–55.

153. Hayward and Grodecki, "Les Vitraux d'Angers," pp. 9, 50–51 (demi-medallions: N-2, N-3); pp. 34–37 (circles: S-8, N-8).

154. Angers: ibid., p. 24 (Bays S-4, S-5). Poitiers: Grodecki, "A Stained Glass Atelier of the Thirteenth Century," pl. 22c (St Blaise). This sort of un-Parisian polygon can be seen later at Tours: Bays 202 (Infancy); 214 (Eustace).

155. Raguin, *Stained Glass in Burgundy*, pp. 80–81.

156. Grodecki, "Les Vitraux du Mans," p. 82, has compared it to the late transept glass at Chartres.

157. While unpainted mosaic might be considered a simplification, pearled filets are certainly more trouble, not less.

158. Papanicolaou, "Windows of the Choir of Tours," p. 230: this color is "very like the south clerestory windows of the second campaign at Tours."

159. Ibid., p. 229; see the color plate in Grodecki and Brisac, *Le Vitrail gothique*, p. 129 (Bay 103).

160. Raguin, *Stained Glass in Burgundy*, p. 81.

161. Papanicolaou, "Windows of the Choir of Tours," pp. 230–31: another painting style in the Bourges rosaces is related to Tours, and the "Le Mans" and "Tours" painters can even be found together in the same medallion.

162. Grodecki, in *Vitraux de France de XIe au XVIe siècle*, Musée des Arts Décoratifs (Paris: 1953), p. 56, pl. 12, no. 18.

163. *Le Vitrail français*, p. 320 n65. To identify restorations and study the original painting, compare two illustrations: (1) Ellen Beer, *Die Glasmalereien der Schweiz vom 12. bis zum Beginn des 14. Jahrhunderts*, Corpus Vitrearum Medii Aevi, Schweiz I (Basel: 1956), Vergleichsabb. 33; (2) *Gray Is the Color*, exh. cat., Rice University (Houston, Tex.: 1974), p. 27, pl. 1.

164. See the donor row of Bay 203 as well as his later work, mentioned below. It is for this reason that I have suggested (n. 109) that the Decorator did the glass cutting (and therefore the color selection) for the upper rows of Bay 203. He did not paint them, however.

CHAPTER 3

1. In 1302 there were three monks and the prior; in 1350, eight monks and the prior; in 1451 there was only a prior, though places for seven others: Guy de Valous, *Le Monachisme clunisien des origines au XVe siècle* (Paris: 1970), vol. 2, p. 194. In 1697 there were four monks: Marcel Lachiver, *Histoire de Mantes et du mantois à travers chroniques et mémoires des origines à 1792* (Meulan: 1971), pp. 369–70. In 1739 the remaining monks moved to the Collège de Cluny in

Paris and the parish expanded from its chapel within the church to take over the choir: Arch. dept. ancien Seine-et-Oise G 686.

A manuscript of ca. 1250–1272 lists eleven *parrochiani,* that is, heads of families: Auguste Longnon, *Pouillés de la province de Sens,* Recueil des historiens de la France, Pouillés IV (Paris: 1904), pp. xii–xiii, 119. In 1738 and in 1759 the parish had sixty-six *feux* but only eighty communicants: Lachiver, p. 421; Arch. dept. ancien Seine-et-Oise 10 F 13 (fonds Grave), fol. 173.

2. Eudes was not on a visitation; Gassicourt was in the diocese of Chartres. He was returning home from Pontoise, Blanche having been buried at Maubuisson: *The Register of Eudes of Rouen,* ed. Jeremiah O'Sullivan, trans. Sydney Brown (New York: 1964), p. 167 (Nov. 30, 1252). Eudes Rigaud also stayed at Gassicourt Aug. 20, 1264, on his way to Paris, and Aug. 30, 1264, on his way back (*Register of Eudes,* p. 564).

3. Dom Beaunier, *Recueil historique des archévêchés, évêchés, abbayes et prieurés de France,* Archives de la France Monastique, IV, ed. J. M. Besse (Ligugé: 1906), introduction p. 11; de Valous, *Le Monachisme clunisien,* pp. 120–21.

4. The famous orator Bossuet, bishop of Meaux from 1681, was *doyen* of Gassicourt from 1660 until his death in 1703, though not unchallenged. See: M. Benoit in *Procès-verbaux, Société archéologique d'Eure-et-Loir* 5 (1876), pp. 170–72; Victor-Eugène Grave, "Bossuet, prieur de Gassicourt," *Bulletin de la Commission des antiquités et des arts de Seine-et-Oise* 14 (1894), pp. 110–15.

5. There was an existing church on the site and a Merovingian cemetery has been excavated: Roger Tatincloux, "Site 'Sainte Anne,' cimetière merovingien, Mantes-Gassicourt," *Bulletin du Centre de recherches archéologiques de la région mantaise* (1973, no. 3). The monastic buildings were constructed ca. 1070 at the expense of Simon, count of Mantes: Alexandre Bruel, *Recueil des chartes de l'abbaye de Cluny* (Paris: 1888), vol. 4, no. 3477.

On Raoul Mauvoisin's donation, see ibid., nos. 3050, 3051, 3476. The charters of foundation date after 1049, the beginning of St Hugh's abbacy at Cluny, but probably closer to 1074, when Raoul Mauvoisin died.

6. Auguste Moutié, "Chevreuse, recherches historiques, archéologiques et généalogiques," *Mémoires et documents publiés par la Société archéologique de Rambouillet* 3 (1875–76), pp. 233–34.

7. Bruel, *Chartes de Cluny,* vol. 5, no. 4228.

8. J. Gagniare de Joursanvault, *Catalogue analytique des archives de M. le baron de Joursanvault, contenant une précieuse collection de manuscrits, chartes et documents originaux* (Paris: 1838), vol. 2, no. 3542, p. 262: "Manassé Mauvoisin (*Malvesinus*) rend aux religieux de Saint-Sulpice de Gassicourt les revenus de *Fontenetum,* dont il les avait injustement dépouillés (1200. Original. Latin.)."

9. Paris, Bibl. nat. collection Vexin 14 (Lévrier, "Histoire du Vexin" preuves): no. 906, fol. 156v (July 19, 1237).

10. In 1739 the lord of Rosny was the Marquis Olivier de Senozan. The other ratifiers were the abbot of Cluny, the Collège de Cluny, and Bossuet *doyen,* nephew of the famous orator who had preceded him as Gassicourt's dean (Arch. dept. ancien Seine-et-Oise G 686).

11. Pierre Brière, "La Région parisienne au moyen-âge, I. Une Alliance familiale entre les Garlande, les Mauvoisin et les Mello au XIIe siècle," *Bulletin de la Société historique de Lagny* (1961, no. 1), pp. 3–12, corrects earlier studies by Depoin and Estournet. Among the twelfth-century Mauvoisins in high office was Samson (d. 1160), archbishop of Reims and brother of Raoul de Mauvoisin. One is tempted to connect him with the handsome prelate's tomb recently found beneath the pavement at Gassicourt, but he is said to have been buried at Igny. On the tomb: Léon Pressouyre, "Le Gisant de Gassicourt (XIIe siècle)," *Monuments Piot,* Monuments et mémoires publiés par l'Académie des inscriptions et belles-lettres, commission de la fondation Piot, 66 (1983), pp. 55–66. On Samson's burial at Igny: Hans Reinhardt, *La Cathédrale de Reims* (Paris: 1963), p. 62.

12. Moutié, "Chevreuse," pp. 233–38, 253–55, is a reliable history of the Mauvoisins in the Gothic period. On Pierre see p. 254. On Robert see p. 236, citing the chronicler Pierre des Vaux-de-Cernay's high opinion of him. He is mentioned twice by Villehardouin in less glowing terms. On Robert as troubadour, see Alphonse Durand and Victor-Eugène Grave, *La Chronique de Mantes* (Mantes: 1883), p. 159; *Histoire littéraire de la France,* Académie des inscriptions et belles-lettres (Paris: 1733–), vol. 23, pp. 751, 753–54.

13. Natalis de Wailly, ed., *Histoire de Saint Louis par Joinville* (Paris: 1865), chaps. 50, 54–55, 83 (1250–51).

14. The Clos Mauvoisin was located east of Saint-Julien on the Left Bank in Paris: see Adrien Friedmann, *Paris, ses rues, ses paroisses du moyen âge à la Révolution* (Paris: 1959), plan IV, ca. 1150 (p. 94) and plan XV, 1202 (p. 248). Robert the *chansonnier* founded a funerary chapel of Saint-Pierre within the grounds of the Cistercian nunnery of Saint-Antoine near the Bastille and was buried there ca. 1215; his sister became the fourth abbess about 1233: Moutié, "Chevreuse," pp. 237–39.

 For charters of the Mauvoisins in Mantes, dating 1256–1281, see: Durand and Grave, *La Chronique de Mantes,* p. 158; Edgar Boutaric, *Actes du parlement de Paris* (Paris: 1863–1867), vol. 1, p. 86 (no. 921), p. 195 (no. 2111); Paris, Bibl. nat. Vexin 15, no. 1099. In addition to numerous charters there is also the evidence of Eudes Rigaud, who discovered the daughter of the knight Robert Mauvoisin installed simoniacally and against his orders in the Cistercian nunnery of Saint-Aubin near Gournay (Seine-Maritime), north of Mantes. He ordered her returned to her father's house: *Register of Eudes* (as in n. 2), p. 411 (Mar. 5, 1260).

15. Boutaric, *Actes du parlement,* vol. 1, p. ccciv, no. 15, dated before 1236.

16. At Candelmas 1262 (n.s.) Gui's son (Guyot de Rhôny) was still a minor and Gui still alive: Paris, Bibl. nat. Vexin 14, no. 1000, fol. 236. Guyot was of age and had inherited Rosny in 1266: Boutaric, *Actes du parlement,* vol. 1, p. 98, no. 1057. He had married Isabelle de Mello in 1265: Gilles-André de la Roque, *Histoire généalogique de la maison de Harcourt* (Paris: 1662), vol. 2, p. 1863 (the date of 1285 on p. 1816 is incorrect, as she is mentioned in charters before then).

17. On the church: Lefèvre-Pontalis, "Eglise de Gassicourt" (1919), pp. 227–35; Lefèvre-Pontalis, "Notice archéologique sur l'église de Gassicourt," *Commission des antiquités et des arts de Seine-et-Oise* (1888), pp. 128–37. The vestiges of the monastic buildings to the north of the church were excavated in 1971–72: Jean-Marie Jacqueau, "Le Prieuré Saint-Sulpice de Gassicourt; le chantier Sainte Anne de Gassicourt," *Bulletin du Centre de recherches archéologiques de la région mantaise* (1973, no. 3).

 On the redecoration: the south transept was painted with grisaille murals: Lefèvre-Pontalis, "Eglise de Gassicourt" (1919), pp. 232–33. The sixteenth-century nave vault he described has been replaced since World War II. Thirty-two stalls with fine misericords and two wooden choir screens survive from ca. 1500: Gaston Bideaux, "Les Grilles de clôture de l'église de Gassicourt," *Revue de l'art chrétien* (Mar.–Apr. 1910), pp. 104–108; ibid., "Les Stalles de Gassicourt," *Revue de l'art chrétien* (May–June 1912), pp. 224–26; Amédée Boinet, "Les Stalles de l'église de Gassicourt," *Congrès archéologique* 82d session (1919), pp. 236–48; many are illustrated in Dominique Hervier, "Un Monde à decouvrir: Les Stalles de Gassicourt," *Histoire et archéologie dans les Yvelines,* suppl. to *Connaître les Yvelines* (June 1978), pp. 11–17; and in Dorothy Kraus and Henry Kraus, *The Hidden World of Misericords* (New York: 1975), pls. 12, 60, 65. The stalls, now in the choir, were originally made for the first two bays of the nave, and the screens closed off the arms of the transept (Boinet, pp. 236–37). It is a mystery why the tiny community, never documented as large as a dozen, needed so many stalls; see n. 1 above.

 Mantes was bombed thirty-four times between 1939 and 1945, sustaining the worst damage from the American attack of May 30, 1944. A postwar description of Gassicourt and its treasures is found in *Dictionnaire des églises de France,* ed. Robert Laffont (Paris: 1968), IV D 101.

18. The transepts, choir, and crossing were vaulted, the latter beneath the still extant Romanesque bell tower. Since the original chevet was so completely rebuilt in this campaign, there is conflicting opinion whether it was apsidal or square.

19. Durand and Grave, *La Chronique de Mantes,* p. 175. According to a related local tradition, Gassicourt's early thirteenth-century wooden cult statue of the enthroned Virgin and Child offered portraits of Blanche and her son Louix IX: Benoit, *Procès-verbaux d'Eure-et-Loir* (1876) (as in n. 4), pp. 173–74; Paul Joanne, *Dictionnaire géographique et administratif de la France* (Paris: 1894), vol. 3, p. 1644. Both heads are modern: Joan Evans, *Cluniac Art of the Romanesque Period* (Cambridge: 1950), p. 37, fig. 44; opinions on the statue's date are collected by Jean Taralon, "Le Trésor d'Evron" (1961), p. 316. Other regional traditions maintain that Blanche gave stained glass to the abbey of Saint-Corentin near Mantes (Durand and Grave, p. 175) and to the collegiate church of Mantes: Jean Bony, "La Collégiale de Mantes," *Congrès archéologique* 104th session (1946), p. 167.

20. The bay numbering follows CVFR I, pp. 131–32. The negligible scraps of glass remaining in Bay 2 on the opposite side of the choir will be discussed with Bay 1.

21. Bays 1 and 2, by the Master of the Big Saints, are almost completely unknown in stained glass literature; they received a brief nod from Marcel Aubert, *Le Vitrail en France* (Paris: 1946), p. 32. They are doublet-and-rose windows of only two lancets, a simpler design than the other newly enlarged windows (all of which the congregation could have seen). Since the moldings are similar to the other new windows they do not seem to be earlier, just simpler. The doublet-and-rose makes its last appearance in large buildings ca. 1240 (see Lillich, *Saint-Père,* p. 7 and n. 12) but remains in use in small rural structures, for example at Aunou (Chap. VI, p. 208 below).

22. Bay 1, important restorations: Sulpice's face; some draperies and part of the inscription of St Nicholas, which Guilhermy does not mention having seen.

 The nineteenth-century glass has fared better than the medieval remains, in illustrations: St Eligius may be seen in Lefèvre-Pontalis, "Eglise de Gassicourt" (1919), p. 233; St Hugo is the frontispiece in Evans, *Cluniac Art* (dated thirteenth century). In 1852 Moutié stated that Bay 2 "a malheureusement été entièrement détruite" (Auguste Moutié, *Mantes, histoire, monuments, environs* [Chartres: 1852], p. 109). However, St Hugo's mitre, hair, and halo are partly old.

 Guilhermy visited in 1842 and 1843 and added notes in 1854 and 1869, all before the restoration of Bay 2 after 1876. His manuscript is now Paris, Bibl. nat. nouv. acq. fr. 6100, fol. 394v. The restoration dossier of 1876–77 in the Monuments historiques provides the following data: Bay 2 was then boarded up and in ruins; the fragments of the bishop saint had been removed from the window for safekeeping by the priest about 1870; the glazier Duhamel Marette of Evreux made designs for three new saints and the restored bishop, with the names Peter, Joseph, Eligius, and Gaucher; these were ultimately corrected to Peter, Paul, Eligius, and Hugo. Duhamel estimated that 4 m. of old glass could be reused, necessitating only 6.2 m. of new. In the present window, however, the only old glass is in "St Hugo": parts of his mitre, hair, and halo, and bits of the border and lower robes. The old glass shows clearly in late nineteenth-century photographs of the exterior: MH cl. 6368 and 58109. The sources of the nineteenth-century iconography are obvious: Peter, Paul, and Hugo are Cluniac; the church had a chapel of St Eloi, documented in 1739 (Arch. dept. ancien Seine-et-Oise G 686); and Gaucher was a local saint, born in Meulan and by tradition a Mauvoisin and founder of Gassicourt: François de Blois, *La Vie de S. Gaucher* (Paris: 1652), pp. 9–10; Benoit in *Procès-verbaux, Société archéologique d'Eure-et-Loir* 6 (1880), pp. 230–31.

23. See n. 8 above (document lost). Existing charters do not name Saint-Sulpice until much later: see Martin Marrier, *Bibliotheca cluniacensis* (Brussels: 1915), col. 1716, dated 1350.

24. The pilgrimage, mentioned by Guillaume de Saint Pathus, predated the thirteenth century. On the new church see Branner, *Saint Louis and the Court Style,* pp. 74–75; and bibliography in CVFR I, p. 84.

25. On the chapel and château, Armand Cassan, *Statistique de l'arrondissement de Mantes* (Mantes: 1833), p. 296. On the rents of the chapel of Fontenay, refer to the charter cited at n. 7 above, also probably n. 8 (document lost).

26. An interesting study on the Agnus Dei device is: William Chester Jordan, "The Lamb Triumphant and the Municipal Seals of Western Languedoc in the Early Thirteenth Century," *Revue belge de numismatique et de sigillographie* 123 (1977), pp. 213–19. On St John with the palm, see Chap. II n. 53; on the Virgin with palm, Chap. II, p. 43.

27. See generally *Lexikon der Christlichen Ikonographie: Heilige* (Rome: 1974), vol. 7, cols. 191–93. On the early Roman examples: Alexandre Masseron, *Saint Jean Baptiste dans l'art* (Paris: 1957), pp. 154–56; Giuseppe Bovini, *Mosaici paleocristiani di Roma (Secoli III–VI)* (Bologna: 1971), pp. 213–23. The Lateran itself was dedicated to the Evangelist, and the Lateran Baptistery had a chapel to both Johns. The tradition associating the two saints with papal iconography lingers past 1307 in the decoration of the papal palace at Avignon, and no doubt in Duccio's *Maestà*.

28. On the Baptism, see the complicated baptism program of the early twelfth-century font of Rainier de Huy in Liège: *Rhein und Maas: Kunst und Kultur, 800–1400* (Cologne: 1972), pp. 238–40.

 On the Last Judgment: the iconographic program of the Parma baptistery is the most elaborate statement of this concept I know of in medieval art.

 On Basel: François Mauer, *The Cathedral of Basle,* Guides to Swiss Monuments (Basel: 1977), pp. 20–22; *Suisse romane* (La Pierre-qui-vire: 1967), p. 305 (where the iconographic program is not grasped). As at Parma, the themes are mostly from Matt. 24 and 25. The program as well as the style of Basel's St Gall portal is Italian (Emilian) Romanesque: compare the porches of San Zeno and the cathedrals of Verona, Ferrara, and Piacenza, all of which have the two Johns in the spandrels. The papal iconography (see previous note) of these Italian porches is the major theme of Christine Verzár Bornstein, *Portals and Politics in the Early Italian City-State: The Sculpture of Nicholaus in Context* (Parma: 1988).

29. Victor Beyer, *La Cathédrale de Strasbourg,* Chefs-d'oeuvre du vitrail européen (Paris: 1970), p. 24, pl. IV.

30. For example: Giotto's Peruzzi Chapel in Santa Croce (for Giovanni Peruzzi); the Tiptoft Missal, Morgan MS 107, fol. 142 (for John Clavering), illustrated in *The Pierpont Morgan Library, Exhibition of Illuminated Manuscripts Held at the New York Public Library* (New York: 1934), pl. 62.

31. Wilhelm Ludwig Schreiber, *Holzschnitte aus dem ersten und zweiten drittel des fünfzehnten Jahrhunderts in der Königlichen Graphischen Sammlung zu München* (Strasbourg: 1912), vol. 1, p. 22 (no. 5). In fifteenth-century Flemish painting the two St Johns are paired frequently and for many reasons: to mention the most obvious examples, the Ghent Altarpiece and the works of Memling.

32. On Saint-Denis, see Louis Grodecki, *Les Vitraux de Saint-Denis,* Corpus Vitrearum Medii Aevi France, Etudes I (Paris: 1976), pp. 30–31. The chapel's dedication was changed in the thirteenth century, and again in the nineteenth.

 On Tours, see Papanicolaou, "Windows of the Choir of Tours," pp. 115–20; CVFR II, p. 129.

33. Louis Grodecki in *Les Vitraux de Notre-Dame et de la Sainte-Chapelle de Paris,* Corpus Vitrearum Medii Aevi, France I (Paris: 1959), Bay I (pp. 185f.), Bay G (pp. 207f.).

34. Louise Lefrançois-Pillion, "Un Tympan de porte à la cathédrale de Rouen, la mort de saint Jean l'Evangéliste," *Revue de l'art chrétien* 4th ser., 15 (1904), p. 187 and n. 3: "Il est probable que ces chapelles sont postérieures au tympan dont je m'occupe, mais elles ne font que consacrer le souvenir de traditions anciennes." On the seal of the Agnus Dei used by the commune of Rouen, see the bibliography amassed by Jordan, "The Lamb Triumphant," p. 214n5. Willibald Sauerländer, *Gothic Sculpture in France, 1140–1270* (New York: 1972), p. 470, dates the tympanum ca. 1240.

35. On the chaplaincies of Saint-Jean-dans-la-nef (later called the Chapelle des Belles verrières) see: Jean François Pommeraye, *Histoire de l'église cathédrale de Rouen* (Rouen: 1686), p. 528, quoting an inventory of 1429. The Baptist was the titular saint and Jean de Bordeny the founder. See now Michael Cothren, "The Seven Sleepers and the Seven Kneelers: Prolegomena to a Study of the 'Belles Verrières' of the Cathedral of Rouen," *Gesta* 25/2 (1986), pp. 203–26, with bibliography.

On Saint-Jean-jouxte-les-fonts, see Pommeraye, *Cathédrale de Rouen*, pp. 526–27, listing the chaplaincies. The chapel is now dedicated to the Saint-Sacrement. The thirteenth-century glass is illustrated in Georges Ritter, *Les Vitraux de la cathédrale de Rouen* (Rouen: 1926), pl. XXVIII (St John the Evangelist on Patmos), pl. XXX (John the Baptist baptizing Christ).

36. *The Golden Legend of Jacobus de Voragine*, tr. Granger Ryan and Helmut Ripperger (New York: 1969), p. 326. In the straightforward program of saints in the ambulatory of Saint-Ouen de Rouen in the fourteenth century, the two St Johns are in the chapel north of axial: Jean Lafond, *Les Vitraux de Saint-Ouen*, pp. 86–92 (Bays 33 and 35).

37. In 1945 the thirteenth-century fragments that remained over the Renaissance window were moved elsewhere in the cathedral: Grodecki in *Cathédrales*, exh. cat., Musée du Louvre (Paris: 1962), pp. 157–59, no. 155. The original location was the south transept chapel "du Saint-Esprit" (now "Jeanne d'Arc"), where there was an altar to the three deacon saints: Ritter, *Les Vitraux de Rouen*, p. 50, pl. XXVII; Pommeraye, *Rouen*, p. 532. See p. 55 below.

38. On the same detail at Dol cathedral, see Chap. V, p. 124.

39. Not "fleurs de lys et Navarre" as recorded in CVFR I, p. 132. Both motifs occur at Le Mans but never combined in borders; similarly button-crocketed canopies are extremely rare there, though common in Normandy and used by the Norman Infancy Master of Gassicourt. The Master of the Big Saints no doubt picked up these formulas after he left Le Mans. See n. 98 below.

40. On the change to uncial ("Lombardic") lettering, which occurs in this generation in France, see Lillich, *Saint-Père*, pp. 29–31. The changes are gradual; in the only other inscriptions in Gassicourt, those in the traceries of the Deacons window (Bay 4), capitals N and T and blocklike spacing give an earlier appearance.

41. See p. 53 above. At Bourges the chapel south of the axial chapel of the chevet has a whole window devoted to each deacon. At Le Mans their martyrdoms are piled one atop the other in Bay 201 of the clerestory, a lancet of the Principal Atelier.

42. *Cathédrales*, pp. 160–61, 163, no. 157: the major restorations are identified. The present order of scenes in the church is slightly different.

43. At Le Mans the only artist familiar with the same energetic traditions is the Tric-trac Master, who came into the chantier rather late and adapted himself easily to the traditions of the Principal Atelier. See p. 46 above.

44. On the *carré quadrilobé*: Jurgis Baltrušaitis, *Le Moyen Âge fantastique* (Paris: 1955), pp. 93–95; Georges Marçais, "Le Carré quadrilobé, histoire d'une forme décorative de l'art gothique," *Études d'art publiées par le Musée national des beaux arts d'Alger* 1 (1945), pp. 67–79. Marçais establishes that the *carré quadrilobé*, unknown in Romanesque art, is established in the west in the thirteenth century and probably came from the Coptic and Fatimid arts of Egypt, perhaps transmitted through Norman Sicily.

On Angers (Bay 103, second quarter thirteenth century), see Hayward and Grodecki, "Les Vitraux d'Angers," pp. 39–40; on Dol, Grodecki and Brisac, *Le Vitrail gothique*, p. 164; on Fécamp, ibid., p. 146. The Rouen cathedral *soubassement* reliefs (north transept, Portail des Libraires) have *carré quadrilobé* frames.

45. On the Christ Church panels: CV Checklist I, pp. 68–69; *Medieval and Renaissance Stained Glass from New England Collections*, ed. Madeline Caviness, exh. cat., Busch-Reisinger Museum, Harvard University (Medford, Mass.: 1978), pp. 35–37: restorations and stopgaps are noted. These panels no doubt left Gassicourt by the same highway as the Visitation and Nativity panels from Gassicourt's Infancy window, since all four are now in Massachusetts; unlike the latter, the Massachusetts panels of Stephen and Lawrence are not mentioned by Guilhermy. See p. 45 below.

The ordination of Stephen occurs in more expanded form on the lintel of the Stephen portal, west facade of Bourges (ca. 1240), illustrated in Tania Bayard, *Bourges Cathedral: The West Portals* (New York: 1976), pls. 37, 58. The Charity of St Lawrence is shown in the twelfth-century window of Poitiers, east wall.

46. The upper figure of Stephen is modern. Nothing is mentioned there by Guilhermy, who notes the inscriptions on fol. 395.

47. BERNARD' EPC ME DEDIT MCCLXIX. Illustrated in Elisabeth von Witzleben, *Stained Glass in French Cathedrals* (London: 1968), pl. XXX. The Bernardus inscription at Amiens was recorded many times in the nineteenth century, for example by: Ferdinand de Lasteyrie, *Histoire de la peinture sur verre* (Paris: 1853–1857), vol. 1, pp. 147–48, 152; Guilhermy, Paris, Bibl. nat. nouv. acq. fr. 6094, fol. 234r.

48. *Golden Legend* (as in n. 36), pp. 114–16; Grodecki and Brisac, *Le Vitrail gothique*, p. 251.

49. *Golden Legend*, p. 440: of the three named persons baptized by Lawrence two were martyred, St Hippolytus being the more important (see his entry, pp. 446–49). The figure in the tub at Gassicourt is haloed. The St Lawrence window at Angers includes a baptism scene: Hayward and Grodecki, "Les Vitraux d'Angers," p. 39.

50. See the lintel of the St Stephen portal, Bourges: Bayard, *Bourges*, pl. 61.

51. The scene of Vincent dying in bed is included in the window at Rouen (*Cathédrales*, p. 159); also at Tours (Bay 211).

52. *Golden Legend*, pp. 440–41.

53. On the winged helmet see Lillich, *Saint-Père*, p. 108.

54. Although no old borders remain the location of the Infancy window is probably original, since Guilhermy reported it: Paris, Bibl. nat. nouv. acq. fr. 6100, fol. 395v. Exhibition in Paris: *Cathédrales*, pp. 162–63, no. 158 (restorations are noted). The modern surrounds are by Gruber. The two panels in Massachusetts: CV Checklist I, p. 68; *Stained Glass from New England Collections*, nos. 11b, 12, pp. 30–34. Color plate in Grodecki and Brisac, *Le Vitrail gothique*, p. 145.

55. Octave Homberg, *Catalogue des objets d'art et de haute curiosité . . . composant la collection de feu M. O. Homberg . . . 11–16 mai*, Galeries Georges Petit (Paris: 1908), p. 60, ills. 442 (Visitation, Nativity, Adoration), 443 (two panels from Deacons window). Guilhermy specifies that the Visitation and Birth of Christ in the sacristy window were removed to Paris in 1854 (fol. 396); he adds in 1868 that Didron kept fragments including a Visitation and an Adoration of the Magi and "l'architect de l'église n'a pas pensé à les réclamer" (fol. 394v).

56. The soldiers are in chain mail with helmets, and one carries a gold shield charged with an *escarboucle*. This is apparently not a heraldic charge but simply a traditional shield decoration, the *escarboucle* supposedly having derived from the ornamental knob in the center of the shield: for a contrary opinion carrying no conviction see Gerard Brault, *Early Blazon* (Oxford: 1972), p. 139. Shields *escarbouclés* appear in art with both heroes (Roland and Charlemagne in the Charlemagne window of Chartres) and villains (soldier of Baligant, Charlemagne's opponent, in a manuscript of ca. 1290, Saint Gall Stadtbibliothek MS 302, fol. 662, illustrated in D. D. R. Owen, *The Legend of Roland* [London: 1973], pl. XVII).

57. Bay 6, dated 1255: CVFR I, p. 85. Illustrated in Grodecki and Brisac, *Le Vitrail gothique*, pp. 141–43.

58. At least it was so dedicated by the eighteenth century. Whether the parish was dedicated to St Anne in the thirteenth century cannot be established by texts, though it is likely since Gassicourt was in the diocese of Chartres, whose cathedral received the famous relic of St Anne's head in 1204.

 Guérard added—and therefore Longnon omitted—the current parish name-saints in their publications of the thirteenth-century register. See: Benjamin Guérard, *Cartulaire de l'abbaye de Saint-Père de Chartres* (Paris: 1840), vol. 1, p. cccxxv; Longnon, *Pouillés de Sens* (as in n. 1), pp. xiii n2, 119.

59. *Cathédrales*, p. 163. The Cluny Baptist panels will be omitted from my stylistic discussion since their provenance is unknown; except for the facial types they are close to Gassicourt. If they can be identified with the panels of Herod's Feast and the beheading of the Baptist that Le Vieil saw in Notre-Dame, chapel of the Baptist, then they may date ca. 1286. In the chapel they were flanked by the kneeling figures and the coats of arms of Philippe le Bel and his wife Jeanne de

Navarre; they were married in 1284 and crowned in 1286. Pierre Le Vieil, *L'Art de la peinture sur verre et de la vitrerie* (Paris: 1774), p. 29 note b.

60. On Sainte-Vaubourg see: Lafond, "Le Vitrail en Normandie," p. 332; Grodecki, *Les Vitraux de Saint-Denis* (as in n. 32), pls. 218–21, 223, 226.

61. Ritter, *Les Vitraux de Rouen*, pls. XXIX, XXXIII; see also the displaced fragments, pls. III, IV.

62. There is little stained glass left in Normandy before almost 1250, but the commonness of framing arcades and looped curtains at Canterbury provides much food for thought on the development of the Norman style. See Caviness, *The Early Stained Glass of Canterbury Cathedral*, pls. 63, 97, 137, 187, 197, 206, 210, etc.

63. Illustrations: *Art de Basse-Normandie* 89–91 (1984–85), p. 108, color pl. (Lisieux panel, head is a restoration); Lafond, "Le Vitrail en Normandie," pp. 335, 343, 347.

64. *Cathédrales*, p. 163. The window was not in the exhibition and is for all intents and purposes unpublished. The medallion of Christ washing the apostles' feet (illustrated in CVFR I, p. 132) is totally modern on the left and right thirds; the center is original except for the bottom piece of Christ's robe, but it is worn and hardly an apt example of this remarkable painter's talent.

65. Modern: Christ on the Mount of Olives; Emmaus; one of the Pentecost groups (lancet head second from the right). Significant areas of restoration:

> Row 1: Entry to Jerusalem—boy in tree; lower part of Christ's robe
> City of Jerusalem—left side
> Last Supper—right side
> Row 2: Washing of Feet—left side; right side; bottom part of Christ's robe
> Paying Judas—right figure
> Row 3: Arrest of Christ—left side; right side
> Row 4: Marys at the Tomb—two center soldiers
> Row 5: Resurrection—top of panel
> Row 6: Ascension (second lancet head from left)—center figures
> Traceries: almost entirely new

The window was releaded in 1939.

66. These scenes only rarely appear together; see Lillich, *Saint-Père*, pp. 152, 181n125.

67. The iconography of the Washing of Feet following the Last Supper appears in the Dol east window. See Chap. V, p. 139.

68. Pierpont Morgan MS 638: *Old Testament Miniatures*, ed. Sydney Cockerell and John Plummer (New York: n.d.).

69. CVFR I, pp. 84–85 (dated ca. 1280); Grodecki and Brisac, *Le Vitrail gothique*, p. 259.

70. Papanicolaou, "Windows of the Choir of Tours," pp. 223f. See also Raguin, *Stained Glass in Burgundy*, pp. 79–80 and CVFR II, p. 120f.

71. Papanicolaou, "Stained Glass from Saint-Julien," p. 75.

72. See Lillich, *Saint-Père*, p. 76n1.

73. Raguin, *Stained Glass in Burgundy*, p. 80.

74. Few old grisailles remain. Guilhermy reported them in the mid-nineteenth century: Paris, Bibl. nat. nouv. acq. fr. 6111, fol. 34r.

75. The differences are analyzed by Papanicolaou, "Windows of the Choir of Tours," pp. 160–61.

76. I collected the evidence for a provenance in the Château de Rouen ca. 1260 (Lafond's hypothesis) in: Lillich, "Three Essays on French Thirteenth-Century Grisaille Glass," pp. 73–75; see also Lillich in *Medieval Art in Upstate New York*, exh. cat., Everson Museum of Art (Syracuse: 1974), pp. 20–21.

77. On Saint-Germer-de-Fly, see CVFR I, pp. 206–207 and fig. 114, the border of which resembles the Tours triforium borders. The glass of Saint-Germer, including the bays of grisaille, is now the subject of a master's thesis undertaken by Laura Good at Tufts University. I see more Norman influence in it than did Lafond, "Le Vitrail en Normandie," pp. 356–57.

78. On criteria for dating grisailles see: Lillich, *Saint-Père*, pp. 26–29; Meredith Lillich, "A Redating of the Thirteenth-Century Grisaille Windows of Chartres Cathedral," *Gesta* 11/1 (1972), pp. 11–18.

79. The complicated evidence for these assertions is published in Lillich, "The Triforium Windows of Tours," pp. 29–35. The coats of arms are visible in the window in the photograph made for Clarence Ward in or before 1932 (photo study collection, National Gallery of Art, Ward neg. 32541).

80. In addition to Lillich, "The Triforium Windows of Tours," n. 5 (charter of 1235), see also an accord of 1266 between Pierre de Binanville and the abbey of Marmoutier: Arch. dept. Seine-Inférieure 7 H 2186, among the charters of Saint-Georges de Mantes.

81. The document of 1245 that I cited in n. 16 of "The Triforium Windows of Tours" should be cited correctly in full as: Paris, Bibl. nat. Vexin 7 (Lévrier preuves), fol. 581. In it Mauvoisin and Binanville and three others stood caution for two fellow knights who had killed the prior of Juziers and had been condemned to make ritual processions of penance (*hachée*) to several churches barefoot, in rags, and carrying flails. See Cassan, *Statistique de Mantes* (as in n. 25), p. 254.

82. The capital of the Norman Vexin was Gisors (Eure); of the French Vexin, Pontoise (ancien Seine-et-Oise, now Yvelines).

83. Compare for example the pure profile figures of Tours with the early ones at Saint-Père: Lillich, "The Triforium Windows of Tours," fig. 7; Papanicolaou, "Windows of the Choir of Tours," pls. 6, 9, 11; Lillich, *Saint-Père*, pl. 88 (Tours), color pl. II, pl. 24, etc.

84. Note the outstretched hand of Saint-Père Bay 4 and Tours Bays 102 and 100; the clenched hand of Saint-Père Bay 2 and Tours Bays 100 and 103; the scooplike hand holding a book, Saint-Père Bay 1 and Tours Bay 101. The palm-up gesture of Tours Bay 101 already appears in the nearly contemporary figure in Saint-Père Bay 14.

85. The Saint-Denis campaign began in 1231 with the choir, and Branner dates the lost glazing of that section to a hiatus in building from 1241 to 1258. See Branner, *Saint Louis and the Court Style*, pp. 46–47 and appendix C; also n. 90 below.

86. Kurmann and Winterfeld, "Gautier de Varinfroy," pp. 101–59. This remarkable study has found a sympathetic reception; see the review by Alain Villes in *Bulletin monumental* 136 (1978), pp. 80–83. That the architecture of Tours and Saint-Père is related has been generally accepted; see my summary, *Saint-Père*, pp. 7–8.

87. Lillich, *Saint-Père*, chap. 2, especially pp. 38–39.

88. This paragraph adds new evidence to my argument in "Monastic Stained Glass," pp. 225–34 and appendices. On the Saint-Denis restorations see Grodecki, *Les Vitraux de Saint-Denis* (as in n. 32): p. 48 (on the present colored designs of 1839–1842); p. 47nn.5, 11 (on the Napoleonic remodeling); p. 39 (on the eighteenth-century *badigeonnage* of the church).

89. The Hubert Robert painting appears in color in Jean Starobinski, *1789: Les Emblèmes de la raison* (Paris: 1973), pl. 39. Hubert Robert observed the scene shown in his painting between October 14–25, 1793, was arrested October 29, and spent almost a year in prison, occupying his time with painting; he died in 1808, before the Napoleonic refurbishing of Saint-Denis was under way. On the Robert painting (Musée Carnavalet, inv. P. 1477) see: Bernard de Montgolfier, "Hubert Robert, peintre de Paris au Musée Carnavalet," *Bulletin du Musée Carnavalet* 17, nos. 1–2 (1964), pp. 22, 27 (fig. 19), 35n38. I warmly thank Linda Papanicolaou, whose recollection of a painting she once saw exhibited in the old Saint-Denis museum (now in storage in the new museum) led me to the Hubert Robert, of which it is a copy. An aquatint also in the collection of the Saint-Denis museum, published in 1806 by W. Miller, London, and signed by J. C. Nattes, also shows clear glass clerestories and darkened triforium in the transept.

The late eighteenth-century painting by Lafontaine and Demarne is illustrated in *Le Trésor de Saint-Denis*, exh. cat., Musée du Louvre (Paris: 1991), pp. 42, 58; see also Blaise de Montesquiou-Fezensac and Danielle Gaborit-Chopin, *Le Trésor de Saint-Denis*, Vol. 3, *Planches et notices*

(Paris: 1977), pp. 98–99, pl. 89a. I am grateful to the owner for permission to reproduce it here.

90. The Millet text is printed in "Monasticism and the Arts," p. 241. On the Glencairn grisaille lobe see Jane Hayward, Walter Cahn et al., *Radiance and Reflection*, exh. cat., The Metropolitan Museum of Art (New York: 1982), pp. 195–97. Bruzelius dates the north rose before the south one, both in the early 1240s: Caroline Bruzelius, *The 13th-Century Church at St-Denis* (New Haven: 1985), pp. 106, 111–13. Bouttier indicates that the north rose traceries are more advanced than those of the surrounding transept and dates the installation of both roses to ca. 1245: Michel Bouttier, "La Reconstruction de l'abbatiale de Saint-Denis au XIIIe siècle," *Bulletin monumental* 145 (1987), pp. 375–76.

91. On verbal accounts by patrons as a source of transmission see M. F. Hearn, *Romanesque Sculpture* (Ithaca: 1981), p. 142.

92. Lillich, *Saint-Père*, pls. 43, 88.

93. To these scenes of Peter and Paul can be added the donor figure and his canopy, although his inscription identifies him as Jehan de Mantes, abbot in 1306. I have always assumed that the new abbot commandeered the figure and had his name added for the new clerestory window, which launched the nave-glazing campaign. On the early panels recycled in Bay 22 (where space did not allow a border) see Lillich, *Saint-Père*, pp. 61–62, 156–67 *passim*; CVFR II, pp. 54, 57. The standard Peter scenes of the early group are close to those in Bay 108 of the Le Mans upper ambulatory, which also has a nailed crucifixion of Peter. In 1990 and 1991 Saint-Pere Bay 22 was studied and restored, and its panels rearranged and augmented yet one more time: Jean-Marie Braguy, "La Restauration du vitrail de saint Pierre et saint Paul de l'église Saint-Pierre de Chartres," *Vitrea* 7, pt. 1 (1991), pp. 11–26 and illustrations pp. 38–39.

94. Lafond, "Le Vitrail en Normandie," pp. 327–28. See also my discussion of the Protais Master at Sées, Chap. VI, pp. 202–5.

95. Lafond, "Le Vitrail en Normandie," p. 327. He states that the left head is not original, that the midsection of that figure seems to have been remade, and that the blue ground includes a *boudine* (*verre bosselé*). On *bosselage du verre* in glass of the western school see Lillich, *Saint-Père*, p. 71. Lafond also makes a comparison to the north rose of Notre-Dame which I have never been able to find there.

96. The bright trio-of-primaries coloration of the Saint-Père campaign of ca. 1260 I have attributed to the choice of the glass cutter, the expressionist discussed above.

97. Lafond, "Le Vitrail en Normandie," p. 345. Lafond also points out the three grisailles of the third quarter of the thirteenth century in the nave clerestories of Evreux, published by Lewis Day, *Windows*, 3rd ed. (London: 1909), pp. 156, 160, 278. The thirteenth-century glass of Evreux is now being studied in a French thesis.

98. The Evreux borders—of which fragments are original—include the design used by the Gassicourt Master of the Big Saints and this is where his button crockets come from, as well. See G. Bonnenfant, *Notre-Dame d'Evreux* (Paris: 1939), pp. 41–42, pl. XV/2-4.

99. Jules Fossey, *Monographie de la cathédrale d'Evreux* (Evreux: 1898), p. 55; Lafond, "Le Vitrail en Normandie," p. 345.

100. Kurmann and Winterfeld, "Gautier de Varinfroy," pp. 118–19; the quote is from n. 58.

101. See for example their treatment of the customary dating of the Sens choir clerestories: ibid., p. 133.

102. Another example would be Villers-Saint-Paul (Oise), which has a colored figure in a grisaille surround, a glazing formula I have connected to Notre-Dame in Paris, and repeated in a number of country churches of its diocese, as well as at Auxerre (see Chap. I, pp. 6–8). Michael Cothren has grouped the painting style of Villers-Saint-Paul with its region of the Beauvaisis in the 1240s and 1250s. See Cothren, "Glazing of the Choir of Beauvais," pp. 82, 87; Cothren, in *Stained Glass from New England Collections* (as in n. 45), p. 23.

CHAPTER 4

1. *Butler's Lives of the Saints,* ed. Herbert Thurston and Donald Attwater (New York: 1963), vol. 3, pp. 318–20 (with bibliography), states that the "figure of St. Radegund . . . is undeniably the most authentic and the best known of her century." Her nunnery followed the rule of Caesarius of Arles, becoming Benedictine under the reform of Louis the Pious in 816.

2. A flamboyant portal was added to the entrance porch about 1455: René Crozet, *L'Art roman en Poitou* (Paris: 1948), pp. 72–73; Jacques Bidaut, "Eglise Sainte-Radegonde de Poitiers," *Congrès archéologique* 109th session (1951), pp. 96–117. On the nave: Mussat, *Le Style gothique de l'ouest,* pp. 264f.; Kraus, *Gold Was the Mortar,* pls. 33, 34.

3. On Pepin's tomb see Bidaut, "Eglise Sainte-Radegonde," p. 99; André Rhein, "Eglise de Sainte-Radegonde," *Congrès archéologique* 79th session (1912), vol. 1, p. 271. Pepin's tomb is documented by three sources in *Recueil des historiens des Gaules et de la France,* ed. M. Bouquet (Paris: 1738), vol. 6. On Anne of Austria's gifts see Bidaut, p. 115; Rhein, p. 274.

4. Dom Pierre de Monsabert, O.S.B., "Etat sommaire des fonds concernant l'histoire monastique conservés dans la série H des Archives départementales de la Vienne," *Revue Mabillon* 8 (1912–13), pp. 44f. (liasse 44); ibid., "Documents inédits pour servir à l'histoire de l'abbaye de Ste. Croix de Poitiers et de ses domaines jusqu'à la fin du XIIIe siècle," *Revue Mabillon* 9 (Nov. 1913), pp. 259–61 (charters XXIII, XXIV).

5. A letter of 1269 from the count begins: "Alfonsus, etc., dilecto et fideli clerico suo Guichardo, canonico Cameracensi, salutem et dilectionem sinceram. . . ." Auguste Molinier, *Correspondance administrative d'Alfonse de Poitiers* (Paris: 1894), vol. 1, p. 720, no. 1167. Guichart had received the canonry of Cambrai by 1265. On Maître Guichart, who served Alphonse as tax collector in the Poitou, see: Edouard Audouin, *Recueil de documents concernant la commune et la ville de Poitiers, I (de 1063 à 1327),* Archives historiques du Poitou, 44 (Poitiers: 1923), pp. 114, 118, 123. Alphonse's letter calling him canon of Sainte-Radegonde (Feb. 23, 1268) is published by Molinier, vol. 1, p. 48, no. 75.

6. Gift of 1269; Arch. nat. JJ 24D, fol. 10, published by Audouin, *Documents de Poitiers;* also Bélisaire Ledain, *Histoire d'Alphonse frère de Saint Louis . . .* (Poitiers: 1869), p. 119, no. 113. Testament of 1270: Elie Berger, *Layettes du trésor des chartes, IV (1261–1270)* (Paris: 1902), pp. 453f., no. 5712.

7. See Pierre's will, published by Charles Du Cange in notes to *Jean de Joinville, Histoire de S. Lovys, IX dv nom* (Paris: 1668), pt. 1, pp. 181–86. Maître Guillaume is called "nostre amé clerc."

8. The nineteenth century preferred a date of 1311–1316 for the glass, when Philippe le Long was appanaged with Poitou before becoming king. This theory is based on an incorrect heraldic interpretation (see n. 73 below). The date of 1290 that has occasionally been adopted recently is a peculiar and illogical compromise between the two Poitevin counts, Alphonse (1269) and Philippe (1311–1316).

9. The best editions of Fortunatus and Baudonivia are in *Monumenta germaniae historica* (hereafter *MGH*), *Scriptores rerum merovingicarum,* vol. 2, pp. 364–95. Gregory of Tours mentions Radegonde in *Historiae francorum,* Book III, chap. 7 and Book IX, chaps. 39–43 (see *History of the Franks,* as in n. 44 below); and in *De gloria confessorum* 106 (*Patrol. Latina,* ed. Migne [Paris: 1844–1864] vol. 71, cols. 905–907).

10. H. Bodenstaff, "Miracles de sainte Radegonde XIIIe et XIVe siècle," *Analecta bollandiana* 23 (1904), pp. 433–47. The thirteenth-century miracles are recorded in Poitiers, Bibl. mun. MS 252, fol. 96f. (manuscript of the late thirteenth century). See pp. 92–93 below.

11. Monsabert, "Documents de Ste. Croix de Poitiers," 9 (Nov. 1913), p. 278.

12. E. Martene and U. Durand, eds., *Veterum scriptorium et monumentorum amplissima collectio* (Paris: 1724–1733), vol. 6, cols. 1219–38: "De Felici obitu Johannae comitissae Alenconii et Blesensis, ex ms. praemonstratensi." I am very grateful for this reference to Elizabeth A. R. Brown, who shares my fascination with Jeanne de Châtillon.

13. *Oeuvres de Froissart*, ed. Kervyn de Lettenhove, *Chroniques*, vol. 5 (1346–1356) (Brussels: 1868), pp. 112–14.

14. The chronicle of Bouchet recounts that the tomb was opened in 1412 at the request of the duke; the wedding ring was easily slipped off the saint's finger, but her hand then closed on her ring of religion, leaving the prince to content himself with only one souvenir. See Jean Bouchet, *l'Histoire et cronicque de Clotaire premier de ce nom, VII roy des Francois Et de sa tres illustre espouse, Madame saincte Radegonde* (Poitiers: 1527), Book 4, fols. 88–89r. I would like to thank Anthony J. Amodeo of the Newberry Library for kind assistance in verifying this reference.

15. See M. Lecointre-Dupont, "Mémoire sur le miracle des clefs et sur la procession du lundi de Pacques," *Mémoires de la Société des antiquaires de l'ouest*, 1st ser., 12 (1845), p. 245.

16. Arch. Vienne G 1529, fol. 53, published by René Crozet, *Textes et documents relatifs à l'histoire des arts en Poitou (Moyen âge—debut de la Renaissance)*, Archives historiques du Poitou, 53 (Poitiers: 1942), p. 137, no. 544. *Rappiller = rhabiller* (renovate). I would like to thank Rosalind Landy for help with this translation.

17. Crozet, *Textes*, p. 256, publishes this excerpt; the inventory of damage is printed by Em. Briand, *Histoire de sainte Radegonde, reine de France, et des sanctuaires et pèlerinages en son honneur* (Paris: 1898), pp. 290f.; a full summary is given in *Inventaire-sommaire des Archives départementales antérieures à 1790: Vienne, Série G* (Poitiers: 1960), vol. 2, pp. 87–88. The documents are Arch. Vienne G 1347, G 1588, G 1589. The only subjects mentioned for the broken chapel windows ("ung saint Sebastien et les Juifs a grant personnages") probably indicate Renaissance designs.

18. Arch. Vienne G 1590; *Inventaire-sommaire, Vienne*, p. 89.

19. Arch. Vienne G 1535; *Inventaire-sommaire, Vienne*, p. 67. Since Marquet received only ten sous for both the windows and for cleaning the pavement in front of the church, it seems likely that he filled them not with glass but with board. *Arentelé = arenja, arrenga, arregna* (to arrange). I would like to thank Rosaline Landy for help with this translation.

20. Leduc: Arch. Vienne G 1624, G 1625; *Inventaire-sommaire, Vienne*, pp. 119, 120. Pascault: Arch. Vienne G 1564, fol. 169r.

21. Benjamin Fillon, "Notice sur les vitraux de Sainte-Radegonde," *Mémoires de la Société des antiquaires de l'ouest* 11 (1844), p. 491. Miel was copying the button-window format of the Infancy series in the bay opposite. His glazed "signature" no doubt reveals pride in his achievement, rare in 1768.

22. Or a modern copy of a medieval window, which it is not. A detail of it is even illustrated in Hugh Arnold, *Stained Glass of the Middle Ages in England and France* (reprint, London: 1956), pl. XV (lower left). All Carot's full-scale cartoons, for both restorations and new designs, are inventoried in the Bibliothèque du Patrimoine, Paris (nos. 66597–612). The panels of his modern St Radegonde bay are nos. 66605 (1–8) and 66606 (1–8), dated 1899. The series also comprises cartoons for Bays 113 and 109, and for an unrealized project for the nave on the subject of the life of the Virgin and Christ (nos. 66611, 66612 [1–15]).

23. Pre-1950 photographs show this band at the bottom of Bay 114. It is my hypothesis that the scraps originated in Bay 112 and in Bays 107 and 108, the two small flanking lights at the apse, though when they were removed is uncertain.

24. Evidence for the appearance of the glass after 1768 is provided by Fillon's 1844 article, "Les Vitraux de Sainte-Radegonde," used by Baron Guilhermy among others. Evidence for the glazing arrangement between 1709 and 1768 must rely on the Maurist Dom Fonteneau, who observed that the church was dark because it had four "painted windows" in the nave. No doubt the 1768 restoration was intended to spread out the "dark" colored debris to provide more light for the canons, who complained that they could not read their breviaries (see Barbier de Montault in Robuchon, cited in n. 28 below). I theorize that Dom Fonteneau's four windows were: (1) St Radegonde appliqué (two bays put together, probably occupying Bay 111); (2) Last Judgment Bay 113 (with Infancy and Passion cycles moved into the lancets from Bays 110 and 116 on the

south); (3) Blaise bay (Bay 115); and (4) the latticework grisaille Bay 114, patched indiscriminately with debris from Bays 116 and 112 on the south. Dom Fonteneau's manuscripts, dated 1741–1769, are in the Poitiers Bibliothèque municipale; his remark on the windows (vol. 79, p. 25) has been published by Ginot, "Le Manuscrit de Sainte Radegonde" (as in n. 39 below), p. 56n2.

25. Bidaut, "Eglise Sainte-Radegonde" (as in n. 2), p. 110, dates the flamboyant portal to this time; Rhein, "Eglise de Sainte-Radegonde" (as in n. 3), p. 276, notes that its decoration includes the royal arms. On Charles VII's gratitude to St Radegonde for his victories over the English ending the Hundred Years' War, see p. 79 above.

26. Several modern disasters prove this point. An explosion in Vendôme in 1870 devastated the Renaissance glass without too much damage to the Gothic panels. At Evron, where the vaults fell in July 1974, only the Renaissance head used as a stopgap in one south clerestory was broken seriously.

27. For another possible arrangement of the glass in Bays 111, 112, 109, and 110, see p. 113 below.

28. In the mid-eighteenth century Dom Fonteneau noted the Radegonde appliqué window among four colored windows in the nave; see n. 24 above.

 Nineteenth-century sources, predating Carot's restoration, include: Mgr. X. Barbier de Montault, in Jules Robuchon, *Paysages et monuments du Poitou* (Poitiers: 1890), vol. 1, p. 109; Guilhermy, Paris, Bibl. nat. nouv. acq. fr. 6106, fol. 90v; Fillon, "Les Vitraux de Sainte-Radegonde," pp. 483–95; drawings of the Radegonde appliqué window and the Last Judgment window published by Ferdinand de Lasteyrie, *Histoire de la peinture sur verre* (Paris: 1853–1857), pls. XIX, XX (pp. 124–28). My judgments have been based on the most valuable source of all, the full set of photographs of the Radegonde appliqué window taken before Carot's restoration, most of which are here published for the first time. They date 1881.

29. The round-headed lancets of Bays 111 and 109 are 118 cm. wide (borders 15 cm., panels 83.5 cm. inside the leads); both bays are illustrated in Kraus, *Gold Was the Mortar*, pl. 33. The opposite bay, 110, is reasonably close in dimensions, the left lancet measuring 118 cm. and the right one reduced to 112 cm. because of a vaulted chamber in the buttress at that point. Such a difference could, however, be accommodated by border filets. One would normally expect that facing bays would have the same measurements but this is by no means always true at Sainte-Radegonde, where, for example, the lancets of Bay 112 are much wider (210 cm. each).

30. His reports in the dossiers of the Monuments historiques give no indication, nor could there have been any idea of the pre-Huguenot disposition. He had restored the old appliqué window in 1899 for the Monuments historiques; the commission for the matching window came not from there but from the *fabrique*.

31. His lack of sympathy with the folk style of the Appliqué Master can be adduced by the style of his added panels.

32. Alphonse's arms appear in the Last Judgment bay and are discussed below, p. 97.

33. See Marcel Aubert in *Le Vitrail français*, pp. 165, 167. To these examples one can add a Crucifixion panel with donors (Cologne, ca. 1313): Suzanne Beeh-Lustenberger, *Glasmalerei um 800–1900 im Hessischen Landesmuseum in Darmstadt* (Frankfurt and Hanau: 1967–1973), pp. 81–83, Abb. 62–64.

34. Lafond, "Le Vitrail en Normandie," pp. 321, 335; Lillich, "The Band Window," p. 32n16.

35. For the evolution of grisaille in the second half of the thirteenth century see: Lillich, *Saint-Père*, pp. 26–29, citing previous studies.

36. Papanicolaou has dated the Tours campaign that includes the band windows to 1264–1267. They are Bays 205 and 206.

37. Dom Fonteneau, Maurist skeptic that he was, had Dom Pernety make a copy of the images of MS 250 so that he could test the tradition by observations from the catwalk: Fonteneau MS, vol. 79, p. 25. Dom Pernety's copy, now MS 251 in the Bibliothèque municipale, is believed to preserve images since lost from the *libellus*, but none are helpful for the study of the window.

38. The importance of the *libellus* of a pilgrimage saint has been discussed by Caviness, *The Early Stained Glass of Canterbury Cathedral*, p. 142; Lillich, "Monastic Stained Glass," pp. 208–11. On Poitiers MS 250 see most recently Magdalena Elizabeth Carrasco, "Spirituality in Context: The Romanesque Illustrated Life of St. Radegund of Poitiers (Poitiers, Bibl. Mun., MS 250)," *Art Bulletin* 72 (1990), pp. 413–35.

39. Emile Ginot, "Le Manuscrit de Sainte Radegonde de Poitiers et ses peintures du XIe siècle," *Bulletin de la Société française de reproductions de manuscrits à peintures* (Paris: 1914–1920). Since Ginot the problem was worked on by E. Rayon, "Inventaire des vitraux du département de la Vienne—1925," pls. 211f. (MS in library of the Monuments historiques); and by Jean Verdon, "Etude iconographique et historique des vitraux consacrés à la vie de sainte Radegonde," June 1959 (Diplôme d'études supérieures, Mémoire secondaire, Université de Poitiers). Ginot used Carot photographs; Verdon used pre-Carot photographs. Nonetheless everybody made some mistakes.

40. The Fortunatus vita is published in *MGH scriptores rerum merovingicarum*, vol. 2, pp. 364–77.

41. The window is illustrated in *Le Vitrail français*, p. 159; Lillich, "Cleanliness with Godliness: A Discussion of Medieval Monastic Plumbing," *Mélanges Dimier*, pt. 3, vol. 5 (Arbois: 1982), pl. 2. See also n. 44 below.

42. On reversals in stained glass see Caviness, *The Early Stained Glass of Canterbury Cathedral*, p. 122.

43. The manuscript and window are illustrated in Lillich, "Monastic Stained Glass," pl. 1. The hair shirt of St Radegonde was a relic mentioned in the inventory of 1573. The inventories have been studied by Mgr. X. Barbier de Montault, "Le Trésor de l'abbaye de Sainte-Croix de Poitiers avant la Revolution," *Mémoires de la Société des antiquaires de l'ouest*, 2d ser., 4 (1881), pp. 55f. (on the "hayre," see pp. 129, 133f.).

44. For illustrations see n. 41 above. Radegonde was famous for her interest in washing and bathing. The baths she had built for her convent are described by her admiring contemporary Gregory of Tours, *The History of the Franks*, tr. O. M. Dalton (Oxford: 1927), vol. 2, p. 450 (PL vol. 71: chap. X, sec. 16). Since she spent the last twenty-seven years of her life sealed up in a hermit's cell, she could not have bathed often herself, however.

45. The vita written by Baudonivia is published in *MGH scriptores rerum merovingicarum*, vol. 2, pp. 377–95. It usually follows Fortunatus in medieval manuscripts.

46. See Briand, *Histoire de sainte Radegonde* (as in n. 17), p. 217; René Aigrain, *Sainte Radegonde (vers 520–587)* (Paris: 1930), p. 163.

47. On the chapel(s) built over the stone of the Pas-Dieu see Rhein, "Eglise de Sainte-Radegonde" (as in n. 3), pp. 269–70; B. de la Liborlière, *Vieux souvenirs du Poitiers d'avant 1789* (Poitiers: 1846), p. 78. The stone and the baroque statues of Christ and Radegonde were transferred to their present location in the church at the time of the Revolution; a chapel was rebuilt on the original site, however, in 1912.

48. Briand says it was well established in 1392: *Histoire de sainte Radegonde*, p. 218n2.

49. Monsabert, "Documents de Ste. Croix de Poitiers" (as in n. 4), 10 (1914), p. 381n1.

50. The scene looks something like a Noli me tangere. The matrix is listed in Amédée Brouillet, *Notice des tableaux, dessins, gravures . . . composant les collections de la ville de Poitiers*, pt. 2 (Poitiers: 1886), p. 698, no. 6938. I was unable to locate this matrix in Poitiers.

51. De Lasteyrie recognized that the figure was not a bishop, and identified the scene as Radegonde visiting the monk Jean at Chinon: *Histoire de la peinture sur verre* (as in n. 28), p. 124.

52. Briand, *Histoire de sainte Radegonde*, pp. 394f. The banner of the Grand' Goule is first mentioned in a charter of 1466, by which time it was a well-established tradition: Barbier de Montault, "Le Trésor de Sainte-Croix," pp. 228f. The tradition of parading dragons in Rogations processions is mentioned "especially in the churches of Gaul" by Voragine: *The Golden Legend of Jacobus de Voragine*, ed. Granger Ryan and Helmut Ripperger (New York: 1969), p. 280.

The relic of the True Cross was sent to Radegonde in 569 by the emperor of Byzantium, in an enameled reliquary of the *staurotheca* (double traverse) type. It is mentioned by both Baudonivia and Gregory of Tours, and Fortunatus composed his famous hymn *Vexilla regis prodeunt* for the ceremony when it arrived in Poitiers. A seventeenth-century painting shows the reliquary, according to Briand, p. 391.

53. The account of his miraculous cure is no. 5 in the late thirteenth-century manuscript Poitiers, Bibl. mun. MS 252, published by Bodenstaff, "Miracles de sainte Radegonde" (as in n. 10).

54. Ibid., pp. 433–47; the texts of the thirteen miracles are pp. 438–45.

55. Ibid., pp. 445–47 (dated 1303, 1306). The fifteenth-century manuscript is Poitiers MS 253.

56. The women were: the widow of Châteauroux in 1249; wife of Pierre de Leissac in 1265; Radegonde of La Rochelle, wife of Guy le Breton, in 1269. The men were: Philippe l'Anglois, 1265; Pierre de Jardfort near Montberon, 1265; Guillaume, son of Pierre de Vilars, 1268; Maître Girard de Piolan, 1268; Guillaume *dit* Munier, the carpenter, 1270.

57. The *infirmitate sancte Radegundis* is specified as such in a miracle of 1306: Bodenstaff, "Miracles de sainte Radegonde," p. 446. On St Radegonde's specialty see also Barbier de Montault, "Miracle de sainte Radegonde" (as in n. 108 below). In the Archives départementales de Vienne are depositions about miraculous cures of leg problems as late as 1678 (G 1609), 1707–08 (G 1625), and 1712–13 (G 1629).

58. Since the original statue existed before 1200, as we shall see, it was no doubt of the Romanesque type. It was destroyed by the Huguenots and quickly replaced by the present sixteenth-century copy.

59. Lecointre-Dupont, "Le Miracle des clefs" (as in n. 15), pp. 209–48, is a thorough investigation of the whole question of the authenticity of the legend and of its development. His conclusion is that the basic historic event is "completely disfigured" but possibly was connected to the bands of Mercadier, captain of the English, who were pillaging the west in 1200.

60. According to Lecointre-Dupont, ibid., the Proper of Notre-Dame-la-Grande, source of the 1463 text, gives the date as Easter Sunday, Apr. 15, 1200. Since Easter was on Apr. 14 in 1200, the date is sometimes changed to 1202. However, the English were occupying Poitiers in both 1200 and 1202; it became French only in 1204.

61. Lecointre-Dupont (ibid., p. 237) dates the facade niches to the time of the duc de Berry; the three niches of the south porch, which still exist, are also datable to that era. I have seen engravings (or perhaps copies of them) of the type here described in Poitevin antique shops but have never been able to trace their origin.

62. In 1257 the canons of Notre-Dame-la-Grande won a legal quarrel with the agents of Count Alphonse over their "ancient" right to keep the keys to the city from Monday of Rogations to the following Wednesday, and more important, to enjoy the income from the jurisdiction thus implied. They did not mention the miracle but a charter of privilege granted by Richard the Lionhearted (1174) and confirmed by Philippe Auguste and King John (Lecointre-Dupont, ibid., p. 219). Establishing the Miracle of the Keys legend was thus of economic value to Notre-Dame-la-Grande.

63. Crenellations are absent from both her hermit cell in the Blind Bella panel and the walls of the nunnery from which the devils flee. In the Pas-Dieu panel the crenellated piece may be a patch that Carot did not distinguish but in fact enlarged in his restoration.

64. See above at n. 36.

65. On the Evron Master see Chap. II, pp. 29–33. The painting style relates not to Poitou but to Sées: Chap. VI, pp. 206f.

66. The appearance of these idiosyncratic facial traits in a recently uncovered fresco in Poitiers cathedral suggests that the Appliqué Master may have been a local jack-of-all-trades; the fresco's discovery is reported by Marie-Pasquine Suber-Picot, "Vienne: Découverte de peintures murales dans la cathédrale Saint-Pierre de Poitiers," *Bulletin monumental* 148 (1990), pp. 200–203. On the Primelles panel see Chap. II at n. 163.

67. On the Master of Bishop Geoffroy de Loudun see Chap. II, pp. 18–24.

68. De Lasteyrie, *Histoire de la peinture sur verre* (as in n. 28), pl. XX. An attempt was made by Roland Sanfaçon to chart the restorations, but since Carot polished the backs and repainted important areas of the front, everything must be questioned prima facie: Sanfaçon, "Un Vitrail de Sainte-Radegonde" (slightly different versions exist in the library of the Patrimoine in Paris and in Poitiers CESCM). See p. 406 below.

69. On the Gassicourt Deacons Master, see pp. 54–56; on Poitiers cathedral see Grodecki's studies referred to in Chap. II at nn. 40 and 62.

70. It is not significant that de Lasteyrie (*Histoire de la peinture sur verre*) omits the grisaille in Bay 113, since his pl. XIX of the appliqué window omits the plain grisaille panel at the base of each lancet.

71. Bay 114 is now made into a band window but most probably originally held only grisaille. Whatever color its small rose may have had has been replaced with the fifteenth-century king's arms.

72. For the text of the gift, see n. 6 above.

73. Until recently it has been repeated that the kneeling figure was perhaps Philippe le Long as count of Poitiers, 1311–1316, although this theory had been bombarded by Alfred Richard, "Les Armoires du comte du Poitou," *Mémoires de la Société des antiquaires de l'ouest* 62 (1894), pp. 432–58. Philippe's arms before he became king were: *France ancien au lambel componé* (the pendants of the lambel vary in number). See seals: Louis Douët-d'Arcq, *Collection de sceaux des archives de l'Empire* (Paris: 1863), no. 1080; Francis Eygun, *Sigillographie du Poitou* (Poitiers: 1938), no. 12, pl. II. As a province, Poitiers did not have arms at this time; Richard suggests that the duc de Berry established them (p. 458). The arms are blazoned in Walford's Roll, discussed by Max Prinet, "Armoiries françaises et allemandes décrites dans un ancien rôle d'armes anglais," *Le Moyen Âge* 34 (1923), p. 227 and n. 2. See also seals: Douët-d'Arcq, no. 1077; Eygun, nos. 8, 9, pl. I.

74. De Lasteyrie noted this: *Histoire de la peinture sur verre,* p. 127.

75. See Lillich, "Vendôme," p. 249n61.

76. On Maître Guichart see n. 5 above, and Audouin, *Documents de Poitiers* (as in n. 5), passim.

77. Sts Agnes and Disciole shared a feast May 12 in the late thirteenth-century calendar of the abbey. See: Monsabert, "Documents de Ste. Croix de Poitiers" (as in n. 4), 10 (Feb. 1914), pp. 373f.

78. Gloria Gilmore-House, "Angers Cathedral: An Early Twentieth-Century Restoration of Mid-Fifteenth-Century Glass," *Journal of Glass Studies* 26 (1984), pp. 77–85.

79. Louis Grodecki, "Les Vitraux de la cathédrale de Poitiers," *Congrès archéologique* 109th session (1951), p. 161.

80. Grodecki, "A Stained Glass Atelier of the Thirteenth Century," pp. 89, 97 (color); 104 (pearled edgings).

81. Panels of questionable identification include a Death of the Virgin (or of St Radegonde?) and a resurrection of a shrouded figure by Christ (Lazarus?).

82. This fragment is now remade as the right half of a medallion in the right lancet of Bay 116.

83. On the relic of the True Cross obtained by St Radegonde for her nunnery see n. 52 above. Scenes of Radegonde and of the miracles caused by the relic of the True Cross at the nunnery (mentioned by both Baudonivia and Gregory of Tours) also could have formed part of the original medallion program of Bay 116.

84. In the *Golden Legend* (as in n. 52), p. 275: "and at once the nails came into view, shining like gold out of the earth."

85. Grodecki, "A Stained Glass Atelier of the Thirteenth Century," p. 105.

86. Examples listed in Lillich, "The Band Window," n. 15.

87. Sanfaçon, "Un Vitrail de Sainte-Radegonde," p. 21.

88. Carot overpainted with a black, deadening line but did not invent. If he did not refire, perhaps it will come off?

89. This was realized by the architect in 1901, who proposed to reinstall the Infancy panels there (dossiers, Monuments historiques). The project was not funded, no doubt because the sacristy roof would have had to be rebuilt before the blinded lancet could have been unblocked to receive the glass.

90. The half-medallions are 40 cm. wide without borders; the borders are 16 cm. wide, inside the leads. Three of the eight extant panels have yellow corner bosses; the rest have red. I cannot make a logical iconographic sequence by color, however: the yellow ones are Presentation in Temple, Flight to Egypt, Christ among the Doctors.

91. The Flight to Egypt is illustrated in a colored drawing in Arnold, *Stained Glass* (as in n. 22), pl. XV.

92. On the Glencairn Visitation: CV Checklist II, p. 133 (with bibliography). Fillon listed the Visitation in the window in 1844; Carot's cartoon of it (inv. no. 66597 [17], as in n. 22 above) is dated 1904. The panel is heavily restored, with stress cracks; the right head and most of the grisaille are old.

93. Illustrations: CVFR II, p. 289 (Bay 102); Hayward and Grodecki, "Les Vitraux d'Angers," pp. 50–51 (border); pp. 38, 43 (medallion shape); pp. 43, 44 (faces, figures). The thin, delicate brushwork of the Julien window at Angers is not found at Sainte-Radegonde but does turn up in the work of the chantier at Dol, which was familiar with the glazing traditions of Sainte-Radegonde. The conditions of these three ensembles—each damaged and retouched in different ways—make their interrelationships difficult to chart further. On Dol see Chap. V.

94. *The Sketchbook of Villard de Honnecourt,* ed. Theodore Bowie (Bloomington, Ind.: 1959), no. 32; also the frontal horse, no. 18. Frontal horses are common in the Cantigas manuscript made for Alfonso el Sabio, ca. 1284 (Escorial, Bibl. Real T.I.I.): José Guerrero Lovillo, *Las Cantigas: Estudio arqueologico de sus miniaturas* (Madrid: 1949).

95. CVFR II, pp. 294–95 (Bay 129).

96. Fillon, "Les Vitraux de Sainte-Radegonde," pp. 484–86.

97. The fragment of the archangel Michael killing the dragon, now in the rosace, is too large in scale and must have originated elsewhere. The left kite has only fragments; the "angel" in the right kite has been made up from odd pieces and a nice head.

98. A general indication of the level of their destruction, described "as high as a demilance," can be obtained from Bay 115. This is useful in postulating the original program, locations of cycles, lost scenes, etc.

99. The restoration of Bays 115 and 116 was in progress in the early 1950s: Bidaut, "Eglise Sainte-Radegonde" (as in n. 2), p. 113. The dossiers in the Monuments historiques specify that the excessive light bothered the organist and was damaging the organ (Bays 115–116 light the organ tribune). On the eight medallions composed by Miel see pp. 79–83.

100. The customary, dated between 1284 and 1297, was published by Monsabert, "Documents de Ste. Croix de Poitiers" (as in n. 4), 10 (Feb. 1914), pp. 373f. Blaise's feasts are Feb. 3 and Feb. 15; Lawrence's are Aug. 10 and the octave, Aug. 17. The calendar contains very few octaves. It should be noted that Poitiers cathedral has an important Lawrence window in the twelfth-century glazing of the east wall (Grodecki, "Les Vitraux de Poitiers" [as in n. 79], pp. 148–49); and a Blaise window in the thirteenth-century program largely devoted to the Old Testament (Grodecki, "A Stained Glass Atelier of the Thirteenth Century," pls. 17, 22c).

101. The text of the miracle, from a fifteenth-century lectionary (Poitiers, Bibl. mun. MS 253), is edited by Bodenstaff, "Miracles de sainte Radegonde" (as in n. 10), pp. 446–47.

102. Barbier de Montault, "Le Trésor de Sainte-Croix" (as in n. 43), pp. 59–60. The reliquary of St Blaise was damaged by the Huguenots; as late as the Revolution the church had a chaplaincy of St Lawrence and an altar for Blaise. Briand published this data: *Histoire de sainte Radegonde* (as in n. 17), pp. 290f.; see also Arch. de la Vienne G 1361, G 1589, G 1629.

103. Arch. de la Vienne G 1589.

104. On the conflation see Louis Réau, *Iconographie de l'art chrétien*, vol. 3: *Iconographie des saints*, pt. 2 (Paris: 1958), pp. 793f. On the cult of St Lazarus (brother of Mary Magdalene) see: Emile Mâle, *Religious Art in France, the Twelfth Century* (Princeton: 1978), pp. 213–17. There was a chapel of the Magdalene at Sainte-Radegonde: Arch. de la Vienne G 1598; Briand, *Histoire de sainte Radegonde*, p. 293.

105. Charles Altman, "The Medieval Marquee: Church Portal Sculpture as Publicity," *Journal of Popular Culture* 14/1 (1980), pp. 41–44. His notes list many examples of the parable in art, among which can be mentioned the frescoes at Nohant-Vicq (Indre) and the ambulatory window of Bourges.

106. The two small images of the Agnus Dei are by different painters, the Blaise Master's version touched with his usual charm. On the original location of the Agnus Dei roundel now in Bay 114 see discussion above, p. 83.

107. The Agnus Dei was growing in popularity at this time. William Jordan has studied its significance to St Louis ("Saint Louis's Influence on French Society and Life in the Thirteenth Century: The Social Content of the Crusade of the Mid-Century [1248–1254]" [Ph.D. diss., Princeton University, 1973], pp. 242–64); it became a personal emblem of Philippe le Bel; and as the "mouton" coin it had a very long popular existence as a motif. Having begun as an attribute of John the Baptist (when attributes began to develop in the early thirteenth century), it eventually was transferred on occasion to St Agnes (*agna dei*). As a basic Christological symbol of the Triumph of Christ it does not seem to have been incorporated into narratives such as the Passion or Last Judgment (St Matthew version) and remained an abstraction, at least until the fifteenth century. For a full discussion of the Agnus Dei as a symbol of Christ's death and resurrection see Gertrud Schiller, *Iconography of Christian Art* (New York: 1966), vol. 2, p. 117f.

108. Bodenstaff, "Miracles de sainte Radegonde," p. 444; Mgr. X. Barbier de Montault, "Miracle de sainte Radegonde en faveur d'une bordelaise l'an 1269," *Revue de Saintonge et d'Aunis* 12 (1892), pp. 415–61.

109. The abbess was Jehanne de Plaisance from 1263 to 1269, and thereafter Jehanne de Lavergne. The office of abbess may also have suggested the Agnus Dei, since the first abbess was Radegonde's disciple St Agnes, depicted next to St Radegonde in the Bay 113 traceries and honored in the liturgical calendar on May 12. See Monsabert, "Documents de Ste. Croix de Poitiers" (as in n. 4), 10 (Feb. 1914), pp. 373f.

110. Since it is difficult to remove glass from very small tracery lights, and since the glass is quite protected in such locations, it is often left there when the remainder is removed for safekeeping or restoration.

111. *Golden Legend* (as in n. 52), pp. 439–40. The twelfth-century Lawrence window of Poitiers cathedral also has three scenes in which the saint is led before a magistrate or prince: see Grodecki, "Les Vitraux de Poitiers" (as in n. 79), p. 148.

112. *Golden Legend*, pp. 154–55.

113. On the *carré quadrilobé* see Chap. III, n. 44. The Angers bays are illustrated in Hayward and Grodecki, "Les Vitraux d'Angers," pp. 47–48 (Passion); 9, 50, 51 (St Julien); 40 (*carré quadrilobé*, St Lawrence).

114. Among the debris now in Bay 116 are about a half dozen heads by the Blaise Master, several of them among his most remarkable creations. One scene shows a saint (Lawrence?) flagellated by two figures; other subjects cannot be identified.

115. The borders of the Appliqué window are 15 cm. wide within the leading; those of the latticework grisaille are 10–11 cm.

116. The latticework grisailles of Fécamp (MH 247480) are different: the latticework is much simpler and the grisaille foliage grows vertically against a clear ground, the whole producing a much more airy effect. This is also true of the quasi-latticework at Saint-Urbain de Troyes (*Le Vitrail français*, p. 71, pl. VIII).

117. On Sées see Chap. VI; on the Last Judgment window of Alphonse de Poitiers, see pp. 96f. above.

118. Pre-1950 photographs show Miel's eight Gothicizing medallions in place. The patchwork of debris across the bottom (now moved to the middle of the window) and the grisaille scraps and shield of the traceries were possibly post-Huguenot installations. The shield is post-medieval.

119. The original latticework grisaille was overpainted cold, and the obtrusive black paint is already flaking off. Is it really necessary?

120. The original location of the four windows (two Radegonde bays by the Appliqué Master, one Infancy window, and one Radegonde bay by the Infancy Master) within Bays 109–112 cannot be established. Bays 111 and 109 have the same dimensions, Bay 110 nearly the same. The two lancets of Bay 112 are vastly wider than any others in the church: 210 cm. each. If the scraps of the Infancy Master's Radegonde bay can be established at approximately 70 cm. wide, a double row of medallions could have been accommodated in Bay 112 even with a wide border.

121. This identification was first made by Fillon, "Les Vitraux de Sainte-Radegonde" (as in n. 21), pp. 493–94. The fifteenth-century French version of the legend has been published from Paris, Bibl. nat. fr. 1784 by Briand, *Histoire de sainte Radegonde* (as in n. 17), p. 67n2.

122. Mâle discusses the apocryphal episode embroidering the Flight to Egypt in *Religious Art in France: The Thirteenth Century* (Princeton: 1984), p. 222.

123. Arnold, *Stained Glass* (as in n. 22), pl. XV, has drawings of the heads of Radegonde and the female disciple.

124. Bodenstaff, "Miracles de sainte Radegonde" (as in n. 10), pp. 436–37 with bibliography; Dom François Chamard, *Histoire ecclésiastique du Poitou* (Poitiers: 1880), vol. 2, p. 217.

125. Monsabert, "Documents de Ste. Croix de Poitiers" (as in n. 4), 10 (Feb. 1914), p. 375. Monsabert states that the feast of Reversion (Translation) is also in a list of late thirteenth- or early fourteenth-century foundations, in the Arch. Vienne; he analyzes these in "Etat sommaire des fonds" (as in n. 4), 8 (1912–13), pp. 43f.

126. Aigrain, *Sainte Radegonde* (as in n. 46), pp. 64–65; but see Abbé D. Leroux, *Sainte Radegonde à Saix* (Poitiers: 1877), pp. 120–23.

127. Bodenstaff, "Miracles de sainte Radegonde," pp. 445–46, publishes the text of this miracle from Poitiers MS 253 (fifteenth century). It was still the custom to offer oats to St Radegonde in the nineteenth century.

128. I am grateful to Linda Papanicolaou for these clues. See also her "Windows of the Choir of Tours," p. 231.

129. On the stained glass of Saint-Martin-aux-Bois see CVFR I, p. 208. The customary date of 1260 for this panel, which is too early, is based on the erroneous date of 1260 that *Gallia christiana* gives for Abbot Hugues de Rouvillers. The previous abbot was still in office in 1271, according to Emile Morel, "L'Abbaye de Saint-Martin-aux-Bois," *Mémoires de la Société archéologique et historique de Clermont(-en-Beauvaisis) (Oise),* fasc. 2 (1907), pp. 80–81. MESIERES IEHA. . DE ROVCOVSVILER (Jean de Rouvillers), shown as a donor in the window, is not a priest but a layman, as pointed out by J.-B. Martinval, *Notice sur l'église de Saint-Martin-aux-Bois* (Montdidier: 1866), p. 4. He is therefore not the prior of Pomponne but probably his namesake, the Jean de Rouvillers who was son of Mennessier de Rouvillers and, by 1260, married to Perronnelle. On the Rouvillers see Morel, pp. 34–36.

130. I have discussed the appearance of three fleurs-de-lis in the thirteenth century in "Vendôme," pp. 248–49 and nn. 58–59. See also Max Prinet, "Les Variations du nombre des fleurs de lis dans les armes de France," *Bulletin monumental* 75 (1911), p. 170 and n. 1.

131. The king's foundation of Sept. 1276 is recorded in an inventory of charters of 1645: Arch. Vienne G 1578 (published in *Inventaire-sommaire, Vienne* [as in n. 17], vol. 2, p. 78). Alphonse de Poitiers's will is Arch. nat. K 33 no. 14 (copies and vidimus J406 no. 5, J 192 no. 57): Berger, *Layettes du trésor des chartes* (as in n. 6), pp. 453f. (no. 5712). Philippe le Hardi won final judgment over the county of Poitou against Charles d'Anjou in 1283: *Gallia christiana* (1739), vol. 6, col. 81.

132. Arch. Vienne G 1361, dated 1682.

133. Without scaffolding one cannot get a closer measurement. The glass now in the right window is signed "L. Lobin, Tours, 1859." One could provide proof for my sequential hypothesis by tracing the curve of the fragments of the wide heraldic border in Bay 114 and seeing if it would fit the round heads of these two lancets. For both tasks one would need scaffolding.

134. A letter to Alphonse dated May 31, 1253, from Robert Gauceline, lord of Lunel, assures him that every effort is being made to comply with Alphonse's request to send a certain Jewish doctor Abraham, from Aragon, known for expertise in eye ailments. The doctor wished letters patent for safe conduct, letters of intercession to the king of Aragon, assurance that he would not be detained against his will, and secrecy. See Solomon Grayzel, *The Church and the Jews in the XIIIth Century* (New York: 1966), pp. 346–47.

135. The diagnosis of Alphonse's ailments as neuritis following adult diphtheria was made by Auguste Brachet, *Pathologie mentale des rois de France, Louis XI et ses ascendants* (Paris: 1903), pp. 354–75.

<div style="text-align:center">CHAPTER 5</div>

1. Differences are outlined by Pierre Héliot, "Triforiums et coursières dans les églises gothiques de Bretagne et de Normandie," *Annales de Normandie* 19 (June 1969), pp. 115–54. Angevin influence in Brittany is discussed by Mussat, *Le Style gothique de l'ouest*, pp. 284–89, but Dol is only mentioned in notes on pp. 289 and 355.

2. Nowhere is this more obvious than at Saint-Sauveur de Redon, a church which Héliot ("Triforiums et coursières") relates to the cathedral of Tours, with a "French chevet," pierced triforium, and traceried clerestories in the *rayonnant* idiom. See the illustration in *Dictionnaire des églises de France*, ed. Robert Laffont (Paris: 1968), IV A 124. The windows were glazed, most probably in the late thirteenth century, and removed about 1785–1790: see Lillich, "Gothic Glaziers," pp. 84–85.

3. See generally Augustus Potthast, ed., *Regesta pontificum romanorum* . . . (London: 1875), vol. 1, pp. 69–70. The bull has been published several times: Dom Hyacinthe Morice, *Mémoires pour servir de preuves à l'histoire ecclésiastique et civile de Bretagne* (Paris: 1742–1746), vol. 1, cols. 759f. For a summary of the dispute see *Histoire littéraire de la France*, Académie des inscriptions et belles-lettres (Paris: 1733–1927), vol. 15 (1820), pp. 334–37.

4. Geoffroy of Monmouth states that King Arthur gave St Samson the archbishopric of York: *History of the Kings of Britain*, Book VIII, chap. 12. That Samson was identified in the Middle Ages with the St Samson who founded Dol in the sixth century, whose relics were there, and who was honored as its "first bishop." On Samson see p. 140 below. On the strength of the Arthurian cult at the court of Edward I see Denholm-Young, *History and Heraldry, 1254 to 1310*, pp. 48–49.

5. See generally Alfred Baudrillart, *Dictionnaire d'histoire et de géographie ecclésiastique* (Paris: 1912), "Dol," col. 570; Amédée de Guillotin de Corson, *Pouillé historique de l'archévêché de Rennes* (Paris: 1880), vol. 1, pp. 380–90.

6. On the bull of Boniface VIII: Potthast, *Regesta pontificum romanorum*, vol. 2, p. 1987, no. 24847. This bull is printed often: Albert Le Grand, *Les Catalogues des évêques, abbés et abbesses et des princes souverains de Bretagne* (1636; new ed., Quimper: 1901), p. 197; Jean Ogee, *Dictionnaire historique et géographique de la province de Bretagne* (1779; new ed., Rennes: 1843), vol. 1, p. 243.

 On the court of Anne de Bretagne: François Duine, "Histoire civile et politique de Dol jusqu'en 1789," *L'Hermine, Revue littéraire et artistique de Bretagne* 38 (1908), p. 159n7.

7. Duine, "Histoire de Dol," *L'Hermine* 37 (1907), pp. 84–86. On Thibaud's services to Philippe le Hardi see p. 151 below. He continued to serve Philippe le Bel in numerous capacities for the rest of his life.

8. See: Bertrand Robidou, *Histoire et panorama d'un beau pays* (Dinan: 1861), p. 101; Ogee, *Dictionnaire* (Nantes: 1779), vol. 2, p. 35.

9. The patronage of the dukes and many noble families in the second half of the thirteenth century was directed toward abbeys: on Saint-Méen (Ille-et-Vilaine) and Léhon (Côtes-du-Nord) see pp. 155 f. below; on the Carmelite house at Ploërmel and Saint-Sauveur de Redon see Lillich, "Gothic Glaziers," pp. 84–85. Usually the intention was to establish a family mausoleum at the abbey. The bourgeoisie seems to have been too weak and undeveloped in Brittany in this period to have had any significance as patrons.

10. On the Gothic building see: Héliot, "Triforiums et coursières," pp. 135–36; René Couffon, "La Cathédrale de Dol," *Congrès archéologique* 126th session (1968), pp. 37–59; André Rhein, "La Cathédrale de Dol," *Bulletin monumental* 74 (1910), pp. 369–433.

11. Héliot, "Triforiums et coursières," compares the nave to Saint-Etienne de Caen and the choir of Lincoln; in his opinion it combines a general construction in the Anglo-Norman mode (interior clerestory passage with "screen") with some northern French detail (aisle windows).

12. The text of the letter of Theobaldus, archbishop of Rouen, concerning the relics' return, is published in Morice, *Preuves* (as in n. 3), vol. 1, p. 850; *Gallia christiana* (Paris: 1856), vol. 14, Instrumenta col. 257.

13. Rhein, "La Cathédrale de Dol," p. 384. The statutes are discussed by Guillotin de Corson, *Pouillé de Rennes,* vol. 1, pp. 467–70. There is no firm evidence that Bishop Etienne was buried in the (new) choir, as Gautier believed. Bishop Jean Mahé (d. 1279) was, however, buried there and his tomb was described by the Maurists. See Toussaint Gautier, *Cathédrale de Dol: Histoire de sa fondation, son état ancien et son état actual* (Dol: 1860), pp. 27–34, 66.

14. Anne Prache, "Les Influences anglaises sur l'architecture de la cathédrale de Dol," *Bulletin de la Société nationale des antiquaires de France* (1980–81), pp. 290–94. Previous scholars have sought connections in Normandy or Anjou. Héliot, "Triforiums et coursières," notes that the interior clerestory passage can be related to Norman types, while the triforium evokes Corneilles-en-Vexin or the transept of Saint-Jacques de Dieppe. Flat chevets do occur in the Angevin west; see Mussat, *Le Style gothique de l'ouest,* pp. 328–29. One could also recall the Gothic flat chevet of Saint-Julien de Tours: Marcel Deyres, "Le Projet de construction du choeur à l'église St.-Julien de Tours," *Bulletin de la Société archéologique de Touraine* 35 (1969), pp. 397–406.

15. On the Breton nobility in the reign of St Louis, what little evidence William Chester Jordan could find indicated a positive relationship from the late 1240s on: *Louis IX and the Challenge of the Crusade,* pp. 55 n110, 67, 200.

16. In "Gothic Glaziers" I investigated the documentation for Gothic campaigns for which no glass now remains: Saint-Sauveur de Redon and the Carmelite house of Ploërmel.

17. A drawing of an angel's head is published by J. Brune, "Essai sur les vitraux peints du département d'Ille-et-Vilaine," *Bulletin archéologique de l'Association bretonne* 2 (1850), pl. 6 at end of volume. The fragments are carefully listed by Charles Robert, "La Grande verrière du XIIIe siècle et autres vitraux anciens de la cathédrale de Dol," *Mémoires de la Société archéologique d'Ille-et-Vilaine* 22 (1893), pp. 26–27; and more accurately dated by Couffon, "La Cathédrale de Dol," p. 56. Several are listed in *Le Vitrail en Bretagne,* p. 20.

18. "Go then, rejoice over the church of Dol / For its beautiful window opens the heavens to you" (trans. Paul Archambault). For the complete poem see Duine, "Histoire de Dol" (as in n. 6), pp. 158–59. The statutes (*Recueil de statuts synodaux de Dol*) were published in Nantes in 1509, and the cathedral's breviary was also printed by Bishop Mathurin de Pledran in the same period. The stained glass restoration no doubt proceeded apace. The north tower repairs, which included the bishop's arms (now hammered out), had been supported by indulgences for that purpose advertised in a poster the bishop had printed in 1506. Another poster advertising indulgences in 1519 suggests that the tower restorations needed money; they were only completed after he died in 1521. The posters are in Arch. dept. Ille-et-Vilaine G 681.

19. Late seventeenth- to early eighteenth-century accounts list small payments to a *vitrier* almost yearly (Arch. dept. Ille-et-Vilaine G 377 A, B). In 1731–1734 the *fabrique* paid "a dernault vitrier et a sa soeur" and others for repairs (Arch. dept. Ille-et-Vilaine G 377c, Compte de la fabrique 1731–1734, p. 16). An extensive releading and reglazing was paid for in 1768 to another woman glazier, "La veuve duvergee vitrier" (Arch. dept. Ille-et-Vilaine G 281, "Mémoire des reparations . . . 1768," with three pages of repairs listed).

20. For Mazot's receipt and account of work done see Arch. dept. Ille-et-Vilaine 1 V 679.

21. Gautier, writing in 1858 (*Cathédrale de Dol,* pp. 95–97), states that these documents were in the archives of the Mairie de Dol, fonds M. 4.

22. On such graffiti, scratched with a diamond tool by later restorers, see Françoise Perrot, "L'Art de la signature: VIII. La Signature des peintres-verriers," *Revue de l'art* 26 (1974), p. 40nn.10–12, fig. 13.

23. Prosper Merimée, *Notes de voyage* (1836; new ed., Paris: 1971), p. 306; Guilhermy's notes are Paris, Bibl. nat. nouv. acq. fr. 6099, fol. 346r–v.

24. The drawings of two panels, one from the sixteenth century, are now in the archives of the Monuments historiques. The path of Ramé's report through Parisian bureaucratic channels can be tracked in: *Bulletin du Comité de la langue, de l'histoire et des arts de la France,* Ministère de l'Instruction publique et des cultes, 3e section—archéologie, 2 (1853–1855), p. 507 (Nov. 1854), p. 572 (Jan. 19, 1855), p. 584 (Feb. 5, 1855); *Revue des Sociétés savantes des départements,* 4th ser., 9 (1869), pp. 385–86. It was published in *Journal de Rennes,* 12th year, nos. 37 (Mar. 27, 1855) and 38 (Mar. 29, 1855): "Rapport de M. A. Ramé au Comité de l'histoire et des arts de la France." I found this newspaper in the Bibliothèque municipale de Rennes.

25. The fullest description of the south transept window is by J. Brune, "Des vitraux peints existant dans le département d'Ille-et-Vilaine," *Congrès scientifique de France,* 16th session, pt. 2 (1849–50), p. 85:

> La grande fenêtre du pignon sud a conservé quelques lambeaux de mosaïques et de petites figures de prophètes tenant des banderolles. Entre les meneaux subsistent aussi quatre panneaux, dont un a été remplacé avec si peu d'intelligence que les personnages sont vus la tête en bas. Un autre se compose de pièces incohérentes; un troisième laisse voir un saint présentant un personnage agenouillé à l'Enfant Jésus dans les bras de sa Mère: peut-être est-ce le donateur de la vitre. Le quatrième contient deux personnages élevant en haut des vases allongés et surmontés de disques de couleur rosée. Dans un petit compartiment réservé entre les deux grandes ogives sont deux léopards d'argent passant sur un champ de gueules.

The leopards, which survive, are Bishop Thibaud's arms. The "donor" must be from a later design, since donors were not commonly presented by their patron saints until at least the fourteenth century. Since neither Merimée nor Guilhermy mentions this later debris, it is possible that it was collected in the south window lancets in the 1840s.

26. The curé paid for it and told the government inspector that he could do as he pleased in his church; the minister authorized the window ex post facto, in spite of reports that it was "d'une composition et d'un dessin détestables" (Monuments historiques, dossiers 1885–86).

27. Brune ("Des Vitraux d'Ille-et-Vilaine," p. 85) clearly states that only three remained, even in mutilated form. Ramé ("Rapport," *Journal de Rennes* 38) says there were four, and suggests that they represented the four bishops reigning during the thirteenth-century construction. An identical bishop lancet of largely nineteenth-century reconstruction is now in Forest Lawn, Glendale, Calif., where it was damaged by fire. It is illustrated in CV Checklist III, p. 50.

28. The curé's idea clearly came from Ramé (see previous note). In 1893 Robert, "La Grande verrière de Dol," pp. 22–23, reported the newly installed coats of arms, which everyone realized were fantasizing and inaccurate.

29. The bishops are 50–52 cm. wide and were at least four panels high. The nave clerestories are five panels high. I was unable to locate an entrance to the interior ledge in order to measure them, but their width would amply accommodate a bishop within broad borders.

30. In Bay 209 see the right two lancets (particularly the lower row), which are further removed from the style of the Master of Bishop Geoffroy than the left lancets. Le Mans Bay 209 and Bay 204 are discussed in Chap. II, pp. 37–38.

31. The piece of glass with the fingers and ring is replaced, so one must presume that the restorer copied the ring from the original design. The left bishop of Bay 204, of the same cartoon, now has a blackened hand. I am grateful to Helen Zakin for checking the photomontages in the Archives photographiques for me.

 A later example has recently come to my attention, in the figure of the blessing St Nicholas in the traceries of Bay 7, Saint-Gengoult, Toul (datable after 1269 and before 1285): Lillich, "The Ex-Voto Window at St.-Gengoult, Toul," *Art Bulletin* 70, no. 1 (1988), p. 125, figs. 3, 4.

32. On lancet G see pp. 143f. below. All three major artists of the east window worked on this lancet. The Samson Master, whose painting style is closest to the Blessing Bishops Master, uses a very different, rainbow-hued palette.

33. The restoration of 1509 used warm, gay colors, including salmon pink. The color of Oudinot's 1870 panels is thin and washed out, while that of Gruber is raw and oversaturated.

34. Gloria Gilmore-House, "The Mid-Fifteenth-Century Stained Glass by André Robin in Saint-Maurice Cathedral, Angers, France" (Ph.D. diss., Columbia University, 1982), deals with these roses. See also Hayward and Grodecki, "Les Vitraux d'Angers," pp. 53–60.

35. The Latin poem listed the relics in a new silver *châsse* donated by Bishop Alain de Lespervez (1437–1444), in the inventory of 1441. See Guillotin de Corson, *Pouillé de Rennes* (as in n. 5), pp. 530–31, for the entire poem.

36. The document of July 1223 was seen by Duine in the archives of Saint-Lô: François Duine, "Les Traditions populaires du pays de Dol," *Annales de Bretagne* 15 (1899–1900), p. 491. (The Archives départementales de la Manche at Saint-Lô were totally destroyed in 1944.) In 1357 the head of St Margaret was returned with other relics to Dol from Mont-Saint-Michel, where they had been sent for safekeeping when war threatened. Duine publishes the document in *Notes sur les saints bretons: les saints de Dol* (Rennes: 1902), p. 22.

37. St Catherine's feast is indicated in black in the *Livre rouge* (datable between 1312 and 1323) while Margaret's is in red. Without the east window and the *Livre rouge* there would be no way to establish Catherine's importance at Dol before the fifteenth century, when in addition to the Latin poem, a feast day and a chapel are listed for her: Guillotin de Corson, *Pouillé de Rennes*, pp. 527, 537. On the *Livre rouge* see n. 109 below.

38. The tree of Mambre is mentioned in Gen. 18:8. The relic is not otherwise documented at Dol, but since Abraham cycles are rare (see n. 58 below), the east window lancet offers good evidence for the relic's being at Dol in the thirteenth century. The fifteenth-century *châsse* also contained the swaddling clothes of the Infant Jesus, a bone of St Joseph, bits of the True Cross, Holy Lance, etc., but whether these relics were at Dol in the thirteenth century and if so, whether their possession influenced the depiction of the Infancy and Passion in the east window, cannot be judged. Nothing left in those cycles suggests an unusual emphasis, though most of the Infancy is now post-medieval.

39. Samson's body was returned to Dol from safekeeping in 1223 (see n. 12 above) and again in 1357 (see n. 36 above). On Samson's legend and cures see pp. 140–42 below.

40. See n. 4 above. On the general acceptance of the legend in the thirteenth century see François Duine, "Saint Samson en Angleterre," *L'Hermine* 21 (1899), p. 152.

41. In the twelfth-century adjudications over Dol's claims of primacy, the list of archbishop-saints was given as Samson, Magloire, Budoc, Genevée, Restoald, Armel, Jumael, and Turiaw. Leucher (Loucher) is mentioned in the oldest vita of St Samson. Of these only the relics of Samson and Magloire can be documented at Dol in the thirteenth century and thereafter. By the twelfth

century Genevée's relics were in Loudun; those of Turiaw were in Saint-Germain-des-Prés in Paris; and St Armel was buried at Ploërmel. Budoc had been buried at Dol and Leucher's body had been sent into safekeeping during the Norman invasions with those of Samson and Magloire; but whether they were at Dol in the Gothic period cannot be established. See: Louis Duchesne, *Fastes épiscopaux de l'ancienne Gaule* (Paris: 1899), vol. 2, pp. 382–83; Guillotin de Corson, *Pouillé de Rennes*, pp. 392–93; Duine, *Saints brêtons: Dol*, pp. 9–36.

42. See nos. 126 (dated between 1205 and 1231) and 171 (1290) of H. Bourd de la Rogerie, "Inventaire des sceaux anciens des diocèses de Rennes et de Dol," *Bulletin et mémoires de la Société archéologique du département d'Ille-et-Vilaine* 52 (1925), pp. 136 and 150. See also n. 45 below.

43. The sanguine has an oily, iridescent appearance on the exterior. It is remarkably durable. For an introduction to these techniques see Jean Lafond, *Le Vitrail* (Paris: 1966), pp. 38–40.

44. Dated images of such costumes may be found in D. L. Galbreath, *Manuel du blason*, ed. Léon Jéquier (Lausanne: 1977), pp. 60–61, 208, fig. 73 (ca. 1380), fig. 74 (ca. 1370), fig. 598 (1369). These late fourteenth-century costumes, and the use of silver stain, were noted by Eagle, who on these bases dated the entire east window to the mid-fourteenth century: William Eagle, "La Date du vitrail du chevet de la cathédrale de Dol (Ille-et-Vilaine)," *Bulletin monumental* 88 (1929), pp. 511–12. His opinion was challenged by Evellin, who pointed out that the silver-stain panels were restorations, which he dated equally erroneously to the fifteenth century: E. Evellin, "Cathédrale de Dol," *Bulletin et mémoires de la Société archéologique du département d'Ille-et-Vilaine* 60 (1934), pp. 169–70.

45. The only previous attempt to account for the flowers held by Dol's blessed was by Robert, "La Grande verrière de Dol" (as in n. 17), p. 8, who guessed that the roses stand for martyrdom. On the lilies and roses of paradise: Barbara Seward, *The Symbolic Rose* (New York: 1960), p. 21; Gertrud Schiller, *Iconography of Christian Art* (New York: 1966), vol. 1, pp. 51, 54 (Early Christian); J. Huizinga, *The Waning of the Middle Ages* (London: 1970), p. 185; *The Golden Legend of Jacobus de Voragine*, trans. Granger Ryan and Helmut Ripperger (New York: 1969), p. 452.

46. On Châteauroux, which reflects the Bourges axial bay, see Chap. II, pp. 20f. At Bourges and at Le Mans, which also copies it, the expansion of the subject is severely limited by the space available.

47. On Sainte-Radegonde see Chap. IV, pp. 97–100. Blood does not spurt from Christ's wounds, probably an indication of a different model from Bourges. On the style of the Dol painters see pp. 148–50 below.

48. J. Brune, *Résumé du cours d'archéologie professé au séminaire de Rennes* (Rennes: 1846), p. 259; Ramé, "Rapport," *Journal de Rennes* 37 (as in n. 24); Abbé Lecarlatte, *Essai historique sur les monuments de Dol* (Paris: 1864), pp. 20–21.

49. On the relic of Margaret's head see nn. 36, 37 above. The famous silk belt of St Margaret, also owned by Dol and loaned out to noble ladies in childbirth (against a very steep security bond) cannot be documented before the inventory of 1441: Guillotin de Corson, *Pouillé de Rennes*, pp. 529, 533–34; Edouard Quesnet, "Inventaire des reliques et des biens du chapitre de l'église de Dol, en Bretagne," *Bulletin du Comité de la langue, de l'histoire et des arts de la France* 2 (1853–1855), pp. 66 (belt), 69 (head). Margaret's interest in childbirth was already established in the thirteenth century; see the *Golden Legend*, p. 354. Ultimately four churches in France alone claimed to own her belt: Louis Réau, *Iconographie de l'art chrétien*, vol. 3, *Iconographie des saints*, pt. 2 (Paris: 1958), p. 879.

50. Ramé, "Rapport," *Journal de Rennes* 37; Lecarlatte, *Les Monuments de Dol*, p. 21.

51. Yves Delaporte and Etienne Houvet, *Les Vitraux de la cathédrale de Chartres* (Chartres: 1926), vol. 1, pl. LXVII.

52. Réau, *Iconographie des saints*, vol. 2, p. 876.

53. Lecarlatte (*Les Monuments de Dol*, pp. 20–21) described the scene, excepting the dragon, as it appears now: "Une princesse, au milieu de châteaux, aperçoit au-devant et au-dessus de sa tête une main sur laquelle elle arrête son regard." For the Margaret window of Auxerre see Raguin,

Stained Glass in Burgundy, pp. 151–52; for Clermont-Ferrand see Henry du Ranquet, *Les Vitraux de la cathédrale de Clermont-Ferrand* (Clermont-Ferrand: 1932), pp. 223–41.

54. Olibrius has a crown and scepter in Chartres Bay 26 (Delaporte and Houvet, *Les Vitraux de Chartres,* vol. 1, pl. LXVII) and he is occasionally crowned as at Clermont-Ferrand (see du Ranquet, *Les Vitraux de Clermont-Ferrand,* ill. p. 236).

55. Ramé mentions this ogive in place ("Rapport," *Journal de Rennes* 37). The recently inserted head of Christ is a handsome example of the loving care taken by early restorers at Dol; see V.9.C for the type of Gothic head the artist was copying.

56. See n. 38 above.

57. Ramé ("Rapport," *Journal de Rennes* 37) describes the sixteenth-century panel; for the Sacrifice of Abraham see Lecarlatte, *Les Monuments de Dol,* p. 21; Brune, "Des vitraux d'Ille-et-Vilaine" (as in n. 25), p. 85.

58. On Poitiers: Louis Grodecki, "Les Vitraux de la cathédrale de Poitiers," *Congrès archéologique* 109th session (1951), pp. 150–52. On Auxerre: Raguin, *Stained Glass in Burgundy,* pp. 160–61.

59. Lecarlatte, *Les Monuments de Dol,* p. 21. Ramé ("Rapport," *Journal de Rennes* 37) identifies it as an Adoration of the Shepherds. The sixth panel in the lancet at that time was the 1509 scene of the beheading of St Margaret, described by Ramé and now lost. See p. 133 above.

60. Lecarlatte (*Les Monuments de Dol*) and Ramé ("Rapport," *Journal de Rennes* 37) declared it illegible. Brune, *Archéologie de Rennes* (as in n. 48), p. 260, thought it was the Agony in the Garden, but if so, it would have been out of place.

61. It looks like a bread roll. Judas occasionally hides a money bag or a fish. On the latter see Schiller, *Iconography of Christian Art* (as in n. 45), vol. 2, p. 36, citing F. Röhrig, *Der Verduner Altar* (Vienna: 1955), p. 70.

62. The head illustrated in Grodecki and Brisac, *Le Vitrail gothique,* p. 165, is probably not by the Abraham Master. In the Dol shop the attempt was made to vary faces in a group by having different painters paint them; this practice is clear in the Last Judgment groups of resurrected souls, the blessed, etc. This head is probably an apprentice piece by the Catherine Master. The relationship of the Abraham and Catherine masters is addressed below.

63. See generally Schiller, *Iconography of Christian Art,* vol. 2, pp. 164–67.

64. On the scene's rarity see ibid., vol. 2, p. 24. The coins are specifically mentioned by Ramé ("Rapport," *Journal de Rennes* 37).

65. Ernst Kantorowicz, "The Baptism of the Apostles," *Dumbarton Oaks Papers* 9–10 (1956), p. 223. I have relied heavily on the rich notes and ideas in this study.

66. On the Gassicourt Passion window (which, it must be emphasized, may have been rearranged) see Chap. III, p. 60. The Gassicourt Washing of Feet is illustrated in CVFR I, p. 132.

67. Kantorowicz, "The Baptism of the Apostles," pp. 240–41. See for example the Gothic window of Angers, illustrated in Hayward and Grodecki, "Les Vitraux d'Angers," p. 47.

68. London, Brit. Lib. Cotton Nero C. IV. The Last Supper and the Washing of the Feet (fol. 20r) are illustrated in Lillich, *Saint-Père,* pl. 95, and in Kantorowicz, "The Baptism of the Apostles," pl. 37. On this manuscript see C. M. Kauffmann, *Romanesque Manuscripts* (London: 1975), pp. 105–6, no. 78.

69. On an iconographic tradition copied and altered when it was no longer understood see Lillich, *Saint-Père,* pp. 133–34 (midwife in the Nativity).

70. Ibid., pp. 147, 150, 155, 189. Since I have been criticized by one reviewer for my theory of the twelfth-century pen-drawn source of the Saint-Père Passion bay (G. D. S. Henderson in *Journal of Ecclesiastical History* 32/1 [Jan. 1981], p. 93), it is particularly gratifying to have that theory buttressed by the present inquiry into the Washing of the Feet. Both Peter's gesture and the sequence following the Last Supper are rare details in western Europe—but found in the Saint Swithin's psalter. In answer to Henderson's other criticism, the dwarf Malchus is *retardataire* in English fourteenth-century art and unknown in French Gothic works. In the latter it must therefore be considered archaic.

71. The psalter includes a reference to Saint Swithin's; St Hugh of Cluny is in the calendar; it was connected with Henry of Blois, abbot of the Benedictine Glastonbury, who had been at Cluny as a young man; and it was later owned by the Benedictine nuns of Shaftsbury.

72. Gilduin, a young canon elected by his chapter to be archbishop of Dol in the late eleventh century, went to Rome to decline the honor and upon his return, while visiting his mother's relatives (Puiset) in Chartres, died at the abbey of Saint-Père and was buried there in the odor of sanctity. The rediscovery of his tomb (and subsequent miracles) made possible the financing of the Gothic church of Saint-Père. Guillotin de Corson, *Pouillé de Rennes* (as in n. 5), p. 398; Lillich, *Saint-Père*, pp. 7, 51, 93–95, pls. 4, 5.

73. Guillotin de Corson, *Pouillé de Rennes*, p. 405.

74. For example, the Ecclesia and Synagoga in the Crucifixion of the Saint-Père Passion window are related to the *Te igitur* of a Chartrain missal: Lillich, *Saint-Père*, pp. 151–52. It is unlikely that the detailed subjects of Christ's suffering at Gassicourt were derived from a twelfth-century source, when such subjects are not stressed.

75. See above, nn. 39–41.

76. The grillwork on the niche was removed between 1841 and 1866 and the custom suspended because it was getting embarrassing: Duine, "Traditions populaires" (as in n. 36), *Annales de Bretagne* 14 (1899), p. 409.

77. On the real St Samson see *Butler's Lives of the Saints*, ed. Herbert Thurston and Donald Attwater (New York: 1963), vol. 3, p. 203; Guillotin de Corson, *Pouillé de Rennes*, pp. 373–78, 391.

78. For a summary of the relationships of the vitae, see *Butler's Lives of the Saints*, vol. 3, pp. 203–204. The literature on these vitae is extensive: Dom François Plaine, *La Très ancienne vie inédite de S. Samson* (Paris: 1887); Duine, *Saints bretons: Dol* (as in n. 36), with bibliography; Robert Fawtier, *La Vie de Saint Samson, essai de critique hagiographique* (Paris: 1912); Duine, "La Vie de Saint Samson à propos d'un ouvrage récent," *Annales de Bretagne* 28 (1912–13), pp. 334f. (review of Fawtier); Plaine, "Vita antiqua sancti dolensis episcopi," *Analecta Bollandiana* 6 (1887), pp. 77–150; Thomas Taylor, *The Life of St. Samson of Dol* (London: 1925). On Baudri de Bourgueil see *Histoire littéraire de la France* (as in n. 3), vol. 11 (1841), p. 107; Duine, "Saint Samson en Angleterre" (as in n. 40), p. 113.

79. Duine, "Traditions populaires" (as in n. 36), *Annales de Bretagne* 14 (1899), p. 409, did not realize that the panel was sixteenth century, and it is not clear if he based his judgment on the evidence of the window only, in which case it is a circular argument.

80. Vincent of Beauvais, *Speculum historiale* (new ed.; Graz: 1965), vol. 6, p. 853 (chap. 113, book 21). This miracle is in the oldest vita: Taylor, *St. Samson*, pp. 52–53.

81. Paris, Bibl. nat. lat. 1023. This is the late thirteenth-century Parisian breviary sometimes attributed to the illuminator Honoré and probably made for a queen or princess: Victor Leroquais, *Les Bréviaires manuscrits des bibliothèques publiques de France* (Paris: 1934), vol. 2, pp. 465f. The Samson initial on fol. 374 shows the saint with crozier rather than cross staff; a kneeling woman behind him prays, while a barefoot girl half reclining before him also prays. It is a stock image.

82. Ramé, "Rapport," *Journal de Rennes* 37 (as in n. 24), and Lecarlatte, *Les Monuments de Dol* (as in n. 48), p. 23, both make this mistake.

83. That is one version of the street's name. Another is that the dragon commemorated is that of St Margaret, one of whose belts was owned by the abbey Saint-Germain-des-Prés in that *quartier*. The street still exists off the boulevard Saint-Germain.

84. For the St Martin bay of Tours see: Henri Boissonnot, *Les Verrières de la cathédrale de Tours* (Paris: 1932), pl. X (drawing); Papanicolaou, "Windows of the Choir of Tours," pls. 39–40. The Angers St Martin window shows a fruited tree similar to the one at Dol; Hayward and Grodecki, "Les Vitraux d'Angers," p. 24.

85. Papanicolaou, "Windows of the Choir of Tours," pp. 49–61.

86. This lack of inscriptions has not, of course, stopped authors from attempting to identify the figures, and various lists have been given depending upon the date and historicity of the sources employed. See most recently *Le Vitrail en Bretagne*, p. 16.

87. See n. 78 above; Duchesne, *Fastes épiscopaux* (as in n. 41), p. 382.

88. The relics of Leucher had been sent to Paris with those of Samson and Magloire during the Norman invasions. Those of Turiaw were at Saint Germain-des-Prés; he was listed in Usuard's martyrology, and is included (with Samson and Magloire) in the Breviary of Philippe le Bel (see n. 81 above). See the sources listed in n. 41 above.

89. This is the panel traced by Ramé in 1855 (V.3.B). See n. 24 above.

90. There are windows of St Catherine at Angers, Chartres, Rouen, Auxerre, Fécamp, and Saint-Père de Chartres. See Lillich, *Saint-Père*, p. 145 and notes; also Raguin, *Stained Glass in Burgundy*, pp. 137–38.

91. A similar piece of furniture appears in the Seven Sleepers panels from Rouen (ca. 1210–1220), illustrated in *The Year 1200, I: The Exhibition*, The Metropolitan Museum of Art (New York: 1970), p. 203.

92. Meyer Schapiro has pointed out that medieval people were aware that the roll had preceded the book. See Lillich, *Saint-Père*, p. 148.

93. See n. 45.

94. *Golden Legend* (as in n. 45), pp. 714–15. Catherine's supposed relics are still at Mount Sinai, though her existence is universally questioned. On the Mount Sinai legend see: *Butler's Lives of the Saints* (as in n. 77), vol. 4, pp. 420–21; Réau, *Iconographie des saints* (as in n. 49), pt. 1, p. 271.

95. Hayward and Grodecki, "Les Vitraux d'Angers," p. 19; Grodecki, *Le Vitrail roman*, p. 84; *Le Vitrail français*, p. 103.

96. The Fécamp series is roughly contemporary with Gassicourt. Saint-Urbain is illustrated in *Le Vitrail français*, p. 71.

97. The fourteenth-century borders at Saint-Ouen de Rouen retain many types of rising naturalistic foliage amid the drier and more recently introduced cassette motifs: Lafond, *Les Vitraux de Saint-Ouen*, p. 29.

98. On the varying meanings of the term chef d'oeuvre see the explorative study by Walter Cahn, *Masterpieces: Chapters on the History of an Idea* (Princeton: 1979).

99. Hayward and Grodecki, "Les Vitraux d'Angers," pp. 9, 50.

100. Ibid., p. 40.

101. I have tried to collect evidence for this very much needed study in my article "Gothic Glaziers."

102. The evidence for women glaziers and the texts for the Bordins are printed in my "Gothic Glaziers," pp. 80–82, 86–87.

103. Lafond, "Les Vitraux de Sées," p. 77.

104. The lord of La Guerche was present at the council of barons at Nantes in 1225. La Guerche was not one of the nine ancient Breton baronies, which in any case are probably mythical. See the composite volume of Alexander de la Bigne, *Recueil des blasons de Bretagne* and Arthur de la Borderie, *Les Neuf barons de Bretagne* (Rennes: 1895), pp. xliii–xliv.

105. The genealogies of La Guerche put Thibaud in too early a generation, as younger son of Guillaume II (d. 1223); the best of the genealogies nonetheless is Marquis de Praulx, *Notice généalogique et historique sur Pouancé et La Guerche* (Paris: 1832), which goes beyond Du Paz (1620) and incorporates unpublished data of Guérin (1750). See de Praulx, p. 34, making Thibaud a man of more than sixty years of age when he became bishop, and well over eighty when he died, which in view of his incessant, frenetic activity seems unlikely. See also Amédée de Guillotin de Corson, *Les Grandes seigneuries de Haute-Bretagne* (Rennes: 1898), vol. 2, pp. 208–209. On Thibaud's service to Philippe le Bel see the many entries listed in the index of Joseph Strayer, *The Reign of Philip the Fair*.

106. Louis Douët-d'Arcq, *Collection de sceaux des archives de l'Empire* (Paris: 1863), no. 7653.

107. On the poisoning: *Recueil des historiens des Gaules et de la France,* ed. M. Bouquet et al. (Paris: 1855; reprint, Paris: 1968), vol. 21, pp. 94–95, "Chronique anonyme finissant en M.CC.LXXXVI." On Visemale see Lillich, *Rainbow Like an Emerald,* pp. 114–17. On the judgment over Poitou: *Gallia Christiana* (1739) vol. 6, p. 81. On his travels to Gerona: *Recueil des historiens,* vol. 22, p. 668, "Compotus ballivorum Franciae de termino omnium sanctorum anno 1285."

108. François Duine, "Un Evêque de Dol dans un sermon du moyen-âge," *Annales de Bretagne* 18/4 (July 1903), pp. 597–98. Duine identifies the source, which I have not examined, as Paris, Bibl. Sainte-Geneviève MS 1445, fol. 188r (collection of Dominican exempla).

109. The cope is listed in the inventory of 1440: Guillotin de Corson, *Pouillé de Rennes* (as in n. 5), p. 539. The prebend was founded in 1293, confirmed by Pope John XXII in 1330: G. Mollat, "Etudes et documents sur l'histoire de Bretagne (XIIIe–XVIe siècle)," *Annales de Bretagne* 24 (1908), pp. 114–17. Thibaud's anniversary is in the *Livre rouge* (March 30 = martius III Kal.): Arch. dépt. Ille-et-Vilaine G 281, written between 1312 and 1323.

110. The arms are verifiable by his two seals: of 1275 (see n. 106 above); and as bishop of Dol in 1296 (Douët-d'Arcq, *Sceaux de l'Empire,* no. 6600 counterseal). Compare also the seal of Geoffroi de Pouancé of 1234 (Douët-d'Arcq, no. 3289, equestrian). On the south window's lost fleurs-de-lis see Ferdinand de Lasteyrie, *Histoire de la peinture sur verre* (Paris: 1853–1857), p. 194.

111. Aside from scattered areas the best-conserved grisailles are as follows:

North choir clerestory:	Bay 201	Left trefoil and throughout the lancets
	Bay 203	Some in left trefoil; one lancet panel
	Bay 207	Center of quatrefoil
	Bay 209	Quatrefoil
South choir clerestory:	Bay 206	Left trefoil
	Bay 210	Lobes of quatrefoil
Choir Triforium:	Trif. Bay 102	Right quatrefoil
Choir Triforium:	Trif. Bay 101	Lancet ogive (right), scattered pieces
West side of transepts:		Old panels in both south bays (218 and 220) and in north bay (217) nearest facade.

On the restoration of 1890 see p. 123 above. The west side of the transepts was restored later by J. B. Anglade, who conserved a few panels whole. They are now nearly opaque.

112. Brune, "Des vitraux d'Ille-et-Vilaine" (as in n. 25), p. 85.

113. Lillich, *Saint-Père,* pls. 14, IX; Lafond, *Les Vitraux de Saint-Ouen,* p. 29, drawing of the Saint-Ouen border motifs, including many geometric cassettes. The reason *France* and *Castille* borders fell into disuse, beginning with the death of Philippe le Hardi (1285), was political. I have reiterated this most recently in *Rainbow Like an Emerald,* p. 88.

114. Lillich, "Three Essays on French Thirteenth-Century Grisaille Glass," pp. 76–77, fig. 11.

115. Lillich, *Saint-Père,* pls. 44–45.

116. Cothren, "Glazing of the Choir of Beauvais," pp. 202–206, 358–63, pl. 128; and on Evreux, pp. 202–206, pl. 138.

117. On Sées see *Radiance and Reflection* exh. cat., The Metropolitan Museum of Art (New York: 1982), pp. 227–28, where the motif is called "a root-like base." Contemporary with Sées, flower pots appear in the grisailles of Saint-Gengoult, Toul (ca. 1265–79): Lillich, *Rainbow Like an Emerald,* p. 38, pls. II.18a, II.19.

118. Examples of floating cueballs: Saint-Denis ("isolated rosettes"; *Radiance and Reflections,* pp. 195–97); Sens (illustrated by Cahier-Martin; see above, Chap. I, n. 50); Soissons, and Saint-Urbain de Troyes (illustrated in Lewis Day, *Windows,* 3rd ed. [London: 1909], pp. 139, 323).

119. The band windows of Sées, filling both clerestory and aisle chapels, are discussed in Chap. VI. Grisailles of bulged quarry design had been imported to Brittany before Dol, by the duke. See discussion and reconstruction of the west window of the chapel, château of the duke of Brittany at Suscinio (Morbihan): Patrick André, "Morbihan. La Chapelle ducale du château de Suscinio," *Bulletin monumental* 142 (1984), pp. 189–90. Grodecki's hypothesized date is too early; the best comparison for both grisaille and border is Saint-Martin-aux-Bois. On the dating of Saint-Martin see Chap. IV, n. 129.

120. Colored subjects still remained in the traceries in the nineteenth century: see p. 358n25 above. The combination of colored traceries with grisaille lancets occurs at Sées (north choir aisle), and was probably at Sainte-Radegonde: see Chaps. VI, p. 177, and IV, p. 97.

121. The grisailles in the east transept clerestories are now totally nineteenth century.

122. For example, the architectural "remodeler" Gautier de Varinfroy ended his fairly mobile career with a large commission at Sens, after the collapse of the vaults in 1268. His family had established itself there by the fourteenth century. See Chap. III at n. 86.

123. Dom Beaunier, *Recueil historique des archévêchés, évêchés, abbayes et prieurés de France,* ed. J. M. Besse (Ligugé: 1920), vol. 8, pp. 200–300; Dom Cottineau, *Répertoire topo-bibliographique des abbayes et prieurés* (Macon: 1939), vol. 2, cols. 2810–11.

124. *Dictionnaire des églises de France* (as in n. 2), IV A 144–45.

125. Alfred Ramé, in *Bulletin archéologique de l'Association bretonne* 1 (1849), p. 26, publishing the *procès-verbaux* of the Congrès de Quimper of 1847.

126. Brune, *Archéologie de Rennes* (as in n. 48), pp. 299–300; Pol Potier de Courcy, *De Rennes à Brest et à Saint-Malo,* Collection des Guides Joanne (Paris: 1864), pp. 31–32; Auguste André, "De la verrerie et des vitraux peints dans l'ancienne province de Bretagne," *Bulletin et mémoires de la Société archéologique du département d'Ille-et-Vilaine,* 12 (1878), pp. 195–97. Brune's fanciful subject identifications were largely rejected by the others, who recognized the group as parts of a Last Judgment.

127. Ramé's drawing (see n. 125 above) was preserved in the Musée archéologique de Rennes according to Paul Baneat, *Le Département d'Ille-et-Vilaine, histoire, archéologie, monuments* (Rennes: 1929), vol. 4, p. 35.

128. Ramé's drawing shows Peter leading three souls from the hellmouth, in a sexfoil with palmette lobes. The palmette lobes are now found in the other sexfoil. The left and right souls have been removed and made into another "group." And the green hellmouth, mistaken for foliage, has been moved to the top half of the roundel and has been extended around with modern glass like a wreath. The old glass shows very clearly from the exterior, in this as well as in all the panels.

129. Michel Pastoureau, "L'Héraldique bretonne des origines à la guerre de succession de Bretagne (1341)," *Bulletin de la Société archéologique du Finistère* 101 (1973), pp. 133–34, states that it is solidly established that the dukes of Brittany abandoned *Dreux échiqueté* for *hermine plain* in 1316.

130. Guillotin de Corson, *Pouillé de Rennes* (as in n. 5), vol. 2, p. 137.

131. Christ is as irregular as Peter in this context (see p. 130). Peter holds his keys to the kingdom of heaven, denoting the power given him to loose and to bind (Matt. 16:19). He is normally stationed at the gates of heaven in Last Judgment depictions, however. The image at Saint-Méen recalls the Irish legend that St Patrick was allowed to release souls from hell (seven every Thursday and twelve every Saturday); or the legend that St Lawrence went to purgatory to release a soul each Friday. See Réau, *Iconographie des saints* (as in n. 49), pt. 3, pp. 1032–33 (Patrick); pt. 2, p. 789 (Lawrence).

132. See Beaunier, *Recueil historique,* vol. 8, pp. 302–303; Cottineau, *Répertoire topo-bibliographique,* cols. 1581–82; Jean-Yves Ruaux, *Léhon et son abbaye* (Rennes: 1979).

133. In 1815 it was still intact; by 1833 it was a desolate ruin; and in 1843 the last remaining vault came down. See: Abbé Fouéré-Macé, *Le Prieuré royal de Saint-Magloire de Léhon* (Rennes: 1892),

pp. 257–60. Fouéré-Macé was the parish priest during the restorations and wrote voluminously about the old abbey. His work is uncritical but fairly reliable.

134. On the restoration see ibid.; on the church at present, *Dictionnaire des églises de France* (as in n. 2), IV A 64–65.

135. René Couffon, "Contribution à l'étude des verrières anciennes du département des Côtes-du-Nord," *Bulletin et mémoires de la Société d'émulation des Côtes-du-Nord* 67 (1935), pp. 84–86 and fig. 2. Lafond's quote in the following sentence appears on p. 78 of his article "Les Vitraux de Sées."

136. On the Samson Master see pp. 147–49 above; on Sées expressionists, Chap. VI, pp. 210f. The masterpiece in this style at Sées is the magnificent head of St Peter (see *VI.25* below).

137. Fouéré-Macé, *Saint-Magloire*, pp. 278–81. He wrote other books on the new glass, the consecration, the tombs, the restorations, etc.

138. The heraldic robes of the lost donors allowed their identification as the seigneur de l'Echapt and his wife, who was of the family of Labbé de la Commerière. See ibid., p. 280; Couffon, "Verrières anciennes des Côtes-du-Nord," p. 85.

139. Ramé, "Rapport," *Journal de Rennes* 38 (as in n. 24). The existing bearded head may be the remains of Jean-Baptiste, though Fouéré-Macé, *Saint-Magloire*, identified an Adam (with Eve chased from paradise).

140. Ramé, "Procès-verbaux" (as in n. 125), p. 26.

141. On the trellis grounds of Le Mans, which derive from the Bourges choir, see Chap. II, n. 43. Such grounds are found as late as the fourteenth-century Bay 26 (John the Baptist) in the Saint-Père nave.

142. The *boules* at Le Mans are made of colored glass; see in particular Bay 209. They also appear in Bay 201, though not in the lancet designed by the Master of Bishop Geoffroy de Loudun.

143. Dubuisson-Aubenay describes this glass in *Itineraire de Bretagne en 1636*, Archives de Bretagne, no. 9 (Nantes: 1898), p. 49.

 The tracery of this east window was supposedly dated 1490, though if so, the Gothic glass in it may have been replaced from an earlier window. The traceries were completely gone from the bay in the 1830s, according to accounts and to a drawing illustrated by Fouéré-Macé, *Saint-Magloire*, p. 259. The restoration of the 1890s replaced it with rather dry Gothic forms.

144. Some tombs, in most cases later than the thirteenth century, are illustrated in drawings in Fouéré-Macé, *Saint-Magloire*, pp. 269, 273. Six tombs were moved to the Musée de Dinan in 1843, among them one with the arms of Beaumanoir (p. 277). The two Gothic tombs now in the nave are supposedly those of Gervaise de Dinan and her daughter Marguerite d'Avaugour (see Chap. II, p. 41). The documents of Gervaise's donations to Léhon are published by Fouéré-Macé, pp. 320–22.

145. Chifflet-Prinet roll, no. 139: Max Prinet, "Armorial de France composé à la fin du XIIIe siècle ou au commencement du XIVe," *Le Moyen âge*, 2d ser., 22 (1920), p. 45; Gerard Brault, *Eight Thirteenth-Century Rolls of Arms in French and Anglo-Norman Blazon* (University Park, Pa., 1973), pp. 9–10, 83 (as no. 141). Wijnberghen roll, no. 987: Paul Adam-Even and Léon Jéquier, "Un Armorial français du XIIIe siècle, l'armorial Wijnberghen," *Archives héraldiques suisses* 68 (1954), p. 64 (on the dating of the march of Bretagne see vol. 65 [1951], pp. 53–54).

146. Dubuisson-Aubenay, *Itineraire de Bretagne en 1636*, calls Léhon a priory of the Benedictines of Cluny, which would explain the Peter and Paul, who were patrons of Cluny. In 1181 Léhon had been given to Marmoutier, where the importance of Peter and Paul was based upon their appearance in visions to St Martin, founder of Marmoutier. The early relationship of Marmoutier to Cluny was still important in the thirteenth century, since it was the basis for the extension of Cluniac exemptions to Marmoutier and its priories in 1220: see Edmond Martène, *Histoire de l'abbaye de Marmoutier*, ed. C. U. Chevalier (Tours: 1874), vol. 1, pp. 44, 109; vol. 2, pp. 153, 195.

147. Although the Dol Crucifixion has been replaced by Gruber, a comparison can be made between it and the Deposition from the Cross, where the body of Christ and the gesture of John holding his hand to his face are similar. See also Bay 200 of Le Mans.

148. Couffon, "Verrières anciennes des Côtes-du-Nord," pp. 87–93. Saint-Alban is rarely even listed in the standard guidebooks or ecclesiastical bibliographies. See: Jules Henri Geslin de Bourgogne, "Projet de classement des monuments des Côtes-du-Nord," *Congrès archéologique,* 14th session (1847), pp. 436, 438; André, "Verrerie de Bretagne" (as in n. 126), p. 222.

149. Couffon, "Verrières anciennes des Côtes-du-Nord," p. 92, cites archival material, including a lawsuit which indicates that the right to install one's arms in the traceries, in place of older ones, was later even bought and sold. Thus the original donor's arms (probably Tournemine, see below) had long since been replaced by the modern era.

150. The Entry to Jerusalem is illustrated in *Le Vitrail en Bretagne,* p. 19; a color detail of the Last Supper is in Louis-Michel Gohel, *Les Vitraux de Bretagne* (Rennes: 1981), p. 4.

151. One subject at Dol is now completely missing. The Crucifixion and Noli me tangere occur there, as does the Descent to Limbo (in the Dol traceries). Among the Saint-Alban panels of Renaissance manufacture, only the Pietà is a subject unknown in the thirteenth century. Even if the sixteenth-century panels of Saint-Alban had originally been inserted in sequence, only the Gothic Deposition and Entombment would have been in locations different from the present ones.

152. On the sequence of the Washing of the Feet following the Last Supper, atypical of Gothic France, see p. 139 above.

153. Couffon, "Verrières anciennes des Côtes-du-Nord," noted the resemblance of the Saint-Alban Deposition to Dol's (p. 90), though the two windows are of different styles (p. 88 and n. 59).

154. See n. 129 above; also Hervé Pinoteau, "Les Armes de Bretagne," *Archivum heraldicum* 73/4 (1959), p. 56.

155. This paragraph is based on the slightly variant genealogies in: Anatole de Barthélemy, "Généalogies historiques, IV. Maison de Tournemine," *Revue historique, nobiliaire et biographique,* n.s., 7 (1872), pp. 1–4; Jules Henri Geslin de Bourgogne and Anatole de Barthélemy, *Anciens Evêchés de Bretagne* (Paris: 1863), vol. 3, p. 179 (Alanus), vol. 5, pp. 281–87, 294. The Tournemine line only ran out in the early seventeenth century.

156. As an indication of their wealth, Pierre Tournemine at the *Ost de Ploërmel* called by the duke in 1294 was required to provide four knights: Geslin de Bourgogne and de Barthélemy, *Anciens Evêchés,* vol. 5, p. 286. On the *Ost de Ploërmel* see Pastoureau, "L'Héraldique bretonne" (as in n. 129), pp. 140–41.

157. Lillich, "European Stained Glass around 1300," esp. pp. 51–52.

158. Ibid., pp. 45, 51–52. On the Norman style see Chap. III, p. 71.

159. See the fifteenth- and sixteenth-century charts in Jean Rollet, *Les Maîtres de la lumière* (Paris: 1980), pp. 44 and 48; *Le Vitrail en Bretagne,* pp. 21–40, 43–62; Gohel, *Les Vitraux de Bretagne,* pp. 6–29; *Le Vitrail breton, Arts de l'ouest* no. III, pt. 1, Université de Haute Bretagne, Centre de recherche sur les arts de l'ouest (Rennes: 1977).

CHAPTER 6

1. Lafond, "Le Vitrail en Normandie," p. 349.

2. Lafond, "Les Vitraux de Sées," pp. 50–83. Of the five major styles at Sées he illustrates four; I shall refer to them as the Protais Master (Lafond, p. 65), the Magdalene Master (p. 67), the Nicholas Master (p. 71), and the Jean de Bernières Master (p. 74). The fifth painter is a primitive whose folklike style, based on conventions of pattern, did not appeal to Lafond. See p. 212 below.

3. The speed with which the glass is losing transparency can be seen only too well by comparing the windows with several photographs of 1896: P. Barret, *La Normandie monumentale et pittoresque, IV: Orne, première partie* (Le Havre: 1896), pp. 117, 119. Restoration began in 1990 with

the glass of ca. 1375 in chapel N II: Michel Petit, "La Protection d'un vitrail de la cathédrale de Sées par double-verrière," *Vitrea* 7, pt. 2 (1991), pp. 97–98 and illustrations in pt. 1, pp. 30–33.

4. Lafond, "Les Vitraux de Sées," p. 76. Guilhermy (1860): "Les figures sont d'un style médiocre" (Paris, Bibl. nat. nouv. acq. fr. 6109, fol. 68). Ferdinand de Lasteyrie: "la vitrerie de cette église est beaucoup moins intéressante que ne l'ont cru certains archéologiques" (*Histoire de la peinture sur verre* [Paris: 1853–1857], p. 54).

5. Nat Hubert John Westlake, *History of Design in Painted Glass* (London: 1882), vol. 2, p. 70.

6. Lafond, "Les Vitraux de Sées," pp. 77–78. For comments of visitors to the church, see for example Léon de la Sicotière and Auguste Poulet-Malassis, *Le Département de l'Orne archéologique et pittoresque* (Laigle: 1845), p. 9.

7. Not all the choir and transepts retain the medieval glazing. There is no evidence whatsoever that the original glass differed in format, but rather the contrary.

8. On the Tours band windows: Papanicolaou, "Windows of the Choir of Tours," pp. 63–65, 173–75, pls. 44–47; Lillich, "The Band Window," fig. 1; Lillich, "The Triforium Windows of Tours," pp. 32–34. On Saint-Père: see Chap. III, pp. 67 f.; Lillich, *Saint-Père*, Chap. II, pls. II–IV, 17–42, opposite p. 140. On Dol: see Chap. V, p. 154.

9. See Chap. III, pp. 69, 74. Previously I have suggested the custom of banding color and grisaille in rural parish church glazing as the source of band windows. It is possible to have one's cake and eat it, too, in dealing with this question; see pp. 197 f. below.

10. Dom L. H. Cottineau, *Répertoire topo-bibliographique des abbayes et prieurés* (Macon: 1936), vol. 2, col. 2992; Fourier Bonnard, *Histoire de l'abbaye royale et de l'ordre des chanoines réguliers de Saint-Victor de Paris* (Paris: 1904), vol. 1, pp. 143–46; John C. Dickinson, *The Origins of the Austin Canons and Their Introduction into England* (London: 1950), p. 29.

11. Dom Beaunier, *Recueil historique des archévêchés, évêchés, abbayes et prieurés de France*, ed. J. M. Besse (Ligugé: 1906), vol. 7, p. 212n2, with bibliography.

12. On the twelfth century see Frank Barlow, *The Letters of Arnulf of Lisieux*, Camden Third Series, no. 61 (London: 1939), pp. xvii–xviii, xxxv, 55–56.

13. J. Rombault, "Les du Merle au XIIIe siècle," *Bulletin de la Société historique et archéologique de l'Orne* 13 (1894), pp. 456–57.

14. The sixteenth-century church of Saint-Victor is pictured in an engraving by Marot, reproduced by Jacques Hillairet, *Dictionnaire historique des rues de Paris* (Paris: 1963), vol. 1, p. 696, and by Yvan Christ, *Eglises parisiennes actuelles et disparues* (Paris: 1947), pl. 17. An eyewitness account of the groundbreaking ceremony may be found in Ludovic Lalanne, *Journal d'un bourgeois de Paris sous le règne de François Premier (1515–1536)* (reprint; Paris: 1854), pp. 77–78.

15. Christ, *Eglises parisiennes*, p. 23; Paul Biver, *Abbayes, monastères, et couvents de Paris, des origines à la fin du XVIIIe siècle* (Paris: 1970), pp. 154–55. Hillairet, *Rues de Paris*, p. 696 states: "La partie du quai de la station 'Jussieu' . . . du métro située à la hauteur des écriteaux '1ʳᵉ classe' et 'direction La Villette-Saint-Gervais' occupe l'emplacement de la partie occidentale de la crypte de cette église, le couloir de correspondance en occupant la partie centrale."

16. Biver, *Abbayes de Paris*, p. 154; Jean Aymer Piganiol de la Force, *Description historique de Paris, de Versailles, de Marly . . .* (Paris: 1765), vol. 5, pp. 268–69.

17. *Traité des sept vices* (Paris, Bibl. nat. MS lat. 14245 fol. 191v). See: Jean Porcher, *Manuscrits à peintures du XIIIe au XVIe siècle* (Paris: 1955), no. 225; also fig. 51 of *Paris and Its People*, ed. Robert Laffont (London: 1958). The illumination shows the death of a monk of Saint-Victor. The infirmary windows are glazed with lozenge grisailles.

18. E. H. Langlois, *Essai historique et descriptif sur la peinture sur verre* (Rouen: 1832), p. 155.

19. The influence of the Victorine theologians (chiefly Hugh of Saint-Victor) on the Abbot Suger has been increasingly emphasized: Grover A. Zinn, Jr., "Suger, Theology, and the Pseudo-Dionysian Tradition," *Abbot Suger and Saint-Denis: A Symposium*, ed. Paula Gerson (New York: 1986), pp. 33–40; Conrad Rudolph, *Artistic Change at St-Denis* (Princeton: 1990), emphasizes the role of Hugh of Saint-Victor while disputing the presumed Pseudo-Dionysian basis of Suger's writings.

20. I have sketched the shift in the Parisian interpretation of the Pseudo-Dionysius in Chap. I, p. 6; and at greater length in Lillich, "Monastic Stained Glass."

21. Or at least grisailles, as at another Victorine church, Saint-Martin-aux-Bois; its Victorine status is established by Bonnard, *Histoire de Saint-Victor* (as in n. 10), vol. 1, p. 172; vol. 2, p. 121.

22. Eudes Rigaud visited Sées in 1250, 1255, and 1260. Things did not improve much. See *The Register of Eudes of Rouen*, ed. Jeremiah O'Sullivan, trans. Sydney Brown (New York: 1964), pp. 91–93 (1250), 259 (1255), 422–23 (1260).

23. The work occupied Ruprich-Robert from 1878 until his death in 1887 and was completed by his successors Petitgrand and de la Rocque. In Ruprich-Robert's report of 1885 he states that the main vessel and axial chapel were finished, and only the four radiating chapels remained to be rebuilt: V. Ruprich-Robert, *La Cathédrale de Sées (Orne),* extrait du rapport adressé à M. le ministre de l'instruction publique et des cultes (Paris: 1885), introduction. The project is documented in Arch. nat. F19 7880-2 and F19 4566.

　　Several photographs taken by Mieusement during this drastic rebuilding are available in *Mieusement: Cathédrales de France, Photographies du XIXe siècle,* text by Françoise Bercé and Sylvie Cohen, exh. cat., Palais de Tokyo (Paris: 1988), nos. 12, 13.

24. See for example: Eugène Viollet-le-Duc, *Dictionnaire raisonné de l'architecture française du XIe au XVIe siècle* (Paris: 1854–1868), vol. 2, p. 358; "Chronique," *Revue de l'art chrétien* 34 (3rd ser., vol. 2) (April 1884), pp. 245–46; and later, François Deshoulières, review of René Gobillot, *La Cathédrale de Sées* (1937), in *Bulletin monumental* 97 (1938), p. 235.

25. The early criticisms, quite unfounded, were no doubt the basis for Sées's tarnished reputation. See for example R. Charles, "Destruction du choeur de la cathédrale de Sées," *Bulletin monumental* 50 (1884), pp. 294–96. The myth was nurtured later by Camille Enlart, *Manuel d'archéologie française, architecture religieuse* (Paris: 1920), p. 706.

26. Pierre Héliot, "Triforiums et coursières dans les églises gothiques de Bretagne et de Normandie," *Annales de Normandie* 19 (June 1969), pp. 127–30, fig. 3. See now Jean Bony, *French Gothic Architecture of the 12th and 13th Centuries* (Berkeley: 1983), pp. 427–29.

27. In 1786 the bishop put the cathedral under the patronage of the Virgin, whom he believed to be the original patron. The patronage of Gervais and Protais in the Middle Ages is attested, among other places, by Orderic Vitalis and by the cathedral's seal of 1278: J. Roman, *Manuel de sigillographie française* (Paris: 1912), p. 212; Louis Douët-d'Arcq, *Collection de sceaux des archives de l'Empire* (Paris: 1863), no. 7320; see p. 191 below.

　　On Orderic Vitalis: H. Marais and H. Beaudoin, *Essai historique sur la cathédrale et le chapitre de Séez* (Alençon: 1876), pp. 37f.; *The Ecclesiastical History of Orderic Vitalis,* ed. Marjorie Chibnall (Oxford: 1978), vol. 6, p. 367 (Book XII, chap. 44).

28. Ruprich-Robert, *La Cathédrale de Sées,* p. 12. Viollet-le-Duc went so far as to attribute the cage-like masonry of the *rayonnant* church to a desire not to overload the weakened foundations: *Dictionnaire de l'architecture,* vol. 2, p. 258.

29. On the nave, see Héliot, "Triforiums et coursières," p. 123. Guilhermy, who visited Sées in 1837 and 1860, noted that no colored glass at all remained in the nave (Paris, Bibl. nat. nouv. acq. fr. 6109, fol. 68v). The "petits fragments ça et là" reported by Marais and Beaudoin, *Essai sur Séez,* pp. 421–23, were probably grisailles.

30. Barret, *Normandie monumentale,* p. 105. Marais and Beaudoin reached the same conclusion, *Essai sur Séez,* p. 98. The latter work is a useful review of the charters of Sées.

31. The charter is published in Léopold Delisle, *Mandements et actes divers de Charles V (1364–1380)* (Paris: 1874), no. 1126 (May 14, 1375). On the north chapel windows: Lafond, "Les Vitraux de Sées," pp. 80–83 and illustration; see also Petit, "La Protection d'un vitrail" (as in n. 3). On the restored heads: the most obvious example I have found is that of St Paul (Bay 5), discussed p. 183 below.

32. *Gallia christiana* (Paris: 1715–1765) vol. 11, col. 699.

33. M. de Maurey d'Orville, *Recherches historiques sur la ville, les évêques et le diocèse de Séez* (Séez: 1829), p. 163; H. Fisquet, *La France pontificale* (Paris: n.d. [1866?]), vol. 18, p. 49.

34. De la Sicotière and Poulet-Malassis, *Orne archéologique* (as in n. 6), p. 9. These sixteenth-century coats of arms are all gone now.

35. *Procès-verbal* of 11 Oct. 1568, in cartulary of 1633 (Alençon, Bibl. mun. MS 177), cited by de la Sicotière and Poulet-Malassis, *Orne archéologique*, p. 6n3; and by Abbé L.-V. Dumaine, *La Cathédrale de Sées, coup d'oeil sur son histoire et ses beautés* (Sées: 1892), p. 34.

36. Guilhermy (1860), fol. 68, describes the coat of arms without identifying it. The blazon he provides—*argent à 3 coquilles sable au besant gueules*—can be identified as the arms of Bishop Louis du Moulinet, given in Maurey d'Orville, *Recherches sur Séez*, p. 379, and in Fisquet, *La France pontificale*, p. 54.

37. René Gobillot, *La Cathédrale de Sées* (Paris: 1937), pp. 24–28, summarizes the legal arguments over responsibility and the actions to lighten the load and buttress the endangered fabric. At the same time, new interior decorating was undertaken. Remarkable for its "head-in-the-sand" approach is the account of Germain Jean Lebailly, *Mémoires pour servir à l'histoire de l'église cathédrale de Sées* (Alençon: 1775), pp. 129, 164, 177, 202, 309 (microfilm of this work in Arch. dépt. de l'Orne, A Mi 3). See Barret, *Normandie monumentale*, p. 121; Henri Tournoüer, "La Cathédrale de Sées," extract from *Société historique et archéologique de l'Orne* 16 (1897), pp. 14–17.

38. Dumaine, *La Cathedrale de Sées*, p. 47; Barret, *Normandie monumentale*, p. 121.

39. On the 1817–18 repairs (architect Alavoine) see Paris, Arch. nat. F19 7876. On those of 1837 (architect Dedaux) see Arcisse de Caumont, "Session générale," *Bulletin monumental* 3 (1837), p. 337.

 On the south transept: Vaudoyer's report of 1849 states that the medieval windows "pour la plupart sont en très mauvais état" (Paris, Arch. nat. F19 7877). Work began on the south because the extensive damage and repair on that flank, dating from a violent hailstorm of July 4, 1611, no doubt offered quite a jumble. On the storm and its aftermath see Lebailly, *Mémoires de Sées*, p. 202.

 On the Steinheil and Coffetier restorations: Paris, Arch. nat. F19 4546–4549, F19 7878; Arch. dépt. de l'Orne, séries V, 10.V.1. The modern designs (dated 1857) were published by Thomas H. King, *Etudes pratiques tirées de l'architecture et des arts du moyen âge* (London: 1869), vol. 1, pls. 72–74; see also Gobillot, *La Cathedrale de Sées*, pp. 76–77, for several of them. No one seemed to realize that they were modern fabrications.

40. The medieval designs were augmented by totally modern work only where originals were missing, primarily in the north rose gallery (which bears the inscription *Restaurata Paris 1877*), and the band of figures in the clerestories of the north transept, west wall (Bays 217, 219, 221), and in Bay 213 on the east wall adjoining the rose.

41. Paris, Arch. nat. F19 7880, 7882.

42. Guilhermy's notes from 1837 and 1860 are found on fols. 64v–69. Marais and Beaudoin, *Essai sur Séez* (as in n. 27), pp. 421–26.

43. Lafond, "Les Vitraux de Sées," p. 63.

44. The gallery is not mentioned by Guilhermy, or by de la Sicotière and Poulet-Malassis (*Orne archéologique*), and now contains a series of Leprévost's saints; see n. 40 above. A color plate of the rose and gallery is in Patrick Cowen, *Rose Windows* (San Francisco: 1979), pl. 14.

 Eliminated by Leprévost were the nonconforming fragments inserted by Bishop Jacques de Silly (1511–1539); see at n. 34 above. Guilhermy listed among the debris two medallions—John the Baptist holding an Agnus Dei disk and a seated evangelist—as well as later fleurons.

45. Lucien Magne, "Inventaire des vitraux anciens . . . restés sans emploi chez M. Leprévost," Archives de la Direction de l'architecture, dossier Vitraux, July 10, 1884; Lafond, "Les Vitraux de Sées," pp. 78–79.

46. Guilhermy (fol. 68) noted grisailles throughout, and five figures on the east side: three in Bay 209 and two in Bay 211. They were retained by Leprévost in 1869–1878; he copied the existing glass to make up a full complement in the transept.

47. Lillich, "A Stained Glass Apostle from Sées Cathedral (Normandy) in the Victoria and Albert Museum," *Burlington Magazine* 119, no. 892 (July 1977), pp. 497–500 and frontispiece. Bernard Rackham, *A Guide to the Collections of Stained Glass,* Victoria and Albert Museum, Department of Ceramics (London: 1936), p. 26, pl. 1.

48. De Lasteyrie, *Histoire de la peinture sur verre* (as in n. 4), pl. X. If the Agnus Dei symbolizes a donor named Jean, as it does at Le Mans and possibly also at Sainte-Radegonde, Vendôme, etc., it would undoubtedly be Jean de Bernières, whose window is around the corner immediately to the left. There would be no necessity to postdate the north ambulatory bay (and therefore the similar north rose) after 1278 when he became bishop, since it seems likely that the glazing was well under way upon his arrival, and that he inserted his glass on a space-available basis.

49. Guilhermy (and also de la Sicotière and Poulet-Malassis, *Orne archéologique*) read "Elizabeth," and Guilhermy guessed the other inscription to be the Magdalene. She holds a book, stands on a checkered floor, and has an admittedly remade inscription (see p. 195 below). Lafond, "Les Vitraux de Sées," discusses these two figures, pp. 74–75.

50. Aunou is discussed on pp. 208–10 below; see also my "Stained Glass Apostle from Sées Cathedral," p. 500 and fig. 40.

51. The styles of these masters are discussed pp. 205–7. The Nicholas Master's figures are spreading and slightly swaying, and the hair is cut from a separate piece of glass when possible. The painting here is, however, absolutely typical of the Jean de Bernières Master.

52. It is puzzling that Lafond believed the entire donor figure and other fragments throughout the bay to be authentic: "Les Vitraux de Sées," p. 75n1; "Le Vitrail en Normandie," p. 351n1. Wishful thinking on his part?

53. The piece of glass is modern. Guilhermy noted only that "le nom y était."

54. On Johannes III Galliot see *Gallia christiana* (as in n. 32), vol. 11, col. 709. He is documented in 1287; the previous prior is documented 1238–1252.

55. Paris, Arch. nat. F19 4564; F19 7880, 7882.

56. Helen Jackson Zakin, "Grisailles in the Pitcairn Collection," pp. 84–87; Lillich, "Stained Glass from Western France (1250–1325) in American Collections," *Journal of Glass Studies* 25 (1983), pp. 124–26. See also n. 121 below.

57. At present two copies of the Glencairn panel are in the chapel. The color of the glass allows us to conclude that the Glencairn panel was originally in the right bay. Guilhermy described the debris in the St Augustine chapel in 1860: a St Peter with a very large key (probably the figure now in the axial chapel Bay 6); a *figure rapiecé;* and a group (the Glencairn panel). The 1876 description by Marais and Beaudoin (*Essai sur Séez* [as in n. 27], p. 425) is comparable: St Peter with key; next to him "figures difficult to decipher."

58. Lafond, "Les Vitraux de Sées," p. 66.

59. On Mgr. Trégaro's window see Barret, *Normandie monumentale* (as in n. 3), p. 119. The chapel had received some modern glass before the episcopacy of Mgr. Trégaro: Marais and Beaudoin, *Essai sur Séez,* p. 425.

60. The extraordinary eye of Michael Cothren first connected the Los Angeles glass with the Protais Master of Sées. My warm gratitude for his generosity in bringing it to my attention, and to Red Wetherill for making it possible for me to see the glass in Los Angeles. I published the Los Angeles angels (and grisaille trefoils, see note following) in "Les Vitraux de la cathédrale de Sées à Los Angeles et dans d'autres musées américains," *Annales de Normandie* 40/3–4 (1990), pp. 151–75.

61. See nn. 56 and 121. This too was Michael Cothren's discovery, in 1978.

62. Guilhermy, fol. 69; Marais and Beaudoin, *Essai sur Séez,* p. 425. No part of the present canopy, border, or colonnettes is original. The figure itself has only minor repairs.

63. Guilhermy's visits to Sées (1837 and 1860) pre- and postdated the drastic reglazing of the south rose. His remarks on the Annunciation in the upper *écoinçons* (now gone) must date from 1837 (fol. 64v); his notes on the modern subject program are found on fol. 68.

64. Elise Whitlock Rose, *Cathedrals and Cloisters of Northern France* (London: 1914), vol. 2, p. 115, states that the south transept portal sculptures portray the life of the Virgin. This portal is now inaccessible.

65. The original of this medallion was in Paris in the 1880s. See n. 45 above.

66. Dol is a more contemporary example, discussed pp. 137–39 above. See Lillich, *Saint-Père*, p. 152, for a general discussion of the scene.

67. For a general summary of the evolution of Emmaus scenes, as well as the Doubting Thomas discussed below, see ibid., pp. 153–54.

68. Auguste Longnon, *Pouillés de la province de Rouen*, Recueil des historiens de la France (Paris: 1903), pp. xliii–xliv.

69. Leprévost moved things most recently, shifting into the left bays of the north chapels the glass that had been inserted into their central windows ca. 1375. Guilhermy's notes establish this move. Leprévost copied original grisaille patterns represented in several American museums (see nn. 56, 121, 122); it must be stressed, however, that old photographs establish that very little old grisaille remained. He did not destroy or sell it wholesale.

70. Guilhermy was not fooled. See however: M. Lecointre-Dupont, "La Légende dè St. Julien le pauvre, d'après un manuscrit de la Bibliothèque d'Alençon," *Mémoires de la Société des antiquaires de l'ouest* 5 (1838), p. 210, pl. VII; de la Sicotière and Poulet-Malassis, *Orne archéologique* (as in n. 6), p. 10; and finally L.-V. Dumaine, "La Verrière de St. Nicolas à la cathédrale de Séez," *Bulletin des amis des monuments ornais* 4 (1904), pp. 27–30. The present panel of the father in bed was supplied by Leprévost.

71. Lafond, "Le Vitrail en Normandie," p. 320. I photographed the Nicholas lancet of Champ-Dominel in 1976.

72. The donor panel was probably moved when the window of ca. 1375 was installed, showing the chaplain Oudin before St Nicholas. The latter is illustrated by Barret, *Normandie monumental* (as in n. 3), p. 119, and by Lafond, "Les Vitraux de Sées," pp. 80–82. Oudin was secretary to Bishop Guillaume de Rances and had come to Sées ca. 1363.

73. So far as I can tell, Amicus Dei was first identified by Barret, *Normandie monumentale*, p. 105. Lafond, "Les Vitraux de Sées," pp. 59–60, was able to add the documentation of the *Register of Eudes Rigaud*, and also a testament that can probably be identified as his (Gervasius Amicus Dei, presbyter): Arch. dept. de l'Orne H 3533, dated Feb. 1286 (n.s.). See n. 22 above for a more recent translation of the *Register*.

74. Lafond, "Les Vitraux de Sées," p. 70n4. On Argentan see Xavier Rousseau, *Argentan, figures et choses du passé* (Argentan: 1940), pp. 19–52.

75. See Louis Réau, *Iconographie de l'art chrétien*, vol. 1, *Ancien Testament* (Paris: 1958), pt. 1, p. 436.

76. The Calimala split off from the drapers who handled local Florentine cloth in 1193: Pier Luigi Barzellotti, *I Beni dell'arte della lana* (Florence: 1880), p. 5. Since 1157 they had administered the Florence baptistery, S. Giovanni: Armando Comez, *I Lanaioli fiorentini e le belle arti* (Rome: 1949), p. 8. The feast of John the Baptist is mentioned in the oldest preserved statutes of the guild, dated 1307: Giovanni Fillippi, *L'Arte dei mercanti di Calimala in Firenze ed il suo più antico statuto* (Turin: 1889), p. 7. I would like to thank Mary Louise Wood for this documentation.

77. The central window is modern except for the inscription, the saint's miter, and the lower panel of the monks' group. Several of the original grisaille panels (copied by Leprévost in the chapel) are now in the Corning Museum of Glass: see nn. 56, 121, 122.

78. The scene was already garbled before Leprévost's addition of the male figure at the left. Guilhermy, and also Marais and Beaudoin (*Essai sur Séez* [as in n. 27]), mention the Christ at table, the Magdalene beneath it, and a smaller scale woman to the right. The face of Christ is among the inept, ancient stopgaps. See Lafond's remarks, "Les Vitraux de Sées," pp. 72–73.

79. Rousseau states, however, that the first mention of it dates 1468 (p. 62): see Rousseau, *Argentan*, pp. 57–72. The *hôtel* was destroyed in 1919. A leprosarium two kilometers south of Sées, La Madeleine, still had the remains of a thirteenth-century portal in 1896: Barret, *Normandie monu-*

mentale, p. 140. I have been unable to establish a donor, or a relationship between the leprosarium construction and Amicus Dei.

80. Amicus Dei was appointed Inquisitor for Sées by Eudes Rigaud. See *Register of Eudes* (as in n. 22), p. 323 (Sept. 12, 1257).

81. Lafond, "Les Vitraux de Sées," particularly p. 68.

82. I published the following argument in "Los Angeles" (see n. 60 above). For the *pouillé* see Longnon, *Pouillés de Rouen* (as in n. 68), pp. xliii–xliv. Marais and Beaudoin (*Essai sur Séez,* pp. 402f.) give the original dedication of the chapel as the Annunciation, on no evidence at all. The Annunciation chapel may have been in the north transept (where stained glass fragments of the subject are still found), or the south transept (where the south rose contained that subject, and the south portal an Infancy cycle): see nn. 63–64 above.

83. See n. 27 above; de la Sicotière and Poulet-Malassis, *Orne archéologique* (as in n. 6), p. 4, state that M. d'Argentré in 1786 put the diocese and cathedral under the patronage of the Virgin, supposedly the patron of the first cathedral.

84. Jean Fournée, *Le Culte populaire et l'iconographie des saints en Normandie* (Paris: 1973), pp. 25, 36.

85. M. du Mesnil du Buisson, "Les Origines d'Alençon, Sées, Gacé, Exmes et Argentan," *Bulletin de la Société historique et archéologique de l'Orne* 67 (1949), pp. 26–27, 32–34. The ruins of Notre-Dame-du-Vivier, which Barret considered Romanesque (north wall) and Gothic (south), served as a slaughterhouse in 1896 and as a storage area for the Ponts et Chaussées in 1949; Mesnil du Buisson, p. 33; Barret, *Normandie monumentale,* pp. 139–40.

86. *Orderic Vitalis* (as in n. 27), Book XII, mentions an altar of Mary in 1123 (sect. 35); and the consecration of the church to Gervais in 1126 (sect. 44). I published the following hypothesis, identifying the episcopal (axial) chapel with the Virgin of the Assumption, in *Annales de Normandie* (as in n. 60).

87. Longnon, *Pouillés de Rouen,* pp. xliii, xliv and n. 3.

88. See color plate XVI, opposite p. 292, in CVFR II.

89. A later example is in the Chapelle Vendôme at Chartres. The Evreux Coronation of ca. 1335 is illustrated in Monique Beucher, "Les Verrières du choeur d'Evreux," *Dossiers de l'archéologie,* no. 26 (Jan.–Feb. 1978), p. 69. Beucher's comparison with sculpture (pp. 74–75) is particularly apt for Sées, where the hypothesized Coronation would have been joined by the Virgin and Child in the traceries. High Gothic portals of the Triumph of the Virgin normally include the Coronation in the tympanum and the Virgin and Child on the trumeau.

90. *Register of Eudes* (as in n. 22), p. 261 (Jan. 28, 1256 n.s.).

91. Lafond, "Les Vitraux de Sées," p. 77, citing G. Demay, *Le Costume du moyen âge d'après les sceaux* (Paris: 1880), pp. 57, 62.

92. Sixteen bishops of Sées were honored locally as saints, although *Gallia christiana* reduces the official number to seven. The most popular were Latuin, Annobert, Loyer, and Godegrand. Relics of Latuin and Gérard were burned by the Huguenots in 1568 (see n. 35 above). On the bishop saints of Sées including Hubert in Bay 203: Abbé J.-B.-N. Blin, *Vies des saints du diocèse de Séez et histoire de leur culte* (Laigle: 1873); Fournée, *Le Culte populaire,* pp. 15, 45–46, 231; Louis Réau, *Iconographie de l'art chrétien,* vol. 3, *Iconographie des saints,* pt. 3 (Paris: 1958), p. 1432.

93. Lafond, "Les Vitraux de Sées," p. 76. Latuin (Lain) is a likely choice, as the cathedral possessed his relic from the mid-eleventh century until its destruction by the Huguenots: Abbé Pierre Flament, "Recherches sur saint Latuin, premier évêque et apôtre du diocèse de Séez," *Bulletin de la Société historique et archéologique de l'Orne* 88 (1970), pp. 30–31. On Latuin see also: Patrice Boussel, *Des reliques et de leur bon usage* (Paris: 1971), p. 42. On Godegrand (Chrodegand), bishop of Sées martyred in 775 near Nonant-le-Pin (Orne), I have found no evidence of a particular cult at Sées in the Gothic era. His relics were in Saint-Martin-des-Champs in Paris and at L'Isle-Adam near Pontoise (Seine-et-Marne), according to Réau, *Iconographie des saints,* pt. 1, p. 314.

94. On the legend of St Vaast's bear, see Réau, *Iconographie des saints,* pt. 3, p. 1302; and Gertrude Sparrow Simpson and W. Sparrow Simpson, *The Life and Legend of S. Vedast* (London: 1896), pp. 34, 54, 64–67.

95. Longnon, *Pouillés de Rouen,* p. xliii.

96. The head of the child Virgin is original, contrary to Lafond, "Les Vitraux de Sées," p. 76n2.

97. Marais and Beaudoin, *Essai sur Séez* (as in n. 27), p. 103 and n. 3, state that the cloister chapel still existed (in 1876). They seem to be describing the existing eleventh-century structure north of the nave, now a museum. More likely to be the remains of the cloister chapel is a tiny roofless ruin off the north transept.

98. See p. 179 above. Guilhermy (fol. 68) states that the name was there, though he could not read it, and mentions the Baptist's Agnus Dei as well as the "mutilated" apostle to the left. On his evidence it is possible to have some confidence that the nineteenth-century restorations of the clerestory were as faithful as possible to the medieval remains.

99. Lafond, "Les Vitraux de Sées," p. 60.

100. The collegiate church of Saint-Nicolas in Le Merlerault is mentioned in a document of 1271 and was destroyed in 1791. See: J. Rombault, "La Collégiale de Saint-Nicolas du Merlerault," *Bulletin de la Société historique et archéologique de l'Orne* 5 (1886), pp. 270–82; Rombault, "Les du Merle" (as in n. 13), p. 455.

 The relics of Saint Ursin were received in Lisieux in 1055: G. Bouet, "Visite de quelques monuments de Lisieux," *Congrès archéologique* 37th session (1870), pp. 222–23; Réau, *Iconographie des saints,* pt. 3, p. 1295.

101. Douët-d'Arcq, *Sceaux de l'Empire* (as in n. 27), no. 6662, dated 1274.

102. The arms of Fouques du Merle appear on the Wijnberghen Roll (Adam-Even and Jéquier, *Archives héraldiques suisses* 66 [1952], p. 34, no. 407); the Chifflet-Prinet Roll (Prinet, p. 30, no. 91; Brault, p. 81, no. 92). (For the above references see Chap. V, n. 145.) On Fouques du Merle's seal of 1302, G. Demay, *Inventaire des sceaux de la collection Clairambault à la Bibliothèque nationale* (Paris: 1888), no. 6010. Fouques appears on a chart of 1271; was *armiger* in 1273; *maréchal* of France in 1302; deceased 1314. See: Rombault, "Les du Merle," p. 462; Père Anselme, *Histoire généalogique de la maison royale de France* (Paris: 1730), vol. 6, p. 641.

103. If Bishop Gui du Merle was in fact the younger brother of Fouques du Merle, *maréchal* of France, as Rombault believes, then he places Fouques's birthdate too late (ca. 1246): "Les du Merle," p. 462. Gui was already precentor of the cathedral of Rouen in 1255: *Register of Eudes* (as in n. 22), p. 261. It is more likely that Gui was his uncle, that is, the younger brother of the Fouques du Merle who was tutor of Robert d'Artois and died with him on crusade at Mansourah in 1250: Natalis de Wailly, ed., *Histoire de Saint Louis par Joinville* (Paris: 1865), chaps. 46–47.

104. The merlette was also used by other cadets in the family. See the seal of Guillaume du Merle (dated 1369): Demay, *Sceaux de Clairambault,* no. 6011.

105. Rombault, "Les du Merle," pp. 462–70; Fisquet, *La France pontificale,* vol. 18, p. 33.

106. It was dedicated under his successor. Although the authenticity of the lost tomb epitaph was doubted by Henri Tournoüer ("Monographie de la cathédrale de Sées," *Ecole nationale des chartes, Position des thèses* 48 [1887], p. 121, pt. 2) there seems no reason to question it. It was reported in 1623 by Dom Marin Prouverre Bichetaux ("Histoire ecclésiastique du diocèse de Séez") and "discovered" in his manuscript in 1846. See: Marais and Beaudoin, *Essai sur Séez,* p. 98 (text of inscription); Fisquet, *La France pontificale* (as in n. 33), p. 34. Prouverre Bichetaux is listed by Jacques Lelong, *Bibliothèque historique de la France* (Paris: 1768), vol. 1, no. 9958; Michael Cothren has informed me that a manuscript copy dated 1624 was in the Paris book trade in 1981.

107. The family and arms of Jean de Bernières are unknown; the arms attributed to him in the nineteenth century (for example, Fisquet, *La France pontificale,* p. 34) are false, being those found under Bernières in standard modern references such as Rietstap and Grandmaison. Noth-

ing connects Bishop Jean de Bernières with the modern family that emerged in 1413 as bourgeois of Saint-Pierre-sur-Dives (Henri Emedy, *Le Sang de Jeanne d'Arc au pays de Falaise* [Falaise: 1967], p. 8); even less with the English Berners, whose thirteenth-century arms are found in Planche's Roll and Walford's Roll. *Gueules au pal d'argent* occurs in the arms of Vauville in Lower Normandy (Wijnberghen Roll, no. 486, the Herald Navarre, nos. 248, 425), but I have been unable to establish a connection with Bishop Jean.

108. Longnon, *Pouillés de Rouen* (as in n. 68), p. xliv. On the suggested location of the Annunciation chapel as the axial chapel see discussion at n. 82 above. An alternate hypothesis to the one I am discussing is of course possible, viz. that the axial chapel was in fact the Annunciation chapel and that these two inscriptions came from the lost axial window there. They are so different from the elaborate, elegant canopies and inscriptions of the rest of the program there that it seems unlikely.

109. Abbé L. Hommey, *Histoire générale, ecclésiastique et civile du diocèse de Sées* (Alençon: 1899), vol. 3, p. 137; *Gallia christiana* (as in n. 32), vol. 11, col. 695.

110. Lafond, "Les Vitraux de Sées," p. 77.

111. It is unclear who his patron was, but he no doubt had one, since he was only a clerk when elected to the episcopate, and was ordained priest and consecrated bishop on consecutive days, Dec. 21 and 22, 1258 (*Register of Eudes* [as in n. 22], p. 375).

112. Dates range from Mar. 1 to May 1: Hommey, *Histoire générale,* vol. 3, p. 139; Fisquet, *La France pontificale,* vol. 18, p. 33; Marais and Beaudoin, *Essai sur Séez* (as in n. 27), p. 93.

113. The prince's antagonism eventually passed into the folklore of Sées, if one can judge by the fantastic history composed 1727–1734 by Baratte, "Histoire de l'église de Séez," Bibl. mun. Alençon MS 103, vol. 6, pp. "mmm" and following. See later Hommey, *Histoire générale,* vol. 3, pp. 139f.

114. For views from various vantage points see: *Gallia christiana,* vol. 11, col. 695; Louis Mannoury, *Du Comté d'Alençon* (seventeenth-century manuscript), ed. Graville-Desules (Paris: 1863), p. 11; Edgar Boutaric, *Actes du Parlement de Paris* (Paris: 1863), vol. 1, p. 169, n. 1835; Comte Beugnot, *Les Olim ou registres des arrêts rendus par la cour du roi* (Paris: 1839), vol. 1, p. 900, no. XLVII.

115. Guilhermy, fol. 68v. There are also castles but no fleurs-de-lis at the cathedral of Tours. Papanicolaou has argued that they signify the "châtel tournois," used on the chapter seal ("Windows of the Choir of Tours," pp. 169–73).

116. For the prince's donation of 1282 see: Paris, Bibl. nat. lat. 11058, fol. 74. The document is a transcription by a student of Delisle from a cartulary of 1472 (Stein no. 3650) and is generally unknown to local historians of Sées.

117. Cothren, "Glazing of the Choir of Beauvais," pp. 169–85 passim, pls. 102–111, 117–18.

118. Lillich, "The Band Window," p. 33n29, illustrated figs. 9–10. Lafond, "Le Vitrail en Normandie," p. 323 discusses Saint-Pierre-sur-Dives.

119. "Cassette" is a useful term in grisaille studies. As with borders, the term implies an independent framed motif. In grisailles it distinguishes from quarry designs in general those that have a repeated motif within a painted filet frame around all four sides, and thus no sense of continuity. Such cassette or unit quarries make a much more two-dimensional effect than those maintaining a continuous pattern.

120. On the Primelles panel see Chap. II, n. 163, and Chap. IV, p. 96.

121. Illustrations and bibliography: see n. 56 above; Grodecki and Brisac, *Le Vitrail gothique,* p. 151 (color pl.); CV Checklist I, pp. 74, 103; CV Checklist II, p. 135.

122. The modern grisailles in Bays 202 and 204 of the south clerestory have curved leading of the common bulged quarries type. They do not resemble any of the old grisailles of the clerestory, and Leprévost may have copied their designs from the chapels he was working on.

123. The Dol grisailles are much more standard bulged quarries patterns: see Chap. V, p. 153. The "ball bearings" and "sacred cueballs" of Dol are not found at Sées.

124. On Vendôme see Chap. VII, p. 224. On Saint-Père see Lillich, *Saint-Père*, pls. 46, 75, 84.

125. Five grisaille panels (three designs) removed from Sées cathedral before 1884 were put on permanent exhibition from 1910 to 1934 by Lucien Magne in the Trocadéro, this grisaille being his no. 58: Lucien Magne, *Notice sommaire,* Palais du Trocadéro, Musée de sculpture comparée, Galerie de vitraux anciens (Paris: n.d. [1911]), p. 6, nos. 58–60.

 See also: Lafond, "Les Vitraux de Sées," p. 63; *Vitraux de France du XIe au XVIe siècle,* exh. cat., Musée des arts décoratifs (Paris: 1953), no. 25. The drawing is in L. Ottin, *Le Vitrail* (Paris: 1896), p. 37. A photograph of the Saint-Père grisaille is provided in Lillich, *Saint-Père,* pl. 44.

126. See for example Lafond, "Les Vitraux de Sées," p. 76n3.

127. As in the Virgin chapel panels in the Glencairn Museum, mentioned at n. 61. I know of only one other example, in the Saint-Père nave (early fourteenth century), where the stem rises along one side only: Lillich, *Saint-Père,* pl. 46.

128. The whole axial clerestory of Sées is odd. It is the only clerestory of the Nicholas Master; its borders somewhat resemble those in the axial chapel in the Protais Master's designs (Bays 3 and 4); its grisaille appears to be unique, though so much grisaille at Sées has been redone that this cannot be stated definitively.

129. One can only guess why. I have guessed that they may have been an unpleasant reminder of the prince. See p. 196 above.

130. In the axial chapel I refer to the borders on Sts Gervais and Protais and the two bishops of Sées (Bays 3 and 4); all others are modern. A different variant of the rising palmette border occurs in Bay 204 in the clerestory.

131. Nonetheless the formula is clear, and certainly postdates the two primitive canopies widened and reused in Bay 23, the north lancet of the Jean de Bernières chapel. See p. 177 above.

132. The Nicholas Master prefers to draw facial features and hair on separate pieces of glass, and although almost everything else in the Baptist chapel ensemble has been replaced, the original hair and headgear of the donors remain.

133. Lafond, "Les Vitraux de Sées," p. 68n2. All of the figures in the axial chapel have been thus shortened, including the émigré apostles that I believe originated in the transept clerestories. Thus it seems likely that the truncation was performed when those apostles were moved here, possibly ca. 1375.

134. Lafond, "Les Vitraux de Sées," pp. 65–66. The tracery angels in Los Angeles, also by the Protais Master, are too small in scale for these refinements (see p. 182 above).

135. I published the following argument in "Los Angeles" (see n. 60 above). On Fécamp: Lafond, "Le Vitrail en Normandie," pp. 327–28; Jean Lafond, "Les Vitraux de l'abbaye de la Trinité de Fécamp," in *L'Abbaye bénédictine de Fécamp: Ouvrage scientifique du XIIIe centenaire, 658–1959* (Fécamp: 1961), vol. 3, p. 99.

136. Indeed the delicate painting of heads and hands at Fécamp does not match up with that of the draperies, and I presume that the cartoons were made and draperies mostly executed by a different artist than the one we are concerned with here. I have a hypothesis as to the style but, considering the wreckage of the evidence, will remain silent; perhaps close observation of the plates in this book will suggest it.

137. Lafond, "Les Vitraux de Sées," pp. 79–80.

138. This compartmentalization suggests that he was responsible for the two donor panels now in Bay 7 in the Baptist chapel, which are largely modern copies. See n. 132 above. One of the bishops in the Protais Master's axial chapel group has separate hair, but the head is modern (Bay 3, left lancet).

139. Gobillot, *La Cathédrale de Sées* (as in n. 37), p. 72; Lafond, "Le Vitrail en Normandie," p. 351.

140. The heads of the two large bishop saints are remarkably ugly nineteenth-century replacements; the head of the right-hand angel is original though now nearly black. Barret's photo of 1896 (*Normandie monumentale* [as in n. 3], p. 117) shows the glass before it had darkened.

141. Backpainting is a technique in need of investigation, though weathering and nineteenth-century polishing make it very difficult to study. It is my impression that it was an individual matter. The Norman master of the Infancy window of Gassicourt used backpainting, unlike his shop fellows. In the clerestory of Sées the Norman Nicholas Master does not use backpainting, while the expressionists do; at chapel level the grilles covering the windows make it impossible to tell.

142. On Bay 105 of the Le Mans upper ambulatory, the gift of the abbot of Evron, see Chap. II, pp. 29–33. The abbey of Evron, consecrated shortly before Le Mans, may have been glazed by the artist, whose work is technically sure and proficient. On the Evron church of 1252 see Chap. VIII, p. 254.

143. The torsion in the axis of the body was probably present in the pattern, since it appears in the axial clerestory figures of the Nicholas Master and elsewhere, although it is downplayed by the greater mass and realism of the Protais Master's figures. The Jean de Bernières artist accentuates it.

144. On this concocted bay, see p. 177 above. The canopies have been reused from a narrower design, and a large pearled filet has been added inside Jean de Bernières's border to take up some of the slack. This oversized pearl border reappears only in the Nicholas Master's axial clerestory (Bay 200).

145. He is not Peter; the key part of his baton is modern. This figure came from lancet B of the north transept Bay 211. A full discussion of the documentation on the transepts may be found in Lillich, "Apostle from Sées" (as in n. 47), pp. 497–500.

146. Lafond, "Les Vitraux de Sées," p. 67n2. One apostle has a book and staff, the other has an attribute that may have been a palm(?).

147. All the figures now in the axial chapel, including those of the Protais Master's original scheme, have been thus truncated. See n. 133 above.

148. Those in Bay 5 (north) have a book and a sword; the apostle with the sword (Paul) has a balding head, dating probably from the ca. 1375 repairs. The apostles in Bay 6 (south) have a Latin cross and a key; the latter is the St Peter painted by the Madgalene Master, his only remaining contribution to the series.

149. The flanking colonnettes here and in the axial chapel are in some cases old, but do not occur in the transept. They were probably added when these panels were widened to fit the chapel windows (ca. 1375?). The widening is noticeable in a comparison of their architectural superstructure with that still in the transept, some of which is old.

150. Lafond, "Les Vitraux de Sées," pp. 66–67.

151. A general description of Aunou, though marred by historical errors, may be found in: Odette Salles, "L'Eglise d'Aunou-sur-Orne," *Bulletin de la Société historique et archéologique de l'Orne* 80 (1962), pp. 145–50. A reliable survey of the charters is in the text of Barret, *Normandie monumentale,* pp. 143–45, with an illustration of the exterior.

152. The brothers were Robert, Simon, and Maître Jean de la Ferrière (the latter a canon of Le Mans cathedral). Robert died about 1265, the year his heir (also named Robert) confirmed one of his father's charters. See Arch. dept. de l'Orne H 199. I published the documentation on Aunou in "Vitrail normand du XIIIe siècle aux armes de La Ferrière," *Archivum heraldicum* 3–4 (1977), pp. 34–37, with illustrations of the coats of arms.

153. Her legend was an eighth-century compilation from two older, disparate Spanish sources. The version including the beheading is found in a tenth-century manuscript of Chartres and many later examples (Henri Moretus, S.J., "Les saintes Eulalies," *Revue des questions historiques* 39 [1911], esp. pp. 85, 97, 115). She is included in a customary of Bayeux cathedral dated between 1228 and 1270: Ulysse Chevalier, *Ordinaire et coutumier de l'église cathédrale de Bayeux, XIIIe siècle* (Paris: 1902), p. 208.

154. Paris, Bibl. nat. fr. 19864, fol. 35r (inventory of 1669).

155. CV Checklist II, p. 134 with bibliography. Michael Cothren has identified two fragments of heads by the same painter, also in the Glencairn Museum (acc. no. 03.SG.153): CV Checklist II, p. 147. The fragments have been polished on the back, around the original backpainting.

156. The face of Christ is a small-scale repair, as is the woman flanking him. The other flanking figure is modern. The original scale can be gauged by the feet that remain under the table and by Christ's blessing hand.

157. Lafond, "Le Vitrail en Normandie," p. 327; Kraus, *Gold Was the Mortar*, pp. 179–80. I have discussed the longshoremen panels on p. 71 above.

158. Donors in Bays 205 and 202 have modern heads and Bay 206 is entirely new. There are no donors in Bays 203 and 201.

159. The grotesque hands in the Magdalene supper are the work of this artist.

160. *Vitraux de France* (as in n. 125), pp. 24–25. He was comparing fourteenth-century glass at Saint-Père de Chartres and Evreux.

161. Sts Gervais and Protais in the Jean de Bernières window (north transept, Bay 21) are made from the same cartoon, with head reversed. The cartoon is based upon a pattern used by the Protais Master in Bays 3 and 4 in the axial chapel. See p. 206 above.

162. On modelbooks see: R. W. Scheller, *A Survey of Medieval Model Books* (Haarlem: 1963); D. J. A. Ross, "A Late Twelfth-Century Artist's Pattern Sheet," *Journal of the Warburg and Courtauld Institutes* 25 (1962), pp. 119–28; *The Year 1200, I: The Exhibition*, The Metropolitan Museum of Art (New York: 1970), no. 268.

163. Among the manuscripts sometimes suggested to have served as glass designs are Pierpont Morgan MS 44, late twelfth century (*The Year 1200, I*, no. 242); the Guthlac Roll of ca. 1200, British Library Harley Y 6 (G. Warner, *The Guthlac Roll*, Roxburghe Club [Oxford: 1928]); and the Villard de Honnecourt sketchbook, first half thirteenth century.

164. See for example Hans Wentzel, "Un Projet de vitrail du 14e siècle," *Revue de l'art* 10 (1970), pp. 7–14. On the use of popular books and prints as models in the later Middle Ages, see the remarks of Virginia Raguin, *Northern Renaissance Stained Glass: Continuity and Transformations*, exh. cat., College of the Holy Cross (Worcester, Mass.: 1987), pp. 12–13.

165. See p. 206 above. Only the upper half of the bodies can be related, since the Protais Master's deacons now have modern lower panels probably copied from the single remaining old panel in the axial chapel group, the bishop of Sées now in Bay 4 (south).

166. Probably based on the same cartoon is the bishop saint of Bay 200, lancet D, greatly elongated and squeezed into a narrow space (*Pl.45.A*). Note how the angle of the crozier is constant but, in designs of different proportions, it hits the hem at different points in the three artists' cartoons.

167. See also Lillich, "Apostle from Sées" (as in n. 47), fig. 1 (London), fig. 38 (north transept, middle bay), fig. 39 (émigré in axial chapel, south wall, Bay 6A). Figs. 1 and 38 are by the Jean de Bernières Master; Fig. 39 is by the Magdalene Master.

168. Important studies on the nature of the medieval artist's use of models have been done by Mary Evelyn Stringer, "The Twelfth-Century Illustrations of the Life of Saint Cuthbert" (Ph.D. diss., Harvard University, 1973).

169. Eva Frodl-Kraft, "Le Vitrail médiéval, technique et esthétique," *Cahiers de civilisation médiévale* 10 (1967), p. 2.

170. Henry de Ségogne, *Les Curiosités touristiques de la France: Orne* (Paris: 1952), p. 5.

171. Papanicolaou noted the reemergence of the regional idiom at Tours by the end of the campaign ("Windows of the Choir of Tours," chap. VI, pp. 223–34). My analysis of the chronology of Le Mans (Chap. II) noted the strong presence of the Principal Atelier (in the upper ambulatory) dissipating before the end of that series and only sporadically present in the late clerestories.

172. There is a medallion in the east wall of the north transept, and two scraps now set in the north wall. See Lafond, "Le Vitrail en Normandie," pp. 319–20, 334; an illustration is cited in Chap. III, n. 63 above. Although the Victorine reform was less successful at Lisieux than at Sées, the two cathedrals maintained close ties. On Lisieux, see Bonnard, *Histoire de Saint-Victor* (as in n. 10), vol. 1, pp. 144, 260.

173. The cathedral formula was retained at Clermont-Ferrand, an ensemble of approximately contemporary date. Its logic was ignored in coeval programs where small-scale narratives were put, more illogically, in high windows: the Le Mans upper ambulatory, at Tours and Dol, later at Saint-Père de Chartres. The impact of the Sainte-Chapelle does not provide a totally satisfactory explanation.

CHAPTER 7

1. Grodecki, *Le Vitrail roman,* pp. 78–79, 295; CVFR II, p. 152, Baie o (bibliography).
2. Grodecki and Brisac, *Le Vitrail gothique,* p. 74; CVFR II, pp. 154–55, Baie 23 (bibliography).
3. Lillich, "Vendôme," p. 240 n11 and fig. 2.
4. See ibid., pp. 239–40 and nn8, 10. Abbé Gabriel Plat, *L'Eglise de la Trinité de Vendôme* (Paris: 1934), p. 83, was the only previous observer to mention the Gothic grisaille debris, which he noted above the Renaissance glass of the chapels. See now CVFR II, pp. 151–58.
5. The Album of Launay is in the Bibliothèque municipale of Vendôme. Most of the drawings are dated from the 1840s to 1860s. Those of Bays 205 and 206 are in vol. 1, pl. 16; see *VII.11.B* below.
6. Paris, Bibl. nat. nouv. acq. fr. 6111, fols. 290–98 (this quote is a marginal note on fol. 293v).
7. Since even the Renaissance glass of the adjoining Bay 203 survived the 1870 explosion, the grisailles of Bay 205 probably sustained minor damage as did the Gothic figure band of Bay 201 to the other side of Bay 203. The grisaille borders of Bay 205 are now largely motley debris.
8. My best guess is that they were in the axial chapel, where, besides Renaissance glass, Guilhermy noted, "Le retable de l'autel cache quelques vitraux de XIVe siècle" (fol. 294v). The slightly tighter, earlier foliage type would be logical in the axial chapel, first section of the *rayonnant* construction. The narrow width of the early grisailles (49.5 cm.) would fit the hemicycle, but the triforium there retains all its old glazing (delicate grisailles in Bays 101 and 102, fifteenth- and nineteenth-century glass in Bay 100, confirmed by Guilhermy before the explosion).
9. On the band window variants at Tours (two rows of figures) and Saint-Père (vertical banding) see Chap. III, pp. 68f. My analysis of the evidence of the original schema at Vendôme has evolved since 1975 when I was unwilling to draw a conclusion (Lillich, "Vendôme," p. 240).
10. For the correct interpretation of the bull see ibid., pp. 244–45; Frédéric Lesueur, *Les Eglises de Loir-et-Cher* (Paris: 1969), p. 439. I would like to thank my colleague Professor Kenneth Pennington for invaluable help with this document.
11. Lillich, "Vendôme," p. 245.
12. Lafond, "Le Vitrail du XIVe siècle en France," p. 212. The bull is actually dated 1307 (o.s.).
13. Construction resumed at the northeast corner of the nave, where the arms of Abbot Jean de Buffa (1317–1342) have provided a convenient date. The grisaille in the northeast nave chapel predates that time, however, and is not appreciably advanced from that of Bay 205.
14. For Vendôme "non-conforming" grisailles, see at n. 8 above. For Tours see Papanicolaou, "Windows of the Choir of Tours," pp. 174, 192, pls. 45, 47. The Vendôme grisaille can be compared most closely to that of the Saint-Père choir triforium of ca. 1270, which however does not yet include as large a number of naturalistic leaves: Lillich, *Saint-Père,* pl. 43.
15. Abbé Charles Métais, *Cartulaire de l'abbaye cardinale de la Trinité de Vendôme* (Paris: 1893–1904), vol. 1, no. CCXXII. The location of the chapel dedicated in 1070 (now replaced, see n. 16) has been confused with the Romanesque chapel still extant just south of the choir (see at n. 55 below) by Penelope D. Johnson, *Prayer, Patronage and Power: The Abbey de la Trinité, Vendôme, 1032–1187* (New York: 1981), pp. 27–28. Her reasoning is faulty on several counts. According to the charter, the chapel of 1070 was located in the cemetery for the poor and the abbey's servants. Such a lay cemetery would almost certainly be in the western, public area of a

Benedictine monastery, on the side of the grounds opposite the monastic cloister. Thus at Ven-dôme the cloister is to the south while the almshouse, and this lay chapel, are to the north (no. 16 on Johnson's fig. 2), both provided with entrances from beyond the abbey walls. On the contrary, the extant Romanesque chapel (marked V, Sacristy, on Johnson's fig. 2) was in the monastery's most private area, related to the big church roughly as was Cluny's Lady Chapel to its abbey church. Such primitive chapels were frequently built as the original place of worship in a newly founded monastery; after a larger monastic church had been financed and con-structed, the first structure often served as the abbot's chapel, or that of the monks' infirmary, etc. Its use at Vendôme as a sacristy is certainly *tardive*, as is suggested by the inclusion on the eighteenth-century plan of the original dedications to the Virgin and St Christopher.

16. This double dedication appears on a large-scale plan of the abbey in the seventeenth century (Paris, Arch. nat. NII Loir-et-Cher 1¹) and is reported by the Marquis de Rochambeau, *Le Vendomois, épigraphie et iconographie* (Paris: 1889), vol. 1, p. 49, where he states that it was rebuilt in 1670 and completely replaced ca. 1848. The original 1070 charter listed a great many more saints to whom the chapel was dedicated (see n. 15 above, Métais).

17. Ferdinand de Lasteyrie, *Histoire de la peinture sur verre* (Paris: 1853–1857), p. 38; Emile Mâle, *L'Art religieux du XIIe siècle en France* (Paris: 1928), p. 183. Guilhermy was not fooled, however (fol. 293v).

18. Grodecki, "A Stained Glass Atelier of the Thirteenth Century," p. 108n4.

19. On the Gnadenstuhl, see Wolfgang Braunfels, *Die Heilige Dreifaltigkeit* (Düsseldorf: 1954), pp. 35–43; Gertrud Schiller, *Iconography of Christian Art* (New York: 1966), vol. 2, pp. 122–24.

20. Adelheid Heimann, "L'Iconographie de la Trinité: I. Une Formule byzantine et son développement en occident," *L'Art chrétien, Revue mensuelle* 1 (1934), esp. pp. 48, 51, 54–55.

21. The mandorla and evangelist symbols are present in a manuscript initial of the beginning of the thirteenth century (Troyes, Bibl. mun. MS 2251, fol. 2v, gospels), illustrated in Schiller, *Iconography of Christian Art,* vol. 1, fig. 4. An elaborate throne of ca. 1250–1270 (altar retable from Wiesenkirche, Soest, in Berlin, Staatliche Museen, Stiftung Preussicher Kulturbesitz, Westphalian Master) is illustrated in ibid., vol. 2, fig. 412.

22. Cambrai, Bibl. mun. MS 234, fol. 2. See: ibid., vol. 2, p. 122, fig. 413; Victor Leroquais, *Le Bréviaire de Philippe le Bon* (Paris: 1929), p. 121, pl. doc. 96; Leroquais, *Les Sacramentaires et les missels manuscrits des bibliothèques publiques de France* (Paris: 1924), pp. 222–24, no. 103.

23. Judith Oliver, "The 'Lambert-le-Bègue' Psalters: A Study in Thirteenth-Century Mosan Illumination" (Ph.D. diss., Columbia University, 1976), pp. 274–75.

24. On the modern history of the relic, popularly known as Madame Sainte-Larme, see Patrice Boussel, *Des reliques et de leur bon usage* (Paris: 1971), pp. 113–22. From 1699 to 1724 it was the subject of a notorious debate between the Benedictine scholar Mabillon and the priest Jean-Baptiste Thiers.

25. Paris, Bibl. nat. Est. Va 81 (Topographie de la France, Loir-et-Cher, Vendôme). See René Crozet, "Le Monument de la sainte larme à la Trinité de Vendôme," *Bulletin monumental* 121 (1963), p. 175.

26. A full account of the documents in support of this paragraph may be found in Lesueur, *Les Eglises de Loir-et-Cher,* p. 437; Johnson, *Prayer, Patronage and Power,* chaps. I, II passim.

27. I have discussed briefly the telescoping of time and layering of meanings as typical of monastic thinking in "Monastic Stained Glass," pp. 213–14.

28. My identification of Pierre's window ("Vendôme," pp. 246f.) led to this conclusion, and it is gratifying to see it verified by Jean-Bernard de Vaivre, "Une Représentation de Pierre d'Alençon sur les verrières de la Trinité de Vendôme (circa 1280)," *Bulletin monumental* 140 (1982), pp. 305–13. I would like to thank M. de Vaivre for his generous gift of handsome photographs of the prince's seals.

29. On Pierre d'Alençon see generally Père Anselme, *Histoire généalogique de la maison royale de France* (Paris: 1726), vol. 1, p. 86; Jean Bernier, *Histoire de Blois* (Paris: 1682), pp. 312–13; various chronicles published in *Recueil des historiens des Gaules et de la France,* ed. M. Bouquet et al. (1855; Paris: 1968), vol. 21, pp. 124–25, 97–98, 804. His testament is published in Charles Du Cange, *Jean de Joinville, Histoire de S. Lovys, IX du nom, roi de France* (Paris: 1668), pt. 1, pp. 181–86.

30. On Jean de Châtillon see Bernier, *Histoire de Blois,* pp. 204–205, 310–312; André Duchesne, *Histoire de la maison de Chastillon-sur-Marne* (Paris: 1621), p. 108 and passim. He was buried at the abbey he founded, La Guiche near Blois, and though the abbey has been destroyed, his tomb still exists. See Lesueur, *Les Eglises de Loir-et-Cher,* pp. 124–25; Jules Laurand, "Notice historique et archéologique sur l'ancienne abbaye de Notre-Dame de la Garde, dite La Guiche," *Société archéologique et historique de l'Orléanais, Mémoires,* 4 (1858), pp. 184–98.

31. The local lord, Count Jean V de Vendôme (1272–1315), served the prince Charles d'Anjou, mostly in the field, and his relations with the abbey were not good: see Lillich, "Vendôme," pp. 246–47. Trouble is already indicated by bulls of Gregory IX, dated 1229, begging his legate and the French king to take immediate action to protect La Trinité from molestations by the count of Vendôme: Abbé Simon, *Histoire de Vendôme* (Vendôme: 1834), vol. 2, p. 231. Blois and Vendôme were fighting over their borders by 1328, when the king had to intervene (Simon, vol. 1, pp. 148–49).

32. See Lillich, "Vendôme," p. 243n24. He is identified as Louis IX in the 1929 report by E. Rayon, "Les Vitraux du Loir-et-Cher, Inventaire," MS in Paris, Monuments historiques, pls. 25, 26, 33.

33. For my full argument see Lillich, "Vendôme," pp. 247–49. References are added below only where I introduce material not presented before.

34. See, for example, *The Matthew Paris Shields,* ed. Thomas Daniel Tremlett, in *Rolls of Arms, Henry III,* Aspilogia II (London: 1967), p. 3, frontispiece (c).

35. See Maurice Keen, *Chivalry* (New Haven: 1984), pp. 174f.; also Marc de Vulson de la Colombiere, *Le Vray theatre d'honneur et de chevalerie* (Paris: 1648), vol. 2, chap. 51 passim (pp. 558–78).

36. The abbot is in the left lancet, the standing saint in the right, and the center lancet has a Virgin and Child of modern fabrication, which, however, predate Guilhermy's visit. Guilhermy said that the Virgin was modern and the abbot and saint were fifteenth century (fol. 293v). The triforium bays to either side of the axial bay are still glazed in their thirteenth-century grisailles.

37. Lafond in *Le Vitrail français,* p. 188.

38. Micheas is illustrated in Becksmann, *Die architektonische Rahmung,* pl. 3. The definitive study of Saint-Urbain de Troyes by Jane Hayward was presented at Brown University in 1977 at the symposium "Transformations of the Court Style: Gothic Art in Europe 1270 to 1330."

39. Cothren, "Glazing of the Choir of Beauvais," pp. 347, 356–57, pl. 111 (N IV); CVFR I, p. 180.

40. Cothren, "Glazing of the Choir of Beauvais," p. 202, pls. 138–39; M. Baudot, "Les Verrières de la cathédrale d'Evreux: cinq siècles d'histoire. Les Vitraux des XIIIe et XIVe siècles," *Nouvelles de l'Eure* 27 (1966), p. 29.

41. In German glass, on the contrary, the frontal leaf crockets enjoyed long popularity. See Becksmann, *Die architektonische Rahmung,* figs. 59, 64–67, etc.

42. In the quatrefoil traceries of the Saint-Père hemicycle very similar clover leaves decorate the scenes of a similar painter. I believe it is the same artist (see the Saint-Père Crucifixion of Peter): p. 308 below. The comparison tells more about Saint-Père than about Vendôme, i.e., that the patched glass of the straight choir was in place and the first work had begun on the hemicycle in the 1280s. This painter disappeared from Saint-Père before the hemicycle traceries were finished.

43. Karen Gould, *The Psalter and Hours of Yolande of Soissons* (Cambridge, Mass.: 1978), pl. 7 (fol. 15r, the Holy Face), pls. 35–37 (fols. 332v, 337v, 345v, illustrating the Hours of the Cross). The Holy Face is inserted into its present location in the manuscript (Gould, p. 82). On Gould's preferred dating between 1280 and 1285, see p. 52.

44. If there is a connection to Tours it is to the north clerestory atelier of the cathedral, dated by Papanicolaou 1270–1276/79, a shop that also worked at the abbey of Saint-Julien in Tours. The shop used "Parisian" head types with short, stocky, compact bodies, though the color harmony of the cathedral bays is lighter and brighter than that of Vendôme. See Papanicolaou, "Windows of the Choir of Tours," pp. 192–98. All of these Tours windows are small-scale medallions, making comparison with the gabled lancets of Vendôme inconclusive.

45. The tomb of Jeanne's children, the princes Louis and Philippe, dead at twelve months and fourteen months, is depicted in a Gaignières drawing: Paris, Bibl. nat. Est., Rés. Pe 11c, fol. 32, illustrated in Jean Adhémar, "Les Tombeaux de la collection Gaignières," *Gazette des beaux-arts*, 6th per., 84 (July–Sept. 1974), no. 259. The tomb is now in the north aisle of Saint-Denis. On the baby princes see Anselme, *Histoire de la maison royale* (as in n. 29), vol. 1, p. 86.

 On Jeanne's mother, Alix de Bretagne, see A. Dupré, "Les Comtesses de Chartres et de Blois," *Société archéologique d'Eure-et-Loir, Mémoires* 5 (1872), pp. 227–29. She died in Acre, according to a charter in the Archives départementales de Loir-et-Cher published by Laurand, "Notice sur la Guiche" (as in n. 30), p. 194.

 For information on Jeanne de Châtillon in addition to that cited in Lillich, "Vendôme," pp. 246f., I am indebted to the generous help of Elizabeth A. R. Brown.

46. Pierre and his wife were in litigation in 1280 over control of Jeanne's inheritance from her father. See: Comte Beugnot, ed., *Les Olim ou registres des arrêts rendus par la cour du roi* (Paris: 1862), vol. 2, no. XXX, p. 164; Edgar Boutaric, *Actes du parlement de Paris* (Paris: 1863), vol. 1, p. 220, no. 2300.

47. I know of two charters dated May 1285, Carcassonne: (1) Bernier, *Histoire de Blois* (as in n. 29), preuves, p. xvii; (2) Jules Tardif, *Monuments historiques, Inventaires et documents publiés par l'ordre de l'empéreur* (Paris: 1866; reprint, Paris: 1977), p. 356, no. 929 (Paris, Arch. nat. K 36 no. 1).

48. The sale of Chartres: Paris, Arch. nat. J 173, no. 5 (AB XIX 94); K 36, no. 4. The sale of Avesnes: Paris, Arch. nat. J 226, no. 22 (AB XIX 98); see also Alphonse Wauters, *Table chronologique des chartes et diplômes imprimés concernant l'histoire de la Belgique* (Brussels: 1881), vol. 6, pp. 278, 291.

49. The Gaignières drawing is illustrated and discussed in Lillich, "Vendôme," p. 246n50, fig. 6. Aubin-Louis Millin, *Antiquités nationales* (Paris: an VII [1798]), vol. 5, art. LII, pl. X, p. 61, actually reproduces a copy of the fresco made of painted panel and placed in front of it in 1712 as a "restoration," by the count of Châtillon and his brother: Dupré, "Les Comtesses de Chartres et de Blois," p. 234. The original is called a fresco by Bernier and by Gaignières, who could see it; and a bas-relief (by Millin and Piganiol de la Force) or incised slab (by Félibien) by those who could only see the "restoration" copy, which included an inscription stating that the original underneath was "sur plâtre." See the references in *Histoire littéraire de la France*, Académie des inscriptions et belles-lettres (Paris: 1842), vol. 20, p. 108, to which should be added: Jean Aymer Piganiol de la Force, *Description historique de Paris, de Versailles, de Marly . . .* (Paris: 1765), vol. 7, p. 242.

50. Jeanne de Châtillon's will is published by Duchesne, *Histoire de Chastillon-sur-Marne*, preuves, pp. 72–82. On the date see Lillich, "Vendôme," p. 246n46.

51. E. Martene and U. Durand, eds., *Veterum scriptorum et monumentorum amplissima collectio* (Paris: 1724–1733), vol. 5, cols. 1219–38. I am most grateful to Elizabeth A. R. Brown for this reference, which she has been able to authenticate by locating two early copies of the death scene.

52. This action would suggest that Vendôme was his ancestral funerary chapel but it was not. Four generations of his ancestors, including Jeanne and her father, were buried at the nunnery of La Guiche, founded to receive the tombs of the dynasty. See Lesueur, *Les Eglises de Loir-et-Cher*, pp. 124–27. For the anniversary see the cartularies of La Trinité: Vendôme, Bibl. mun. MS 161, fol. 159v; MS 100, fol. 160r; also Métais, *Cartulaire de la Trinité de Vendôme* (as in n. 15), vol. 3, pp. 265f. (no. 787), vol. 4, p. 418.

53. Much of the evidence for this paragraph is found in Lillich, *Saint-Père,* pp. 93–98, 118–21, pls. 55–56, 72, 74, 83. Related groups at Evron and in the Saint-Père hemicycle have no inscriptions.

54. The Benedictine abbey of Saint-Ouen de Rouen also commemorated Benedict in its choir clerestory windows. See Lafond, *Les Vitraux de Saint-Ouen,* pp. 181, 244–45. The Benedictine habit is colored blue at both Vendôme and Saint-Ouen. The Vendôme Benedict now holds the coat of arms *France moderne* upside-down and inside-out; see p. 231 above.

55. On this chapel see Lillich, "Vendôme," n. 27.

56. On Eutrope see ibid., n. 30; Charles Métais, "Les Saintes reliques de Vendôme," offprint, *Semaine religieuse de Blois* (1887–88), pp. 9–10. The relics of St Eutrope were kept in the vault of the Sainte Larme, according to Rochambeau, *Le Vendômois* (as in n. 16), p. 54, and R. de Saint-Venant, *Dictionnaire topographique, historique, biographique, généalogique et héraldique du Vendômois . . .* (Blois: 1912–1917; reprint, 1969), vol. 3, p. 62; they were kept in the matutinal altar, according to Abbé Gabriel Plat, "Vendôme," *Congrès archéologique* 88th session (1925), p. 260.

57. The Launay sketchbook includes a color drawing of Bay 203 made in the mid-nineteenth century: Vendôme, Bibl. mun., pl. 17 (top). My photographs of this window were greatly overexposed and reveal more than the eye can see. No photographs were attempted when the glass was deposed in World War II.

58. The omission of Bay 204 from the Launay sketchbook suggests that it was then already a wreck, as does Guilhermy's taciturn identification of Peter, Paul, and Andrew as "trois apôtres" (fol. 294r).

59. Plat, *L'Eglise de la Trinité de Vendôme* (as in n. 4), p. 86, is the only author to have remarked on this difference, which he considered to mark the start of a new campaign. I would not put it so strongly since they are unquestionably products of the same shop.

60. Benjamin Guérard, *Cartulaire de l'église Notre-Dame de Paris,* Collection des cartulaires de France, vol. 7 (Paris: 1850), pt. 4, Obituarium, p. 182, no. 314; Abbé Lebeuf, *Histoire de la ville et de tout le diocèse de Paris* (Paris: 1754–58; reprint, 1883–1893), vol. 4, p. 153. The feast of St Eutrope is added to the calendar of the famous Parisian manuscript often attributed to Honoré, the so-called Breviary of Philippe le Bel (Paris, Bibl. nat. MS lat. 1023), dated by Delisle to 1296; see discussion in Victor Leroquais, *Les Bréviaires manuscrits des bibliothèques publiques de France* (Paris: 1934), vol. 2, pp. 465–75.

61. The charters are published by Louis Audiat, "Saint Eutrope et son prieuré," *Archives historiques de la Saintonge et de l'Aunis* 2 (1875), pp. 271–72, 275–76.

62. I would like to thank François Maillard for pointing out to me that Philippe le Bel was in Saintes (Paris, Arch. nat. JJ53, no. 144, Saint-Jean d'Angely). Edward I's request is published by Audiat, "Saint Eutrope," p. 276. For overviews of the Aragon negotiations see Strayer, *The Reign of Philip the Fair,* pp. 368–69; Steven Runciman, *The Sicilian Vespers* (Baltimore: 1960), pp. 289–90.

63. See Marcel Aubert, *Notre-Dame de Paris, sa place dans l'histoire de l'architecture du XI au XIV siècle* (Paris: 1920), p. 146. The images of the king and queen with their arms were in the stained glass either of that chapel or the Baptist chapel adjoining it: see Henry Kraus, "Notre-Dame's Vanished Medieval Glass," *Gazette des beaux-arts* 68 (July–Dec. 1966), p. 134, and *Gold Was the Mortar,* p. 215n28.

64. Audiat, "Saint Eutrope," pp. 253–64; Jeanne Vielliard, *Le Guide du pèlerin de Saint-Jacques de Compostelle* (Macon: 1969), pp. 65–79.

65. The literature on the promotion of the cult of Dionysius/Denis by the abbey of Saint-Denis is vast. See for example Gabrielle Spiegel, "The Cult of St. Denis and Capetian Kingship," *Journal of Medieval History* 1/1 (Apr. 1975), pp. 43–69.

66. See Paul Deschamps, "A propos de la statue de Saint Louis à Mainneville," *Bulletin monumental* 127 (1969), p. 38; Robert-Henri Bautier, "Diplomatique et histoire politique: ce que la critique diplomatique nous apprend sur la personnalité de Philippe le Bel," *Revue historique* 259 (Jan.–Mar. 1978), pp. 19–20 and n. 70.

67. On the St Louis of the Saint-Père axial bay see Lillich, "An Early Image of Saint Louis," *Gazette des beaux-arts* 75 (Apr. 1970), pp. 251–56; Lillich, *Saint-Père*, p. 101nn16–19, pl. 5 (before 1905 restorations). See also Chap. IX, p. 311 f. below.

68. Since the Western Atelier, following Vendôme, worked for the Châtillon family at the abbey of Evron, in the absence of documentation this possibility cannot be ruled out.

69. Haloes were distributed with abandon by the Western Atelier. Even the young Châtillon knight in his heraldic surcoat, in the hemicycle of Evron, has one. See Chap. VIII, *VIII.4*, p. 260. In the case of St Louis, popular opinion "sainted" him immediately upon his death: see Jean Favier, *Philippe le Bel* (Paris: 1978), p. 6.

70. Georgia Sommers, "The Tomb of Saint Louis," *Journal of the Warburg and Courtauld Institutes* 34 (1971), p. 74.

71. Elizabeth A. R. Brown, "The Chapels and Cult of Saint Louis at Saint-Denis," *Mediaevalia* 10 (1988, for 1984), pp. 279–80. Sommers ("Tomb of Saint Louis," p. 74) dates the commissioning of the silver-gilt tomb between 1274 and 1280, and its erection in the church between March 1277 and late 1282.

72. Paris, Arch. nat. LL 1240, fol. 60v. See Sommers, "Tomb of Saint Louis," p. 74n48; Alain Erlande-Brandenburg, "Le Tombeau de saint Louis," *Bulletin monumental* 126 (1968), p. 10.

73. The principal combatants have been Alain Erlande-Brandenburg (for example, *Le Roi est mort* [Geneva: 1975], p. 166nn11–12) and Georgia Sommers (review of *Le Roi est mort* in *Speculum* 52 [Oct. 1977], pp. 956–61). I had the opportunity to rebut the French attacks on my work in *Saint-Père*, p. 101n16.

 More recently, see Brown, "The Chapels and Cult"; and Claudia Rabel-Jullien, "Images des tombeaux et images du mort dans l'enluminure médiévale," in *La Figuration des morts dans la Chrétienté médiévale jusqu'à la fin du premier quart du XIVe siècle*, ed. Roger Grégoire (Fontevraud: 1989), pp. 29–48.

74. Elizabeth A. R. Brown, "The Chapel of St. Louis at Saint-Denis," *Gesta* 17/1 (1978), p. 76; emphasis added. See also "The Chapels and Cult," pp. 292–97.

75. Not only was Louis IX himself bearded at his death in 1270, but many of the figures on royal tombs he commissioned at Saint-Denis had a similar small beard: see the plates in Erlande-Brandenburg, *Le Roi est mort* (for example pls. 132–33, 136–37, 144–48, 150–51). The king buried in 1285, Louis IX's son Philippe le Hardi (pl. 159), is shown on his tomb clean-shaven as was the fashion in thirteenth-century society, and the idiosyncratic facial features certainly suggest a likeness rather than a type.

76. Elizabeth A. R. Brown has pointed out to me that the term *main de justice* dates much later and that *main* is more correctly applied here, though *main de justice* regularly occurs in the literature.

77. The mantle secured at the right shoulder may be seen, for example, on seals of Philippe Auguste and Louis IX, illustrated by Eugène Viollet-le-Duc, *Dictionnaire raisonné du mobilier français* (reprint; Paris: 1914), vol. 4, pp. 322, 324.

78. The best manuscript of the Ordo of Reims is Reims, Bibl. mun. MS 326, formerly dated between 1260 and 1274 (but see n. 79 below). See: Percy Ernst Schramm, *Der König von Frankreich*, 2d ed. (Weimar: 1960), vol. 1, pp. 212–13, vol. 2, p. 4, no. 14; Schramm, "Ordines-Studien II: Die Krönung bei den Westfranken und den Franzosen," *Archiv für Urkundenforschung und Quellenkunde des Mittelalters* 15 (1938), pp. 24–28; Jean de Pange, *Le Roi très chrétien* (Paris: 1949), pp. 374–77; Ulysse Chevalier, *Sacramentaire et martyrologe de l'abbaye de Saint-Remy, Martyrologe calendrier, ordinaires et prosaire de la métropole de Reims (VIIIe–XIIIe siècles . . .)*, Bibliothèque liturgique, 7 (Paris: 1900), pp. 222–23.

79. Richard A. Jackson, "Les Manuscrits des *ordines* de couronnement de la bibliothèque de Charles V, roi de France," *Le Moyen Âge*, 4th ser., 31 (1976), p. 73n19; Jackson, *Vive le roi!* (Chapel Hill: 1984), p. 222. Jackson dates the Ordo of Reims from ca. 1230 to ca. 1245, but strongly prefers the earlier date. For Pinoteau's opinion see "La Tenue de sacre" (cited in n. 98 below). Both

scholars have been very generous with their help; I would also like to thank Isa Ragusa and Elizabeth A. R. Brown for their aid.

80. *Le Roi est mort,* pp. 19–22.

81. Ch. Baudon de Mony, "La Mort et les funérailles de Philippe le Bel d'après un compte rendu à la cour de Majorque," *Bibliothèque de l'Ecole des chartes* 58 (1897), pp. 7, 11.

82. Elizabeth A. R. Brown, "The Ceremonial of Royal Succession in Capetian France: The Double Funeral of Louis X," *Traditio* 34 (1978), p. 229; Brown, "The Ceremonial of Royal Succession in Capetian France: The Funeral of Philip V," *Speculum* 55 (1980), pp. 279, 286.

83. There are two Gaignières drawings of the Poissy tomb (Paris, Bibl. nat. Est., Rés. Pe 11 c, fols. 49 and 7), illustrated in Adhémar, "Les Tombeaux Gaignières" (as in n. 45), nos. 558–59. Also: Alain Erlande-Brandenburg, "La Priorale Saint-Louis de Poissy," *Bulletin monumental* 129 (1971), pp. 111–12. The tomb of Philippe le Bel's corpse, as well as that of his father Philippe le Hardi, both at Saint-Denis, were stone *gisants* of the standard type established for the Carolingian and Capetian dynasties in the campaign of the 1260s. Each wears a belted garment under an open cloak connected by a tie-string; the right hand has a scepter, the left hand makes the so-called regal gesture, tugging at the tie-string. See Roger Adams, "The Chartres Clerestory Apostle Windows: An Iconographic Aberration?" *Gesta* 26/2 (1987), pp. 143f.

84. Bautier, "Diplomatique et histoire politique" (as in n. 66), esp. pp. 19ff.; see also Elizabeth A. R. Brown, "The Prince Is Father of the King: The Character and Childhood of Philip the Fair of France," *Mediaeval Studies* 49 (1987), pp. 310–14, 326–29, 332–33. Philippe le Bel was two years old when Louis IX died, and about fourteen when the silver-gilt tomb was installed at Saint-Denis. In 1289 he named his firstborn son Louis, rather than for the child's grandfather (Philippe le Hardi) according to standard practice.

85. This is the theory of Erlande-Brandenburg, based upon a manuscript illumination of ca. 1490 (Grandes Chroniques, Baltimore, Walters MS 306, fol. 304) and inventories of 1505 and 1634, well after the tomb's disappearance. See *Le Roi est mort,* p. 166; *La France de saint Louis,* no. 23, pp. 29–31. This theory has recently been espoused by both Brown and Rabel-Jullien (see n. 73 above).

86. This is the theory of Georgia Sommers, based on manuscript illuminations in the Hours of Jeanne d'Evreux (New York, Cloisters 54.1.2, dated 1325–1328) and Guillaume de Saint-Pathus (Paris, Bibl. nat. MS fr. 5716, ca. 1330–1340), as well as the stained glass of the Great Sacristy.

87. Passages from the chronicles of Primat and Guillaume de Nangis are discussed by Erlande-Brandenburg in *Le Roi est mort,* p. 166 and n. 3, and Sommers, "The Tomb of Saint Louis," p. 70.

88. For literature on the inquests see Brown, "The Chapels and Cult," p. 309n5.

89. Brown, "Saint-Denis, Philip the Fair, and the Legacy of Saint Louis" (paper given at New England Medieval Conference on Medieval Kingship, Dartmouth College, Hanover, N.H., 1979), p. 7.

90. Sommers, "The Tomb of Saint Louis," p. 76. Work continued on the shrine of St Edward into the 1270s, according to Paul Binski, "The Cosmati at Westminster and the English Court Style," *Art Bulletin* 72 (1990), p. 17. He maintains that the Matthew Paris drawing cited by Sommers (Cambridge University, MS EE. iii, 59, fol. 30r) predates the shrine and cannot present its actual appearance.

91. On the *montjoies* there are two studies, often conflicting in detail: Robert Branner, "The Montjoies of Saint Louis," *Essays in the History of Architecture Presented to Rudolf Wittkower* (London: 1967), vol. 1, pp. 13–16; Anne Lombard-Jourdan, "*Montjoies* et *montjoie* dans la plaine Saint-Denis," *Fédération des Sociétés historiques et archéologiques de Paris et de l'Ile-de-France, Mémoires* 25 (1974), pp. 141–81.

92. See, for other illustrations: Branner, "The Montjoies," fig. 3; Lombard-Jourdan, "*Montjoies,*" fig. XII.

93. Lombard-Jordan, "*Montjoies,*" p. 171.

94. I say at least one tomb, since the exact appearance of the silver-gilt tomb of Philippe Auguste, of about the same date, is unknown; the tomb of his father Louis VII at Barbeaux, however, did show him in coronation regalia and chlamys (Erlande-Brandenburg, *Le Roi est mort*, pp. 161–62, pls. 37–38). Seals of Philippe Auguste show him in the chlamys: Viollet-le-Duc, *Dictionnaire du mobilier* (as in n. 77), p. 322.

 On the bronze tomb of Charles the Bald see Erlande-Brandenburg, pp. 122, 153, pls. 57–58. Dagobert, also of paramount importance to Saint-Denis and the Capetians, was depicted in the chlamys on his tomb *gisant*: ibid., pl. 83.

95. On the political need to associate the Capetian dynasty with the Carolingian line, see now Elizabeth A. R. Brown, "La Notion de la légitimité et la prophétie à la cour de Philippe Auguste," *La France de Philippe Auguste: le temps des mutations*, ed. Robert-Henri Bautier (Paris: 1982), pp. 77–111; also p. 81 on Dagobert. On the Carolingian traditions at Saint-Denis, see Spiegel, "The Cult of Saint Denis" (as in n. 65), pp. 58–61.

96. Illustrated in *La France de saint Louis*, p. 17, no. 21.

97. Ibid., p. 90, no. 165.

98. See the numerous studies by Hervé Pinoteau: "La Main de justice des rois de France; essai d'explication," *Bulletin de la Société nationale des antiquaires de France* (1978–79), pp. 262–65; "Les Insignes du pouvoir des capétiens directs," *Itinéraires* 323 (May 1988), pp. 48–50; and two articles reprinted in his *Vingt-cinq ans d'études dynastiques* (Paris: 1982), "Quelques réflexions sur l'oeuvre de Jean du Tillet et la symbolique royale française," pp. 108, 129–31, and "La Tenue de sacre de saint Louis IX roi de France: son arrière-plan symbolique et la 'renovatio regni Juda,'" pp. 460–61.

99. I quote Mme Gauthier here partly to make reference to her bibliography collecting the vast scholarship on the Saint-Denis treasury (her n. 35) and chiefly to draw attention to her study drawing a parallel between the *mains de justice* and arm reliquaries ending in blessing hands: Gauthier, "Un Saint du pays de Liège au bras long," *Etudes d'art médiéval offertes à Louis Grodecki* (Paris: 1981), pp. 105–18. A *main de justice* probably made for Napoleon and now in the Louvre is illustrated in *La France de saint Louis*, p. 114, no. 219; see Danielle Gaborit-Chopin, "Faux ivoires des collections publiques," *Revue de l'art* 21 (1973), pp. 96–99 and n. 11. I would like to thank Isa Ragusa for this reference.

100. On the Ordo of Reims, see nn. 78–79 above. I am quoting here from the published text of U. Chevalier from Reims, MS 326: *Sacramentaire* (as in n. 78), pp. 223–24.

101. For pursuing the concept of *regnum et sacerdotium*, studied by Schramm and Kantorowicz among others, as it surfaces in French Gothic arts, the best guide is still the discussion, notes, and bibliography of Adolf Katzenellenbogen, *The Sculptural Programs of Chartres Cathedral: Christ-Mary-Ecclesia* (Baltimore: 1959), esp. pp. 27f.

102. Ibid., pp. 69–70.

103. On Louis IX and Solomon see: William Chester Jordan, "Saint Louis' Influence on French Society and Life in the Thirteenth Century: The Social Content of the Crusade of the Mid-Century (1248–1254)" (Ph.D. diss., Princeton University, 1973), pp. 227–29. In the lancet below the Chartres north rose the figure of Solomon/Louis holds a scepter and makes the royal gesture holding the tie-string of his open mantle. The rose ensemble is illustrated in color as pl. III of *Le Vitrail français*; the image of Solomon/Louis may be found in color on the cover of Paul Popesco, *La Cathédrale de Chartres*, Chefs-d'oeuvre du vitrail européen (Paris: 1970). The north rose is dated ca. 1240 by Hervé Pinoteau, "Autour de la bulle 'Dei filius,'" *Vingt-cinq ans d'études dynastiques*, pp. 295–313.

104. One can mention the iconographic program of the Sainte-Chapelle and the popularity of *bibles moralisés* and of Old Testament cycles in psalters. William Chester Jordan has investigated the question of the king's self-identification with the Old Testament Joseph in a very thought-provoking section of his dissertation, pp. 229–37. See also Jordan, *Louis IX and the Challenge of the Crusade*, p. 131.

105. Iconography: saints' attributes only begin to take over from inscriptions the task of identification at the beginning of the thirteenth century, and remain fluid for many generations as artists struggle with the problems of comprehensible visual symbols. See Lillich, *Saint-Père*, pp. 96–98, 117f.; Emile Mâle, *Religious Art in France: The Thirteenth Century* (Princeton: 1984), pp. 304f.

Heraldry: the earliest roll of arms, the Bigot Roll of 1254, reflects the heraldic system at an advanced enough state to be recognizable to modern heralds, while of course beautiful coats of arms are introduced into the stained glass of Chartres well over a generation before. On the Bigot Roll: Paul Adam-Even, "Un Armorial français du milieu du XIIIe siècle, le rôle d'armes Bigot, 1254," *Archives héraldiques suisses* 63 (1949), pp. 15–22, 68–75, 115–21; Gerard Brault, *Eight Thirteenth-Century Rolls of Arms in French and Anglo-Norman Blazon* (University Park, Pa: 1973), pp. 6–7, 16–30. The Chartres coats of arms are being studied by J. B. de Vaivre.

106. Ernst Kantorowicz, *Laudes regiae: A Study in Liturgical Acclamations and Medieval Ruler Worship* (Berkeley: 1958), pp. 3–4 and passim.

107. The Grand' Salle was probably finished before the knighting ceremony of the king's sons and others in 1313, according to Sabine Salet, "La Sculpture à Paris sous Philippe le Bel," *Document Archéologia* 3 (1973), p. 44. See also: Jean Guérout, "Le Palais de la Cité à Paris des origines à 1417," *Fédération des Sociétés historiques et archéologiques de Paris et de l'Ile-de-France, Mémoires* 2 (1950), pp. 30–31, 62–63, 132–35. The text inscriptions naming each king and giving the dates of his reign are attributed to the early fourteenth century by Noël Valois, in "Compte-rendu des séances," *Bulletin de la Société de l'histoire de Paris et de l'Ile-de-France* 30 (1903), pp. 87f.

108. Gilles Corrozet, *Les Antiquitez de Paris* (Paris: 1586), fol. 98v. The description of the statues in 1322 by Jean de Jandun ("Tractatus de laudibus parisius," chap. 2) does not mention the *mains*: Antoine Le Roux de Lincy and L. M. Tisserand, eds., *Paris et ses historiens aux XIVe et XVe siècles* (Paris: 1867), p. 48. Since neither author specifies whether the statues were standing or sitting, fragments of seated figures excavated in 1899 (now at Vincennes) have been supposed to come from the series, although the Androuet engraving (see VII:15 and n. 107) clearly shows standing figures. The fragments are illustrated in Salet, "La Sculpture sous Philippe le Bel," pp. 45–46.

109. Corrozet, *Les Antiquitez de Paris*, p. 102r. On the chapel: Jacques Hillairet, *Dictionnaire historique des rues de Paris* (Paris: 1963), vol. 1, p. 426; Yvan Christ, *Eglises parisiennes actuelles et disparues* (Paris: 1947), p. 26, pl. 28 (chapel in 1809). On the statues flanking the portal, see the references in Elizabeth A. R. Brown, "Persona et Gesta: The Image and Deeds of the Thirteenth-Century Capetians: The Case of Philip the Fair," *Viator* 19 (1988), pp. 224–25. More recently she believes, following Corrozet, that there were two sets of statues of the king and queen, the first pair flanking the entry to the building (recorded by Gaignières) and the second flanking the chapel's entry (inscriptions in Launoy).

110. Most famous of these is the Mainneville statue of 1306–1315, on which the literature is voluminous: see *La France de saint Louis*, pp. 32–33, no. 26; Sommers, "The Tomb of Saint Louis," pp. 77–78; a full statement of the controversy over the Mainneville statue may be found in Jean Fournée, "Le saint Louis de Mainneville," *Saint Louis et la Normandie*, special issue of *Art de Basse-Normandie* 61 (1973), pp. 29–34. Illustrations of early statues—not all of which wear the chlamys, it must be pointed out—are collected by Sommers, pls. 23–24; *Saint Louis et la Normandie*, pp. 38–39; *La France de saint Louis*, pp. 32, 122, etc.

111. Paris, Arch. nat. JJ 57 (AE II 327), containing regulations from August 1261 to 1320: *La France de saint Louis*, pp. 108, 110, no. 213. Elizabeth A. R. Brown and her friends at the Archives museum very kindly removed the folio from its case and measured the miniature, and she reports that it is 5 × 7.1 cm. inside the fringe of gold leaves, thus slightly larger than the most spectacular of French commemorative postage stamps. An illustration giving some idea of the size may be found in *Le Siècle de saint Louis* (Paris: 1970), p. 56; vastly enlarged color illustrations are found on the covers of *Saint Louis à la Sainte Chapelle*, exh. cat., La Sainte-Chapelle (Paris: 1961), no. 90, and of *Archeologia* 31 (Nov.–Dec. 1969).

112. The *Vie et Miracles de Saint Louis* by Guillaume de Saint-Pathus (Paris, Bibl. nat. fr. 5716, ca. 1330–1340) contains thirty-one scenes of miracles including the saint's statue, which the artist has varied to avoid monotony, "so that the figure appears almost animated" (Sommers, "The Tomb of Saint Louis," p. 67 and pl. 20c). Many statues wear the chlamys and most carry scepter and *main*. Compare also the *Vie de saint Louis* added to the ca. 1275 exemplar of the Grandes Chroniques (Paris, Bibl. Sainte-Geneviève MS 782, fol. 327r): illustrated in *La France de saint Louis*, p. 110, no. 211. The standing saint is bearded, wears the chlamys with fleurs-de-lis and holds a scepter and a dollhouse-sized Sainte-Chapelle.

113. See, for example, *La France de saint Louis*, pp. 30–31. Pinoteau ("La Tenue de sacre" [as in n. 98], p. 494n81) has drawn attention to the seal of the Dominican convent Saint-Louis d'Evreux, dedicated to him in 1299, which showed the king with scepter and *main*: Jules Charvet, *Description de la collection de sceaux-matrices de M. E. Donge* (Paris: 1872), p. 51, no. 79, and pl. 1, no. 1.

114. Dom Michel Félibien, *Histoire de l'abbaye royale de Saint-Denys-en-France* (Paris: 1708; reprint, 1973), p. 254.

115. Ibid., p. 242: "Il [Mathieu de Vendôme] paroist tout d'un coup elevé sur le siège abbatial de Saint-Denys, & presqu'en même temps au rang des principaux conseillers du roy S. Louis." Félibien guesses that he added Vendôme to his name to indicate his place of birth.

CHAPTER 8

1. On the comparative obscurity of Evron see for example Jean Taralon, "Le Trésor d'Evron," *Congrès archéologique* 119th session (1961), p. 307n1.

2. The enthroned figure is 1.43 m. high. Recent restorations removed paint and repairs of 1858 of such mediocrity that they had put the statue's authenticity in question. The statue has been discussed in Chap. II at n. 85. See also: Taralon, "Le Trésor d'Evron" (1961), pp. 311–18; Taralon, "Le Trésor d'Evron," *Les Monuments historiques de la France* 8 (1962), pp. 31–40.

3. Georges Picquenard and René Diehl, "Evron (Mayenne)," *Dictionnaire des églises de France*, ed. Robert Laffont (Paris: 1967), vol. 3, D 72; Pierre Lavedan, "Evron," *Congrès archéologique*, 119th session (1961), p. 296; Eugène Lefèvre-Pontalis, "L'Eglise d'Evron," pp. 10–11, 14–16, 26. The south portal of the nave was rebuilt about 1500; the north aisle was demolished ca. 1615; the south clerestories (and one on the north) were enlarged in 1666 to light the organ; a grand stairway with beautiful ironwork was built into the tower-narthex in the eighteenth century.

 Recently a crypt has been excavated, from the *l'an mil* construction: B. Decaris, "Mayenne: Basilique d'Evron, découverte d'une crypte," *Bulletin monumental* 143 (1985), pp. 156–57; "Chronique des fouilles médiévales en France, Evron (Mayenne). Basilique," *Archéologie médiévale* 17 (1987), pp. 197–98. See also Lefèvre-Pontalis, p. 13.

4. See Picquenard and Diehl, "Evron," vol. 3, D 74; Lefèvre-Pontalis, "L'Eglise d'Evron," pp. 39–40. In 1614 the structure was sold, and until 1845 it was used for secular purposes. In recent times it has been dedicated to the Virgin but neither its medieval dedication nor its precise function, so far as I can tell, is established. The chapel's "folk" name derives from the decoration of the *voussoirs* of the portal, a motif resembling shoe soles (St Crépin was the patron of shoemakers). See at n. 40 below.

 Enlart visited Evron in 1913: see Augustin Ceuneau, *Evron la basilique et l'abbaye bénédictines, la ville* (Evron: 1949), pp. 34–35.

5. Prosper Mérimée visited Evron in 1841 and was instrumental thereafter in persuading the state to buy the structure and reestablish the cult; see Ceuneau, *Evron*, p. 35.

 The frescoes had been damaged by smoke when soldiers were bivouacked in the chapel in 1832. Before their restoration in 1846, they were described by M. Gérault, *Notice historique sur Evron, son abbaye et ses monumens*, 2d ed. (Laval: 1840), p. 56; and pre-restoration drawings

NOTES TO PAGES 251–54

were published as pl. XXVI and fig. A of Pierre Gelis-Didot and H. Laffillée, *La Peinture décorative en France du XIe au XVIe siècle,* 2d ed. (Paris: 1891). The restoration of 1846 was so complete that modern restorers have found almost nothing old underneath; see the report of Taralon, "Le Trésor d'Evron" (1961), pp. 318–19 (also Lavedan, "Evron," pp. 300–301; Lefèvre-Pontalis, "L'Eglise d'Evron," pp. 41–42).

6. The tombs: the original Gaignières drawings are in the Bodleian Library, Oxford; they are discussed in Lefèvre-Pontalis, "L'Eglise d'Evron," pp. 28–29.

 The fourteenth-century fresco of the Virgin and Child with angels is on the north side of the nave (Lefèvre-Pontalis, p. 14). A recent church pamphlet establishes that a second fresco of an angel head has been found nearby.

7. Lavedan, "Evron," discusses the seventeenth-century plans (not carried out) and those of the eighteenth century (built only in part) on pp. 301–306.

8. Silver-gilt Virgin: see *Les Trésors des églises de France,* exh. cat., Musée des arts décoratifs (Paris: 1965), pp. 134–35, no. 252; Jean Taralon, *Treasures of the Churches of France* (London: 1966), pls. 162–63; Taralon, "Le Trésor d'Evron" (1961), p. 308; Taralon, "Le Trésor d'Evron" (1962), p. 30. Ceuneau, *Evron,* states that the Virgin was exhibited in 1900 and 1937 (p. 31), as well as in 1950 and 1951.

 Enamel reliquary: see *Trésors* catalog (1965), p. 134, no. 251; Taralon, *Treasures* (1966), pl. 164 and fig. 34; Taralon (1961), pp. 310–11; Taralon (1962), pp. 30–31. It was also exhibited in Laval (1951), no. 145, and previously at the Exposition universelle in Paris in 1900.

 Busts: See Taralon (1962), p. 30 and n. 2; Ceuneau, pp. 109–10. Exhibited in Angers (1960) and Paris (1900).

9. Most of the furnishings and many paintings and sculptures are classed as *monuments historiques* by the state. See: Taralon, "Le Trésor d'Evron" (1961), p.308n1; Lefèvre-Pontalis, "L'Eglise d'Evron," p. 22; Ceuneau, *Evron,* pp. 24–26, 36, 108–109.

10. Until the choir was rearranged in 1782 (Gérault, *Notice sur Evron,* 2d ed., p. 75) this well was opened for pilgrims on feast days of the Virgin. Such a practice is recorded as late as 1711–1716 by the visitor Maucourt de Bourjolly (*Mémoires chronologiques sur la ville de Laval,* cited by Ceuneau, *Evron,* p. 43). The new stalls of 1782 were placed over the well intentionally to close it, since the monks felt that abuses were occurring (Lefèvre-Pontalis, "L'Eglise d'Evron," p. 11).

11. In 1606 a *flèche* seventy meters high was constructed on the crossing. By 1901 it was leaning badly, and was then largely removed but not before inflicting structural damage that was being repaired at the time of the disaster. My work at the church was done in 1965 and 1970; and after the vaults fell, in 1976, I was able to examine and photograph the windows in storage in the atelier of Avice in Le Mans. I would like to thank Monsieur Roger Avice, also the architects Hervé Baptiste and M. T. Tulasne, and at Evron J. Vannier, M. Vadepied, P. Ceuneau, the photo studio Manic, and the sacristan Clément Foisnet, for gracious cooperation.

12. G. Busson and A. Ledru, *Actus pontificum cenomannis in urbe degentium* (Le Mans: 1902), pp. 154–56, publish the text. On its forgeries and a criticism of Busson and Ledru, see Walter Goffart, *The Le Mans Forgeries* (Cambridge, Mass.: 1966), esp. pp. 48–50, 154–55.

13. On Mérole see Busson and Ledru, *Actus pontificum,* p. 267; Goffart, *The Le Mans Forgeries,* pp. 204–205. For Hadouin's testament, considered authentic, see *Gallia christiana* (Paris: 1715–1765), vol. 14, col. 487 and *Instrumenta,* col. 122; Louis Duchesne, *Fastes épiscopaux de l'ancienne Gaule* (Paris: 1899), vol. 2, p. 309. For Thuribe's chapel see Busson and Ledru, p. 155.

14. The reader is warned that practically everything written on Evron is hypothetical, wrong, or both, and is advised to begin with Ch. Berthelot du Chesnay, "Evron," in *Dictionnaire d'histoire et de géographie ecclésiastique,* ed. R. Aubert (Paris: 1967), vol. 16, cols. 214–18.

15. The Normans pillaged Le Mans in 853. Presumably not even the exact location of the abbey of Evron was sure at the moment of reestablishment.

16. For current accepted opinion see Picquenard and Diehl, "Evron," vol. 3, D 72. On the viscounts of Maine, probably become hereditary, as did the counts of Maine about this time, see: Robert Latouche, *Histoire du comté du Maine pendant le XIe et le XIIe siècle,* Bibliothèque de l'Ecole des hautes études, fasc. 183 (Paris: 1910), pp. 128–31.

17. Although the forgeries were suspected by many nineteenth-century scholars, Abbé A. Angot published the complicated argument in "Le Restaurateur de l'abbaye d'Evron," *Bulletin de la Commission historique et archéologique de la Mayenne,* 2d ser., 29 (1913), offprint pp. 443f.

18. Lefèvre-Pontalis, "L'Eglise d'Evron," pp. 8, 16, notes this arcaded bay.

19. The infirmary chapel of Saint-Michel, given a lamp in 1211 by Juhel de Mayenne and his mother, was destroyed for building materials in 1611 (Gérault, *Notice sur Evron,* [as in n. 5], pp. 21, 54–55). Excavations in 1836 and 1839 established its location north of the church, adjacent to the cloister (Lefèvre-Pontalis, "L'Eglise d'Evron," p. 10). Ceuneau, *Evron* (as in n. 4), p. 53, reports that one of two remaining walls is decorated with ten Romanesque arcades.

The parish church of Saint-Martin is mentioned in a charter of 1221 (Gérault, p. 24 and *pièce justif.* no. 20); it was demolished by order of Nov. 1, 1792 (Abbé A. Angot, *Dictionnaire historique, topographique et biographique de la Mayenne* [Laval: 1900], vol. 3, pp. 141–42). The structure "n'avait rien de remarquable, sous le rapport de l'architecture." The arms of Jean de la Chapelle were in its stained glass (Gérault, pp. 21, 93, 269–70) and suggest a thirteenth-century campaign of refurbishment.

Saint-Nicolas, a house and chapel for lepers near town on the road to Néau, was built for and donated to the abbey on Holy Thursday 1218 by its great benefactor, Jean de la Chapelle, Seigneur de la Peillerie, whose tomb was in the church. Saint-Nicolas was demolished in 1793. (Document of establishment: Arch. dépt. de la Mayenne H 204, p. 64; Gérault, p. 21; Angot, *Dictionnaire,* vol. 2, p. 145.)

20. *Gallia christiana,* vol. 14, col. 487; Arch. dept. de la Sarthe H. 1405 (16th-cent. copy); Arch. dept. de la Mayenne H 204, p. 167 (cartulary of Dom Chevalier, 1668); Paris, Bibl. nat. fr. 19864, fol. 21r (Chevalier, 1669). On the Evron charters see n. 22 below.

21. Why the family de l'Isle from near Vendôme should have established its funerary church in the Maine is another mystery, but not such an uncommon one. The funerary chapel of the Binanvilles from near Mantes was at Châteaudun (Lillich, "The Triforium Windows of Tours," p. 31); the chapel of the de la Ferrière family was at Aunou outside of Sées (Lillich, "Vitrail normand du XIIIe siècle aux armes de La Ferrière," *Archivum heraldicum* 3–4 [1977], p. 36). Juhel de Mayenne's ancestors were buried in the chapel of St Michel at Evron, to which he contributed a lamp in 1211; but he himself founded Fontaine-Daniel for his own burial place, and his wife and second daughter were buried in Dinan in Brittany (see refs. in pp. 336n135 and 366n144). The famous establishment by Louis IX of a family burial abbey at Royaumont follows a contemporary pattern which, to my knowledge, has not received much attention. Examples following Louis are perhaps easier to recognize than those that precede him, for example the founding by Jean de Châtillon of La Guiche, where he and considerable numbers of descendants were buried. Among them were Jeanne de Châtillon (tomb now lost), and her nephew Guy de Châtillon (tomb still there), who figures largely in this chapter on Evron: see p. 261 below.

22. According to Angot the mother of Renaud de l'Isle, Mahaut, did not die until 1218 ("Le Restaurateur d'Evron," p. 18). The original charters of Evron are lost, and all authors depend on the cartulary of Dom Ig. Chevalier of 1668 (Henri Stein, *Bibliographie générale des cartulaires français . . .* [Paris: 1907], no. 1300). On Robert, viscount of Blois, see: Dom Chevalier, "Histoire de l'Abbaye de N. Dame d'Evron," Paris, Bibl. nat. fr. 19864 (1669), fols. 37r–v, 44r, 54r; Dom Briant, "Collectanea cenomanensia," Paris, Bibl. nat. lat. 10038 (18th-cent.), fol. 80 and ff.

23. Two pairs of stone *gisants* of a knight and his wife are still extant. They (and other stone tombs) were mutilated in 1777 to make benches, were replaced in 1866, and presently occupy niches in the end walls of the transepts. Both pairs were drawn for Gaignières: (a) Pe 1 g, fol. 221 (Jean Adhémar, "Les Tombeaux de la collection Gaignières," *Gazette des beaux-arts,* 6th per., 84

[July–Sept. 1974], no. 144; Lefèvre-Pontalis, "L'Eglise d'Evron," opp. p. 30; also Joseph Guibert, *Les Dessins d'archéologie de Roger de Gaignières, Série I: Tombeaux* [Paris: n.d.], pl. I.660); and (b) Pe 1 g, fol. 222 (Adhémar, no. 145, illustrated in Guibert, pl. I.661). The former, who wears a circlet of three rosettes on his head, has been identified since the time of Dom Chevalier as Robert, viscount of Blois and "founder." The latter, bareheaded, is unidentified, though some have suggested that he is Robert's father: see Abbé A. Angot, *Epigraphie de la Mayenne* (Paris: 1907), vol. 1, p. 300. All references in this note are to the copies in the Bibl. nat.; the originals are in Oxford, Bodleian Library.

24. On the necrology, mentioned by both Dom Chevalier and Dom Briant, see Angot, *Epigraphie Mayenne,* vol. 1, p. 302; also Dom Paul Piolin, *Histoire de l'église du Mans* (Paris: 1856), vol. 3, p. 23n2. Piolin dates the necrology early thirteenth century, but it was probably after 1288: see my argument, p. 258 below.

25. There are two forged charters, one of "985" (forged before 1073) and one of "989," which Angot believes to reflect the authentic foundation charter except for the altering of the names in the thirteenth century. He bases the date of the latter forgery on a later misreading of R and K, much more likely in Gothic script. See n. 17 above (esp. Angot, "Le Restaurateur d'Evron," pp. 6f., 18–19); also Angot, *Généalogies féodales mayennaises du XIe au XIIIe siècle* (Laval: 1942), pp. 15–17.

26. Dom Briant, fol. 83v. He distinguishes this reference from those arms that he saw in the windows of the choir. On the arms of the family de l'Isle see n. 31 below.

27. See the seventeenth-century plan of the abbey (Paris, Arch. nat. NIII¹ Mayenne) illustrated in: Lavedan, "Evron" (as in n. 3), p. 303.

28. Lefèvre-Pontalis, "L'Eglise d'Evron," pp. 15–19. His interpretations of these irregularities are not convincing stylistically or structurally.

29. The Gaignières drawing is Oxford, Bodleian MS Gough Gaignières 14, fol. 205. This tomb was sold to produce revenue for a restoration of the choir. Dom Chevalier's seventeenth-century description is reprinted in Angot, *Epigraphie Mayenne,* vol. 1, p. 303. The inscription (given by Lefèvre-Pontalis, "L'Eglise d'Evron," p. 29) has been frequently discussed.

30. There is no reason to date Renaud's tomb as late as ca. 1310–1320, as Angot would have it: Angot, *Epigraphie Mayenne,* vol. 1, pp. 302–304. On the western French gilt and enameled tombs see Lillich, "Tric-trac Window," p. 28 and pl. 10; comparable tombs are illustrated in Adhémar, "Les Tombeaux Gaignières," nos. 265, 267, 323, 446. On Juhel de Mayenne and Guillaume Roland, bishop of Le Man (d. 1260), see Chap. II, pp. 40 and 41.

31. Paul Adam-Even, "Un Armorial français du milieu du XIIIe siècle, le rôle d'armes Bigot—1254," *Archives héraldiques suisses* 63 (1949), p. 119, no. 266 (citing his seal of 1269, Paris, Bibl. nat. 5419, fol. 27). In the Bigot Roll he is identified as living "a II lieustes de Vendome, pres de Viel Casteldun."

32. Adam-Even, "Armorial Bigot," corrects the genealogy found in Angot, "Le Restaurateur d'Evron," pp. 18–19, though both are based on Abbé Charles Métais, *Cartulaire de l'abbaye cardinale de la Trinité de Vendôme* (Paris: 1893–1904). Renaud II (d. 1277) was the son of Geoffroy (Godefroid), alive in 1214 and in 1231, and dead by 1249 when his son was viscount. Geoffroy was the younger brother of the Renaud I who had established the Evron anniversary in 1211. Thus Renaud II was the nephew (and heir) of the Renaud of the Evron anniversary, not his son. Renaud II was married to Ersende but had no heirs outliving him.

33. Lefèvre-Pontalis treats the tombs of Evron in more or less chronological order ("L'Eglise d'Evron," pp. 28–39). On Abbot Jean's tomb and its inscription see pp. 29–30; also Adhémar, "Les Tombeaux Gaignières," no. 411; Guibert, *Les Dessins de Gaignières,* p. 664. Angot (*Epigraphie Mayenne,* vol. 1, pp. 303–304) discusses it and also the date when Jean became abbot, not 1260 but 1263, citing the article by Dom Léon Guilloreau, "Les Tribulations d'Ernaud, abbé d'Evron (1262–63)," *Bulletin historique de la Mayenne,* vol. 20, pp. 414–22 (I have located this article only in an offprint published in Laval in 1904).

34. The locations given by Gaignières and by *Gallia christiana* (as in n. 13), vol. 14, col. 487, vary somewhat. See Lefèvre-Pontalis, "L'Eglise d'Evron," pp. 28–30.

35. On the tomb of Gilles du Chastelet see Lefèvre-Pontalis, "L'Eglise d'Evron," p. 31; Adhémar, "Les Tombeaux Gaignières," no. 120; Guibert, *Les Dessins de Gaignières*, p. 662. This tomb is still in the church. There is absolutely no basis either for Angot's theory that Gilles sculpted his own tomb and others or for Robert Triger's extended version, making Gilles the master of an atelier of sculptors and responsible for the Infancy cycle statues decorating the hemicycle piers: Triger, "Evron," *Revue historique et archéologique du Maine* 62 (1907), pp. 147–50.

36. Lavedan, "Evron" (as in n. 3), p. 297, summarizes the opinions, none of which postdate 1907. See particularly Angot, *Epigraphie Mayenne*, pp. 306–307. The beautiful chevet of Evron, like the equally beautiful chevet of Sées, has not been studied by modern architectural historians, and both are due for attention. The same remark can be applied to the architectural sculpture that adorns both buildings.

37. The use of these arms has been studied and misrepresented by Abbé A. Angot, *Armorial monumental de la Mayenne* (Laval: 1913), pp. 171–75, the basis for all comments by others. The reader is referred to that study for illustrations of examples but warned about placing too much reliance on the interpretations in the text. Certainly his example no. 294 (a seventeenth-century woolen embroidery in the Laval museum) has nothing to do with Evron. Angot regarded the stained glass in the Evron chevet as fifteenth century.

38. Angot, *Armorial Mayenne*, p. 171, no. 290. The arms without *chef* are thus the abbot's baronial arms (after 1515), not the abbey's arms "preceding those in use subsequently" as Angot and others would have it. The baronial arms of the abbot occur in the eighteenth century concurrently with those of the abbey.

39. Angot's fanciful notion (*Armorial Mayenne*, p. 173), that these arms of the abbey (vair below, Virgin in *chef*) reflected the stained glass of Bay 103, is without foundation. The stained glass escutcheon (vair) was moved to Bay 103 beneath the Virgin there by Carot only ca. 1900; from 1840 to 1900 it was a stopgap in Bay 101. Its original location is discussed below.

40. In the nineteenth century the motif was considered to represent the bell-shaped heraldic vair on the abbey's baroque arms: see Léon de La Sicotière, *Excursions dans le Maine* (Le Mans: 1841), p. 37; Baron de Wismes, *Le Maine et l'Anjou historiques, archéologiques et pittoresques* (Nantes: 1858–1864), vol. 1, "Evron," p. 2, and more recently Jean Durand de Saint-Front, "Excursion dans la région d'Evron (Est de la Mayenne)," *Bulletin de la Société historique et archéologique de l'Orne* 72–73 (1954–55), p. 59. Of course the abbey had no arms when the "St Crépin" chapel was built, heraldry being then in its embryonic stages.

41. On Hugues de Châtillon see André Duchesne, *Histoire de la maison de Chastillon-sur-Marne* (Paris: 1621), pp. 124–25, 131–35; Jean Bernier, *Histoire de Blois* (Paris: 1682), pp. 315–16. The sale of Avesnes (Paris, Arch. nat. J 226, no. 22, Pontorson, April 1289) is signed and sealed by Hugues and his brothers Guy and Jacques.

42. On the careers of Guy de Saint-Pol (*bouteillier* of France, d. 1317), Jacques de Saint-Pol (governor of Flanders, d. 1302), and their famous cousin Gaucher de Châtillon (constable of France) see: Strayer, *The Reign of Philip the Fair*, esp. pp. 71, 76, 332–34, 372–73, 376; Jean Favier, *Philippe le Bel* (Paris: 1978), esp. pp. 17, 73, 516.

43. Bernier, *Histoire de Blois*, pp. 315–16; Duchesne, *Histoire de Chastillon-sur-Marne*, pp. 134–35.

44. See Lesueur, *Les Eglises de Loir-et-Cher*, pp. 124–26.

45. Hugues's will of 1299 is published by Duchesne, *Histoire de Chastillon-sur-Marne*, pp. 92–95. Both Duchesne and Courcelles place Hugues's death tentatively at ca. 1303; see Chevalier de Courcelles, *Généalogie de la maison de Chastillon-sur-Marne* (Paris: 1830), p. 74. Hugues's son Guy was still a minor in 1306 when his uncle Guy de Saint-Pol issued an *ordonnance* on the Blois coinage in his capacity as regent; the charter is published in Duchesne, preuves pp. 97–98.

46. The arms of the various Châtillon lords are recorded in many rolls. Only the counts of Blois bore the arms *plain* without cadence. Guy de Châtillon's seal of 1316 is described in Duchesne,

Histoire de Chastillon-sur-Marne, preuves p. 98 (Châtillon *plain*). Compare the arms of his two uncles and various cousins: Louis Douët-d'Arcq, *Collection de sceaux des archives de l'Empire* (Paris: 1863), nos. 368–72; Paul Adam-Even, "Rôle d'armes de l'ost de Flandre (Juin 1297)," *Archivum heraldicum* 73 (1959), p. 4, nos. 9–10.

47. He married Marguerite de Valois, niece of Philippe le Bel. On the date see Joseph Petit, *Charles de Valois, 1270–1325* (Paris: 1900), pp. 241–43. Various chronicles mentioning the event are in *Recueil des historiens des Gaules et de la France,* ed. M. Bouquet et al. (Paris: 1855; reprint, 1968), vol. 21, pp. 31, 652, 655. Guy de Châtillon fought with the king in 1338 and died in 1342.

48. *Recueil des historiens,* vol. 21, p. 38. On the age of knighting, the importance of being knighted by the king himself, and the mass knighting in London in 1306 (Feast of the Swans, when Edward I knighted 250 young Englishmen), probably the model for Philippe le Bel's ceremony of 1313, see: Denholm-Young, *History and Heraldry, 1254 to 1310,* pp. 25–26, 28, 49.

 The knighting of Pentecost 1313 is described by Geoffroi de Paris in *La Chronique rimée* (*Recueil des historiens,* vol. 22, pp. 135–38); see also Favier, *Philippe le Bel,* pp. 60–62. On the tax for this knighting see Strayer, *The Reign of Philip the Fair,* esp. pp. 84–85, 393.

49. Overviews of the financial crisis of 1295–1304 are provided by Favier, *Philippe le Bel,* chap. VII, esp. pp. 188–98, and by Strayer, *The Reign of Philip the Fair,* pp. 148–91; on the taxes paid by monasteries, Strayer, pp. 255f.

50. Jean Lafond, "Un Vitrail du Mesnil-Villeman (1313) et les origines du jaune d'argent," *Bulletin de la Société nationale des antiquaires de France* (Dec. 8, 1954), pp. 94–95.

51. Jean Lafond, "Essai historique sur le jaune d'argent," *Trois études sur la technique du vitrail* (Rouen: 1943), p. 55 n36bis. The Canon Thierry strip is illustrated in color in Jean Rollet, *Les Maîtres de la lumière* (Paris: 1980), p. 43.

52. In addition to the bibliography in CVFR II, p. 218, see those in CV Checklist II, pp. 138–39, 149.

53. This figure was in the hemicycle clerestory (Bay 101), where it was described by Lefèvre-Pontalis, "L'Eglise d'Evron," p. 22, and may be seen in nineteenth-century photographs. Carot moved it to its present location.

54. A Renaissance head, used as a stopgap in the right figure of Bay 104, was broken in 1974; a Renaissance head (recently set into Bay 12) was included in one of the panels of the Acézat sale (as in n. 67). Both had scalloped haloes.

55. Chevalier, Paris, Bibl. nat. fr. 19864, fol. 7v; Briant, Paris, Bibl. nat. lat. 10038, fol. 83v. Although some authors state that the arms of Jean de la Chapelle (*or à une croix du sable*), founder of the leper house in 1218, were also in the church windows, Gérault makes clear that they were in the glass of the parish church of Saint-Martin, destroyed in 1789: *Notice sur Evron* (as in n. 5), pp. 21, 270.

56. These arms do not occur in medieval rolls and are nearly identical to those of the family Ricoeur, which moved to the Mayenne from Normandy in the seventeenth century: Angot, *Armorial Mayenne* (as in n. 37), no. 487, pp. 311, 314–18.

57. See p. 259 above and pp. 276 and 290 below. Gérault, *Notice sur Evron,* 2d ed., p. 46n1, notes that this shield was in the north choir glass, and it can be identified in old photographs. Thomas Cauvin lists another coat of arms in the Evron windows (*gueules à 3 pals d'argent*), probably a mistake for the Châtillon shield in Bay 102, in his completely unreliable book, *Essai sur l'armorial du diocèse du Mans* (Le Mans: 1840), p. 31.

58. The same arms were on Renaud de l'Isle's enameled tomb, probably located originally near this stained glass shield. See p. 257 above.

59. Gérault, *Notice sur Evron,* 2d ed., pp. 50–52, 163 (*Procès-verbal* of May 30, 1577); Lefèvre-Pontalis, "L'Eglise d'Evron," pp. 9–11; Angot, *Dictionnaire* (as in n. 19), vol. 2 ("Evron"), pp. 147–48; Ceuneau, *Evron* (as in n. 4), pp. 45, 85.

60. Grodecki in conversation in 1970 mentioned having heard of a church in southern France where bricked-in windows had concealed old glass.

61. The restorer of 1943 was Jean-Jacques Gruber. Bays 105 (five apostles) and 107 (grisailles and colored tracery lights) were deposed, the remainder repaired in situ. Bay 105 was stored in the Pantheon until restoration in 1955. The Evron windows had not been taken down in the war. (Paris, Monuments historiques, dossiers: Mayenne, Evron, Eglise, 1943ff.)

62. Photographs of the deposed glass taken in 1974 by the restorer Avice are available in the Monuments historiques, Documentation des objets mobiliers. No Gothic heads were lost and much of the cracked glass is of Renaissance or modern repairs (as in the explosion of 1870 in Vendôme; see Chap. VII, p. 223).

63. Abbé Tournesac, "Sarthe et Mayenne," *Bulletin monumental* (1837), p. 132; Gérault, *Notice historique sur Evron*, 1st ed. (Laval: 1838), pp. 28, 84.

64. La Sicotière, *Excursions dans le Maine* (as in n. 40), p. 33. His remarks are dated Aug. 1839–Oct. 1840. Two masons began work at Evron in August 1838 on repairing and rebuilding traceries while money was still being raised for restoration. Gérault, *Notice sur Evron*, 2d ed. (as in n. 5), p. 115, lists the sums voted for 1839 and 1840. A report of June 1839 to the Beaux-Arts from the Conseil de fabrique de l'église d'Evron (Mayenne) also suggests that the choir ensemble was damaged but still recognizable: "Les ogives du choeur conservent encore des vitraux aux peintures antiques qui rappelent l'histoire de la fondation du monastère."

65. Gérault, *Notice sur Evron*, 2d ed., p. 115. A contemporary appreciation of his completed glass restoration may be found in J. Duchemin-Descepeaux, *Mémorial de la Mayenne* 1 (1842), p. 342. The priest Gérault was in a far greater hurry to finish restorations than the government would have been, and the Evron glass thus had a narrow escape for which modern art historians can be greatly thankful. Tournesac, inspector of the Sarthe, was occupied in the late 1830s with the restoration (and in effect the destruction) of the nave windows of La Couture in Le Mans; by the time he turned his attentions to Evron the glass was already replaced in the windows, since he mentions only *mobilier* in his report of June 1844. See: *Bulletin monumental* 3 (1837), pp. 133–34; "Rapport (Séance tenue au Mans . . . le 11 juin 1844)," *Bulletin monumental* 10 (1844), pp. 440–41.

66. Carot's report is in the Monuments historiques dossiers (Mayenne, Evron, Eglise, report dated 1899); Lefèvre-Pontalis, "L'Eglise d'Evron," p. 21. The photograph he published opp. p. 20 is from a large glass negative dated ca. 1875 (MH 1147), perhaps made to commemorate the glazing of the axial chapel of 1872, designed by Renouard and painted by the Carmelites of Le Mans (see Ceuneau, *Evron*, p. 28). Other photos (MH 34780, 34781) offer angled views that establish that the north bays (Bays 105 and 107) were glazed in their present forms in the nineteenth century.

67. The cartoons are nos. 66547 and 66546. I examined the Carot cartoons at the Bibliothèque du Patrimoine in Paris in 1990. On the glass: CVFR II, p. 218; both are illustrated in color on the cover of the sale catalog, *Vente après décès, A. Ancienne collection de M. Michel Acézat, Vitraux français . . .*, Rheims et Laurin, Hôtel Drouot, Nov. 14 and 25 (Paris: 1969), nos. 31 and 30. A third item Carot had offered to sell to the government in 1911, a sixteenth-century Crucifixion, was not in the Acézat sale and is untraceable. By the time of the sale the St Michael and the Gnadenstuhl had been provided with modern canopies and made into false band windows by the addition of grisaille above and below, as was Acézat's normal practice. The Gnadenstuhl, ruinous and grossly reworked, includes a fifteenth-century fragment used as the head of God; it will not be considered further here. The authentic parts may have originated in the axial chapel, formerly dedicated to the Trinity (Lefèvre-Pontalis, "L'Eglise d'Evron," p. 24). I would like to thank Jane Hayward for bringing these panels to my attention. I examined and photographed them in Paris in 1970, before their installation in the Evron nave.

68. Cartoons nos. 66558 (Virgin), 66557 (1–2) (St Paul). The old photos show both figures with their canopies in the left lancet of Bay 102; Carot reused them as the bottom row left and right. He replaced the grounds with a strong saturated blue at odds with the medieval colors, added

the vial in Paul's hand, and gave the Virgin a flower, a new halo, a largely modern Child, and a modern lower panel including bare(!) feet. Both figures are illustrated in CVFR II, p. 20. The Virgin is a rather more pedestrian design than the St Paul. He may have come from the chapel of St Peter, which Gaignières located on the right side of the choir (Adhémar, "Les Tombeaux Gaignières" [as in n. 23], no. 144).

69. Jean Lafond reported to the minister in 1969 that "Saint Michel est en grande partie ancien" though he noted that anomalies between the head and body panels suggested tinkering. The width is 44.5 cm. The head panel is truncated at the top in relation to the Glencairn trio of bishops, and Carot no doubt took that measurement and concocted two body sections of equal size; thus Michael's body is now far longer than those of the bishops, made of only two panels. The cartoon of the head panel is only lightly sketched (the face is blank); the glass itself is polished, but old photos confirm the design as original. The cartoon of the middle panel is heavily drawn and shaded, and the green glass making up most of the body is thickly coated with artificial patination, suggesting that the entire design of this panel is modern. The cartoon of the bottom panel includes heavily drawn feet as well as the sections of drapery adjacent to the panel above, and the glass varies greatly in weathering and in painting style, all of which suggest that the panel is a composite using old fragments.

70. I discussed the program and the Dennis King photo in "Bishops from Evron," pp. 93–106. Except for my mistake in assuming that the bishops left Evron in the nineteenth century, all conclusions in that article stand. For bibliography see CV Checklist II, pp. 138–39. The 1922 publication mentioned in this paragraph is: Roy Grosvenor Thomas, *Stained Glass: Its Origin and Application* (New York: 1922), opp. p. 4.

71. See CV Checklist II, p. 149. The panel is permanently installed high in the museum's Gothic chapel. I examined the front from a ladder in 1970 and found it to be powdering and crudely overpainted, even over pitting on the inside of some of the glass. Recently Renée Burnam has examined the back and provided me with a restoration chart indicating that much of the canopy is new as well as all of St Nicholas except his halo. Here the cartoon (no. 66521) seems to be a tracing of the original panel with indications of missing pieces of the architectural border, and it provides us with a hint of what the original Nicholas looked like—much fresher and more appealing than Carot's masklike version. The Philadelphia panel, at 48.8 cm. wide, is the largest of the bishops, all of which would fit exactly into Bay 106 (five lancets averaging 48.2 cm. in width). It is improbable that they came from the northwest clerestory, Bay 107 (lancets over 62 cm. wide), as proposed in *Radiance and Reflection* (as in Chap. V, n. 117), p. 241.

72. Illustrated in color in *Canada Collects the Middle Ages,* exh. cat., Norman Mackenzie Art Gallery (Regina, Saskatchewan: 1986), pp. 28, 98, no. 18. The panel is no. 35 in the Acézat sale catalog (as in n. 67 above). I have not had the opportunity to examine it.

73. The Anne/Virgin panels are illustrated in CV Checklist III, pp. 23 (color), 51. I have not had the opportunity to examine them. The "Joachim" panel could not come from Bay 105 (old Bay 116) as indicated in the Inventory of cartoons. It is 50 cm. wide and the *panneautage* is totally different from the five apostles in Bay 105 (illustrated in CVFR II, p. 221), where the lancet width averages 48.2 cm.

74. Inscriptions coeval with Evron reading ANNA: Michael Stettler, *Swiss Stained Glass of the Fourteenth Century from the Church of Koenigsfelden* (London: 1949), pl. IV; Victor Beyer et al., *Les Vitraux de la cathédrale Notre-Dame de Strasbourg,* Corpus Vitrearum France IX-1 (Paris: 1986), p. 211 (Bay sIII, south nave aisle); Hans Wentzel, *Die Glasmalereien in Schwaben von 1200–1350,* Corpus Vitrearum Deutschland I-1 (Berlin: 1958), pl. 319 (Annunciation to Anne, panel from Esslingen, Frauenkirche, in Moritzburg-Museum, Halle/Saale).

 The patterned ground in the California panel is composed of two elements, a quatrefoil-filled cassette pattern and an unpainted outline following the contours of the figures and frame. Both elements, almost unknown in French Gothic art, occur regularly in Germany but never together.

In German glass, cassette or lozenge grounds always run uninterrupted, while unpainted outlines appear only with foliage *rinceaux* ground patterns that are irregular and variable in nature. There is only one medieval example, as far as I know, of the combination found in the California panel: Strasbourg cathedral, Bay sIV panel 5b, the Temptation of Christ (Beyer, p. 222, fig. 187). The panel is a unicum, unlike anything in its bay, its cathedral, its region, or indeed anywhere. The comparisons in Beyer, n. 42, are all combinations of the outlining strip with foliate, not cassette, grounds.

75. St Anne and the Virgin are always discreetly shod in medieval art. It should be recalled that Carot also provided shocking bare feet for the Virgin in Bay 102 (see n. 68 above). The child Virgin's crown: a representative survey of images is provided by Gertrud Schiller, *Ikonographie der christlichen Kunst* (Gütersloh: 1980), vol. 4, pt. 2, pp. 326–35, pls. 542–61. A crown appears in German fourteenth-century examples, but the high crown is found only ca. 1400 (Ulm, stained glass, pl. 546; see also an altar painting in Vienna, ca. 1435, pl. 555).

76. The Presentation of the Virgin in the temple: Schiller, *Ikonographie,* pp. 67–72, 326–28; Louis Réau, *Iconographie de l'art chrétien,* vol. 2, pt. 2: *Nouveau Testament* (Paris: 1957), pp. 164–66. The subject of St Anne teaching the Virgin to read: Schiller, pp. 75–76, 335; Réau, pp. 165–66; Christopher Norton et al., *Dominican Painting in East Anglia* (Woodbridge: 1987), pp. 51–52 n100; Pamela Sheingorn, "'The Wise Mother': The Image of St. Anne Teaching the Virgin Mary," *Gesta* 32/1 (1993), pp. 69–80. The scene of the Virgin with other children in school: Chartres cathedral Bay 28 (south choir, ca. 1220): CVFR II, p. 31.

Bay nII in the Frauenkirche, Esslingen (a cycle of the childhood of the Virgin, ca. 1330) includes figure groups and ground patterns close to the California panels. Esslingen panel 10a (the Virgin leading the Christ Child to school, Wentzel, *Glasmalereien in Schwaben,* pl. 305) is a composition close to the California panel of Anne leading the Virgin. Panel 4a (Presentation of the Virgin in the temple, Wentzel, pl. 309) and panel 4b (Mary praying in the temple, pl. 291) offer praying hands like those in the California Education panel, as well as the detail of the loop of skirt tucked up by the Virgin's arm in the California panel of Anne leading the Virgin. Carot has exaggerated the little heart-shaped trace line in the loop of cloth into a sort of valentine. The Frauenkirche glass was published by E. Demmler, "Die mittelalterlichen Glasmalereien in Esslingen," *Christliches Kunstblatt für Kirche, Schule und Haus* 42 (1900), pp. 84ff.

A window added to the northwestern ambulatory chapel of the cathedral of Sées between 1876 and 1896, by the restorer Leprévost, depicts a figural grouping very similar to one of the California panels: against a damasquin ground, St Anne holds by the hand the young Virgin, who grasps a book and holds up a fold of her skirt with her other hand.

77. The Glasgow figure (inv. no. 71, Reg. no. 45.368) was bought by Sir William Burrell from Seligman in 1928; illustrated in Glasgow Art Museum, *Stained and Painted Glass, Burrell Collection: Figure and Ornamental Subjects,* ed. William Wells (Glasgow: 1965), p. 9, no. 5. I examined the glass in 1970. I would like to thank Jane Hayward for bringing it to my attention, and Robert Gibbs for his fine photography and good company in Glasgow in 1983.

On the shape and decoration of the medieval papal tiara see Eugène Müntz, *La Tiara pontificale du VIIIe au XVIe siècle,* extract from *Mémoires de l'Academie des inscriptions et belles-lettres* 36, pt. 1 (Paris: 1897), pp. 242–79 passim.

78. Réau, *Iconographie de l'art chrétien,* vol. 3, pt. 2, p. 742: Johannes Andreas (Giovanni d'Andrea) compiled Jerome's works in the *Hieronymianus.* Illustrations of Jerome: for the south transept portal of Chartres, see Peter Kidson, *Sculpture at Chartres* (London: 1958), pl. 109; for the Saint-Ouen clerestory, see Lafond, *Les Vitraux de Saint-Ouen,* pls. 71, 73. The eyebrows of the Burrell saint and the matching "Gregory" cartoon, which fork upward at the bridge of the nose, are found at Saint-Ouen (see pl. 70). They do not appear at Evron.

79. Ceuneau (as in n. 4), p. 65. The brother-saints' names vary, sometimes spelled with an S and with accents ranging from one to three: Céneri = Cénéric, Sénery, Serenicus; Céneré = Sénéré, Seneridus, Serenus, the name having transmuted into Sérène (Sérené) before 1600 in the diocese of Angers as he became paired with the Angevin saint René. See: *Butler's Lives of the Saints,* ed. Herbert Thurston and Donald Attwater (New York: 1963), vol. 2, p. 247 (Serenicus and Serenus); Jacques Levron, *Les Saints du pays angevin* (Paris: 1943), pp. 109–18; Abbé J.-B.-N. Blin, *Vies des saints du diocèse de Séez et histoire de leur culte* (Laigle: 1873), pp. xiv, 418–66; Madeleine Pré, "La Peinture murale dans le Maine et ses confins angevins aux XIIIe et XIVe siècles," *Gazette des beaux-arts,* 6th ser., 41 (1953), pp. 85–86, 91–92; Pierre Souty, "Saint Cénéric et le Poitou," *Bulletin de la Société des Antiquaires de l'ouest* 3rd ser., 4 (1947), pp. 171–73; Abbé Em. Delbez, *Saint Cénéric, sa vie, son culte,* extract of *Annales de la Société historique et archéologique de Château-Thierry* (Château-Thierry: 1928), pp. 6–27.

 On the church and parish of Saint-Céneré owned by Evron see: Léon Maître, *Dictionnaire topographique du département de la Mayenne* (Paris: 1878), p. 293; Angot (as in n. 19), pp. 517–20.

80. On the establishment of red as the color of cardinals: "Cardinal," *La Grande encyclopédie,* ed. Larousse (Paris: 1972), vol. 4, p. 2328. A high crowned hat appears on the tomb of Cardinal Jean le Moine, d. 1313, in the drawing made for Gaignières: Adhémar (as in n. 23), n. 586, see also no. 601. The brother-saints always have a tall red hat in art: for the Gothic frescoes of Saint-Céneri-le-Gerei (Orne) see Henri Pastoureau, "Histoire de Saint-Céneri-le-Gerei," *Bulletin de la Société historique et archéologique de l'Orne* 84 (1966), pp. 43, 45; for later folk sculpture see Levron, opp. p. 113; also Pastoureau, "Histoire de Saint-Céneri-le-Gerei," *Bulletin de la Société historique et archéologique de l'Orne* 83 (1965), p. 25. Angot, p. 518, states that Cénéré's feast day (June 9), in 1618, was popularly called the "feste des potz," and he does not know why. The term *pot,* as the name of the tall sixteenth-century helmet, is obsolete.

81. The uppermost tracery light has an Agnus Dei of more recent manufacture. There is no information about when it was made or if it replaced an earlier one. The other tracery glass is in varying states of repair, although the basic designs are trustworthy and the modern pieces easy to identify from the exterior.

82. Lefèvre-Pontalis, "L'Eglise d'Evron," p. 317. His list runs: unknown, Matthew with lance, Paul with sword, Mathias with ax, John with chalice [*sic*].

83. On Barnabas see Lillich, *Saint-Père,* pp. 72, 96, 118–19. Barnabas is included in Vendôme Bay 206, the Saint-Père hemicycle, and Bay 28 of the Saint-Père nave (where he is named by inscription).

84. The five lancets of Bay 105 are about 48 cm. wide, and each panel about 52 cm. high (three panels, two for the figure and one for the canopywork above). The grisailles in the six lancets of Bay 107 are 61 to 62.3 cm. wide (47.5 cm. inside the borders) and 43 cm. high. If Bay 107 did have a row of apostles originally, their proportions would have varied somewhat from those of Bay 105.

85. See the drawing (made before the nineteenth-century overpainting) in Gelis-Didot and Laffillée, *La Peinture décorative* (as in n. 5).

86. The tiny crucifixus has a modern head and upper torso made by Carot. Since the Gnadenstuhl panel he composed and offered to the government in 1911 (Acézat sale [as in n. 67], no. 30) contains those very sections in a later, silver-stained technique, it seems reasonable to hypothesize that the tiny figure of the crucified Christ in Bay 100 had been repaired in the late Middle Ages with a piece that Carot removed, replaced, and used as part of his Gnadenstuhl concoction. The Acézat panel is now installed in Bay 12 in the south aisle: CVFR II, p. 218.

87. This panel was in the same location in the nineteenth century, when the head was already broken. Most of the body and the little window he offers are old. He is wearing the blue robe that glaziers often provide for Benedictines (cf. St Benedict, Vendôme Bay 205).

88. Lafond, "Le Vitrail du XIVe siècle en France," p. 212.

89. Becksmann, *Die architektonische Rahmung des hochgotischen Bildfensters*, pp. 14f., 38f., 41. See also the review by Madeline Caviness, *Art Bulletin* 52 (1970), pp. 432–34.

90. There are only three original heads left in the oeuvre of the Master of the Soaring Canopies: God the Father (Bay 100), the saint with flail (Bay 104), and the magus who points to the star (Bay 103). The shapes of the modern heads would indicate that the swollen jaw was the most common type and thus, as indicated in other details, that the Canopies Master and the Pilgrim Master were products of the same training.

91. Backpainting is most noticeable in the Canopies Master's oeuvre in Bay 100 (all robes), Bay 103 (the left magus), and Bay 104 (lower panel of saint with flail). On more deteriorated panels it may have disappeared.

92. Lefèvre-Pontalis, "L'Eglise d'Evron," p. 21; Lavedan, "Evron" (as in n. 3), pp. 298–99; Ceuneau, *Evron* (as in n. 4), p. 23.

93. Lefèvre-Pontalis, "L'Eglise d'Evron," p. 18; Lavedan, "Evron," p. 298; Ceuneau, *Evron*, pp. 20–21.

94. Réau (as in n. 76), p. 239.

95. See Chap. II n. 80. Schiller indicates that the magi narratives enjoyed popularity in the Carolingian period and again in the twelfth century, and were not often depicted in such detail thereafter: Gertrud Schiller, *Iconography of Christian Art* (New York: 1966), vol. 1, pp. 98–100, 114.

96. The Châtillon arms (in a totally modern surround) were installed in the spot ca. 1900 by Carot.

97. The face of the saint on the left is Carot's work, but his tonsure and parts of the hair and halo are old; the feet panel is entirely modern. The head of the figure with flail is original, as is most of the figure.

98. That it is a flail seems certain, since a flail made of three balls attached to a rod is used in the martyrdom of St Vincent in the left lancet of the same clerestory at Le Mans (Bay 201). It is illustrated in *Le Vitrail français*, p. 153, pl. 117. In the twelfth-century glass of Le Mans both Gervais and Protais are shown being beaten with a flail.

99. The abbot before Langlois appears in charters through 1300; there is a gap between them: Angot, *Dictionnaire* (as in n. 19), vol. 2, p. 139. See *Gallia christiana* (as in n. 13), vol. 14, cols. 487–88.
 Gérault, *Notice sur Evron*, 2d ed. (as in n. 5), p. 31, describes the arms; he does not give his source and I have been unable to verify it.

100. Lefèvre-Pontalis, "L'Eglise d'Evron," p. 31.

101. The inscription exists in the Gaignières drawing (Oxford, Bodleian MS Gough Gaignières 15, fol. 91r) and in slightly varying versions in three old sources, among them Dom Chevalier (1669), fol. 100r–v. It has been commented on by Berthelot du Chesnay, "Evron" (as in n. 14), col. 216; and most thoroughly studied by Angot, *Epigraphie Mayenne* (as in n. 23), vol. 1, p. 304 DV, who came to the conclusion that the date should read 1320.

102. On the ampullae of the Virgin's milk, including that owned by Evron, see also Patrice Boussel, *Des reliques et de leur bon usage* (Paris: 1971), pp. 178–80, who mentions that Calvin was moved to complain that, since there were so many of them, the Virgin must have been a cow or else nursed all of her life. The relic of Evron was the most standard type brought from the Holy Land, consisting of white earth supposedly blanched when the Virgin expressed some of her milk upon the ground before nursing her Child on the Flight to Egypt.

103. Compare the clear black-and-white illustrations in Lillich, "Bishops from Evron," p. 103 (Evron Bay 101), and CVFR II, p. 157 (Vendôme Bay 202).

104. Eudes de Châtillon was elected pope in 1088, as Urban II. He dedicated Cluny III, preached the crusade at Clermont, and was responsible for several miracles, causing some to refer to him as a saint. Although Urban was never canonized, Duchesne's frontispiece depicts an image of him labeled "Saint Urbain" (*Histoire de Chastillon-sur-Marne* [as in n. 41], pp. 24–25).

Guy I de Châtillon's second son, Charles de Blois (born 1319, married in 1337 to Jeanne "la Boiteuse" de Bretagne, and at war from then until his death in 1364 over his rights to her duchy) was nicknamed The Hermit as a child by his elder brother, and commonly called St Charles later. An inquest for canonization was ordered in 1369 but seems to have been quashed for political reasons. He gave up the Châtillon arms for those of Brittany upon his marriage. See Duchesne frontispiece and pp. 145, 201–39; Courcelles, *Généalogie de Chastillon-sur-Marne* (as in n. 45), pp. 85–97; Père Anselme, *Histoire généalogique de la maison royale de France* (Paris: 1726–1733), vol. 1, pp. 450–51.

105. Lefèvre-Pontalis, "L'Eglise d'Evron," pp. 23–24.

106. As I have outlined earlier, the original secular founder, second founder after the Viking raids, was historically the viscount of Maine around the year 1000. The monastery had already rewritten its charters to substitute as second founder the viscount of Blois of the family de l'Isle by the twelfth century. The last de l'Isle had died among the monks in 1288. The Châtillon family, counts of Blois, then assumed the role of second founder, and that is presumably the state of things in the ambulatory relief as well as in Bay 102 above in the clerestory.

107. The design of this Virgin and Child probably survives in the wreckage assembled, probably by the restorer Acézat, to produce the saleable lancet shown on the cover of the sale catalog of his collection, *Vente après décès . . . Acézat* (as in n. 67), no. 29, where the entry states that the glass is 68 cm. wide (about the same as the Evron window), that it includes "Restaurations, parties refaites," and that it came from Vendôme. There is no evidence for a Vendôme provenance. Elements of the lower architectural frame resemble the Evron window, and the Virgin is facing the viewer's right, which would be the correct position at Evron. The heavily restored lancet is now in the Violette collection in Montreal: *Canada Collects the Middle Ages* (as in n. 72), no. 23, illustrated p. 102. My thanks to Michael Cothren for his examination report.

108. Coats of arms are commonly placed in traceries, as in Bay 19 of Saint-Père (arms of Dreux and Montfort-l'Amaury), the triforium of Tours (arms of Binanville and his wife), Sées (the du Merle clerestory bay), Saint-Méen (Brittany), Aunou (de la Ferrière), etc.

109. The one unsilverstained panel is St Lawrence; see at n. 72 above.

110. The Carot cartoons (discussed pp. 264 f. above) establish the panels he found in the church, restored, and reinstalled there; the panels he designed and installed there (such as canopywork); and the panels (associated with the Evron job in his atelier) that he prepared for sale. What they do not establish is the authenticity of the latter group, since original and new designs are not distinguished on the cartoons. Not represented among the cartoons are several other museum panels, associated with Evron by scholars in the past, for which no connection to the church glazing can be established: CV Checklist I, p. 180; CV Checklist III, p. 66.

111. Many details constitute an artistic handwriting, for example the dotted-circle decoration on miters, the crozier heads with a dotted pattern on the extrados, and a trefoil curling inside from the end, a very curious ear with blackened areas forming an E or 3 pattern, the gloved hand showing the inside of the opening, etc. The elegance of his final gesturing hands was preceded by such exquisite draftsmanship as the extraordinarily beautiful feet of the Pilgrim in Bay 102.

112. One other location is possible: the east and west clerestories of the north transept both have five lancets each, approximately 48 to 49.5 cm. wide.

113. Charles Williams Jones, *Saint Nicholas of Myra, Bari, and Manhattan* (Chicago: 1978), p. 248, citing J. T. Fowler, "Some Legends of St. Nicholas, with Special Reference to the Seal of Picklington Grammar School," *Yorkshire Archaeological Journal* 17 (1903), pp. 257–58.

114. Dom Chevalier (1669), fol. 35r, listed the inventory of the abbey's relics. Julien resuscitated three youths, the son of Anastasius, the son of Jovinianus, and the son of the lord of Pruillé: Abbé A. Voisin, *Vie de Saint Julien et des autres confesseurs pontifes ses successeurs* (Le Mans: 1844), pp. 72–75. St Julien is shown resuscitating a youth in Le Mans Bay 107 (upper ambulatory, gift of the winegrowers, 1254) as well as in the twelfth-century fragments in the cathedral: Grodecki, "Les Vitraux du Mans," p. 72. On St Julien at Le Mans cathedral, see Chap. II, passim.

115. On the well under the high altar see n. 10 above. The identity of Thuribe's fountain is sometimes disputed, since there was also a miraculous spring at Assé-le-Beranger near Evron: Voisin, *Vie de Saint Julien,* pp. 186–88.

116. Lafond, "Un Vitrail du Mesnil-Villeman" (as in n. 50), p. 94; Lillich, "European Stained Glass around 1300."

117. Lewis Day, *Windows* (London: 1903), p. 68.

CHAPTER 9

1. The iconographic studies of the Passion windows of Gassicourt and Dol, for instance, have buttressed my argument for the model used for Saint-Père's Passion cycle (Bay 18), probably a twelfth-century manuscript resembling the monastic psalter of St Swithin's Priory: see Lillich, *Saint-Père,* pp. 150, 155, 189, pl. 95; Chap. III, p. 60, and Chap. V, pp. 139 f. That the Benedictine abbey of Saint-Père owned such a venerable and no doubt famous object seems fairly clear from the amassed circumstantial evidence.

2. The identification of the architect of the *rayonnant* superstructure of the Saint-Père choir, Gautier de Varinfroy, has been discussed, Chap. III, p. 67. New studies have appeared of the two manuscripts of the abbey of Saint-Denis that, I believe, were used as models by the glazier of the St Denis lancet (Bay 23): Lillich, *Saint-Père,* pp. 138–42; see p. 314 below. Elizabeth A. R. Brown's research has made possible a new look at the iconography of St Louis, in which I have indulged in the discussion of Vendôme (Chap. VIII, pp. 241 f.) and on p. 311 of this chapter.

3. On the hemicycle, see Lillich, *Saint-Père,* chaps. III, VIII, and IX. Bay 7 (south) was walled up when the *tourelle d'escalier* was built in the fourteenth century; see following note.

4. On the fragment see: Lillich, *Saint-Père,* pp. 19n15, 20n25, pl. 15; Lillich, "Découverte d'un vitrail perdu de Saint-Père de Chartres," *Bulletin de la Société archéologique d'Eure-et-Loir, Mémoires,* year 108, 13 (1964), pp. 264–68.

5. I here repent my sins of pp. 95–96 in Lillich, *Saint-Père.*

6. For the program of the south portal of Chartres Cathedral see: Adolf Katzenellenbogen, *The Sculptural Programs of Chartres Cathedral: Christ-Mary-Ecclesia* (Baltimore: 1959), chap. III; and Peter Kidson, *Sculpture at Chartres* (London: 1974), pp. 32, 38–46, 53–54.

7. See n. 9 below.

8. An old photograph shows this abbot interchanged with the apostle in the bottom of the left lancet (Bartholomew with knife): see Lillich, *Saint-Père,* pls. 9 and 12.

9. It must be admitted that the fragment that I have identified from this bay, the torso of a bishop, does not fit this program (see n. 4 above). It is almost the only element that does not, and perhaps it was exchanged with the apostle above the bishop in the right lancet of Bay 4, the other nonconforming element in the program I have outlined. Both of these nonconformists have a blue ground; hence their substitution would not disturb the color polyphony I have charted (p. 301 above).

10. Lillich, *Saint-Père,* p. 71.

11. On the structure of the nave program at Saint-Père see Lillich, *Saint-Père,* p. 79 (chart) and chap. VI passim.

12. In Chartres MS 519, a missal of Saint-Père of the early fourteenth century (destroyed in World War II), Matthew and Bartholomew were the only apostles to receive an illuminated initial of their own in the sanctoral (fols. 199r, 211v). The only other apostles included were Philip and James (sharing an initial on fol. 163v) and Simon and Jude (sharing an initial on fol. 224r). See Yves Delaporte, *Les Manuscrits enluminés de la Bibliothèque de Chartres* (Chartres: 1929), pp. 92–93. James, however, is very important in the nave windows, where two images (in addition to a James Minor) are included: Lillich, *Saint-Père,* pp. 118–19.

13. All twenty-four cannot readily be identified, and they are not all illustrated even in Etienne Houvet, *Cathédrale de Chartres: portail sud* (Chelles: 1919).

14. Bay 209, produced by his followers, already adopts it. The Master of the Big Saints at Gassicourt brought this lesson among others from his training at Le Mans. On Le Mans see Chap. II; on Gassicourt, Chap. III, pp. 51–54.

15. On the campaign of ca. 1270 at Saint-Père see Lillich, *Saint-Père,* chaps. II and VII; also above, Chap. III, pp. 67–72.

16. On the Master of Pierre d'Alençon (Bays 201, 200, 202) at Vendôme, see Chap. VII, pp. 232f. One of the Saint-Père quatrefoils (traceries of Bay 6) has lobes filled with the colored lozenge grounds that appear in several early bays at Le Mans and before that at Bourges: Lillich, *Saint-Père,* pl. 13.

17. The Crucifixion of Peter (Bay 2) and the martyrdom of Eustace (Bay 6), both illustrated on p. 51 of CVFR II, indicate clearly the range of painters. The Eustace panel, off-balance and *naif,* resembles the childlike tracery designs of Evron Bay 107 (see Chap. VIII, p. 274). Since each appears to be unique in its respective church, I have omitted this observation from any hypothesis about the movement of glaziers between these abbeys.

18. I have listed the cartoons in *Saint-Père,* p. 50.

19. This facial convention, the reserving of two large circles from the wash on the forehead, is much older, though only one master uses it in the hemicycle. It can be seen on the balding patriarchs of Bay 14 (ca. 1270). It is also used by at least one painter in the nave (Bays 20, 24).

20. A linear hand, related to the master favoring big eyes and facial whiskers, is in Bays 3 (lower right) and 5 (upper left); a dull master in the more delicate style is in Bays 4 (upper left) and 6 (upper left). The painter of the axial bay Crucifixion and Virgin and Child does not surface in the other lancets. There are also several styles of restored heads, which seem to have been copied through the glass from broken originals in most cases. Only the head of St Louis and Bay 6 (lower left) are obvious modern designs.

21. All these remarks are from Colin Eisler's review of Millard Meiss, *French Painting in the Time of Jean de Berry: The Limbourgs and Their Contemporaries,* in *Art Bulletin* 63 (June 1981), p. 330.

22. The face is a dreadful modern drawing. See an older face in the pre-restoration photograph, as well as the Montfaucon drawing: Lillich, "An Early Image of Saint Louis," *Gazette des beaux-arts* 75 (1970), pp. 251–56; Lillich, *Saint-Père,* p. 101nn16–17.

23. See Chap. VII, pp. 241–48, discussion of the St Louis in Bay 206 of Vendôme.

24. Georgia Sommers, "The Tomb of Saint Louis," (as in Chap. VII, n. 70), p. 67.

25. Alain Erlande-Brandenburg, "Le Tombeau de saint Louis," *Bulletin monumental* 126 (1968), pp. 25–26.

26. Both are illustrated by Sommers, "The Tomb of Saint Louis," pls. 23e and 24c.

27. The chapel of Jarry at Saint-Cyr de Bailleul (Manche). The terra-cotta is illustrated by Jean Fournée. "Le Culte et l'iconographie de saint Louis en Normandie," *Saint Louis et la Normandie, Art de Basse-Normandie,* special number 61 (1973), p. 41, pl. 7.

28. Robert-Henri Bautier, "Diplomatique et histoire politique: ce que la critique diplomatique nous apprend sur la personalité de Philippe le Bel," *Revue historique* 259 (1978), pp. 3–27; Elizabeth A. R. Brown, "Philippe le Bel and the Remains of Saint Louis," *Gazette des beaux-arts,* 6th per., 95 (1980), pp. 175–82.

29. Joseph Petit, *Charles de Valois, 1270–1325* (Paris: 1900), pp. 19, 24–25. Laurent Voisin was *clerc du conseil royal* in 1290 and *chancelier* to Charles from at least 1291 (pp. 251, 295) through at least December 1314 (pp. 59, 295, 301, 307).

30. On the nave donors see: Lillich, *Saint-Père,* pp. 11–12, 121–22, 129–30, 146, 158–59.

31. The tomb of Philippe des Cierges was drawn for Gaignières: Jean Adhémar, "Les Tombeaux de la collection Gaignières," *Gazette des beaux-arts,* 6th per., 84 (July–Sept. 1974), no. 675 (the original is in Oxford, Bodleian Library). His abbacy began sometime after 1311 (when he was still cellarer) and by 1320: *Gallia christiana* (Paris: 1715–1765), vol. 8, col. 1229.

32. Paris, Bibl. nat. nouv. acq. fr. 1098: Robert Branner, *Manuscript Painting in Paris during the Reign of Saint Louis* (Berkeley: 1977), pp. 87–93 passim and catalog p. 225.

33. Paris, Bibl. nat. fr. 2090–92: Charlotte Lacaze, The "Vie de St. Denis" Manuscript (Paris, Biblio-thèque Nationale, Ms. fr. 2090–92), Garland series, Outstanding Dissertations in the Fine Arts (New York: 1979), esp. pp. 115–22, 251. See Lillich, Saint-Père, pp. 138–42.

34. Illustrations of the deported panels in the ambulatory: Lillich, Saint-Père, pl. 71; Jean-Marie Braguy, "La Restauration du vitrail de saint Pierre et saint Paul de l'église Saint-Pierre de Char-tres," Vitrea 7 (1991), pp. 16, 18, 19. Restoration of the nave began in 1979 and is still under way: see CVFR II, pp. 48, 52. On Bays 20–21: Saint-Père, pls. 55–57; p. 66n10. For spectacular color photographs of an apostle of Bay 20 before and after, see the covers of pts. 1 and 2 of Vitrea 7 (1991).

35. On the touches of Pseudo-Bonaventura in Bay 26 see Lillich, Saint-Père, pp. 167–72 passim.

36. The program and donors of the Saint-Père nave are discussed in Lillich, Saint-Père, chaps. X and XI. One might add the observation that the two remaining inscriptions in Bay 25 (S MARTINVS, SEnt LVBIN) suggest that the standing saints of the south nave (Bays 21, 25, 29) originally formed an "identity group" rather more elaborate than those at Vendôme and Evron. Saint-Père had a priory south of town called Saint-Lubin-des-Vignes; the most ancient Christian site in Chartres was the monastery of Saint-Martin-au-Val, which in the thirteenth century was a priory of Mar-moutier, the Benedictine abbey where St Martin had lived. Alfred Baudrillart, Dictionnaire d'his-toire et de géographie ecclésiastiques (Paris: 1953), vol. 12, col. 560.

 Pope SILVESTER (Bay 21) was believed by the Waldensian heretics to have been the first to pervert Christ's church, and they traced their origins to his reign: see Edward Peters, ed., Heresy and Authority in Medieval Europe (Philadelphia: 1980), p. 142; and N. A. Weber, "Waldenses," The Catholic Encyclopedia, vol. 15 (New York: 1912), p. 528. Thus an image of Silvester might carry connotations not only of orthodox monarchy, as I suggested in 1978, but of orthodox religion. The support of the Capetian monarchy and the attack on heresy were closely connected in the mind of King Philippe le Bel: see Strayer, The Reign of Philip the Fair, pp. 13–14, 17, 26ff. I would like to thank Susan Kyser for the references to the Waldensians.

37. Chartres MS 519 (see n. 12 above): St Anne (fol. 183r); St Clement (fol. 232v); St Denis (fol. 219r); St Agnes (fol. 145v); the Baptist (fol. 173r). Peter's feasts are illustrated with scenes of Peter as pope (fol. 155v), the crucifixion of Peter (fol. 175v), and Peter delivered from prison (fol. 187r).

38. On the Passion bay see Lillich, Saint-Père, pp. 146–55; Gassicourt, Chap. III, p. 60; on Dol, Chap. V, pp. 139f.

39. On the Saint-Denis libelli see: Lacaze, The "Vie de St. Denis" Manuscript, p. 112 (Paris, Bibl. nat. nouv. acq. fr. 1098, fol. 33v) and pp. 24–25, pl. 20 (Paris, Bibl. nat. fr. 2091, fol. 1); also nn. 32–33 above. The Dormition of Bay 19 is illustrated in Lillich, Saint-Père, pl. 54. On the ico-nography of the Dormition: Joseph Duhr, S.J., "La 'Dormition' de Marie dans l'art chrétien," Nouvelle revue théologique 72 (1950), pp. 134–57; Gertrud Schiller, Ikonographie der christlichen Kunst (Gütersloh: 1980), vol. 4, pt. 2, pp. 92–130.

40. The Toulouse casket is illustrated in Schiller, Ikonographie, vol. 4, pt. 2, pl. 465 (p. 46). The Joachim-Anne lancet is discussed in Lillich, Saint-Père, pp. 130–32, 173n14; a detail is illus-trated in Grodecki and Brisac, Le Vitrail gothique, p. 160.

41. The first such design is the window of St Chéron in the north ambulatory of Chartres cathedral (Delaporte Bay 42): Yves Delaporte and Etienne Houvet, Les Vitraux de la cathédrale de Chartres (Chartres: 1926), pls. CXXIII–CXXVI. On Fécamp (lives of Sts Edward and Louis and the Desert Fathers): Jean Lafond, "Les Vitraux de l'abbaye de la Trinité de Fécamp," in L'Abbaye bénédictine de Fécamp: Ouvrage scientifique du XIIIe centenaire (658–1958) (Fécamp: 1958), vol. 3, pp. 99–120, 253–64; Madeline Harrison [Caviness], "A Life of St. Edward the Confessor in Early Fourteenth-Century Stained Glass at Fécamp in Normandy," Journal of the Warburg and Courtauld Institutes 16 (1963), pp. 22–37; Philippe Verdier in Art and the Courts: France and England from 1259 to 1328, vol. 1, pp. 173–75, no. 98 (scenes from the lives of St Edward and St Louis); Lafond, "Le Vitrail du XIVe siècle en France," pp. 189–91 and n. 4.

42. See Lillich, *Saint-Père*, pls. 46, 47, 74.

43. The only exception is Bay 22, which is composed of earlier pairs of scenes of Peter and Paul expanded for the nave location. This is the bay with which Abbot Jean de Mantes inaugurated the campaign, and his kneeling image is found in the bottom row of the left lancet. See Chap. III, n. 93.

44. Note the extraordinary similarity of faces in the Baptist Bay (*Le Vitrail français*, p. 175) and the scenes of St Denis (Grodecki and Brisac, *Le Vitrail gothique*, p. 160). The differences between these two masters, which lie chiefly in their approach to design, are discussed below. In *Saint-Père* (pp. 63–65, 192) I refused to give "names" to painters so totally absorbed into the chantier's syntax; here, in addition to these two masters, I have only commented on the two painters whose styles recur in the Evron hemicycle (the Pilgrim Master and the Master of the Soaring Canopies). Many more artists were employed at Saint-Père, and as the Chartres cathedral windows are restored evidence is turning up that the Saint-Père shop contributed an occasional repair up the hill: see illustration in Michel Petit, "Restauration du vitrail de Notre-Dame de la Belle Verrière," *Vitrea* 7, pt. 2 (1991), p. 109 (the only fourteenth-century head in the window).

45. See also Lillich, "Bishops from Evron," p. 101.

46. Lillich, *Saint-Père*, pp. 33–34, 37, 69, 73.

47. Branner, *Saint Louis and the Court Style*, pp. 30, 39–54 passim; Jean Bony, *French Gothic Architecture of the 12th and 13th Centuries* (Berkeley: 1983), pp. 370–75; Norbert Bongartz, *Die frühen Bauteile der Kathedrale in Troyes, Architekturgeschichtliche Monographie* (Stuttgart: 1979), pp. 234–43; Caroline Bruzelius, *The Thirteenth-Century Church at St-Denis* (New Haven: 1985), pp. 167–71; Michel Bouttier, "La Reconstruction de l'abbatiale de Saint-Denis au XIIIe siècle," *Bulletin monumental* 145 (1987), pp. 370, 380.

48. Grodecki, *Les Vitraux de Saint-Denis*, Corpus Vitrearum Medii Aevi France, Etudes 1 (Paris: 1976), p. 30.

49. I would like to thank Ian McGee for slides he made for me in 1974 of the grisailles in the south transept clerestory. On Troyes, its nineteenth-century restorations, and its mid-thirteenth-century grisailles see: Jean Lafond, "Les Vitraux de la cathédrale Saint-Pierre de Troyes," *Congrès archéologique* 113th session (1955), pp. 32–45 passim, 46–48, 50–51; Elizabeth Pastan, "The Early Stained Glass of Troyes Cathedral: The Ambulatory Chapel Glazing, c. 1200–1240" (Ph.D. diss., Brown University, 1986), chap. III and p. 102, pls. 126–27; Pastan, "Restoring the Stained Glass of Troyes Cathedral: The Ambiguous Legacy of Viollet-le-Duc," *Gesta* 29/2 (1990), pp. 155–66. The grisaille is reset in Bay 218 (CVFR IV, pp. 230–31).

50. Lillich, *Saint-Père*, pp. 70, 71, 74. At Sées, on the other hand, the Norman presence is demonstrable (see Chap. VI above).

51. Bertolt Brecht, "A Worker Reads History," in *Selected Poems*, trans. H. R. Hays (New York: 1947), p. 109.

52. Kurmann and Winterfeld, "Gautier de Varinfroy," pp. 101–59.

SELECTED BIBLIOGRAPHY

Art and the Courts: France and England from 1259 to 1328, exh. cat., National Gallery of Canada, 2 vols. (Ottawa: 1972).

Becksmann, Rüdiger, *Die architektonische Rahmung des hochgotischen Bildfensters* (Berlin: 1967).

Branner, Robert, *Saint Louis and the Court Style in Gothic Architecture* (London: 1965).

Brown, Elizabeth A. R., "The Chapels and Cult of Saint Louis at Saint-Denis," *Mediaevalia* 10 (1984), pp. 279–307.

La Cathédrale du Mans, text by André Mussat et al. (Paris: 1981).

Caviness, Madeline, *The Early Stained Glass of Canterbury Cathedral, Circa 1175–1220* (Princeton: 1977).

Cothren, Michael, "The Thirteenth- and Fourteenth-Century Glazing of the Choir of the Cathedral of Beauvais," Ph.D. diss., Columbia University, 1980.

Couffon, René, "Contribution à l'étude des verrières anciennes du département des Côtes-du-Nord," *Bulletin et mémoires de la Société d'émulation des Côtes-du-Nord* 67 (1935), pp. 65–228.

CV Checklist I, II, III: See below, *Stained Glass before 1700 in American Collections,* Corpus Vitrearum Checklist I, II, III.

CVFR I: *Les Vitraux de Paris, de la région parisienne, de la Picardie et du Nord-Pas-de-Calais,* Corpus Vitrearum Medii Aevi France, Recensement I (Paris: 1978).

CVFR II: *Les Vitraux du Centre et des pays de la Loire,* Corpus Vitrearum France, Recensement II (Paris: 1981).

CVFR III: *Les Vitraux de Bourgogne, Franche-Comté et Rhône-Alpes,* Corpus Vitrearum France, Recensement III (Paris: 1986).

CVFR IV: *Les Vitraux de Champagne-Ardenne.* Corpus Vitrearum France, Recensement IV (Paris: 1992).

Denholm-Young, Noel, *History and Heraldry 1254 to 1310* (Oxford: 1965).

La France de saint Louis, exh. cat., Salle des gens d'armes du Palais (Paris: 1970).

Frodl-Kraft, Eva, "Le Vitrail médiéval, technique et esthétique," *Cahiers de civilisation médiévale* 10 (1967), pp. 1–13.

Grodecki, Louis, "A Stained Glass Atelier of the Thirteenth Century," *Journal of the Warburg and Courtauld Institutes* 11 (1948), pp. 87–111.

———, *Le Vitrail roman* (Fribourg: 1977).

———, "Les Vitraux de la cathédrale du Mans," *Congrès archéologique* 119th session (1961), pp. 59–99.

Grodecki, Louis, and Catherine Brisac, *Le Vitrail gothique au XIIIe siècle* (Fribourg: 1984).

Gruber, Jean-Jacques, "Quelques aspects de l'art et de la technique du vitrail en France (Dernier tiers du XIIIe siècle, premier tiers du XIVe)," in Université de Paris, Faculté des lettres, *Travaux des étudiants du Groupe d'histoire de l'art* (Paris: 1927–1928), pp. 71–94.

Hayward, Jane, and Louis Grodecki, "Les Vitraux de la cathédrale d'Angers," *Bulletin monumental* 124 (1966), pp. 7–67.

Jordan, William Chester, *Louis IX and the Challenge of the Crusade* (Princeton: 1979).

Kraus, Henry, *Gold Was the Mortar* (London: 1979).

Kurmann, Peter, and Dethard von Winterfeld, "Gautier de Varinfroy, ein 'Denkmalpfleger' im 13. Jahrhundert," *Festschrift für Otto von Simson zum 65. Geburtstag* (Berlin: 1977), pp. 101–59.

Lafond, Jean, "Le Vitrail du XIVe siècle en France," in Louise Lefrançois-Pillion, *L'Art du XIVe siècle en France* (Paris: 1954).

———, "Le Vitrail en Normandie de 1250 à 1300," *Bulletin monumental* 111 (1953), pp. 317–58.

———, *Les Vitraux de l'église Saint-Ouen de Rouen,* Corpus vitrearum medii aevi France, IV-2 (Paris: 1970).

———, "Les Vitraux de la cathédrale de Sées," *Congrès archéologique* 111th session (1953), pp. 59–83.

Lefèvre-Pontalis, Eugène, "Eglise de Gassicourt," *Congrès archéologique* 82d session (1919), pp. 227–35.

Lesueur, Frédéric, *Les Eglises de Loir-et-Cher* (Paris: 1969).

Lillich, Meredith, "The Band Window: A Theory of Origin and Development," *Gesta* 9/1 (1970), pp. 26–33.

———, "Bishops from Evron: Three Saints in the Pitcairn Collection and a Fourth in the Philadelphia Museum," *Studies on Medieval Stained Glass,* Corpus Vitrearum United States, Occasional Papers 1, ed. Madeline Caviness and Timothy Husband (New York: 1985), pp. 93–106.

———, "The Choir Clerestory Windows of La Trinité at Vendôme: Dating and Patronage," *Journal of the Society of Architectural Historians* 34 (1975), pp. 238–50.

———, "The Consecration of 1254: Heraldry and History in the Windows of Le Mans Cathedral," *Traditio* 38 (1982), pp. 344–52.

———, "European Stained Glass around 1300: The Introduction of Silver Stain," *Die Akten des 25. internationalen Kongresses für Kunstgeschichte,* ed. Hermann Fillitz and Martina Pippal, 6 (Vienna: 1986), pp. 45–60, 287–90.

———, "Gothic Glaziers: Monks, Jews, Taxpayers, Bretons, Women," *Journal of Glass Studies* 27 (1985), pp. 72–92.

———, "Monastic Stained Glass: Patronage and Style," *Monasticism and the Arts,* ed. Timothy Verdon (Syracuse: 1984), pp. 207–54.

———, *Rainbow Like an Emerald: Stained Glass in Lorraine in the Thirteenth and Early Fourteenth Centuries* (University Park, Pa.: 1991).

———, *The Stained Glass of Saint-Père de Chartres* (Middletown, Conn.: 1978).

———, "Three Essays on French Thirteenth-Century Grisaille Glass," *Journal of Glass Studies* 15 (1973), pp. 69–78.

———, "The Tric-trac Window of Le Mans," *Art Bulletin* 65 (1983), pp. 23–33.

———, "The Triforium Windows of Tours," *Gesta* 19/1 (1980), pp. 29–35.

———, "Les Vitraux de la cathédrale de Sées à Los Angeles et dans d'autres musées américains," *Annales de Normandie* 40, nos. 3–4 (1990), pp. 151–75.

Mussat, André, *Le Style gothique de l'ouest de la France (XIIe–XIIIe siècles)* (Paris: 1963).

Papanicolaou, Linda, "Stained Glass Windows of the Choir of the Cathedral of Tours," Ph.D. diss., New York University, 1979.

———, "Thirteenth-Century Stained Glass from the Abbey Church of Saint-Julien at Tours and Its Parisian Sources," *Gesta* 17/1 (1978), pp. 75–76.

Raguin, Virginia, *Stained Glass in Burgundy during the Thirteenth Century* (Princeton: 1985).

Sanfaçon, Roland, "Un Vitrail de l'église Sainte-Radegonde de Poitiers, Scènes de la vie du Christ et Judgment Dernier. Deuxième travée de la nef, côté nord," Diplôme d'études supérieures, Mémoire annexe, Université de Poitiers (1959–1960).

Stained Glass before 1700 in American Collections: New England and New York, Corpus Vitrearum Checklist I, *Studies in the History of Art* 15, Monograph Series 1 (Washington, D.C.: 1985).

Stained Glass before 1700 in American Collections: Mid-Atlantic and Southeastern Seaboard States, Corpus Vitrearum Checklist II, *Studies in the History of Art* 23, Monograph Series 1 (Washington, D.C.: 1987).

Stained Glass before 1700 in American Collections: Midwestern and Western States, Corpus Vitrearum Checklist III, *Studies in the History of Art* 28, Monograph Series 1 (Washington, D.C.: 1989).

Strayer, Joseph, *The Reign of Philip the Fair* (Princeton: 1980).

Taralon, Jean, "Le Trésor d'Evron," *Congrès archéologique* 119th session (1961), pp. 307–19.

Transformations of the Court Style: Gothic Art in Europe 1270 to 1330, ed. Dorothy Gillerman, Rhode Island School of Design (Providence: 1977).

Le Vitrail en Bretagne, Inventaire général des monuments et des richesses artistiques de la France (Rennes: 1980).

Le Vitrail français, text by Marcel Aubert et al. (Paris: 1958).

Zakin, Helen Jackson, "Grisailles in the Pitcairn Collection," *Studies on Medieval Stained Glass,* Corpus Vitrearum United States, Occasional Papers 1, ed. Madeline Caviness and Timothy Husband (New York: 1985), pp. 82–92.

GENERAL INDEX

A separate Index of Monuments and Works of Art follows this General Index.

INDEX OF MONUMENTS AND WORKS OF ART